Capital
Culture

Capital
Culture

J. Carter Brown,

the National Gallery of Art,

and the Reinvention of the

Museum Experience

Neil Harris

The University of Chicago Press
Chicago and London

NEIL HARRIS is the Preston and Sterling Morton Professor of History and Art History Emeritus at the University of Chicago. He is the author of several books, including *The Artist in American Society*; *Humbug: The Art of P. T. Barnum*; *Cultural Excursions: Marketing Appetites and Cultural Tastes in Modern America*; and *The Chicagoan: A Lost Magazine of the Jazz Age*.

The University of Chicago Press, Chicago 60637
The University of Chicago Press, Ltd., London
© 2013 by Neil Harris
All rights reserved. Published 2013.
Printed in the United States of America

22 21 20 19 18 17 16 15 14 13 1 2 3 4 5

ISBN-13: 978-0-226-06770-4 (cloth)
ISBN-13: 978-0-226-06784-1 (e-book)
DOI: 10.7208/chicago/9780226067841.001.0001 (e-book)

Library of Congress Cataloging-in-Publication Data

Harris, Neil, 1938– author.
 Capital culture : J. Carter Brown, the National Gallery of Art, and the reinvention of the museum experience / Neil Harris.
 pages cm
 Includes bibliographical references and index.
 ISBN 978-0-226-06770-4 (cloth : alkaline paper)
 ISBN 978-0-226-06784-1 (e-book)
 1. Brown, J. Carter (John Carter), 1934–2002. 2. National Gallery of Art (U.S.)—History. I. Title.
N856.H37 2013
708.153—dc23

2013016602

♾ This paper meets the requirements of ANSI/NISO Z39.48-1992 (Permanence of Paper).

In memory of Barry D. Karl

Contents

Galleries of photographs follow pages 136 and 328.

Introduction

The last third of the twentieth century can easily claim to have been a museum age. Attendance growth, new foundations, building additions, architectural novelties, dazzling acquisitions, spectacular exhibitions, public subsidies, and dramatic promotions all combined to make the museum, the art museum especially, the subject of public conversation and extensive news coverage. To some extent this was a worldwide phenomenon, but nowhere was the trend more striking than in the United States, and nowhere more emphatic than in the capital, Washington, DC.

Washington's history, surprisingly perhaps, made it a natural museum site. Thrust abruptly onto a world stage in the early twentieth century, neither its climate nor its diversions seemed particularly attractive to sophisticated visitors. Unlike many of its storied counterparts abroad, the capital was relatively small, recently established, and without impressive institutions of culture and education. It housed no celebrated universities, no major opera or ballet companies, no famous orchestra. A fluid, somewhat permeable social structure and increasing political power did attract money, lobbyists, and ambitious newcomers. It enjoyed flourishing clubs, a major league baseball team (until 1971, and again since 2005), and a lively press. These were not enough to give it substantial cultural standing, particularly with the national metropolis a few hours away.

But by the 1930s, thanks to the Smithsonian Institution, the Library of Congress, and some munificent collectors like W. W. Corcoran, Charles Freer, Duncan Phillips, and Henry Clay Folger, Washington hosted a set of museums, galleries, and libraries that were unusual, in number and

quality, for a city of its size. The art displays may have been modest compared to those in London, Paris, and Berlin, but transformation loomed in 1941 with the opening of the National Gallery of Art. Andrew Mellon's gift, amplified by several other major art benefactions, provided the city with instant status in the museum world, and helped call attention to its growing cultural charms. It was certainly the smallest city in the United States to contain such impressive holdings.

These enterprises were stoked by private enthusiasms. The federal government itself, except for brief periods of crisis like the Great Depression, studiously avoided direct arts funding. Shamed, challenged, or impressed by gifts like James Smithson's and Andrew Mellon's, Congress did maintain the national museums, paying for staff and upkeep, but many lawmakers remained suspicious about the connection and skeptical about possible expansion. In the 1950s, however, increasing leisure and affluence, Cold War rivalries, communications changes, and government growth helped prepare for a shift of attitude. As worldwide confrontations with the Russians intensified, politicians found themselves leading an international coalition in defense of democracy. Culture famously became a weapon in this struggle, an instrument to influence foreign opinion by championing American achievements—in scholarship, science, music, architecture and, above all, cultivation of the arts. The suspicions of modernism rampant in the 1940s and early 1950s, which crippled early cultural interventions, slowly started to ease, although they remained much in evidence, particularly among congressmen.

Trends toward liberalization were clear even before 1960, but the Kennedy administration's cultivation of intellectuals and the new president's embrace of high culture signaled higher levels of support on the horizon. Plans for government nurture of the arts and humanities, as well as a national performing arts center in Washington—under discussion during the thousand days of John F. Kennedy's tenure (and even before)—were realized with Lyndon Johnson's active encouragement. The two national endowments and the Kennedy Center for the Performing Arts were among the fruits of this labor. The following decade saw creation of an institute to promote museum services as well. Largely unprecedented in scale as well as purpose, these actions reflected changing patterns of consumption in the country as a whole, and renewed debates about the significance of high culture and its merchandising.

Washington's great museum complexes, the National Gallery of Art

and the Smithsonian Institution, were poised to take advantage of congressional endorsement and private philanthropy. They exemplified the rewards of public-private partnerships. It could be argued that even without the appointment of two new leaders in the 1960s, both would have become central players in the expanding role played by American museums. But the lengthy tenures of J. Carter Brown at the National Gallery, and S. Dillon Ripley at the Smithsonian, held important consequences both for the cultural life of Washington and the character of the American museum world as a whole. These two opinionated patricians, cultivated, highly educated, self-absorbed, competitive, and authoritarian, transformed the practices and expanded the aspirations of their respective institutions, at the same time helping to reshape museum calendars and procedures throughout the country.

The National Gallery of Art, just two decades old when Brown joined the staff in 1961 (only three years before Ripley's arrival as Smithsonian secretary), had amassed an extraordinary art collection in that short period. Both for locals and for tourists from across the country, it occupied a special status by reason of its very name. This giant marble temple on the Mall faced and was abutted by buildings belonging to the much older Smithsonian Institution. Smithsonian secretaries and National Gallery directors enjoyed, by reason of their titles, easy access to the press, nationally and locally, to the point where they could become authoritative voices on a variety of issues and spokesmen for a series of professional causes. Nonetheless, few Americans would have recognized the names of Brown's and Ripley's predecessors, who maintained a certain level of self-effacement, a degree of snobbery, and an aversion to the press. Carter Brown and Dillon Ripley changed that. Their management styles, rhetoric, and gift for publicity allowed for easy identification and close association with the expanded world of museum experience. Both worked hard to increase awareness of and admiration for their respective institutions.

The book that follows concentrates upon Carter Brown, a museum director greatly involved with exhibition planning, acquisitions, and architectural schemes and backed by a small, deeply committed board of trustees, led during much of his time by Paul Mellon, the founder's son. Coming to prominence in the 1960s, Brown followed upon a generation or two of specialized museum administrators, many of them trained in Harvard's famous Fogg seminars, led by Paul J. Sachs. Achieving highly visible positions throughout the country, this group established stan-

dards of connoisseurship and professional control in the years just before and after World War II. Brown built upon their accomplishments but pursued a more aggressive merchandising strategy. His effort to expand audiences and diversify public involvement mirrored and oriented approaches elsewhere, lending legitimacy to more vulnerable institutions. Inhabiting a hothouse world of gossip and scrutiny, he recognized how personal promotion could dramatize issues of display as have few museum officials in America before or since. Only his archrival, Thomas Hoving at the Metropolitan Museum in New York, came close, and his directorship was far shorter.

The two chapters treating Ripley are meant to suggest a contrasting style of institutional management. Ripley's sway was imperial, but necessarily further removed from the practical challenges raised by a single museum operation. These last form the heart of this text, an inquiry into just how a major art museum adjusted to and helped shape changing public taste. It is Brown, by reason of his expertise and focus, who epitomizes the changing character of the American art museum.

Thus this book is centered on the National Gallery during Brown's tenure, using his life and career as points of entry and continuity. But rather than a narrative devoted primarily to personal history, it is an effort to write institutional biography, suggesting where and how one life story intersected with museum policies and programs, and by extension helped shape professional practices and reputations more generally.

Carter Brown's influence in Washington also rested on his multi-decade chairmanship of the city's Fine Arts Commission, a watchdog group originally created during Washington's early twentieth-century revisioning and appointed by the president. The commission was charged with evaluating additions and changes to much of the District's landscape, especially public monuments, government buildings on or near the Mall, and large portions of Georgetown. In this capacity, Brown felt responsible for protecting the capital's physical heritage and preserving the city's distinctive character. Controversial decisions kept him in the public eye for thirty years, as frustrated developers and preservationists warred with one another to get commission endorsement for their positions, and as planners sought to realize old schemes or introduce new ones.

Successful museum leaders must be many things, particularly in Washington: lobbyists, fund-raisers, diplomats, courtiers, budget managers, entrepreneurs, celebrities, and visionaries. Brown promoted his

programs and expanded his resources by persistently exploiting the networks opened up and sustained by family and social connections. A tireless promoter, at home in academic, political, and diplomatic venues, inveterately cosmopolitan, innately optimistic, responsive to new technologies and mass-media opportunities, he left an important if not fully realizable legacy, more fragile and perhaps less permanent than he might have hoped.

The confluence of political opportunities, strong personalities, and philanthropic munificence made this era special for Washington's great museums. It may also have made it unrepeatable. While crowds still march through exhibition galleries and new museums continue to appear, the pace of American expansion seems glacial compared with earlier decades. Only a few exhibitions compete with the scale and impact of the blockbusters of twenty, thirty, and forty years ago. Brown, along with Ripley, understood his moment and harnessed the ambitions of politicians, diplomats, collectors, and connoisseurs to his own. The intensity and comprehensiveness of the results they achieved may have been temporary. Their benevolence may at times have been questioned, and their methods have occasioned controversy. But they permanently altered the institutional life of the capital, and by extension, of the country at large. That is the story to be told here.

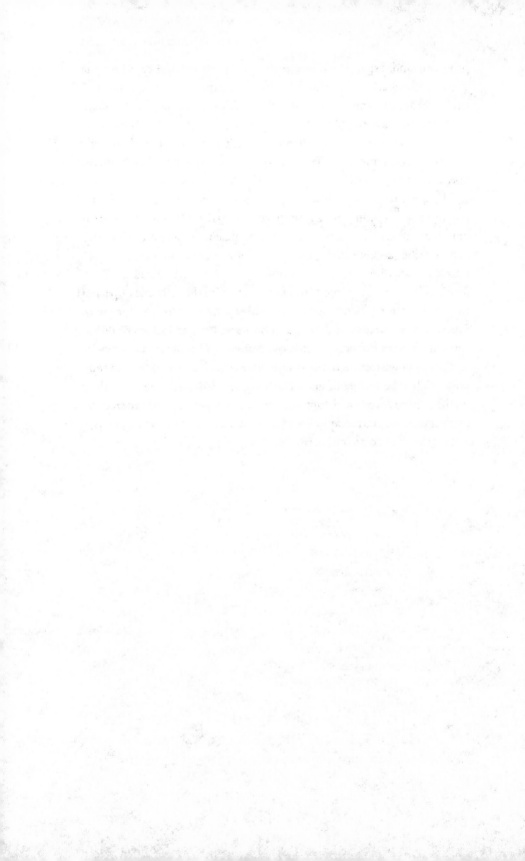

Becoming Carter Brown

F ew Americans of his day were born with more advantages than J. Carter Brown III. And even fewer were blessed, or burdened, with more self-consciousness about these privileges. Simultaneously well-born and self-made, he remains elusive as a private person, despite an extensive public record. The major biographical details have been assembled, cited, and reordered again and again, in service to his later career, but they continue to fascinate.

Carter's birth, in 1934, to John Nicholas and Anne Kinsolving Brown, the second of three children, commenced a life whose high ambitions, tightly woven discipline, and extraordinary energies were all driven by an acute sense of heritage and a nagging personal insecurity. The need to live up to, and perhaps move beyond, an inheritance of formidable social, economic, and intellectual dimensions, remained fundamental to Carter Brown's sense of personal worth. Some friends labeled his distinctive if highly scripted blend of personal frugality and utopian extravagance Puritan, a convenient though misleading label. Constraint and ecstasy can cohabit the Puritan sensibility, along with incessant introspection, though Carter's cultivation of a breezy optimism and generally cheerful public demeanor belie the label's usual implications. More to the point, the broad and seemingly limitless range of possibilities his early years afforded would feed his lifelong confidence in the redemptive powers of art. And that passion was certainly not Puritan in tone. If, as Louis Pasteur famously remarked, chance favors the prepared mind, extended preparation might make chance unnecessary. Carter Brown's

single-minded pursuit of ambitious goals left as little to chance as possible, though without his family connections his career path would have been much less certain.

The Browns of Providence had enjoyed local prominence, and even some national celebrity, since the seventeenth century.[1] Their deep involvement in the public and economic life of Rhode Island began almost immediately after the colony's establishment. The wide-ranging and sometimes conflicting activities of this large family—variously abolitionists and slave traders, merchants and manufacturers, bankers and philanthropists, speculators in western lands and investors in new technologies, China traders and connoisseurs—fostered extensive political involvement and cultural activism. Churches, libraries, hospitals, architects, artists and artisans, and, of course, the eponymous university all benefited from the family's attention and patronage. Collectors, builders, even architects themselves, they filled their great houses on Brown and Benefit Streets in Providence with elegant furniture, antiquarian books, and family portraits. Extensive possessions and large staffs of servants testified to their elevated social status and considerable fortunes, supplemented, in time, by elaborate showplaces at Newport, just a few miles away.

Academic and popular historians alike have reconstructed the complex genealogies, domestic alliances, and commercial strategies that underwrote this success. Carter Brown, coming of age in an era that publicly repudiated but secretly relished such unusual continuity, not surprisingly became a serious student of his family's history. With a retentive memory and a delight in the telling anecdote, he deployed details of his family's grand lifestyle masterfully, recalling encounters with relatives amid a series of uncommon establishments. Countless press releases and journalistic commentaries familiarized the public of his day with some of the more colorful particulars, as Carter moved up the ladder of advancement and collected a string of singular honors along the way.

There were, to be sure, some special circumstances worth attending. By the beginning of the twentieth century, the Browns of Rhode Island, despite their lengthy history (and some collateral branches bearing different names), had essentially devolved onto a single family line, centering on the person of John Nicholas Brown, Carter's father. As Carter once mused, contrasting his own family's compactness with the sprawling network of the Du Ponts of Delaware, had his father, an only child, died

early, this gifted and accomplished family line would, in essence, have come to an end.[2]

John Nicholas Brown, however, survived handsomely, emerging as the dominant influence and life model for his son Carter. Competition and emulation were as entwined in Carter's relationship to his father as the correlations he sought between their two lives. Carter's last great (and uncompleted) project, occupying time and attention during his final illness, was a joint biography-autobiography. "Braided Lives," as he tentatively titled it, was meant to highlight what he considered to be the many parallels that linked the two men, while acknowledging the undeniable contrasts that distinguished them.

John Nicholas Brown's own father and uncle had died within weeks of the boy's 1900 birth in New York City (under a Rhode Island flag his mother, Natalie Bayard Brown, had placed in the bedroom), giving rise to the epithet that stalked him for much of his life: "the richest baby in America," or even "in the world"! Whether or not this was true, John Nicholas would ultimately inherit a substantial family fortune—hundreds of millions of dollars, in today's terms. But just as significantly, he was heir to physical and intellectual qualities that would make him a force in several different worlds. Brought up under the careful and doting eye of his widowed mother, a cosmopolitan art lover of impeccable New York descent (Peter Stuyvesant was one ancestor, Colonel Nicholas Fish another) and independent (though decidedly Francophile) tastes, John Nicholas spent much of his boyhood in a stately, thirty-four-room mansion at Newport.[3] Supposedly he was tethered to his governess with a silk handkerchief, tied at the wrist, to guard against any lurking kidnappers. There had, in fact, been threats against the boy, and these would apparently continue. The great house had been designed specifically for this small family of mother and son by the noted American architect (and devoted friend) Ralph Adams Cram. Along with its elegant French references, Harbour Court, with its English orthography and gothicized outlines, testified to the power that the English Arts and Crafts movement, and the complementary appeal of the Anglican Church's Oxford movement, exercised upon several members of the Brown family.

Natalie Brown served as guardian for her son, under terms of the various trust funds that would be inherited by him. As a boy, he attended the Episcopalian-affiliated St. George's School in nearby Middletown, driven

there from Newport each day, his son Carter tells us, in a shooting brake. This schooling furthered both John Nicholas's religious interests and his aesthetic sensibilities. His cosmopolitan curiosities were nurtured as well by frequent and extended trips to Europe, taken with his adventurous mother, as well as more exotic journeys to Japan and the Middle East. Natalie Brown traveled with a retinue of servants, which included a personal physician charged with the care of her only son.

Natalie Brown's oversight would necessarily become less constant when John Nicholas matriculated at Harvard College. As an undergraduate, he lived on Cambridge's Gold Coast, enjoyed his own valet and chauffeur, and gratified his love of history and the arts, graduating with the class of 1922 after inventing his own concentration under the wider rubric of history and literature. This program, mingling study of the classics and the Middle Ages, left him with mastery of Latin and Greek, and broad interests in the visual arts. Barely into his twenties, and winner of a John Harvard Fellowship upon graduation, John Nicholas organized a tour of medieval Spanish sites, with a Rolls Royce and an attentive professor at his command. "No sooner had the last exam book been slammed closed than I was off to Europe armed with a Dago Dazzler," he told his classmates in their twenty-fifth-anniversary report.[4] Paintings and drawings were available. A keen eye and ample wallet produced some remarkable finds.

After a year-long trip to Europe and Egypt (mother and son were present as the tomb of King Tutankhamun was being excavated), and a brief but decidedly uninspiring stint in the family business, John Nicholas returned to Harvard to concentrate on art history. As a graduate student, he found open to him the legendary seminars offered by Paul J. Sachs, those innovative training sessions for the first generation of professionally schooled American museum directors and art curators. (During this period his mother purchased and renovated a residence on Commonwealth Avenue in Boston's Back Bay, to be closer at hand.[5] Natalie Brown continued to spend part of the year in her Boston home for much of the rest of her life.)

At ease in several languages, attracted by classical, Byzantine, medieval, and contemporary art alike, John Nicholas Brown faced few impediments to a professional or curatorial career apart from his own immense wealth and family obligations. At least six feet, five inches tall (his son pegged him at six feet, six and a half), striking rather than handsome,

with a long, deeply chiseled face, he cut an imposing figure. It was, however, his curiosity and zest for intellectual independence that distinguished him from most of his wealthy friends and contemporaries. He did share with some of his neighbors a passion for sailing, but outdoor athleticism was complemented by an absorption with art and ideas, by broad tolerances and genuine curiosity about the thought and work of others. Engrossed by music as well as art, and an avid student of church liturgy, John Nicholas Brown also found time to be psychoanalyzed in Boston (one unsurprising insight being his recognition of a "mother fixation") and to develop considerable enthusiasm for modernism, which during his years at Harvard came to enjoy the support of a lively and well-heeled group of students that included future National Gallery director, John Walker.[6]

Brown became a founding trustee of the Harvard Society for Contemporary Art in 1928, and the following year joined the Museum of Modern Art's Junior Advisory Committee, chaired by Nelson Rockefeller. The museum had been established that very year. Brown designed a modern bedroom for his mother's Boston house, purchased Paul Frankl skyscraper bookcases, and devised a bed whose headboard featured stylized skyscrapers.[7] Some years later, in the mid-1930s, he would even more firmly endorse modernist principles by commissioning from Richard Neutra, the Austrian émigré architect living and working in California, one of the earliest great modern houses on the East Coast, Windshield. Constructed on Fishers Island, where the Browns often summered, Windshield made them neighbors of John Walker and his family. Brown was also an active presence at the Rhode Island School of Design and in the late 1930s pressed for the appointment as director of the school's museum of Alexander Dorner, an innovative, even radical exponent of contextual display, who had just left his post in Germany.

By then, as well, John Nicholas was married and raising his own family. His wife, Carter's mother, Anne Seddon Kinsolving, was another of the powerful, self-assertive women that the Brown men, across generations, seemed to favor.[8] Anne Kinsolving's roots were in Baltimore and linked to several prominent families, although their economic level was far below the Browns. Her mother was a Bruce, a Maryland dynasty once occupying a status much like the Browns of Rhode Island, which would make Carter a cousin of Andrew Mellon's son-in-law, the future diplomat David K. E. Bruce. The Kinsolvings themselves were active communicants

in the Episcopal Church, Anne's father a rector at Old St. Paul's Episcopal Church in Baltimore. A number of other Kinsolvings had become bishops. When John Nicholas Brown met her, Anne Kinsolving, one of seven children, was working as a reporter for the *Baltimore News*.

She had already achieved a colorful reputation. Legend had her covering the funeral of Rudolph Valentino, driving a cross-country locomotive, becoming friendly with Enrico Caruso, drinking beer on a weekly basis with H. L. Mencken, and flying upside down in a plane over the Washington Monument with a military air ace. A violinist in the Johns Hopkins orchestra, she became in 1926, in the words of one sports journalist, "tennis's first personal press agent," working for French star Suzanne Lenglen and accompanying her on a lengthy American tour.[9] Her way with words earned many enemies; she once described a celebrated lady cellist as resembling "an enormous crab embracing an indifferent oyster."[10] A whirlwind courtship punctuated by dramatic events (Brown proposed to her in the hospital while she was recovering from appendicitis surgery) was followed by an elaborate November 1930 wedding in Baltimore, covered closely by the press as a major social event. Anne was twenty-four years old, six years younger than her new husband. After a yearlong honeymoon, which featured a world tour (during which, according to Carter, the couple read *War and Peace* aloud to each other), and accompanied, for part of the time, by her groom's mother and nanny, Anne Brown then moved into the celebrated Nightingale-Brown mansion at 357 Benefit Street on the elegant east side of Providence. The large wooden house had been owned by Browns since 1814. The marriage would end only with the death of John Nicholas some forty-eight years later.

Anne Brown shared her husband's musical passion, religious commitments, sailing ardor, and collecting sensibility. Her massive collection of toy soldiers—thousands of them—was begun during their honeymoon, and in later years she would assemble a library on the history of military costume. The horde of books and soldiers grew so large that John Nicholas designed mirrored cases and basement stacks, with dehumidification and special lighting, for the Benefit Street house. Anyone within reach was enlisted to help. Anne Brown even got her formidable mother-in-law to paint newly cast soldiers, in just the correct colors.[11]

Indeed Anne Brown developed a mastery over the minutiae of uniforms and medals that became legendary within the larger field, and on family tours could sometimes date obscure paintings that contained

military references with astonishing precision. Her acquisitions would form the basis of the Anne S. K. Brown Military Collection, now held by Brown University, comprising more than five thousand miniature soldiers and tens of thousands of prints, scrapbooks, albums, and books.

Both John Nicholas Brown and his new wife, then, possessed broad but precisely defined cultural tastes, enjoyed lofty social positions, and, initially at least, toyed with the idea of professional careers. After their marriage, Anne Brown even urged her husband to become an architect. Their personalities, however, were quite different. Intense, tough-minded, energetic, commanding, even intimidating, Anne Kinsolving Brown quickly grew into a dominating position in the worlds of Providence and Newport, and demonstrated throughout her life independence, high spirits, and a powerfully assertive sense of self.

Her husband, by most accounts, owned an easier, gentler, more amiable temperament, seemed more comfortable with himself and with open expressions of affection, and was adored and idolized by Carter and his siblings. Using a phrase from his grandmother, Carter remarked in 1985 that "my father was the smoother-over," while "my mother was the stirrer-up."[12] "Anne has often tried me," John Nicholas once put it, "but she's never bored me." "She's famous in Providence for being terrifying," said a less friendly commentator. Not all of her thousands of lead soldiers held fixed bayonets, but many of them did.[13]

The three Brown children, Nicholas, Carter, and Angela, grew up in this high energy household, connected by family, taste, money, and cultivation to a chain of intellectual and artistic circles. Nicholas Brown's birth, in 1932, was marked as a "Milestone" in *Time*.[14] Carter followed in 1934, Angela in 1938. There were trips to Salzburg to attend the premiere of Samuel Barber's opera *Vanessa*, visits with the Serge Koussevitzkys at Tanglewood, sailing expeditions aboard one of the family's famous yachts, and lengthy, extraordinarily detailed letters from John Nicholas and Anne Brown to their children, describing the exotic and extended trips the couple made throughout the world. The young Carter, impressionable and, by his own admission, theatrical, feasted on the sensory excitement. Moving seasonally through a series of great houses in Providence and Newport, attended by a considerable staff of servants and guardians, speaking, as he recalled, French before he spoke English (thanks to his French nanny), enraptured by the chamber music concerts his parents hosted, and absorbed by the masterworks on their

walls, Carter accumulated a range of impressions that lasted his entire life. Reminiscing just months before his death, he mused on the power of family protocols within the large, eighteenth-century frame house at 357 Benefit Street, recalling a silver tea set of 1791, the great Goddard-Townsend secretary that stood in the den, the red damask walls on which hung an El Greco painting and a Leonardo da Vinci drawing, family portraits, and a lapis lazuli desk set presented by the last czar of Russia to Thomas Whittemore, a family friend. The objects highlighted a range of domestic rituals orchestrated and dominated by his impressively accomplished parents. Formally dressing for dinner was a daily occurrence in the Brown household, and John Nicholas Brown's collection of velvet dinner jackets became legendary. Many evenings the children, when young, would join their parents before dinner for a shared cocktail hour (only the adults consumed alcohol), then would be taken away by some of the many servants (the French nanny had been succeeded by a Scottish nanny) for their own prepared meal.

The excitement hovering around the senior Browns' absorption in the arts, along with John Nicholas Brown's devotion to yachting and ownership of a series (supposedly twenty-one in all) of celebrated yachts, was accentuated by construction of Windshield on Fishers Island. This enormous, expensive, and innovative summer house—14,500 square feet, twenty-eight rooms, eight bathrooms—cost Brown more than two hundred thousand dollars during the heart of the Great Depression, several million dollars in today's values. With movie projection facilities, a children's dining room, play rooms, a music room, and, eventually, an elaborate soda fountain, Windshield was constructed, between 1936 and 1938, after a remarkably detailed mandate from Brown and his wife, delivered to the architect, Richard Neutra, in response to his questionnaire. The memorandum constituted, in effect, a detailed description of the family's daily lifestyle and ongoing needs, as well as a summary autobiography. Almost everything imaginable was specified, from the size and furnishings of the soundproof music room and the extended length of the ironing boards (testament to John Nicholas's height) to the bedside ashtrays serving Anne Brown's cigarette habit and the couple's taste for secluded sunbathing, along with comments about the site, the summer temperature range, and the size of their household staff.[15] The house became for Carter another wonderland, through whose precincts he expertly guided, as a child, the many visitors attracted by either the Brown family

or the home's novelty. "Years before I ended up recording Acoustiguides," Carter wrote, "I relished explaining the vertical circulation . . . demonstrating the innovative, high-tech sound system in the music room; pointing out the miraculous garage-door opener . . . peeking into the special rooms for drying clothes and sails, or for preserving Stradivarius violins."[16] Every detail of the house was imprinted on Carter's remarkable visual memory, available for almost total recall sixty years later.[17] Indeed Carter declared, as a result of this experience, his intention to become an architect, although his mother supposedly advised him on the need for another line of work since, she pointed out with characteristic candor, he could neither draw nor add.[18] Carter was, his sister recalled, an instinctive eclectic, placing modern objects alongside the period pieces that filled his rooms on Benefit Street. And at Harvard she remembered him building with his own hands a replica of their eighteenth-century home.[19]

Long before making any vocational decisions, however, Carter, with the rest of the family, went through the trauma of the great hurricane of September 1938, which blew the roof off of Windshield, severely damaged the house, and almost ended his life. Carter, age three, was awakened by his brother, Nicholas, to come and watch the storm. Only "minutes after," he recalled many years later, "the bed that I had been lying in was a mass of twisted aluminum and broken glass. The window walls on that side of the house had imploded. . . . So I really owe my life to my brother at that point," Carter declared.[20] This certainly made up for an earlier episode, recalled by Carter with glee many years later and the subject of family legend, in which Nicholas apparently tried to smother his younger brother in his crib but was thwarted by a nursemaid's quick actions.[21]

The devastating storm struck only weeks after the Browns moved in. Despite the cost and the disappointment, John Nicholas Brown quickly rebuilt Windshield (he wrote in a Harvard class report that it should have been renamed Won'tshield), and the family was able to return the following summer, 1939. But the Browns used the house only until 1941, when the United States entered World War II, and for several years after 1945, before Brown moved the family to Washington, where he served in a subcabinet position for the Truman administration. Although there were more periods of residence, John Nicholas Brown put the house up for sale in 1959, and after several years without a purchaser donated it to a

local club. Windshield had some major problems, as Brown told Neutra, and did not convert many of its neighbors to the cause of modernism. Even so, its fleeting service as a family home allowed Carter to develop some of the impresario-like qualities that would serve him so well in later years, and to start developing his command of architectural vocabularies. He delighted in the duties of a modernist cicerone, however precociously he performed them.

Carter's schooling began at Gordon School in Providence, but after the first two grades he attended St. Michael's School in Newport, where the family was living. A large and apparently devoted staff of servants—more than a dozen, both on Benefit Street and at Harbour Court—provided personal security. In the aftermath of the Lindbergh baby kidnapping the children of the very rich were forced to accept some close policing, a reprise of concerns from his father's childhood. Casual, unsupervised wandering was not possible. There were also, Carter recalled, some embarrassments. In the "early days going to school in Providence, when my father's chauffeur used to wear gaiters and a chauffeur's uniform," Carter would insist he be dropped off several blocks from the school and allowed to walk. "Too painful to have to be such a misfit!"[22]

The predictable pattern of New England schooling was interrupted, however, during World War II. Fears of asthma (in the case of Nicholas) and, Carter later argued, concern about the vulnerability of life in Newport, with German U-boats entering Narragansett Bay (presumably enticed by the presence of the Naval War College), led the parents to move both boys to school in the west. Carter had no medical reasons for going, but "Newport was in the cross hairs of the Nazi onslaught"; daily air drills and blackouts added to the sense of tension. Thus, at the age of eight, Carter was sent off to the Arizona Desert School in Tucson.

Sunny Arizona attracted other easterners, and the exotic landscape supported camping trips, horseback riding, and even polo. There Carter met Paul Matisse, the grandson of the painter Henri Matisse and son of the art dealer Pierre Matisse. The boys shared a craving for classical music and established a friendship that would last to the end of Carter's life. At midwinter breaks the elder Browns came for visits and organized family excursions. There were visits to the Grand Canyon, Sun Valley, and various other places, including Southern California, always in grand style. Connections and associations brought introductions to a series of Hollywood personalities, including Charles Brackett, Rhode Island–born

screenwriting partner of Billy Wilder, and the great director George Cukor. The family stayed in splendid fashion at the fabled Beverly Hills Hotel, and Carter's memories of the West, almost sixty years later, were fond and vivid.

But Arizona, with all its attractions, seemed unsuitable for long-term schooling to these northeasterners. So in the fall of 1946, Carter began the first of five years at Groton, in Massachusetts. Here, at one of New England's most famous prep schools, he discovered many of his intellectual interests and honed a fiercely competitive streak. He also began to battle with feelings of inadequacy and disappointment. He recalled graduating "first in my class; there were various prizes; but it wasn't hard because there wasn't that much competition." Some of his fellow students may well have been brighter, "but they were so bound up in athletics that they were doing that and it wasn't cool to be seen studying." Groton itself exuded a "philistine atmosphere," which discouraged introspection and excluded art history. In typical Brown fashion, Carter's parents gave the school a room with a phonograph, art books, and classical records, "a place where students could go and quietly listen or read on their own. I will never forgive Groton for quietly dismantling that room," he declared in later years.

Carter's own athletic ambitions were dampened by the first in a series of knee injuries and the discovery that he simply did not perform well on the playing field. He loved football, so long as he didn't have to touch the ball. "Anything that involves a ball I have great difficulty with coordinating!" he once told an interviewer. Nonetheless, athletics dominated Carter's memories of Groton. And it was as the manager of the football team, rather than as a player, that he obtained the glory of being "tossed in a blanket as someone who had helped win the St. Mark's game." "I felt so lucky and out of place at the same time."[23]

Indeed, Carter admitted to being quite unhappy during his Groton years, sensing that he was "just not accepted," even "laughed at." Two years younger than almost everyone else in his class, he dreaded feeling "like a misfit." He did become president of the Groton Dramatic Club, played clarinet in the band, took piano lessons, and sang, but even this was not enough. The experience of having earned his athletic letter as a manager seemed to Carter "metaphorical of my career, where I knew early on I wasn't good enough to be a practicing artist in any one of the art forms I was interested in." Despite childhood piano lessons, for instance, he was

never able to play as well as his mother. So instead he began searching for a different niche, a professional role in which his artistic sensitivity and managerial skills could be of service: "From a very early age I had doped out that's what I wanted to do with my life."[24]

In 1946, while Carter was enrolled in Groton, his father, a Democrat in a Republican social world (Natalie Brown had been a Democrat as well), accepted Harry Truman's offer to become assistant secretary of the navy, a post he would hold for three years. This was not his first experience with government service. John Nicholas Brown had spent part of the war years as an important member of the Roberts Commission, which worked with the army's Monument, Fine Arts, and Archives program to find, rescue, and eventually return the immense hoard of art masterpieces looted by the Nazis. Staffed by a legendary group of art historians, museum curators, and collectors, the commission had undertaken service that included exposure to physical danger, rancorous debates, and endless ego smoothing. All of this impressed and entertained young Carter, as did his father's labors in the Navy Department, where he struggled to assert the navy's continuing role in air power amid a fundamental reorganization of the nation's military forces.

The Browns moved part of their art collection to Washington to keep them company, and they acquired a taste for the city. Indeed, the cabinet assignment would lead to an encounter reported endlessly by the press decades later. Driving past the gleaming, new National Gallery of Art one day, Carter, still at Groton, turned to his parents and declared that it was the kind of place where he would like to work when he grew up. For a twelve-year-old, this was a somewhat unusual ambition, but Carter always insisted the incident was true and formed the moment when he had determined on his life's course. (His mother declared it had never happened.)[25] He had, at an earlier point, or perhaps about the same time, apparently played with the idea of becoming a minister, inspired partly by the gothic chapel at Groton. In either case, as Carter later confessed, spiritual values and evangelical purposes were important to him.

It was the notion of becoming a mediator, an interpreter, an intermediary between performers or artists (or athletes), on the one side, and a set of publics, on the other, that captured Carter's imagination and never surrendered it. This aspiration rested, even while he was young, on an assessment of his own qualities, as he understood them, and a sense of service as a family tradition. It may also have reflected some insecurity about

his own capacity for creative personal achievement, a nagging belief that facilitating, coordinating, administering, describing, or organizing the exploits of others was somehow less significant than producing his own. Despite an active life as a sailor and sometime riding enthusiast, musical performer, actor, and amateur architect, Carter occasionally betrayed some guilt about his function as a promotor and facilitator for the talents of others, although he pursued this role to the very end of his life.

Graduating from Groton at the age of sixteen, Carter, like his father before him, was accepted at Harvard, but his parents felt he was a bit too young to start college right away. "He is rather quiet and has a good sense of humor," his mother wrote to a prospective schoolmaster, "amenable to discipline, conscientious in his work and though no athlete . . . has a lively interest in sports." There was initial family agreement that he would spend a year at school in Winchester, not far from the sea. "France would not be right," his mother wrote him. "Too hard doing advanced work in a foreign language. Getting out of France in an emergency would be difficult." England was "another story. The English keep calm under stress and we have so many friends there who could look out for you in case of illness." If not Winchester, she mused, somewhat improbably, perhaps a midwestern agricultural college would be best.

Instead, in early 1951, a tutor at Magdalen College in Oxford suggested Carter be enrolled at Stowe. The choice proved apt. The school was housed in a magnificent country house with a legendary garden, designed in the eighteenth century by a succession of distinguished architects. Its beauties had been celebrated by generations of poets. While Carter found it "scary at the beginning," his headmaster wrote John Nicholas Brown, in October 1951, that the boy had already made a great impression. Ultimately Carter declared the experience congenial, and even inspiring, particularly the chance to live in a great eighteenth-century setting. To be sure, Stowe was another "jock-oriented" school, he reminisced, but he was able to fulfill athletic requirements by appearing in plays and became scorer of the cricket side, traveling to Harrow, Eton, Winchester, and other storied public schools with the team. There were also special highlights, like viewing the lying in state and funeral procession of George VI, guided by Leigh Ashton, director of the Victoria and Albert Museum, "an old family friend."

The year at Stowe, and in England more generally, would figure importantly in one of Carter's most memorable National Gallery exhibi-

tions thirty years later. And vacations with his family in Spain, as well as a summer excursion through the Continent, nurtured interests already whetted by reading, conversation, and the long letters that Anne and John Nicholas Brown had sent back from their travels throughout the world. A post-Stowe trip to Belgium and Carter's discovery of Flemish art in Bruges and Ghent created a lasting impression.

His *Wanderjahr* over, Carter entered Harvard in the fall of 1952. In typical family fashion, he ended up spending his first days at his father's suite at the Ritz in Boston, while Harvard sorted out a confusion in room assignments that would have had him living temporarily in the gymnasium. Freshman dean Skiddy von Stade interviewed two potential roommates, Charles Cunningham Jr. and Steven C. Swett, both settled in Thayer, a freshman dormitory, about their willingness to room with the son of a famous yachtsman, the owner of the fabled *Bolero*. Both Swett and Cunningham were sailors and expressed their eagerness to share a suite with the new arrival. On his fiftieth-class reunion Swett recalled the arrival of "the chauffeur-driven Chrysler," with Brown "full of enthusiasm" and accompanied by "an icebox, a rug, pictures to put on the walls and eventually a sofa."[26] Both Swett and Cunningham would become good friends and admirers.

Once settled, Carter discovered, to his delight, that there were others his age who shared his intellectual interests, a revelation after the athletics-dominated years at Groton. Active in the Eliot House drama group, the orchestra, and the Harvard Glee Club (of which he became president), he decided, despite his passion for the theater, not to spend much time on the stage. He worried about undergraduate extracurricular activities taking him over and "wanted to have a rational life and not be out in the wee hours in rehearsals and being battered about." The glee club had its stipulated rehearsal times, and he was able to organize his courses around that. In later years Carter wondered if he could have succeeded as a director or producer, but at the time he found it too big a risk. He sought something more stable, more fixed, more admired, and found it in museum work. There "was something about an art museum as an institution that could stand for something in its community," he told one of his many interviewers, "because the permanent collection was permanent, and it was there, and it gave cachet to everything you did." Unlike other forms of cultural administration, like foundation work, which involved "getting your kicks out of vicarious funding of other peoples'

creativity," to be "hands on with real objects and real creativity, in an art museum setting," that was satisfying. And so, in retrospect, the decision to abandon any undergraduate theater ambitions seemed to have been the right one.

Nonetheless, despite his developing commitment to a museum career, Carter was determined not to major in art history. Sitting through some lectures in the art history introductory class, he concluded, "This is a waste of my time. . . . I know all this stuff already." Instead, he followed the advice of at least one of the museum directors he talked to (his father's eminence gave young Carter access to almost anyone he wanted to consult), who suggested that a broad education made more sense at this point. This counsel came from Francis Henry Taylor, now back at the Worcester Art Museum after a stint directing the Metropolitan Museum of Art. Taylor suggested he do his undergraduate work in cultural history, go to Europe and "wash your eyeballs," and then go to business school.[27] So Carter entered Harvard's History and Literary program—an "elite field," he observed later. But while he did not major in art history, Carter soon met and began work with several members of that department, including a renowned specialist in Dutch painting, Seymour Slive, and his colleague in Italian Renaissance art, Jacob Rosenberg. Slive and another faculty member Carter got to know, Sydney Freedberg, would play important roles in later years at the National Gallery of Art. Carter also took classes with notable members of the English Department, like Walter Jackson Bate and Douglas Bush, and enjoyed the friendship of other faculty members like the master of Eliot House, John Finley.

Beyond gratifying his love for music, and his delight in the broader intellectual stimulation Cambridge offered, these undergraduate years do not seem to have played as large, or at least not as memorable, a role in Carter's development as those before and after graduation. His sharpening sense of mission, his focus on art museum work, threw much else into shadow, except for the glee club. Driven to academic success, he worked hard and with self-discipline, producing an impressive grade record as well as a summa cum laude senior thesis. Grades were important to him. His father, Carter recalled with some satisfaction, had graduated only magna cum laude. In one revealing anecdote told in later years, Carter remembered an embarrassing moment in Douglas Bush's Milton course. Just after the final examination he discovered, in conversation with another student, that he was meant to answer two questions, whereas he

had answered only one. "I made a rapid calculation. I said, 'If I did that perfectly, the highest mark I could get was a 60.' And after all that work in that course, which I loved." So he wrote a note to Douglas Bush, admitting the error and throwing himself on his mercy. Bush responded with an A. "He didn't have to do that," Carter remembered. "He was a sweet man."[28] Charm, intelligence, and social standing never eclipsed Carter's strong competitive urges, and he would do what had to be done to ensure victory, in contests great and small. His circle of friends provided intellectual stimulation, although it was probably dominated by fellow music lovers. But there are suggestions that full social success did not come easily, and that Carter was, at the time of graduation, relatively immature. Personal needs and desires seemed hostages to his professional quest.

This was exemplified by Carter's receipt, and ultimately his rejection, of Harvard's award of a Fiske Scholarship to study at the University of Cambridge. After four years of hard work, the chance to enjoy the decorous pleasures of life in a Cambridge college, Trinity in particular, might have appeared overwhelmingly attractive to a twenty-one-year-old senior. But Carter was intent on basing his decision on opportunity costs. A quick visit to Cambridge, and problems getting rooms in college, convinced him of its deficits. He had already passed an extended time in England, at Stowe, and the intellectual rewards of further residence seemed dubious. Thurston Dart, the famed harpsichordist, wrote that he would not be accepted as a student for a degree in music. He urged on Carter the study of fine arts or moral philosophy instead. A friend advised against sitting for the tripos examinations; lectures were generally poor, he continued, and the best thing to do was to obtain "research student" status. Carter determined to spend the summer in European travel and then start immediately on a two-year course at the Harvard Business School.

This decision was, from many standpoints, surprising. Carter's background and values were overwhelmingly humanistic, and he certainly had no plans to work in the business world. His normally supportive father urged him to think about a legal career instead, and at his father's urging Carter took both the law and business school examinations, doing better, he recalled, on the pre-law than the pre-business test. Carter believed, however, that museum administrators needed business training more than legal preparation, and he saw acquisition of an MBA as an essential step in his training program. This was a view that would gain pop-

ularity in later years, although most future museum directors contented themselves with shorter academic programs and avoided the formality of an actual business degree.

Getting into Harvard Business School was for most candidates probably harder than staying in. This had long been a standard pattern for the major universities. Typically, Carter took the work quite seriously. He acknowledged the continuing pressures but greatly enjoyed the case-study method, likening the "three cases a day" normally assigned to short stories. As subject matter, the Brown family entered both the case studies and the business history course, which Carter found particularly entertaining, and he also had time to cross-register and take Sydney Freedberg's course on seventeenth-century Italian painting. He enjoyed the intellectual juxtaposition and relished, as his father had before him, turning curricular rules upside down. "What it took to convince the bureaucracy to allow me to do that was as educational as anything I did!"

Business school was punctuated by two bouts of summer employment, the only gainful employment Carter would ever know aside from the National Gallery. Indeed, he had to obtain a Social Security number for the first time. One summer he spent working in the statistical quality-control department of a Warwick, Rhode Island, manufacturer, owned by a family friend. Protecting his identity by parking his Porsche blocks from the plant and using the name John C. Brown, Carter was outed by Providence newspaper coverage of his brother's wedding in Paris, in July 1957, which he attended during a brief vacation.[29]

The adventure of moving between two very different worlds, keeping each distinct from the other, recurred during a summer stint with a Wall Street broker in New York (again, a family friend and another avid sailor), where Carter was introduced to the arcana of municipal bonds. He lived in a small, non–air conditioned apartment and recalled, years later, "running down to that smelly subway every day to work, just craving Friday and getting on the train to New London, taking the ferry over to Fishers Island and those cool breezes."[30] Wall Street, and money-making itself, exerted little appeal for Carter, beyond exposing opportunities for corruption and providing some unexpected encounters with technology. Turned off by statistical summaries, it was the "things that had a human aspect" that turned him on. His only real memory of this episode came from the little green boxes that lit up when a telephone line was engaged in the brokerage office; the "green was so beautiful," he recalled, suggest-

ing "the depths of the sea, and of all my business experience, that is what I treasure most."[31]

Overall, it is unclear what benefits, beyond a credential, the Harvard Business School provided Carter in later years. Some of the gains were undoubtedly rhetorical. He would invoke his training on a variety of occasions, particularly when it came to organizational issues, personnel problems, and spatial planning. And he used it, in later years, when appealing to corporate executives who he hoped would subsidize major exhibitions. Certainly Brown's ability to read a budget and analyze revenue projections were enhanced, but more significant, perhaps, was his encounter with a slightly older business student, who would become a lifelong friend and adviser. This was the future management specialist Anthony Athos.

Tony Athos, as Carter admitted, was a source of fascination to him.[32] This was partly due to his formidable intelligence and management skills, but perhaps just as much because his background so dramatically contrasted with Carter's own. Born in Detroit and raised in Flint, Michigan, Athos had gone to work for General Motors. There, some executives quickly spotted his management skills. After earning a certificate in engineering from the General Motors Institute, he came east for the first time, upon being granted admission to the Harvard Business School. Athos thrived at Harvard, earned selection as a Baker Scholar (limited to the top 5 percent of each class), and eventually became the dean of admissions and holder of the Straus Chair of Business Administration. As a dean in the late 1960s, Athos transformed the makeup of the student body, radically increasing the representation of women and minorities. He also became celebrated and well published as an analyst of Japanese business practices and served, in later years, as a consultant to corporate management undertaking major changes.

Aside from serving as source of inspiration and sometime adviser to Carter, Athos functioned as a plain-talking, devoted friend, whose letters over the years mixed affection and criticism with occasional doses of envy and high-minded self-righteousness. Socially awkward and bewildered by the complexities of the Brown household, which he visited several times, he marred his first appearance there by shaking hands with the butler. Treated with some hauteur by Carter's mother, who increased his sense of social insecurity, Athos told Carter at a later point that he considered Anne Brown a "piranha," and the source of many of Carter's

personal problems, particularly his relations with women.[33] None of this, apparently, put Carter off; he turned to Athos for help on matters large and small, and after installation as director of the National Gallery commissioned a reorganization study from him.

That lay, however, in the future. In his final year at business school, 1957–1958, Carter had begun to work out the next steps of his professional "grand design," proceeding with the meticulous care of a military strategist to determine the next steps of his training. In doing so, he was able to enlist several of the most eminent art historians and museum directors in the Western world. His father's wealth, social position, public service, institutional philanthropy, and broader reputation opened any door Carter chose to knock on. Intense, amiable, and ambitious, the would-be museum administrator conducted, in effect, a one-man study of the state of American art history in 1958, and its relevance to a museum career. His notes on interviews and his correspondence document some fascinating commentaries.

While he had initiated many contacts earlier, Carter got going at full speed in the fall of 1957, visiting his earlier mentor in Worcester, Francis Henry Taylor. Taylor, who would die unexpectedly not long thereafter, urged Carter to get a PhD, which he insisted was a union card for future advancement. (Taylor had not completed his own degree at Princeton.) Unfortunately, Taylor found no place in America worthy of Carter's attendance.[34] The German refugees who had lent their distinction to the faculty of New York University's Institute for Fine Arts were dying off, and that had been the most promising possibility. Europe, alas, wasn't much better. Germany and Rome Taylor dismissed. The Ecole du Louvre, while it held some figures of distinction, lacked prestige, and the Sorbonne was politically rotten. That left only the Courtauld Institute of the University of London, which Carter, Taylor thought, could combine with volunteer work at museums. In the end, Carter might look forward to a job at the National Gallery or the Metropolitan. The MBA was a big help "to get through the chores," and Taylor reiterated his earlier belief that a fine arts major would have limited Carter's possibilities. A knowledge of history was the main thing. Museums, he continued, stood at a crossroads, at the beginning of a struggle for independence that universities had won a generation earlier. They would be in a fight for survival as they sought to end the era of robber-baron patronage. Taylor found summer jobs to be superficial and palliative. Instead, he urged Carter to get more

business experience, collect art "up to the capacity of your means," and make himself unique and precious to a future museum employer. Carter's background, without any further education, was already "of a sophistication almost unique in America."

Much as he admired Taylor, something of an iconoclast in the American museum world and famously sharp-tongued, Carter decided to seek further counsel. For a time he did take solemnly the advice to pursue a PhD, focusing, despite Taylor's skepticism, upon Yale, Columbia, and New York University's Institute of Fine Arts, along with the Courtauld. As usual, he worked the top levels for further information and advice. He wrote professors George Kubler at Yale and Craig Hugh Smyth at NYU, noting in his letter to Smyth that "my father mentioned seeing you recently. He often talks of the Monuments, Fine Arts & Archives days with great warmth."[35] An interview with John Coolidge, sometime director of the Fogg Museum and a senior art historian at Harvard, led to further advice.[36] Yale was like an hourglass, Coolidge told Carter, good at the freshman level and in seminars, but ineffective in between. Its faculty had become too ingrown. NYU students took a long time to get their degrees because they interspersed education with jobs, needing the money, but that was not necessarily bad. Princeton was a gamble because of recent retirements, and Coolidge saw Carter as an urban type, in danger of suffocation in a sylvan retreat. And the Courtauld, while blessed with good staff, was better for high-level work than for its underpinnings. He advised Carter to cultivate connections and be certain to pick out the best men in his field for recommendations. The facts of life, he concluded cynically, "are that the demand for you varies in proportion to your ability to do a television series."

Charles Cunningham, father of Carter's Harvard roommate, director of the Wadsworth Atheneum in Hartford, and one of the first American graduates of the Courtauld, responded to Carter's letter by allowing that European study would bring him closer to the sources.[37] But since Carter had grown up with art and already undertaken lots of travel, perhaps he could find academic happiness as easily in the United States. A Harvard or Yale MA might be appropriate. If Carter wished to move ahead with a PhD, it could be done in Europe, but Cunningham disagreed with Taylor that a PhD was as critical in museum work as it would be in teaching. In effect, Cunningham urged the course Carter eventually took. In another

sign of the closely knit museum world of that day, he told Carter he was staying with John Walker, the National Gallery's director, when John Nicholas Brown telephoned to discuss his son's interest in going into museum work. Walker, in turn, having also been contacted by John Nicholas, wrote Carter that he had contacted the British art historian Anthony Blunt about the possibility of his studying at the Courtauld.[38] Since Blunt was in Washington at the time giving the Mellon Lectures at the National Gallery, a telephone call was easily made. The network of connections was apparently endless.

The Courtauld, however, proved a tough nut to crack. Since Carter had not been an art history major, the Board of Studies would have required him to do at least a year's work there and pass a qualifying examination before recommending registration.[39] This despite the good wishes and support of Kenneth Clark, a former director of London's National Gallery. Six years at Harvard were insufficient. Perhaps, Carter speculated much later, they considered it a colonial university. When, in later years, the Courtauld would ask him to head a benefit or some similar task, Carter declared that he would tell them, "I've been a lot of places that I owe, but I don't owe you a thing!" Disappointed, he postponed any decision to apply, but he stayed in touch with Anthony Blunt, proposing a meeting in London later that spring.

Meanwhile, the great connoisseur of Italian painting, Bernard Berenson, had himself contacted John Nicholas Brown, urging Carter to come as soon as possible and to stay at least a year or two at his villa outside of Florence, I Tatti. "It is constant contact, discussion, working together that counts," though "all this is by way of suggestion," Berenson added. "I have no desire to clamp my will and authority on anybody."[40] Certainly the notion of Carter's spending time with Berenson would have appealed to John Walker, who had put in a lengthy Florentine apprenticeship with him years earlier. "It's a shame that Carter can't combine the Courtauld and I Tatti," Walker wrote John Nicholas Brown.[41] "As your father doubtless has told you, I am very interested in your choice of a career, and I want to be helpful in any way I can," he wrote Carter about the same time.[42]

Bolstered by these expressions of confidence from the leading lights in the field, if perhaps a bit confused by the competing visions they offered, in the end Carter would combine academic and applied experience. First he took the year off for travel and further investigation of the

possibilities for European training. In the late spring he arrived in London, where he asked Ernst Gombrich, the Viennese-born art historian who had achieved celebrity with his much read *The Story of Art*, to serve as his mentor. Gombrich, however, declined. Further undergraduate work (the Courtauld requirement) seemed absurd to Carter, so, with some reluctance, he abandoned any thoughts of enrollment.

There were, however, friends accessible in most of the capitals of Europe who were eager to entertain, instruct, or divert the young art history apprentice. So Carter began to move from place to place, drawing on his family's extensive social contacts and his own charm. Part of that summer of 1958 he spent in Munich, improving his colloquial German, acquiring a girlfriend, and sailing with newly acquired acquaintances. Then it was off to Florence, waiting on Berenson. In typical fashion, Carter was ahead of the curve. He had already met the great man two years before, when the Harvard Glee Club had given a private performance at I Tatti. In conversation with Berenson, Carter had invoked his father, the Byzantine Institute, and anything else he could think of to impress the celebrated scholar. Apparently he did so.[43] Two years later, Carter confessed he expected to "cash in" on the invitation quickly proffered and to be invited to work with him. He came to Florence and waited his turn. There were some delays, but finally he was asked to lunch with Berenson. Nervous about the interview, Carter wrote his parents that, with Berenson staring intensely at him "I felt like a Taddeo Gaddi behind a Giotto label." But then things loosened up. "From then on it was like rolling down hill and when I got to the bottom I felt without any way of knowing that it had been a complete success." Berenson told him that he must "look, and look, and look, until you are blind with looking. And from this blindness comes illumination." He wanted Carter "to stay all the time."[44] Berenson wrote John Nicholas Brown that of all the young people whose art studies he had tried to direct, "none of them was remotely as gifted as Carter." His ideas were "startlingly original," and having him stay at I Tatti was "sheer delight."[45]

The Florentine apprenticeship would, however, turn out to be brief. Carter left his Florence pensione, spending several months at the villa, punctuated by visits to other nearby celebrities, and engaging in extended conversations with the fabled but elderly connoisseur. He was stimulated by I Tatti's atmosphere, "the most profoundly affecting of similar duration in my short life." But communication with Berenson was

"splotchy," evidence of his "decline in powers."[46] After a while, "I recognized that I really needed to get away from I Tatti," Carter told an interviewer many years later. "Berenson was getting older—he was like someone in the hospital who would rally, if you could stimulate him." It was essentially a "laying on of hands, and he was a walking time machine—he could reminisce about Henry James and Matisse." Admiring and respectful as he was of Berenson, Carter determined to move on.

Returning to France, he enrolled as an auditor in the Ecole du Louvre, one of the places that Henry Francis Taylor had proposed as a possibility. He moved in with his French relatives for a time, and later took his own apartment—a space once owned, Carter bragged, by the poet, novelist, and playwright Jean Cocteau. While taking three courses and improving his French, he enjoyed social diversions like a dinner in his honor at the home of Baron Philippe de Rothschild, at which the guests included the Sorbonne art historian André Chastel.[47] Carter's resources allowed him to make field trips across the Channel to examine Sumerian reliefs in the British Museum and, after a course in Egyptian art, to travel to Egypt during spring vacation. In the summer that followed he studied in Holland, earning a certificate from the Netherlands Institute for Art History in the Hague, and learning some Dutch.

In the fall of 1959 Carter returned to New York to begin work on what would turn out to be his final degree program, at the Institute of Fine Arts on Fifth Avenue and East Seventy-Eighth Street. His statement for the NYU application had declared, somewhat portentously, that "in an age of increasing leisure time and material well-being it is the responsibility of our museums of art to assume a growing role as a cultural force in their communities." This was still, after all, the 1950s, the Eisenhower era, when decades of prosperity were expected to bring with them their own special but solvable problems. His business administration training formed the first part of his effort at preparation, Carter continued. Now he hoped to obtain, in a rigorous academic setting, a more disciplined and comprehensive knowledge of the history of art, "which has been acquired so far primarily through travel and study on my own." With his French and German retouched, some newly acquired Dutch in hand, a set of adventures behind him, and renewed familiarity with most of the great museums of Europe, Carter took up residence in Manhattan.

After passing a comprehensive examination at the start of the program (Carter later boasted that most students took the examination just before

finishing the degree), he began his classes and in the fall of 1959 moved into an apartment at 8 East Seventy-Ninth Street, just a block from the imposing former James B. Duke mansion, which functions as the Institute of Fine Arts' headquarters. The assembled students included several who would go on to distinguished careers in the worlds of scholarship and museum administration. And the presence, just a five-minute walk away, of the greatest art museum in America, filled to overflowing with the trophies of wealthy New Yorkers and soon to undergo an immense expansion, certainly quickened the spirits of the participants and raised the stakes of the game.

The Metropolitan Museum of Art served—and still serves—as the Institute's training laboratory, curatorial seminars introducing students both to museum practices and to the vast range of art objects being sheltered and displayed in its galleries. Reflecting a long-standing interest in seventeenth-century Dutch painting, nurtured earlier by Seymour Slive at Harvard, Carter chose to do his master's essay on the painter Jan van Goyen, convinced it would be the first part of his PhD thesis. He was still planning to complete a doctorate, following up on Francis Henry Taylor's advice, as well as the adage of another celebrated museum director, Fiske Kimball of Philadelphia, who had once remarked, "It's easier to get your PhD than to explain why you haven't got it." During Carter's first year of residence at the Institute of Fine Arts, Slive proposed that he attend another summer session at the Netherlands Institute but warned him not to choose van Goyen as a thesis subject until learning more about the painter; Slive recommended several additional artists and texts to examine.

In New York, as elsewhere, charm, family connections, youth, and intelligence brought a wide circle of influential connections, including the friendship of Charles and Jayne Wrightsman, renowned collectors and, in time, a major force at the Metropolitan. The two years in New York were also active socially, in contrast to his lengthy Harvard years. Carter, according to the recollections of others and as confirmed by his correspondence, loosened up considerably, taking more time off for recreation (and dating), returning now and again to visit old friends and loves in Cambridge, while furthering his long-standing reputation for personal frugality. He recalled one evening when he picked up a classmate for an excursion and took her to the bus stop. "You know," she complained, "the usual thing if you take someone out is you actually spring for a taxi!" That

was something Carter did not like to do, at least with his own money. Friends predicted that his inclination to thrift—or even parsimony— would never change. They were right.

The emotional climax to the Institute years came when Carter scored another of his classroom triumphs, an incident that would be affectionately recalled in years to come. As one of their last exercises, students were asked to identify and purchase, for less than 125 dollars, an art object worth exhibiting, and then make a presentation. After seeking the advice of Cooper Union curators, identifying appropriate dealers, and then scouring flea markets, Carter made a lucky find, some textile shreds he suspected might be important. Placing them on a stretched canvas, he was able to present an entire repeat of an important eighteenth-century Indian fabric.[48] He gave his requisite speech, but that was the least of it. One of his classmates recalled, years later, the extraordinary sight of young Carter appearing in class, his trophy textile carried in an anonymous-looking bag by none other than James Rorimer, the director of the Metropolitan Museum of Art (to whom Carter would later present it as a gift). The experience left an impression of wonder that remained undiminished almost fifty years later.[49] Even by the lofty standards of the Institute, this was something of a coup!

Certainly Carter's professional future had been assured long before he completed his degree. Museum directors across the country, few of whom could have been unaware of his professional progress, must have been looking at Carter with the hungry expectations entertained by a major league manager enthralled by the reputation of a dazzling minor league baseball player. Never hesitant to exploit the wealth of contacts he had available, Carter followed up his opportunities. He initiated a correspondence with Thomas Howe, director of the Palace of the Legion of Honor in San Francisco and then president of the American Association of Museums, whom his parents had recently visited and to whom Carter had sent some exotic jams and jellies. And he stayed in touch with Leslie Cheek Jr., the energetic and innovative director of the Virginia Museum of Fine Arts in Richmond. Carter didn't spare the flattery. "To the extent that institutional hero-worship is possible," he wrote Cheek, "I'm afraid I've got it bad for the Virginia Museum," which he called the most interesting museum in America.[50] Cheek, a trained architect, had startled veteran museumgoers with his theatricality, putting his guards into costume, employing vignetted spotlights, and developing "sensur-

round" galleries. His aggressive approach to installation remained long in Brown's memory, and years later he would publish a tribute to the Virginian.[51]

Opportunities were multiplying. The director of the Detroit Institute of Arts, Edgar P. Richardson, had, according to Carter, already offered him the opportunity to lead its Founders Society, the support group that subsidized this publicly owned museum.[52] And, Carter claimed, he had agreed to take the job.[53] But that commitment was a brief one. The Midwest would probably only have been a detour, and John Walker—old family friend, sailing companion, Fishers Island neighbor, and personal adviser—was determined to enter the chase. He had already served as a go-between for Carter and Anthony Blunt, and on a visit to New York he had asked Carter if he would like to head the National Gallery's education department. When Carter insisted that he wished to pursue a doctorate, Walker invited him down to Washington for a National Gallery opening. Meeting with him at his Georgetown house, in December 1959, Walker pressed his case. When asked what he wanted to do with his life, Carter responded, "I would like to be director of a museum in some small community around the United States, where I could build in the performing arts and literature as well as the visual arts, and make it as a kind of cultural center for the community." Using the same argument Carter would employ decades later in appealing to collectors across the United States for gifts, Walker responded, according to Carter's recollection, "Well, that sounds good. How would you like to do that for the nation?"[54]

Walker was really searching not for a museum educator but for a personal assistant and, quite probably, an eventual successor. The decision was actually, Carter insisted in recollection, more difficult than it seemed later. He certainly wanted to complete his master's degree, and that meant finishing the thesis. He told Walker that the earliest he could come to Washington was the end of the summer of 1960: "I've talked the question over with my parents, " he wrote, "who agree strongly that, in view of the fact I do not even have an undergraduate degree in the fine arts, that I should not give up this undertaking once started."[55] An agreement was worked out. Carter moved to Washington but returned to New York on a leave of absence to complete the thesis. Walker, Carter argued later, would have hired someone else if he had not accepted.

In fact, the same month Walker was talking to Brown, he was also in contact with Francis Keppel, dean of the Harvard School of Education,

about becoming his assistant director. In a letter to Keppel, Walker emphasized the National Gallery's educational possibilities, proposing that Keppel try it out for a year, to see what the museum was like.[56] Keppel was twenty-two years older than Carter and had entered Harvard in 1934, the year of Carter's birth. It would certainly have been an interesting if unusual choice. Keppel did have some art background; he had studied at the American Academy in Rome after graduation. Deeply engaged in fund-raising for a new education building at Harvard, Keppel declined Walker's offer—"a very lively interest resisted by prior commitments"—although he would come to Washington in 1962, as John F. Kennedy's commissioner of education.[57]

Apparently Carter didn't know about this exchange with Keppel, but, after browsing National Gallery files, he claimed that Walker had been in touch with Charles Cunningham about joining him in Washington. Cunningham had been directing the Wadsworth Atheneum in Hartford for more than ten years; just a few years later he would be appointed director of the Art Institute of Chicago. Carter insisted that Cunningham was the next on Walker's list, and would have been offered the job had he turned it down.[58]

If the offer was indeed made, it is unclear whether Cunningham would have accepted it. And had he (or Keppel) accepted, it would not have been the same job that Carter Brown was offered. Cunningham, after all, had far more experience and, indeed, had offered Carter career advice several years earlier. Of distinguished New England lineage, he fit nicely into the National Gallery's social circle. A veteran of Paul Sachs's museum course at Harvard, Cunningham was just a few years younger than Walker. Presumably, then, this would have been a deputy or assistant directorship, something Carter would not achieve for several years. But even so, that a job search might have placed a twenty-five-year-old student with no administrative experience ahead of the director of a major American art museum suggests some of the special circumstances surrounding the leadership of art museums, as well as the extraordinary promise hovering around Brown's career. Eager to have Carter join him, Walker was prepared to mold the job to meet his limited experience and to abandon the prospect of adding to his staff an accomplished professional. When, more than a decade later, Carter assumed the directorship, he did not hesitate to select as his own deputy a senior, and much older, museum administrator.

The two years in New York had added considerably to Carter's self-confidence and social skills. Letters suggest a widened circle of friends, active dating with women in both New York and Cambridge, and some torrid love affairs. While he continued to travel and tour museums elsewhere, in Europe and America, it was in New York that he underwent his only sustained experience of art historical study, completing a broad range of courses in the history of European art—French, Spanish, Dutch, Italian—along with hands-on training at the Metropolitan Museum. Following this track, Carter was able to become more knowledgeable about certain aspects of installation, particularly issues of museum lighting, that would remain of interest for the rest of his life.

This academic training was shortened by his acceptance of John Walker's offer, but it provided the basis for the next thirty years of public commentary and curatorial judgments. Throughout his professional career, Carter presented himself as someone whose training straddled two worlds—academic and business—and in a literal sense it had. But while stints at Harvard Business School and the Institute of Fine Arts provided the appropriate vocabulary and credentials, neither would be the basis for his success in years to come. This rested on other sources. Carter would champion scholarship, in later years, as a planner for the National Gallery's research center, and as a commissioner of exhibition catalogs. He valued scholarly judgments, admired the pursuit of knowledge, and was not above presenting himself, in public, as a member of the learned priesthood, dedicated to the painstaking pursuit of insight and illumination. Interviewers, usually journalists, were transfixed by his demonstrations of erudition, which reflected his powers of concentration, phenomenal recall, and capacity for interpretive regurgitation. In fact, Carter published almost nothing of scholarly merit and probably lacked the patience or even the desire to spend long hours in systematic research. But his retentive memory, analytical skills, witty repartee, and command of languages allowed him to adopt the role of middleman, once again, translating the arcana of specialists for the sometimes dazzled journalists whose job it was to explain the mysteries of high art and high society to curious readers. In such settings Carter appeared, inevitably, to be a dutiful scholar himself.

With modest writings behind him, Carter never served in a formal curatorial position. But he understood what advanced scholarship was about, admired its pursuit, and endorsed its central importance to the

ongoing work of the museum. Like his father he felt at ease in the company of academics, and like his father he was frequently in a position to be of considerable assistance to them. In various ways Carter helped bring the expanding possibilities of scholarship to the curatorial staffs of art museums, extending to them some of the possibilities for leave and research support that were taken for granted by successful faculty members. Indeed, while serving his apprenticeship during the expansive 1960s, he worried that the lure of university life might leave museums without the intellectual talent they needed. Competitive though he was in so many ways, he never seemed defensive about the scholarly achievements of others, once he had decided just what his central mission would become.

And that mission, again, was to transpose, translate, mediate among sets of sometimes oppositional constituencies—museums and their visitors, artists and businessmen, scholars and corporate funders, curators and installation designers, architects and clients, lenders and recipients, foreigners and Americans, benefactors and beneficiaries, politicians and administrators—ambassadorial functions whose success depended less upon any specific fund of knowledge and more upon an ability to keep all sides responsive and mutually supportive. By temperament this was what Carter most enjoyed doing: exercising leadership by mobilizing the energies of others, through inspiration as well as example, serving as an honest broker whose satisfaction rested upon the larger achievement and greater glory of the institution he would work for. He may not have been "good enough to be a practicing artist," he told an interviewer, but he sought a role where he could "bridge the gap between the arts and the public."[59] There were moments, to be sure, when this must have seemed an inadequate fulfillment of his gifts and great advantages, but they were usually tamped down by the excitement of the task at hand.

At the age of twenty-seven, then, Brown's preparation for museum work was complete. While it did include some formal training in both business and the arts, the credentials it yielded, however frequently invoked by him and in press accounts, were not fundamental to his future. They were enabling rather than defining. Carter's most important special talents were the results of heredity and upbringing rather than higher education: early, continuous, informed exposure to the arts writ large, an attractive and ingratiating physical presence, well-established social and familial connections, a pedigreed profile highly visible to the world

at large, a facility for foreign languages, a sharp eye, an extraordinarily retentive visual memory, an extended, even astonishing capacity for verbal expression, an enormous, seemingly inexhaustible fund of energy, and an optimistic, sometimes overwhelming sense of personal mission. He owed his deficits to the same sources: doubts about his own self worth, reluctance to let his feelings about others show, an assumed mask of perpetual exuberance and cultivated innocence, a discomfort with casual social encounters, a need for concentration that discouraged him from maintaining easy eye contact with others, a continuing thirst for approval, a craving for control and admiration, as well as an intense ambition that kept him, for many years, from committing to long-term relationships. With these assets, most of them clear, and accompanying debilities, not all of them fully apparent, he moved to Washington permanently in 1961, to commence an affiliation that would soon attract considerable attention and propel him forward upon a career of professional influence and popular celebrity.

The National Gallery

Directions and Deviations

The city of Washington, with its dense network of cultural institutions, stood on the eve of several revolutions when Carter Brown arrived in the summer of 1961 to serve as John Walker's personal assistant at the National Gallery of Art. Coming barely six months after the presidential inauguration of another New Englander, John F. Kennedy, Brown's move from New York began more than forty years of continuous involvement with Washington life and culture. He would serve as the city's champion through a period of striking transformations, many of them rooted in a set of demographic shifts, political events, and legal decisions that were reshaping local as well as national consciousness. These trends had been ongoing at least since the end of World War II, going back in some cases to the 1930s and even earlier. But they had deepened during the later years of the Eisenhower administration, most notably through Supreme Court decisions on racial segregation, the growing civil rights movement, and the cultural ambitions attached to service as a Cold War capital.

The District of Columbia's unusual relationship to national political traditions was underscored by its colonial political status, which in turn was reemphasized by its racial makeup. Not until final passage of the Twenty-Third Amendment to the Constitution in 1961 did residents get an opportunity to vote in presidential elections, and it took another thirteen years, and several acts of Congress, before a home-rule bill created a more typical mayor and city council structure for city governance. But many fundamental decisions about the District of Columbia's finances

and development still lay in the hands of a congressional committee, and the federal establishment, with its enormous work force and control over much of the city's real estate and infrastructure, remained the single most important element in shaping the city's character.

The struggle to achieve some measure of self-government, which attained some successes in the 1960s and 1970s, was closely linked to increasing self-awareness among the community's African-American members. Until then, despite their majority status, they had been given little opportunity to exercise power. Although Washington's anomalous political status owed something to eighteenth-century constitutional debates, state rivalries, and anxieties about governmental despotism, there is little question that in the twentieth century its growing African-American population predisposed many congressional leaders to oppose municipal self-government. Through the mid-1950s Washington retained a high degree of racial segregation in many areas of institutional life, moderated to some extent by federal facilities and their practices. The frustrations and tensions thus produced would explode soon after Brown moved there, and while fundamental to the city's subsequent history, they would form only a backdrop to his work. Nonetheless, the civil unrest of the 1960s, the heightened rhetoric of the 1970s, and growing unease about the city's crime rates and social pathology intensified debates about the proper division of its museum responsibilities between local and national audiences.

More central to the National Gallery's future, however, were the heightened ambitions of the national political leadership and the ongoing needs of the broader political system. In an era increasingly dominated by television, and transfixed by tourism, the connections between the state and its citizens stood in need of redefinition. The bureaucracy and taxes supporting national government seemed destined to endless growth. What better way to explain why than by enhancing the appeals of pilgrimage to the shrines of federal authority, and the incomparable institutions supported and supervised by national tax dollars? Visits to the national capital were an instrumental part of a national civics education, a family and school ritual that resonated across long distances. Systematic visiting had been going on for many decades. High school seniors and juniors from throughout the country enjoyed annual school trips designed to combine entertainment and pedagogy. Special agencies were organized to plan and supervise these visits. Family groups came

to the city, sometimes for a once-in-a-lifetime trip, to tour monuments, museums, and the halls of government. And, in many instances, to meet with individual legislators. Such travel expenditures were an important part of the local economy.

But by 1961 there was a nagging sense that Washington was not fully living up to its promises or world status. Many in the new administration, led by President Kennedy himself, looked around the national capital and concluded, as Andrew Mellon had more than thirty years earlier, that its cultural amenities and physical accommodations were in sore need of amendment. Since the early twentieth century, architects and planners had been attempting both to recover the grandeur of the storied Pierre L'Enfant plan and to adapt the city structure to modern urban needs. Much was done between the two world wars to adorn and improve the city, including the dedications of the Lincoln and Jefferson Memorials, the construction of major new federal buildings, from the Supreme Court to the Federal Triangle, the opening of large, luxurious hotels and department stores, and the establishment of new museums, among them the Phillips Collection, the Smithsonian's Freer Gallery, the Folger Library, and, in 1941, the National Gallery of Art. Suburbs in Virginia and Maryland blossomed, and highways expanded their reach, while elegant apartment houses and commodious private homes redefined Washington's Northwest district.

While remarkable for a city of fewer than a million people, these achievements were still insufficient to meet the growing expectations entertained by professionals, diplomats, lawyers, lobbyists, bureaucrats, and others drawn there by the government's presence. Those with experience living in European capitals, or bred to expect the rich diversity of cities like New York, continued to express disappointment. At the height of the Cold War in the 1950s and 1960s, Washington had become the headquarters city of the Western world, at least in a political sense, the planning center for a global effort aimed at consolidating and extending American power and resisting the forces of international communism. The discrepancy between the city's claims to metropolitan distinction and its more limited range of uplifting diversions had, since the early nineteenth century, served as the basis for commonplace observations, but now it seemed possible to do something about it. And to serve notice on its patronizing and complacent rival to the north, New York City.

Climate as well as size and geography posed severe constraints. Wash-

ington's hot, humid summers were notoriously uncomfortable, particularly for newcomers and temporary residents. Before World War II the capital basically closed down for the summer, as high officials and diplomats sought cooler ground. These long vacations in New England or abroad did not disappear in the 1950s and 1960s—indeed National Gallery director John Walker spent almost every summer in Europe for much of his tenure—but the systematic installation of air conditioning, which coincided with the eight years of the Eisenhower administration, suggested that year-long residence, year-long work, and year-long visitation might not be impossible goals. Although air conditioning was first installed in the Capitol in the late 1920s, and a number of other government buildings in the 1930s, it took a couple of decades more for the amenity to spread to public transport, hotels and motels, offices, and private homes. Urban life, especially in the South, was dramatically changed. As in several other American cities, particularly in Florida, Georgia, and Texas, Washington's attractions (and ambitions) considerably expanded.[1]

These ambitions obviously included—indeed, emphasized—mass tourism. Because of the discrepancy between its political importance and its physical size, Washington had long fascinated observers intent on uncovering the special character of national government. There was, in fact, little competition from other institutions. Visiting the city in the spring of 1905, Henry James argued that the great Capitol building performed in Washington life "very much that part that St. Peter's, of old, had seemed to me to play in Roman: it offered afternoon entertainment, at the end of a longish walk, to any spirit in the humour for the uplifted and flattered vision."[2] Generations of visitors focused their attention on the drama of national politics, the heady mixture of great political and economic stakes, histrionic oratorical presentations, corrupt practices, and mundane constraints. The proceedings of the House and Senate, punctuated by the entertainments and ceremonials of the White House, made for the best show in town. Occasional nineteenth-century painters, like Samuel F. B. Morse, serviced public fascination with detailed canvasses, and in the late nineteenth century a new generation of cartoonists, several of them German-born, made the features of political actors notorious.

The farcical as well as tragic features of government were captured, in the years just before and after World War II, by dramatists and filmmakers like Russel Crouse, Frank Capra, Garson Kanin, Robert E. Sherwood, and Maxwell Anderson. While many themes surfaced, reflecting

attitudes toward partisanship, corruption, power, and pretension, the significance of national shrines like the Lincoln Memorial and curiosity about the actual legislative and executive settings formed part of the films' appeal to audiences. The cinematography and elaborate sets of movies like *Mr. Smith Goes to Washington, Wilson, Born Yesterday,* and *State of the Union* made for compelling renditions of the national capital.[3] In a pre-television age the rites of government were mysterious for many people, and even after television's rise to influence, constraints on live coverage of Congress meant that actual visits to the Capitol would continue to produce a powerful impact.

Complementing the drama of government itself, and the opportunities face-to-face visits provided for elected officials to ingratiate themselves with their constituents, were the shrines to democracy and the tributes to a higher life. Tourist Washington in the 1960s, once the precincts of government had been covered, alternated between hallowed sites, like Arlington National Cemetery and the Lincoln Memorial, and the Mall museums, notably the Smithsonian's Museum of Natural History, Freer Gallery, and new Museum of History and Technology and, of course, the National Gallery of Art. Almost immediately upon the National Gallery's opening in 1941, the John Russell Pope building had become one of the city's icons, a neoclassical art temple that brought to a climax more than a half century of constructing such monuments in the United States. Chicago, Philadelphia, Minneapolis, Cleveland, St. Louis, Kansas City, Detroit, and San Francisco all sported impressive examples, but the capital version appeared quintessential. The building "was intended to satisfy an often unrecognized desire" on the part of the American public, wrote John Walker. Living "for the most part in apartments and small houses," Americans "feel the need for buildings more sumptuous, more spacious, and less utilitarian than their everyday surroundings." Buildings with "dignity, splendor, permanence" offered people enhanced personalities. Even without the collections, "visitors receive great pleasure from the National Gallery simply as architecture."[4]

This imposing hulk of pink Tennessee marble, the largest marble building in the world when built, had been framing the capital's cultural ambitions for just twenty years at the time of Carter Brown's arrival. With a gravity that belied its youth, the Gallery constituted something like a community center for high arts lovers, reassuring, reinforcing, and comforting at the same time. This was more than simply a museum. Beyond

the splendid paintings on the walls, and the pieces of Italian sculpture punctuating the vast galleries, its own greenhouses supplied the lush plantings in the garden courts, and its own orchestra performed at concerts scheduled throughout the year. Poised as a counterweight to the mundane and sometimes coarse needs of government itself, an asylum for bureaucrats, visitors, and foreign diplomats alike, the Gallery cemented its broader popular appeal during World War II, when Washington was filled with military recruits from throughout the country.

The hospitality, along with the art-filled galleries, reflected the personality and energy of the National Gallery's first director, David E. Finley Jr., still a living presence in 1961. On the face of it, Finley was an improbable choice for the founding directorship. A genial South Carolina–born lawyer and longtime Treasury Department bureaucrat, Finley owed his position entirely to his close association with Andrew W. Mellon, who headed the Treasury Department for more than ten years under three Republican presidents.[5] Mellon's imperial art collecting, and his interest in establishing an art gallery in Washington—dating to the late 1920s—have been examined in a series of histories and biographies.[6] Finley, as his closest personal aide, was knowledgeable about Mellon's art activities and objectives. Another lawyer, Donald Shepard, helped craft the legislation creating the National Gallery in the late 1930s, and became its first general counsel, but Finley remained closely informed about every stage of the project and directly involved with Mellon's art accumulations. The congressional charter, and its interpretation, were to prove immensely important to the ongoing story of the Gallery. Lawyers and legal opinions would be central to its operations, and as one of the founding attorneys, Finley, with his close personal and professional links to Mellon and his high social status (furthered by his marriage to Margaret Eustis, from an old Virginia family) made excellent sense as a choice for the first director.

Finley's outgoing and cordial personality proved helpful in a variety of projects. He would be instrumental in establishing the National Trust for Historic Preservation and the White House Historical Association, and he became an active force in saving the old Patent Office building from destruction, preserving it as a home for the newly created National Portrait Gallery, which he also helped create. All of this was supplemented by a lengthy chairmanship of the US Commission of Fine Arts, referees of new construction in official Washington. At the National Gal-

lery itself, supported by the connoiseurship and suavity of his second in command, the Berenson-trained chief curator John Walker, Finley satisfied the first and most pressing of the Gallery's needs, to start filling the vast structure with works of art. In a series of remarkable coups, Finley and Walker persuaded several of the nation's greatest collectors—Joseph Widener, Samuel Kress, and Lessing Rosenwald—to loan, and ultimately to give, their extraordinary holdings to the Gallery, gifts that quantitatively overwhelmed the relatively small, but superlative, set of artworks Andrew Mellon had provided. The original 126 paintings and 26 pieces of sculpture were joined by more than five hundred artworks from Kress and Widener within a year of the building's opening (the Kress presentations actually had come in the summer of 1939), and the Rosenwald gift was announced in 1943. That same decade the first loans came from the Chester Dale collection—mainly impressionist and postimpressionist masterpieces—and on Dale's death, not long after Brown's arrival, another area of strength came to the museum collections. No other American art museum had managed in just two decades of operation to achieve anything like the status of the National Gallery, and its leadership was not reticent in pointing this out.

One of the reasons for the National Gallery's success lay in its unique structure and self-imposed limits. These limits gave the Gallery a special character. It was never intended to be a universal survey museum, like the Metropolitan Museum of Art or the great museums of Philadelphia, Chicago, Cleveland, and Boston. Its collecting areas would be limited to the United States and Europe, its media confined to paintings, the graphic arts, and sculpture (with some exceptions made for the Widener's family's porcelains, tapestries, and furniture), and, in its original conception, no artist could join the permanent collection who had not been dead for at least twenty years. Only works of the highest quality would be allowed entry.

The model shaping these intentions was London's National Gallery in Trafalgar Square, which had enormously impressed Andrew Mellon during his brief ambassadorship to England in the early 1930s. He visited the London museum often. This relatively small collection of paintings, begun just a century earlier, had evolved into an internationally celebrated institution renowned for the high quality of its masterpieces. Other, later London institutions—notably the Tate and the National Portrait Gallery (analogues to which Mellon also hoped would be established

in Washington)—complemented the National Gallery, while the older British Museum accommodated a far broader geography and time frame. A similar pattern seemed possible for Washington. Mellon left to the Smithsonian Institution responsibility for the art of Asia, and subsequent foundations there would focus upon Africa and the Middle East. But the National Gallery's concentration on European painting and sculpture (along with some American examples), gave it both distinctiveness and prestige.

Prestige was also supplied by its unique system of administration, modeled upon but somewhat dissimilar to that of the Smithsonian. This reflected the special circumstances of the Mellon gift. In return for offering his collection to the president in 1936, and paying for the building, Andrew Mellon received an act of Congress the following year, committing the federal government to the support and maintenance of the new institution, at a level appropriate to the importance of the gift. The legislation, in addition to providing the land itself, plus a small triangular plot just to its east, reserved for expansion, would be invoked in almost incantatory tones by successive directors over the next decades, as they sought the congressional appropriations necessary for the building's operations and for various programs reflecting its national responsibilities. The increasingly valuable collection, whose pecuniary worth was fed by additional gifts and by an astounding inflation in the price of art, was a hostage held by the trustees against both congressional parsimony and congressional intervention. If the enabling act were violated, the collection presumably would revert to the board, which held it in trust for the American people. Such an occurrence was almost unthinkable, but the potential for embarrassment remained, at a minimum, a rhetorical talking point for Gallery staff as they worked out strategies to nurture their budget.

The enabling act also made clear, right from the start, that lawyers would play a significant role in shaping museum policy. In the early 1940s American art museums, while not immune to litigation or legal controversy, were rarely involved in the continuing debates over provenance, liability, intellectual property, and other issues that keep their legal staffs busy today. When needed, external counsel would be hired; more than occasionally, prominent and useful attorneys found their way onto boards of trustees. Certainly they facilitated the settlement of estates and

advised on the scope of conditional gifts. Almost no art museum of the time had standing counsel.

But the charter of the National Gallery specified that one of the five executive officers on staff be its general counsel (who would serve also as secretary). Four other positions—director, assistant director, administrator, and treasurer—were also mandated, although they would sometimes be combined and sometimes renamed. Most years, a chief curator was also part of the management team. Lawyers—Finley, Shepard, and Huntington Cairns (another Treasury Department lawyer, who succeeded Shepard as secretary and general counsel)—dominated the Gallery's early years. Harry A. McBride, the first administrator, had a diplomatic background, having spent some years in the Foreign Service, and ending up in the State Department before being appointed. The assistant director, Macgill James, was unusual in possessing some previous museum experience, having directed the Peale Museum in Baltimore.

In later years, the general counsel's office would grow in size, and other staff members would come from legal or bureaucratic backgrounds. From the moment of foundation, Gallery leaders were aggressively on the alert to identify and resist governmental demands that in any way impinged upon the independence of their institution. These threats were almost exclusively associated with Congress. They also mastered the increasingly complex worlds of the Federal Register and political lobbying. Reputation was crucial. Protecting it from political controversy meant, among other things, ensuring that the Gallery's broader public relations efforts worked in harmony with its policy goals. The National Gallery of Art, its various general counsels insisted, was not a branch of government. It was, like its older sister, the Smithsonian, a trust held by the government, a conditional gift. Its administrative boundaries had to be scrupulously respected and continuously defended.

On the other hand, as senior staff repeatedly told representatives of private interests seeking their own concessions or influence, it was also a public institution with special obligations—custodian, again, for the American people, of a great treasure. Its status was meant to protect it from exploitation. The public-private balancing act was reflected in the makeup of the museum's board of trustees. Chaired by the chief justice of the United States, its other specified members—the secretaries of state, treasury, and the Smithsonian Institution—were joined by just five

private citizens. Gaining admission to this exclusive group was perhaps the highest prize for any collector or art lover in the United States, and during the first few decades board membership reflected the interests of the original donors. Paul Mellon, the founder's son, after a short initial stay on the board, became an active presence and a board officer starting in the 1950s. Other trustees included collectors Samuel (and later Rush) Kress, Lessing Rosenwald, Duncan Phillips, John Hay Whitney, and, starting in 1964, Franklin Murphy (representing the generous Kress Foundation, whose board he chaired). The opportunity to serve on the board proved especially tempting to New Yorker Chester Dale, who, ten years after his election to it, moved his paintings from art museums in Chicago and Philadelphia directly to the National Gallery. There he proceeded to play a tantalizing cat-and-mouse game, until at last, upon his death, he yielded up his art.

So small a board, while it limited the options available to attract potential donors, simplified the task of governance. In practice, cabinet secretaries often sent representatives to the meetings, which meant that the five private, or general, members (often fewer than that because of illness or other commitments) were an extremely powerful force in shaping policy. Unlike the Smithsonian regents, the Gallery board was entirely self-perpetuating, and members did not require Senate confirmation.

The senior staff of the Gallery, on the other hand, was less centralized. The director shared power with an administrator (in charge of the physical building and its support), a secretary, and a general counsel. The chief curator exercised considerable control over acquisitions and exhibitions and, for the first fifteen years of the Gallery's life, was the only person who had much actual knowledge of art. John Walker, who occupied this position until 1956, had helped plan the National Gallery's system of display. Indeed, with David and Margaret Finley he supervised the detailed appearance of individual rooms. The death of John Russell Pope, the architect, before the building's completion made the contributions of Finley and Walker even more central. In an interview many years later, Walker argued that it increased their direct influence on the planning; Pope's associates were far more responsive to their suggestions than he would ever have been. Emphasizing pleasure and comfort rather than didacticism, Walker and Finley made war on traditional museum clutter, hanging the paintings, as Walker recalled, "twice as far apart as one usually sees them in other galleries."[7] By isolating individual artworks and

placing them against backgrounds suggestive of prevailing architectural styles—plaster, damask, oak or painted paneling—they hoped to concentrate visitor attention rather than diffuse it. Such an approach was not entirely unprecedented. Other American museums in the 1920s and 1930s—the Freer in Washington, the Rhode Island School of Design in Providence, the Fogg in Cambridge, among them—had developed installations meant to be uncluttered and undistracting, far more selective and focused than conventional displays. But no museum had managed this as consistently as the National Gallery, or on its enormous scale. The opulence of the setting combined with its decorative restraint to produce a distinctive effect, one achieved hardly anywhere else.

When "Johnny" Walker invited Brown to come to Washington as his personal assistant, he had occupied the position of director for just half a dozen years, but he had been at the Gallery since its inception. Its appearance reflected his personal values as clearly as his management style. From a Pittsburgh family of high social standing, he had known the Mellons, as he had the Browns, because of shared backgrounds and experiences. Six years younger than John Nicholas Brown, Carter's father, Walker had played an important role, as a Harvard undergraduate, in the cultivation of modernist art and artists, before going abroad to spend several years in apprenticeship with Bernard Berenson at I Tatti and then serve on the staff of the American Academy in Rome. Walker's experiences in Florence were formative, and throughout his life he remained profoundly attached both to Berenson and the ideals of high connoisseurship and scholarship associated with him. Had it not been for his work at the National Gallery, Walker might well have become the director of I Tatti himself, and he kept close tabs on Berenson's fortunes during the difficult war years. A gifted writer and an active presence on the Washington social scene, he met and corresponded with a range of collectors and intellectuals— Archibald MacLeish, S. N. Behrman, Stringfellow Barr, Edward M. M. Warburg, Felix Frankfurter, Walter Lippmann, Philip Hofer, Paul Sachs, Royal Cortissoz, and Arthur Pope, to name a few.

Walker worked closely with Finley to capture the impressive collections that flowed into Washington in those early years. He was particularly crucial in obtaining the Kress art, and except for the Widener arrangement, which Finley and Shepard handled themselves, he was never far from Finley's side in the wooing of potential donors. Cultivated, fastidious, ostentatiously well mannered (if that is a possibility), married

to the daughter of the Earl of Perth, the British ambassador to Rome in the 1930s, Walker was deeply conservative in many respects and skeptical about the social role of art museums. By the end of his life he had grown cynical about populist goals and expansive educational activities. He mistrusted growth and expansion and favored intimacy over breadth. His favorite art museum in America, he admitted, was the Frick Collection. Reviewing *Masterpieces of the Frick Collection* for the *New York Times*, in his later years, Walker noted approvingly that the officers of the Frick had "always avoided noisy publicity," "disdained attendance figures, often fictitious," and "acted on the belief that works of art, even in a public gallery, are intended for those happily qualified to appreciate them."[8]

Such views he expressed repeatedly. Reviewing another book just weeks later, Walter Whitehill's history of the Boston Museum of Fine Arts, Walker contrasted the Boston institution's aristocratic traditions with the boastful excesses of the Metropolitan Museum's early director, Luigi di Cesnola. In comments that may well have been aimed either at Dillon Ripley, secretary of the Smithsonian Institution, or at Museum of Fine Arts director Perry Rathbone, Walker noted approvingly that Whitehill was "not enthusiastic about advertising in buses, about opening exhibitions with fashion shows, about introducing artificial ice for fancy skating in the rotunda, or about fusillades of cannon shots to announce a Civil War show."[9] As his elegantly written memoir, *Self-Portrait with Donors*, disclosed, Walker was deeply conflicted and often self-loathing about his courtship of major donors, whose taste, motives, lifestyles, and manners he often found offensive, even while being impressed by their energy, ambition, and persistence. Reviewing his book in the *New York Times*, John Canaday complained of snobbishness and condescension, observing that "inherited wealth and education at a select university seem the prerequisites for acceptance in Mr. Walker's world."[10] Walker's tempestuous and agonized relationship with one of his donors, Chester Dale, held particular significance for Walker's own tenure and for relationships with his trustees and staff.

Chester Dale was the poster boy for the impossible trustee.[11] Aggressive, demanding, imperious, egotistical, rude, and impetuous, he had nonetheless (or as a consequence) assembled an extraordinary group of impressionist and postimpressionist paintings, which he dangled in front of the National Gallery for decades. Hostile to the Kresses and to Duncan Phillips, and given to summoning Gallery officers to his homes in Florida

or Long Island for difficult confrontations, Dale became especially active in 1956, when David Finley was retired from his directorship. This larger story is told elsewhere, in some detail.[12] Walker had every reason to believe that, after fifteen years as chief curator, he was Finley's natural successor. No one else had been so fundamental to the Gallery's growth. But Dale, who was the newly elected president of the Gallery, decided that the next director should be Huntington Cairns, the general counsel, a multifaceted attorney with literary aspirations but without any art training or competence.[13] In fact, Walker had been partly responsible for Cairns's original appointment, never suspecting he would be creating a rival.

While Rush Kress supported Walker, Dale sought to work around the full board and enlist a small committee majority to effect his wishes. He momentarily even intimidated fellow board member Paul Mellon into supporting Cairns. After threatening to give his paintings to the Louvre, Dale argued that Walker was not practical enough for the job, and even suggested other possible candidates, some of them outsiders like Allan McNab from the Art Institute of Chicago. Years later Mellon expressed remorse for his own behavior in allowing Dale, even for a short time, to challenge Walker's appointment. "[I] was in a very difficult position," Mellon remembered. "If I didn't agree, I foresaw the risk of the Chester Dale collection being removed from the National Gallery with the same lack of ceremony with which it had previously been taken away from the Art Institute of Chicago and the Philadelphia Museum."[14]

Complicating the problem was Rush Kress, a new trustee who succeeded his brother Samuel upon his death (although he had been standing in for his invalided sibling for some time). Kress was loyal and committed to Finley, who in effect wrote some of his letters of protest. Kress now threatened to abandon all support for the National Gallery if the full board did not take up the succession issue. Franklin Murphy agreed to transmit his concerns to Chief Justice Earl Warren, who chaired the board.[15] Things were heading toward an impasse. Finally Paul Mellon arranged a dinner with Dale and secretary of state John Foster Dulles, an ex officio trustee. He also invited Dale's attorney, Stoddard Stevens of Sullivan & Cromwell, a major New York law firm. Stevens would eventually become Mellon's own lawyer and join the Gallery board. At the dinner, Dale agreed to drop his opposition.[16] To Mellon's happy surprise, the angry dispute never hit the newspapers, and John Walker succeeded to

the directorship without any accompanying public controversy. None-
theless, Walker, Cairns, and Finley, in addition to the trustees, knew the
full story. Had he not been appointed, Walker would certainly have left
the Gallery and gone to Florence to take over I Tatti. Even after he was
offered the job, he consulted Berenson to make sure he endorsed the
decision.

The appointment experience, so Brown believed, seared Walker, and
made him, despite his cynicism about the governance system, extremely
reluctant to confront his board of trustees on any policy matter. "Of a
nervous disposition," Brown recalled years later, Walker "never felt se-
cure enough to assert authority through any other means but personal
charm."[17] As he had promised beforehand, Huntington Cairns remained
general counsel (and secretary-treasurer) for much of Walker's director-
ship, and Dale continued as president of the Gallery until his death in
1962. Among other things he interviewed a nervous Carter Brown before
his appointment was approved. Dale's will included a personal bequest
to Walker, partial compensation for the considerable grief he had caused
him, before and after his directorship.

Successions were not easy occurrences at the National Gallery. Finley
himself had not wanted to retire, and despite the fulsome tributes offered
on his retirement, no gesture was made to him of an honorary trusteeship,
again one of Paul Mellon's later regrets. Walker himself would be forced
into retirement thirteen years later, reluctantly and unhappily. With so
small a governing board, such matters could be decided by just one or
two powerful members, and the decisions thus tended to be viewed as
highly personal. During Walker's term the position of power broker was
increasingly occupied by Paul Mellon, who became board president after
Dale's death.

With Walker as director, the management team at the Gallery seemed
to concentrate on maintaining the Pope building's splendor, acquiring
new collections, and, above all, staying out of trouble. This last meant,
among other things, avoidance of contemporary art. "Our support in the
Senate and the House might have been jeopardized had we shown avant-
garde work," Walker wrote in his brief history of the National Gallery,
defending his exclusion of living artists, particularly while political op-
portunists like Michigan congressman George A. Dondero were leading
crusades against modernists.[18] Walker personally collected modern art
and had, as noted earlier, been active as an undergraduate in arranging

exhibitions of modern masters. He was also involved with the selection of contemporary art for international presentations, in the 1940s and 1950s. But abstract expressionism did not suit his taste, and he was bloodied by assaults from critics when he chaired a fine arts advisory committee for the 1958 Brussels world's fair.[19] His predecessor, David Finley, had also been wary of the politicization that followed in the wake of such activities. Thus Walker acted to shield his institution from political dangers, even when this meant withdrawal from the contemporary art scene. And he retained as a model London's National Gallery, which studiously avoided recent art.

Walker was also reluctant to involve the Gallery in loan shows from other museums. Except for the American collections, Walker believed the Gallery simply did not have enough artworks to lend out. "As the National Gallery belongs to the whole country," he wrote in 1966 to a DC resident, unhappy that there were not more visiting exhibitions coming to her city, "we want to have on view our own great treasures for the millions of tourists." People from "outside metropolitan Washington far outnumber our Washington visitors by a large percentage." "If we began lending our great masterpieces of European painting and sculpture, visitors to Washington might often discover that their favorite painting or piece of sculpture was not on view. As we do not lend such pictures and statues, I hesitate, for reasons of reciprocity, to ask other museums to lend their masterpieces to us."[20] The most frequent loans that were made were to places like the White House and the State Department, although American pictures were circulated to a number of museums for special shows.

Walker also sustained and defended the Gallery's insistence on being the opening venue for any jointly sponsored exhibitions. "Over the years I can recall only one exhibition which would have come to the National Gallery of Art had it not been for our policy of exhibiting shows first," he wrote another disappointed correspondent in 1966, upset by Washington's failure to land an important Manet retrospective. The Gallery position, insisted the letter writer, was vain, peevish, and childish. "What justification is there for such a policy?" she asked. Walker had no easy answer, and in the end evaded the issue by defining it as a marginal problem, arguing that other museums deferred to the National Gallery as a courtesy.[21]

Walker's temperament, training, and values led him to avoid initia-

tives that had as their principal goals increasing public participation or even attendance. In 1950, while still chief curator, he declined Arthur Schlesinger Jr.'s invitation to join the Congress for Cultural Freedom, or at least to serve on its governing committee. "All my instinctive feelings," he told Schlesinger, "are contrary to the idea of political or cultural action groups. I think the great privilige [sic] of our way of life consists in the possibility of people like myself remaining aloof from such organizations.... This is perhaps the supreme luxury of a democracy."[22]

Although Walker invoked democratic sentiments to defend his unwillingness to participate, he betrayed little affection for them on other occasions. Three years earlier, in 1947, he had solicited Paul Mellon to help support a Dumbarton Oaks concert series featuring music "one doesn't hear at commercial concerts." According to Walker, this meant Bach, Mozart, Stravinsky, and Purcell. "So much is done to provide music for the man in the street, so little to provide it for people with more intellectual tastes." Admitting that the Dumbarton Oaks music was not meant for "the common man," Walker argued that, with enough support, it might become an "American Glyndebourne," referring to the annual summer festival in England.[23] Decades later, in concluding his memoir, Walker protested misguided efforts to make museums more "democratic." Certain museums—history museums among them—were "the logical places to cater to our ethnic groups." They could be governed "without regard to wealth or position." But "some museums should exist for that vast audience of cultured and culturally aspiring people, who have rights as well. They are the elite," and "we are fortunate that they are so numerous. They should not be denied the pleasure of contemplating works of art.... Museums do not exist solely for the noise and turmoil of hordes of schoolchildren."[24]

Walker remained zealous about the museum's broader calling. He believed in distributing stored art to institutions that would display it, long-term loans to small-town museums, for example. He supported a whole variety of educational programs at the National Gallery, some of them novel and innovative, like the famous Lectours, recorded commentaries on the displayed art that visitors could listen to as they toured. And he accepted, as a natural duty for a national gallery, the active acquisition of American art. Under this policy, the National Gallery's American collection began to rival the storied holdings of older museums in Boston and Philadelphia.

But the growing size and activism of American art museums remained repellent to him. Walker wrote James Rorimer, director of the Metropolitan, that his claims of visitor numbers were impossible. "He was not amused."[25] Too many museum boards were fixated on attendance and "more interested in quantity than quality." "They count the spectators as though they were Broadway producers. The poor director then is expected to play the role of impresario, and if need be to paper the house with a captive audience of schoolchildren." Under such circumstances, Walker argued, falsifying attendance was no sin. If high figures encouraged support, whether from public or private authority, then providing high figures became something of an administrative duty. Spending OPM—"other people's money," in the shorthand vocabulary he employed on many occasions (still in currency at the National Gallery of Art)—was an acceptable vice for Walker. If great art went into intimate, human-scaled museums, like the Frick or the Freer, so much the better. His final regret, voiced in *Self-Portrait with Donors*, was that he had himself contributed to the expansion of the National Gallery, and so had helped damage the kind of art experience he valued most highly.[26]

This, then, was the director who recruited Carter Brown to Washington. When Brown arrived, Walker was the only member of the original staff still there. Macgill James (Carter's uncle by marriage), a former assistant director, had retired, and Walker had no assistant director. Huntington Cairns, who joined the Gallery after World War II, remained secretary-treasurer and general counsel; the administrator was a former naval officer, Ernest Feidler. The atmosphere, according to some outsiders, was that of a gentleman's club. Long summer vacations engaged in writing or touring were the rule for Walker, who often spent them in Scotland, and for Cairns, who retired annually to North Carolina for several months. The chief curator, Perry Cott, Walker's successor in that position, was a scholar who had served as associate director of the Worcester Art Museum for several years before coming to Washington. He was, however, the only published art specialist among the senior staff (save for those working on catalogs), and the curatorial ranks below him were not particularly distinguished. All of this, in Brown's judgment, was complicated further by the very existence of the multiple executives mandated by the original charter. The executive offices specified in Andrew Mellon's original gift formed an unwieldy oligarchy, he believed. When, about this time, a national magazine illustrated an article with head shots

featuring the leaders of major Washington agencies, the National Gallery of Art had a group photograph taken of all five senior executives.

The flavor of these years, and of John Walker's managerial style, was suggestively captured by his longtime secretary, Elizabeth Foy, in a revealing oral history interview made after Walker's death.[27] Foy, who served both Walker and then, for many years, Brown, held mixed impressions of her first boss. Walker had a volatile temper and, while extraordinarily charming to donors and friends, could be rude and difficult with staff members. "I think there was a lot of resentment," Foy said, particularly on the part of curators. Some of this centered on the director's writing practice. A prolific and gifted writer, Walker delegated research assignments to his underlings, then incorporated the results into his own publications. This lack of acknowledgment apparently upset the lower echelons.[28]

Hierarchical divisions at the Gallery were clear. The executive offices, where the director and his senior staff worked, were known as Peacock Alley. This was where "the royal family lived," preening in their well-dressed glory, according to staff cynics.[29] The administrators' section lay around some corners. The director, assistant director, secretaries, and chauffeur-messenger all worked in a suite of offices opposite the board room. Foy took dictation, composed many letters herself (sometimes signing them), kept Walker's appointment calendar, received his visitors, and served as a go-between with other staff. He "would make these outrageous requests that he needed certain research materials, or he needed somebody to do something," and she had to do the telephoning and listen to the complaints.[30] In fact, Foy acknowledged, the staff were sympathetic to her position, feeling she had become the "fall guy," and did their best to accommodate her requests. Walker's taste was for receiving only important people. She also had to make sure that Amontillado sherry and Walker's favorite Haut-Brion wine were accessible in the locked safe located in a coat closet.

Walker's entertainments followed, for the most part, the same levels of genteel restraint, understated to the point of invisibility. While some lunches were accommodated in the Gallery board room, celebratory dinners and other luncheons were held at either the F Street Club or the Sulgrave Club. No dinners at all were allowed in the National Gallery building—although there had been one for Harry Truman's inaugural

in 1949, during Finley's directorship. "We don't do that sort of thing," Brown told the *New York Times* in March 1966 at a party celebrating the Gallery's twenty-fifth anniversary. "The music and the art works that came from the walls of Mellon houses were the only forms of entertainment," Charlotte Curtis reported.[31]

There weren't many dinners either inside or outside the Gallery. What festivities existed were carefully managed with advice from the State Department's chief of protocol, Clement Conger. Exhibition openings were generally low-key affairs. While Walker patrolled his galleries scrupulously, and met his senior staff each morning at eleven, he let his chief curator, Perry Cott, make decisions about picture placement and installation for those temporary shows the Gallery did host. These were not Walker's chief interest. Visits to collectors and collections throughout the world were of greater concern, in Walker's ongoing quest to add to the National Gallery's possessions. "If private collections can be compared to treasure ships," wrote *Art News* on his retirement, "John Walker has boarded many and steered them safely to his own berth, even though their original destination might have been hundreds of miles away."[32]

In this respect, Walker's relationship with Ailsa Mellon Bruce, Andrew Mellon's daughter and Paul Mellon's sister, was absolutely crucial. Walker was careful to maintain good connections with both Mellons, particularly after Paul Mellon became Gallery president, but Ailsa's confidence and goodwill were especially important. Shy, somewhat reclusive, and notoriously indecisive about matters large and small, she was devoted to her father's memory, and she became the Gallery's most generous single benefactor during Walker's directorship. Collecting primarily for her various houses and apartments, she relied on Walker to negotiate with dealers, and in the end, to his stated surprise, she left her entire collection to the National Gallery. No art, in fact, went to her grandchildren, which Walker bemoaned since he wanted the next generation to be cultivated for further support. "I have always thought museum directors should practice *enlightened* selfishness, not just selfishness," he wrote in connection with this bequest.[33]

But it was the money Ailsa provided during her lifetime, millions of dollars over several decades, that most distinguished her support. With art prices rising through the 1960s, and a relatively modest endowment to work with, Walker depended upon her to provide the funds for major

purchases. No public moneys could be used for acquisitions, and while great gifts of art came in during these years, there were few friends with both the desire and the ability to provide substantial amounts of cash. The relationship with Ailsa Bruce not only benefited the Gallery, it proved a source of strength to Walker himself when, in the waning years of his directorship there was some sentiment favoring his retirement. That day could not be postponed indefinitely, but the close connection lessened Walker's vulnerability to board pressures. Paul Mellon, in the 1950s and 1960s, certainly seconded his sister's warm feelings, but his spectacular art gifts would come, for the most part, in later years.

By most accounts, in 1961, when Carter Brown arrived, the National Gallery was perceived as an estimable but self-contained institution, living quietly off its accumulated treasures, serving a blend of Washingtonians and tourists who enjoyed its quiet opulence, its music, and the comfortable security of its high standards. While Walker insisted that attendance was not an accurate gauge of quality, the fact that annual attendance had slipped beneath one million, to eight hundred thousand, in the 1960s, produced some uneasiness within the congressional committee evaluating the Gallery's budgets. While the museum maintained an active, even innovative, education program and served both local and national communities with a series of projects, its exhibition schedule was scarcely energetic. Its staff, moreover, published little in the way of serious scholarship, and could not, with just a few exceptions, be termed prominent or distinguished within the world of American art museums.

But as the thousand days of the Kennedy administration began to unfold, higher expectations about the Gallery's role and the place of the visual arts more generally soon found their voices. The blend of glamour, intellectuality, social privilege, and high-mindedness that flavored the epoch was a perfect milieu for Brown. As an assistant to the director, he quickly became a personal link to the White House, to various embassies, and to a variety of public officials. One in a series of personal assistants employed by Walker, albeit one with more imposing pedigree and a brighter future, Brown impressed Elizabeth Foy with his willingness to do his own homework, to become acquainted with other staff members, to work late hours and on weekends, to read curatorial files, and to work in the library. He may have been a protégé of John Walker, Foy observed, but Walker rarely took him aside to explain how things worked. For that, Brown was on his own, but he was, as always, a quick study. Placed, for a

time, in an office between the director and the president—Chester Dale for a year or two, and then Paul Mellon—he was then moved up into a loft area. "I found my life very much akin to that of a servant behind the green baize door," Brown wrote in an obituary tribute to Walker, his "professional father." "There was a buzzer on John Walker's desk that sounded angrily in my office and demanded my immediate presence, regardless of whom I might be meeting with or speaking to on the telephone."[34]

In those first years Brown was gregarious, frequently joining staff who gathered in the afternoons at a big table in the cafeteria. But as his duties mounted, Foy observed, he had less time for socializing. "There was some criticism on the part of some of the staff, who felt that he sort of dropped them."[35] But this, Foy concluded, may have been unfair. The growing list of areas for which Brown became responsible was the real cause.

In the beginning, Brown made himself useful by adapting to any demand. He accepted the fact that he was there to do odd jobs, "to do anything the director doesn't know how to do!" as one staff member put it. He answered correspondence delegated by the director, attended meetings, joined panels and seminars, judged art competitions in the Washington area, escorted visiting dignitaries through the galleries, and appeared at various social occasions. Journalists found him to be good copy: attractive, articulate, and ingratiating.

Barbara Kober, writing for the *Los Angeles Herald-Examiner* in 1962, interviewed Brown on the impact of the Kennedy administration on the National Gallery. He pointed out that attendance had increased by one-third since the inaugural, and that the first lady, Jacqueline Kennedy, had participated actively in the Gallery's twentieth anniversary, attending and often presiding at official openings.[36]

The assistant to the director was also enlisted for unusual duties. Thus when Chester Dale, as Gallery president, purchased, for $875,000 of Ailsa Mellon Bruce's money, Jean-Honoré Fragonard's painting *La Liseuse*, at the celebrated Alfred Erickson sale in November 1961 (the pre-auction estimate had been less than half that figure), Brown, along with the Gallery treasurer, escorted the picture from New York's Parke-Bernet auction house to Washington in a locked Pullman compartment. The *Washington Evening Star* reported breathlessly on the trip, describing the prearranged signal from the porter delivering dinner to the (momentarily) unlocked compartment.[37] Brown stayed with the picture until it was safely delivered to the Gallery's truck at Union Station, to be carried

the short distance to its new home. The attendant publicity, built around the extravagant price, served the Gallery well.

Carter Brown seemed to be everywhere, at least in newspaper accounts. In 1962 Paul Mellon led Jackie Kennedy on an after-hours tour of the Gallery to see the André Meyer collection. In turn, she took him back to the White House in a limousine to view her new rose garden. The Mellon Mercedes was left parked in the National Gallery's driveway and had to be moved, but the Secret Service officer could not figure out how to start it. Walker and Brown offered to help, to no avail, until Brown suggested that an instruction book might be in the glove compartment. Et voilà, there it was, but in French! Brown managed to translate, and the "red-faced" officer drove off in hot pursuit of the Kennedy motorcade.[38] A somewhat less flattering story in the *Washington Post* made Ernest Feidler, the Gallery administrator, the source of the suggestion, and referred to Brown as the Gallery's "publicity man."[39]

Not long thereafter Maxine Cheshire, the *Post*'s society columnist, reported that Brown was almost mobbed at a "posh" affair after having been mistaken for the prizewinning pianist Van Cliburn. He was confused so often for Cliburn, Brown remarked, that he had given up protesting that he wasn't, and when in Moscow had even signed autograph albums for admiring Russians.[40]

In a more substantive mode, Brown noticed that John Walker was writing all of the gallery's press releases and that relations with local journalists were not what they should be. He offered to start writing the releases himself, and cultivating those who received them. Walker agreed. A couple of years later Brown, not yet director, was able to get the Gallery to appoint a public relations officer, bringing an experienced journalist, Bill Morrison, from the Virginia Museum of Fine Arts to Washington for a five-year stint (although, by failing to warn Paul Mellon that he was diverting talent from one of his favored institutions, he made a rare error of administrative judgment). Walker also allowed Brown to involve himself more fully in the education department, particularly its extension division, which reached a national audience with slides and filmstrips.

Brown already had his own notions of what the Gallery needed. He reacted against Walker's notion of making temporary art exhibitions "look as much as possible like the permanent collection which was his great love. . . . You hardly ever knew when you were going into the lent stuff, and when you went out of it." Brown, by contrast, thought of special ex-

hibitions as having a beginning, a middle, and an end, very different from the timeless character of the permanent collection. He hoped to give visitors to temporary shows an experience that "knocks their socks off by the end of it," though as an assistant to the director this lay far beyond his reach.

Using his loosely defined staff position as a means of exploring almost every aspect of the Gallery's operations, Brown took a particular interest in making Gallery interpretation more accessible to visitors. Typical was a proposal he made in late 1961, just a few months after his arrival. His memo to John Walker, entitled "A New Kind of Catalogue for the National Gallery," argued for an accessible handlist of the paintings and sculpture actually on display, with minimal but relevant information about each work and space for visitors to take notes. Alphabetically organized, it would offer data about each object's size, medium, date, donor, and school, and could be compiled using the Gallery's existing addressograph plates. With twenty entries to the page, Brown estimated that the handbook, run off on the Gallery's multilith equipment, might occupy somewhere between fifty and sixty pages. Its loose-leaf form would accommodate ongoing changes and, when placed throughout the Gallery, could answer many questions.[41]

The combination of minute attention to detail and ambitious rhetoric typified Brown's many reports of the next several decades. He rarely stopped with generalities. Thus, in his proposed handbook, placed in blue binders with the Gallery seal "in gold," the entries would be preceded by a title page, handsomely printed, "perhaps in two colors," to "lend the document dignity." This consolidated listing of the museum's visible works would, he pointed out, be simultaneously current, portable, and inexpensive, and would mediate between the cumbersome, multivolume catalogs, filled with scholarly information, and scattered, ephemeral leaflets covering just portions of the collection.[42]

As he developed both the rationale for the handlist and its possible applications, young Brown demonstrated his optimism about the museum experience, and a recipe for improving it. The handlist, he pointed out, would help the visitor plan his tour, "giv[ing] him a place, during the visit, to put down his thoughts . . . and a device to help him remember, after the next visit, what he saw and what remains to be seen the next time." The assumption that the viewer would be returning, and would be interested in systematically moving through the parts of the collection not

yet seen, posited an ideal art consumer. It did not necessarily describe the average National Gallery patron. Nonetheless, the potential influence of such a publication, according to Brown, made it worthy of serious consideration. "By pioneering in this area," he pointed out to Walker," as it has already with such successes as the Lectour, and the Gallery Leaflets— the National Gallery would again be fulfilling its responsibility for leadership among the museums of this country and the world."[43] It is not clear that the suggestion was ever acted on, but the fervor and enthusiasm Brown brought to a somewhat prosaic project indicated his capacity for imaginative improvement and his dedication to a broader mission.

Photogenic, articulate, a suave exotic amid the predictable bureaucrats jockeying for power in Washington, Brown soon became a favorite of the press corps, his name and photograph popping up in the society columns of local newspapers and in magazines with names like *Glamour*. As an eligible bachelor from a prominent wealthy family, he was a frequent guest at political and diplomatic dinners, seated next to visiting royalty, taking tea at the White House with Jackie Kennedy, or squiring around one of President Johnson's daughters during the next administration. Local columnists declared him one of the ten best looking men in Washington (along with Sargent Shriver and William Fulbright), praising his face as "full of bones and sensitivity, the perfect cheek alignment for a man whose world is that of the great artists."[44] Sailing in Chesapeake Bay, or with his family in New England, partying, dating, and traveling, kept Brown busy when he was not actually working. Upon his arrival in Washington, he had bought a home at 3330 Reservoir Road, in Georgetown, for seventy-two thousand dollars (his friend Tony Athos told him at once that he had paid too much), but "I thought it was too showy to live in, so I shared a house with two other guys on a rental basis," he explained later. He rented out the new purchase—originally the slave quarters for a nearby plantation house—for almost six months but finally moved in and built a small addition. There he would live until his first marriage in 1971.

Among other tributes to his youthful celebrity were elections to various prestigious clubs. Already a member of the New York Yacht Club, the Agawam Hunt in Providence, and the National Press Club, at the tender age of twenty-nine, Brown was contacted by Frederick B. Adams, head of the Morgan Library in New York, about joining the Century Association, a venerable social and intellectual institution.[45] He was elected to

membership not long after; his references included Winthrop Aldrich, Archibald MacLeish, Nathan Pusey (then president of Harvard), John Walker, and James Rorimer, director of the Metropolitan Museum of Art. His letter to Adams, describing his interests and affiliations, proclaimed that his proudest achievement at Harvard was persuading the business school to allow him to credit an art history course with Sydney Freedberg toward his MBA. As suggested earlier, Brown savored this memory to the end of his life.

At least as extraordinary an indication of Brown's charm and status was his election, in the early 1960s, to the Zodiac Club, a small, select group who dined together several times a year, each member assuming the name of one of the signs of the zodiac.[46] The club had been initiated in the late nineteenth century; among its early members was J. P. Morgan, who took a strong interest in astrological mysteries. The twelve members entertained one another in their clubs. Over the years prominent figures in business, finance, and cultural life filled its ranks. As Taurus, Brown joined an institution whose recent members included James Conant, former president of Harvard, Dillon Ripley, the secretary of the Smithsonian Institution, Devereux Josephs, a life insurance executive and trustee of the Metropolitan, Roland Redmond, another Metropolitan trustee, and Robert Lovett, a former secretary of defense. Brown was in New York frequently enough to make active participation in these New York clubs practical.

Brown also was personally linked to the White House on a variety of occasions. Deeply involved in discussions about the role of a White House art adviser, he also participated directly in the historic effort, led by Jackie Kennedy and Henry F. du Pont, to restore the furnishings of the presidential mansion. Here his road was smoothed, presumably, by the active presence of David Finley, the retired Gallery director, and the first lady herself. Attached to Jackie Kennedy, and sharing a common background with her, Brown's note of sympathy on the death of a newborn inspired a response from her secretary saying that Jackie thought his letter "one of the most beautifully expressed of all the letters she received."[47]

His circle of friendships was large, but the life he was leading could be seen as socially superficial. That much was argued by one of Brown's most faithful correspondents, Anthony Athos. In 1963, recently married and with a new child, Athos enjoyed reading Brown's descriptions of his exciting Washington life but feared that his friend might be lonely. "Be-

coming a bachelor after years of just being single, is great fun," he wrote in 1963, "but remaining one when one's peers are deserting to marriage is at times unpleasant." He acknowledged that it was going to be challenging to find a soul mate who was simultaneously acceptable to the powers that be in Providence. "I hope for you that the gal will be more right for you, inside, than for the others, outside."[48] There was, in Brown's life, no scarcity of women, some of whom had been brought up to Benefit Street to meet the family.

The Gallery absorbed as much energy as Brown could pour into it, and that seemed almost infinite. Generally deferential to his elders and superiors, he didn't hesitate to voice his opinion on policy or procedure. On Thanksgiving Day 1966, having been at the Gallery for five years, he wrote Paul Mellon about the then still confidential plans to create a new museum, in New Haven, for Mellon's British art collection. (This would in time be known as the Yale Center for British Art.) Leaks were multiplying. Brown had just been told by a Washington reporter (and former Smithsonian employee) about the plan, and he worried about the form a public announcement should take. The gift might be seen by some as a slap at the Gallery, Paul Mellon's principal museum affiliation, and the challenge was to include the Gallery in the statement without making it seem apologetic.

Mellon himself had wanted some reference to the Gallery. So, Brown took upon himself the construction of a possible statement. "I send it on to you simply as a staff member whose role it is to see that as many options as may be useful get drawn up, even if ultimately rejected." He was careful to maintain due deference to the Gallery's president and generous benefactor. "Isolated as I am up here for the long weekend in Providence, I realize the unorthodoxy of doing this directly; but time may be short. . . . I'm in way over my depth. Too much Turkey. Please forgive."[49] Forwarding a copy on to John Walker, Brown proposed language indicating that some of the paintings and drawings might eventually go to the National Gallery, though most would probably remain on view in New Haven, "as the amount of additional space available at the National Gallery for the exhibition of British art is extremely limited."

The letter typified Brown's style: working on a holiday, prepared to take his case to the highest court, sensitive to any possible damage to the Gallery's reputation, accepting the appropriate lines of authority, assuming a tone that was rhetorically self-deprecating while supremely self-

confident, sharing the information with his superior officer, yet ready to assume responsibility for the new statement himself. John Walker wrote later confessing his disappointment about losing Mellon's British collection, but he acknowledged the impossibility of housing the thousands of paintings, watercolors, and prints within the existing Gallery building. He also accepted the value of placing it within a scholarly setting. Washington, he allowed, "is a tourist city, and the National Gallery of Art a tourist museum. Only certain masterpieces Paul has acquired would be of significance to most of the Gallery's visitors."[50] This conception of the Gallery's audience was not one that Brown would share.

During his eight-year apprenticeship, Brown carved out his own special niche at the Gallery, moving up the ranks from assistant to the director to assistant director in 1964 and then deputy director in 1968. Always fascinated by the latest gadgetry and particularly absorbed by the possibilities of filmmaking, Brown was able to fulfill dramatic ambitions he had entertained since boyhood. Walker had managed to get some money together to finance a film on Jackie Kennedy's White House renovations, but the November 1963 assassination ended that specific scheme. The money had not been spent, however, and Walker helped get it assigned to the National Gallery for an Extension Service project on American art. The filmmaker sent through some scripts that Walker rejected, so Brown decided to write the narrative himself, without informing anyone of his involvement, and busied himself with everything down to the camera directions. Walker found this version much better than its predecessor, but when he asked Brown who wrote it, he was furious to learn the authorship. "We want to save you up," he told Brown.

Even so, with funds, scripts, and crew in hand, Brown was allowed to go ahead, working closely with the composer of the sound track and getting Burgess Meredith to do the narration. This involved a trip to Hollywood; "I learned a lot about directing," Brown confessed, describing, years later, his encounter with Meredith. He recorded the actor in a military recording studio and, on returning to Washington, got further absorbed by film details. Concerned by Brown's cinematic commitments, Walker warned him that "we're not losing you to the museum profession. No more films!" Work on the script meant getting up at 4 a.m. and spending several hours in the Gallery before the day's routine started, Brown reminisced. But *The American Vision*, the film that emerged, gained a preview at the White House in 1965 and ecstatic responses from local critics. The *Washington*

Post described the enthusiasm of the "packed and spellbound audience" witnessing its first public showing at the National Gallery in early 1966; the film opened the Gallery's twenty-fifth anniversary year with a flourish.[51] *The American Vision* went on to collect prizes at international film festivals and enjoyed repeated showings at the Gallery.

Despite his short tenure at the Gallery, Brown was soon also being mentioned as a candidate for major positions at other museums. When James Rorimer of the Metropolitan died suddenly of a heart attack in May 1966, Brown's name surfaced as a possible successor—along with Sherman Lee of Cleveland, Evan Turner of Philadelphia, and the eventual choice, Thomas Hoving. But to Washington insiders, and to many on the Gallery staff, Brown's future as the next director of the National Gallery seemed almost inevitable. His social, intellectual, and practical qualifications for the position appeared embarrassingly obvious, and many felt that Walker had, in effect, selected his own heir. Indeed, by the late 1960s the National Gallery seemed itself to be moving, with all deliberate speed, into a new era.

The twenty-fifth-anniversary year of 1966 brought together a number of important trends. Among them were some revisionist views of the Gallery's buildings and collections, friendlier than they had been two and a half decades earlier. John Canaday, the *New York Times* art critic, was still hedging his bets, but even he saw better times ahead. The "impeccably frigid monument on Constitution Avenue," he wrote that spring, seems to have acquired "not a stain, not a crack and not a speck of dust. Nor has it acquired the breath of life, or so it seemed to me until this week, when I walked through all its rooms in sequence for the first time in a long while." The settings had always seemed "so obsessively chaste" that they sterilized the objects contained. And the audience was "the least rewarding in the world," "mainly tourists seeing a sight, not art."[52]

All this had changed, wrote Canaday, with the coming of the Dale collection the previous year. Replacing the respectful art that filled holes alongside Mellon and Widener masterpieces, the Dale pictures were consistently exciting and first class. They had "thrown the National Gallery of Art out of kilter, and a good thing it is too. The place has had too much kilter and too little accent." If it remained intent on filling historical gaps and becoming the perfect textbook, the Gallery, wrote Canaday, would never fully succeed, but once it opened itself up to good things, the future was bright. The Dale collection could be the opening wedge.

One week later Emily Genauer, in another review, was even more positive, actually repudiating a piece she had written twenty-five years earlier, on the Gallery's opening. Then she had concluded that the Gallery was "not a really first-class museum at all, still a hope, primarily, rather than a fulfillment." Masterpieces were drowned in an ocean of school pieces by obscure artists. There were huge gaps. The sofas were comfortable, the lighting good, and the rooms spacious. Only the art was lacking.[53] Now, on a tour with Walker, Genauer saw a transformation. Of the 723 pictures on the walls in 1941, only 263 remained hanging. Many of the missing pieces had been sent out by the Kress Foundation to museums throughout the country. Meanwhile, Finley and Walker had coaxed out of the Kress Foundation some twenty-five million dollars to help expand the Gallery's masterpiece collections. And the building looked better than it had in 1941. Then Genauer had been dismissive. "Those towering marble columns, that vast rotunda, those broad corridors teams of horses could ride through, are all too grandiose. They will overwhelm visitors, and serve only to memorialize wealthy collectors and a way of life that is done with." One can't always be right, Genauer now admitted. The broad corridors were great for large crowds, the rotunda perfect for assembling visiting school groups, and everyone liked the great columns. Walker advised her, if she liked modern architecture, to take a look at the recent State Department building, a real horror show. Genauer was prepared to eat her words.[54]

Encouragement was coming from the top of the political establishment as well. In August 1966, Brown sent director Walker a memo describing a conversation with vice president Hubert Humphrey. The vice president spoke positively of his visit for the anniversary celebration and urged the Gallery to hold a series of exhibitions devoted to the art of foreign countries. He mentioned specifically the art of Senegal.[55]

In fact, the twenty-fifth anniversary served as a sign that the National Gallery was indeed becoming both more inclusive and more activist. Its educational programs were booming, it offered a series of recorded tours to tempt visitors, outside designers were starting to install a few temporary exhibitions, and modern art was beginning to penetrate its halls.[56] Just three years before, the Gallery had hosted a major loan exhibition from the Museum of Modern Art. Brown himself announced the show to the press, pointing out that work by Mark Rothko, Jackson Pollock, Willem de Kooning, Ad Reinhardt, and many others, all selected by MoMA director Alfred Barr, would go on view, the first time that anything ap-

proaching avant-garde art had been allowed in.[57] Picasso, Modigliani, and Dalí were already being shown, a result of Chester Dale's insistence, but this was carrying things much further. John Walker, symbol to some of the Gallery's conservative stance, enthusiastically endorsed the MoMA show, indicating that it reflected a new tolerance by the federal establishment toward modern art itself. Critics noted that the throngs swarming the MoMA exhibition were younger and more animated than traditional Gallery audiences.[58] So crowded was the show that conducted gallery tours had to be abandoned, and the auditorium was filled for lectures on the history of modernism. This was the most comprehensive presentation of modern art the capital had ever seen; that it was hosted by the National Gallery seemed newsworthy in itself.

Paul Mellon and his sister celebrated the anniversary with a somewhat less radical gesture toward the modern by displaying their French paintings, mainly nineteenth- and twentieth-century, and attracting so many visitors that the Gallery extended its hours each night until 10 p.m. Almost half a million people viewed the 250 paintings, drawings, and watercolors during their relatively short, six-week exhibition.[59] Fifty canvases owned by Ailsa Mellon Bruce and purchased from a Parisian decorator were slated to remain on indefinite loan. Lady Bird Johnson attended the opening amid a spate of lavish dinner parties (all of them held outside the Gallery itself). Some of the interest was incited by the prices several of the paintings had achieved. Four of them—two Cézannes, a Renoir, and a Monet—were among the most expensive purchases ever made (though they would soon be dwarfed by others), all bought at auction within the previous half dozen years.

The National Gallery also emphasized its continuing commitment to acquisition by highlighting, as temporary exhibitions, individual collections from different parts of the country. One of the first was the May 1967 showing of the Leigh and Mary Block collection from Chicago. Block, a steel company executive, was a trustee of the Art Institute of Chicago.[60] Along with his wife, the former Mary Lasker, daughter of the advertising dynamo Albert Lasker, he had amassed a significant group of modern artworks, which had never been publicly shown before. The decision to highlight them in Washington suggested both the power of the National Gallery's national podium and its interest in attracting the goodwill of nonresident art enthusiasts. It also hinted at growing tolerance toward modernism.

The Block exhibition was celebrated by Chicago's establishment as a legitimating gesture toward the city and the entire region. The governor of Illinois, senior Art Institute officers, and a host of local notables flew to Washington for the opening dinner at the Sulgrave Club, joined by area legislators and government officials.[61] Chicago newspapers crowed that this was the first time midwestern institutions (or individuals) had been invited to show their collections anywhere east of the Appalachians. "There has been no recognition with respect to the taste of the people who live in Chicago until now," Mary Block was quoted as saying. "This is the only reason Leigh and I are here—with our nails in the walls at home." In traditional Chicago fashion she deplored eastern condescension toward her city, traditionally centered on weather and crime. "I feel so strongly that this might change the image of Chicago."[62] Chicago and Washington newspapers alike covered the festivities, the fashions, and the notables in attendance, among whom, of course, was the assistant—soon to be deputy—director, J. Carter Brown.

The high prices of modern and impressionist paintings, and the growing receptivity of the Gallery to their presence, could not diminish the popular cachet of older masterpieces, signaled by their own increasingly awesome purchase levels. The same auction where the Gallery triumphantly captured Fragonard's *La Liseuse* saw the Metropolitan Museum of Art win, for more than two million dollars, Rembrandt's *Aristotle Contemplating a Bust of Homer*. It took just four minutes of bidding.[63] Director James Rorimer had seen the painting—then dealer-owned—at Chicago's 1933 Century of Progress Exposition and had never forgotten it. Over the years he had sought to bring the Rembrandt to the Met, and this was his chance. The vigorous competition for it at the Erickson sale (the Cleveland Museum of Art, Pittsburgh's Carnegie Institute, and Baron von Thyssen-Bornemisza were other bidders) stunned the art world and made the picture into an instant celebrity, quickly eclipsing—in the national press—the National Gallery's new trophy.[64] Chastened Gallery officials were soon challenging the notion that the Met had acquired the world's most expensive painting, arguing that Andrew Mellon's purchase of Raphael's *Alba Madonna* from the Russians some two decades earlier, when corrected for inflation, would beat out the $2.3 million price tag of the Rembrandt by some three thousand dollars.[65] Attendance at each museum soared when the new acquisitions were put on display. The Met was particularly happy. During the first six weeks after the Rembrandt

was hung, attendance more than doubled relative to the same period a year earlier.[66] The Gallery registered an impressive spike as well.

The Erickson sale also provided an opportunity for some New Yorkers to vent their contempt for Washington and its relatively new museum. Writing with some bitterness in the *Nation*, Lincoln Kirstein, an old comrade in arms of John Walker from his Harvard days, took out after the Gallery. Criticizing the Metropolitan for its inflated Rembrandt bid, he reserved greater scorn for the Gallery's acquisition, labeling the Fragonard "not first vintage." Putting "National" in quotes before Gallery, Kirstein called the Metropolitan the "Nation's Gallery." The "National" Gallery was "far more an agglomeration of gentlemanly taste, with some incomparable masterpieces and much trash." The Met's breadth and curatorial expertise, on the other hand, had made it the "greatest systematic repository of documentary resources in this country, if not the world."[67] Here, years before Hoving and Brown had forged their bitter competition, was strong evidence of Gotham's skepticism about the National Gallery's mission, and disdain for its collecting ambitions. The attitudes that Genauer and, to some extent, John Canaday, were revising in 1966, retained a strong hold upon others in New York's cultural leadership.

Kirstein's comments produced little reaction. And the National Gallery happily basked in the glow of newly purchased masterpieces even when they were destined for other institutions. In March 1965, the California business tycoon Norton Simon acquired in London another great Rembrandt, the portrait of the artist's son Titus, for $2.2 million. Before taking it on to Los Angeles, Simon placed the painting on view at the National Gallery, apparently in large part for California tax reasons.[68]

Caught up by the collecting fever and bankrolled by its most generous benefactor, Ailsa Bruce, the Gallery about this time (with Brown in a subordinate but coordinating role) launched a campaign to outflank every other institution and acquire an absolutely unequaled old master painting, burnishing its reputation to a polish that recalled the great Mellon purchases more than thirty-five years before. The quest, which became a memorable adventure for all participants, helped propel Brown still further along the road to his directorship, adding both to his skills and to his reputation. The quarry would be a trophy of the highest level: a painting by Leonardo da Vinci. None other then existed in America. And none other does now.

Stalking the Prey

The Quest for Old Masters

With its wealth of artistic masterpieces, the National Gallery of Art was always ready for more, its leadership and staff conditioned by training and appetite to seek out additional treasures. In this they were certainly not alone. No matter how impressive their collections, major art museums operate under an expansionist compulsion. Like sharks they are always in motion, ceaselessly seeking nutriment, their institutional status measured in part through added trophies. During the 1960s and 1970s it was becoming emphatically clear that the available pool of old master artworks had shrunk irrevocably, that their prices had grown astonishingly, and that collecting ambitions would have to center on more recent and even contemporary art. But despite increasing rarity and stratospheric costs, the pursuit of old masters continued to energize, and sometimes to obsess, directors and curators; it certainly excited their governing boards.

During the late 1990s Carter Brown reminisced how, long before, a group of students at New York University's Institute of Fine Arts had asked a visiting museum director to single out the most exciting aspect of an art museum career. The answer was clear: "The chase. Stalking and bringing down an acquisition." "It was just my luck," Brown added, "to be in for the kill for what was probably the major acquisition of a single work of art in the history of American public institutions," the National Gallery's purchase of Leonardo da Vinci's *Ginevra de' Benci*. It was also Brown's fate to lose out in pursuit of another great painting, Diego Velázquez's *Juan de Pareja*.[1] Both stories, of elation and disappointment,

were formative for the young museum administrator, acquisition ordeals that remained fresh even decades later.

In literal terms the Leonardo painting was John Walker's acquisition, the climax to his decades of accumulation. Walker's connections with *Ginevra de' Benci* went back many years, rooted in a series of romantic associations. In *Self-Portrait with Donors*, he recalled seeing the painting during a student visit to the Liechtenstein palace in Vienna in 1931 (at which point the princely family was not yet living in Liechtenstein itself). "I was enthralled by her moon-pale face enframed by an umbrageous juniper," he wrote.[2] An early Leonardo, the small, approximately fifteen-by-fifteen-inch panel, painted on both sides, had been cut down many years before, presumably because of damage. The subject, Ginevra de' Benci, was the recently married wife of a Florentine businessman. She was also the platonic love interest of Bernardo Bembo, Venetian ambassador to Florence. The downcast expression, so much in contrast with Leonardo's *Mona Lisa*, was interpreted by some as a lament for Bembo's absence from Florence at the time of her portrait sittings.[3]

Memories of "that stony, resentful stare" haunted Walker when, soon thereafter, he came to Florence to work with Bernard Berenson. Walker actually rented a room in a palace where Ginevra had lived until her marriage. He saw the portrait again, a few years after World War II, in London's National Gallery, as part of a larger exhibition. The National Gallery in Washington had been approached about exhibiting *Ginevra* and expressed considerable enthusiasm, according to Walker's memoir, but the reigning prince decided on London instead. David Finley sought, through influential (and royal) Austrian connections, to persuade the prince to sell it not long thereafter, but he was unsuccessful.

The painting led an eventful life during the 1930s and 1940s, taken for safety first to Salzburg, then to a monastery, and finally, by Prince Franz Josef II himself, to his castle in the Liechtenstein capital of Vaduz. There it remained for the rest of the war and for some years afterward. The prince possessed one of the great private art collections in Europe, filled with masterpieces, but *Ginevra* stood out even among them and was kept under special security in a castle cellar. While chief curator at the National Gallery, Walker had attempted to see the painting but was turned down. The Liechtensteins did make a visit in 1956 to Washington and the Gallery, and apparently came away impressed, but nothing more developed.

Then, in 1960, Walker, now director and making a trip through Switzerland, was invited to view the Liechtenstein collection by its curator. This was his third encounter with *Ginevra*. As described by Walker in his autobiography, the visit narrowly avoided a tragic end, as Walker almost fell while climbing back from his dungeon visit on a treacherous stone staircase and was saved only by the quick action of his host, the prince's curator, Gustav Wilhelm.[4] The Liechtenstein connection was healthy because the National Gallery had begun to buy pictures from a Zurich art dealer linked to the prince, Marianne Feilchenfeldt, who became friendly with Walker's chief curator, Perry Cott. The prince also had his own agent, a Hungarian named Josef Farago, and dealing through him the National Gallery was able to acquire important works by Orazio Gentileschi and Peter Paul Rubens.

Thus, by the time Brown arrived at the National Gallery, there was an established history of purchasing from the Liechtenstein collection and the great Leonardo had been firmly placed on the radar screen of Gallery officials. Walker and Cott continued to press their suit for the Leonardo during occasional visits to Liechtenstein. And Brown, fired up by the enthusiasm of the art historian Richard Offner, and his own childhood exposure to the Leonardo drawing in his Benefit Street home, urged Walker to make a strong effort to buy the *Ginevra*.[5] Meanwhile Liechtenstein, a tiny principality of twenty thousand or so, hedged between Austria and Switzerland, was slowly undergoing a transition from one of the poorest, most backward corners of Western Europe to a prosperous tax haven for the wealthy and a fabled manufacturer of postage stamps. In a few years per capita income would exceed even that of Switzerland, and unemployment become practically unknown.

The prince was embarked on a shrewd campaign to increase his personal wealth and investments. While it is not clear how badly he needed art sales to finance their growth, his family was certainly pruning its thirteen-hundred-picture collection; purchasers including the Kress Foundation, London's National Gallery, and the National Gallery of Canada, which had acquired work by Rembrandt, Chardin, and Guido Reni, among others.[6] *Ginevra*, however, was a special case. That the family, not the principality, owned the paintings, and Liechtenstein had no laws restricting the export of art, made the collection a frequent target for press speculation. And *Ginevra*, the only Leonardo known to remain in private hands, was a particularly appealing subject.

There are four important questions concerning the acquisition of masterpieces on this level: First, will the owner actually sell? Second, what price will he ask? Third, is the work accurately ascribed? And fourth, is it in good condition? In the case of *Ginevra*, none of these were simple matters. Despite the frequent denials that Walker and others encountered, rumors about the prince's willingness to sell emerged from time to time; occasionally newspapers reported that he had actually sold it. But it was not until 1965 that National Gallery officials learned there was a real possibility of purchase. That year Walker, accompanied by Cott and his new secretary-treasurer, Ernest Feidler, made still another visit to examine the picture. As evidence of a new and more welcoming attitude, *Ginevra* was released from her castle dungeon and brought to the home of Josef Farago for closer inspection. Walker retained some misgivings, but he remained hopeful about the acquisition. Now, however, the issue of cost would become significant.

It was hard to calculate the painting's fair value. The last available record for the purchase of a Leonardo, according to Gerald Reitlinger's then recently published *The Economics of Taste*, invoked by Brown in his recollections, occurred just before World War I, when Czar Nicholas II of Russia, exercising an option, bought a Leonardo *Madonna* from the prominent Benois family.[7] Leonty Benois, an architect attached to the court, and brother to the famous scenic designer Alexandre Benois, had inherited the picture from his father-in-law. Some Russian leaders had expressed concern about the picture leaving the country, and it was bought specifically for the Hermitage museum. Beating out the firm of Duveen Brothers, which thought it had finalized the deal and planned to sell the painting to Henry Clay Frick, the czar offered just over 310,000 pounds sterling, or a bit more than one and a half million dollars at the current exchange rate. In mid-1960s values (keeping the older pound-dollar ratio), this worked out to something approaching ten million dollars, almost five times the record price achieved by the Rembrandt *Aristotle* at the Erickson sale of 1961. Indeed, as of 1961, the year Reitlinger published the first volume of his book, and using available price records, the Benois Leonardo was widely argued to be the most expensive picture ever sold.[8] But this was the only recorded sale of a Leonardo in the twentieth century, and one cannot base meaningful expectations on a single price.

The National Gallery did have money to spend. Ailsa Mellon Bruce, devoted to her father's memory and aware that public moneys could not

be used to buy art, had provided an impressive pool of funds. But according to Brown, Walker was nervous about the purchase, despite his acknowledgement of the picture's greatness. While he had deeply desired the picture for years past, he admitted that he did not find the sitter attractive; a "pallid, slightly-cross-eyed lady" was the formulation Brown recalled him employing.[9] Walker worried that Mrs. Bruce would not find the picture appealing and might consider withdrawing her vital financial support in the future.

And then there was the timing. By the late 1960s, the final years of the Johnson administration, the ongoing war in Vietnam, budgetary strains, civil rights protests, and new antipoverty programs all contributed to a charged atmosphere in which so grand and expensive a purchase would be difficult to justify, even if paid for with private money.

Finally, there were important condition problems, centering on some older crude repairs.

Whether the prince was influenced by the Benois sale or not, there was an interesting coincidence: Walker was informed that the asking price was ten million dollars. Despite the generosity of Ailsa Bruce, this was far too high a price; there were, however, clear indications that it was not a final figure. Gallery people learned that an offer of four million dollars had been made by Wildenstein & Company, one of the premier dealers in old masters, and this had been rejected. So the final price would, presumably, be somewhere between four and ten million, possibly much closer to four—though the final cost to the Gallery might also reflect commissions given to brokers, friends, or go-betweens, whose goodwill was frequently indispensable to a successful transaction of this magnitude.

In June 1966, the Gallery was told that the Wildenstein firm had an option on the painting and were prepared to sell it. The price, despite Wildenstein's claim that it would take no commission, remained high, and Walker was skeptical about the dealer's altruism. Nonetheless, Walker, with board authorization, flew to Paris to negotiate with Daniel Wildenstein. The meeting never took place, and after several fits and starts Wildenstein called Walker and told him the Liechtenstein ruler wanted to stop further negotiations. That fall, however, Walker learned that the picture had returned to the market, and a price was proposed. Gun-shy after so many ups and downs, Walker insisted on a firm option, in writing, and this was produced. The option ran through the end of 1966.

There was one further complication. Although negotiations had been proceeding on the premise that the painting was by Leonardo da Vinci, Bernard Berenson, years before, had attributed it to Verrocchio, in whose workshop Leonardo had worked. Walker's admiration of Berenson, his closeness to him for almost thirty years, made this attribution significant. Nonetheless, Berenson had, for many years, been on record urging the Gallery to obtain *Ginevra*, deeming it an "indispensable" acquisition. But there were other experts who also challenged Leonardo's authorship, notably Magdeleine Hours, at the Louvre. Hours, a well published specialist on the use of X-ray technology to analyze old paintings, had based her unfavorable conclusion on some old, and arguably inadequate, X-rays made in London when the painting was exhibited at the National Gallery two decades earlier. Even so, such doubts would need to be allayed.

So in mid-December 1966, and again shortly after Christmas, Carter Brown, as assistant director, and with five years of experience at the Gallery, was sent to Zurich, which was close to Liechtenstein and served as a convenient meeting point, to help with the complex tasks of answering questions of attribution, evaluating the painting's physical condition, finalizing a price, and, if all went well, arranging for the prize to be brought home. For Brown the operation was an immensely thrilling adventure, although the precise nature of his charge and the extent of his decision-making authority are unclear. He was accompanied on these journeys by experts who knew far more than he did about technical evidence. And the spending reins stayed in Walker's hands. But Brown seemed a good choice as coordinator. He enjoyed bouncing ideas back and forth with colleagues, was a good synthesizer as well as a rapid learner, and relished the challenge of mastering a mass of complex details. Most of all, he was a gifted social broker, and hugely impressed by the magnitude of the task.

Brown's involvement was largely confined to these European trips, which also entailed side trips to London and Paris. The cast of characters was not large but included, aside from the principals, friends, agents (on either side), experts, and, in the distance, other would-be buyers—individuals, institutions, and dealers. There were a number of surprising connections. At some point during these two trips Brown remembered holding several telephone conversations with Senator Claiborne Pell. A fellow Rhode Islander, Pell was of course well acquainted with the Brown family. He and his wife had met Prince Franz Josef II and his consort, Princess Gena, during World War II, and had become close friends of the

Liechtenstein family. Indeed, Hans Adam, the heir apparent, had served in Washington as an intern for Senator Pell in the early 1960s, and the Pells would attend his elaborate, three-day wedding festivities in early 1967.[10] Brown had never met the prince himself and hoped that Pell might provide an introduction. Pell, it turned out, believed the prince should retain this great picture as part of his larger legacy, a position that would not notably assist Brown's objective, but his introduction, and the larger connection it signified, would turn out to be useful.

Brown, accompanied by Cott, arrived in London on December 14, 1966. He found time there for a series of engagements: visits to art dealers and the National Gallery, a stop at Turnbull & Asser to order shirts, and some long-distance telephoning with Walker and Senator Pell. He then flew to Zurich and dinner with the widow of Josef Farago, to open the actual discussions. Frau Farago, whose husband had died the previous year, was, like him, an antiques dealer. How the Hungarian-born Faragos had met the prince is unclear, but they had become good friends and Josef had served as his negotiating agent. Now his wife had taken over that role. She lived part of each year in Liechtenstein (for the tax benefits) and part in London. She would be the principal conduit for the negotiations and Brown's principal connection to the royal entourage. The day after Brown's arrival, she introduced him to the resident curator in Vaduz, Dr. Gustav Wilhelm, as the inspection of the painting began. Over the next week or two, Brown pressed Farago to indicate what kind of commission she expected from the sale, but she demurred, saying the prince would take care of that. She did, though, seem curious about the customary size of those fees; Brown suspected she was trying to figure out what the prince might pay her.

Returning to Zurich after meeting Wilhelm, Brown dined with a childhood friend, "Nini" Roberts, whom he recalled from a children's party at Harbour Court many years before. Roberts was the granddaughter of Gladys Vanderbilt, Countess Széchenyi. As a young woman Gladys Vanderbilt had grown up in the Breakers, in Newport, and had been friendly with John Nicholas Brown, Carter's father. Her granddaughter knew the prince and princess, and Brown hoped to use this as still another connection to meet with the prince.

But there was other work to be done before accepting the painting as genuine. There followed a quick visit to Paris, to discuss the X-rays with the skeptical Louvre curator, Magdeleine Hours. Brown returned to the

United States for Christmas but flew back to Europe on December 26. A snowstorm forced the cancellation of his scheduled flight from Providence to New York, but the magnitude of his mission led him to charter a plane to New York—a cost shared with a few other desperate passengers. From there he flew to Paris with Cott and Ernest Feidler to try again to persuade Hours that *Ginevra* was indeed by Leonardo and not Verrocchio. The London X-rays remained a problem. Brown concluded that given twenty years' advances in X-ray technology, new films were called for, and he was able to persuade the prince to send the painting to Zurich for a secret X-ray evaluation. But that would come later.

The visits with the Liechtenstein group were complicated exercises in etiquette. During the first trip, curator Wilhelm had told Brown that the prince would invite his party to tea. Brown responded that his friend Nini Roberts had suggested they might be invited to dinner, and said he preferred to wait for that invitation. This caused a "certain consternation," according to Brown, and after Wilhelm left, Frau Farago explained that the prince was willing to invite Brown to dinner but not his colleague Perry Cott. She did not wish to insult the prince by having Brown decline his invitation to tea, so instead instructed Wilhelm to say that he had not yet arrived. She had told Wilhelm that Brown came from "a good family." No call came from the "big house" that day, so Brown and his group remained in Zurich and dined there, after inspecting another great painting, a fifteenth-century work then thought to be by Fouquet. Painted on vellum, it was, despite the National Gallery's interest, not for sale. Tea with the prince was set for the following day, Friday, December 16.

That evening, and the next morning, Frau Farago coached Brown on what to say and what not to say when he met the prince. He was warned not to speak of the National Gallery or anything that "could be interpreted as buying the Leonardo." This despite the fact that the Gallery's option on the painting's purchase was set to expire in just over two weeks, at the end of the year. Nor were stamps a good subject, despite the fact that they were Liechtenstein's main source of revenue. The prince just wasn't interested. It was all right to talk about art in general, to invoke aristocratic friends, and to discuss hunting, one arena in which Brown had no competence.

While Farago made small talk with Brown, assuring him of her honesty and her disinterestedness, Perry Cott was peering with magnifiers at the Leonardo, now out of its frame and lying on her dining room table.

"Even seeing it upside down I caught my breath," Brown remembered. Cott was comparing it "crackle by crackle" with the X-ray and infrared images that had just been made in Zurich. Early restoration efforts were revealed, particularly around the nose, and Cott offered opinions on some other areas that Brown was concerned about. There was less damage than he feared, and the painting as a whole, at least in Brown's view, revealed Leonardo's mastery.

Discussions continued, and then it was time to prepare for the crucial tea. The need for secrecy remained strong. When the chauffeur taking them to the castle asked Brown if he was from Washington, he denied it, declaring he was from New York. Earlier he had persuaded the hotel proprietor in Vaduz to let him glance at the register, checking to see if there was a record for Rick Brown, director of the Kimbell Museum in Fort Worth, Texas, which was perhaps the most richly endowed art museum in America at that point, and rumored to be interested in the Leonardo. Carter didn't find his name.

Finally the group was assembled and arrived at the castle to meet the prince. "Very tall, aristocratic, narrow face, a little moustache," Brown recalled. "We probably spoke in English. Those aristocrats are all polyglot." Conversation was designed to put the prince at ease and to establish social credentials. Brown was never above trading on his contacts, acquaintanceships, family connections, or anything else that might help in the process of a negotiation. He had a lot to work with. While Cott talked about his part in saving the Liechtenstein palace in Vienna after World War II, Brown dropped the names of "the Széchenyis, her daughter Countess Eltz, Kaiser Otto, the Emperor Hapsburg," and anyone else who might bolster his credibility. He did refrain, for reasons unspecified, "from mentioning Franz of Bavaria, who was a friend." There were tours of the gun collection, the guest rooms, a refectory, and other features of the castle, some of them, like the drawbridge, installed in the late nineteenth century. And some viewing of other works of art. But no conversation about the real reason for the meeting. The prince, just before their departure, asked to be remembered to John Walker. There was no other mention of the matter at hand. "All very delicate," Brown recalled.

Late in the day Frau Farago hosted a postmortem about the tea at her home. There was a sense of some progress and even accomplishment. In all the years of speculation about *Ginevra*, no would-be purchasers—not even Walker—had been summoned for a princely audience. Farago as-

sured Brown that his visit was unique, and seemed interested in promoting the sale. When Brown suggested that the prince was very rich, and thus might not be interested in alienating the picture, she argued that he needed to sell in order to transfer some of his assets to income-yielding securities. Brown had also heard rumors of gambling binges that might have produced some financial embarrassment, but these could not be confirmed.

While the discussion with Frau Farago was franker than that with the prince, there was still lots of dancing about issues of price and condition. Brown expressed his concern that "the prince with the pride of every collector and being told by those close to him what he wants to hear . . . may overrate in his own mind the value of his painting." He conceded that he and his colleagues were not too worried about several areas of loss and crackle, which were typical in five-hundred-year-old pictures. But there was considerable damage to portions of the nose and some of the landscape. And, Brown continued, while he personally believed the painting was by Leonardo ("she smiled rather condescendingly, I thought, at that"), others did not, and at least one expert had changed his position in recent years. The National Gallery had the funds to buy, but in view of the ongoing Vietnam conflict, the tightness of money, and Walker's lack of personal enthusiasm, perhaps the best thing to do was withdraw the picture from the market. Brown represented this as Walker's conclusion.

"She seemed surprised," Brown remembered, as the feinting and parrying continued. This was, after all, the last remaining Leonardo in private hands, Frau Farago reminded them, and she had already received an offer of six million dollars. Brown wondered if this was from Norton Simon, another potential buyer, who reportedly had made the offer in early 1965 and been rejected by the prince.[11] But there were many such rumors. She was really on the Gallery's side in this matter, Farago reassured him and his colleagues, continuing to insist she would accept no commission from the Gallery.

What was now certain, however, was that Brown had fallen in love with the Leonardo. "The power of the picture as a whole," he wrote Walker, "has a hallucinatory presence, a strange and compelling luminescence as if the light came from within the form. The color is gorgeous; the warmth of the tonality of the face and the overall unity astounded me." He agreed with Cott's conclusion, that "it is a miracle of painting," and

with his teacher, Richard Offner, that, even after having been cut down, *Ginevra* is "one of the great portraits of the world." Brown had been an advocate for the purchase ever since arriving at the National Gallery five years before; now he made the case with almost religious zeal.

Discussions continued, and at some point (exactly when is unclear) a price was agreed upon. The figure was never released officially by the National Gallery but is reliably stated to be somewhere between five and six million dollars. Brown himself does not seem to have been involved in the final price-setting; he was not, presumably, authorized to act for the Gallery on a matter of this importance, but rather served to send signals from Walker and to respond to information provided by Farago on behalf of the prince.

All of this occurred during the heady hours of Brown's first visit. He then flew home for Christmas, after doing some shopping in Paris, speaking to his French sister-in-law, and escorting Paul Mellon's stepdaughter to the airport for her own return home. The second visit, in the very last days of 1966, was somewhat less dramatic, involving efforts to persuade Magdeleine Hours of Leonardo's authorship and discussions with Mario Modestini, a favorite Gallery restorer, to obtain his opinion of the condition and authenticity of the painting. Modestini's recollection was that he did most of the work while Brown enjoyed the beauty of the place, the tapestries, and the Rubens collection in the castle.[12] After close examination of the panel, and one more splendid lunch in Vaduz, Modestini affirmed his support of the Leonardo pedigree and expressed confidence that any disfigurements could be handled satisfactorily. He promised that in the end the picture's condition, with some careful but limited interventions, would yield universal satisfaction. A final, more modern X-ray and ultraviolet examination in Zurich ensued, and Hours too was at last satisfied of the painting's authenticity. On January 17 the National Gallery board of trustees voted to make the acquisition. This was, Brown wrote later, "heady wine! Imagine having the opportunity to be involved in a major decision of this magnitude. And I didn't want to blow it. I wanted to make sure every possible base was covered." He had done "all the due diligence," inspecting the picture, intent on warning Walker of "any rocks or shoals" that might lie ahead. He had found none.

With price, condition, and authenticity settled, it was time to arrange *Ginevra*'s passage to the New World. Brown would have loved to carry

the picture back to America, capping his efforts and satisfying his own delight in public performance. But, he wrote later, secrecy and security were the orders of the day, and he himself "was considered to be too high visibility" to escort the picture. Instead, Ernest Feidler and Mario Modestini were sent to Liechtenstein in February, Feidler to sign the final agreement, Modestini to help manage the transport.

Given the value of the painting and publicity surrounding the protracted negotiations, every precaution needed to be taken. To avoid a sudden change in humidity, which Brown, among others, feared might damage the picture, the wood panel on which it was painted would be wrapped in plastic and placed within a plywood box. This in turn fit into a gray metal container that resembled an ordinary suitcase, created with the help of the Mellon Institute in Pittsburgh, host to a broad range of art conservation projects. The goal was make the shipment entirely inconspicuous. Under an address flap, however, was a gauge that registered the interior humidity, and the case was lined with Styrofoam to protect against any knocks or blows. It was also made waterproof, and in the event of a plane crash was meant to float. The layered structure was likened by Feidler, in a subsequent newspaper desription, to a thermos jug.[13] Brown wanted to go still further, proposing to Walker that there be two couriers and two identical suitcases, one flying from Geneva and one from Zurich. "If there were any plots in the underworld to apprehend or hijack this on the way, it would reduce the risk by 50%," he argued. However, it was "a little too James Bond" for Walker, who decided to assume the risk of buying just one set of plane tickets.

The trip from Vaduz to the Zurich airport, through the snow on February 8, held its own dangers. Once on the 1 p.m. Swissair flight to New York's John F. Kennedy International Airport, in its own first-class window seat, *Ginevra* seemed safe, registered for the flight as Mrs. Modestini. Surrounding passengers, Modestini recalled in an interview, were very curious.[14] Arrangements had been made to transfer the picture directly to a Gulf Oil company plane at JFK, without clearing customs (Pittsburgh-based Gulf was controlled by Mellon interests, and the secretary of the treasury, by statute a Gallery trustee, approved the request to bypass customs officials). A New York snowstorm briefly threatened to divert the plane to Pittsburgh. But in the end the JFK landing and the transfer went forward without complication; the picture was carried by FBI agents on to the Gulf plane, then taken safely on to Washington.

The National Gallery wanted to keep the news quiet until it was ready to unveil the painting, but rumors of a sale continued to circulate, and on February 19, almost two weeks after *Ginevra*'s arrival in Washington, the story broke.[15] Brown, who was in overall charge of press relations at the time, claimed that a *New York Times* reporter found out about the deal. While it couldn't get confirmation, the *Times* ("in its infinite self-confidence," Brown noted) decided to run the story anyway, on the front page of its Sunday edition.[16] The paper would assume an adversarial relationship with Brown from time to time in years ahead, particularly when it came to competition with the Metropolitan, and he bore some scars.[17] The *Washington Post* behaved better, Brown recalled, attempting to contact him for official confirmation. But he refused to answer the telephone, stuffing it under his pillow to muffle the noise. It ran the story nonetheless, in a late edition, but only because the *Times* had already done so.[18]

The *Times* article, which included a denial by Liechtenstein adviser Dr. Gustav Wilhelm, precipitated the Gallery's release of a three-page statement by Walker and a telephone interview given to the reporter, Milton Esterow. Walker's press officer, William Morrison, declared that these kinds of statements were how the Gallery announced all acquisitions, although rumors may have pushed the release earlier than was hoped.[19] The *Washington Post* story included details provided by Modestini about the flight and the specially designed suitcase.[20] The National Gallery announced that after a few more weeks of acclimatization in a special vault, the "world's costliest painting" would go on public display on March 17, the twenty-sixth anniversary of the Gallery's opening. It was also St. Patrick's Day. "He has always been a good patron saint of the Gallery," Walker commented to the *Times* correspondent, adding that he himself was a Scot, not an Irishman.[21] More than forty-four hundred people visited the National Gallery for a first-day viewing, crowding in front of *Ginevra* for at least a glimpse of the heavily publicized painting.

As the only Leonardo da Vinci painting in the New World, the first to be sold in more than fifty years, and, quite probably, the most expensive individual work of art in history, *Ginevra* was a natural for institutional promotion, and Gallery staff rose to the occasion. There were dainty steps taken around the actual price and the source for the money. Brown declared publicly that while the final figure would not be revealed, five million dollars was not too much for an artwork this valuable; newspapers often invoked a figure of $5.8 million, and sometimes talked of

six million. When, in late February 1967, the National Gallery proposed to sell 111,000 shares of Gulf Oil stock, worth approximately $6.6 million, there was speculation that a connection existed between the securities donated by Paul Mellon and his sister Ailsa and the cost of the painting. "Sheer coincidence," was Ernest Feidler's comment. Gallery officials also refused to identify Ailsa Mellon Bruce as the principal donor, although at her death, just a couple of years later, she was widely identified with the purchase of the world's most expensive painting.[22]

The reaction to the acquisition was, despite some initial fears, overwhelmingly favorable. The high price was no problem, particularly for locals, who saw the Leonardo acquisition as another sign of Washington's growing cultural significance. "It's been a long time since Washington had a winner," the *Post* editorialized in March "The Senators don't come close. The Redskins are trying hard. . . . But the National Gallery of Art is making a habit of winning the big ones." It described John Walker's feat as a "major triumph," although it admitted there were no details on "how the coup was arranged" or "where the money came from." The Leonardo demonstrated that the museum was moving ahead to assume the position of "*the* great national collection." And with other new institutions on line there was room to believe that the Mall would soon possess "the finest permanent collection of art and sculpture in the world."[23] Costliness elicited respect rather than charges of self-indulgence. Andrew Hudson, the *Post*'s art critic, saw the purchase as a fitting climax to the Gallery's twenty-fifth anniversary year, joining important recent acquisitions like Rubens's *Daniel in the Lions' Den* and van der Weyden's *Saint George and the Dragon* as a sign of the city's continuing growth as an art center.[24] "It's appropriate that the Leonardo should come here, rather than New York," Hudson wrote soon after *Ginevra*'s arrival, for while the Met was richer in nineteenth-century French art, "Washington has the supreme collection of Italian art in the country."[25]

Newspapers throughout the country, in editorials and news stories, used the occasion to salute Washington, the donors, and an apparent national awakening of interest in the arts. Henry J. Seldis in the *Los Angeles Times* argued that headlines about price should not distract from the marvel of the painting. "A country like ours with its vast material resources can afford to support the development of a national gallery, second to none," even while promoting contemporary art and scholarship. Washington, in the coming decade, was likely to "achieve those

cultural aspects that have long distinguished many lesser capitals of the world."[26] Indeed, Seldis went on to contrast the purchase with the Metropolitan's acquisition of *Aristotle Contemplating a Bust of Homer*, the trophy picture so recently in the news. While the Met was simply adding to its large stock of Rembrandts, the purchase of this last privately owned Leonardo "represents an act of national significance." Other newspapers played up the story that Norton Simon had made an even larger offer to the Liechtenstein ruling family but had been turned down in favor of placing the picture in a national museum. The recent growth of attendance at the National Gallery was somehow linked to the great purchase. One newspaper editorial suggested that the Leonardo had acted like a magnet, even in advance of its announcement. "Popular interest in cultural affairs in recent years has been so wide-spread and so intense as to have been characterized as a 'cultural explosion,'" declared the *Shreveport Times*—and several other newspapers—in late March, commenting upon the enormous popularity both of Leonardo and of Andrew Wyeth. The writer drew comfort from Wyeth's success and the interest being shown in Leonardo, reassurance for those who feared that the "paint-drizzling imitators of Pollock," or the soup paintings of Pop artists like Warhol, had temporarily blinded the art-loving public.[27]

Magazines and broadcast outlets also provided extensive publicity. *Life, Newsweek*, even the *Weekly Reader*, all did stories. NBC News ran a documentary on the Gallery months later, reporting excitedly its purchase "for a sum reportedly in excess of five million dollars."[28] There were some rather bizarre commentaries as well. David Braaten, writing in the *Washington Star*, wondered if the Central Intelligence Agency had bankrolled the purchase, in an effort to prevent the strategic principality of Liechtenstein from going communist. Perhaps a foundation backed with CIA money had been responsible.[29] Other newspapers picked up on the speculation. And Salvador Dalí announced that he would set five million dollars as the price for his next picture. If Leonardo da Vinci could reach that height, Dalí could as well.

A graver dissenting note was struck by *New York Times* art critic John Canaday. After attending the fifteen-minute news conference held before the painting's public debut, he described *Ginevra* as "looking terribly out of sorts and more than a little out of drawing—the two sides of her face have never matched." He skeptically parsed Walker's five reasons why "this is one of the most precious paintings in the world." Why had

Walker, who had been begging for just one news story that did not mention the rumored five million dollar price, so emphasized the rarity of the picture? And how, in observing that the painting was "remarkably preserved," could he ignore the fact that the bottom part of the panel had been chopped off? Canaday acknowledged that the remaining portion of the picture was in considerably better condition than the *Mona Lisa*, but he contended that without Leonardo's name attached *Ginevra* would be one of dozens of Renaissance portraits "that individuals might regard as a favorite." Like the *Mona Lisa*, it was becoming "a legend rather than a painting, and hence any independent response to its inherent virtues and shortcomings is obscured"—a riposte, perhaps, to Henry Seldis's unflattering reference to the high-priced Rembrandt now at the Met. In the end, while judging the picture "not inspiring," Canaday extended a "patient welcome" while "we wait for the exaggerated excitement to die down."[30]

Years later, the Gallery was still taking some heat for the transaction, from Canaday, among others. Reviewing Walker's memoir in 1974, Canaday recalled "how ostentatiously" he had packaged for a press conference "the super expensive piece of merchandise he acquired for the National Gallery."[31] In 1972 a television film narrated by Sir John Gielgud spent some time on *Ginevra* and on Carter Brown, by then the Gallery's director. It attracted the attention of Washington critic Frank Getlein, who found the level of self-promotion shameless. Brown's making *Ginevra* the "Emma Bovary of her day" was probably harmless, Getlein wrote, "but the picture, magnificent as it is, is simply not as important, either in the work of Leonardo or in the history of European art, as Brown says it is." As for the film, the script was trite, the color manipulated, but "sometimes Leonardo triumphs over all."[32] John J. O'Connor in the *New York Times* contented himself with calling the documentary "relentlessly and sometimes overwhelmingly dull."[33]

Once the purchase had been consummated, commercial opportunities were quickly exploited. B. Altman, the New York department store, included *Ginevra* among its "superb full-color reproductions of old and modern masters," and within months NBC News was declaring, in advertisements for its *American Profile: The National Gallery of Art*, that "No painting in Washington's National Gallery of Art gets more attention than the da Vinci portrait of Ginevra de' Benci." Fueling John Walker's ongoing irritation, it went on to declare that the painting was "said to

have brought" the highest price ever paid, "reportedly" in excess of five million dollars. The newspaper advertisement was titled "Dear Lady" and featured a reproduction.[34] Ymelda Dixon reported enthusiastically for Washingtonians that American Tourister, maker of the artwork's famous temperature-controlled traveling case, had ordered reproductions of the painting and would give one to each future purchaser of an American Tourister suitcase.[35]

And there were some who recoiled at the reputedly huge price tag, casting it as indicative of broader problems. One letter writer to the *Washington Post*, calling the purchase an example of "group madness," complained that when private individuals, in the name of beauty, competed to ante up the cost of a painting like *Ginevra*, it was not "the purchase of a work of art which has been consummated, but the mania for collectorship." Washington schoolchildren, she continued, "will return from the well-lit marble splendors of the National Gallery to their overcrowded, underheated, dingy classrooms, and an underpaid policeman will stand on a corner directing traffic to the Gallery."[36] This was precisely the kind of reaction Gallery officials had dreaded, contrasting the huge sums consumed by art purchases with broader social needs. Bob Collins in the *Indianapolis Star*, asserting that some old masters were "more overpriced than women's cosmetics," declared that if Leonardo were painting in the late twentieth century he'd make so much money that J. Paul Getty would end up working for him.[37] And the artist Harold Town, in *Toronto Life*, called for an end to those "stupid Mickey Mouse art competitions." Reacting to a proposal by Jean Sutherland Boggs, director of Canada's National Gallery in Ottawa, to purchase a small Renaissance painting for a million dollars, Town argued that it was a "sleazy idea" to think that rarity was worth any price. The notion that acquiring a great old master would make Ottawa into a tourist attraction insulted the future of Canadian art. Far better to spend such money on a great international biennial of contemporary art.[38] Still other newspapers proposed using such funds to fight disease.

Overall, however, the American response was one of pride rather than guilt; satisfaction outweighed anxiety. Bringing a Leonardo to Washington on Mellon money to be shown in a national gallery did not seem excessive or outrageous to most observers. Indeed, it soon became a benchmark in Gallery promotion, a point of comparison when other great purchases were made (or gifts received), and a source of commendation

from foreign critics. Kenneth Clark told Brown, a few years later, that *Ginevra* was worth whatever price had been paid, and André Malraux, in a widely covered second visit to the National Gallery, paid special attention to *Ginevra*, which he had never seen before.[39] "When I was last here, in 1962, it was a good gallery," he declared at a luncheon in 1972. "In the 10 years since, it has become a superb gallery."[40]

Much of the excitement and some of the ambiguity surrounding the National Gallery's acquisition of *Ginevra* was caused by uncertainty as to its price. Critics, journalists, and collectors might invoke a figure of 5.6 or 5.8 or even 6 million dollars, but the Gallery never acknowledged a definitive figure, and, the sale having been a private transaction between a reigning prince and a secretive museum, nobody could force one out. A few hundred thousand dollars either way didn't seem to matter much, except when comparisons with other art purchases were being made.

The next great opportunity for a masterpiece at this level came just three years later, in 1970, soon after Brown marked his first anniversary as Gallery director. This was no quiet private transaction but a very public auction in the sales rooms of Christie's famous establishment, and it would prove to be as intense as the *Ginevra* negotiations, if far less satisfying. In interviews taped not long before his death, Brown produced some strident accusations, reflecting the rancor that he still felt about his loss. The winning opponent was his chief rival within the American museum establishment, another wealthy, well-educated, charismatic young patrician, who had taken over the Metropolitan Museum just as *Ginevra* was being brought to the National Gallery. Indeed, Thomas Hoving had thought briefly of intervening and making that purchase himself, during a rumored lull in the Liechtenstein dickering. In the end he decided not to, but he realized that Mellon money and taste made for an important adversary in the hunt for masterpieces.

The campaign to acquire Diego Velázquez's *Juan de Pareja* has been vividly described in a chapter of Hoving's confessional memoir, *Making the Mummies Dance*.[41] Hoving recalled being introduced to the picture by his close friend and chief curator, Ted Rousseau, who told him he considered it to be "one of the most beautiful, most *living* portraits ever painted," and by "the greatest painter in history." The subject was an assistant of Velázquez, a *marisco* of mixed heritage, who eventually would become well known in his own right. Early on, the picture had provoked astonished reactions by the painter's contemporaries, who seem almost

to have expected the figure to speak. The picture had been at Longford Castle, in possession of the Earls of Radnor, for more than 150 years. The Radnors had been besieged by offers from dealers and collectors for a long time, turning them all down, but after the theft of several other artworks from the castle, they finally decided to put it up for auction.

Hoving was enthusiastic, despite predictions that the painting might cost as much as three or four million dollars. "The most basic duty of the Metropolitan was to seize such treasures," he declared frankly. "Not making a major effort would be tantamount to dereliction of duty."[42] Moreover, it was the Met's centennial year, and a grand gesture of this magnitude seemed appropriate. Once a decision had been made, it was necessary to find someone to inspect the painting carefully, to make the bid, and, above all, to raise the necessary money. Hoving immediately called Wildenstein & Company, a firm that had previously expressed interest in the Velázquez, and asked it to act as the Met's representative. He and several colleagues—Rousseau, Everett Fahy, Hubert von Sonnenburg—immersed themselves in Velázquez studies and prepared to make trips to Madrid and Rome to examine other Velázquez paintings along with *Juan*. And then they set about convincing Douglas Dillon, president of the museum, along with a few key trustees, that digging deep into both institutional and personal pockets made sense.

Hoving's chapter reads like an adventure story, with ample suggestions of a spy-based mystery. The group, Hoving asserted, resorted to trickery to gain the opportunity to see *Juan* at close range, in order to ascertain the picture's actual condition and try to determine if its original intensity was recoverable. Dillon, he wrote, "was amused about our espionage and riveted by our findings."[43] Much like Brown and his colleagues in their pursuit of *Ginevra* three years before, the Met group pored over every inch of the painted surface, reassured and inspired by the sense of competing for a worthy prize. The heart of the chapter concerns the effort to raise the money and what Hoving contends were his suggestions about bidding strategy.

It was vital that competitors be sniffed out, evaluated, and outmaneuvered. There was a long list of potential rivals, chief among them London's National Gallery, the Louvre, the Cleveland Museum of Art, and Washington's National Gallery. In response to concerns that the Met would be spending a huge sum at a time of fiscal constraint and huge budget cuts, Hoving proposed calling the directors of four major American

museums—in Boston, Cleveland, Washington, and San Francisco—to see if any of them would agree to buy the painting in partnership with the Met, sharing costs, and display time, on an equal basis. All responded negatively, citing money worries, concerns about the canvas, or the notion that the time was not right to adopt such a strategy. Based on their answers, Hoving concluded that the Met had only one serious competitor, and that was the National Gallery in Washington.

This seemed, Hoving wrote, a surprise to his boss, Douglas Dillon. For in response to a direct question, Paul Mellon had declared that the National Gallery was not "especially interested" in the Velázquez.[44] Hoving would have been persuaded if Mellon had cited the cost, other priorities, or staff objections. But this explanation was unconvincing. "You couldn't be uninterested in the single finest Velazquez ever to come up to sale. They were in."

Hoving was right to draw that conclusion. The National Gallery certainly was interested. Moreover, unlike the Met, which was frantically trying to figure out how to mortgage endowment funds for years to come and drum up personal contributions from a group of key trustees, the National Gallery, thanks to Ailsa Mellon Bruce, had the money in hand. Typically, as Carter Brown remembered it, the roots of his own involvement were personal. While visiting the Earl of Pembroke "at his wonderful house, it's Palladian, great art collection," he told an interviewer, his host took him over to a nearby country house owned by the Earl of Radnor, which included "an absolutely dazzling portrait of a black man by Velázquez." John Walker, meanwhile, had been keeping notebooks of visits to British country houses, assigning ratings to possible acquisitions. *Juan de Pareja* had received an A+. "And so it seemed inevitable that we should go after it." The question now was how to do it.

Geoffrey Agnew had served as the Gallery's bidding agent in many previous old master quests; this time, in order to "keep people off the scent," they instead turned to Wildenstein. But Hoving had been there first, and the head of the firm declared that he was already committed. Brown knew that Hoving was their client. Hoving "had always used the National Gallery as his device to unite his trustees about a common enemy," Brown reminisced. He had picked up the habit from his director predecessor, James Rorimer, "pathologically eaten out by jealousy of the National Gallery," which Rorimer termed "all pink marble and prestige."[45]

Journalists and New York collectors fanned the flames. As noted already, even while criticizing the Met for spending so much on Rembrandt's *Aristotle Contemplating a Bust of Homer* at the Erickson sale in 1961, Lincoln Kirstein had mocked its Washington rival even more bitingly.[46]

Brown's explanation for the Met's rising anger was simple. "Here the Met was cock of the walk since 1870, and suddenly in 1941 this nova in the sky with the United States government and the Mellons and Chester Dale and Lessing Rosenwald and the Kresses all behind it" suddenly appeared. Despite the very different character of the two institutions—the Met, a universal museum committed to the art of the entire world, and the National Gallery, confined to painting, the graphic arts, and sculpture of Western Europe and the United States—they were set up by the press, Brown said, and by the Met's directors, to be rivals. The longevity of the competition may well have been exaggerated by Brown. There is little record of it going back much beyond Rorimer and the 1960s—although it was certainly in place then—and there is every sense that the rivalry may have served the interests of the National Gallery as much as those of the Met. After all, if Washington was disliked in New York, many in the federal establishment were at least as unhappy about Gotham's frequently stated contempt for the capital's cultural assets. But caricatured and hyped up by newspapers as it may have been, the relationship between the Met and the National Gallery did play an important role not only in determining acquisition policy but even more, as will soon be shown, in the development of visiting exhibition programs.

Like Hoving, Brown and his staff tried to figure out how many institutions were in the hunt, and how much money they would have to spend. They believed they knew, from published figures, the funding the Met had available (they turned out to be wrong) and determined to double it. But then Geoffrey Agnew advised them that their bid would have to be increased still more. Here Brown ran into opposition from some members of his board, notably Mellon lawyer Stoddard Stevens, a longtime thorn in his side. Stevens warned of a negative public reaction to a huge expenditure (unlike the price paid for the Leonardo, this figure would be published). Brown himself claimed to be concerned about how this sale might contribute to inflation in the art market. Further, paying more for Velázquez than for Leonardo da Vinci seemed unjustified. But the painting was highly appealing, particularly "in terms of the fact that the sitter

was black, and I thought that in Washington that would be very helpful." There must have been a similar appeal in New York. In any event, Brown and some of his staff paid a visit to Christie's to inspect the painting—the same day, it turned out, that Hoving's group was there. Brown recalled the offer to share but noted Paul Mellon's thought that this "was a non-starter . . . he had the feeling that he could afford it, so why cut the Met into it just because they were worse off?"

Meanwhile, Hoving had organized what he admitted was a "misinformation campaign," spreading rumors that the Met was not actually interested in the picture, that the city of New York had prohibited it from bidding, that it was totally out of money, all to confuse potential rivals. In the case of the National Gallery the deception appeared to work. We "breathed a sigh of relief," Brown remembered. Meanwhile the Met moved ahead. Hoving labored through a series of plans to create, in the end, a bidding strategy. Wildenstein would enter late, with an even number, and plan to make one more, final bid after others had reached two million guineas (about five million dollars). He was convinced that Brown's agent would stop at 2.1 million guineas and not respond to anything higher.

Brown's relief was short-lived. Persuaded that "Tom would stop at nothing, and that my phone at the National Gallery was probably bugged," he went to a public pay phone at nearby Union Station and made his final call to Geoffrey Agnew, indicating the bidding limit imposed by the Gallery board. Agnew insisted they needed to get in the bidding at just the right level, so that their final bid—2.1 million guineas, just as Hoving had anticipated—would carry the day. Despite very natural apprehension, he and Brown felt confident, so confident that Brown prepared a draft of a press release claiming victory, even working through a Spanish-language version. On November 27, 1970, however, in an unusually rapid series of bids, rising, toward the end, by hundreds of thousands of dollars every few seconds, *Juan de Pareja* took just two and a half minutes to reach the record auction sum of 2.2 million guineas, or $5,544,000, and an unhappy Geoffrey Agnew had to telephone Brown with the sad news that he had been outbid.[47] Wildenstein had come away with the painting.[48]

Bitterly disappointed, Brown asked who Wildenstein had been bidding for. Agnew didn't know, nor did anyone else. Alec Wildenstein, the winning bidder, and Louis Goldenberg, president of the firm, declared, "We bought it for ourselves, and the picture will go in inventory"—giving

the Met trustees time to prepare their case both for the public and for the rest of their board. Brown himself did nothing to dispel the uncertainty, which would persist for some time, declining comment when asked if the National Gallery had been one of the auction participants.

On Saturday night, November 28, Paul Mellon hosted a dinner at the National Gallery honoring two American museums that were celebrating their centennials, the Metropolitan and the Museum of Fine Arts, Boston. Trustees from all three institutions were in attendance, and there was naturally talk about the record-setting auction the previous day.[49] An account of the event in the *Washington Post* quoted Roswell Gilpatric, former secretary of defense, Met trustee, and chairman of its centennial committee, as saying that the Met (partnering with Boston) had asked Agnew to submit its bid and was much disappointed at losing the picture. Some Washingtonians were apparently bewildered by the thought that the vice president of the United States was making auction bids (most Americans knew only one Agnew).[50] Actually Gilpatric, clearly outside the loop of significant Metropolitan trustees, was confused about just what actions had been taken. This reflected the strategy adopted by Dillon and Hoving, to keep knowledge of the arrangements, and especially of the bid limits, within a small group of trustees, the Met's acquisitions committee. The plan was to rely on restricted acquisitions funds, thus avoiding the need for an advance report to the larger board. And if they did get the painting, they knew secrecy would be necessary until an export permit had been obtained; until then, the British government retained the right to buy it back and prevent its leaving the country.

Brown felt angry and cheated. There were several villains. He blamed, among others, Wildenstein, which had gambled that eventually the Met would come up with the necessary funds; if it didn't, the firm would keep the painting for a while but ultimately sell it to someone else. He blamed Hoving for being a "buccaneer" and disobeying his trustees, getting the picture first and only afterward trying to raise the money. He blamed himself and his "silly New England moral grounds" for not going higher than he did, when the National Gallery could have afforded it. The bitterness reflected the fact that this was Brown's maiden voyage in the high-flying world of international art auctions. The further discovery, which Met curators had already suspected, that part of the canvas had been folded over, giving them, after cleaning, an even larger and more impressive work of art than had been on display, made the defeat still

harder to take. Brown, Mellon, and Agnew had been outmaneuvered by the New Yorkers.

Brown remained convinced that Hoving had tapped his phones, and disclosed to an interviewer that Douglas Dillon had called subsequently, told him that Hoving had admitted to the wiretap, apologized, and declared his embarrassment at the illegal tactic.[51] But in any case, he could scarcely blame his loss on bugs, having transmitted the final bid limit on a telephone that Hoving could not have anticipated him using.

There was, in retrospect, at least one solace for Brown. He believed that the Met's stunning victory had set in motion events that would eventually cost Hoving his directorship. The outlay for the Velázquez was so large that in order to sustain the institution's cash flow, endowment capital would be tapped and an aggressive deaccessioning policy adopted, especially from the Adelaide Milton de Groot bequest. Both actions brought attention from New York's attorney general and a hungry press corps, perpetually sniffing for scandal. These, and a number of other issues, ultimately led to Hoving's 1977 resignation.[52]

It took a long time for the Met to declare victory. The painting was cleaned, reframed, and quietly sent to New York. The British government declined to prevent its export. Increasingly nervous about making an announcement—economies had just forced Monday closures—the Met announced its win in mid-May 1971, almost six months after the auction, declaring *Juan de Pareja* to be one of the half dozen most important single acquisitions in its history. The money, it asserted, came from purchase funds left by Isaac Fletcher and Jacob Rogers, in addition to individual contributions from various trustees.[53] While some Metropolitan staff members, particularly those in its education department, reacted angrily, seeing in the huge expenditure a violation of the museum's broad priorities, the larger response was more positive.

Thus, even before it became known that the Met was the purchaser, John Canaday, who just three years earlier had been skeptical about the National Gallery's acquisition of *Ginevra*, expressed his enthusiasm. The first question, he wrote, was "whether the announced figure is legitimate." And "the answer is an irrefutable yes."[54] "A work of art is worth in money whatever it will bring in money, and that is that." Velázquez paintings were rare, Velázquez was a supreme painter, and this was one of his best works. Some might wonder whether it was appropriate to spend so much on a painting when the world had so many other needs. The case

for the purchase, Canaday concluded, lay in the role museums played, distilling "from human experience . . . the eternal spiritual and intellectual truths by which men fulfill themselves." Safeguarding a few square feet of canvas "takes precedence over more practical but ephemeral contributions to humanity such as clearing a slum."

The absence of serious criticism may also have reflected the subject of this Velázquez painting, a black apprentice artist, suggestive, for some at least, of museum interest in representing on their walls (and attracting to their premises) a more diverse constituency. Moreover, by the early 1970s, as inflation surged, the growth in art costs suggested that art purchases might constitute an intelligent investment strategy. But the huge jumps in price, for modern works as well as old masters, precluded the active auction participation of most American art museums. For the most part the colossal sums paid in the decades that followed would come from individual collectors, bidding on behalf of themselves rather than for favored museums. Norton Simon and Paul Mellon remained notable exceptions, but the prices they paid would soon be completely overshadowed. To give just one example, in 1966, four years before the *Juan de Pareja* sale, the extraordinary Chester Dale collection—240 paintings, along with sculpture and several pieces of graphic art—was officially appraised at slightly more than twenty-two million dollars. The highest valuation of a single painting, a Renoir, was $750,000. The eighty-eight paintings in Dale's suite at the Plaza Hotel—among them major works by Degas and Modigliani—were collectively appraised at six million dollars.[55]

More than that, the travails faced by the Met after its auction victory suggested the need for caution in drawing upon multiple years of endowment income or the proceeds from deaccessioned artworks to finance great purchases. Indeed, after a 1973 investigation of the Met's deaccessioning of portions of the De Groot bequest, generally through trades with art dealers, the museum found itself the subject of new legislation, which imposed requirements that it sell art only through public auctions.

Buying was another matter. Museums might ask trustees to bid for particular works and present them as gifts, but entering an auction directly as a purchaser was difficult—except, perhaps, for the Metropolitan, the Cleveland Museum of Art, and the Getty.[56] Future institutional collecting would rely heavily, as it had in the past, on the cultivation of donor-collectors; the National Gallery in general, and Carter Brown in

particular, would pursue such prospects throughout the country. Court-
ing rituals could be elaborate—hosting exhibitions of individual col-
lections, producing elegantly printed and closely annotated catalogs,
sponsoring lavish and well-publicized opening galas—and these occa-
sionally produced results. But the more significant activities took place
backstage, and over extended periods of time, offering fewer dramatic
opportunities for journalists than the quests and auction sales of the late
1960s and early 1970s. This slower pace had characterized the acquisition
of great collections—Kress, Widener, Dale, Rosenwald—during the Na-
tional Gallery's early years, and it would be reinstated, with somewhat
less spectacular results, during the Brown administration.

The spectacle of the great acquisition would be replaced, under
Brown, by the pageantry and excitement of the great exhibition. While
never suspending efforts to acquire masterpiece gifts, and indeed land-
ing some impressive works of art for his institution, Brown increasingly
poured his energies and imagination into a temporary exhibition sched-
ule that would dramatically increase the Gallery's attendance, enlarge the
in-house design and interpretative staff, and bring it national publicity
and international prestige. He was also vitally concerned with expand-
ing the time frame of the National Gallery's collecting interests, since the
market for recent art certainly offered more attractive buying opportu-
nities, both for collectors and for institutions.

But this turn to the modern was also a response to changing devel-
opments in Washington and to the expansionist policies of another
principal actor in the museum universe, S. Dillon Ripley, the recently
appointed secretary of the Smithsonian Institution. Ripley's life and ca-
reer present suggestive parallels and provocative contrasts with those of
Carter Brown. They throw into relief the successes and the limitations of
the National Gallery of Art, and set up the circumstances leading to dra-
matic growth in both the Smithsonian and the National Gallery.

The Secretary Arrives

Dillon Ripley and the Smithsonian Challenge

Whet Congress created the National Gallery of Art in 1937, responding to Andrew Mellon's offer, it confronted an administrative dilemma. The Gallery board was to be self-perpetuating, five of its nine members private citizens, but it needed some place of residence within the vast federal bureaucracy, some settled location where it could rely upon established procedures and standards. The federal government's only experience with museum administration lay in the Smithsonian Institution, which by then had been functioning for almost a hundred years, growing into an internationally recognized web of museums and bureaus. So the secretary of the Smithsonian was placed on the Gallery board, as one of the four public members, and the Gallery itself positioned within the Smithsonian's embrace, a vaguely defined relationship that defied easy explanation, as things would turn out. The Gallery was *in* but not *of* the Smithsonian; the secretary neither appointed its director nor approved its budget, yet it was part of their larger table of organization.

For twenty-three years this arrangement had caused few problems. Smithsonian secretaries were deferential and noninterventionist, quietly abandoning the very name National Gallery of Art, which had previously titled one of their own museums, and acknowledging the new priorities with no evident reluctance. Science and history, rather than art, dominated their thinking. Buoyed by fabulous gifts and a splendid building, the National Gallery pursued its own independent course, untroubled by its putative overseer.

But in 1964 this happy tranquillity began to dissolve, as a new secretary arrived in Washington to begin a twenty-year tenure that would be, in its way, just as transformational as Carter Brown's leadership of the National Gallery. S. Dillon Ripley shared the honors with Brown as one of Washington's cultural power brokers during this period, presiding over an even larger, richer, and more complex institution. Like Brown, Ripley had emerged from a highly privileged background; family connections and personal friendships linked him to a wide circuit of influential, accomplished, and powerful people. Like Brown also, Ripley enjoyed the role of impresario, demonstrating how dramatic showmanship could attract broad audiences.

But there were serious differences as well. Ripley, more than twenty years older, had a well-recognized scientific career before coming to Washington, and a record of attracting attention. In 1950, while still in his mid-thirties and associate curator of zoology at Yale's Peabody Museum, Ripley became the subject of a lengthy and admiring Geoffrey Hellman profile in the *New Yorker*. Hellman, Yale '28, pronounced him "one of the country's outstanding authorities" on "birds of the far east," and proceeded to detail Ripley's feats and adventures during World War II and after.[1]

With solid academic credentials, a major figure in world ornithology, Ripley brought to the task of energizing his institution a sense of imperial possibility that dwarfed Brown's more focused quest for distinction. Accepting, even sometimes inviting controversy, Ripley juggled ongoing scientific interests and ambitious fund-raising efforts with the day-to-day tasks of supervising an increasingly distended organization. He also embraced extremely populist goals for audience cultivation and museum activity, reflecting an unusually tolerant and inclusive set of values. The self-confidence and assurance that underwrote these energies was born, like Carter Brown's, from a life filled with extravagant adventure and remarkable personalities. As such, it merits closer attention.

Like Brown, Ripley became interested in narrating his life story.[2] But he began doing so much earlier. Starting in 1977, thirteen years into his secretaryship, Ripley commenced a series of recorded interviews that continued, at widely scattered intervals, over the next eleven years. In all, he would participate in more than thirty of them. Gifted with a remarkable memory for detail and an impressive capacity for self-absorption, he was able to bring together a compelling set of stories, even while immersed in the cumbersome daily duties of his office.

His first recollections were of New York City in the years surrounding World War I, a child's wonder-struck impressions of the metropolis. Ripley was born in New York on September 20, 1913, in the family's home at 48 West Fifty-Second Street. His given names reflected the fame of a maternal great-grandfather, Sidney Dillon, railroad builder and president of the Union Pacific Railroad for more than a dozen years in the late nineteenth century. The youngest of four children (the oldest had been born in 1902), Ripley claimed he was coddled by his siblings, a good thing too because his parents were divorced not long after his birth. His father had been ready to start Yale when a substantial inheritance removed any incentive to enter college. He instead became a broker, selling stocks and bonds. But some years after his marriage, Louis Ripley essentially abandoned his family. His removal from the domestic scene meant that Dillon was brought up by his mother, Constance, Canadian-born and trained as a nurse at the school of nursing Columbia University had recently established. In later years, Ripley identified himself with New York's urbanity and cosmopolitanism, recalling passing parades, friendly traffic policemen, goings-on at nearby great mansions, and visits to the Metropolitan Museum of Art and the Bronx Zoo. His first school, a Montessori kindergarten on Madison Avenue, employed physical exercises that improved his dexterity. Those early years "made me forever interested in looking, feeling, examining, and handling objects, as distinct from merely reading about them."[3]

Again like Brown, Ripley's extended family, which had international branches, contained some eccentrics. His great-aunt Cora, an object of Dillon's adoration, lived in an Elsie de Wolfe–decorated apartment and employed both a chauffeur and a footman for her Renault automobile; they wore, at her command, leather puttees while on duty. Her husband, Dillon's uncle, a physician who was forced to give up his practice to handle the social obligations incurred by his wife, tended to fall asleep smoking cigars. His shirts, made by Charvet in Paris, contained alternating threads of asbestos so the cigars wouldn't burn holes in their vulnerable fronts.

New York City was not Ripley's only world. A trip to an uncle's ranch in British Columbia introduced the five-year-old to wild animals in their natural habitat—rattlesnakes and golden eagles prominent among them—and to spectacular views of the aurora borealis. A family move, first to Cambridge and then to Boston, meant new schools and new chal-

lenges. Anxieties about his absent father haunted the boy; no one ever explained to him why he was not living with the family. Dillon would not meet Louis Ripley again for some twenty-five years, and then in greatly reduced circumstances. The long deprivation, however, did not rob him of genuine affection for his amiable, rather unaffected parent, who enjoyed golf and good company, and apparently hated snobbery and pretense. These last aversions were claimed by Dillon as a natural inheritance.

Young Ripley was not a natural athlete and was bullied by older boys at one or two of his early schools. He developed an interest in birds while enrolled at the otherwise disagreeable Fay School in Southborough, Massachusetts, and chaired a bird bath committee of the boys' club. Summers were happily spent on a family farm in Litchfield, Connecticut, property purchased originally by Sidney Dillon, in an enormous stone house containing more than sixty rooms, nine bathrooms, innumerable nooks and crannies, and some terrifying secret passages. It seemed to the Ripley children like a fairy castle, its inchoate massiveness reflecting the sometimes casual and disorderly but caring family life they led.

International travel was part of the family regimen. In 1924 his mother, having returned to New York to spend time with friends, decided to take the family to Europe rather than rent an apartment in the city. Travel ensued, to Naples aboard a "crack" Italian steamer, with visits to Rome, Vienna, and Paris, where Dillon spoke French with a young woman every day. There were French cousins who took the family on excursions. In London, the Ripleys stayed at the Cavendish Hotel, owned by Rosa Lewis, the mistress of Lord Ribblesdale and a local celebrity. Adventures followed, both in London and elsewhere in England and Scotland, including a drive up to John O'Groat's, which featured a stop in his mother's family place, Castle Kilvarock.

But this European trip was soon surpassed by something far more ambitious. Without having graduated from the Fay School, Dillon, just into his teens, was enrolled at St. Paul's School in Concord, New Hampshire, but almost at once got involved in a life-changing adventure. His sisters had finished boarding school, come out formally in society, and did not intend to go to college. His brother, just eighteen, had completed his business training. They were free to take up an invitation from family friends to visit them in India, and the three older Ripley children decided to make the journey from the West Coast, through Japan and China. After much importuning of his headmaster, Dillon received permission to

leave school at Christmas and spend the rest of the winter, spring, and summer traveling to India with his mother. The plan was to move east, sail across the Atlantic, take a train from Paris to Marseilles, then a steamer to Port Said in Egypt (with a side trip by train to Cairo, and a visit to Luxor to see the pyramids), and finally a boat to Bombay (today's Mumbai) to meet the rest of the family and their hosts. The exotic sights, smells, and sensations stayed with Ripley for the rest of his life, as he recalled donkey rides at Luxor, camping in the desert near the pyramids, riding camels, encountering dust storms and snake charmers, and staying at the fabled Shepheard's Hotel in Cairo. He also remembered, less happily, the snobbery of his fellow passengers aboard their luxurious liner to India, returning civil servants "incredibly ignorant" about America and rather hostile to the few Americans sharing the voyage.[4]

India itself brought visits to Bombay, Calcutta, Agra, and Delhi, a reunion with his sisters and brother fresh from Singapore, Angkor, and China, a tiger shoot, stops with family friends and old connections, a memorable stay in Kashmir, picnics in the Shalimar Gardens, encounters with the hill people of Afghanistan, and finally a monastery initiation ceremony in Tibet. Forty years later Ripley still retained a solar topee purchased in Bombay, recognized the hierarchy of gun salutes offered various maharajahs, and recoiled at the memory of the slinking dogs, hungry and devoid of fur, that he encountered traveling to Calcutta. Finally came a lengthy series of sea voyages, climaxed by passage on the *Berengaria* back to the United States in September 1927, during which crossing Dillon celebrated his fourteenth birthday. Filled with remarkable stories, and armed with photographs and a diary, he continued on at St. Paul's, graduating in 1932, having made some enduring friendships and engaged in a number of distinctive, if unusual, schoolboy activities. One of them, saving several ducks damaged by ocean oil releases, presaged his later career; others were simply idiosyncratic, such as forming an Offal Eating Club, picking up the occasional pheasant, grouse, or rabbit hit by a passing car and cooking it over a gas flame in the dormitory. But his ornithological interests were still rather vague, and young Dillon entertained thoughts of going on the stage.

The Great Depression, however, had hit the Ripley family fortunes very hard, and the need to earn a living suddenly assumed more importance. Dillon's mother and brother, acknowledging his argumentative and histrionic skills, suggested he become a lawyer. Ripley consulted the

rector of his school, who advised him to go eventually to Harvard Law School but felt enrolling there as an undergraduate would be unwise; he feared that Dillon "would disappear into the library and never be seen again." Instead, he recommended Yale, "because there you'll surely learn how to slap people on the back."[5]

Ripley took the advice and after graduating cum laude from St. Paul's arrived in New Haven in September 1932, intending to major in history as a preparation for legal studies. His travel experiences had given him international interests, and he grew friendly with several younger faculty members who shared these concerns, including A. Whitney Griswold, an American historian who would in time become president of Yale. In his sophomore year, Ripley roomed with August Heckscher, a future New York park commissioner, who remained a lifelong friend. And during the summer of 1933 he took a six-week trip to Europe with his school friend Dallas Pratt, part of a colorful and historically important family. Visiting Paris, taking the Orient Express to Venice, swimming in the Lido, the Yale undergraduate was plunged into a heady social round, taking a cruise on the Adriatic and enjoying the attentions of Pratt's mother, owner of a canary yellow Rolls Royce convertible whose chauffeur, a former racing driver, took Ripley on high-speed trips along the Dalmatian coast.

At Yale, also, Ripley became interested in book collecting, purchasing illustrated bird books and Bewick engravings. A class with the legendary Chauncey Tinker of the English Department, who nurtured undergraduate interest in the Yale Library, was complemented by encountering Wilmarth "Lefty" Lewis, who was assembling a great library on eighteenth-century English literature at his Connecticut home.[6] Along with other student enthusiasts, Ripley was invited to join the Jared Eliot Society, a newly established undergraduate book club sponsored by Lewis, which featured an annual luncheon at Lewis's home. Ripley's friends in this group included, besides Heckscher, John Warrington, a Cincinnatian whose father was an important book collector, and Walter Pforzheimer, another book collector, who would play a major role in creating and building the Central Intelligence Agency.[7]

Meanwhile, Ripley's ornithological interests blossomed during the summers. On the family farm at Litchfield, he and some school friends excavated a pond to make a duck enclosure. Frederic Walcott, a family friend, leader in the worlds of conservation and game management, and

United States senator, lived nearby and frequently visited. Walcott introduced legislation creating wildlife refuges and helped found the Wildlife Management Institute. He, along with some neighbors and associates, was especially interested in the restoration of duck habitats and preservation of duck species. With support from his mother, Ripley bought ducks from nearby breeders, while relatives introduced him to other enthusiasts. Litchfield and ducks would remain central to Dillon Ripley for the rest of his life, and he, with his brother and sisters, would fight hard to preserve the family acreage against the rising demands of developers and tax collectors.

At Yale, Ripley became friendly with the curator at the Peabody Museum of Natural History, studied taxidermy, and obtained permission to take bird specimens back to his room. While ornithology itself was given little attention at Yale, he encountered some interested faculty, among them Leonard Sanford, who taught at the medical school, and G. Evelyn Hutchinson, an English-born zoologist who was training ecologists. He still toyed with thoughts of going into the theater, writing dramatic criticism for both the *Yale Daily News* and the *New Haven Journal Courier*, but, he confided to an interviewer, he found the career too lightweight: "You didn't really have an outward looking sensation of service or professional accomplishment which would make you feel that you had used your life to the best purpose."[8] Several classmates stepped easily into family corporations, but no "cushy job" awaited him. With a declining interest in law, Ripley determined to fall back on biology or zoology, and upon graduating enrolled at Columbia University to study biology. In the heart of the Great Depression, New York seemed dirty and squalid; he disliked Columbia, and things had rolled down to a dead end. But family connections again came to his rescue. The daughter of a friend of his mother's wrote him, looking for someone to sail with them to New Guinea and collect zoological specimens. He happily abandoned Columbia and leapt at the offer. His host was Charis Denison Crockett, a graduate student of Ernest Hooton, the famed Harvard anthropologist and primatologist; her husband, Frederick, had accompanied Admiral Byrd on his second expedition to the South Pole. Charis Crockett wanted to work on the tribal rituals that Margaret Mead had recently made famous and, with her husband, had purchased a fifty-nine-foot schooner that would carry seven. The colorful eighteen-month, thirty-thousand-mile trip was de-

scribed by Ripley several years later in his first book, *The Trail of the Money Bird*. He returned to the United States with dozens of live birds and many more specimens.

These cruises and expeditions led Ripley into a part of the world that was simultaneously obscure and contested. Visiting Japan and meeting with fellow ornithologists, he became convinced that war was imminent. Back in America, working as a volunteer at the American Museum of Natural History, he attempted, through Mrs. Kermit Roosevelt, a friend, and Vincent Astor, the millionaire realtor and philanthropist who was a trustee of the New York Zoological Society, to return to New Guinea, touting his Japanese contacts and his bird-collecting interests.[9] Naval authorities, however, concluded the trip was too dangerous. In 1940 Ripley enrolled as a graduate student at Harvard, spending half of his time at its Peabody Museum, studying birds. He tried to apply for the navy but failed a physical; he was underweight, for his six-foot-four-inch frame, and had previously contracted malaria. Passing his Harvard oral examinations in February 1942, he was offered a Smithsonian appointment, which permitted him to complete his dissertation. He received his PhD in 1943 and published his thesis the following year.

The challenge was deciding what to do next. The young scientist felt the Smithsonian to be an intellectual backwater, his salary was low, and his love of adventure suggested the preferability of war work. This would soon become possible. While in Washington, Ripley became involved with what would eventually become the OSS, a wartime intelligence agency created to coordinate espionage work for the military services. Ripley joined a group selected by the fabled William "Wild Bill" Donovan, who was looking for people knowledgeable about specific areas of the world—businessmen, diplomats, academics, naturalists.[10] Here were Harold Jefferson Coolidge, a veteran of expeditions to Indochina, Liberia, and Borneo; Colonel David Bruce, Andrew Mellon's son-in-law and the first president of the National Gallery of Art; Lefty Lewis, who was putting his considerable knowledge of library cataloging and indexing techniques at the service of the OSS; his college friends August Heckscher and Walter Pforzheimer; Harvard historian William Langer; and a number of other strong personalities.

The young Ripley was also introduced to the intricacies of personal politics, as rivalries and simmering suspicions hovered over the wartime espionage establishment. The FBI, according to Ripley, hated Donovan

and his associates, and the entrenched cabinet departments of state, war, and navy were similarly suspicious. The theater of war under General Douglas MacArthur was closed to anyone who worked for Donovan, because of MacArthur's distrust of Washington, and his particular jealousy of Donovan, a Congressional Medal of Honor winner. Ripley demonstrated his interest in what was then called the East Indies by lecturing and writing articles (he had obtained a literary agent by this time). In, out, and then in again at the OSS, Ripley hoped and expected to operate in the Far East. He visited India once more and went to Ceylon in 1943, where he helped coordinate reports coming in from the Dutch East Indies. Just as the war was ending, in the summer of 1945, he was given a mission to Thailand, part of an effort to obtain information about Japanese troop movements there. Ripley's wartime activities became part of his personal legend, endlessly repeated by his biographers and publicists; most notable was a parachute jump into Thailand, supposedly attired in a dinner jacket in order to attend, immediately, a diplomatic function. Some details got hazy, but the blend of derring-do, scholarly knowledge, and aristocratic finesse would characterize something of Ripley's authoritarian style in later years, combining unflappable self-assurance with driving ambition.

With the war ending, it was time to find a civilian job. Not particularly enthusiastic about the Smithsonian—secretary Charles Abbot had refused to hold his position for him during his OSS service—Ripley had two offers, one from Harvard, the other from Yale. Lefty Lewis advised him to go to Yale, while some fellow ornithologists argued for Harvard. Ripley decided for Yale. It was, he admitted, a smaller pond, but that meant more could be done. Harvard, he feared, was too large and faceless. With one close friend, G. Evelyn Hutchinson, already on the Yale faculty, he could make progress. And Litchfield was an hour away.

The Yale proposal was a combined position: associate curator at the Peabody and assistant professor. His annual pay was thirty-six hundred dollars, the rate for an instructor. When Ripley discovered that, sometime later, he was furious. However, he was able to live well.[11] A number of classmates occupied positions of power; meanwhile, Ripley lectured in various parts of the university, sat on major committees, prepared a bibliography of a notable collection of bird books he had obtained for Yale, and became a prolific author. In 1949 he married Mary Livingston, a wealthy, recently divorced descendant of a celebrated New York fam-

ily. It proved to be an enduring relationship, bringing Ripley some additional income and the support of a lively and astute partner, as well as three daughters, all born in the 1950s. With a house and garden, and his Litchfield farm, domestic life flourished. Ornithological and organizational trips to Asia, some of them accompanied by his wife and daughters, punctuated his Yale years, and in 1959 Yale's president, his friend A. Whitney Griswold, invited him to direct the Peabody Museum. According to Ripley, Griswold described it as a terrible job, stuffy and dull, and hoped he wouldn't accept.[12] But of course Ripley pounced on it.

Directing the Peabody marked the climax of Ripley's faculty years at Yale. During his short tenure, less than five years, he was able to apply a number of his activist notions about museums and fine-tune his management of potential donors and supporters. His wife played a role as well. Noting that the Yale University Art Gallery had started both a friends group and an alumni council, the Ripleys established a women's committee, built around the corps of docents. To help finance the docent program, he sought subscriptions from schools and encouraged the visits of schoolchildren. The women's committee soon became a more general associates group, with special lectures, events, field trips to other museums, and a budget of its own. Membership dues and sponsored events benefited the museum considerably, and by 1964, the year of Ripley's departure, the associates numbered more than a thousand.

Among other innovations, Ripley established a medal named for the museum's first naturalist, employed a trailer to tour the state and encourage visitation, and began a periodical, *Postilla*, that published short research papers by curators. "I believe in getting things out, especially monographic things," Ripley remarked years later. "Let them have mistakes in them, because then one's colleagues bother to read them and point out the mistakes that they have discovered. . . . If you put out an absolutely blameless, diamond-like publication, which is so flawless that nothing need ever be said again, it will go to sleep on the shelves."[13] Professional criticism had never embarrassed him, Ripley confessed.

He also managed to obtain, in 1962, a monthlong slot for the Peabody to host the first American exhibition of Tutankhamun relics, organized around the need to raise funds for the Abu Simbel complex. This Tut show, like its successors, attracted huge crowds across the country, and New Haven was no exception. But Ripley, as director, would leave nothing to chance. As a promotional stunt for the opening, and as a fund-

raiser, he arranged a benefit dinner featuring a belly dancer to entertain the guests. President Griswold thought the idea somewhat vulgar and refused to attend. The event attracted lots of publicity, however, and, according to Ripley, achieved just what he had hoped: "It made the Peabody Museum an integral part of the life . . . [of] the university."[14] Ripley's goal, during his directorship, was to increase public appreciation for the museum, and he made the case, internally, that Yale should not neglect this opportunity for hosting popular audiences.

These activities helped establish a broader reputation for Ripley, one associated with shaking things up and challenging the status quo. He was able to sustain a powerful professional reputation and simultaneously nurture a set of "old boy" ties that would shortly prove invaluable. Highly social, with wide-ranging interests, at ease with the wealthy and well connected, Ripley was ideally placed for his next, and final, assignment. That it developed just when it did, in 1963–1964, was the result of two events, one, the anticipated retirement of Smithsonian secretary Leonard Carmichael, the other, sudden and sad, the death of Ripley's principal sponsor at Yale.

Although Carmichael's retirement was being bruited for the rest of that year—Crawford Greenewalt, a Smithsonian regent, after discussing the Smithsonian more broadly with Dillon, asked Mary Ripley whether her husband would be interested in becoming secretary—little more was said about the position for the next six months.[15] In February 1963, Ripley attended a college dinner for McGeorge Bundy, then President Kennedy's national security adviser, and sat next to Walter Miles, an emeritus professor of physiology.[16] Miles mentioned that Carmichael was about to retire and said he had written Jerome Hunsaker, a member of the National Academy of Sciences, about Ripley's possible candidacy. In fact, Ripley's name had been discussed more than a decade earlier, when the Carmichael appointment was made, but that had gone nowhere. Miles sent on to Hunsaker recent annual reports of the Peabody, and they seemed to have made good reading. Hunsaker wrote back that Ripley's name should be held in reserve, and pushed forward at the appropriate moment.

Less than two weeks later, a Yale friend and classmate invited Ripley to lunch to meet John Nicholas Brown, Carter's father. Brown was also a Smithsonian regent, and, with Greenewalt and Caryl Haskins, a member of the search committee. Ripley found Brown charming, and passed on to him

the latest Peabody report.[17] Ripley himself had been quietly planting the seeds of his appointment. Some time earlier, a friend of Ripley's, Mrs. Joseph M. Patterson, widow of the publisher of the *New York Daily News*, confided that she had lunched with Carter Brown and reported that "he was most receptive to the idea of passing your name along to his father. In fact, he said his father had asked him if he had any ideas on the matter."[18]

The second event was the death, in April 1963, of Yale president A. Whitney Griswold. A longtime personal friend—Ripley would serve as an honorary pallbearer at his funeral—Griswold had been a consistent supporter of his work at the Peabody. The loss was a heavy one. Ripley, according to his recollection, also discovered that some were pressing his candidacy for Yale's presidency. Nearing fifty, ambitious, energetic, with a Yale degree and influential classmates, possessing an international scientific reputation, administrative experience, and demonstrated capacity at fund-raising, he was certainly a plausible candidate. But at some point, realizing his chances were slim, Ripley withdrew his name from consideration. A friend at the *Saturday Evening Post*, class of 1929, declared that Ripley should have started his campaign sooner: "Attention should have been called to the administrative phase of your career. This is the age of the brilliant administrator. Also, you should have made some speeches or written papers on New Frontiers in Education (Conant style). You should have also sounded off on today's materialism[,] the corruption of our society."[19]

The wheels, however, were already in motion. Yale's provost, Kingman Brewster, who had come to Yale from Harvard Law School in 1960, was quickly made acting president, and five months later, after a national search, the corporation appointed him president. It was, Ripley recalled, a time of change, and "I went through quite a revolution. I mean my roots were shaken. I could not tell what life was going to be like under the new president."[20] Funds were short, and he feared that the museums and library would be downgraded in a moment of financial stress. Without a patron at Yale, feeling somewhat underappreciated, Ripley was receptive to the overtures soon coming from Washington. In May 1963, Crawford Greenewalt flew to New Haven, on behalf of the regents, to invite him to become the next secretary. A letter from Chief Justice Earl Warren, titular head of the regents, making the formal offer, quickly followed.[21] For the next several weeks the Ripley family discussed the options. Ripley had informed Brewster about the situation, indicating his

desire for a chair; Brewster wrote back that he could not make an imme-
diate promise, and that the whole system of appointing faculty to named
chairs was now under review. Ripley responded somewhat indignantly,
reviewed his accomplishments at Yale—the graduate students produced,
the fund-raising, the books and papers written (more than two hundred
titles, Ripley asserted), and the larger task of overcoming attitudes to or-
nithology and the museum that were "parochial" and "stereotyped." Yet
Brewster still could not yet promise him a chair. "It does seem unfair to
me," Ripley went on, "that due to the circumstances of pressure and hurry,
of no dean's having sponsored me or the overall need for examination of
the criteria of chairs and their inconsistent handing out in the past, that
my case should be deemed the one which elicits the stop signal. Unless
there can be some reconsideration of this, and faced with the uncertain
future here, my option is plain."[22]

Ripley's good friend, Lefty Lewis, now a member of the Yale Corpora-
tion, sympathized with his situation. The Smithsonian invitation "comes
at an awkward time: if you stay at Yale and feel frustrated by the new
president that will be bad, and if you go and the new man is eager to for-
ward the work of the Museum that will be ironic."[23] But whatever Ripley's
decision, Lewis offered his full blessing and best wishes.

The decision to leave was not cut and dried. The Ripleys had lived
happily in New Haven for fourteen years; they had many friends, across
many departments. Ripley's professional work had flourished. The three
young girls would have to transfer schools. And they would be locating
the family some distance from Litchfield and Ripley's beloved ducks.

The attractions, however, were powerful. The Smithsonian, or so it
had seemed to Ripley and a number of his colleagues in the early 1960s,
was largely dormant and inactive, barely known in many circles. But it
did not have to be so. It had an extraordinary history and great collec-
tions, and there were signs of broader cultural interests surfacing. Leon-
ard Carmichael, the retiring secretary, often portrayed as the representa-
tive of an older, more passive regime (by Ripley himself), had actually
been presiding over some startling expansions on the Mall, including the
planning of both the Museum of History and Technology, as it was then
called (now the National Museum of American History), and the Air and
Space Museum. These would be the first new Smithsonian Mall museums
since the Freer Gallery of Art had opened some forty years earlier. Carmi-
chael also oversaw construction of two large new wings for the National

Museum of Natural History and effected a merger with the Harvard College Observatory.

Acknowledging the value of media attention, Carmichael encouraged some spectacular public relations coups, like the acquisition of the Hope Diamond from jeweler Harry Winston, and negotiations with Marjorie Merriweather Post concerning her intention to bequeath her Hillwood estate, and all its contents, to the Smithsonian. Finally, Carmichael proved to be an effective lobbyist, along with former National Gallery director David Finley, in saving the old Patent Office Building from destruction, and seeing that the National Portrait Gallery (which he helped create) and the National Collection of Fine Arts were placed within it.

Despite these important (and generally unacknowledged) accomplishments, Carmichael did little to change Smithsonian structure, nurture its scholarly functions, or develop new sources of public support. These were areas Ripley felt required attention. He argued, in words similar to those used by Carter Brown to describe Washington's museums, that the Smithsonian itself was a "sleeping beauty" needing the kiss of leadership to fulfill its cultural destiny.[24] Outside Washington, the status of both the Smithsonian and its secretary seemed in urgent need of rejuvenation. Ripley recalled that Kingman Brewster was "incredulous" that a senior professor and director of the Peabody might consider the secretaryship a more attractive and powerful post. "This seemed to him to be an incomprehensible decision, someone who was sort of casting professional career and hopes for the future aside and deciding to do something almost unmentionable. The sort of bland indifference that Mr. Brewster had about the Smithsonian galvanized me into a conviction that I was probably right in thinking of going."[25] If he didn't know much about this important place, Dillon Ripley would undertake to teach him.

Before committing himself, however, Ripley entered into some hard negotiations, which centered on pension rights in the event of disability or forced retirement. A staff letter outlining the possibilities horrified him. He would have to work for ten years before getting any benefit under the existing provisions. If he left before then, none of the amount contributed to his retirement would be transferrable. "I began to feel it would be like a jail sentence, that I would be stuck with this job so many years before I could opt out." I "was Scottish enough [that] if I got out," Dillon told his interviewer, "I wanted to take out with me whatever it was I'd brought into it."[26]

This seems an odd issue to focus on. While his Yale salary at the time was not much more than seventeen thousand dollars, Ripley reported dividends almost six times that amount on his tax returns, thanks to a trust fund from his wife's mother.[27] Nonetheless, he found the conditions demeaning. If the Smithsonian ever got someone with sufficient stature, that person might well be too old ever to accumulate retirement. This was, apparently, the only point of contention, and it was finally resolved to Ripley's satisfaction. He found it mildly amusing that a committee would spend so much of its time on minor mechanical matters rather than intellectual or programmatic concerns. Ripley claimed, moreover, to have heard little gossip about the search, beyond a story that Senator Leverett Saltonstall of Massachusetts, a Smithsonian regent, had confused Dillon with his first cousin, Sidney Ripley, who had served in World War I and was old enough to be Dillon's father. Saltonstall had roomed with the cousin at St. Mark's and was unimpressed by his intelligence. His remarks supposedly prompted consternation among the regents for a time, but caused few problems in the end.[28]

Ripley communicated his decision to the Smithsonian in July 1963, indicating that he would leave Yale officially on February 1, 1964, after the semester's exams had been concluded. His family would move in late spring, after his daughters had completed their school year. Carmichael was a bit disappointed by the delay, as he hoped to assume a new post at the National Geographic Society. But Ripley found him kind and pleasant, easy to work with during the transition. In a telegram Carmichael welcomed him to "The Most Interesting Job in the World."[29]

Nonetheless, Ripley deemed his predecessor straitlaced and formal. During one visit to Washington, Carmichael took him to the Great Hall in the Smithsonian Castle, which featured a series of exhibit cases holding memorabilia of previous secretaries. "It was a dry-as-dust exhibition, full of robes and academic hoods and gold medals and diplomas," Ripley recalled. It was "oppressive to me and seemed overly portentous." Even more disturbing was an incident that followed. As Carmichael and Ripley walked through the hall, they noticed someone moving along its north wall. Carmichael clutched Ripley's elbow and said, "Stay." They both paused, the man failed to see them, and he went out through a door. "That was a curator," Carmichael declared.[30]

Ripley found the comment odd and felt it represented something of the spirit he hoped to transform. There was too much distance between

the secretary and the curatorial staff. That would soon change. After the official announcement of his acceptance was made in July, letters of congratulation poured in. Ripley's friends were exuberant about things to come. Robert Goelet declared his delight but added, "I have a horrid fear that the Federal deficit is going to increase markedly, but at least the dough will be used for a good purpose!"[31] Ernst Mayr wrote from the Harvard Museum of Comparative Zoology, commiserating on the difficult decision Ripley had to make. But the challenge, he asserted, "must be irresistible! The Smithsonian was once this country's leading institution." Carmichael had started some reforms, but "there is a long way to go." Mayr felt the Smithsonian might be crucial in upgrading the universities of the District. "The sky is the limit to the opportunities."[32]

The fall of 1963 brought a series of parties at Yale, as Ripley's colleagues prepared to bid him adieu. In late November there came the shocking news of the Kennedy assassination. Kingman Brewster asked Mary Ripley if this event might change Dillon's mind about accepting the job. Mary replied that she thought it would make little difference; after all the president, she pointed out, did not run the Smithsonian. But a general air of depression was palpable. Reflecting, years later, Ripley recalled the mood of despair that succeeded the assassination, particularly among intellectuals who felt that Kennedy's reassertion of ties linking government and the nation's academic and creative communities might now be lost in the hands of his successors. Ripley refused to share the mood, believing the momentum created by Kennedy would last, and finding Lyndon Johnson, overall, a more sympathetic figure than his predecessor. Ripley rated the Kennedys as too superficial and "jet-setty" for comfort. While the Johnsons were derided as hicks, "I felt that they would have more essential respect for the Smithsonian as a typical example of the aspirations from the heartland of America for culture and history. . . . They would be more understanding and more supportive."[33]

Meanwhile, there were personal appearances and social gestures, some traditional and some not. In January 1964, Ripley was invited to participate as a guest in his first regents meeting, which coincided with the opening of the Museum of History and Technology. To celebrate, the regents hosted a dinner in the new museum, with wines and cocktails, the first time in the known history of the Smithsonian, Ripley reported, that liquor had been served.[34] The new building, however "gawkish" it might have seemed, revealed to visitors the breadth and depth of the Smithso-

nian historical collections, confined until then within the old Arts and Industries Building next to the Castle. Within months it recorded a million visitors.

Controversy soon erupted. The new building contained an auditorium designed, among other things, for performances featuring the Smithsonian's superb collection of musical instruments. Secretary Carmichael had determined to adorn the angular room with murals by Allyn Cox, a celebrated if highly traditional muralist. The plan, Ripley believed, was to adopt the spirit that had animated the decorating of Constitution Hall, home of the Daughters of the American Revolution, with flying cherubs, swags, and masks of Thespus. Ripley, to the relief of some museum officials, stopped the project, but ended up on the receiving end of resolutions from muralist societies, condemning him to a terrible fate.[35]

The social transition was easier. Smithsonian officials, led by Leonard Carmichael, quickly moved to connect Ripley with local power brokers, putting him up for a series of local clubs, including the Cosmos, the Sulgrave, the Metropolitan, and the Chevy Chase Country Club. Ripley was, by this time, a veteran club man, and already knew some of the membership. He also began to recruit senior staff who would help him navigate the complex hazards of Smithsonian administration. One of them, Charles Blitzer, who would spend several decades at the Smithsonian as Ripley's major adviser and close friend, was a former Yale faculty member and New Haven alderman. After working for the American Council of Learned Societies, Blitzer had become the staff director for the new National Commission on the Humanities. In that position, he had conferred with Smithsonian officials on details of fellowships and grants. Another, shorter-lived appointment, was that of Philip Ritterbush, Rhodes Scholar, Oxford DPhil, author, and aide to Senator Thomas J. McIntyre of New Hampshire. Ritterbush had been a star student in Ripley's museum history course at Yale, and Ripley considered him an "ideal candidate" to "set some fires" under various bureau chiefs. Ritterbush acted for a time as the head of academic programs. But he became "a stormy petrel" among his colleagues, Ripley admitted, and eventually left the Smithsonian.[36]

Washington reporters flocked to do profiles on the new secretary, recounting, for a broader public, his colorful career and enticing attributes: the parachute jump in formal wear, the belly dancer at the New Haven benefit, the Litchfield aviary and its man-made ponds, the trips to India, Ceylon, Malaysia, and Indonesia, Mary Ripley's skill with a gun,

the OSS years. "My wife is never without a bottle of cyanide," Ripley confided to newspaper reporters, describing her interest in moths.[37] According to the *Washington Star*, Ripley's broader goals included energizing the Mall, and indeed all of downtown Washington. He had thoughts of keeping the museums open until 10 p.m. in the summers and creating shady spots with benches. He envisioned a sculpture garden near where a proposed Tenth Street mall was to intersect the existing Mall, along with concerts, a bandstand, ice skating, an oriental garden near the Freer, more parking, and a host of other improvements to gladden the hearts of local boosters.[38]

Ripley hit the ground running, and his energy—some called it impetuousness—quickly brought on some confrontations with standing interests. Chief among them was the National Gallery of Art, headed by John Walker, now with eight years on the job. Ripley's position was complicated. As a board member he was privy to National Gallery policies, plans, and procedures, and he did not hesitate to make use of this information in his own capacity as secretary of the Smithsonian. The National Gallery found itself in the awkward position of sharing its operational agenda with a competitor, and one who found its values elitist and condescending.

Ripley was also disappointed by the Smithsonian's record of indifference to art; only one regent, he recalled, showed any interest in doing something about it, and that was John Nicholas Brown.[39] Ripley threw himself into the reinvigoration of the National Collection of Fine Arts, approving the appointment of David Winfield Scott as acting director and then as director. Scott, an artist and former academic in California, had come to the NCFA as a curator a few years earlier—Carmichael found him interesting—and quickly demonstrated a capacity to energize the staff, organize popular exhibitions, and spot interesting acquisition possibilities, particularly in areas of contemporary art.[40] Although some on his board tried to resist these purchases, Scott moved ahead. In the mid-1960s there seemed a real possibility that the NCFA, given the National Gallery's prohibitions against the hanging of living or even recently dead artists, might become a major site for modern art, something that Washington sorely needed. Twentieth-century painting and sculpture were largely missing from the capital's collections, and perhaps Scott and Ripley could succeed in making the Smithsonian the center of collecting and exhibiting energy.

Ripley would also actively support broadening the National Portrait Gallery's charge by expanding its mission to include photography. Until the mid-1970s, the act creating the Portrait Gallery prohibited it from collecting photographs, prints, films, and similar likenesses of important Americans. The restrictive language had been imposed, according to Ripley, at the request of the Library of Congress, which feared it would face competition in the collecting of prints and photographs.[41] By 1975 the Library of Congress had dropped its objection, and Ripley was able to avoid this confrontation.

But there was another, faster route to modernist hegemony besides expanding the focus of some existing Smithsonian museums. In taking it, Ripley would bring to Washington an entirely new museum and involve himself in a series of unhappy battles with critics in Congress, the press, and the National Gallery itself. There are various origin myths, but according to Ripley, after casting about for major collectors of modern art who might find the Smithsonian appealing, he came across Joseph Hirshhorn's name while reading Aline Saarinen's popular and influential study of American art collectors, *The Proud Possessors*. First published in 1958, the book offered dramatic portraits of figures like Mrs. Potter Palmer and Martin Ryerson of Chicago, John Johnson of Philadelphia, and the Rockefellers and J. P. Morgan of New York. It also contained a lively chapter detailing the collecting exploits of Hirshhorn, an entrepreneur who had made huge sums of money in Canadian uranium investments and who now collected contemporary paintings and sculpture on a vast scale.

As Saarinen described him, Hirshhorn was "a tough, wise-cracking dynamo with a mind like an accelerated precision tool, the seasoned gambler's sense of the calculated risk and a big heart as sentimental as the calendar art he first admired."[42] He had become, she wrote, "the single largest collector" of living American artists, with holdings so extensive that no one was certain exactly how big they were. Abram Lerner, his recently appointed curator, estimated that Hirshhorn owned at least 1,800 paintings and 450 pieces of sculpture, and he was still buying.[43] Brought up in poverty, the self-made millionaire descended on artists and dealers like a whirlwind, not hesitating to drive hard bargains with impoverished painters and sculptors but seized by a genuine passion, both for the art, according to Saarinen, and for the artists' welfare. Hirshhorn was also in frequent trouble with Canadian authorities for his equally aggressive and sometimes questionable business practices.

Ripley was fascinated by Hirshhorn's energy and ambition. As a self-declared foe of pretension and affectation, he admired his combative stance, his rough-hewn, even vulgar directness, and his status as a social outsider. More than that, his was a collection that could, overnight, vault the Smithsonian into a totally new area. In typical fashion, Ripley cast about to see how he might build upon any existing personal connections.

Hirshhorn, who had various houses and apartments, was spending a good part of the year at a home in Greenwich, Connecticut. Roger Stevens, the Broadway producer who "knew everyone in New York" and would soon become head of the new John F. Kennedy Center for the Performing Arts, told Ripley that the Greenwich connection was the one to try. Stevens and Ripley went to Greenwich, and soon there came a meeting. Ripley liked Hirshhorn immediately "because he was so real." Hirshhorn had made it big "in the best possible way, and believed in himself, and really wanted to succeed, and had an extraordinary innate taste."[44]

But other prospectors were also calling. Governor Nelson Rockefeller approached, having set aside money to build a museum and cultural center in Purchase, the site of a State University of New York campus. This was very close to Greenwich and constituted an undeniable attraction. The city of Beverly Hills, California, was interested. So were the British. David Drummond, the Earl of Perth and brother-in-law of National Gallery director John Walker, offered Hirshhorn Regent's Park acreage in London, and a building to be constructed with British funds, in return for the collection. Even Walker contacted Hirshhorn, hoping to get some of his sculpture for the sculpture garden just west of the National Gallery.[45] There were also feelers being put out by Israelis.

Ripley confessed that his "competitive sense was aroused." While still in his first year as secretary, Ripley informed National Gallery trustees and administrators that he was trying to land the Hirshhorn collection, and also revealed his plans for a sculpture garden, stretching across the Mall. His declaration "was greeted with a thunderous silence. . . . So jealousy reared its head at that point, and they decided to make an end run and introduce their own legislation" proposing a National Sculpture Garden to be administered by the National Gallery and the National Park Service.

Ripley was convinced that the Gallery acted only because it felt threatened by the Smithsonian move: "John Walker and Paul Mellon together were at this stage quite antagonistic towards myself and towards our do-

ing anything positive n the field of art. They felt there was only ONE art museum in Washington—just ONE—and that was called the National Gallery. Period. And it should do everything for culture, art, the world.... Period." John Walker told him, years later, Ripley went on, that "he did everything in his power to oppose anything that we suggested about the advancement of art and culture for the Smithsonian because they viewed it as a rival effort to their hegemony over the art and culture picture in Washington." Ripley contended that from the time Andrew Mellon founded the Gallery through the early 1960s, those in charge believed "they were the high priests of art and culture and that nothing could be done to change that." Scientists were below the salt and could not be entrusted with the possession or display of art.[46]

Such a view may well have been encouraged by the Smithsonian itself. Its own collection of American paintings had originally been poorly displayed in the Museum of Natural History. David Finley told Ripley that when Andrew Mellon was secretary of the treasury, in the 1920s, the two of them would pass through the collection breathing contempt. It was, Ripley thought, "like the story of the pharisees": "they would draw their skirts aside to avoid the leper, because they thought this collection epitomized the indifference and neglect represented by the Smithsonian administration—the administration of Secretary Abbot." A celebrated scholar, Charles Greeley Abbot "seemed to scorn social intercourse and cultural activities in his concentration on the solar tables and astronomy," throwing daily letters from their silver salver directly into the wastebasket, unopened.[47] Mellon and Finley wanted no association with such an operation. Ripley believed this was the origin of the National Gallery's distaste for Smithsonian procedures and personnel. As he prepared to get Hirshhorn excited about a possible Mall spot for his collection, he had to think about another site for the building that would house it on the southern, Independence Avenue side of the Mall.

Still other Smithsonian initiatives in the arts went forward under Ripley's prodding, most of them attended by considerable difficulty in funding, identifying personnel, or reconstruction. There was, for example, the Renwick Gallery. This Second Empire–style building near the White House had housed Washington's first major art gallery, designed by New York architect James Renwick and built by the banker William W. Corcoran between 1859 and 1870. Seized during the Civil War and occupied by Quartermaster General Montgomery Meigs (Corcoran,

a Democrat and Confederate sympathizer, fled to Europe during the conflict), it was returned to Corcoran and opened to public visitation in 1874. Just twenty-five years later, the Corcoran Gallery and its collection moved to a new building some blocks away.

The opulent structure had suffered many fates in the sixty years since the new Corcoran opened, most recently hosting the Court of Claims, which had subdivided it into offices. In the mid-1960s it stood vacant, and various Washington interests had their eyes on it. As Ripley recalled, Elizabeth Rowe, the wife of the chairman of the National Capital Planning Commission, decided it could serve as the commission's headquarters. This too "aroused my competitive instinct," and he determined to rescue the structure for its original purpose. Built as a gallery, he vowed it should become a gallery again. Responding to the bureaucratic lobbies that wanted to take it over, Ripley enlisted several White House aides in his effort, including Harry McPherson and Douglass Cater, who promised to use their influence with the president. Ripley argued that it could become an extension of nearby Blair House, made into a diversion for the visiting heads of state who often stayed there, a place to entertain visitors "when they were tired of talking about politics and bombs."[48] Ripley and President Johnson crossed Pennsylvania Avenue together, dodging traffic, Ripley remembered, to take a look, and Johnson became enthusiastic about the redemptive project. It was another indication to Ripley that the president shared his love of history and making historical connections, and that, even more than his predecessor, John F. Kennedy, he possessed an old-fashioned enthusiasm for spreading culture widely. Viewed in retrospect, this Ripley initiative fit well within larger Cold War campaigns that emphasized American accomplishments in the arts within an international perspective. Johnson signed an executive order in 1965 transferring the building to the Smithsonian for the uses Ripley had proposed.

The dramatic rescue was followed by years of contention. There were, first of all, budgetary problems. Ripley thought briefly that things were "in the bag," only to discover that because money had already been appropriated for office building modifications, it would be necessary to go back to congressional committees and get the necessary millions for renovation as a museum. Two budget cycles passed, and Ripley found the delay "a terrible comedown." By the time the moneys were appropriated and contracts signed, the notion of entertaining presidential guests there

had become more doubtful. Blair House itself was used less frequently, and receptions were increasingly held in the larger embassies or the city's hotels. So other ideas were canvassed, including notions of turning the Renwick into a miniature Smithsonian, a museum of Washington history, or developing it as an orientation center. Finally, after a series of expensive restoration efforts that required replacement of a rapidly decaying brownstone facade, the Renwick opened to the public in 1972. It was placed within the aegis of the National Collection of Fine Arts but had its own director, Lloyd Herman, who developed it into a site for frequently changing exhibitions on American crafts. Herman, with backgrounds in theater, marketing, and merchandising, was another of Ripley's nontraditional appointments. With his big-tent notion of art—mingling existing definitions and categories like folk, decorative, fine, applied—Herman found Ripley to be a loyal supporter. He declared his impatience with trying to compartmentalize things, separating forms out into discrete groupings. Ironically, while the building had been given to the Smithsonian on the understanding that its huge reception room could be used occasionally by the president or the State Department for entertaining, it turned out to be unavailable for anything not related to the Gallery's programs. Despite a long string of hassles, some lawsuits, and angry debates about the quality and cost of the extensive renovations, the emergence of the Renwick as a venue for contemporary American craft artists seemed worth the extended effort.

And so did some other expansions into the arts, like the establishment of Cooper-Hewitt Museum in New York City, the Smithsonian's first museum outside the Washington area. Smithsonian involvement came about because Ripley was receptive to calls for help coming from some eminent (and wealthy) friends. The eclectic collections had been created in the nineteenth century by the daughters of New York industrialist Abram Hewitt, and held by the Cooper Union, an educational institution established by Peter Cooper in the late nineteenth century. Early on in his tenure as secretary, Ripley received a call from Henry Francis Du Pont. Du Pont was creating, at his great country house and gardens in Winterthur, Delaware, a museum of early American decorative art; Ripley, an old friend, sat on his board. Du Pont explained that the trustees of the Cooper Union, wishing to concentrate their assets on the school's educational mission, and specifically to strengthen its engineering program, were anxious to divest themselves of the Hewitts' collection

of applied and decorative art objects, and thus of the costs of maintaining a museum. The collection and the associated library, however, held real treasures, and a number of local institutions, including the Metropolitan Museum of Art, were already circling the vulnerable establishment in hopes of acquiring specific objects. Du Pont was chairing a committee to keep the Cooper-Hewitt collection intact, and he appealed to Ripley, as a former New Yorker, not to let it die. It constituted the nucleus of a national museum of design and could become a major asset for New York City's design industries. Du Pont, who would eventually chair the museum board, made a gift of more than three hundred thousand dollars toward the project, and promised to repeat it annually. Unfortunately, he lived for only a few years longer; with his 1969 death, the young museum lost one of its principal benefactors.[49]

Persuading the Smithsonian regents to accept responsibility for the Cooper-Hewitt was a challenge, and occupied Ripley for much of the second half of the 1960s. Of them only John Nicholas Brown, Ripley recalled, displayed much enthusiasm, but he was able to persuade the others to take an interest. The orphaned museum was, for a time, placed in the hands of a commission chaired by Charles van Ravenswaay of St. Louis (who would shortly be appointed to head Winterthur). The commission report urged retention of the collection as a whole, suggesting that if Cooper Union did not wish to keep the museum it should be given to another institution. The Smithsonian was its first choice. The problem was that Peter Cooper's will forbade any move out of New York City. The regents were concerned about supervising a museum outside of Washington, and some felt it should be supported only by private funds. The collections could be placed in storage, but there would still be maintenance and security expenses to be met. In the end, Ripley went to Congress for appropriations, taking criticism from senators and representatives who complained they had not been told of these plans in advance, plunging Ripley into what would become, over the next decade, a series of uncomfortable authorization hearings.

Ripley would spend a good deal of time in the 1960s and 1970s trying to raise money for the Cooper-Hewitt. In 1969 he appointed Lisa Taylor to its directorship. Taylor had studied at Washington's Corcoran School of Art in the early 1960s and then became a Smithsonian program director, active in the creation of the National Associates. Ripley admired her energy and realized the Cooper-Hewitt needed lots of attention. Working

with her, Ripley immersed himself in development schemes, commenting on everything from the seating plans at benefit dinners to the menus themselves. In the interest of the new museum, he pursued possible donors with vigor and determination. He was particularly active in seeking the extraordinary array of objects assembled by New Yorkers Jack and Belle Linsky, who had sold their Swingline Corporation, maker of staplers, for 210 million dollars in 1970. But their collection of paintings and French furniture would eventually go just down the street, to the nearby Metropolitan Museum.[50] Ripley had more success with Mrs. Leonard Firestone, the rubber heiress, who had assembled some spectacular silver pieces.

These focused efforts took place mainly in the mid-1970s, after the Cooper-Hewitt had been offered—and accepted—a new site, the old Andrew Carnegie mansion on Fifth Avenue, recently occupied by Columbia University's School of Social Work. The house, which had belonged to Carnegie's daughter and son-in-law, was transferred to Smithsonian ownership in 1972. The location, a few blocks north of the Met, was appealing, and the large home contained a series of handsome public rooms. But it would be expensive to remodel for exhibition and curatorial purposes, and Smithsonian officials worked frantically to expand the base of benefactors and tap into major corporations as well as private donors.

Smithsonian art concerns were still further broadened in the early 1970s by an agreement to host the Archives of American Art, an enormous collection of manuscript materials, business records, correspondence, and memorabilia associated with the creation, marketing, and exhibition of American art since the eighteenth century.[51] Established in 1954 at the Detroit Institute of Arts by art dealer Lawrence Fleischman and director Edgar Richardson, the Archives had outgrown its original spaces and sources of support. For a time Archives officials wanted the collection to move to New York, but Charles Blitzer, negotiating for the Smithsonian, convinced them to send it to Washington, and the Smithsonian accepted the responsibility to maintain it. There was a sense at Smithsonian that this would provide a critical addition to its art library, and make living artists more enthusiastic about giving work to the art collection. Ripley felt the agreement to be a bonanza for his institution. The recently appointed directors of the National Portrait Gallery, Marvin Sadik, and of the National Collection of Fine Arts, Joshua Taylor, both of whom oper-

ated out of the old Patent Office Building, expressed their enthusiasm. Once again, however, the Smithsonian would have to find money, both through private sources and congressional appropriations, to support this operation.[52]

During the 1960s, as the Smithsonian extended its reach across the visual arts, Ripley was busy seeking to develop a national constituency whose contributions would relieve intense budgetary pressures. The first step was to follow through on earlier plans to create something called the Smithsonian Associates. Secretary Carmichael and the regents had discussed the possibility of creating a national society of friends. But it was Ripley who carried the idea to fruition and labored to interest potential directors in the job. One congressional regent, he wrote to Marshall Fishwick of *American Heritage*, warned that Congress might ultimately insist that the Smithsonian be supported directly by the people. A national membership would make possible new programs that would move beyond the boundaries of federally supported activities. "I continue to believe," Ripley wrote, "that our diversity, our curious development into a quasi-federal and private institution, and our treasure house aura, all enable the Institution to make unique and creative contributions to continuing education."[53] In particular, he declared a desire to attract those "who have had most of their zest and delight in learning squeezed out by the educational system." He wanted to reinforce the notion that museums were places to go for personal involvement as well as to encounter objects of interest.

Along with the national associates, Ripley yearned to create a popular magazine that would interpret and publicize the Smithsonian's vast range of activities. He sought the kinds of readers who subscribed to *National Geographic*, *American Heritage*, and *Time*. After trying to interest Kenneth MacLeish, of *National Geographic*, in the editorial job, Ripley went to Edward K. Thompson, a former editor of *Life* who was now with the State Department, and Thompson soon turned *Smithsonian* into an enormous success.[54]

Dillon Ripley's ambitious reconstruction of the Smithsonian, and his forceful entry into the visual arts, strained relations with National Gallery officers. It "seemed to get under their skin that the Smithsonian existed," Ripley reflected many years later, "and that it was, in a sense, active and doing a lot of things, and therefore competitive. . . . I think that they objected to the fact that I attempted to make the Smithsonian bet-

ter known to the public in Washington. And the public in Washington involves, of course, a kind of political atmosphere which everyone has to be conscious of and attempt to work with." They were afraid, Ripley believed, that he was stealing their thunder and challenging the Gallery's dominance.[55] Ripley, a regular attendee at board meetings, complained that the Gallery felt like a big bank; the Mellons had traveled from Pittsburgh to Washington and kept their values intact. "It was awesome and rather off-putting for me. It just excited my more liberal, more democratic tendencies, so that I would occasionally speak up at the meetings in a way that might make them uncomfortable, but I couldn't help it. And I was also frustrated, because I felt that we were all one family, and it was mean that they were competitive, really mean, because it extended, of course, into the tea party conversation, the gossip conversation . . . trading, as it were, on money and prestige, and society."[56]

When he joined the Gallery board in 1964, Ripley charged, with modest exaggeration, that there was not a single PhD on the museum's staff, from John Walker and Carter Brown on down. Their ideas about scholarship and grants came from Smithsonian people, he insisted. Ripley acknowledged the distinguished connoisseurship so clearly evident, but he decried the tone of condescension. When, entertaining Paul Mellon and John Walker at a dinner opening at the Museum of History and Technology, he suggested dining at the National Gallery of Art instead of at the Sulgrave Club or someone's home, the response was, "But what if someone threw a martini into a Matisse?" This threat was literally impossible, of course; no Matisse yet hung at the Gallery.[57]

Ripley also remained bitter that his own bureau directors felt snubbed by National Gallery officials; they were not invited to special events, for example. And unlike other ex officio members of the Gallery board (the chief justice, and the secretaries of state and treasury), Ripley could not send a representative to board meetings if he was unable to attend himself. He had tried, on one occasion, to have his assistant secretary, Charles Blitzer, attend in his place, but was told "summarily" that the board members could not accept Blitzer's presence; on a second occasion they said, a bit more softly, they would rather not have him come. Finally, albeit reluctantly, they agreed. "But that is straight snobbism and elitism, you know . . . and I don't think it's fair and nice." Sometimes, Ripley charged, the Gallery was actually duplicitous, as in the case of five Gilbert Stuart portraits that Andrew Mellon had given to the National Gallery of Art

but willed to a national portrait gallery, if such were created. After the National Portrait Gallery was established, John Walker and Paul Mellon, he said, simply refused to make the transfer.[58]

The resentment Ripley felt in those early years was reciprocated by those threatened by the sweep of his ambitions. Sensitive about their ambiguous place in the Smithsonian's organization chart, and wary of Ripley's broad interests, National Gallery trustees and senior staff vented their frustrations in a variety of ways. In late 1964 Paul Mellon wrote Ripley about plans for the sculpture garden between the National Gallery of Art and the Museum of Natural History. This was part of a much larger space, stretching across the entire mall, that Ripley, just months into his appointment, had suggested using for a Hirshhorn-inspired sculpture garden. (The project would eventually be vetoed by planning authorities.) Mellon reminded him that there had been an earlier suggestion, in the report of a Presidential Council on Pennsylvania Avenue, that the National Gallery of Art create a sculpture garden here. The acquisitions committee intended to recommend that the board of the National Gallery fund some pieces of sculpture, the artists to be chosen by the Fine Arts Commission. While the final decision about whether the Gallery would create a sculpture garden rested with the board, Mellon believed that its undertaking would help make Washington more beautiful. He concluded, somewhat ominously, "I am, of course, most anxious to make certain the excellent relations which the Gallery has had with the Smithsonian Institution for twenty-five years continue unchanged."[59]

Ripley was not quite ready to yield. The acquisitions committee did recommend to the National Gallery board the creation of a National Sculpture Garden and cooperation with the National Park Service. Ripley, however, proposed that the National Gallery, the Smithsonian regents, and the secretary of the interior undertake the sculpture garden as a joint venture.[60] The matter would drag forward, or backward, for a number of years.[61] In the end, the National Gallery and the Smithsonian's Hirshhorn Museum would each construct its own sculpture garden, although it would be decades before the National Gallery completed its plan, and the Hirshhorn plot would be much more limited than Ripley originally intended. Indeed, it would be considerably smaller than the sculpture garden Hirshhorn had already created on his Connecticut estate.[62]

Internal memos and a series of letters suggest that by 1964 the National Gallery was increasingly troubled by the activism demonstrated

by the National Collection of Fine Arts and its new director, David Scott, an "energetic and ambitious young man," according to John Walker. The Smithsonian, Walker pointed out in memos, was considering expansion of its holdings in American art, especially contemporary American art.[63] To protect its own interest in American art, Walker urged the Gallery to place new emphasis on established American masters, enlarge its existing extension work, request funds to complete the Index of American Design (a major project that had originated during the New Deal), lend reproductions to government offices, and continue to restore government-owned works wherever they might be—all this in the hope of retaining major influence within the federal establishment. The challenge was real. The Smithsonian public-funds budget request for the National Collection of Fine Arts had dramatically increased from the previous year's $180,000 to $1,240,000 for fiscal 1966.

Walker also acknowledged in a memo that National Galley relations with the Smithsonian had been challenged by the sculpture garden issue. The garden "present[ed] an opportunity to show the National Gallery's interest in modern art. The Director would recommend that we do our utmost to control the landscaping and sculptural adornment of this important space. He would further recommend that we use some of our accumulated purchase funds to commission works by living sculptors."[64] In late 1964 the National Gallery took another step toward asserting its interest in more modern art, by modifying its twenty-year rule, which had prohibited entry into the collection of artists who had not yet managed to be dead that long. In view of the Chester Dale bequest, Walker recommended that more recent works be added to the "Collection," which he distinguished from the "Permanent Collection," and be shown on the ground floor.[65]

Nineteen sixty-five, Ripley's second year in office, brought a series of apparently minor incidents, connected only by their revelation of tensions that had been building in the wake of the new secretary's expansionist dreams. On October 6, John Walker wrote to Alan Pryce-Jones of the *New York Herald Tribune*, correcting a statement Pryce-Jones had made while reviewing former Smithsonian secretary Leonard Carmichael's book on his Washington years. "The Smithsonian has no jurisdiction over the National Gallery of Art," Walker declared, "though we technically are a bureau. We have our own Board of Trustees who have complete authority. I haven't read Leonard Carmichael's book, but I

feel sure he would not have implied such jurisdiction, as he was always scrupulously careful to keep these two institutions apart." The actual review, published a week earlier, termed the book dull, long, and inert. But Walker felt it necessary to score some points.[66]

Smithsonian officials responded in their own way. When Geoffrey Hellman, a Ripley partisan, published a book on the Smithsonian's history not long after, he made it clear that he would say nothing about the "new National Gallery" (he had talked earlier about the "old" National Gallery that was part of the Smithsonian); indeed, he emphasized its peripheral position within Smithsonian. But he couldn't help sniffing at its insistent claims for independence. "Even its light bulbs are autonomous," Hellman noted.[67]

That ruffled feathers needed smoothing was clear when Robert V. Fleming, the chair of the Smithsonian regents executive committee, called to arrange lunch with Paul Mellon and John Walker, to discuss what he described as items of mutual interest.[68] This may well have involved the 1965 celebration to commemorate the bicentennial of James Smithson's birth. To honor the occasion and promote a new vision for the institution, Ripley planned new popular attractions for the Mall and an extensive series of lectures and symposia, with distinguished scholars invited from throughout the world. All would climax in a massive academic procession on the Mall. Academic dress would be required, and special banners were to be commissioned for the fifteen bureaus to be represented in the procession. Paul Mellon, in his published memoir, commented wryly that Ripley was apparently "overcome with theatrical ambitions, or had at least been infected with mild institutional euphoria."[69]

Euphoria may have been understandable, but more irritating was the order to have two members of the Gallery staff, and Paul Mellon as its president, join the line of march. "I had no intention of letting representatives of the Gallery march in the procession," Mellon wrote, "particularly since by reason of the date of our establishment we would bring up the tail end of the column." He met with Ripley at his own office and, declaring that the Gallery was not a "bone fide 'bureau,'" added that they already had a government flag flying. "He was not very pleased," Mellon recalled. In the end, Mellon and John Hay Whitney, the Gallery vice president, decided to march in the procession, but as part of the Yale delegation. Mellon donned his "bright scarlet" Oxford robe (he had studied at Cambridge but was awarded an Oxford DLitt), hoping Ripley might

notice it.[70] A conversation with Chief Justice Earl Warren, who headed both the Smithsonian and National Gallery boards, soon followed, and after that, Mellon reported, things calmed down and Smithsonian relationships became "smooth, businesslike, and cordial." But Mellon made sure that the subheading "Smithsonian Institution" was removed from Gallery stationery and publications, and, in a series of notes to Ripley, indicated his concern about misrepresentations and inaccuracies.[71]

Personality conflicts and displays of temperament aside, there were real issues embedded in the Smithsonian–National Gallery flare-ups. At a moment of expansive growth in the museum world, Ripley was determined to place the Smithsonian in a position of national leadership, and to assert its primacy in the arts and humanities as well as the sciences. The Kennedy-Johnson era produced several pieces of landmark legislation dealing with the arts and with museums. Ripley was particularly active in pushing forward a National Museum Act in 1964. He proposed a coordinated program of research, training, and publication in the museum field, with a Smithsonian official at the center of its administration. Interestingly enough, John Walker's copy of Ripley's November 24, 1964, statement supporting such legislation was labeled, in his own hand, "National Gallery of Art vs. Smithsonian."[72]

As evidence of Ripley's ambitions for leadership within the museum field, he hosted, some months later, in March 1965, a lunch for representatives of various local museums and for delegates from the American Association of Museums and the Office of Education. Ripley planned to present museum issues to the National Council on the Arts, which was having its first meeting in early April. Brown attended the meeting, summarizing it, in characteristically detailed form, for Director Walker. At the meeting Ripley was asked directly if the Smithsonian was not primarily a scientific institution; he replied that his objective was to strengthen its humanities side for a better balance. Much of the meeting was spent debating strategies for maximizing the role of the arts and humanities in the executive branch, in the wake of a recent report written under the direction of August Heckscher, a Ripley friend. This was the commission that Charles Blitzer had coordinated. From it would come the two federal endowments, the National Endowment for the Arts and the National Endowment for the Humanities.

At the moment, these were just recommendations, but it was clearly a critical time for artists and humanists. In pushing forward the report,

the administration was abandoning an existing arrangement, hosting a special White House adviser on the arts. This shift was controversial. Ripley himself was pushing for the continuation of a National Council on the Arts, while the meeting consensus was that such an advisory group might eventually disappear or become ineffective, like the White House advisory post.

There were other useful things for Brown to report. Ripley led a move to oppose the notion, promoted by Roger Stevens, founding chairman of the Kennedy Center, of placing cultural hubs in shopping centers, theaters, and exhibition facilities. The group agreed that museums were already fulfilling these functions and that the Stevens proposal would be a distraction. Ripley also proposed that the new federal foundations, as the endowments were being called, be allowed to offer grants to government institutions (like the Smithsonian). Private museums, like the Corcoran, "felt that our noses were in the public trough already," Ripley acknowledged, but he argued that individuals should not be barred from applying for grants simply because they were employed by public rather than private institutions.[73]

Brown and Ripley shared other meetings during the 1960s, each offering some striking proposals. Both attended, for example, a 1966 conference of museum representatives in Aspen. Brown, assistant director at that point, speculated on the value of "miniature sub-museums on the fringes of big cities." Studies indicated "people wanted to go to their palatial museums as if to a cathedral," but the presence of large crowds, especially on weekends, threatened to lessen the value of their visits. Ripley, on the other hand, worried about the people who never went to museums and suggested bringing them in as if they were entering supermarkets. "Perhaps we should rent vacant stores and bring bits of our museums to these people, hoping that they will go in and out of them naturally."[74] Storefront branches had long been a museum dream and had actually been developed, decades earlier, by the Philadelphia Museum of Art. But it was a short-lived program with few follow-ups.[75]

Ripley overflowed with suggestions. Within a year or two of his arrival in Washington he had assumed a central role at a major policy-making moment. He moved quickly and self-confidently, if not always successfully, into the complex bureaucratic and political swamps of Washington, courting legislators, lecturing colleagues, and stroking potential donors. At celebrations marking his twentieth anniversary as secretary, in 1984,

aides recalled their astonishment at Ripley's immediate full-court press.[76] Expecting to initiate the sheltered academic from New Haven into the niceties of political maneuvering, they found themselves learning from their supposed student about how to make friends and influence people. Ripley mobilized his networks—familial, personal, professional, and now increasingly political—in support of a series of ambitious goals for his own institution, and indeed for museums across America.

But it was the Hirshhorn, again, that probably sealed Ripley's reputation for brinksmanship and audacity, earning him and his administration enemies and critics within both Congress and the press corps. With Joseph Hirshhorn and his attorney, Sam Harris, still on the fence, powerful promises were necessary to secure their agreement to bring the collection to Washington. The lengthy negotiations have been described elsewhere—federal officials laboring feverishly to counter the attractive offers coming from competitors, at home and abroad.[77] Significant moments included the personal intervention of Lady Bird Johnson, a strong advocate for the capital's needs. Between Ripley's Connecticut lunch with Hirshhorn and the inauguration of the museum, ten years would pass, although most of this time was taken up with design, contractual bidding, and construction. Congress actually passed the enabling legislation in late 1966. But the six months that passed between the president's request and congressional authorization brought a series of bitter charges. The tone of acrimony intensified in the years that followed. Not even the Hirshhorn's well-attended opening and popular exhibitions assuaged some of its critics, but the larger battle and the building's reception must be deferred to a later chapter.

Reinventing the National Gallery

Creating the East Building

In 1967, the year of the National Gallery's triumphant acquisition of *Ginevra de' Benci*, another episode in the museum career of Carter Brown began to unfold. This new assignment would prove to be the most significant achievement of his professional apprenticeship, as he demonstrated to his superiors the energy, diplomacy, and concentration required to coordinate a transformative event: the construction of a major new museum building and the organization of an institute of learning and a great scholarly library to be housed within it. In the course of creating what would become the East Building, Brown—first as assistant director, then as deputy director, and from 1969 as director—would help reinvent the National Gallery. The project tested the young gallery officer. But Brown soon demonstrated to the trustees (and Paul Mellon particularly) that he was ready, not simply to see this complex project through to completion, but to lead the institution in its new incarnation.[1]

By 1967 John Russell Pope's National Gallery, the building that had so impressed and inspired the twelve-year-old Carter two decades earlier, was twenty-six years old. While not a long time, those twenty-six years had seen a revolution in architecture, especially in the United States, and they stretched like an enormous gulf between past and present. Throughout much of that period, modernist critics had been battering beaux arts monuments. Pope's Gallery, dismissed stylistically by many critics and architectural professionals, was, if not the last, possibly the greatest of its neoclassical breed. In a much-cited essay, Joseph Hudnut of Harvard

termed it "the last of the Romans," a "collaboration of wealth and power" whose forest of interior columns, supporting nothing, seduced the visitor "with expense and weight, crushing him under its firm assertion of authority."[2] A case can be made—and has been made—that this was the most distinguished structure on the entire Mall. But even among those who thought so, it was fashionable to regard the building as a magnificent anachronism.[3] Its exterior, certainly, could no longer serve architects as a model for new museums of art. Yet it remained widely popular, epitomizing the temple of art, at least among the broader public.

The issue was not purely aesthetic. The National Gallery did need additional space that would harmonize with its existing facility. But the city of Washington needed something too, a building that responded to the cultural politics and urban challenges of the day, as well as to transformations of professional taste. A new structure would have to satisfy the professional needs of the National Gallery but also changing expectations about the functions of museums and their service to American audiences. The East Building would attempt to do so.

Two photographs, taken thirty-seven years apart, suggest how much had changed within the Gallery's relatively brief history. The first, from 1941: the West Building is accepted by the president of the United States on a cold, indeed freezing, March evening; supported by a bevy of dignitaries on an indoor dais, President Franklin Delano Roosevelt, in black tie, addresses a gathering of formally clad guests. The second, from 1978: on a broiling June afternoon, President Jimmy Carter, not celebrated for sartorial formality and wearing a light-colored suit, accepts the East Building, outdoors, before a far more casually dressed assembly. The two constants are the presence of the United States Marine Band and of Paul Mellon. Winter versus summer, indoors versus outdoors, night versus day, traditional propriety versus informal transparency—one could argue the string of contrasts sums up the differences between a somber, Depression-era America on the eve of global military involvement and the contentious, rambunctious, establishment-challenging 1960s and 1970s.

Overstated as a summary, certainly—there were, for example, formal preview dinners of great magnificence associated with the East Building opening—but not fundamentally misconceived. The East Building was designed to bring both Washington and the National Gallery in line with a new set of social and aesthetic priorities, to enable the city and its pre-

mier cultural institution to stay abreast of their times. In the process, it might just help constituted authority regain some of the luster dissipated in the Watergate years surrounding its construction.

Whatever it had done for the study of art and the canonization of masterpieces, what was now called the West Building had created for locals a masterful setting for the enjoyment of high culture. The wartime experience that followed so hard upon its opening, the sudden expansion of government, and the gathering of servicemen in the national capital married this splendid marble palace, with unexpected suddenness, to a popular constituency, which flocked both to its musical performances and to the novelties of serious gallerygoing. The often moving comments from some forty thousand military visitors, preserved today in a carefully kept volume, testify to its institutional impact. The servicemen, courted and entertained by Gallery officials, had their own special reception room. After the war's end, a triumphal display of salvaged treasures from the vanquished enemy brought still larger crowds to the National Gallery, creating a visitor squeeze that, judging by the photographs, would seem almost unimaginable to today's museumgoer. This further dramatized the museum's position within the city and solidified its claims to respect and admiration.

While slow in coming, signs of a more activist stance for the museum accompanied its accumulation of masterpieces. A national extension program, developed in the early 1960s, served an expanded audience through reproductions, filmstrips, slides, and packaged exhibitions that could be sent out across the country. There were docent tours, lectures, visits by schoolchildren—the usual array of art museum activities that had become so well developed all over the United States.

But extension programs aside, by the early 1960s, despite its great collections, this was a museum with distinctive—if self-imposed—limitations, of function as well as collecting scope. Here was an institution that deliberately discouraged loan exhibitions, that refused to lend out its own European paintings, whose temporary installations were haphazardly and ineffectively designed, whose catalogs were written by outsiders, whose minimal conservation program and facilities were labeled a "national scandal" by at least one specialist, whose purchasing power rested on the shoulders of just two donors, and, perhaps most decisively, whose holdings still largely excluded—save for some parts of the Chester Dale gift—great Western art of the twentieth century. No membership

or support groups of any kind existed. With occasional spikes caused by one of those (rare) special exhibitions or visits from international master-pieces, attendance had stabilized at slightly more than one million annu-ally, moving on a gentle upward curve.

A program of fellowships, supported by Kress Foundation funds, brought in academic visitors for short periods, and the annual Mellon Lectures provided a link with outside scholarship. But the connections between the National Gallery and the broader world of erudition were tenuous. Connoisseurship remained at the Gallery's center, linked by the person of its second director, John Walker, to Bernard Berenson's I Tatti and that worldwide network of experts, dealers, and collectors that had been servicing great museums for decades. A scanty library, thin photo-graphic collection, and modest publication program hampered any ef-forts to be more ambitious. "The whole concept of a museum as an ac-tivity center was simply neither in Andrew Mellon's mind nor in Pope's mind," observed a Gallery administrator.[4]

The Gallery's traditionalism and passive attitude toward temporary exhibitions, through the mid-1960s at least, did not fit the larger mood of grand expectations that had come to characterize national scholar-ship. The swelling commitments of American higher education formed one undeniable, if still potential, source of new energy. Few American art museums, at this point, were centers of scholarship in themselves. No major museum yet hosted a research center, although the Sterling and Francine Clark Art Institute in Williamstown, Massachusetts, was slowly getting one under way. Both the research center and the postdoctoral fellowship were recent phenomena in the humanities and social sciences, though certainly growing apace. If Princeton and Palo Alto once stood practically alone, they had been joined more recently by Wesleyan Uni-versity in Connecticut, Harvard's Hellenic Center in Washington, and the same university's assumption of I Tatti's administration, and by ambi-tious plans for a Woodrow Wilson memorial, gradually making their way through Congress (under the aegis of the Smithsonian Institution).

An unmistakable spirit of expansionism hung round the scholarly disciplines, producing PhDs in ever larger numbers to meet a clearly rising demand for faculty in American colleges and universities. Grow-ing numbers of students adopted art history concentrations, as images of a permanent leisure economy began to dance through the heads of foundation leaders and academics alike. It is difficult, after more than

five decades of placement challenges and hiring shrinkages, to evoke or even recall the sense of limitless horizons that inspired the dreams of university administrators and leading academics in the early 1960s. Overall, the number of students involved with some form of higher education doubled in that single decade. Projections predicted some two million enrolled graduate students by the year 2000, almost triple the 1965 figure.[5] There were just not enough trained scholars to meet the coming demand, and foundations invented a range of devices to nurture and promote more of them. As observers like Brown saw it, art museums were under special pressure to attract a new generation of professionals; the great appeals of university life threatened to divert potential curators from museum service.[6] Professors earned more money than curators, had more research time, enjoyed more prestige, and were largely freed from collection responsibilities.

As the Kennedy administration came to power, the challenge for the National Gallery was how, at one and the same time, to harness some of these expansionist energies in its own interest, to reclaim its once dominant role in Washington cultural life, and to retain its older ambitions as an institution of record for art masterpieces. For in the mid-1960s it faced the danger of being outflanked. On one side were proposals like that promoted by John White, a British art historian who had recently joined the faculty of Johns Hopkins University in Baltimore. White called for a center of art historical scholarship, run perhaps by a consortium of universities but based in Washington, where it could exploit the presence of the Library of Congress and various other art collections. He was touring the country seeking support, lobbying the Office of Education as well as foundations on behalf of the scheme.[7]

On the other side was the apparently inexorable advance of the Smithsonian Institution, led by its dynamic new secretary. Dillon Ripley's innovations and proposals shook Gallery officials, who feared he held designs on every available piece of Mall real estate, including the oddly shaped parcel that had been reserved for National Gallery expansion by the 1937 enabling legislation.[8] Almost thirty years later, Brown remembered that "Dillon Ripley's rather dynamic view of the Smithsonian" sharply increased John Walker's anxieties. Walker, he said, found "threatening" "the agglomeration of many new units into the Smithsonian, with a Secretary who, unlike a lot of his predecessors, had a real interest in art."[9] Long after the East Building's construction, Walker insisted, in an interview,

that the National Gallery did not enjoy statutory rights to the East Build-
ing site. The frequently invoked legislative record contradicted him.[10]
Nonetheless, the proliferation of Smithsonian entities in the 1960s and
1970s—some of them inherited by Ripley from the plans of his predeces-
sors—was impressive enough. So was the Institution's aggressive search
for mass support, led by the development of the Smithsonian Associates
and *Smithsonian* magazine.[11] "I am worried," Paul Mellon wrote to Dillon
Ripley a year after his arrival in Washington, about the National Gallery's
"public image in relation to the Smithsonian. Your dynamic approach to
the position of Secretary so admirable for the Smithsonian can have the
reverse effect on the Gallery unless we have your co-operation."[12]

Things were just getting started. The newly created National Collec-
tion of Fine Arts seemed directly competitive, in several areas, with the
National Gallery, and provoked both soul-searching and policy changes.[13]
But far more ominous, in many respects, was the shadow cast by the com-
ing Hirshhorn Museum. Ripley's successful courtship of Joseph Hirsh-
horn—even as Walker pressed the entrepreneur to place some of his
sculpture in a National Gallery garden—constituted a massive entry into
contemporary art by an institution that, until not too long before, had
largely left the art field to others.[14] It became clear, at some point in the
mid-1960s, that a considerable influx of modern and even contemporary
art would be coming to Washington, but under whose auspices? In 1965
Dillon Ripley was telling Paul Mellon that the Smithsonian would soon
create an Institute of Advanced Study, an idea that had the support of
President Lyndon Johnson.[15] "It is Ripley, more than anyone else," wrote
Meg Greenfield in 1966 in the *Reporter*, "who embodies the desire to turn
Washington into a sort of world center of arts and letters, albeit with the
Smithsonian at the center of the center."[16] Greenfield also noted that "the
Smithsonian and its most distinguished stepchild, the National Gallery,
are hardly even on speaking terms any more."

The enthusiasm of Gallery trustees and senior staff for new directions
reflected, then, not merely gratitude to the generous donors offering to
fund a new building, but growing awareness that the role and functions
of their museum, indeed of art museums more generally, were undergo-
ing radical redefinition. And also, to be sure, recognition of the Smithso-
nian's recent advances. To retain its central position in Washington cul-
ture, the Gallery would have to respond with new initiatives. This may
help account for the plan's dramatic expansion between the time Paul

Mellon and his sister announced their initial gift of twenty million dollars in late 1967, and the board's endorsement of a plan, on January 19, 1971. The scale of the project, in those three or four years, would completely change, and its evolution repays close study.[17]

Nineteen sixty-seven was dominated, within the National Gallery, by assistant director Brown's extensive survey of art historical scholarship and research centers—his "safari" among the experts, to use the term supplied by trustee Stoddard Stevens.[18] Its purpose was to prepare a plan of action for a major new research center, months before any public announcement. Brown had by then been at the National Gallery for almost six years; his being assigned this responsibility reflected the trustees' confidence in his capacities and, presumably, their expectations of his bright future at the Gallery.[19] Moving from his cubicle next to the director's office in Peacock Alley, Brown, with a secretary, migrated to a space above the print study room. For six months, Brown abandoned many of his existing duties to conduct dozens of interviews with academics, librarians, museum directors, and foundation administrators, while John Walker conversed with a smaller group of British specialists.[20] Those consulted included Isaiah Berlin, Sir Anthony Blunt, Ernst Gombrich, Franklin Murphy, Bernard Knox, John Pope-Hennessy, Roger Stevens, and Millard Meiss, along with the chairs of more than half a dozen art history departments.

That September, Brown produced a thirty-nine-page report recommending creation of what is now CASVA, the Center for Advanced Study in the Visual Arts.[21] His issues included the mix of senior and junior fellows, a system of administrative governance, the length of fellowship tenure and size of stipends, the inclusion or exclusion of predoctoral students, the nature of fellows' studies, the character of the supporting library, and the desirability of awarding some kind of degree or certificate. Brown condensed and organized the views of his many advisors and added his own ideas, demonstrating yet again his special gift for mating detail with broad vision. That spring, some trustees, among them Paul Mellon and Stoddard Stevens, had still been hoping that a university like Harvard might take over the new center's housekeeping; now, though, Brown's report made the case for an independent center and offered a transformed conception of its structure.[22] The center Brown envisioned would, along with hosting some educational and administrative functions, release space for exhibitions in the West Building (not a pressing

need when planning began). With a library, photographic archive, and some office space, the new facility would serve to awaken Washington, "a sleeping princess" for art scholarship, from its lengthy slumber.[23]

Again, tactics as well as strategy were significant. In one reminiscence Brown admitted that the crusade for the center was partly a pretext to build on the prime Pennsylvania Avenue site before anyone else could invade it. The new building need not be outrageously expensive. Walker, at the time of Lyndon Johnson's White House announcement in early November 1967, told presidential assistant Douglass Cater that the twenty million dollar Mellon gift would cover all of the costs; indeed, there would probably be money left over for an endowment.[24] This was consistent with Paul Mellon's estimate, in July 1967, that fifteen million dollars would cover the cost of construction, assuming three hundred thousand square feet at fifty dollars a square foot.[25] Yet just three years later, the Gallery's board of trustees approved initiation of a fifty-four-million-dollar building project. By the time of the May 1971 groundbreaking, the venture encompassed more than 590,000 square feet, almost a third of which consisted of an underground concourse connecting the new building to the old. The first comprehensive cost estimate, presented to the Trustee Building Committee by Carl Morse, was nearly sixty million dollars.[26]

Much attention has focused on what happened in the ensuing seven years, as costs mounted to the final public figure of ninety-four million dollars. Instead of opening in 1972, as planned in one early timetable, the building opened in 1978.[27] By 1974 it was clear that endowment funds with related purposes would have to be drawn on. There has always been some embarrassment connected with this, although, from a broader view, there should not be. Inflation, strikes, construction costs, and a concern with quality had much to do with the exploding budget. From 1971, when construction began, to 1976, construction costs rose 40 percent nationally. A far bigger factor, however, was the growth of scale early on, which reflected programmatic shifts by the trustees as they came to endorse the vastly more ambitious scheme that is the building we now know. What accounted for this? What made them willing to abandon the model of London's National Gallery, which had served so well for the previous quarter century? In the mid-1960s Walker was still turning to that older model, and the boundaries separating that National Gallery and the Tate Gallery, to explicate the relation between Washington's National Gallery and the newly revived National Collection of Fine Arts.[28]

Four years later the American National Gallery would emerge as something fundamentally different from its British analogue.

The movement was started, to be sure, in 1963, when the bequest of the Chester Dale collection was accepted. As noted earlier, Walker, introducing one of his guides to the collection, justified the Gallery's reluctance to embrace modern art by citing the risk of alienating conservative congressmen and thus endangering the museum's funding.[29] In the 1940s he had expressed skepticism about internationally organized displays of modern art.[30] But the Kennedy years, Walker argued, had brought respectability to modernism, permitting the trustees to move ahead with some confidence that they were not risking their economic future. The Dale works signaled a change of philosophy, which would not, however, be thoroughly explored until the Mellon-Bruce building gift allowed for fuller exposition.

But the turning point in this process of reinvention, between 1967 and 1969, may well have been architectural rather than philanthropic: the realization, highlighted by consulting architect Pietro Belluschi's important analysis, that the odd trapezoidal plot to the east of the Gallery could support a much grander and more imposing structure than the trustees had originally thought possible. By mid-July 1967, Paul Mellon and Stoddard Stevens were giving the green light to proceed with a building "that would provide the maximum amount of space that the Gallery could ever use on that site," although they cautioned that only a portion of it should be finished on "the first go-around."[31] Architecture was destiny for the National Gallery, and territorial ambitions were part of the new dispensation.[32]

It should be observed that these ambitions ran in two geographical directions. Congressional authorization, in the early 1960s, for a sculpture garden on the plot of land just to the west of the existing Gallery building, provoked an immense amount of internal and external discussion, and initiated a more than thirty-year debate about form and content, as well as a continuing quest for funds. It also demonstrated the scope of the Gallery's aspirations. "Our relations with the Smithsonian Institution seem to be brought sharply into focus by the question of the sculpture garden opposite the Archives Building," wrote Walker in 1964, responding to a Ripley memorandum on the Hirshhorn proposal. "It presents an opportunity to show the National Gallery's interest in modern art."[33] In 1966, just before the initial Mellon gift for a new building,

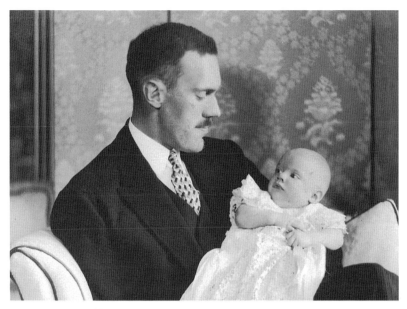

The start of the "braided lives." John Nicholas Brown holding his second child, John Carter III, Providence, 1935. Photo courtesy of John Hay Library, Brown University.

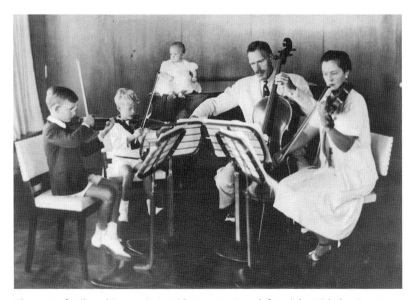

The Brown family making music, Providence, 1938. From left to right: Nicholas, Carter, Angela, John Nicholas, and Anne Seddon Kinsolving Brown. Both parents were accomplished musicians. In later years Carter Brown concentrated on his singing. Photo by Mrs. W. Burden Stage, courtesy of John Hay Library, Brown University.

Carter Brown sketching, ca. 1939. Not a particularly good draftsman, according to his mother. Photo courtesy of John Hay Library, Brown University.

The winner! Carter Brown, Palm Beach, 1940. Photo by Albert E. Guionnaud, courtesy of John Hay Library, Brown University.

A formal occasion. Carter, Angela Brown, and Nicholas in front of Harbour Court, the family home in Newport, RI, 1941 or 1942. Photo courtesy of John Hay Library, Brown University.

The home fleet, 1947. All of the Browns were sailors, and John Nicholas Brown commissioned and owned a succession of famous yachts, all named for dances. Shown here, from left to right, are Nicholas in the *Pavanne*, Carter in the *Conga*, John Nicholas and Anne in the *Polka*, and Angela in the *Pirouette*. They sailed from their summer home on Fishers Island. Photo by Lester Kierstead Henderson, courtesy of John Hay Library, Brown University.

Carter Brown in his Groton jacket in front of Windshield, Fishers Island, ca. 1951. John Nicholas Brown, who commissioned the home from architect Richard Neutra in the 1930s, thought the house should perhaps be called Won'tshield, after a hurricane blew its roof off in 1938. Photo by Lester Kierstead Henderson, courtesy of John Hay Library, Brown University.

Important visitors. First lady Jacqueline Kennedy and French minister of culture André Malraux arrive at the Constitution Avenue entrance of the National Gallery of Art, May 11, 1962. Director John Walker greets them, as his assistant, Carter Brown, looks on. Photo courtesy of National Gallery of Art, Gallery Archives.

Encasing Leonardo. Assistant director Carter Brown working on the installation of *Ginevra de'Benci*, February 1967. Brown played a role in this acquisition. Photo courtesy of National Gallery of Art, Gallery Archives.

Presenting their prize. Director John Walker and Paul Mellon, president of the Gallery's board of trustees, introducing *Ginevra* at a press conference, March 16, 1967. Photo courtesy of National Gallery of Art, Gallery Archives.

The Gallery says good-bye. Director John Walker's retirement party, National Gallery of Art, June 1969. From left to right: Carter Brown, David Finley, the Gallery's first director, and Walker. Rumors had it that Walker wanted to stay on. Photo courtesy of National Gallery of Art, Gallery Archives.

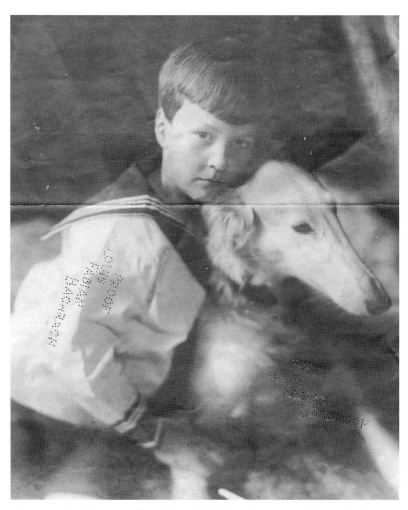

Always an animal lover. S. Dillon Ripley with his borzoi Countess Elka, Cambridge, MA, 1918. Ripley was about five years old at this point, and spent most of his school years in Massachusetts. Photo by Louis Fabian Bachrach/Bachrach; courtesy of Smithsonian Institution Archives.

Far Eastern adventures, personal and scientific, Sorong, Dutch New Guinea, 1938. Dillon Ripley is the leftmost standing figure; his future wife, Mary Livingston, is seated at lower left. Ripley was doing ornithological research. Photo courtesy of Smithsonian Institution Archives.

At work in New Haven. Dillon Ripley, ornithologist and director of Yale University's Peabody Museum, with museum preparator Dale Parsons, 1954. Photo by Albertus Yale News Bureau, courtesy of Smithsonian Institution Archives.

Friendly persuasion. Dillon Ripley, as Smithsonian secretary, discussing plans with President Lyndon B. Johnson in the Court of Claims building (now the Smithsonian's Renwick Gallery), May 26, 1965. Photo by Yoichi Okamoto, courtesy of LBJ Library, Austin, TX.

Ruling body. Meeting of Smithsonian regents, January 25, 1967. Chief Justice Earl Warren is at the near end of the table, with Vice President Hubert Humphrey to his left. Dillon Ripley sits at the far end; to his right is Senator J. W. Fulbright and to his left, John Nicholas Brown, father of Carter Brown. Photo courtesy of Smithsonian Institution Archives.

Contemplating their achievement. National Gallery trustee Stoddard Stevens and Gallery president Paul Mellon examining I. M. Pei's East Building model, April 1974. Photo © Helen Marcus.

Three who made it happen: Carter Brown, Paul Mellon, and architect I. M. Pei in the East Building, January 20, 1978. Photo © Diana Walker/TIME, courtesy of National Gallery of Art, Gallery Archives.

Dedicating the National Gallery, St. Patrick's Day, March 17, 1941. President Franklin Delano Roosevelt addresses dinner guests. Paul Mellon is on the dais. Photo courtesy of National Gallery of Art, Gallery Archives.

Dedicating the East Building. Paul Mellon shaking hands with President Jimmy Carter, June 1, 1978. Photo by Bill Summits, courtesy of National Gallery of Art, Gallery Archives.

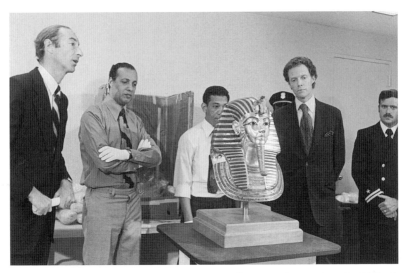

Rivals at work. *Treasures of Tutankhamun* press conference and uncrating of gold death mask of King Tut, Washington, DC, September 8, 1976. From left to right: Thomas Hoving, director of the Metropolitan Museum of Art, New York; representatives from the Cairo Museum of Egyptian Antiquities; and Gallery director Carter Brown. Photo courtesy of National Gallery of Art, Gallery Archives.

No shoving, please. Visitors lined up to enter *Treasures of Tutankhamun* at the National Gallery, 1976–1977. In its 117-day run, the exhibition attracted 835,924 visitors. Photo courtesy of National Gallery of Art, Gallery Archives.

Brown, in a memorandum to Walker, suggested that the still unrealized garden might be used to make the case for Gallery expansion to the east as well as the west, creating, ultimately, a three-part complex, with the Pope building as its centerpiece. There was even some mention of what Brown termed a "double ring ceremony," whereby groundbreaking both for the East Building and for the sculpture garden would be coordinated, though for various reasons—among them the April 1969 congressional decision to eliminate federal funding for the garden—this notion was soon discarded.[34]

In the ensuing, almost nonstop conferences with the intricate web of authorities that govern land use in Washington, Gallery officials emphasized the need for continuous connections among the three parts. Since planning reports issued in 1964 and 1969 by the predecessors of the Pennsylvania Avenue Development Corporation had called for depressing Constitution Avenue and running Fourth and Seventh Streets through tunnels under the Mall, it became clear that some rather expensive solutions would be required. Gallery administrators conjectured that the National Capital Planning Commission and the National Park Service, more interested in a skating rink than in sculpture, were employing the idea in order to strenghten the cross-Mall axis, which would, "in effect divorce the Garden from the Gallery," Robert Engle, a civil engineer recently hired by the National Gallery, wrote Brown in 1971. "I suspect now that the National Capital Planning Commission will oppose the development of a sculpture garden as we conceive it."[35] Brown had some hopes that the pool in the proposed garden might host model sailboats, as in the Luxembourg Gardens in Paris.[36] An almost endless stream of possibilities, many of European inspiration, ran through Brown's conception of the space to the west, though all emphasized Gallery interests and connections.[37] In the end, the National Gallery proposed a bridge to link the West Building with the sculpture garden and an underground passage to connect it with the East Building, this last device making improbable if not impossible a roadway tunneling under the Mall at Fourth Street. The bridge would never be built, nor would Constitution Avenue be depressed, and the proposed tunnel under Seventh Street would be abandoned as well.[38]

The East Building, in fact, was meant to reassert the Gallery's intimate relationship to the fabric of the city. This, in the period from the late 1960s to the mid-1970s, was no mere lip service. The capital's national reputa-

tion was close to its nadir.[39] Stories of poverty and crime abounded in the national media. Running for the presidency in 1968, Richard Nixon had derided the city as one of the nation's crime capitals and suggested that DC could stand for Disorder and Crime.[40] The destructive rioting that followed the assassination of Martin Luther King Jr. in the spring of 1968 took place just blocks from the National Gallery. Recovery was slow and painful. Tourism, so crucial to the local economy (and to politics more generally), plunged immediately. While the East Building was being planned, some of the trustees wondered whether the plentiful display of glass, so inviting a target to potential marauders, would put the art inside at risk.

The federal government had taken note of Washington's problems. In a message to Congress in April 1969, Nixon, now president, declared his commitment to "begin revitalizing the areas damaged during the civil disturbance" and urged Congress to provide improved mechanisms for self-government, which meant, at heart, enfranchising District residents. Noting the more than ten million visitors to the capital each year, as well as the 217,000 federal employees who worked within the District, the president also recommended approval of the proposed ninety-seven-mile, $2.5 billion rapid-rail system and endorsed the grandiose Pennsylvania Avenue Plan, initiated by the administration of President Kennedy and sustained by the support of President Johnson. Three years later, Nixon reasserted his interest in enhancing Washington's attractions in time for the US bicentennial.[41]

Washington's problems were not limited to the effects of civil unrest, disenfranchisement, and a declining share of the area's commercial activity, as evidenced by the somewhat frowsy face of its downtown. In March 1975, in a vitriolic editorial, "The Sickest City," the *Richmond Times-Dispatch* quoted approvingly from a current article in *Fortune* asserting that the city had the highest infant mortality rate in the nation, incidence of venereal disease six times the national average, an appalling public school system, and a municipal government that was "one of the most incompetent and extravagant in the nation." It was "such a dangerous place to live that even some high officials do not answer knocks at their doors without arming themselves in some manner; its middle-class citizens are fleeing by the thousands to the suburbs."[42]

Washington's political and business leadership vigorously denounced such charges and denied that the city's bad reputation was merited. They

pointed to dramatic increases in tourism and a vast range of improvements. The Washington Convention and Visitors Bureau estimated that between 1960 and 1972 the annual number of visitors to the city had almost tripled. Although downtown Washington had acquired only seven private (and no public) buildings during the 1950s, the late 1960s and the 1970s brought a construction boom, some of it stimulated by the 1976 bicentennial celebration and an anticipated onrush of visitors. In 1969 Congress had authorized more than a billion dollars in federal funding for a rapid-transit system, and ground for the Metro was broken within twenty-four hours of the law's signing. The system opened in 1976. As 1978 ended, the *Washington Post* declared that more than a billion dollars' worth of new construction had been completed, started, or announced in that single year. The figure included, of course, the National Gallery's new East Building, which accounted for almost 10 percent of the total. Among other projects were the announced renovation of the Willard Hotel and the conversion of the old Pension Building to the National Building Museum. Also to come were the J. W. Marriott Hotel on Pennsylvania Avenue, which would open in 1984. The *Post* estimate, for construction built or planned, totaled fifty-three hundred new hotel rooms and some 8.2 million square feet of office space.[43]

Cultural investment was a fundamental part of the growth pattern but did draw occasional criticism. Commenting on an announcement heralding the Hirshhorn project and progress in building the National Cultural Center (now the John F. Kennedy Center for the Performing Arts), a Buffalo newsman declared that Washington was acquiring a courtlike atmosphere, complete with courtiers and great museums: "There is enough of pictorial and plastic art in Washington already to give all but the most avid a case of acute aesthetic dyspepsia."[44] But this was a rare negative note. Expansion of the capital's cultural infrastructure was generally applauded, both inside and outside the city.[45]

Of course, other strategies were employed to address problems of congestion, decay, and neglect that mocked the ambitions of governmental leaders and undermined the pride of visitors to the capital. These, however, reflected assumptions about urban problem solving enshrined in the conventional wisdom of contemporary city planning. Construction of the East Building allowed Gallery leadership to challenge the walled-off, carless island favored by Washington planners of the mid-1960s, whose schemes for the center city included sunken roads, superhighway

links, pedestrian malls, monumental plazas, and enormous, megalithic structures that would have condemned locals to a very different future than the one they experienced. The Gallery's board of trustees, in a letter signed by Paul Mellon in the fall of 1964, raised questions about the proposal of the President's Council on Pennsylvania Avenue to depress Constitution Avenue.[46] Gallery officers, although cautious about stating their position, feared being isolated from pedestrians, to say nothing of ongoing challenges to the delivery of everything from art to daily supplies. They were wary of a number of other elements in what became the Pennsylvania Avenue Plan, and continued to voice objections as successive revisions failed to eliminate all of their anxieties.[47]

The distinctiveness of the East Building can be understood only when what was ultimately constructed is considered alongside the projects promoted in the early Pennsylvania Avenue planning recommendations. Pre-Watergate, pre-riots, and pre–Vietnam protest, these proposals invoked a vision of government and its relation to the citizenry that would soon be challenged—politically, intellectually, and aesthetically. Grandiose and imperial, with an emphasis on vast open spaces, working to a climax in a proposed National Square (denounced by local critics as recalling Mussolini's Rome), the plans were almost immediately out of date.[48] Modifications softened the impact but didn't solve the problem.

Over time, as redevelopment needs competed with aesthetic goals, criticism of the plans intensified. Locals protested that the proposals provided for "monuments not for people, for concrete rather than flesh and blood."[49] Grandeur and symbolism were necessary elements of any government planning, acknowledged Wolf von Eckardt, architecture critic for the *Washington Post*, but "effective urban design reconciles grandeur and symbolism with living reality." It takes into account "what the city wants to be," and Washington was "a city that seems to prefer trees over pavements and has had no trouble finding a setting for ceremony and confrontation."[50] The *Washington Post* expressed its opposition to the Pennsylvania Avenue Plan in a series of editorials, some of them defending efforts to preserve structures like the Willard Hotel and the Old Post Office, that "marvelous Romanesque granite pile" "doomed to demolition because it doesn't conform to the classic monotony of the Federal Triangle."[51] Nancy Hanks, the chair of the National Endowment for the Arts, envisioned a people's palace filled with cafes, restaurants, shops,

boutiques, arts and crafts workshops, small cinemas and theaters, and the offices of her organization and the National Endowment for the Humanities—an aspiration far more appealing than what the commission had planned.

Carter Brown's own preferences were shaped by the National Gallery's needs. And his role as chairman of the Fine Arts Commission, a position he assumed in 1971, just two years after becoming Gallery director, gave him a pedestal on which to stand and a solid record of shaping local decision making. In the spring of 1974, as construction of the East Building was moving toward completion, he wrote Leland Allen of the Pennsylvania Avenue Development Corporation, continuing to protest the notion of depressing Constitution Avenue. "Underpasses were a great enthusiasm of the 1960s," Brown admitted, and offered certain advantages "from the engineering viewpoint of a society ruled by the automobile." But they nonetheless created "great gashes in the cityscape." Since Mall planners had reversed their original recommendations and no longer proposed tunneling every Mall cross street, the depression of Constitution Avenue seemed "a very expensive plan to step backwards."[52]

In certain ways, the design and construction of the East Building testified to some of the same ambitions that the Metro system proclaimed when it opened, with two stations in the Gallery's near neighborhood (Judiciary Square and Archives), just two years before the East Building itself: gathering and moving large masses of people, embracing and even celebrating numbers and the resulting congestion, exulting in compression and collective energy.[53] This was crowd culture in a self-expressive mode, the rediscovery of what had made urban life and urban institutions exciting and valued over time, and it reflected as well new respect for the logic of the marketplace and the world of commerce. It was, after all, this same period that brought to broader attention the writings of William Whyte on public places, of Jane Jacobs and Oscar Newman on the values of density and defensible space, of Erving Goffman and Edward T. Hall and a whole series of social scientists, and occasionally art historians, on the complexities of spatial behavior and interactive signals.[54] Presumably Brown, omnivorous reader and observer that he was, knew of this work, and specific references in the archives testify to his awareness of Whyte's writing on plazas.[55] Thomas Hine, reviewing the East Building for the *Philadelphia Inquirer*, juxtaposed its humane deployment of multiple

options for visitors with the Hirshhorn's "herding people through," and found it an encouraging contrast with "the crowd-control philosophy of architecture."[56]

The planning assumptions of the East Building, then, were on the right side of history. Suburban planners like Victor Gruen and hotel builders like John Portman were already playing with great enclosed atriums as devices to recall some of the architectural grandeur of nineteenth-century public spaces and as instruments to achieve a shared consumer experience.[57] In 1956 Gruen had opened Southdale, near Minneapolis, the country's first enclosed shopping mall, one of his efforts to enhance modern community life after the fashion of the Greek agora, the medieval marketplace, and American town squares.[58] The 1970s and 1980s would see, in Washington and other parts of the country, renewed interest in protecting and reclaiming dramatic and sometimes richly decorated interiors, Daniel Burnham's Union Station, the Pension Building, the Old Post Office on Pennsylvania Avenue being just three local examples. "We have rediscovered the past," exclaimed Wolf Von Eckardt, and the charms of "variety, whimsy, ornament, and a cityscape that appeals to the heart."[59] The historic preservation movement, deeply a part of Brown's professional identity, was stimulated to some extent by these extraordinary interior settings, often threatened with demolition. The new vertical malls opening in the 1970s—Chicago's Water Tower Place probably the first, in 1976—were further testaments to this taste. A few critics, like Christian Otto, caught these mercantile connections when the East Building opened. In *The Connoisseur*, Otto likened the study center to a Hyatt Regency lobby.[60]

These relations were most evident, of course, in the great central space. The atrium became, and has remained for most visitors, the defining experience of the East Building. This was Brown's intention and the aspect of I. M. Pei's previous museum forays—notably the Everson Museum of Art in Syracuse, New York—that helped convince him Pei should receive the commission. Visiting the Everson again in the fall of 1968, just a few months after Gallery trustees had given Pei the commission, Brown wrote him admiringly that it showed "what one piece of architecture can do for the psyche of a community," and best of all was "that central volume, and the process of spiraling oneself up and down inside it."[61] In a letter of 1990, Brown insisted that the idea for this central space of orientation, the modern counterpart to the West Building's rotunda,

was actually Pei's. "In fact," he told his correspondent, "I did query the firm several times as to whether there might be a way of making the 'pods' [the exhibition spaces] larger and the central space smaller," but this did not fit the geometry, and "in retrospect, the main space has turned out to be so functional . . . that one can hardly complain."[62]

It may be that Brown's observation reflects the fact that the East Building, in its early stage, was meant more to house services than objects. In 1970 he wrote Pei that the expansion was justified by remembering the Gallery's mandate to circulate materials and works of art throughout the nation.[63] One internal working document, dated July 8, 1968, just two weeks before the trustees announced selection of Pei as architect, stated that, while the existing John Russell Pope structure was "a treasure-house exhibiting precious objects to the public," the "human activities other than viewing these objects are kept discreetly out of sight." Since the Gallery had opened, however, these operations had so grown that they threatened "encroachment upon exhibition space." The East Building was meant to host "professional activities that go beyond the mere possession of a great collection," including the research center, the library, the photographic archives, and the curatorial, musical, and legal departments. If the main building provided "a sense of place directly related to the uniqueness and irreproduceability of great works of art," the East Building "would symbolize the activities of the Gallery, and its dissemination of information at every level." The basic concept as of 1968 was to present the National Gallery as process, its backstage moving to the fore, acknowledging the new transparency of the 1970s and the enormously expanded range of enterprises that the West Building had failed to envisage. The new facility would house temporary exhibition galleries and serve as a showcase for loans, but this was not its initial central purpose.[64]

As plans progressed, however, the drama of exhibition became a more central aspect of the building's personality, both for Brown and for Pei. Increasingly the building was described to the press in terms of the experience it would provide for exhibition visitors. In several statements, public and private, Brown, reflecting in general on exhibition experiences, looked enviously at the greater physical persuasiveness of theatrical performance, which took place only after audience members had moved in some leisurely fashion, checking coats and exchanging greetings, through a lobby and into an auditorium, where they sat down, with

lights adjusted and voices lowered, to enjoy the performance. "It's important for the visitor to recognize that an art museum is just not another branch of their daily chores," Brown argued. Most visitors arrived "during the day, and a lot of them just happen in and they're hot, or harried, or in between errands. What are you going to do to get them to open up their sensitivity . . . and challenge their preconceived ideas?" One way was to "take them by the lapels architecturally" and insist this was not a "normal moment."[65] Many museums operated without initial zones of transition, confronting their visitors almost immediately with the materials on display. The function of the atrium as an aesthetic anteroom, suggesting an order of things that differed from the mundane experiences left outside, was crucial to the larger program. Whatever its origins, then, the atrium met Brown's conceptual needs.

The goal was not, moreover, a hushed, highly structured, or tightly disciplined visitorship, but active, animated, even congested gatherings of people. Indeed, the atrium promised to have its greatest impact when it was most crowded. "Aren't you worried about the tremendous crowds that will jam here as soon as the building opens?" art critic Russell Lynes asked Pei just before the opening. "No," Pei replied, the space was "designed for a mob scene. We needed to make the visit a pleasant one so we built a circus."[66] The West Building's rotunda and garden courts, with their emphasis on tranquility and repose, were sharply different in this respect, although they also served a mediating function. "It was important to him [Brown] that the new gallery should have an orientation space as the main gallery does with its central rotunda," Kiki Levathes told *Washington Star* readers at the time of the 1972 groundbreaking.[67]

To be sure, Brown wanted some limits. He was aware of the dangers of too much flexibility, "of hanging paintings on panels and exposing people's ankles, giving a trade-fair effect," as Levathes put it.[68] Expecting large crowds, "hopefully with many children," Brown urged Pei to retain an outside acoustical consultant. "Since the overall feeling of well-being comes through the ear as well as through the eye," Brown wanted to "crank this dimension" into the planning at the earliest appropriate moment.[69] He was concerned about serving a young audience effectively, even to the point of making some of the public drinking fountains accessible to children. When one of the supervising architects, Yann Weymouth, expressed uneasiness over the "high school corridor" effect produced by a string of drinking fountains, Brown declared that he was

not worried. The structure was, after all, he told planning coordinator David Scott, "a public building, and there might be some welcomingly democratic overtones to adequate provision for visitors' comfort."[70] Both Brown and Pei believed family visits were crucial to the Gallery's future success and sought ways of encouraging them at least as effectively as did the Smithsonian's hugely popular new Air and Space Museum, just across the Mall.[71]

The atrium's effort to join monumental space with aggressively welcoming, informally ingratiating, contemporary ambience was, at heart, the broader goal of the Gallery's project of reinvention—and a goal shared by other museums, particularly those engaged in construction projects at about this time. Commenting admiringly on Pei's West Wing addition to Boston's Museum of Fine Arts in 1981, with its spaces for dining and shopping, Ada Louise Huxtable noted that, like the East Building, it emphasized "spatial and pedestrian" movement "at the social and spectator level," acknowledging the logical connection "between the consumerism of culture and commerce." This was a celebration of "the new museum-going; it emphasizes circulation and shared activity; it is predicated on the social pleasure and communal experience of being there."[72] Pei himself was quoted as saying that museums "have become much more than storehouses for art; they have become also important places of public gathering." The "primary functions" of the central space were "to offer an appropriate space for public coming and going—for people-watching."[73]

Increased activism on the part of the National Gallery signaled a new relationship as well with potential donors and supporters. The initial efforts to create a membership support group came with the East Building project and the need to commission and install, inside and out, contemporary works of art. The Collectors Committee was the first of several groups that would contribute to the Gallery's holdings in a fashion analogous to that found at other art museums across the United States. Because of Mellon generosity, federal subsidy, and the governance structure of the National Gallery, it took the stresses of this singular undertaking to dramatize both the need and the possibilities for special donor support. During Brown's directorship a variety of distinctive affiliations and events were developed to enhance the Gallery's resources and prestige, but all of these flowed, once again, from the initial campaign to flesh out the new building's presentation.[74]

There were two other public areas that also reflected the National Gallery's efforts at reinvention: one exterior, one interior. In some ways, the Fourth Street Plaza, the area between the buildings, proved the most difficult of all the new spaces to create because of jurisdictional issues involving both District of Columbia and federal authorities. Competing visions of traffic flow, concern about the Mall's integrity, urban renewal and development conflicts, and the Pennsylvania Avenue planners' own agenda made for a period of seething uncertainty as prospects for the street's closure or depression rose and fell. The chairman of the National Capital Planning Commission told Gallery officers that without a Fourth Street automobile tunnel they would "have a speedway right outside the building."[75] A tunnel, of course, would have been a death knell for the underground concourse being planned.

Brown vigorously lobbied the Pennsylvania Avenue Commission on these matters, even before his own 1969 appointment as Gallery director. He was not averse to using flattery. In August 1968, for example, he wrote architect Nathaniel Owings, the commission chair (who was reviewing Pei's East Building plans at the time), that he thought Owings was "the best thing that had happened to Washington since Pierre l'Enfant."[76] Brown would later serve as a nonvoting member of the Pennsylvania Avenue Development Corporation, appointed by Richard Nixon in the spring of 1973, just as the Watergate hearings were getting under way. At the time, the National Capital Planning Commission was still vigorously objecting to the paved plaza because the design encouraged pedestrians to move across a busy street from one building to another. They agreed to the final plan, reluctantly, only after the Gallery agreed to ban bus traffic from the plaza and to control pedestrian movement—which was done, of course, through the underground concourse.[77] The vision of a great outdoor space (Brown invoked at various times the Piazza del Popolo in Rome and the Place Vendôme in Paris—enlivened, perhaps, by cafe tables and comfortable street furniture, ultimately fell victim to political and planning exigencies.[78]

Gallery officials and architects put the best face on the outcome. Even after it was absolutely clear that Fourth Street would not be closed, Brown described the proposed area as a "great urban space, a kind of outdoor room," a "carpet of stone connecting the two buildings." Moving Fourth Street underground, a real threat for quite some time, would have seriously compromised the larger building plan, so the status quo

of a through street was actually something of a triumph. Indeed, Brown drafted a note to the chairman of the DC city council arguing that this "great amenity for the city of Washington" be named National Gallery of Art Plaza.[79] (The letter was never sent.) And despite the continuous and distinctive rose granite cobbles (not the easiest of surfaces underfoot), the axial orientation between the two buildings, the flowering trees, the fountain, and the splendid views in each direction, the plaza has never risen to its potential or the rhetoric of its early backers.[80] Moving vehicles might well, as the architects argued, be less distracting than parked vehicles, but they still constituted something of a problem, and the glories of a Roman piazza would prove elusive. Nonetheless, the dream of incorporating such a place was part of the museum's reinvention, objectifying the vision of marrying the monumental with the picturesque that always seemed to lurk in the corners of Carter Brown's mind.

If the Fourth Street Plaza is not a striking part of today's larger Gallery experience, the moving walkway on the underground concourse (suggested in a committee meeting before Pei even got involved with the planning) and the cafeteria—or at least the cascade that abuts it—certainly are.[81] In the detailed records of the East Building's planning, few subjects excite as much sustained, and occasionally hilarious, attention as the eating facilities. Some museum directors find the elaborate comforts of their institutions to be something of an embarrassment, an unhappy shift of attention from collections to visitors.[82] Not so those who shaped the concourse. There was a broad realization that special efforts would be needed to draw the stream of museumgoers from one building to another below grade, something local regulators were eager to encourage in order to prevent interference with traffic on Fourth Street. The novelty of a moving walkway seemed an effective enticement. But it would be expensive, and budget pressures to eliminate it grew as cost overruns mounted. "Let them just walk!" seemed to be the sentiment expressed at one climactic building committee meeting. Architecture critic Wolf Von Eckardt told Brown in early 1971 that he opposed installing a moving sidewalk; it would give the interior, he said, an "airport effect."[83] In the end it was Paul Mellon himself who gave the crucial nod to permit its retention, a dramatic moment in the committee's deliberations that David Scott still remembered vividly two decades later.[84] Commitment to these expensive amenities demonstrated a desire to make a visit to the National Gallery as pleasurable as possible, particularly to rescue the

main cafeteria from the designed dreariness that had overtaken the eating places in so many federal buildings, and to address the "edibility gap" that afflicted almost all of them. The old cafeteria had been popular and crowded and, even when many of the city's restaurants were racially segregated in the 1940s and 1950s, integrated. While widely considered the best of the thirty-two federal cafeterias serving Washington employees and visitors, it was hardly one of the unforgettable features of the Gallery, from either a visual or a culinary standpoint. Brown described it to one *Washington Star* reporter as being "in the last stages of skid row," promising that the "refueling experience" would be the first of the new building's facilities to open.[85]

Brown had been absorbed by restaurant planning since the late 1960s, as arrangements matured for an ice skating rink in the area of the proposed sculpture garden. His energy and consuming curiosity, fed by an impressive travel schedule, led to a torrent of memos on aspects of institutional dining, including seating, cafeteria trays, disposal carts, acoustics, and the shape of tables. In February 1971 he wrote David Scott, noting that in the State Department's state dining rooms "loudspeakers have been unobtrusively built into the ceiling, so that when official toasts and speeches have to be made, the P. A. system necessitates the minimum visual interference."[86] With several aides he scurried around gathering information, especially about an operation developed by Thomas Hoving in New York's Central Park at Seventy-Second Street. In fact, during the next decade, rivalry with the Metropolitan Museum of Art, as well as an interest in glamorizing the new public services, stimulated a high level of planning interest.[87] This was dramatized by a rare indiscretion on Brown's part, which he quickly turned to advantage. The *Washington Post*, in the fall of 1973, nurtured by Brown's whisperings, predicted that the National Gallery of Art would soon offer celebrities a dining room "as resplendent as the Metropolitan's Fountain of Muses Restaurant," where Henry Kissinger had recently hosted a dinner for 450 United Nations diplomats. Brown himself had promised, in a stage whisper during a supper at Roger Stevens's home, that the dining room would have " more flair" than the Met's new restaurant. Its VIP section would be two stories high and feature a "cascade of water plunging down one wall," he told some startled listeners.[88]

The reference to VIPs riled some Washingtonians. One wrote furiously

to the *Post*, pointing out that the Metropolitan's "beautiful restaurant," unlike that planned for the National Gallery, was "open to anyone."[89] Another angrily commented, with heavy irony, "We can hardly wait. This is what the elite have planned for the elite."[90] Brown's remarks had clearly touched some long-standing resentments. He sensed the need for damage control and quickly set the record straight. He had been misquoted, he told both the press and individual correspondents.[91] The new cafeteria, he vowed, would be accessible to all, not just VIPs; the general public would always be welcome.[92] And, he told a correspondent, while the ceiling would be no more than ten feet high, the room would be "more interesting visually than the cafeteria at the Metropolitan Museum," whose decor had been planned "by Dorothy Draper in the 1930s." He couldn't resist one last dig at the competition's eating facility, which had been installed in spaces once used for displaying art (and are again, today). "It has been referred to by a former Director of the Metropolitan as 'the pain in the atrium.'"[93]

Early plans for a great circular ground-level pool of water overflowing down a shaft in the middle of the restaurant were abandoned for engineering and sanitary reasons, but the water slide, proposed originally by an architect in Pei's office, became an acceptable substitution. Joseph Baum of Restaurant Associates (creator of the Four Seasons Restaurant and Tavern on the Green in Central Park) and James Beard were both hired, at different moments, to help design the facilities and the menu, and Brown entertained hopes of creating an all-American atmosphere in the facility. Pei worried a bit that this concept might invoke a colonial revival theme, but Brown had other ideas.[94] The flame-red neon "Buffet" sign became one of the restaurant's distinguishing marks. "We were able to get just the right color," Brown told Elinor Horwitz of the *Washington Star*. The sign, he continued, constituted a nostalgic recollection of those halcyon pre–World War II days, neon being "a native American vernacular," while the horizontal marble elements were said to recall "old drug store counters."[95] With the aluminum acoustical ceiling reflecting the red neon, one staff member cheerfully invoked a "giant microwave oven" as a metaphor. "We love it. . . . We thought we'd be perpetually neo-classical. And here we are with escalators—and with neon!" Brown exclaimed. At least one unhappy critic termed the space "mock art deco," hearkening back to old Horn and Hardart automats.[96]

The naming of the eating area became itself a source of discussion. Brown found "cafeteria" too banal. With all the Gallery was paying Joseph Baum "for ideas, we should be able to get a better word than 'cafeteria' which dates to the thirties, and conjures up a long line," he complained to David Scott in 1974. The Kennedy Center, he pointed out, had a "buffeteria." "Might we try 'refreshment center' . . . or some other, possibly alliterative nomenclature using 'concourse' to give it some appeal without seeming hucksterish[?]"[97] The sculptor Alexander Calder labeled the larger area that enclosed the dining facilities a "universal joint," given its crucial position between the two Gallery buildings, and some wondered whether the cafe might just be called "The Joint."[98] Brown himself suggested "An American Place," pleased that he could bring together a theme of food "that transmogrifies European traditions" and a reference to a landmark twentieth-century art institution, Alfred Stieglitz's celebrated New York gallery. Always seeking multiple references, Brown wrote David Scott asking him to see if they had any Stieglitz photographs that could be blown up. "The conceit could be explained on the menus."[99] But Brown also invited staff suggestions, and dozens soon arrived: the Hungry Eye, Dejeuner sur l'Herbe, Feast Your Eyes, Picasso's Place, Paint & Pentimenti.[100] The rich assortment of nominations does indeed make the present Cascade Cafe seem rather ordinary.

The atrium, too, provided an opportunity to humanize a government building. Here, the East Building acknowledged the city's commercial and tourist needs more candidly than did the West Building, without fully relinquishing the dignities of the federal establishment. The burden of a Pennsylvania Avenue address—the proximity of the Capitol and the heritage of grand official buildings—dominated the rhetoric surrounding the announcement of the architect and the public presentation of the building's plans, as they emerged in the 1970s. This theme was reiterated relentlessly by designers, National Gallery officials, and the architect's office, both as an argument in itself and a response to those who questioned the building's unusual appearance as the construction slowly moved forward.

Some anxiety was justified. When William Walton, artist, journalist, and chair of the Commission of Fine Arts wrote in early 1970 to tell Brown that the East Building design had been approved, he added that he himself had voted against acceptance, expressing concerns about its height and calling the structure a "harsh, overassertive terminus to the

long line of buildings leading toward the Capitol whose environs are a very touchy matter, both aesthetically and politically."[101] Brown and his newly appointed public relations officer, Katherine Warwick, were careful about releasing information while the design process was under way but began cultivating critics and reviewers long before the building itself was completed. An elaborately illustrated press kit was prepared, with a full release promised for May 4, 1971, following the trustees meeting that would approve Pei's plan.[102] An eager local press corps violated earlier agreements and the story broke prematurely, but early responses from critics across the country were overwhelmingly favorable.[103]

There was much to do, and on many fronts. The ongoing construction of the Washington Metro in the first half of the 1970s offered opportunities to institutions like the National Gallery. The location and naming of stations could well influence future attendance. Giving the Archives station a south entrance would put riders closer to the West Building.[104] Some expected Paul Mellon to finance this change personally, though nothing came of it.

More serious was the "Gallery Place" name assigned to the Metro stop located at the National Portrait Gallery and the National Collection of Fine Arts. Smithsonian officers, nervous about further alienating the Gallery, hoped they would not be too upset and indicated the decision was not absolutely final. Brown remarked to Charles Blitzer of the Smithsonian that "Gallery" would more properly be used in association with the National Gallery of Art.[105] Katherine Warwick suggested changing the Gallery Place designation to "Downtown" or "F Street," and calling the Archives station "The Mall." There were other suggestions for the Archives stop, among them "Art Circle," "Mellon Place," and "Paintings Plaza." But "Gallery Place" had been chosen three years earlier, as construction manager Robert Engle pointed out, "Archives" was a long-standing bus stop, and there was no sense in rocking the boat. In the end, Brown decided not to intervene; the Gallery had other battles to fight.

Of far greater significance was the commissioning of artworks to adorn the interior and exterior of the new building. Seven major pieces were finished by opening day. Here there had been no supervisory bodies to consult or arguments with other jurisdictions. Decisions about which artists to approach and where to place the art lay in the hands of the director and his architect. Precedents for this elaborate program had recently multiplied all over the United States, not simply with the construction

of new museum buildings and civic structures but with the opening of commercial skyscrapers whose corporate owners and sponsors sought to associate their enterprises with famous artists. Supposed bastions of midwestern conservatism, from Chicago to Grand Rapids, had begun deploying the work of Picasso, Calder, Miró, and Oldenburg in the later 1960s. Often placed in large public plazas, the sculptures initially attracted skepticism, even scorn, from locals and dismissive newspaper reporters, but this usually changed as tourists flocked in to take a look and residents found themselves targets of admiration. Picasso's untitled piece for Chicago, dedicated in 1967, quickly attracted international attention and became one of a small group of venerated municipal icons. While the East Building was under construction, the General Services Administration announced that 0.5 percent of construction costs for new federal buildings would be used to embellish the structures with art.[106]

Brown threw himself into the project with enormous energy, transformed by this effort into a major patron. He was backed by generous supporters and governed, sometimes prodded, by the taste of his architect, I. M. Pei. The ongoing enterprise brought heady discussions with artists and critics along with travel throughout Europe and the United States, not to mention innumerable photo opportunities. The art would not simply complement the Pei building but would announce the Gallery's new commitment to the contemporary world, its rapprochement with modernity, and its promise for exhibition programs in the future. Contact with storied artists, initiating the creation of entirely new art pieces, and solving problems of color, scale, placement, and medium excited Brown to a point of obsession. Each major commission constituted a story of its own, but something of the flavor can be gleaned from the mass of letters and memos that accompanied the lengthy preparations.

Discussions began in the 1960s, while the East Building was still being planned, but not until the 1970s did details began to emerge. The heavy expenses of commissioning work from celebrated artists were met by foundations and private donors mobilized on behalf of the new building. The Cafritz Foundation, for example, on whose board Brown would later serve, came up first with $250,000 and then with $500,000 to finance the large piece eventually provided by the British sculptor Henry Moore. The Collectors Committee dispensed further sums over the next few years. Brown and Pei visited dozens of artists' studios and made excursions to world-class restaurants, which both of them relished.

In the early 1970s the names of Naum Gabo, David Smith, Eduardo Chillida, and Jacques Lipchitz recurred in correspondence. Pei hoped for a Henry Moore along the Pennsylvania Avenue axis, to be balanced by a large Lipchitz near the entrance. And he wanted to be closely involved with the commissions. Brown was not entirely enthralled by Pei's choices. Writing to Thomas Messer, director of the Guggenheim Museum, he asked for counsel about possibly enlarging an earlier piece by Lipchitz, since he was unimpressed by the later work. Messer agreed that such a course was plausible and "safe." "I remain very unconvinced about the late Lipchitz," he wrote Brown, bemoaning the pieces' quality as "labored and academic."[107]

Some pursuits involved frustration. In April 1973 Brown raised with Roland Penrose, the artist, collector, critic, and close friend of Pablo Picasso, the notion of getting a cast of Picasso's *Bathers* and giving the sculpture a reflecting pool of its own. "It has been my life dream that the building be a shrine for the *Guernica*, but I can imagine that one is pretty far-fetched."[108] Penrose had been involved with the painting's 1938 English visit, and, after a long series of moves, it had been on display for decades at the Museum of Modern Art in New York. It would return to Spain after Franco's death. "Far-fetched" was an understatement when applied to its coming to Washington. But the Gallery needed more Picassos, Brown confided, and anything the painter could offer, either for sale or as a gift, would be taken seriously.

Picasso's death came just days after Brown had written, complicating matters, but the young director was unfazed. "I realize that all will be chaos for some time," he wrote Penrose. "However, our interest in *The Bathers* and in the whole question of representing his other periods remains."[109] The worldwide media attention lavished on the artist immediately after his death demonstrated how deeply he had penetrated public consciousness, and Brown understood how much this connection could benefit the Gallery and the new identity he was bent on achieving.

There were additional possibilities. For a time Brown became interested in four large Marc Chagall backdrops, each thirty-eight by twenty-nine feet, painted for the opera *Aleko*, although he admitted that a commitment to preserve and display these pieces in perpetuity would be a "grave step." In the end he decided that putting them into the Kennedy Center or the National Lending Service made more sense, and the idea was abandoned.[110]

Henri Matisse, the grandfather of his close friend and college room-mate Paul Matisse, was another matter. The notion of creating a room of Matisse decoupages as "a kind of temple to him, and a pilgrimage site," was well advanced by the time of the Picasso overtures. It was encouraged by Matisse's daughter, Marguerite Duthuit, who was well aware of Brown's connection with the family and apparently delighted by his enthusiasm for her father's work. "Life sometimes has strange coincidences," she wrote, responding to his proposals.[111]

Some artists aggressively pursued opportunities. Naum Gabo invited Gallery curators to visit his studio. E. A. Carmean, in charge of twentieth-century art, would call upon him in Connecticut.[112] Staff discussions revealed doubts about deploying a Claes Oldenburg; Brown felt the new building's primary image problem was distinguishing itself from a museum of contemporary art.[113] Older pieces might be better. There was also concern that Isamu Noguchi's use of stone might conflict with the entrance, although in fact a Noguchi in basalt, *Great Rock of Inner Being*, would be installed inside the atrium, paid for by the Sackler Foundation. Mark di Suvero, popular with the Collectors Comittee, was thought to be too "light." Di Suvero is represented today in the Gallery's long-delayed sculpture garden.

There were local pressures as well. At a July 1975 meeting, Brown argued that it might be "nice to have a Washington artist for this project."[114] Jules Olitski came up as a possibility, and Carmean urged Brown to visit him. Pressures were strong to represent American sculptors, both recent artists and what the Gallery advisory group called "Modern Old Masters." Anthony Caro's name surfaced, but it was pointed out that this would mean another non-American piece. In fact, Brown would correspond extensively with Caro, who would supply his *Ledge Piece* for the building's interior. Critics called the Caro choice inspired, but the broader campaign tended to be risk-averse, erring on the side of caution, perhaps reflecting Brown's fear of becoming too contemporary.

Pei certainly played a decisive role, but Brown's level of involvement was specific, detailed, and sometimes quite aggressive. He visited Joan Miró and reported in a memo that the artist was growing more frail, proceeding slowly on his Gallery commission. Miró was concerned about the safety of a maquette that had to be sent to Washington, but Brown assured him that a slide would be just as useful.[115] There was correspondence with Jean Dubuffet and Robert Motherwell, a visit to Jean Arp, and

ongoing contacts with Alexander Calder, whose mobile would become probably the most popular artwork created for the new building. The Calder entailed all sorts of problems of its own. Surprised by the sculptor's decision to fabricate it in France, Brown and his colleagues found it overengineered and clumsy; it weighed too much, and the joints and stiffeners had become too large. Brown brought Paul Matisse in to solve these problems, and he did, although it was a complicated effort.[116] Issues with the huge mobile continued right up to the opening. Dramatic interventions—particularly a shove at just the right moment—got it moving just in time. In the end, computer controls helped meet its challenges.

Most of all, there were lengthy discussions with and about the famed British sculptor Henry Moore, a shrewd negotiator whose ideas about where his work should be placed and just what it should look like sometimes frustrated his patrons' plans. Predictably, Brown got personally involved with the details, which involved some striking changes. He initiated the commission in May 1973, inviting Moore, with Pei's full support, to create a piece for the East Building's Pennsylvania Avenue facade. Pei, a close friend, had already picked the precise spot. "We are convinced," Brown wrote the sculptor, that we "must have" a great Moore there.[117] Moore accepted the commission several weeks after the first letter and visited Washington the following spring to inspect the site, part of a larger North American trip. He promised, once the summer had passed, to concentrate his attention on the job. Thanking him for the visit, Brown wrote Moore that his vision of a truly monumental work along the Pennsylvania Avenue facade was inspiring, even if more costly than originally imagined. But Brown promised to raise the money.

In succeeding months, Brown and Pei dogged Moore for more specific information, but he seemed to be procrastinating. By June 1975 Moore had made a definite project proposal, and Brown wrote Pei to gauge his reaction. Moore had just returned from Berlin, where an enlargement of the *Spindle Piece* that he had been proposing for the Gallery was being cast. In a memo, Brown noted that he had asked Moore if there was any possibility he might create a special piece for the Gallery. Moore "reiterated his position of being categorically opposed to that approach." "I have never done it," he told Brown, arguing that a piece of sculpture should be an entity of itself and look well in a variety of situations. Otherwise, Brown recorded, he "feels it becomes a kind of applied art, sort of interior decoration."[118] Moore did concede that the scale, material, and

general form of the piece had to be appropriate. Brown found *Spindle Piece* "acceptable," although he worried about its sharp points, fearing that journalists might "talk about Pinocchio" when invoking it. When Moore warmed to the notion of sending the cast to Washington to study it on-site and determine the precise scale, Brown felt reassured. Quite obviously, he noted in a memo, Moore "felt that this was such an important commission that no amount of trouble would be too much."[119]

With all of these other issues, Brown didn't want to distract Moore with financial discussions. He did mention the need to have something more precise in writing about the financial arrangements, and declared that he had located a donor willing to pay the (considerable) shipping costs. Moore, who was notoriously careful about money, tight with his employees and meticulous in his calculations, replied that he would never have accepted the project simply for the financial rewards. Comparing small-scale multiples and major commissions, he pointed out the larger profits generated by the former. Brown decided to let things move ahead and, once the foundry costs were set, to obtain approval from the acquisitions committee and additional funds.

On the prowl for more money, Brown turned to Gwendolyn Cafritz, telling her that Moore "has a real feeling that this might be the most important Henry Moore sculpture in the world."[120] In effect, Brown consigned his enthusiasm to Moore for purposes of persuasion, while expanding on the challenges Moore faced: "the sheer scale of the Pei building; and its large taut surfaces of marble, together with the scale demands of Pennsylvania Avenue and the magnificent backdrop" supplied by the Capitol.

Brown continued to transmit his enthusiasm to the sculptor. He hoped that on Moore's next trip the two of them could drive to the Mall "the way so many of Washington's visitors will come to it," from the new visitor center being created at Union Station through a "continuously scheduled mini-bus system in such a way that the Pennsylvania Avenue facade and the Henry Moore will be the first thing they see. It is the introduction to the whole mall experience." It "gladdens my heart," Brown added, that the "clarion call" to this "sacred piece of national property" would be a work of art, and "a Henry Moore in particular."[121]

Almost every part of this prediction turned out wrong. Neither the new visitor center nor the minibuses would materialize; the Henry

Moore sculpture would not sit on Pennsylvania Avenue; nor would it be the *Spindle Piece* that Moore had proposed and Pei had approved. What entirely changed the project was Moore's April 1976 visit to the site, which he had, in fact, inspected earlier. Moore now decided that the Pennsylvania Avenue spot lacked enough sunlight and instead suggested placing something beside the main entrance.[122] *Spindle Piece* was not right for this, so Pei proposed enlarging *Knife Edge Two Piece*, an edition of four, one of which stands near the House of Lords in London. Moore agreed, and *Knife Edge Mirror Two Piece*, as Brown supposedly renamed it, would be placed adjacent to the main door, the largest and perhaps most frequently viewed piece of sculpture Moore ever made. The sudden change did not seem to faze the Gallery director. Despite the rhetoric invested in the Pennsylvania Avenue spot, Brown now told Moore he was excited by both the new location and the new choice.[123] After a challenging passage to and from Southampton, through strikes and logistical mishaps, the two bronze pieces, weighing some fifteen tons, arrived at their final destination, supervised by Moore himself.

The art accents, shaped more heavily by Pei than by Brown, were faithful to the broader mission. The East Building's mediation between tradition and innovation also happily accommodated the National Gallery's largest need: to demonstrate, unmistakably, its fidelity to the original masterpiece mission so clearly exemplified by Pope's monumental structure, and its concurrent response to contemporary needs. These included meeting the demands of energized and expansive scholarship, satisfying expectations of spatial drama and user-friendly service, and hosting an ever-changing blend of educational and exhibition functions. The building's marriage of two rather different museum eras simultaneously mirrored and stimulated the Gallery's broader agenda. Without some new building, it is impossible to conceive of the National Gallery going on to assume its enlarged obligations. But long before this happened, even before it opened on that hot summer day in 1978, the new structure reflected, in its planning as well as its execution, a new style of management, put in place by a new cadre of staff members, and promising a new set of experiences. All of this had been accomplished in the first years of the Brown administration.

"What Hath Brown Wrought?"

P
lanning and construction of the East Building consumed eleven years. Carter Brown served as director for nine of them. Despite this huge project, it was during these years, particularly in the first few of them, that Brown worked out major elements of his management style, made a series of significant staff appointments, experienced complicated changes in his personal life, and, most of all, further extended the social, professional, and political contacts—in Washington and beyond—that would underwrite his program for the Gallery. Between 1969 and 1978 three different presidents lived in the White House, foreign and domestic policies mutated, congressional leadership evolved, and cabinet secretaries came and went. This ongoing flux posed challenges to a publicly supported museum, and Brown sought to turn them into new opportunities to demonstrate the National Gallery's relevance and the expanded role it might play in the larger world.

The staff Brown had inherited from John Walker reflected, to a large extent, the older vision of the Gallery as a monument to established taste, the rules of connoisseurship, and an almost princely elegance. For much of the 1960s, while a transformation had begun in many American museums, the National Gallery, with its well-displayed permanent collection and responsive service to a million or so annual visitors, remained somewhat aloof. Many senior staff members, veterans of government service, had been at the Gallery for decades and reflected the conservatism of lengthy legal, military, or administrative careers. They were unlikely

to challenge existing arrangements or propose startling innovations. But Brown, an activist observer for much of the decade, began with a splash, aided by timely retirements that allowed him to create a new staff.

Walker's retirement was the necessary precondition for Brown's subsequent achievement. Just sixty-three years old, Walker was not convinced, in 1969, that he should step aside. He enjoyed the directorship and believed he could go on longer. He had, of course, brought Brown to the Gallery, and the two had worked closely together, without apparent friction, for eight years. Brown showed Walker every deference, and their shared backgrounds made for mutual respect. But a transition was already taking place. In the summer of 1967, spending his usual several months in Europe, Walker plaintively wrote Brown, in response to a letter, that "your last paragraph saying that I am missed around the Gallery meant more than I can possibly tell you. Everything seems to go so smoothly without me that I sometimes feel I might just as well stay away for good!"[1]

Walker, despite the fact that he had provided the initial inspiration for the Gallery's dramatic expansion, helped secure many of its greatest gifts, and served effectively as its public spokesman for decades, was skeptical about its future and ultimately disillusioned by its fate. Leery about enlargement, he viewed attendance figures suspiciously and held a vision of the new facilities that would never be realized. He had wanted, for example, to put all of the art books from the Library of Congress into the East Building and open it to the general public. This would serve a larger purpose without challenging existing exhibition practices. Instead, the library would be reserved largely for staff and resident scholars, and the building itself become a frequent venue for modern art, a project he could not endorse. "I always thought the National Gallery was too big," he told an interviewer in 1987. "So then I proposed enlarging it. I was really untrue to myself. Pure greed, purely a desire to keep it out of the hands of Dillon Ripley, who was spreading all over Washington. And I got Paul to go along. Now it's lost what intimacy it had."[2]

This was hardly the outlook that would propel the National Gallery into a new age. The trustees, who had given Brown the job of translating the dream into reality, did not want to wait any longer. In a handwritten letter to Brown composed in early 1969, Paul Mellon related that, speaking for the other trustees, he had told Walker that it was time to step

down and that it would be unwise "to compromise the changing of the guard by any sort of provisional period or other means of holding one's breath." We know, Mellon wrote, "that you are convinced you can carry the load of normal Gallery administration and the supervision of the new building too and we are also sure that postponing your Directorship too long will cause delays, dissatisfactions, and unrest in the under echelons."[3] He offered Brown a choice between assuming the post at the end of the calendar year and taking over on July 1. After discussing the options with Walker, Brown chose July. He was eager to move forward as quickly as possible. And, according to some, too quick to cut institutional ties with his predecessor, who was left without office or responsibilities, although he might have felt entitled to something more.[4]

The transition to director had all of the suspense of a dynastic succession. There was no national search, no consultation with other museum leaders, no insistence upon letters of recommendation, no interviews, no contractual negotiations. The public announcement was made in early May 1969, less than two months before Brown would assume his new post. Brown was convinced that memories of the fight over Walker's own appointment played their part in this quick process. The five general trustees knew exactly what they wanted, and they believed they knew precisely what they were getting. The even smaller core of Paul Mellon, John Hay Whitney, and Mellon's own lawyer, Stoddard M. Stevens, were, in essence, running the show. The only possible dissent might have come from Stevens, whom Brown distrusted and had previously found intrusive. But there was little to do about him. Stevens had proved immensely useful to Paul Mellon on a series of occasions, helping to broker the establishment of both Carnegie Mellon University and the Andrew W. Mellon Foundation. He had also, Mellon believed, been instrumental in tamping down protests by the Art Institute of Chicago after the loss of Chester Dale's collection. As a senior partner in Sullivan and Cromwell, he enjoyed Mellon's full confidence. Neither a scholar nor a collector, he mistrusted change and valued orthodoxy. But he was experienced, shrewd, and relentless.

Brown was not the only one to find Stevens's appeal elusive. Rachel (Bunny) Mellon, Paul's wife, told *Time*'s Gerald Clarke in 1978 that anything she disliked about her husband she attributed to Stevens. "Stoddard Stevens took away a good deal of the poetry from my husband's life," she remarked. "He came along when my husband needed a father

figure, and that's what he got."[5] Stevens would be eighty-six when the East Building opened.

Age may also have inflected Stevens response to Brown's rapid ascent. Brown believed that Stevens accepted his appointment because he hoped a young and inexperienced director would be weak and deferential, giving the trustees still more discretionary power. Brown frustrated that hope, although he chafed at Stevens's admonitions and at one point thought of resigning over them.[6] In any case, the kind of fracture that erupted over Walker's appointment never happened, and the transition moved forward quickly and smoothly.[7] Walker himself kept a stiff upper lip and greeted the appoinment warmly. But, as at least one newspaperman pointed out, he never even mentioned Brown's name in his memoir, published five years later.[8]

A whole series of events, some planned, others unexpected, further emphasized the passage to a new era. On July 2, 1969, the second day of Brown's administration, Paul Mellon, as Gallery president, issued an administrative order. Senior staff would now report to the director, bypassing other executive officers.[9] While this formalized some existing arrangements, it suggested a shift from the multiheaded organization that Brown found cumbersome and inefficient to a more vertical hierarchy. The director was no longer *primus inter pares* but, like his counterparts at most other art museums, stood alone at the head of his staff.

New commitments required new positions. Thus, within weeks, David W. Scott, forced out of the National Collection of Fine Arts by Dillon Ripley, became coordinator of the East Building project, Brown's first major appointment. There were also critical openings to fill. Perry Cott, the senior curator, resigned along with Walker. So did Raymond Stites, the longtime curator of education and a popular lecturer, who had recently become an assistant to the director.[10] Also resigning was Ernest Feidler, the secretary, treasurer, and general counsel (the posts would be separated when new appointments were made). These departures signaled significant changes, and more would come in the fall of 1970.

Some of the newcomers suggested continuity with older patterns. Thus, in February 1970, Joseph G. English became the Gallery's deputy administrator (and, the following year, administrator). A Harvard graduate and grandson of a prominent American diplomat, Joseph G. Grew, English moved over from the Bureau of the Budget. In May 1970, Kennedy Watkins, a much older lawyer, again with a Harvard degree, and

an aide to Ernest Feidler, was named the Gallery's secretary and general counsel, on the recommendation of Stoddard Stevens. Brown found both of these appointments wanting, and Watkins served a short term.[11]

But other arrivals implied new directions. The *Washington Post* disclosed, on September 8, 1970, six new staff appointments, including those of Theodore Asmussen, placed in charge of Gallery publishing programs, and Frances Smith, as assistant editor. The accompanying announcement that Gaillard F. Ravenel II had been hired as a research assistant, with an emphasis on exhibition design, hinted little at its momentous impact.[12] Observers were probably more impressed by the appointment, a month later, of Charles Parkhurst as assistant director.[13] In choosing Parkhurst, Brown brought to his side a veteran museum official, experienced, mature, and skilled in a whole series of specialized areas. His salary of forty-eight thousand dollars doubled what he had been receiving as director of the Baltimore Museum of Art.

Parkhurst, who took over his post on January 1, 1971, had studied at Williams and Princeton, and had worked at the National Gallery decades earlier, reporting directly to John Walker, who was then chief curator. He admired both David Finley, the director at the time, and Macgill James, the assistant director, but recalled Walker with less fondness, having found him controlling and inconsiderate.[14] Unhappy about the Gallery's role in exhibiting German art treasures after the war, Parkhurst had gone off to the Albright Museum in Buffalo, spent a short time at Princeton, and then went to Oberlin, where he directed the Allen Memorial Art Museum and became actively involved in a conservation training center. Parkhurst had long-standing interests in the history of color theory and was fascinated by problems of pigmentation. He was also active in a variety of professional organizations, including the American Association of Museums, and was known informally as the "father of accreditation," a credentialing program for American museums that continues to the present. After more than a dozen years at Oberlin he moved east to assume the Baltimore directorship.

Twenty years older than Brown, Parkhurst was impressed by his younger colleague's energy and ideas. Soon after Brown assumed the directorship, Parkhust invited him to speak to a group of his own trustees in Baltimore. He had already stumbled upon Brown checking out the night lighting at the Baltimore museum, a McKim, Mead & White temple completed in the 1920s that shared many features with the National Gallery's

West Building.[15] Frustrated by his own board of trustees and having spent ten years in Baltimore, Parkhurst recalled telling Brown that if he needed help in Washington, he would be interested. Within days he was invited to join the staff as assistant director and chief curator, and he immediately became involved in building up gallery programs and resources, particularly in the areas of conservation, photographic holdings, and the library. During his earlier stint in Washington, Parkhurst had initiated the photo archives; now he was able to expand them and to appoint a director for the formidable new library being planned as part of CASVA, the center for scholarship that would occupy a portion of the East Building. Decimating the conservation department in Baltimore, much to the anguish of his successor, Tom Freudenheim, Parkhurst brought Victor Covey, Kay Silberfield, and John Krill to Washington, and the Gallery's conservation program was launched.

Parkhurst's contacts in the larger museum world were crucial to the growth of the Gallery's staff. Brown, who had concentrated for the previous few years on planning the new building, lacked his broad knowledge of curatorial talent throughout the country. Parkhurst reorganized departmental structure and identified new recruits. He also supervised transformations in the general publications department, now under the direction of Asmussen, particularly the redesign of the Gallery's annual report. For outsiders, this was the most visible and immediate sign of the new administration, and it intimated Brown's interest in dramatizing and personalizing the Gallery's public face.

Until then the Gallery's annual reports had appeared in two forms: within the Smithsonian Institution's yearbooks and as part of the series Studies in the History of Art. In the report for fiscal year 1970, however, Gallery president Paul Mellon declared that for the first time an annual account would be issued separately. The newly designed document had some striking features, with black-and-white photographs scattered amid reports from the various departments and lists of all employees and docents. Its highlight was the director's report, a month-by-month recounting, in which Brown indulged his taste for vivid metaphors and evocative descriptions, engaging readers with his triumphs and frustrations alike. This new, informal narrative (whose form would not change fundamentally for the next twenty-two years) paralleled Secretary Ripley's striking informality in the *Smithsonian Year*.

The director's report provided Brown with a distinctive and highly

personal voice. Lively and animated, his take on the previous twelve months offered engrossing details and sharply etched images. In the 1972 report, after describing the increasing number of exhibitions, appointments, and gifts to the Gallery, Brown paused to note the completion of a twenty-one-foot-long maquette of the East Building that had emerged from I. M. Pei's model shop: an "observer can introduce his head into the great central space and, like an instant Gulliver, peer into the projected galleries," he exulted.[16] "If Damon Runyan thought watching America's Cup races was like watching grass grow," Brown observed in the 1974 report, "he never had the opportunity of watching, day-to-day, the seemingly immutable silhouette of anything as internally complex as the National Gallery's building project."[17]

Far more dramatic, in the same 1974 report, was Brown's report on the Gallery's quest for a Georges de la Tour *Magdalen*, privately owned in France. The possibility of a sale had been broached with the owner a decade earlier, but only toward the end of the 1960s was permission granted to discuss the possible purchase. At issue was the export permit that would have to be issued by the French government. Instead of describing the effort in a single passage, Brown split it into month-by-month installments, turning the story into something of a melodrama as he recounted the exigencies of board of trustee decisions, governmental crises, changing ministries, and other hazards. In November, a contract between buyer and seller was finally worked out. Now it was up to the conseil artistique des musées nationaux in France. In secret session, it determined that the de la Tour should remain in France, and the cabinet minister was unavailable for further discussion. But a shakeup in the government seemed to open new opportunities, and the Gallery pressed on. Then came the death of President Pompidou, new elections, a new cabinet, and new uncertainties. In the spring Brown made a special trip to Paris to "plead for clemency in the affair of the de la Tour." As he closed his report, Brown could only advise nervous readers to wait for next year.[18] And indeed, the 1975 report carried happy news. In September, "a visitor came to us, permanently, from France."[19] Put on view immediately, with a ceremonial dinner at the Gallery, given by secretary of state Henry Kissinger for the French foreign minister, the painting's saga served as one of the many narratives that enlivened this previously rather dull genre.[20]

In his uncompleted memoirs, Brown recalled the heroic effort to land the de la Tour in still more detail. Typically, it was all about contacts,

friendships, and connections. He knew John Irwin, the American ambassador to France, who was helpful to the cause, and René Huyghe, an eminent art historian who also headed the Collège de France. Huyghe, who sat on the Conseil Artistique used by the Louvre to consider export licenses, favored the National Gallery purchase. Pierre Rosenberg, then curator of French paintings at the Louvre, did not. According to Brown, Rosenberg, just before the death of Pompidou, called a meeting while Huyghe was away in Venice. "I wondered whether this arm wrestle would affect my relations with Pierre and with my fellow student Michel Laclotte," who would eventually direct the Louvre. No, they "admired" Brown's persistence. "On fait son métier," Brown continued. They were realists, and Rosenberg even inscribed a copy of his book on de la Tour to Brown, in "warm" terms.[21]

As significant as Parkhurst's arrival was, in the long term, the appointment of Gaillard Ravenel, as previously suggested, would have greater import. A former Kress Fellow, Ravenel, who had studied (and worked) at Duke and the University of North Carolina, Chapel Hill, had long been interested in printmaking; his special passion was for Edvard Munch, the Norwegian artist. But Ravenel, Brown quickly discovered, had a singular genius for something else entirely: the art of museum installation. He, and a department built around him, would define the Gallery style for more than two decades and bring Brown some of his greatest triumphs and most difficult headaches.

During most of its first thirty years the Gallery had downplayed special exhibitions. At the start there was little to lend out; the Mellon collection could be displayed in its entirety in just five galleries, leaving 125 more to fill. When the West Building opened in 1941, Brown once remarked, the prevailing quip was that the guards were there to direct visitors to the next painting.[22] The hanging of the Widener, Kress, and Dale pictures helped enormously, but the memory of prevailing scarcity was slow to die.

By the 1960s there were signs of change. Attempting to increase attendance, the Gallery hosted some special shows, featuring American artists like Gilbert Stuart and Thomas Eakins, art treasures from Turkey, objects from Egypt, and surveys of private collections. These were, on the whole, staid affairs, with few significant publications attached. Some of the more ambitious efforts were organized by an outsider, Annemarie Pope, wife of the director of the Freer Gallery, who directed the Smithsonian's Traveling Exhibition Services and would eventually establish a private

organization known as the International Exhibitions Foundation. Pope turned the National Gallery into one of her major partners. Still, Brown declared in the early 1980s, as late as 1969 no National Gallery budget for a single exhibition had exceeded ten thousand dollars. By the time of that reminiscence, costs for some shows had multiplied by more than three hundred times.[23]

All of these temporary installations had had to cope with serious physical constraints; the Central Gallery, the only facility normally available, consisted of a long corridor with alcoves. The recessed lighting, Brown recalled, was state of the art—for 1939. Mouse gray, cloth-covered walls and spaces that were difficult to enlarge or modify formed the prevailing conditions. Every exhibition had to fit the site. Brown found the existing pattern unacceptable. A temporary exhibition "is an opportunity to produce an event," he told an interviewer.[24] And events were something the National Gallery was inexperienced at promoting.

Brown was eager to start moving. Six months after his appointment, in January 1970, a show of African sculpture opened. It was organized under the auspices of Pope's International Exhibitions Foundation and would travel on to museums in Kansas City and Brooklyn after its Washington stay. Douglas Newton, a curator at New York's Museum of Primitive Art, advised on the installation and special lighting and false walls altered the existing space, both departures from usual Gallery practice. Brown, who had his own ideas about display, found the arrangements unsatisfactory and crowded. Just days before the opening he intervened, enlarging the spaces and reorganizing the show. Years later, one Gallery curator called it "the very first blockbuster" the institution had ever attempted.[25] Brown had wanted to "make a splash" and was determined to make this a more powerful visitor experience. But he had not yet found his real solution.

The changes in presentation became more apparent in 1971, when, for an exhibition of Paul Mellon's British art, Gill Ravenel shocked old-timers by painting the walls a dark, flat blue. The colors in the paintings jumped out, and visitors quickly recognized that they were in for a special experience. Reviewers paid tribute to the unexpected achievement and began to talk about the installation itself as well as the art on display.

Parkhust found himself impressed by Ravenel's immense talent in another early show, devoted to the art of native Alaskans. In the works for several years, the concept had originated with René d'Harnoncourt,

the late director of the Museum of Modern Art, and had been sustained by Mitchell Wilder of the Amon Carter Museum in Fort Worth, Texas. While devoted to the indigenous arts of Alaska, the show could not be labeled as Alaskan, Parkhurst remembered, lest the other forty-nine states clamor for equal treatment.[26] So it was titled *The Art of the Far North*. Parkhurst found the original design proposal hopeless, confining viewers to a series of raised walkways. Ravenel proposed something both entirely different and far more elaborate. Seeking material that would enhance the installation, he discovered a ruined barn, whose weathered exterior seemed perfect for the gallery walls. Sepia-toned period photographs furthered the evocative tone. Setting things up took two months to accomplish. But the enthusiastic response convinced Brown and Parkhurst that they had made the right decision, and Ravenel's career as a nationally acclaimed installer was impressively launched.

The annual reports that Brown used so effectively now contained lengthy descriptions of Gallery installations and their logic, often accompanied by photographs. No other major American art museum devoted so much space to installation issues, or attempted to explain how argument and presentation fit together. At the center of all this was Ravenel, an ambitious impresario with a sometimes ungovernable temper (Parkhust would, in later years, expend much effort attempting to regulate his energies). He possessed, art historian and curator Kirk Varnedoe would recall in a memorial tribute, "the sensibility of a Mantegna Duke in the persona of an Ed Koren cartoon," "a temperament drawn hard and taut—an exacting demand for excellence, a high-strung nervous curiosity, a goadingly impatient intolerance for suffering fools benignly, a fierce temper, and a Borgia's appetite for court intrigue and palace politics." He was simultaneously "a dreaded tyrant and a pitiless enemy" and someone who "could be the most devoted and indulgent of friends."[27] Inside the Gallery, Ravenel was revered and feared, almost always admired for his undeniable gifts but not universally honored for his strategic judgment or self-control.

Brown's partnership with Ravenel was tempestuous and uneven but fundamental to his directorship. He gave Ravenel enormous power—which he occasionally tried to curb—and Ravenel did not hesitate to exercise it. With his soon-to-be wife, Frances (Franny) Smith, the future director of Gallery publications, Ravenel constituted a focus of energy and, some curators believed, created a separate kingdom within the Gallery,

subject to its own rules. Ravenel was far more than an interior designer; he met extensively with curators, did his own research to develop positions on proposed exhibitions, and threw himself into their planning and exposition. During the 1970s and 1980s Ravenel's was a decisive voice in choosing just which exhibitions the Gallery would host or initiate, and curators were, in essence, suppliants for his approval.

In Ravenel, Brown would find an intellectual partner and alter ego, though some curators felt him to be a prisoner of Ravenel's charm and believed he had ceded far too much authority. Brown did delight in constructing installation plans. "I happen to love installing," he told an interviewer. "I feel I know how to get the pictures to get along with each other and sing. It's problem solving . . . like playing multi-dimensional chess."[28] Brown admitted that he and Ravenel "would compete when we really got rolling, but gradually I got the idea that he could do it one step better, and he was given authority." Exhibition committee meetings were events Brown always enjoyed, decisive encounters reached only after preliminary blessings had been granted. There, curators from inside or outside the museum would make presentations (accompanied often by slide shows), exchange ideas, and develop arguments. Once approved, an exhibition would be "massaged" into the larger schedule. Brown and his staff had, he went on, "this extraordinary instrument to play, it was like the registration on an organ," and once the East Building had opened it was possible to think vertically as well as horizontally. Content was as much at stake as form. "It was showbiz to some extent," Brown admitted, "and we needed everybody's best instincts."[29]

Aside from Mellon's British pictures, in that first year, 1970–1971, Ravenel installed the largest American exhibition yet devoted to Albrecht Dürer, in celebration of his five hundredth birthday. Books, prints, and drawings were all part of *Dürer in America*, along with a section devoted to problems of connoisseurship. Deploying examples of different printmaking techniques, watermarks illuminated by light boxes, and instances of forgery and restoration, Ravenel moved the show beyond Dürer himself to considerations of authenticity and curatorial judgment. It further consolidated his reputation for brilliant innovation and particularly delighted Paul Mellon. "In my eleven years of association with him, I cannot remember ever seeing him more spontaneously pleased," Brown wrote his assistant director.[30]

In a very different mode, Ravenel's installation of *African Art in Motion*

attracted broad attention just a few years later. A version of the show, originated by Yale professor Robert Thompson, had been seen earlier at UCLA. A series of textiles, costumes, masks, sculptures, jewelry, dances, and musical extracts, all demonstrating the creativity of sub-Saharan Africa across time, were placed within a setting suggestive of their African birthplace. Ravenel was now assisted by lighting specialist George Sexton. Five mini theaters within the exhibition displayed films Thompson had made of African performances. The show, filling some fourteen galleries, ran for five months, but only after four months of installation. The usual activities attended the exhibition—a preview dinner of African food attended by, among others, first lady Betty Ford, an hour-long visit by former first lady Jackie Kennedy—but most commentators focused on the display.

Reviewers in several cities were rhapsodic in their compliments. Despite a run of recent shows on African art, the Gallery's presentation appeared to break new ground. "African art is action," wrote Paul Richard in the *Washington Post*, and "what sets this show apart is that it manages to evoke a unity that reaches far beyond the world of 'art,'" connecting, in some respects, to African-American performance in contemporary America.[31] John Russell, in the *New York Times*, singled out the filmmaking for praise. "Room after room is alive with music; carpeted bleachers are at our disposition for long looking and listening." The spectacle, he wrote, surpassed the visions of Sir Richard Burton and the Russian ballet impresario Sergei Diaghilev. Such liveliness and energy contrasted with quiet rooms displaying some of the finest pieces. The National Gallery "has ousted the 'museum look' in favor of an installation that abounds in nuances appropriate to the objects on view but keeps well clear of what might be called the 'thinking-man's Disneyland' approach."[32] John Canaday, also in the *Times*, pronounced it a "landmark exhibition" that "tells what African sculpture is all about—or, rather, *was* all about."[33]

These reviewers, and others like them, made special mention of Ravenel and his staff, emphasizing the centrality of his installation philosophy to the exhibition's success. "I get down before Gil [*sic*] Ravenel," curator Thompson declared, using a term common in sub-Saharan Africa to indicate respect.[34] Clearly the era of occasional, farmed-out, innocuously presented special exhibitions was over, as the Gallery transformed both its practices and its reputation in short order.

African Art in Motion was one of dozens of shows the Gallery's expanded

Department of Installation and Design installed in the 1970s and 1980s, sometimes as many as twelve or fifteen in a single year. Scale and elaborateness varied, but one constant feature was high expense. "They don't use pogo panels or thin plywood partitions at the National Gallery of Art," wrote Paul Richard in the *Washington Post*. Brown believed that even temporary shows "should have a look of permanence." When you come here to see Tut, Ravenel declared, "you are supposed to feel you're visiting the Valley of the Kings."[35] Maintenance and expansion of the department staff, acquisition of special materials, labor-intensive re-creations of exotic settings, painting, repainting, and wall moving—these ran up budgets far beyond earlier levels, and did so year after year. Brown could finance these operations only by turning to corporate sponsors, which the Gallery would do on a semipermanent basis starting in the 1970s. Sponsorship brought with it a range of benefits, for the exhibition itself was only part of the complex of spectacles that would soon be built into Gallery culture, spectacles that solidified political as well as corporate relationships. Quickly abandoning John Walker's understated approach to openings, Brown— with the active participation, in the early years, of Gill Ravanel, like himself a wine connoisseur and lover of good food— launched intricately managed social events in connection with the Gallery calendar. He concentrated energy (and expense) on lavish dinners planned around the inauguration of new exhibitions. In a capital where dressing up and partying were central parts of the public drama, the National Gallery soon established itself as a primary actor, a host given to extravagant, ego-soothing gestures that consistently attracted journalistic coverage and not infrequently became entwined with domestic politics and international diplomacy.

The first of these fabled events took place in February 1970, in association with an earlier African sculpture exhibition. Breaking with the traditional off-site, low-key luncheons or receptions, the National Gallery—in effect, Mr. and Mrs. Paul Mellon—hosted a dinner in the area of the West Building displaying the Widener china. Washington newspapers covered the event thoroughly, and Brown himself referred to it in later years as initiating a new era of hospitality. He "turned the gallery on its ear," according to a *Post* reporter, purposely "de-institutionalized" the setting, covering floors with carpets, replacing overhead lights with eye-level lamps, and even putting flowers in the ladies room."[36] An avid horticulturist, Bunny Mellon brought flowers directly from Virginia and

supervised the decorations. Lorraine Cooper, the wife of United States senator John Sherman Cooper, described the event for a Kentucky newspaper, marveling at the varieties of orchids (there were, according to other reports, six different kinds), the African daisies and anemones, the calla lilies and protea, set out on round, candlelit tables. The walls were covered with handwoven African cloth and the tables with cloths in an African print. The "china cabinets with the Widener China have mirrored backings," Cooper told her readers, "so the lights from the hundreds of tiny candles flickered back and forth." The guests were seated on painted blue and green chairs with yellow pillows belonging to the Mellons, brought directly from their Virginia farm.[37] Three different wines were served, and were still being recalled fondly weeks later by a *New York Times* interviewer.[38] Carter Brown was self-consciously breaking with the past. In late 1969 he wrote Douglas Dillon, president of the Metropolitan Museum of Art ("having trained there I have always harbored the most immense affection for it as an institution") that he was hoping to "swing a somewhat precedent shattering prospect" of hosting a dinner on the premises for the International Council of the Museum of Modern Art.[39] Though three years earlier Brown had told the *Times* that the Gallery didn't do food and drink, the April 1970 dinner for MoMA did indeed come off, and many extraordinary evenings would follow.[40]

Thus, in March 1973 the Mellons hosted an official dinner at the Gallery for the Russian minister of culture, Mme. Ekaterina Furtseva, to salute the arrival of forty-one impressionist and postimpressionist paintings from the Hermitage and Pushkin Museums. This, the first such loan exhibition to come from the Soviet Union to the United States, was grandfathered by oil tycoon Armand Hammer, a manipulative benefactor of several American museums but a good friend to Brown. The Gallery had little more than a month to prepare for the installation. Every "aspect of the preparation, from the Aeroflot landings at Kennedy International Airport" to the "uncrating and minute inspection by our curators and registrar," was covered by a camera crew. And a film, *On Loan from Russia: 41 French Masterpieces*, soon found its way to educational television."[41] Brown himself was interviewed by the *New Yorker*, an excited, stream-of-consciousness encounter that enabled him not only to express his enthusiasm for the paintings but to invoke memories of Paul Sachs, Bernard Berenson, and a visit to Russia in 1959.[42]

The Mellons determined to greet the Russian loan with a spectacular

dinner for seventy-five. Again, Bunny Mellon supervised the arrange-
ments, covering the tables now with red cloths, and placing on them bas-
kets of spring flowers, white tulips, red poppies, sheaves of wheat, and
peach blossoms. "I wanted to make it look like springtime in Moscow,"
she told reporters from the *Washington Post*.[43] The baskets of wheat and
poppies were also, according to one staff member, meant to evoke the
Ukraine.[44]

Food, drink, and flowers were not the only attractions. Richard
Bales conducted the Gallery Orchestra in the Palm Court, where Brown
turned the lights out, leaving only a single, specially installed moonbeam
hanging from the high ceiling. Politicians, diplomats, cabinet officers,
and wealthy art lovers mingled at this, the first of three separate evening
receptions (the second was devoted to members of Congress and their
families). Henry Kissinger, reveling in his rock star–like celebrity, traded
jokes (and barbs) with Mme. Furtseva, senior senators of both parties ex-
changed anecdotes, and art lovers crowded in to see the show. Betty Beale,
a society reporter in Washington, declared that the preview drew "the
kind of staggering Dun and Bradstreet crowd we're not used to in Wash-
ington." The Mellons, Whitneys, Becks, and Carters helped make up, in
Brown's words, "a glittering group from a variety of worlds—a smorgas-
bord of all aspects of what makes Washington life glitter."[45] The event
highlighted the Gallery's special status within Washington itself, and its
role helping to shape the modest thaw in Soviet-American relations.

There was also a price to be paid for the Gallery's increasing involve-
ment in foreign policy. This became clear in the last days of 1974 with the
Archaeological Finds of the People's Republic of China. Proposals to include the
United States in an international tour for the spectacular artifacts from
a Han Dynasty tomb had begun, according to Brown, in 1971—before
Nixon's visit to China, at a time when the United States and the People's
Republic had no diplomatic relations. The Gallery had turned to British
officials for help in promoting its cause. But once the president visited
Beijing in January 1972, new possibilities opened up and Washington was
quickly added to the tour. Discussions were aided by the fact that the
head of the United States Liaison Office with China, the first American
envoy to the People's Republic, was David Bruce, a former trustee, Gal-
lery benefactor, and Mellon's confidant and onetime brother-in-law. As
in many other cases, Gallery interests were well served by carefully cul-
tivated diplomatic contacts. The year before, a sympathetic ambassador,

John Irwin, had brightened the prospects for bringing the de la Tour out of France.

The Chinese archaeological relics presented a daunting challenge to Gallery staff. They would occupy eighteen thousand square feet, more than any previous temporary exhibition at the Gallery. Nonetheless, the exhibition was readied for viewing, and a small dinner, hosted by the Mellons, planned for its opening. But the Chinese suddenly raised an unexpected obstacle. The Gallery had invited the Washington press corps for a viewing of the show, its normal practice. The Chinese objected forcefully to the presence of any journalists from Taiwan, South Korea, South Africa, or Israel, demanding assurances that they would be barred from the event. The Gallery refused, and at 1 a.m., after frantic discussions with the State Department and just hours before the showing, it canceled the preview.[46]

The local press was exercised, but the story now drew national attention. A number of dinner guests declined to attend, including Katherine Graham, publisher of the *Washington Post*, Margaret Truman Daniel, daughter of the former president, and representatives of the *New York Times*. But most of the invitees, including some publishers, came, and the mini boycott was just that. Editorialists, however, wondered whether the National Gallery should cancel the entire exhibition, and what kind of signal doing so would send to the Chinese. The *Washington Post* endorsed the Gallery's canceling of the preview but, on learning that the State Department had agreed to give the Chinese some voice in museum arrangements, asked that every detail of the agreement be made public.[47] The State Department denied it had "knuckled under," insisting that the Sino-American understanding permitted a "double veto."[48]

The controversy allowed some Americans, still nervous about the Chinese détente, to attack proverbially weak-kneed diplomats and flay any efforts at compromise. Tom Dowling, in the *Washington Star*, swiped at the "beaming, toothy" Chinese functionaries, then suggested there were three choices: to tell the Chinese to "buzz off," to capitulate meekly, or to cancel the viewing. This last "was, of course, the most paltry, most sniveling, most weasel-like choice available. Naturally it was taken."[49]

While few other newspapers went as far as the *Star*, some did express indignation. "If it was a case of bluffing," declared the *Wilmington Evening Journal*, "the Chinese won and the U.S. lost. If it was a case of sending a signal, the Chinese stirred up a storm instead. If it was a case of scor-

ing a point, the Chinese did it without endangering anything." The *Richmond Post-Dispatch* wrote, "The government of the People's Republic of China deserves first prize for official cheek." The *Portland Telegraph* in Maine pronounced the Chinese "rude and stupid," and the *Boston Herald*, while praising the Gallery for canceling the preview—"these executives deserve a medal"—labeled the Chinese government's actions sinister and absurd. William Buckley asked why the State Department didn't simply close the exhibit and tell the Chinese to ship their treasures home "until they can suppress their vulgar taste for making political points."[50]

The political flap, which may have temporarily embarrassed Gallery officials (Brown was out of town at its height), did not affect the huge attendance, nor the enthusiastic, if occasionally guarded, response to the installation. Hilton Kramer, noting the enormous success the exhibition had already enjoyed in Europe, had warm but qualified praise for the National Gallery, which had scored, he argued, "a coup of its own—at times, even too much of a coup"—in the "dazzling installation designed by Gaillard Ravenel and George Sexton. There is no suggestion of proletarian starkness here. Every object is enclosed in an atmosphere of glamour and high gloss." Each piece in the show, even the smallest, enjoyed maximum visibility. But it was also an installation in which "almost anything—an old sneaker or a paper bag—would look exotic and 'esthetic.'" The error was "overbeautifying," Kramer concluded, noting the enveloping air of contention that itself reflected ambivalent attitudes toward Maoist China.[51]

Paul Richard in the *Washington Post* echoed Kramer's admiration, and with fewer qualifications. The show was "classy, not classless," quipped the review's headline, the installation exuding "restrained yet sumptuous elegance." "The carpeting is thick, the lighting is ideal, the color scheme is subtle, the detailing is flawless." "Paul Mellon Presents China" was Richard's suggestion for an overall label. Ravenel and Sexton had spent months preparing, but the effort had paid off. The handmade cases, curving sheetrock walls, and yards of velvet and silk rendered a tribute of their own to the relics—"the most beautiful objects we've ever had to work with," he quoted Ravenel as saying."[52] The extensive publicity generated by the controversy certainly did not hurt. When the exhibition closed on March 30, 1975, the Gallery reported that 670,000 visitors had seen it, a record (thus far) for a temporary show.

Brown had managed effective damage control, and the very public

Chinese imbroglio turned out to be unique. But it demonstrated the possibilities for embarassment such ventures could raise, particularly with the Gallery's congressional neighbors, ever sensitive to signs of voter indignation. The potential crisis had been defused by skillful compromise, further evidence of Brown's charmed relationship with the press, and eclipsed by the splendor of the objects on display.

Within months, the Gallery hosted another détente show, and again, Armand Hammer's intervention was crucial. This time the Russians sent some thirty old masters, as well as thirteen paintings by Russian artists. Negotiations over just which art pieces to include consumed many weeks. Cranach, Rubens, Cézanne, Picasso, Chardin, Caravaggio, and above all Rembrandt were represented. In return, American museums, including the National Gallery, agreed to lend some of their own old masters, and other Western canvases, to Russia.

Master Paintings from the Hermitage and State Russian Museum Leningrad opened the Gallery's 1975 summer season with another elaborate Mellon dinner. Brown called the show an "impossible dream" and told reporters he almost "fainted" with excitement upon learning that the Russians were thinking of allowing the Caravaggio to travel. By the end of August, attendance had hit two hundred thousand. To get in, John Russell wrote in the *Los Angeles Times*, "you have to be either a friend of the director or a dwarf on rollerskates."[53] Museum visiting, once believed to be a "solitary, ruminative activity," had become a "giddy, collective, other-directed affair." The long waits to get into the Gallery reflected the fact that many of the pictures were virtually unknown known in America.

The string of spectacular exhibitions, the generosity of donors like Paul Mellon and Averell Harriman, and the progress of the East Building construction all nourished the swelling reputation of the Gallery and of Brown's directorship. Katherine Kuh, a veteran curator at the Art Institute of Chicago, now writing art criticism for the *Saturday Review*, was an early admirer. Covering the exhibition *Rodin Drawings—True and False*, in late 1971, she extolled the novelty of its juxtaposing real and counterfeit work. "I stayed to applaud the exhibition and to admire certain innovations the National Gallery of Art is making under its able new director, J. Carter Brown," she confessed. It was rather unusual to encounter "a museum concerned not with programs geared to the latest gimmicks, not to pseudo-sociology, not to fun and education, but to scholarship, preser-

vation, and learning, none of which makes headlines but does, indeed, make sense."[54] Kuh's review, written relatively early in Brown's tenure, before the full force of the Ravenel installations and the blockbuster era had taken hold, suggests the sympathetic attention Brown was getting even then from professional insiders.

Other journalists were also quite supportive. Frank Getlein of the *Washington Star*, a sometime critic of Gallery activities, nonetheless found himself praising Brown's administration in a spring 1973 booster piece for the *Washingtonian*. Aside from its actual accomplishments, the National Gallery was to be commended for what was not happening there. Director Tom Hoving had "let the Metropolitan reel from scandal to scandal, so much so that the museum's vicissitudes have constituted a running story on the bottom of the *Times* front page." By contrast, "the National Gallery has continued in equanimity and serenity, enhancing its collections by an occasional spectacular purchase, re-assessing its holdings as necessary, steadily improving the position implied in its name." We are, Getlein concluded, "no longer the old cultural wasteland now hardly remembered, but the true leader, number one."[55]

Hoving's administration, as Getlein suggested, was confronting almost daily press attacks by the mid mid-1970s, centered upon deaccessioning and failures to obey conditions set in gifts and legacies. Few critics focused upon the Met's temporary exhibition schedule. Still, the National Gallery's success in winning the great Chinese and Egyptian shows of the 1970s rankled Met administrators. Interviewed while the Chinese exhibition was still drawing crowds to the Gallery, Hoving recalled his own efforts. Only weeks after the People's Republic had been seated by the United Nations, he was in touch with Chinese officials visiting the Met, telling them he understood that Chinese museums had been badly damaged by the Cultural Revolution. When they denied it, he suggested they prove it by sending some of their art to the United States. High-level negotiations, aided by Hoving's close relationship with Nelson Rockefeller, soon followed, but when an exhibition was finally arranged, the Metropolitan was not on the list of venues.

Washingtonians' nagging sense of cultural inferiority to New York was, in the 1970s, lightened by this and a series of other heartening developments: a revived theatrical scene, the success of the new Kennedy Center, revved-up planning for the coming bicentennial, new construction, new restaurants, new hotels, and an increasingly respectable local

art scene. Washington, in 1968, welcomed almost seventeen million out-of-town visitors. This was expected to swell to more than twenty-five million in 1976, for the bicentennial.[56]

While New York's troubles cheered some Washington boosters, competition did not preclude collaboration, and National Gallery officers sought to avoid confrontations. At the very end of 1969 Brown noted a conversation with Paul Mellon about the Lehman collection and the possibility of landing it for Washington. "His feeling is that if cranked into our new building it might get us in over our heads. He also felt that he did not want us to end up in a battle with the Metropolitan. He felt that if there was an opportunity at a later time, it would of course be a marvelous thing for the Gallery."[57] Robert Lehman's collection would end up in the Metropolitan, one of Hoving's proudest accomplishments.

Beyond simply avoiding conflict, Brown cooperated with the Metropolitan Museum when he could. He congratulated Hoving on the Met's 1970 centennial, which he felt was carried off "brilliantly": "For any art museum or art subject to be on the front page of the *New York Times* two days in a row must be some kind of first."[58] The two did have a slightly testy exchange when Hoving asked I. M. Pei to testify on behalf of his museum's expansion. Brown wanted Pei not to do so, since he was deeply into the East Building work at this point. But Hoving persisted, seeking to harness Pei's prestige for the Met's cause. In the end, after some debates about etiquette, Brown withdrew his objection so long as Pei made no reference to the National Gallery's expansion. Hoving, he noted in a memorandum for the record, had proposed that the two institutions help each other and, having secured Pei's testimony, "Tom said they now owed us one."[59] Brown himself traveled to New York's city hall to offer his own supportive testimony.[60]

A couple of years later, in response to another Hoving request, Brown sent on an endorsement of the Met's search for construction money from New York City in aid of the American Wing. Carter claimed that more than educational and aesthetic reasons argued for such an appropriation; there was a dollar value also, "bringing in visitors as well as all manner of design professionals."[61]

Deaccessioning, the cause of some of the Met's scandals, did not trouble the National Gallery. There simply wasn't any. The Gallery never sold or traded artworks. This reflected both Andrew Mellon's intention and the fact that everything was held in trust for the people of the United

States. Mellon's original gift mandated accepting only art of a quality commensurate with his own, and the early gifts from Joseph Widener and Samuel Kress fit within this criterion. Through selective acquisition and masterpiece gifts from the Mellon family, this level was maintained. Chester Dale's pictures also had to be retained and, moreover, could never be lent.

But as at other museums, the collections offered by eager donors were of uneven quality, and the Gallery had to make decisions. Here its national outreach became crucial. The National Gallery would contain, in essence, two collections, one on view in Washington, the other made available to institutions elsewhere. This was another innovation of the Brown years. The National Lending Service was created in 1972, partly in response to a gift of paintings from the Harriman Foundation.[62] The lending collection included a broad mix: a few old masters, some eighteenth- and nineteenth-century American works (including the Garbisch collection), a group of 351 George Catlin paintings of American Indians given by Paul Mellon, and many twentieth-century pieces. Participating borrowers, according to National Gallery rules, would have to meet specific standards for environmental controls, promise to exhibit the objects continuously, and pay for packing, transport, and insurance.

The American paintings being transferred to the National Lending Service "are none of our best pictures," Charles Parkhurst wrote in a draft description of the program. We would "never hang them on the main floor of the Gallery." Presumably to reassure the trustees, he also noted that "despite their aesthetic shortcomings," they would "represent the Gallery favorably."[63] Some of this language, which could be taken as patronizing, was excised from the final printed description, the text of which was still being manicured in 1973. By 1977 perhaps two hundred paintings were being lent, many of them to embassies, to universities, to Supreme Court justices. By 1984 there were a thousand items in the collection.

The Lending Service was important both for itself, and for dramatizing the Gallery's broader public mission, something officials were at pains to do again and again. A memorandum of January 1971, not long before creation of the Lending Service, emphasized the significance of extension and publication services; their obvious value, at a time of federal cutbacks, was meant to justify to both Congress and the larger public the expansion of space and staff that the projected East Building repre-

sented. Even an enlarged cafeteria was framed as an expansion of public services.[64]

During the early years of Brown's directorship, under the Nixon and Ford administrations, American museums were encountering the costs of popularity amid continuing national skepticism about the validity of public subsidies. The financial impact of higher maintenance and security levels, inflation, and militant demands for more inclusive and more didactic programming was clear by the start of the 1970s. It became customary to comment upon the troubled passage of art museums from "playthings of the wealthy and well educated," supported by generous donors and predictable endowment income, to a harried and pressure-ridden, day-to-day existence. Some museums had begun to reduce or eliminate free days; others were closing galleries several days a week. Many, almost half the membership of the American Association of Museums, were running deficits. Traditional services—library usage, free curatorial appraisals, educational programs—faced elimination. And some museum directors found themselves abruptly fired or forced to resign—in New York at the Museum of Modern Art, at Syracuse's Everson Museum, at the Museum of Fine Arts in Boston.[65] Congressional leaders, notably Representative Frank Thompson of New Jersey, were already talking about a new agency that would devote its resources to supporting museum operations. While Brown became involved in its planning, the Institute of Museum Services would not become a reality until the late 1970s, and then with a budget of modest proportions.

In this difficult period, the steady success of the National Gallery was the more impressive. Each year under Brown, attendance grew; each year the federal subsidy increased; each year more fabulous visiting exhibitions found their way to Washington, validating the city's claims to cosmopolitanism and its search for national and international respect. Such gains were neither accidental nor coincidental but resulted from careful planning and attention to detail, particularly when it came to congressional appropriations.

The triumphant tone, and a sudden, overwhelmingly positive media spin, were already clearly in evidence during the first months of Brown's tenure. They were, moreover, strengthened by an experience that was destined to leave its mark on his personal ambitions as well as his administrative record. And that was the hosting of Kenneth Clark's enormously popular television series, *Civilisation: A Personal View*. Sir Kenneth Clark

was an internationally known art historian, a prodigy who had assumed directorship of London's National Gallery in 1934, at the age of thirty.[66] After eleven years as director, Clark turned to writing and lecturing, producing a series of well-received scholarly texts. Some hailed him as the most influential voice on behalf of the fine arts since John Ruskin's day, almost a century earlier.

It was during the 1960s, at about the time Brown was creating his own prizewinning film documentaries for the National Gallery, that Clark discovered the potential of television. His presentation of *Is Art Necessary?* made him into something of a media celebrity. The BBC, eager to exploit its recent switch to color broadcasting, proposed a series with film producer Michael Gill. Clark began writing in late 1966, and production consumed almost three years. The upshot was the pathbreaking series *Civilisation* (in the United States, *Civilization*), one of the most celebrated documentaries in the history of television.

Civilisation aired in Britain in 1969. Its thirteen episodes, shot at some one hundred locations in thirteen different countries, had cost more than half a million pounds to produce. Clark won over most academic critics as easily as he seduced a popular market, and he accepted elevation to the peerage in recognition of his accomplishments. The jubilant reception of *Civilisation* attracted American attention, and Brown's friends in Britain were soon rhapsodizing over its impact.

Brown himself had known about it even before production began, thanks to his friendship with Ann Turner, one of the series' directors, and they commiserated when no sponsor would commit to broadcasting *Civilisation* in America.[67] Clark's ties with the National Gallery went back to its earliest days; he recalled working with Andrew Mellon and others on its "constitution" in the 1930s.[68] He had also served as one of its first Mellon Lecturers. In later years, Clark maintained a correspondence with John Walker, sharing memories of Bernard Berenson, discussing attributions, and probing other areas of common interest. In 1960 Walker floated the idea of Clark's doing a book centering on the Gallery's paintings.[69] Nothing came of this, although Clark became a frequent visitor, usually staying at the home of former director David Finley.

Clark and Brown had also been in touch. In the fall of 1968 Brown wrote a lengthy memo regarding a Clark visit to Washington, recording his comments on various paintings. Impressed by some new Guardis, excited by George Stubbs's *Lion Attacking a Horse*, and vigorously endors-

ing the Leonardo *Ginevra*—a good buy, whatever the price, he told an obviously pleased Brown—Clark also singled out other things he didn't particularly like (the sculptures in the rotunda) or thought needed cleaning.[70] Six months later, in London, Brown wrote Clark that he would love to see him.[71]

Thus, when *Civilisation* began its British run, the National Gallery was well positioned to act. It did so. There would be competition. Lacking sponsorship, *Civilisation* could not yet be shown on American television; it could be seen only as a set of thirteen films. By prearrangement, the American premiere was to be in New York City's Town Hall, where the Metropolitan Museum of Art and New York University would serve as joint sponsors. This was planned for late October 1969. The Met would host some black-tie receptions in advance of the October 28 showing, and NYU present Clark with an honorary degree. The National Gallery was to handle the Washington premiere.

In September, however, Dillon Ripley, unaware of these arrangements, wrote to Leonard Miall, the BBC American representative, proposing a series of showings at the Smithsonian Institution, "perhaps the world's leading Anglo-American institution." He offered "a small, select American premiere" with all thirteen hours presented on several successive nights. This "would be a major cultural event attended by an invited audience and accompanied by an appropriate ceremony and public attention." The evenings would unveil a "notable work of art" to an influential cross section of the capital, including perhaps, Ripley hinted, the president and his cabinet. Such exposure could only bolster the case for network transcription and eventual sponsorship.[72]

Miall's reply was delicately worded. Arrangements had already been made, he pointed out, both in New York and Washington, for public showings of the series. The details had been worked out, commitments made, and the films would be presented, serially, some time in the autumn, at the National Gallery. Concluding his remarks, Miall suggested that "in view of the National Gallery's close connection with the Smithsonian Institution I hope that there is some way in which they can avail themselves of your good offices in making the event the total success it ought to be."[73]

Ripley put the best face he could on the situation. He wrote Miall that the National Gallery and the Smithsonian "are jointly moving ahead" with plans for the showing, a letter he copied to William Howard Ad-

ams, the recently appointed director of the Gallery's extension service. Someone in the National Gallery inked a large exclamation point in the margin of Ripley's letter, perhaps an expression of incredulity.[74] In any event, Ripley admitted no disappointment and invited Clark to a Smithsonian dinner.[75]

Others, however, played up the National Gallery's triumph. The *Daily Telegraph* ran a piece declaring that the decision was "a particular victory for the Washington National Gallery over its equally genteel long-term rival in the art world, the Smithsonian Institution, which bid too late."[76] It took note of recent tensions between the two and suggested that some Gallery trustees were trying to make it autonomous. It ended by echoing the BBC's hope that cooperation would ensure a "total success."

Writing to Clark in October (formally addressing him as Lord Clark, in recognition of his recent honor), Brown hoped he would be present for the October 27 premiere. Responding a day later, Clark declared it was a "great pleasure to get a letter signed from you over the word 'Director.'" "I had always hoped and assumed this would happen," he went on, "but, in fact, had not been told about it. You must have nearly beaten my record at the National Gallery in London, but as you are far more mature and experienced than I was when I became Director, I hope that you will not have the same troubles."[77] Setting up a schedule for Clark turned out to be complex—Brown referred, in a letter to David Finley, to "the daily bulletin on l'affaire Clark"—but arrangements were at last formalized.[78] Clark would appear at the Gallery on November 22, a Saturday afternoon, in the interval between two films, and say a few words to the audience. "This would I know give our National Gallery a boost, not to mention the possible future of the films on American T.V."[79] The two would lunch together before the event.

The actual screenings, when they occurred, produced a local sensation. The original plan was to hold them only on Sundays, but this soon changed. William Howard Adams, placed in charge, sent off a summary of early impressions.[80] On Sunday, November 9, during the second weekend of showings, he wrote, crowds were gathering by 10 a.m. to collect tickets for the afternoon. By noon, despite a rain storm, the line stretched for blocks. Estimates had ten thousand seeking admission. "We haven't seen crowds like this since the Mona Lisa was here," one Gallery staff member commented.[81] Given this turnout, Adams decided to offer six sequential screenings of just one of the films. The tickets were all snapped

up before 2 p.m., even with the extra screenings. Clark's visit, two weeks later, added considerable zest to the whole and was choreographed for maximum value. Lunch at the F Street Club, with invited guests, was accompanied by special tickets for the showing. Gallery cars were available to take the guests to prearranged spots where they were guided onto special lines. "This may be the most complicated afternoon in the history of the National Gallery of Art," Brown announced.[82]

Almost a year later, Brown offered Clark some further details of the phenomenon. Attendance at the Gallery had skyrocketed because of the film series. The first Sunday night the series was on offer, instead of the normal daily attendance of four or five thousand, there were twenty thousand visitors. Crowding in the galleries outside the auditorium was close to "panic level," Brown reported. Going on "Red Alert," the film exhibition was pushed to the limit for thirteen weeks, with the original plans for Sunday-only showings abandoned in favor of almost continuous performances every day.[83]

Soon afterward the Gallery launched an appeal to purchase its own copy of *Civilisation*. The set of 35-millimeter prints was priced at ten thousand dollars. An enthusiastic public contributed fifteen thousand dollars, according to newspapers, a figure Brown raised to twenty-five thousand when writing Clark.[84] In 1970 a summer series of *Civilisation* viewings began, with all thirteen films shown over the course of each week. To kick it off, a reception for a thousand student interns featured a rock and roll band. It was a "Never Trust Anyone Over 30 party," Brown declared. This raised some eyebrows among Gallery trustees, he confessed, but the press was wild about it. The place was "a sea of throbbing young bodies, in everything from tie-die togas to lace pajamas," wrote Toni House in the *Washington Star*, June 29, 1970.[85] Some hinted that a light show might be next. "What hath Brown wrought?" House asked. *Civilisation* showings were then doubled.

In all, some 250,000 people saw the films in the Gallery auditorium during that first year. And museum visitation increased by more than 50 percent, to just under two million. In this, Brown's first fiscal year as director, *Civilisation* proved to be an phenomenal asset, and he expressed his gratitude to Clark in a variety of ways.

There were other indications of extraordinary interest and demand. Indeed, there was something of a frenzy. In this Cold War period, the CIA sponsored its own screenings, and the staff at the American embassy in

Moscow requested (and received) their own presentation. The State Department borrowed the films and showed them to overflow crowds every lunch hour. The United States Senate requested a loan, and the Newport Music Festival, in Brown's home state of Rhode Island, held a marathon screening with all thirteen episodes shown back to back. The National Gallery lent out prints to public libraries in the greater Washington area. Clark himself appeared on *Meet the Press*, endured interviews with a series of major newspapers, and saw extracts from the series' companion book printed in a number of periodicals.

The National Gallery went on to arrange for loans of the films through its extension service. Time-Life, the distributor, was nervous about free loans, but when Xerox and the National Endowment for the Arts agreed to underwrite the program—after Xerox purchased the rights to televise the series for half a million dollars—it agreed. Colleges with fewer than two thousand students were eligible and able to show the films not only to their own students but to local communities as well.

In October 1970, almost a year after the initial American showings, Clark returned to Washington, partly to celebrate the college distribution program, but more significantly to receive from Brown's hand the National Gallery's medal for service to education. It had been awarded only once before, and the ceremony produced a dramatic public tribute. Clark called it "the most terrible experience of my life."[86] Brown advised him to walk the length of the museum before receiving the medal. "All the galleries were crammed full of people who stood up and roared at me, waving their hands and stretching them out towards me." Weeks later, he wrote Brown that it was upsetting rather than exhilarating, that he "felt like a man who is supposed to be a doctor, walking through a crowd of earthquake victims who are appealing to him for medical supplies."[87] He had not foreseen such a demonstration of affection, and, as he later wrote Brown, what "disturbed me so much at the National Gallery was partly the physical impact of a crowd of admirers, and partly the fear that I would burst into tears on the platform and be unable to speak."[88] Celebrity itself was nothing new to Clark, but the scale and intensity of the American response jarred him into a sense of inadequacy. "It simply made me feel a hoax."[89]

Critics, reviewers, professional pundits, and scholars analyzed the *Civilisation* phenomenon with breathless intensity. For some, the series itself demonstrated the redemptive capacities of the popular arts, reaching

millions with the best that high culture had to offer. Films and television, reviled so easily by eggheads and academe, were agents of enlightenment in the hands of masters like Kenneth Clark and his BBC directors. Certainly there were doubters, reviewers who grumbled that the series was a "moving coffee-table book," "potted culture," projecting, in William Woods's words, "an illusory sense of wisdom."[90] But they were minority voices; canonizing Clark and the BBC hardly seemed too large a gesture.

As witness to, beneficiary, and promoter of Clark's triumph, Brown expressed his admiration. A tireless crusader on behalf of art, his optimism about the future of civilization was less qualified than Clark's, and far less restrictive about its past accomplishments. But as a filmmaker himself, and a seeker of bully pulpits, he was deeply impressed by the immense success of the enterprise and soon was admitting Clark into a relationship of great intimacy. Despite continuing to address him in formal terms (Clark eventually wrote asking Brown to call him "K"), the young director began inviting Clark to events like his second wedding, in London, and, some years later, the christening of his first child. Clark was, he said, a member of his "spiritual family."[91] Clark, whose health was declining during the 1970s, gamely accepted as many of these invitations as possible, but illnesses prevented him from doing as much as he wished.

Despite their differences in age, both Brown and Clark took new wives in the 1970s. Clark's was a second marriage, and Brown got married twice. It was a decade of considerable personal turbulence for Brown, which he shielded as much as possible from public view, although some publicity was inevitable. By the early 1970s Brown was entrenched as a favorite subject for Washington gossip and society columnists. Rich, good looking, well born, and articulate, he was one of the city's most eligible bachelors and a favored dinner guest at the most exclusive—and best reported—parties. Interviewers were usually charmed by his wit and impressed by his erudition; when hints at amorous attachments were added, the combination became irresistible. His tastes—in food, furnishings, and music, as well as art—attracted continuing attention.

Especially in the period immediately following his appointment as director, Brown did little to discourage press interest, accepting it as a helpful instrument for promoting the Gallery among nontraditional audiences. Treated a bit like a film star by the worshipful press corps—some likened him to Leslie Howard or Van Cliburn, others to a young Charlton Heston—he became skillful at exploiting this coverage. Reporting

on a 1973 opening at the Gallery, this one featuring modern American art, Henry Mitchell observed that "Brown, the Gallery's director, was receiving compliments as usual for his brief and non-ponderous remarks about the glories of art."[92] Critics and celebrities alike showered accolades, and Peter Duchin's orchestra played.

Opening nights, cocktail parties, banquets, balls, benefits, previews, excursions—all enjoyed his presence. And almost everything was covered by the press. Maxine Cheshire, the syndicated society columnist for the *Washington Post*, reported that Brown sat for four hours in a parked Rolls-Royce waiting to alight for a thirty-second scene, as an extra, during the filming of *The Exorcist*.[93] Reporters spoke reverently of "talent, wealth, breeding," and then sought to humanize the young Brown by endowing him with wholesome heterosexual interests. "Dapper," "slender," "intense," "elegant," "youthful," "charming"—happy adjectives jostled one another in most newspaper accounts. He likes living in Washington, John Dorsey told readers of the *Baltimore Sun*, because there was "always a new batch of debutantes coming along." On a "stroll through the gallery his head is turned more often by a short skirt than by a long El Greco."[94] While he often lunched with guests in his private dining room, Brown admitted to "enjoying meals in the cafeteria, sometimes to talk to the girls and check on the sales desk."[95]

Inevitably, however, there were questions about when the young director would marry and settle down, a classic issue for bachelor celebrities. Brown had long reaped the advantages of his apparently freewheeling lifestyle, but now he was pressed about his domestic future. Typically, he sought to deflect questions with humor. The men in his family, he told a *New York Times* interviewer, tended to marry late.[96] There had been, in fact, numerous attachments during these years; some young women had even been taken home to meet the family, but none had passed the test. The Browns up close, Anne Brown in particular, were a formidable group, and Brown seemed reluctant either to make a commitment or defend his preferences with any vigor.

But at the age of thirty-six, in February 1971, Brown abandoned bachelorhood in favor of an engagement to Constance Mellon Byers. The foster child of Constance and Richard King Mellon, Paul Mellon's cousin, Byers had been married twice before (to the same person) and had two young children. She lived comfortably, even extravagantly, in a showcase home decorated by Sister Parrish on fashionable Kalorama Circle

in Washington. Her personal wealth and beauty brought access to the city's highest social circles. She was seen (and photographed) frequently at society events, sometimes in close proximity to Carter Brown.[97] Connie Byers also supported various philanthropies, including the Corcoran Museum of Art (which made her a trustee) and the National Trust.[98]

Despite the riches, social standing, and famous name Connie Byers brought with her, the marriage was not greeted enthusiastically by all members of Brown's own family. While Anne Brown pushed it forward, impressed by Mellon wealth, others were somewhat dismayed by the two earlier marriages, her tastes, and her lifestyle. Both W. Russell Byers, her former husband, and Paul Mellon advised Brown against the match, in strong terms, although Byers also offered his congratulations.[99] Despite one postponement, the marriage took place in June 1971, at Ligonier, Pennsylvania, near Pittsburgh, a Mellon family stronghold.[100] Brown sold his Reservoir Road house for an impressive sum and moved to Kalorama Circle. He apparently adored the two children and enjoyed the idea of an instant family.

The press managed the transition, covering the couple where once the focus had been solely on Brown. NBC photographed them for a television vignette when they were visiting Baron Philippe de Rothschild.[101] Constance Mellon Byers Brown offered *Washington Post* readers the secrets of successful entertaining in early 1973. She preferred no more than eight to dinner, she confided, but her Chippendale table stretched to twelve. More than twenty-two meant a buffet. A full-time cook and a serving couple were usually sufficient. Difficult foods should not be served to beautifully dressed people, so there was no game at fancy parties, except for pheasant and duck. The Browns hosted dinners at least twice a week. On Sundays their Chinese cook prepared a Chinese lunch, which was consumed with chopsticks. She and Brown considered entertaining an art form, and she never planned a menu without his advice.[102]

The opulence was real but the glamour increasingly manufactured. The marriage lasted only two years. Brown's new wife, as he had been told, was neurotic and high-strung, and she resented his all-consuming devotion to work. Their relationship quickly deteriorated. In effect, he was dismissed and thrown out. By 1975, after a divorce, he had resumed a bachelor persona, setting up house in a carefully decorated flat he rented at the Watergate apartment complex. The press seemed as interested as ever in his social life but moved little beyond reports of party sightings

and sailing outings. Most reporters don't try to "get" Brown, wrote a commentator some years later in the *Washington Star*. He and his family were "treated with a kind of hush, like American royalty."[103] To judge from correspondence he remained on friendly terms with his former wife, who would face a series of health problems in the years of life remaining to her. She died in 1983, at the age of forty-one.

During the 1960s and 1970s prominent public figures enjoyed far more privacy than they would in later decades. Rumors may have swirled about would-be scandals, but the mainstream press did not usually report their details.[104] Beyond a simple mention, no *Washington Post* reporter or columnist discussed the Brown divorce or speculated on its origins. Reality shows and blogging lay far in the future. Insulated from prying eyes, politicians and celebrities—at least those outside Hollywood—could indulge their tastes and needs without much fear of unwelcome attention.

During the two years of his increasingly troubled marriage, Brown remained focused upon his work at the Gallery. His capacity for making decisions, absorbing details, and thinking strategically and tactically did not seem to suffer from these distractions. He demonstrated an astounding appetite for work, impressing colleagues with the stuffed briefcases that he carried to and from his office—that is, when he was in town.

Brown would not remain alone for very long after his divorce. A little over two years later, in 1976, he remarried. His new wife was Pamela Braga Drexel, the previously married daughter of a wealthy Cuban sugar broker, with homes in New Jersey and London. The wedding, noted briefly in *Time*, took place in the Henry VII chapel of Westminster Abbey during a quick trip to England.[105] Within the next few years the couple had two children, John Carter Brown IV, known as Jay, and Elissa Lucinda Brown. Brown lost no opportunity to write or talk about their accomplishments. By all accounts, a doting father in the time he made available to them, he suffered through the serious illness of his son, and as the children grew older he tried to instill in them his love of art. Brought up by a formidable and locally celebrated governess, Harriette Grant, they enjoyed special events and invitations. But given Brown's travel schedule, social life, and total absorption with the National Gallery, the time he made available was limited. A ferocious work ethic and competitive passions permitted no real distractions from the professional goals that continued to energize him. His family life, and his marriage, would bear some of the costs.

Presenting King Tut

W hatever dazzling exhibitions had gone before, 1976 remains a banner year in Carter Brown's directorship of the National Gallery. It was also an important moment for the burgeoning fortunes of the American art museum more generally.

The bicentennial of national independence would be celebrated quite differently than had the centennial in 1876. Despite intensive lobbying and elaborate planning, Philadelphia would host no great exposition, as it had a century earlier.[1] Seattle and New Orleans notwithstanding, world's fairs were increasingly seen as costly anachronisms, authoritarian, corporate-driven opportunities for political corruption, as well as dangers to public budgets. There was early talk of producing some sort of national exposition, but it foundered, wrecked on the shoals of partisanship and division. Instead a considerably more decentralized, less formal, more populist series of observances and celebrations took place. State bicentennial commissions were established across the country and millions of dollars spent on a bewildering variety of activities.[2] Their mixed quality disappointed some even while reassuring others, self-conscious about federal authority in the wake of Vietnam and Watergate.

Over the previous hundred years, cultural institutions had flowered to the point where they could host and organize anniversary celebrations, without dependence upon temporary, centralized expositions. And local communities teemed with vernacular projects. Concerts, symposia, reenactments, pageants, tours, landscaping projects, guidebooks, operas, publications, festivals, state visits, family excursions, and maritime

displays all developed variations on the official themes. Some manifestations were admittedly bizarre, if not actually loopy. And there were some serious centerpieces. A "Freedom Train" filled with historic treasures from the National Archives toured the country, while a parade of sailing ships—the tall ships—from around the world visited American ports, to popular delight. Nonetheless, the organizational logic of the bicentennial celebration was dominated by decentralized diversity and illuminated by facile and sometimes self-deprecating touches. Within this broad and immensely varied set of activities, the art and history museums of the United States, with the help of the relatively new national endowments, presented a series of didactic exhibitions, underscoring, heavily or lightly, the larger national story.[3]

Washington museums, along with other area organizations and federal departments, were particularly active in this effort.[4] Aware that the capital's reputation for safety had suffered in recent years, and seeking to strengthen its tourist appeal, local business interests as well as governmental institutions invested time and money preparing for millions of pilgrims. Expanded hotel and motel facilities, spruced-up visitor centers, and innovative public programming exploited Washington's special status for this unique event. In some ways, it was the capital's Olympic Games, a chance to make the most of special opportunities and reestablish its good name.

The Smithsonian Institution embraced the possibilities with great enthusiasm, laced by organizational anxieties. In December 1975, as celebrations were just getting under way, secretary Dillon Ripley confessed to a Los Angeles newspaper his nightmare vision of clogged turnpikes, jammed highways, and thirty million tourists unable to reach the capital where he (and his staff) had prepared sixty million dollars' worth of bicentennial exhibits. The Smithsonian's attractions included the opening of the enormous new National Museum of Air and Space, an exhibit at the Freer Gallery of ninety-five Japanese landscape paintings given in honor of the bicentennial, *America as Art* at the National Collection of Fine Arts, *Abroad in America* at the National Portrait Gallery, *The Golden Door: Artist Immigrants of America* at the Hirshhorn, *We the People* and *A Nation of Nations* at the Museum of History and Technology, and a spate of other special shows. All of this was complemented by the opening of the Cooper-Hewitt Museum, which had taken over the old Andrew Carnegie mansion on New York's Fifth Avenue. Patrick Brogan, the *Times*

(London) critic, reviewing the breadth of the capital's art shows, commented that *A Nation of Nations* proposed the idea that America was "less a melting pot than a tossed salad, with English dressing." James Smithson would have been proud, he concluded.[5]

The National Gallery had its own elaborate agenda. *The European Vision of America* opened on December 7, 1975. Organized by the Cleveland Museum of Art but premiering in the capital (Brown continued to insist on Washington's priority), it commenced an active series of presentations that included a show of Goya paintings sent by the Spanish government as its tribute to the bicentennial, two exhibitions of American flags for the (still provisional) National Sculpture Garden, and, as the centerpiece, an elaborate and immense exhibition, *The Eye of Thomas Jefferson*. This last was accompanied by lectures, concerts, films, and slide shows, its opening marked by a specially created fireworks spectacle on the Mall, titled "The Triumph of Reason and Order over Chaos and War." The fireworks were produced by a French firm that had, two hundred years earlier, created displays witnessed by Jefferson himself.

The Eye of Thomas Jefferson betrayed some, though decidedly not all, of the hallmarks of a National Gallery production in the Brown regime, and confronted many of the typical problems. Officially coordinated by an international advisory committee, headed by Sir Francis Watson, the former director of the Wallace Collection in London, the show built upon two years of preparation and archival research. The actual organizer was a recently recruited Brown appointee, William Howard Adams, who had been brought in from Missouri to administer the Gallery's extension service and had been so important in setting up screenings of Kenneth Clark's *Civilisation* films. Energetic and enthusiastic, Adams made at least five trips to Europe in search of materials, and a hard-working staff pored over possible entries. Excitement and ambition hung around the plans, as Adams reported in a *New Yorker* interview.[6] At twenty-five thousand square feet, *The Eye* constituted the largest temporary exhibition the National Gallery had ever mounted, supported by a $250,000 grant from the Exxon Corporation (which covered about a third of the total cost). It would feature, among other things, a royal visit from Queen Elizabeth II (a lender to the show), a specially created film produced by Charles Guggenheim, and some spectacular European loans, stimulated at least in part by the friendly interest of high federal officials.

This last element, along with royal visits, would become a signature

of many major exhibitions during the Brown era. Obtaining the "Medici Venus" from the Uffizi in Florence was a triumph achieved partly through the office of the president. Eager to consummate what first threatened to be a disappointment, the Gallery (according to an Adams interview with newspaper reporters) suggested to its "Italian friends" that President Gerald Ford's visit to Italy, in the fall of 1975, offered an unparalleled opportunity to announce the loan.[7] The retiring Italian ambassador, Egidio Ortona, apparently assisted. The White House cooperated, and its involvement helped propel an explosion of news stories on the coming loan, part of the intense promotional effort that had become typical of major Gallery shows. Adams (and Brown by association) were hailed as the first to get the Medici Venus out of Italy since Napoleon had managed it, under very different circumstances, more than 150 years earlier.[8]

The idea behind *The Eye of Thomas Jefferson* had developed only after Brown had spent time playing with another notion: surveying the art of the world in 1776. It turned out, he reported, that 1776 was not a particularly good year for art. The notion would be recycled, some years later, as *Circa 1492*, Brown's last major exhibition at the National Gallery. The experience of running into Thomas Jefferson's writings again and again in the course of the preparation, led, according to Brown, to the exhibition's central theme: Jefferson's own encounters with art. Others, notably the designers Charles and Ray Eames, were also grappling with the challenge of organizing a bicentennial show around Jefferson. Their gigantic effort, *The World of Franklin and Jefferson*, which opened in Paris and then visited museums in London, New York, Chicago, and Los Angeles, turned out to pose even more problems than did the National Gallery's venture.[9]

Critics acknowledged the intellectual and aesthetic ambition harnessed by William Howard Adams, but divided on the issue of success. Paul Richard, for the *Washington Post*, labeled *The Eye* simultaneously the "most complex" and the "least successful" major exhibition ever offered by the National Gallery. Jefferson, he pointed out, "loved order, simplicity, correctness. His language and his lists, the details of his architecture, the gardens that he planted and the goblets he designed, are paragons of clarity. This exhibition isn't." Sharp corners, illegible labels, labyrinthine and seemingly endless halls, and difficult traffic arrangements led to befuddlement, he argued. Part of the problem lay with the layout of the National Gallery building, which was not designed for temporary shows and thus a challenge to any designer.[10]

Benjamin Forgey, Richard's counterpart on the *Washington Star*, and future colleague, was, if anything, more corrosive. He blamed the show's designers, architects John Bedenkapp and Elroy Quenroe, for the ineffective displays and contested the very definitions behind the show. *The Eye* was "far and away the most unwieldy, wearying, exasperating exhibition ever put on by the gallery," Forgey complained. The show had grown too far and too fast, confusing visitors with its uncertain criteria for inclusion and exclusion. *The Eye of Thomas Jefferson* "does more than explore its subject," Forgey concluded caustically. "It exhausts it."[11] The *Art Journal* similarly complained of too many small galleries, too many objects, and too many issues, the exhibition looking like "a huge three-dimensional book."[12] Other critics added to the list of challenges unmet.

Still, some reviewers were elated. John Russell in the *New York Times*, usually sympathetic to the Gallery, admired the combination of exaltation, entertainment, enlightenment, and patriotism, and praised the show's capacity to offer something for everyone, "all of it good."[13] Critics in other cities called it exhilarating and a masterpiece, "spectacular" and "magnificent." The wonder, wrote Victoria Donohoe in the *Philadelphia Inquirer*, "is that great crowds have not already lined up in long queues outside the National Gallery."[14] Even detractors commended the show's scholarly rigor. The confusing layout and unhappy juxtapositions might well have resulted from the refusal of the National Gallery's resident installer-designer to work on it. Apparently dismayed by the prospect of fitting the gigantic assemblage into the convoluted spaces of the old building, Gill Ravenel, head of design and intallation, chose to turn his attention to other things and rejected the invitation to participate. Adams was not, at least at that time, one of his favorites. Reminiscing, Brown indicated that he was upset by Ravenel's decision and alarmed by his unhappy relationships with some of the Gallery staff. It was a measure of Ravenel's power that Brown did not overrule him, although the director claimed he managed to smooth some damaged feelings and brought Ravenel to heel.[15] But it was too late for Thomas Jefferson.

Ravenel did, however, agree to design the National Gallery's final major exhibition of the bicentennial year. While it had nothing to do with the official national themes, and indeed could be deemed alien to them, this show turned out to be revolutionary in a whole variety of ways, and thus, ironically, fulfilled the larger celebratory objectives more fully than many of its rivals.[16] It focused upon three dozen extraordinary objects

dug up in Egypt's Valley of the Kings more than fifty years earlier. *Treasures of Tutankhamun* would become the exemplar for the transformation overtaking American art museums in this era.

Ancient Egypt and young America enjoyed an ongoing romance many decades before the Tut exhibition.[17] Egyptian references studded national currency, architectural ornaments, jewelry, and decorative art from the late eighteenth century on. Cemeteries and prisons deployed Egyptian themes as invocations of solemnity and intimations of eternity. Church architects played with such references in stained glass and other ornamental details. Egyptian influences could be seen from Maine to Mississippi in the pre–Civil War years. But it was not until the 1920s that broadly popular interest in Egypt blossomed in the United States, the result of a series of tomb discoveries that began in late 1922, when Howard Carter and the Earl of Carnarvon started unearthing a fabulous set of treasures.[18] American and European fashion designers, manufacturers, interior decorators, department stores, clothiers, jewelers, and a host of other designers exploited public fascination with the newly discovered objects, and the first era of Tutmania was born. Herbert Hoover's pet police dog and a celebrated boxer from Minneapolis, active in the 1920s and 1930s, both answered to the name King Tut. Cats, dogs, apartment houses, restaurants, suburbs, babies, and parlor cars were named for the young pharaoh. There were Tut songs, films, a musical comedy, sweaters, dressing gowns, beaded bags, hats, and neckties. Magazines called King Tut "the man of the hour," rivaling in reputation the president, Charlie Chaplin, and Jack Dempsey. Advertising writers used Tut to epitomize anything old, and capitalized upon Egyptian images and associations. Even tourist visits to the Middle East grew in the 1920s, stimulated by the larger frenzy and by a desire to see what the sites of the discoveries looked like.[19]

The only images available during that decade were black-and-white photographs in newspapers and magazines—the copyright held by the *Times* of London—and the occasional slide show. Officially at least, none of the objects were allowed to leave Egypt, even temporarily. American museums that already housed important Egyptian collections—the Metropolitan, the Brooklyn Museum, the University of Chicago's Oriental Institute—experienced some increase in attendance and publicity, but private entrepreneurs were the chief beneficiaries. By the 1930s the delirium had abated, eclipsed by the Depression and the competition of so

many other 1920s manias. However, Tut had entered the collective memory permanently and lay quiet, like a dormant bacillus (or the legendary mummy in a spate of horror films), awaiting a call back to life.

Tut's next resurrection was, in essence, a function of international relations, politics, and the Cold War. In the early 1960s, an increasingly nationalistic Egypt, led by Gamal Abdel Nasser and joined to Syria in the short-lived United Arab Republic, was simultaneously flirting with the Soviet Union and developing plans to increase its production of electrical power by damming the Nile. The Aswan Valley would be flooded and ancient temples submerged. International concern found expression in a UNESCO-coordinated plan to save some sites from destruction. Newly elected president John F. Kennedy persuaded Congress to appropriate funds in support of the international project, an obvious way of shaping the sentiments of both the Egyptian government and the Egyptian public. The larger fund-raising strategy included creation of an international tour featuring a limited number of objects—not more than three dozen or so—from King Tut's tomb. Eventually more than sixteen million dollars would flow from American donors to aid the cause.

In September 1961 (within weeks of Carter Brown's arrival in Washington), Jackie Kennedy opened, in the rotunda of the National Gallery, the first American Tut exhibition.[20] Her presence, on top of the undeniable appeal of the thirty-four objects, sparked Gallery attendance to astonishing highs. Newspapers reported that by the end of the show's monthlong run, twenty thousand visitors a day were thronging the Gallery, four times the usual numbers.[21] Over the course of the next eighteen months, some seventeen American cities—including Boston, Detroit, Dayton, Los Angeles, Cleveland, Omaha, Chicago, and St. Louis—hosted showings. Almost everywhere the exhibition proved incredibly successful. In Philadelphia, crowds were so great that the University of Pennsylvania's University Museum broke a seventy-five-year-old rule and opened its doors on Sundays. Yale's Peabody Museum, directed then by Dillon Ripley, eclipsed all of its attendance records. Chicago's Field Museum likewise enjoyed impressive crowds during the exhibition's one-month engagement in the summer of 1962.[22] Forty-two thousand visitors streamed in during the first two weeks, and that number almost doubled for the next two. On the show's final day, something of a frenzy, almost thirty thousand tried to get into the museum. The total for the month stood at 125,000, and 78,000 attended lectures, workshops, tours,

and films built around Egypt and King Tut. The Field ended up setting a twenty-eight-year attendance record, increasing the previous year's attendance by 163,000. All in all, more than a million people viewed the Tut show on its American tour, a harbinger of things to come. That the tour's success was soon forgotten—Thomas Hoving totally ignored the episode in his own summary of the later Tut tour—was probably a function of its minimal marketing. Several elaborately illustrated publications appeared to accompany the touring exhibition, but beyond that there seemed little commercial exploitation of the visit. And little ongoing impact.[23]

A dozen years later, matters were very different. Inflation and mounting maintenance costs were putting financial pressure on art museums. Where once endowments and trustee contributions covered basic costs, now, in many cases, they amounted to little more than an annual subsidy. The Metropolitan Museum of Art, despite its size and wealth, was not entirely atypical. Between 1966 and 1976, the portion of the Met's budget covered by its endowment slipped from 67 percent to just 20 percent. In several of those years, deficits were recorded. The difference had to be made up somewhere, and while municipal subsidies helped out, increasingly, the money was coming from museum operations—gift shops, catalog sales, admission fees, restaurants, membership dues.[24] And these depended more and more upon creating a stream of exciting temporary exhibitions, capable of drawing large attendance and expanding the traditional museum audience. In the late 1960s, museum marketing and promotion at the Metropolitan entered on a newly aggressive phase, nourished by the provision of unprecedented international shows.

Hoving's assumption of the directorship of the Met in 1967, only eight years or so after he first joined the staff, constituted the most significant single step toward this new era. Confronting a growing gap between income and expenditures, and anticipating significant annual deficits, Hoving recognized that fundamental operational changes were in order. The route to new sources of revenue seemed clear: greater attendance and expanded operating revenues propelled by a user-friendly attitude toward visitors and the creation of enticing temporary exhibitions. While two of Hoving's predecessors, Francis Henry Taylor and, to a lesser extent, James Rorimer, had anticipated some aspects of his program, the changes they initiated were tentative. Hoving moved forward forcefully with some early entries in what would soon be termed the blockbuster

category, *The Great Age of Fresco*, *In Praise of Kings*, and *From the Land of the Scythians* among them. In the course of so doing, he enlisted the talents of a staff installer, Stuart Silver.[25] Quickly made chief of exhibition design, Silver created dramatic installations that added to the appeal of the special exhibitions and established his own reputation.[26]

Not everyone was entranced. Reviewing the Metropolitan's centennial show, *Masterpieces of Fifty Centuries*, Hilton Kramer complained about the aggressive installation techniques, the "arsenal of tiny spotlights," the "platoons of high-reflection Plexiglass cases," the "acres of shadowy galleries and miles of walls whose colors—deep brown, red, green, blue, purple, you name it—keep up a steady visual roar." Such installations were "based on the assumption that the museum public is no longer capable of looking at the object itself as it really is." Actual artworks were made to resemble glossy magazine and art book reproductions. Kramer likened it to transformations in concert hall sound systems that were making live music sound like high-fidelity recordings. He longed for a reduction of hurly-burly, but that was not about to happen.[27]

The string of shows was surrounded by extensive publicity (including, for some of them, banners hanging across the Met's facade, a signature feature of the Hoving administration), elaborate opening parties, vigorous press agentry, and large attendance. The fresco show, in 1968, proved so popular that the Met extended its hours.[28] All the activity and aggressive promotion touched off occasional hostile critiques from conservatives, but local critics acknowledged the verve and originality of many of the exhibitions, and the shows' popularity did not prove incompatible with scholarship. Meanwhile, the Met began long-term and expansive planning, which would allow it to improve its physical spaces and receive new collections.

None of this could have been lost on Brown as he was serving his apprenticeship. He knew the Met well, having studied at the Institute of Fine Arts, just a few blocks away, and had become a favorite of Hoving's immediate predecessor as director, James Rorimer. Brown and Hoving were approximately the same age, came from privileged backgrounds, would enjoy meteoric rises at their respective institutions, and presented themselves as dynamic innovators succeeding directors whom they much admired but whose management styles and programmatic values they largely repudiated. The parallels fed into an occasionally bitter competition and would probably have created some tensions between New York

and Washington even without a series of incidents and special circumstances.[29] The rancorous contests to obtain the Velázquez at auction have already been described. But the competition was more than personal or even institutional. It reflected the often strained relationship between the national metropolis and the national capital.

The lengthy, bitter struggle to exhibit the glories of ancient Egypt had as its opening protagonists not the usual pairing, the Metropolitan and the National Gallery, but instead the Metropolitan and the Smithsonian. And Hoving's initial rival was not Brown, but the seasoned, wily, if relatively new Washington power broker, Smithsonian secretary S. Dillon Ripley.

At issue was the disposition of one of the temples saved from the flooding of the Aswan Valley, the two-thousand-year-old Temple of Dendur, offered to the people of the United States by a grateful Egyptian government. In 1962 the fifty-foot-long temple had been painstakingly deconstructed into more than six hundred pieces and awaited transport to America. But where would it be housed? Hearing of the offer, numerous American cities, using various justifications, proposed themselves.[30] Some twenty different communities—Philadelphia, Miami, Baltimore, Memphis, even Cairo, Illinois—are supposed to have sent in requests, their mayors, senators, and civic boosters lobbying President Lyndon Johnson. The "Temple of Dendur derby," as it was dubbed by certain newspapers, stimulated arguments about whether the sandstone building needed to be placed indoors. Locals from New Mexico, Arizona, and Southern California pointed out that their climates resembled that of Egypt far more than did northeastern cities, and argued that the fragile stone might disintegrate in an unfriendly outdoor setting. Met director Rorimer and his curator of Egyptian art insisted that the porous temple should be placed indoors, and near "the country's most important collection of Egyptian art." "None of us have yet found a solution to the preservation of stone out of doors," Rorimer was quoted as saying.[31]

But it was Washington that offered the primary challenge to the Met. In 1965 the Smithsonian received in its conservation research laboratory a fourteen-pound block of temple stone, and concluded that "the temple could be situated in any part of the country if it is properly treated for the climate in which it would be put." Facing further questions, Smithsonian officials sent the block to the DuPont laboratory in Wilmington, Delaware, for further advice on chemical conservation methods.

Newspapers quickly latched on to the story of the rivalry, and specialists began to take sides. John A. Wilson, a distinguished Egyptologist at the University of Chicago's Oriental Institute wrote in the *New York Times* that the Nubian sandstone temple had to be kept under cover; the responsibilities that would fall to the host of the temple—"supervised reconstruction, protection against weather and souvenir hunters, detailed study by professionals, and harmony with existing collections"—argued for choosing the Metropolitan.[32] James Rorimer's sudden death in the spring of 1966 and the ensuing search for his replacement coincided with a White House decision to appoint a committee that would make the ultimate site recommendation. But the Smithsonian was asked for names of possible appointees, and competing institutions cried foul. "We feel there is obviously a conflict of interest," the interim administrator at the Met, Joseph Noble, told reporters. "It's obvious that the Smithsonian should disqualify itself since it is a claimant for the temple. The choice of the committee should be made by others." Noble added that "if the sandstone temple were outdoors in Washington, it would be a pile of sand around some stumps in 25 or 20 years." Dillon Ripley denied that the Smithsonian was a claimant, and insisted there was no conflict of interest. "There is a distinction between getting outside opinion and going to your staff."[33]

In his memoir, *Making the Mummies Dance*, Thomas Hoving recalled getting into the debate almost immediately. At the time, he was park commissioner of New York and, as such, an ex officio member of the Met's board. After his appointment as director in late 1966, of course his involvement increased and included a crucial presentation to the five-person commission in Washington. His later account described semiconspiratorial scheming to convert the on-and-off cooperation of Jackie Kennedy and Senator Robert Kennedy (who apparently favored a Washington location as a memorial to the late president) into sustained support. And it recorded a sense of embattlement with Dillon Ripley.[34] According to Hoving, Ripley promised that he was not interested in housing the temple and then suddenly reversed course. In fact, the Smithsonian had been an active and much publicized participant in the earlier discussions.

But the Washington venue was not to be. The commission, which included several prominent Egyptologists, recommended the Met as the preferred site (to his surprise, according to Hoving), and President Johnson announced late in April 1967, the same month Hoving assumed his

new position, that he would make the award. The story was not quite over. Later that year, Egypt broke diplomatic relations with the United States during the Yom Kippur War, and there were fears the entire agreement might break down. But in the end, the government honored its earlier pledge, and the temple arrived in New York aboard a freighter in August 1968, greeted like a visiting celebrity by New York's mayor, the Egyptian ambassador to the United States, Hoving, and members of his staff.[35] Paying for the temple's enclosure would require an appropriation from the city of New York, as well as a farsighted patron, Arthur Sackler, who had been a donor to both Israel and Egypt. Sackler provided more than three million dollars, and by 1970 the reinstallation was complete. The Temple of Dendur was now available for visitors, and as a site for the special events and socializing that Hoving believed were fundamental to the Met's future.

The spirited encounter with the Smithsonian seemed to confirm New York suspicions about Washington institutions seeking to aggrandize their holdings at the expense of the Met, and helped set up a broader series of confrontations. These would be dominated, over the next several years, by the National Gallery rather than the Smithsonian, and Egypt would once more play a role. During the late 1960s and 1970s, American policy makers struggled to define an effective relationship with Egypt. Its dramatic defeat in the 1967 Israeli war, the death of Gamal Nasser, the succession of Anwar Sadat, the expulsion of the Soviets, and the return of Egyptian self-respect in the campaigns of 1973 all made for a period of considerable instability. But it offered American leaders opportunities to reinvent relations between the two countries. Even while vigorously supporting Israeli interests, President Nixon and secretary of state Henry Kissinger actively pursued policies meant to reassure the Egyptians.

The international magic of Tut, meanwhile, was reasserted in 1972, when the British Museum hosted an enormously popular exhibition of selected treasures, commemorating the fiftieth anniversary of the great discoveries by the Earl of Carnarvon and Howard Carter. London crowds attempting to get into the exhibition were enormous; lines extended around the block, and the exhibition made money. It also traveled to several cities in the USSR. Both the Egyptian authorities and American museum directors took notice. Brown and Hoving each had his own special Egyptian connections. Hoving, having landed the Temple of Dendur and raised millions of dollars for a redesign of the Met's Egyptian collections,

had been seeking an exhibition of Tut treasures, according to his own recollection, since the late 1960s, but had been rebuffed by Egyptian officials. Brown, slightly later on the scene because his directorship had begun only in 1969, also began to maneuver by the early 1970s, visiting the Tut show in London. Using his close and continuing contacts with members of the Nixon administration, Brown advanced the National Gallery's cause in Washington, and in January 1974 he visited Cairo in pursuit of the show. But everything depended on high-level diplomacy, for nothing would happen without the intervention of President Sadat.

The real break came in the late spring of 1974, when President Nixon, barely two months before his resignation, made a triumphal visit to Cairo. Kissinger's shuttle diplomacy earlier in the year had defused tensions following the Yom Kippur War and helped warm US-Egyptian relations. Nixon declared himself extremely impressed with President Sadat, reveling in the huge crowds his visit attracted, "the most tumultuous welcome any American president has ever received anywhere in the world," he wrote in his memoirs. Buoyed by the reception, and by the recent expulsion of the Russians from Egypt, Nixon and Kissinger persuaded Sadat to authorize an American tour of selected Tut treasures, on the lines of the European exhibition just being concluded. According to Hoving's recollection, the Egyptians, in particular Gamal Mokhtar, who headed the state antiquities agency, wanted the Met to be put in charge of the exhibition, for safety reasons, and Douglas Dillon, the president of the Metropolitan, told Hoving that the Met would have to assume the responsibility or risk losing all future federal grants.[36] Five American cities were meant to be involved (actually, six would be chosen), and the choice (as well as the order) was supposedly put into the hands of Ronald Berman, chairman of the National Endowment for the Humanities. Hoving soon discovered "the terrible news that the show would open in Washington." In what seemed like a dramatic reversal of the Temple of Dendur affair, Washington now trumped New York.

By this time the Met had lost a string of temporary exhibitions to the National Gallery, most dramatically the show of recent archaeological finds from China in 1974. This show, with its canceled press conference, had been a mixed blessing for the Gallery from some angles but an enormous popular success. Metropolitan officials complained to sympathetic New York journalists that Brown and the National Gallery were unfairly exploiting their close connections with members of the government

and foreign diplomats to land shows that should have come directly to the Metropolitan, on the basis either of existing collections or earlier negotiations.

The loss of the Chinese show had been a particularly bitter pill to swallow. The Met had courted both Chinese and American officials, including Nixon, Kissinger, and Chou En-Lai, offering loans from Met collections in return for a chance to exhibit the extraordinary discoveries. Promises on the highest level apparently were made but not kept, according to Hoving. "From then on," Hoving wrote, "I was determined never to lose another blockbuster, especially to the National Gallery, and its director J Carter Brown, who was a dedicated and effective opponent."[37] With the likely prospect of a national indemnification program in the works, Hoving began to think about a whole series of important international shows: "We've got to get going before Carter Brown grabs it all." The prestige of Washington openings and the potential participation of the president constituted powerful weapons, and would almost inevitably lead to great shows opening in Washington. The tactics of Mellon and Brown, Hoving confessed, "were brilliant, and, over the years, I watched, grinding my teeth, as Carter Brown plucked show after show away from me. I screamed about his behavior in private with my staff but had to admire his talent for deal making. That's what the game is all about."

The strains of the competition, as well as the successful strategy of Brown, became evident in the first announcements of the Tut show and the public relations campaign designed to broaden its appeal. On October 29, 1975, the *New York Times* reported on the National Gallery press conference detailing the coming tour. The announcement followed upon a visit made by Anwar Sadat's wife, who had presented an antique vase to the Kennedy Center as a bicentennial gift. Brown was, naturally, in attendance and dominated the press conference itself. Passing lightly over some earlier preparations, "Mr. Brown, obviously delighted at having this spectacular exhibition to round off the museum's Bicentennial-year presentations," declared the opportunity "a splendid thing" for the Gallery, Linda Charlton wrote.[38] Christine Lilyquist, the Met's curator of Egyptian art, Brown went on, was helping to decide which objects should be included. In another news story, Brown gave the Met some backhanded attention. "They'll produce a catalog and do the dirty work," he reported.[39]

Brown, personalizing National Gallery programs whenever possible,

asserted that he had been "turned on by the romance of Egyptology" during his years as a graduate student in Europe, hitchhiking in Egypt to see its marvels. Upon seeing the London exhibition, he had made another Egyptian visit in January 1974. After learning of the Nixon-Sadat agreement in June of that year, he had written directly to the secretary of state declaring that the National Gallery had already been discussing such a show and would be delighted to be a participant. When Mokhtar, the head of Egyptian antiquities, came to Washington in the fall of 1974, Brown gave "a little dinner" for him. And now, a year later, everything was settled, with Tut scheduled to open at the Gallery in December 1976.[40] At the press conference, Brown added his hope that the pending indemnification legislation, having passed the Senate and making its way through the House, would soon be signed into law and help meet the high insurance costs of the exhibition. President Ford did indeed sign the act on December 20, 1975.

The casual reader in the fall of 1975 could be forgiven if she believed that the arrangement was entirely the work of Brown and the two governments. Metropolitan officials must have been infuriated by the story, and later *New York Times* pieces reinserted Hoving and his staff into the picture, quite literally, showing him with his associates selecting the objects for the show and supervising the preparations. The negotiations to select the fifty-five pieces (the number of years between Howard Carter's original discovery and 1977) were, according to Hoving, exhausting and sometimes farcical in character, and there were also disputes about how to ship the precious cargo. In the end, the United States Navy came to the rescue and transported the artifacts aboard the USS *Sylvania* to Norfolk, Virginia. In early September 1976, two months before the exhibition was to open, the National Gallery hosted a press conference to celebrate the uncrating of the central prop of the coming event, the golden burial mask of King Tut. Such a preview was unprecedented at the Gallery and demonstrates the full-court press Brown's staff conducted to promote the show. As "cameras whirred and clicked" Brown and Hoving spoke to the press, and the "royal head began to appear above the urethane packing." This effort to recapitulate Howard Carter's original discovery amid klieg lights seemed somewhat stagy to journalists like Benjamin Forgey, but it was, he admitted, still a bit exciting. "One could understand why people stood in line for hours in London to see a slightly smaller exhibition." Charging the occasion with his usual energy, Brown trilled that "when

you work in the chocolate factory you should get tired of the chocolate, but it doesn't happen."[41]

The press conference, aside from suggesting that the major museum directors of the day had little to learn from Hollywood about ballyhoo, offered some other insights into the coming extravaganza. One concerned what would soon become famous—or notorious—about the Tut exhibition: its elaborate merchandising program. At the uncrating event, Hoving remarked that the fifty-five Egyptian objects would be accompanied on their tour by some 450 saleable pieces—everything from postcards and books to full-scale replicas, reproductions cast in Egypt from the originals. Prices would run from several dollars to several thousand dollars; a 24-carat gold goblet, for example, was priced at fifteen hundred dollars. The proceeds, after expenses had been met, were to be donated toward the renovation of the museum in Cairo that contained more than three thousand Tut treasures. Tut constituted one of the first truly imperial ventures in museum marketing, setting a pattern that would be repeated and expanded immeasurably in decades to come, in dozens of shows. Hoving, who was in charge of this part of the exhibition, incorporated a series of prominent brands—Hermes, Boehm Porcelains, Limoges, Springmaid linens—in the campaign.

All this was taking place amid the staggering proliferation of variations cashing in on the American bicentennial celebration. In the Washington area, the coming of Tut coincided with the opening of the first full Bloomingdale's store outside metropolitan New York, in Tyson's Corner, Virginia. Naturally enough, Bloomingdale's promised to stock Tut reproductions in time for the December opening. The president of Bloomingdale's, Marvin S. Taub, declared his store to be competing with, among others, the Guggenheim and the Metropolitan Museum of Art as a supplier of merchandise. Now the National Gallery could be added to that list.[42]

Egyptian authorities were guaranteed $2.6 million at the start of the tour, but, Hoving admitted, "it could be more." It was. In the end a sum several times that amount would be sent back to Egypt, although its impact on the Cairo museum remained unclear for some years to come. In later interviews Hoving expanded upon the Met's marketing function. The exclusive contract between the Egyptian government and the six-museum consortium hosting the exhibition meant that all requests for reproduction rights had to come through his group. We are "developing

the concept of traveling shows into a fine art," Hoving declared, "working with the Egyptians on a 10-year program . . . that will generate revenues." The Met was, in essence, serving as "management, architectural, and marketing consultants" in the interests of revenue enhancement.[43]

The marketing bonanza shared space in some newspapers with the Metropolitan–National Gallery feud, which was beginning to assume melodramatic proportions in the press. Grace Glueck in the *New York Times* referred to "backstage rivalry" and Met resentments over the loss of the Chinese show, the opening of a Goya show at the National Gallery, and the Tut inaugural, while Judith Martin in the *Washington Post* parsed Hoving's press conference comments with special care. Hoving, whom she labeled a "guest star," spoke of wearing a "twisted smile" when viewing the Tut treasures because the Met had given up its excavation claims not long before Howard Carter's 1922 discovery. But some of those present, Martin went on, took the twisted smile as "a reference to the rivalry of his museum . . . with the National Gallery."[44] Indeed Hoving repeatedly referred to the Metropolitan as the "national museum," thus suggesting a status that outranked the National Gallery. And the almost simultaneous opening of the Metropolitan's new Egyptian galleries, designed by Kevin Roche and John Dinkeloo to widespread praise, emphasized just where the significant collections were housed. But despite these claims, the spoils of war appeared to have gone to the National Gallery, and Brown made matters worse by indicating that a Thracian gold exhibit from Bulgaria, slated to come to the Metropolitan the following year, was a National Gallery reject. "We had a crack at that . . . but turned it down," Brown told the press.[45]

The opening of the Tut show also provoked some reflections upon the active role museum exhibitions lately seemed to be playing in foreign policy. The involvement of the White House and the State Department was too obvious for commentators to ignore, and the phrase "détente shows" became a journalistic byword. Focusing on the recent appointment of Peter Solmssen as advisor on the arts to the State Department, Grace Glueck of the *Times* asked if shows like Tut were not, in fact, attempts "to exploit American museums for propaganda purposes?" Is the State Department "sweetening its dealings with foreign governments by facilitating the Tut show and others?" she wondered.[46]

Cultural diplomacy was, of course, nothing new for the United States government, although patriots tended to characterize deployment of

the arts in support of political objectives as a communist-bloc tactic during this era of ongoing if muted confrontation. Surprising revelations about the extent and direction of governmental subsidies to scholarship and periodicals, and revisionist explanations for political tolerance of modern art, awaited the scholarship and journalism of the 1980s.[47] But suspicions about an alliance between foreign policy and museum programming were already widespread a decade earlier, and government spokesmen reacted aggressively to charges they claimed were exaggerated. To posit close connections between federal policy makers and cultural institutions was "a distortion of the facts," Solmssen declared from his State Department position. Museums possessed and advanced their own objectives, he insisted. The so-called foreign policy link simply expressed improving international relations; these were what made such popular shows possible. The desire for such exhibitions was decades old, and, he continued, it was doubtful that such enterprises could be simply propaganda vehicles for foreign states.[48]

Solmssen had, in fact, gone to Egypt with Hoving in 1975 to help with the arrangements, had assisted in planning the Met's Scythian gold show, and had pressed Congress to pass the indemnification act, whose origins lay partly in the ideas of Daniel Herrick, Hoving's chief financial officer at the Met. Solmssen was also responsible for the creation of the International Exhibitions Committee, helping pool public and private support for American participation in international festivals. What all of this suggested, despite official denials, was increased public sensitivity to the potential gains of active cultural diplomacy, an awareness that battles for public opinion could be influenced by the immense popularity of shows like Tut. Certainly Brown understood the logic of Cold War strategizing in his continuing quest for international shows to debut at the National Gallery. And so did other museum officials. They had to accept reality. "Hoving and Carter see themselves as contending heavyweights for the rarest of masterpieces anywhere in the world," declared Walter Hopps in 1976, curator of twentieth-century art at the National Collection of Fine Arts. "Political considerations" are "the enzymes that make exhibits happen," he continued in a lengthy comment to the *Washington Post*. It was a way of overcoming the intertia of timid scholars and curators, concerned about the hazards of art travel.[49]

As had the Chinese controversy a couple of years earlier, the Tut exhibition starkly revealed the close ties between government policy and

gallery programs. Then the trustees and staff were opened up primarily to critics on the right. Now the questions were broader, the conclusions more cynical, the sarcasm more ingrained. "Are the eager visitors queuing up at the National Gallery of Art to take a peek at King Tut's golden treasures unwarily placing themselves in the grip of devious diplomatic manipulators," Phillip Kadis asked in the pages of the conservative *Washington Star*. Did museumgoers gaping at an ancient Chinese burial shroud become "unsuspecting objects of a subtle Maoist brainwashing? Did the Bolshoi make opera buffs and balletomanes pine for Brezhnev?"[50] Clearly Kadis was skeptical about the dangers threatening exhibition goers and contemptuous of fears about their impact. But even if brainwashing could be seen as an unlikely consequence, there remained significant political issues. Egypt, Russia, China—it was all the same, Walter Hopps again remarked. Art gives them a "presence in the world," much like showing the flag. Altruism had little to do with it.

Setting to one side the political considerations and the rivalry with the Met, critics and visitors alike were free to concentrate upon the Tut experience itself, which quickly, although not immediately, established itself as one of the seminal museum events of the decade. Brown and his public relations advisers took advantage of every opportunity to promote the exhibition. Thus they persuaded Exxon, the corporate sponsor of the show, to fly Henry Herbert, the current Earl of Carnarvon, from England to the opening. The son of the peer who had financed the original excavation and died soon thereafter from the infamous mosquito bite, Carnarvon, who had recently published a memoir, was soon ensconced (with his butler) at the Hay-Adams hotel. There "Porchy," as he was known, obligingly chatted with squadrons of interviewers, who were still interested in learning more about his attempts to keep his friend, the former Prince of Wales, now the Duke of Windsor, from marrying Mrs. Simpson, forty years earlier.[51] Local department stores like Hecht's exhibited Egyptian objets d'art, some of them lent by the Egyptian ambassador. Garfinckel's featured a range of Egyptian-inspired neckties, and Woodward & Lothrop distributed a line of bed linens with Nubian themes.[52] True to its earlier promise, Bloomingdale's, in the Virginia suburbs, sold T-shirts covered with hieroglyphic symbols. *National Geographic* and *Smithsonian* magazines ran color photographs of the objects on display. *Forecast*, a local entertainment magazine for Washington-Baltimore, placed an Egyptian-dressed model on its color cover.[53] Even the federal

government helped out. The *Monthly Labor Review* of the Department of Labor put one of the treasures on its cover. Local television shows invited Brown to describe the coming exhibition.

The opening night dinner, which faced none of the complications that had troubled the Chinese show, was planned by Bunny Lambert Mellon, wife of the Gallery president. The menu, the flickering candles and calla lilies, and the fashions of the guests received close attention from the press. The boned chicken and hush puppies, served after lobster bisque, did not constitute a culinary high point. But then, the dinner, John Sherwood wrote in the *Washington Star*, was planned to be as "forgetful as Mellon taste would allow," so as not to distract from the real show. The purported star of the evening was Henry Kissinger, who, along with the Egyptian ambassador, spoke (but was not easily heard) in the acoustically challenged East Garden Court. The actual star, according to Sherwood in the *Washington Star*, was the young pharaoh himself. "The temporal power of a mere mortal like Kissinger was soon forgotten in the haunted presence of this ancient king whose power still dominates our senses."[54] Indeed the elaborate dinner itself seemed like something of a desecration; the "broken glass and cigarette butts" that testified to the earlier festivities made it seem that "a gang of grave robbers had intruded again upon the scene."

Critics were simultaneously bemused by the immense publicity the exhibition had developed and entranced by the actual display. Few exhibitions had been as aggressively touted, Hilton Kramer wrote in the *New York Times*, or as avidly anticipated. This was normally a recipe for disaster, particularly for Kramer. But the results were magnificent, thanks to the National Gallery's extraordinary installation team. "It is as an exhibition of art, not of history," that Tut "captivates and bedazzles the senses." Visitors experienced the treasures, not as ancient relics but as modern objects. The piercing light accenting the alabaster vases was the light "not of ancient Egypt" but "of modern display technology." "We have, in a sense, transformed the 'Treasures of Tutankhamen' into something they never were—an art to serve the modern appetite for esthetic delectation."[55] The *Washington Star*'s critic agreed that the exhibition had been "propelled by an almost self-generating publicity machine" and was destined to become "one of the most popular traveling road shows the country has seen." But, despite concern about the adjacent salesrooms, where scarves, jewelry, tote bags, and sculpture were for sale, he admit-

ted that the designers had created an extraordinary show, pulling out "all stops in their considerable bag of tricks to simulate the excitement of the archaeological find without overpowering the objects themselves."[56] Paul Richard in the *Washington Post* termed the show a "thrilling install-ment," lavishing compliments on Gill Ravenel, George Sexton, and other staff members, many of whom had been working as a team for several years. "You have to tear your eyes away from Tutankhamen's treasures to see how well they have been installed at the National Gallery," he wrote. "One can pay no higher compliment to a museum installation." The mix-ture of ambient and direct lighting made the encased objects look as if they had been "bottled in a cube of light." The awkward spaces that over-whelmed *The Eye of Thomas Jefferson* some months earlier had been mas-tered and, despite the huge crowds, there was no sense of congestion or claustrophobia. Subtle shifts of colors, clearly placed and well-designed labels, and geometrical changes in the successive spaces combined to en-hance the display, Richard argued. "Museum-goers here are used to skill-ful installations, but this one is something special."[57] At least one Gallery curator remembered the installation somewhat differently, recalling visi-tors fainting, disoriented by its blackness, and a stretcher corps on call during weekends. This was, however, not the broader impression.[58]

Fresh from a honeymoon trip to China, Brown could bask in the tri-umphant reception for the Washington show. The fervently enthusias-tic reviews demonstrated the success of his larger strategy—assembling, nurturing, and, when necessary, deferring to Ravenel and the team of ex-hibition designers he had helped assemble. The fact that reviewers spent time talking about installation methods, and named the specialists re-sponsible, revealed a growing sensitivity to the aesthetics of display and the increasing centrality of the museum experience to a broader public. The transformation had been relatively recent. Stuart Silver, Ravenel's counterpart at the Met, who had been discovered and then promoted by Hoving in the late 1960s, argued that until the 1870s museums had relied mainly on curators to mount shows. They did so, he went on, "with little or no reference to color, or traffic, or to create something sequential."[59] Now, however, museums had come increasingly to rely on the skills of display specialists, keeping them on staff to take charge of temporary ex-hibitions and using them to rehang permanent collections as well. Sev-eral of those involved in the Washington Tut exhibition, notably Sexton, the lighting specialist, went on to other tour sites like San Francisco and

New Orleans, to ensure a certain consistency in the deployment of objects from city to city.

In the early weeks of the Tut phenomenon, it became apparent that the entire visit—planning when to come, organizing group expeditions, purchasing tickets, standing in enormous lines, meeting and observing fellow viewers, buying souvenirs, finding rest rooms—was assuming epochal proportions. Letter writers poured out their experiences in local newspaper columns. One Reston, Virginia, resident described departing early for the National Gallery, at 8:30 a.m., only to discover that thousands of others had the same idea. Hoping the crowd might dissipate, the group crossed the Mall to the Air and Space Museum, returning at lunch to find that the line had doubled. "At 4:30 we made our final assault on the National Gallery of Art," but just as the double doors came into view they were closed for the day.[60] Newspapers marveled at the throngs, more than thirteen thousand a day. The National Gallery, which had never before issued special tickets, tried briefly to do so in the first few days of the showing, but the numbers overwhelmed the machinery and visitors were confused by the multiple lines.[61] The congestion was attractive enough for professional pickpockets to work the crowds. By the end of the first month, the National Gallery reported that more than two hundred thousand viewers had trooped through.

Indeed the crowds soon became the central story. The *Washington Post* reported in late December 1976 that more than eight thousand had stood in line for longer than four hours trying to get into the Gallery. Administrators attempted to discourage some from the wait, telling them they wouldn't be able to enter, but most persisted.[62] And once in the building itself, further lines had to be endured. One December Sunday, twenty-six thousand people entered the building, but fewer than fourteen thousand actually saw the treasures. Statistically, the Gallery may well have hosted better attended shows—the *Mona Lisa* drew more than twenty thousand a day in 1963, for a shorter time period, and in 1948 a group of rescued art treasures from Berlin managed to attract more than twenty-four thousand in a single day. The physical circumstances of the Tut show— its size and installation—made reaching these figures impossible, but they would have been surpassed had there been room. Editorialists and columnists throughout the country marveled at visitors' willingness to endure cold, rain, and lengthy delays, the camaraderie and good humor of the crowds, the place-saving rituals, the sharing of coffee and sand-

wiches, and the general spirit of excitement. Most commented as well on the commercial frenzy accompanying the exhibition. The flood of Egyptian-oriented products "may make the ancient overflows of the Nile seem minor in comparison," gushed Douglas Crooks for the Medill News Service.[63]

For some, the extensive lines were reassuring testimony to a broad enthusiasm for learning and enlightenment. You can't visit the Tut show in Washington without "becoming intensely aware that there is a cultural explosion going on in this country," wrote Virginia Tanzer in the *Delmarva News*. She identified the show's popularity with a wider interest in the arts, arguing that a visit to the exhibition produced a feeling of humility about older civilizations and punctured the myth that the twentieth century was superior to any that had preceded it.[64] A columnist in the *Norfolk Ledger-Star* claimed that interest in Tut reflected a deep human longing to know more about the past. The turnout "must say something about this country. Something that stands in sharp contrast to the troubles we have known and the flashes of human ugliness."[65] There was energy and commitment, particularly among those who lined up as early as 6 a.m. Others found the event a tribute to Washington's new status as a citadel of culture and detected in the heterogeneous crowds, among them school groups being lectured by teachers and docents while awaiting their turn, signs of normality in the post-Watergate world. "I found it very depressing," reported one frustrated visitor who never did get to see Tut, "until I got worse news, which was how much it costs to fly to Cairo."[66]

Jimmy Carter's administration began while Tut was on display in Washington. The president's family, and finally the president himself, made much publicized visits to see the show.[67] The new informality preached by Carter was exemplified by his wearing a sweater and an open shirt rather than a suit and tie during his Tut encounter. This provoked criticism in certain quarters, along with discussion of how VIP visits to the Gallery, with their privileged arrangements, challenged the egalitarian principles underlying free public access.

Indeed, the stream of notables trekking in (and usually jumping those long lines) stimulated ongoing criticism of how the Gallery handled big-name visitors. The lineup of limousines carrying visiting luminaries drew particular comment. "We are all equal in America—but some are more equal than others," quipped one Virginian to the *Washington Star* in

March.[68] Newspapers reported faithfully the comings and goings of Rex Harrison, Moshe Dayan, Marisa Berenson, Rose Kennedy, Lynda Bird Johnson, Robert Redford, Ronald and Nancy Reagan, André Kostalanetz, Lillian Hellman, Andy Warhol, Herman Wouk, among others, whose attendance brought still further publicity to the promotion-rich show.[69]

But the museum staff and its facilities were clearly overwhelmed. Exhausted switchboard operators reported handling as many as fifty thousand calls a day from prospective visitors wondering about the best time to show up, the length of the wait (averaging six hours at certain points in the exhibition's run), where to eat, and similar issues; once the switchboard simply gave out.[70] Brown at one point had a string quartet perform to keep the crowd happy and quiet, but the keynote for those working at the museum was fatigue. Many frustrated attendees wrote to local newspapers suggesting changes in admission policy. Citing the inadequacy even of lengthened hours, some proposed that the Gallery remain open twenty-four hours a day to accommodate the demand. Embattled and wearied, Gallery administrator Joseph English, not normally the most positive personality, replied that it would be impossible to staff the museum if it remained open around the clock (the show required forty-one guards, many of them with specialized duties, and one full-time attendant did nothing but change the air conditioning filters). Even with such a policy, there would still be huge lines. The potential audience for Tut was, as he put it rather infelicitously, a "bottomless pit." Staff members were already putting in unpaid overtime.[71] The Gallery did permit visitors to carry camp stools, and even allowed some food "so people don't faint on line," English explained. One thousand free passes were handed out at the Constitution Avenue entrance each morning, but these were intended primarily for the elderly and the handicapped. Other would-be visitors sometimes screamed, cursed, cheated, lied, forged passes, beseeched their congressional representatives, and pulled out every stop they could in efforts to enter, and the pressures on staff to accommodate them were intense.

As the first stop on the national tour, the Gallery suffered the pains of adjusting to a new scale of visitation and bore the brunt of frustrated visitors. Katherine Warwick, the public relations officer, interceded between Brown and the press, putting out fires whenever possible, and evaluating a broad range of possible strategies, primarily from the standpoint of institutional reputation. She also had the dubious pleasure of doling

out VIP passes. But despite the damaging publicity that sometimes came along with celebrity line-breakers, her biggest challenges lay in solving crowd-control issues. The Gallery had confronted these before. The 1948 exhibition of German treasures had enticed 964,000 viewers, more than would see Tut. This crowd had stunned the chief curator. The National Gallery looks like "the Grand Central Station on the fourth of July," John Walker wrote Bernard Berenson on that occasion. "I have almost come to the conclusion that interest in the arts in America is overstimulated," Walker added.[72]

But the earlier shows were largely painting exhibitions. The relatively small number of Tut objects on display, and the fact that they were three-dimensional, made it difficult to plan breaks or lulls in crowd movement. The viewers had somehow to be propelled forward, so that the long lines behind them would continue to move. The effect could be nightmar-ish. Waits as long as ten hours were reported; Gallery officials estimated that perhaps a third of those who came to see the show never got in.[73] Among many, one report in a Pennsylvania newspaper captured the frus-trations.[74] After hours of enduring sore feet and stale air, and figuring out ways of outsmarting the guards, the group managed to enter the dark-ened rooms. "Babies clutched by young mothers, young men and women tethered together by tape recorders and ear phones," the wires entangling themselves and others—the scene was horrific. Despite everything, "I'm glad we did it," the writer reported, but "never again" did she imagine she could tolerate a similar experience. "Three hours and two hundred miles to become a robot in a wall of shuffling humanity is not my idea of view-ing any kind of a show." Once in the "overcrowded tiny galleries, filled with pushing, shoving people, no one had a chance to read the labels . . . generously placed on all four sides of each display case. . . . I had looked forward to the show immensely, but by the time we got into it, we were too frustrated and tired to enjoy it." By the end of the show's Washington stay, stories of crowding and long waits had become so endemic that at-tendance and line times actually declined slightly. The last recorded visi-tor, Genevieve Knowles, number 830,430, walked right in, after the wait had fallen to just two hours.[75]

Representatives of the museums waiting to host Tut visited Washing-ton to study the crowd flow and consider possible changes in their own arrangements. "I have nightmares," John Bullard, director of the New Or-leans Museum of Art, told reporters. Larry Klein, of Chicago's Field Mu-

seum, confessed that the Washington experience had frightened Field officials. "There's been lots of panic planning here."[76] One solution was the Field's installation of an entirely new switchboard, using recordings to answer commonly asked questions. Another was its imposition of a numbered-ticket system, with television monitors indicating admission times for specific number groups. This allowed visitors to tour other exhibits or even, if they lived nearby, to go home for a few hours. When the day's tickets had been sold out, a Tut flag flew at half mast in the Field Museum's parking lot. Both Chicago and New Orleans indicated their museums would be open until late in the evening. Some of these arrangements, particularly telephone recordings and time-sensitive ticketing, would become conventional features of blockbusters in later years, but in 1977 they were novelties and attracted lots of attention. So was the use of Ticketron to sell tickets, a tactic employed by the Metropolitan Museum of Art, the last stop on this Tut tour. And just as novel was the emergence of ticket scalpers, doing what they traditionally did for sold-out concerts and Broadway shows.[77] Tut helped to transform operational planning at major American museums and establish levels of excitement—and tension—that were rarely associated with any but the most exceptional events.

If anything, the Tut bonanza erupted even more spectacularly after leaving Washington. The National Gallery, because of space limitations, attracted the lowest total attendance of any museum on the American tour.[78] And because it did not offer paid memberships, it could not reap some of the benefits that accrued elsewhere. In New Orleans, museum memberships advanced from three thousand to twenty thousand in the wake of the show.[79] Tut, claimed John Bullard, was the first major art show to come to the deep South (Atlanta wanted it but lacked the space) and, as such, reaped the rewards. Attendance there averaged 9,500 on weekdays and 14,500 on weekends. Its museum shop, which did seventy-five thousand dollars' worth of business the year before, enjoyed a million dollars in sales during the four months of King Tut's residence.[80] And the city thrived as well. Some 500,000 of the 860,000 attendees came from outside Louisiana, and one study declared that the exhibition had pumped seventy million dollars into the local economy, while returning more than four million dollars in state and local sales taxes. As a benefactor of the city and state, Tut proved popular enough to get a jazzman's funeral.

In Chicago, Tut visitors endured drenching rains and spent more than thirty million dollars at local hotels and restaurants; the Field Museum increased its membership by some forty thousand. Seattle quadrupled its museum membership; in preparation, the city had spent a million dollars to renovate the Seattle Center, a visitor welcome facility that would be turned into a permanent exhibition site.[81] "'Bonanza, *nothing* but bonanza,'" rejoiced one city official there, delirious about the cash flowing into the city.[82] The Los Angeles County Museum dramatically enlarged its shops to carry the flood of publications and consumables, and turned to five major department stores to help sell and distribute tickets.[83] In forty-eight hours, before the show had even opened, 95 percent of the tickets were sold out.[84] Kenneth Donahue, the director, said his museum could have kept the show busy seven days a week, from 8 in the morning to 11:30 at night, for a year.[85] And San Francisco's Palace of the Legion of Honor, added to the itinerary after the tour had begun, installed a new air conditioning system to receive it, its first such effort at environmental control.

So lucrative did the show prove to be that rumors suggested the National Endowment for the Humanities, an early funder, was seeking to get its money back. Joseph Duffey, NEH chairman, denied any such intention, but he did say that had such an immense success been anticipated, a different financing plan might have been adopted.[86] The only museums not enjoying such huge direct benefits were the two institutions most responsible for the show's creation: the National Gallery and the Met. The National Gallery had neither priced admission tickets nor any membership program. And the Met did not offer Tut tickets as an inducement to new members. But there were other rewards. Both institutions enjoyed increased gift shop purchases and restaurant attendance (the National Gallery in its newly opened underground concourse, part of the East Building project). And both museums gained prestige from their installations and publicity from the impressive attendance.

The flood of product development associated with Tut, within museum gift shops and, more generally, in the consumer market, was unprecedented in extent and may have been the exhibition's most influential legacy.[87] Tutglut, Tutmania, Tut Schlock, Tutania, Egyptian Fever, the Pharoah Faucet—word coiners could barely keep up. At least forty publishers brought out Tut-related books.[88] There were several network television specials. Department stores, jewelers, distillers, even Trinity

Church Cemetery in New York, jumped on the advertising bandwagon.[89] Tut swizzle sticks, frisbees, wallpapers, stationery, toaster covers, hand-painted ostrich eggs, jigsaw puzzles, needlepoint pillows, and liquor decanters filled out and amplified the more conventional categories. It was these, and the impassioned energy of the crowds of visitors, suffering torrential downpours, the heat of the sun, the tedium of long waits, just to spend a few minutes with the relics, that astonished even the most astute observers. For more than two years, the show sustained its momentum. "The single most successful art exhibition ever recorded in the history of Western museology," Hilton Kramer admitted grudgingly, even while arguing that other shows were more significant and the Met's newly installed Egyptian galleries far richer. There "are crazes that mere intelligence is helpless to remedy," he continued, concluding that enthusiasm "on this scale belongs more properly to the province of social pathology than to the realm of art criticism."[90]

Brown, as one of the show's creators, confessed soon thereafter, largely in private, his second thoughts. "Our greatest protection in the future," he wrote Harry Parker, then directing the Dallas Museum of Fine Arts in 1980, "is that art exhibitions as a business are not that profitable. Tut has a lot to answer for in creating a kind of once-in-a-lifetime hysteria which I believe is not replicable." It will "probably take a while before the Tut damage is completely repaired." Tut exemplified the dilemma facing art museums, that of "staying out of the poor house" without "getting rich." If museums did not accept the obligation of putting on broadly popular exhibitions, they would happen anyway. I "feel that we as a profession must do everything to keep a handle on this activity, and keep it in the museums—as opposed to arenas, armories, convention centers, you name it."[91]

For many others in the 1980s and 1990s, Tut came to stand for a decisive moment in the history of American museum exhibitions, a moment when curators surrendered—or at least compromised—their commitments to serious scholarship and connoisseurship in favor of crowd appeal. Indeed, Tut may have lingered in the memory of critics even more intensely than it did among museumgoers. Typical were the remarks of Richard Ryan in a May 1992 issue of *Commentary*. While reviewing a much discussed National Gallery exhibition of that year, Ryan invoked the "lamentable" Tut exhibit, of sixteen years earlier, "which had such a

vulgarizing effect on museum curatorship," and set the standard for promotional exuberance.⁹²

Vulgarity did indeed hop a ride on much of the Tut tour. The New Orleans Museum of Art, according to newspaper reports, renamed its toilets "tutlets," and volunteers there began referring to the women's room as the "mummies room." One Seattle restaurant featured a special thirty-nine-dollar Tut meal, for "dining like the Pharaohs of the Nile."⁹³ "Do we not see," asked Kramer in the *New York Times*, "in all the materialism and litter of this vision of the after life an exact reflection of our own civilization?"⁹⁴ Tut was summarizing as well as prophesying. Licensed reproductions had been a part of American museum merchandising for some years by then, and expanded museum stores and holiday catalogs were already in full operation throughout the country.⁹⁵ By the time of the Tut show, *A Shopper's Guide to Museum Stores* had already appeared in print, and the Metropolitan's gift shop was reporting gross sales of more than ten million dollars annually—without benefit of Tut objects. Tut dramatically expanded the commodification of exhibition objects but did not invent it.

What distinguished the Tut show, in the end, was its scale, its longevity, its successful reinventions, and, it must be admitted, its lack of fundamental aesthetic importance. It reflected, in the mid-1970s, that perfect storm of museum need, foreign policy aims, arresting installation, and show business promotion that together would sustain many of the blockbuster exhibitions of this era. It encouraged innovation and ingenuity in both marketing and hosting techniques, and symbolized the competitive struggle of the Metropolitan and the National Gallery for pride of place among the nation's exhibiting sites. That Brown, with his relatively slender and more narrowly defined collection of objects, could have propelled the National Gallery into this improbable contest was a sign of just how successful his broader strategy would become. Tut may have gotten much of its impetus from the stylistic innovations and daring ambitions of Thomas Hoving at the Met. But by the late 1970s, Brown's management style and strategic choices had produced a whole series of changes at the National Gallery, arming it to challenge New York's City's traditional museum dominance, or at least to exasperate some of its usually self-confident leadership. He did this with every intention of exploiting the special resources at his disposal and ensuring they worked

together. "My role is that of an orchestra conductor," Brown declared in 1977, "to keep people operating in harmony."[96]

But there was also dissonance at the National Gallery in the late 1970s. And it went far beyond the internal skirmishing occasioned by Ravenel's increasing power within the museum. Within months of Tut's departure for other cities, and just weeks before the East Building's much heralded opening, the institution would be plunged into the most serious crisis of Brown's twenty-three-year administration. At its heart was a lengthy (and partly public) dispute about the character and competence of the recently installed conservation program, and an airing of the museum's responsibilities, both to its art treasures and its audiences. It would entangle and dismay the National Gallery's most significant single patron, its president, Paul Mellon. As such, it deserves a separate chapter.

Trouble in Paradise

The Light That Failed

G reat art museums do many things, as centers of research and education, producers of texts, hosts of temporary exhibitions, entertainment hubs, and tourist meccas. Nonetheless, their major claim to authority remains their collections. Authenticity and provenance are meant to be above reproach. That works of art be of high quality and created by those whose names adorn their labels, that they are maintained according to the best professional standards—these commitments must be kept. Major museums stake their reputations on this.

But judgments about authenticity and responses to condition rest on continuing evaluation and debate. Definitive conclusions can be hard to reach, and the facade of professional self-confidence is often belied by vigorous disagreements. In the twenty-first century, the public has grown more sophisticated about such matters, prompted by ongoing controversies, media discussions, and even by popular diversions like *Antiques Roadshow*. It understands that judgments must invariably be qualified, that attributions can shift. But five decades ago, institutional risks attached to opening such matters for general discussion.

Some museums acknowledged the ongoing process by offering to evaluate art and antiques. Every Wednesday for a number of years, National Gallery curator H. Lester Cooke operated an Expert Opinion Service, voicing his opinions on the value of artworks to members of the public. Often, Cooke reported, the people who came in were more interesting than their art; he did not encounter a spate of undetected masterpieces.[1] Setting up court near the Fourth Street lobby, surrounded by encyclope-

dias and journals, Cooke, assisted by graduate students and Gallery fellows, would bring the (often) bad news to eager owners. Carter Brown referred to it as Cooke's Cabinet of Dr. Caligari, although some of the younger staff, like C. Douglas Lewis Jr., who would become curator of sculpture, found the experience of immense use.[2] This service would be stopped by the trustees in 1971, citing construction issues associated with the East Building; they were, however, probably more concerned that legal liability might arise from the judgments made by staff, and there were indeed lawsuits.

Offering advice to others was one thing, but reexamining one's own collection was another. During its first thirty years of life, the National Gallery of Art was cautious about interrogating the authorship of its paintings and sculpture. "If the donor had an exaggerated view" of who the art was by, Brown remarked decades later, director John Walker "was not going to rain on that donor's parade."[3] Eager not to offend the Kress Foundation or any of his other major donors, Walker "strenuously edited" the revised attributions offered by some of his curators, notably Charles Seymour, his curator of sculpture. Seymour's eventual successor, Douglas Lewis, argued that this kind of suppression divided the staff and sent some curators back to universities where freedom of speech still obtained.[4] Seymour did return to Yale, leaving the Gallery without a curator of sculpture for decades. Dependent upon gifts and donor goodwill, and sensitive to the costs of bad publicity, museums were often slow to challenge attributions owners assigned (or got assigned) to their art. As for the failure to develop a systematic, well-supported conservation department, tight budgets, as well as innate caution, discouraged such expansion. For a long time after World War II, trained conservators were scarce, and some museum officials feared the effects of aggressive intervention. Angry debates about methods of restoration had been going on for centuries. A conservation department was expensive and potentially disruptive, and the National Gallery turned to outside specialists when it needed help.

As a young director sympathetic to scientific research, Brown determined to leave behind this tradition of passivity and acquiescence. The first signs of change came in a series of well-publicized reattributions, which emphasized the Gallery's (recent) commitment to transparency. In August 1970, writing an admiring piece for the *Washington Post* on Brown's first year as director, Paul Richard foresaw changes in the "tone

of staid and measured grandeur" that the National Gallery projected. On the foundation of the "exalted storerooms" built by his predecessors, Brown planned "an exhibition-generating scholarly machine." As evidence of the new scholarly rigor and public candor, Richard singled out the fresh willingness to discuss openly the questionable Vermeers the Gallery owned.[5]

Andrew Mellon had purchased the two paintings, *The Smiling Girl* and *The Lacemaker*, from the renowned British art dealer Joseph Duveen in the 1920s.[6] Curators were skeptical, and in 1947 W. R. Valentiner, a museum director and Dutch specialist who had endorsed the paintings twenty years earlier, admitted that "I made a fool of myself," and declared the two to be fakes.[7] In 1948 A. B. de Vries, another Dutch specialist, asserted that they had either been retouched to make them look like Vermeer's own work or were "premeditated falsifications." John Walker entertained his own doubts, sending the pictures to Brussels for expert examination. The investigator concluded they could not have been painted by Vermeer.[8] Further research, however, challenged this conclusion, and indicated the paintings were at least a hundred years old.

As Richard pointed out, it was not until Brown became director that these doubts became public. "There are pictures in the National Gallery that I like less than others," Brown admitted, referring to the putative Vermeers. "These are among the ones I like least."[9] Internal debate was not new, but public discussion was. Local newspapers joined the conversation. The *Washington Post* praised the National Gallery on its editorial page for not immediately removing the two suspected paintings, given the new evidence. In the end, however, the Vermeer labels would be removed.[10] Some gallerygoers and newspaper reporters scratched their heads about the reattributions. "Does one drop or hide a friend . . . when one discovers that he was adopted, or has no pedigree?" asked Alexis Lachman in a letter to the *Washington Post*. "Is the National Gallery afraid its slip will be showing?"[11] How can an object that "was beautiful enough and masterful enough yesterday to be regarded with pride and delight," asked a writer in the *Akron Beacon Journal*, today, suddenly, be nothing? "What is this mystery that only the cognoscenti, and never newspapermen, can penetrate?"[12] Alexander Fried in the *San Francisco Examiner & Chronicle* made a similar point. If "so great a museum as the National Gallery" can deal out "revised valuations," who can feel sure of anything?[13] Virtue had to be proven, again and again.[14]

Brown, however, was unafraid to risk any loss of authority that might follow from reattribution. Indeed he believed the museum should address the issue in some of its own shows. Shortly after his appointment as director, Brown visited Stanford professor Albert Elsen and stood transfixed by hundreds of photographs of Rodin drawings displayed in his office, part of Kirk Varnedoe's dissertation research.[15] Just two years later, in November 1971, the Gallery hosted *Rodin Drawings—True and False*. Organized by Elsen and Varnedoe, now a Finley Fellow in Washington, the show attracted more than sixty thousand visitors in its two-month run, and included drawings by Ernst Durig, a forger. Viewers were shown a series of unlabeled fakes and originals mixed together. A preview (requiring a forty-dollar subscription) invited guesses as to which were authentic and which counterfeit. The winner was entitled to a drawing—presumably a counterfeit—to be awarded at a French embassy reception. Katherine Kuh, as noted earlier, wrote admiringly about the show, and the new director, in the *Saturday Review*.[16]

Brown himself, some years later, acknowledged the shift. Reacting in 1989 to an editorial in *Apollo* that charged Gallery trustees with overriding academic judgments, he admitted that, "in its formative days," the National Gallery was "circumspect" about attribution questions that "might have risked the ire of key donors and potential donors."[17] But much had changed. "One of our highest priorities," he insisted, was making attributions reflect scholarly consensus. In the previous twenty years, attributions had been changed (on the advice of Gallery staff) for 173 paintings. Not one of these judgments was challenged by the trustees, Brown maintained.

More than that, starting almost at once in his directorship, Brown had defended more active methods to preserve the art on display. "Every painting in the gallery is deteriorating by virtue of the light falling on it," he declared in July 1969, just weeks after taking over.[18] Pointing proudly to laboratory research sponsored by the Gallery, he spoke about developing filters to screen out ultraviolet light and infrared rays, "reducing the radiation of the visible spectrum." Over the years he wrote a string of memos on the subject of lighting, keeping abreast of technical research, observing the efforts of other institutions to mitigate environmental effects, and sending on suggestions to his staff.[19] To ensure that future visitors would be able to view the great legacy hanging on the walls, active structural and aesthetic conservation would be required. And here

Brown set in motion what would simultaneously be one of the National Gallery's signal accomplishments and one of its most troubling ordeals. When Brown took over as director, the National Gallery had a fairly limited program of conservation. But it recognized the larger problem. As far back as 1950, when Dr. Robert Feller was appointed as a technical adviser, the Gallery had supported laboratory research into the chemistry of paints and varnishes, working with a Mellon-supported program at the Mellon Institute, a forerunner of today's Carnegie Mellon University.

Restoration methods had long excited disagreements.[20] A particularly nasty controversy erupted in the 1840s in London, when artists and critics claimed that the cleaning of old masters in the National Gallery had, in effect, destroyed them. This was not the first time that connoisseurs, artists, and curators had debated the impact of such interventions, but it produced significant action and questions in Parliament. Responding to the criticisms, the House of Commons commissioned a voluminous thousand-page report that found the damage to have been minimal. But that hardly put the matter to rest. Generations later, specialists were still debating the effects of such interventions.

These controversies did not stop art museums from developing their own conservation programs. They began to pursue the issues systematically starting in the late 1880s, when Berlin's major art museum set up the world's first museum laboratory, headed by a prominent chemist, Friedrich Rathgen. The development of X-ray technology in the following decades was succeeded by a range of ever more sophisticated techniques of analysis and visualization, aided by improved photography. In the 1920s and 1930s the British Museum, the Louvre, and the Museum of Fine Arts in Boston all created their own scientific laboratories, while Harvard, in 1925, became the first university to create a research department concerned with picture conservation. Its Fogg Museum was already a major center for such investigation and, starting in 1933, produced the first American periodical devoted to object conservation, *Technical Studies in the Fine Arts*.[21] International conferences and networking accompanied these early efforts, which were stimulated further by the devastations of World War II and the need to address a whole range of damaged buildings and art objects.

Again, London's National Gallery became the focus of attention. It had unleashed a storm of comments in 1936 and 1937 by cleaning Velázquez's *Philip IV of Spain in Brown and Silver*, but this was just a prelude

to a battle ten years later. Many of its masterpieces had been removed to Welsh mines during the war, for safety, and officials took the opportunity to have almost seventy of them cleaned. Upon their return to exhibition, which came gradually in 1946, letters of protest poured into the *Times*, claiming the paintings had been destroyed by overly aggressive treatment. In 1947 the museum decided to confront this head on and hosted *An Exhibition of Cleaned Pictures, 1936–1947*.[22] The National Gallery's director, Philip Hendy, wrote a forward to the catalog, describing in some detail what had been done. The cleaning program had actually begun in 1936, but the pace obviously quickened during the war years.[23]

Attempting to mollify hostile critics, Hendy argued that most of the Gallery's pictures were covered with nineteenth-century varnishes that had darkened the paintings and made the colors warmer.[24] This technique had been condemned almost a century earlier, but little had been done about it. Dark varnishes, Hendy went on, "by subduing contrasts, give a negative unity," which "upset[s] the balance of the artist's composition." Admitting that the cleaned pictures looked very different, Hendy argued that the dark varnish disguised the subtle transitions, tonal accents, and individualities of brushwork closely associated with great seventeenth-century painting masters. Rubens, Velázquez, and Rembrandt were particularly vulnerable to these changes. They had been repeatedly at the center of disagreements and would continue to be so decades later, in Washington.

Hendy also defended his museum's reliance upon different restorers, "remaining free to employ on any one picture the man whom it considers the best for that particular work." No two restorers employed precisely the same methods, he pointed out. The purpose of the exhibition was not simply to "do justice to the cleaned pictures" but to "bring about a higher standard of criticism." Truthful scholarship should be complemented by truthful exhibition, allowing a wide margin for "legitimate discussion." Much of the criticism came, Hendy allowed, from those who "best know and most love the pictures, in the ownership of which they have a share."

The exhibition and its catalog did not quiet debates about the ethics and methods of cleaning. But the issues raised forecast what would befall Washington's National Gallery thirty years later. During the interval, an enlarged corps of American conservators had been generated, many of them trained and nurtured by recently established programs. The 1950s

and 1960s were crucial decades. A growing consciousness of historic preservation and the needs of museum collections propelled training programs. Between 1971 and 1978, grants for conservation allocated by the National Endowment for the Arts increased tenfold. The Institute of Fine Arts at New York University opened a Conservation Center, the first graduate training program, in 1961, just as Carter Brown was finishing his training. The center was founded by Sheldon Keck, who had studied at the Fogg Art Museum and worked at the Brooklyn Museum. With his wife Caroline, he would shortly establish the conservation training program at Cooperstown, New York. Both the Fogg and the Winterthur Museum in Delaware were also administering conservation programs, although the Fogg did not supply any formal degree.

Charles Parkhurst's arrival as Brown's assistant director brought to Washington someone with special conservation experience and interest. While directing Oberlin College's Allen Memorial Art Museum in 1953, Parkhurst, along with Richard Buck, then at the Fogg Museum, established the Intermuseum Conservation Association within the Allen. Buck moved to Oberlin to direct it. The new laboratory had access to Oberlin's departments and provided services to art museums in need of conservation help. This led ultimately to an important if short-lived graduate training program, created after Parkhurst had left Oberlin. By the time of his appointment at the National Gallery, then, Parkhurst had available a new generation of American-trained specialists, contacts with many of the central figures, and Brown's agreement that the museum would reexamine the physical state of its collections.

The maturation of American conservation methods did not pass unnoticed in Europe, where a substantial number of scholars and curators remained skeptical about aggressive cleaning. Ernst Gombrich, the internationally celebrated art historian, sparred publicly with Helmut Ruhemann, one of the London National Gallery's advisers, about the prevalence of dark varnishes on the old masters and the nature of the evidence for it. Endorsing Max Friedlander's contention that the restorer's task was a thankless one, Gombrich nonetheless declared himself an opponent of "radical 'cleaning'" and concluded that the "case for conservatism is quite simply that the slow inevitable changes of time are perhaps less disruptive" of the internal relationships of an artwork "than any violent interference can be." When structure was threatened, Gombrich agreed, intervention was necessary. But the aim must remain the "conservation

of our heritage as long as possible rather than the restoration of a condition which is beyond human recall," that is, the artist's original intentions. This school of commentators, many of whom used less diplomatic language than did Gombrich, found both the arguments and methods of the restorers to be unconvincing. They increasingly stamped a love for intervention based on technical capacity, rather than aesthetic insight, as a peculiarly American vice. That curators and scholars were divided about certain of these issues on both sides of the Atlantic did little to reduce this exercise in national stereotyping.

Thus, when the National Gallery imported a brand-new team of trained specialists to attend to its conservation, it was moving onto contested ground. Parkhurst's mandate from Brown was, among other things, to improve the library, expand the photo archives, identify and help appoint scholars to the staff, and develop an in-house conservation team. Parkhurst moved ahead on all of these fronts, and raided his own previous employer, the Baltimore Museum of Art, for three specialists: Victor Covey, an "objects man" with "incredible hands"; Kay Silberfeld, a painting conservator trained by Buck whom Parkhurst had known at Oberlin and brought to Baltimore; and John Krill, a paper conservator.[25] They would be joined by William Leisher, who became the assistant paintings conservator. It was, on the whole, a young staff. Some Gallery officials, like treasurer Lloyd Hayes, could not understand why the Gallery had to invest so much in this activity, Parkhurst remembered. The pictures seemed good when they arrived, and they were best left alone. John Walker was "scared to death" by conservation, Parkhurst believed, and even Brown was prone to caution.[26] However, the new director was also willing to listen to "common sense" and acknowledge the need to move ahead. In fact, Brown had been a member of the Washington Conservation Guild since its founding in 1967. So by the early 1970s a course had been set.

As in London on earlier occasions, the storm center, for the paintings at least, would be the seventeenth century, especially Dutch and Flemish art, and more especially Rembrandt. These pictures had been largely untouched since arriving at the National Gallery, and they had since grown darker and more obscure. Some saw the origins of the crisis in a purchase made by the Gallery not long after Brown took over, in 1971. This was Peter Paul Rubens's *Deborah Kip, Wife of Sir Balthasar Gerbier, and Her Children*. Deborah Kip was the wife of a Flemish art dealer and diplomat.

Rubens lived with the family in 1629, while on a mission from the king of Spain. The picture was unfinished when Rubens left England to return to Antwerp, and some specialists believe it was completed in his workshop by one or more of his assistants. The large canvas, connected through images of the Gerbier children to a more celebrated Rubens hanging in London's National Gallery, was probably the first major purchase of the Brown regime, acquired from its British owners through Thomas Agnew and Sons, British art dealers who had a long-standing relationship with the Gallery. Geoffrey Agnew was a friend of former director John Walker and enjoyed close ties with Paul Mellon as well.

The condition of the painting when the National Gallery received it became a subject of later contention. It was dirty and certainly needed attention. For one reason or another, the Agnew restorer had not been given the task of cleaning it. The National Gallery was still assembling its own team; not until 1972 was it fully established. Mario Modestini, a prominent restorer and friend of John Walker, who had worked extensively for the Kress interests, was asked by Brown to undertake the task, but he was still in Europe when the telegram came. Concerned about the delay, Brown sent the painting to Oberlin for treatment by Richard Buck.[27] Buck, who died in 1977, supervised the cleaning and relining of the painting. There are hints that Brown wanted it back as soon as possible, so that his new acquisition, supposedly one of Rubens's greatest group portraits, could be shown to the public. But there were many condition issues, and the work took longer than anticipated.

In any event, the picture was placed on display and quickly provoked criticism, particularly from Agnew and the art historian Michael Jaffé, a Rubens specialist and adviser to the firm. In later years Agnew would complain that the relining supervised by Buck had been unsuccessful, that the picture had been overcleaned and unevenly cleaned, that too strong a solvent had been used, that its heavy varnish had been "recklessly attacked with the strong solvent," and that "Rubens's glazes in the lighter part of the central figures had probably been removed in the process." What had been a splendid Rubens, he argued, was no longer a Rubens at all.[28]

Others would dispute Agnew's charges, some contending that the painting he had sold the Gallery was far less attractive than first thought. Cleaning had simply made this clear. The dealer sought to blame the restorer for deficiencies that were part of the canvas, according to this

view. Agnew, however, had the ear of Paul Mellon and began to voice his complaints early on. Thus, for the next half dozen years, while the newly created department worked on dozens of pictures, the president of the Gallery was hearing strong criticisms.

In the meantime, broader challenges to American conservation techniques were being raised, particularly by John Brealey, who came to the United States in 1975 to head paintings conservation at the Metropolitan Museum of Art. Brealey, without formal degrees in either art history or conservation, had spent a year at the Courtauld Institute and three years traing with a German-born restorer, Dr. Johannes Hell, before going into private restoration work in the early 1950s. Highly regarded, by the 1970s his clients included the Ashmolean and Fitzwilliam Museums, in Oxford and Cambridge, the Royal Collections, J. Paul Getty, the Courtauld Institute, and Paul Mellon. He would train graduate students and curators over the next fifteen years in a series of well-attended seminars at the Metropolitan Museum of Art. His greatest triumph would come in the 1980s when he was hired by the Prado to restore Velázquez's *Las Meninas* and did so to wide enthusiasm. He would also become a highly articulate and even charismatic spokesman for minimal interference and aesthetic sensitivity, a vocal critic of what he found to be the overly aggressive intervention of American conservation specialists.[29] Interviewed by Sylvia Hochfield for an *Art News* article in 1976, Brealey threw down the gauntlet: an overemphasis "on the scientific aspects of conservation has resulted in an underemphasis on other important aspects of the work." Hochfield seemed, in her essay, to be converted by his arguments for "conservative cleaning," contrasting them with the "more stringent position" of "scientifically oriented conservators" like Sheldon Keck. Wittingly or unwittingly, Hochfield increased the polemical tone and overstated contrasts and distinctions. In an article purportedly about the need for more active support of conservation, Hochfield sounded much like a zealous Brealey convert. She argued that the Titians in the Metropolitan Museum of Art compared favorably with those in London's National Gallery because of their less drastic cleaning. The Met's pictures "are still in balance, the colors still in harmony," the "spatial relationships seem right." In the case of the London paintings, on the other hand, in the name of objectivity, "crucial esthetic decisions were made, almost offhandedly." She believed the pictures might "reflect Titian's original intentions more closely if some of the old varnish had been left alone," labeling them "ruined Titians."[30]

The level of mutual contempt often ran high. In a 1976 *Town and Country* article entitled "The Whitecoats Are Coming!" Leon Harris likened the animus of museum directors toward the scientists in their midst to the contempt King John held for his rebellious barons.[31] The year before, the former head of research at the Freer Gallery in Washington, Rutherford J. Gettens, had told one visitor that the "colossal arrogance of some museum directors like John Walker and Tom Hoving is a direct function of their scientific ignorance." Gettens's successor at the Freer, W. Thomas Chase, maintained the outspoken tradition. "It is impossible to exaggerate the fatuousness of categorical statements by curators who know less basic science than their school-age children," he remarked.

There had, indeed, been some cleaning disasters. Invited to Yale and soon involved with the development of the Yale Center for British Art, one of Paul Mellon's major benefactions, Brealey encountered one of the more notorious examples of damaging intervention. The Yale University Art Gallery was home to the celebrated Jarves collection of early Italian paintings.[32] Having been subject to hundreds of years of cleaning and repainting, these artworks seemed, in the 1950s, to be likely candidates for a strenuous, "purist" program. With the approval and active encouragement of Professor Charles Seymour, Andrew Petryn and his assistants set about removing anything not by the original hand of the artist. But the cleaning agents also sometimes damaged the original paint. Work was stopped in the early 1970s, but by then dozens of pictures had huge areas of loss, distracting viewers and promoting a sense that they had been ruined. The apparent pursuit of "honesty" had badly damaged their appearance, according to critics, although later efforts would do much to compensate for the losses.[33] The Jarves collection exemplified the trends Brealey found so troublesome, as he championed careful cleaning guided by observation and visual understanding, a focus on a painting's aesthetic qualities.[34] He battled against "complete cleaning," what he "contemptuously called archaeological or hygienic cleaning," his student, Dianne Dwyer Modestini recalled.[35]

Thus, by the mid-1970s many of the key personalities who would be involved in Washington's National Gallery controversy were already linked, and journalists were beginning to pay attention to their philosophical disputes. The National Gallery episode was precipitated by an article in the *Washington Post* written by its art reviewer, Paul Richard, in September 1977. Richard, citing the work of the Gallery's curator of

Dutch and Flemish painting, Arthur Wheelock, revealed that *The Mill*, the "most important and most often questioned Rembrandt landscape in America," had been removed from exhibition and was in the process of being cleaned.[36] It had been sold, in 1911, rather notoriously, by the Marquess of Lansdowne to Philadelphia millionaire Peter A. B. Widener for the huge sum of five hundred thousand dollars.[37] A subscription campaign was launched to save the painting for Britain, but it failed. During the nineteenth century, *The Mill* was increasingly celebrated for its golden tone, which, art historians have argued, probably owed much to the darkening of its varnish. Admired (on other grounds) by painters like J. M. W. Turner, by 1911 it needed to be "relieved of the disagreeable mess of yellow-tinted varnish with which it has at one time been smeared, presumably to give it an air of fictitious mellowness and vulnerability." These were the words of the famous critic Roger Fry.[38] The painting was sent to Berlin after Widener's purchase, where a German restorer spent just a few days removing some patches, declaring that the picture would be spoiled if the varnish were taken off.

Even then, despite the painting's enormous popularity in England and the semireligious veneration it inspired, there were some who doubted the authenticity of the unsigned and undated picture, and for much of the later twentieth century a series of experts refused to accept it as an autograph work. Nonetheless, *The Mill* had a legion of admirers, none more fervent than former National Gallery director John Walker. This claque, Paul Richard reported, "love it dirty," and know that, once cleaned "the moody landscape" would never look the same. Richard discussed the painting's storied history and, using Wheelock as his source, summarized the attribution debates. "Scholars nowadays prefer a harsher light" than the glow of *The Mill* and "want to see it clean" before settling its authorship, he wrote. The painting was to be examined carefully and minutely, under microscopes and X-rays. "Using gentle solvents and many tiny swabs," Kay Silberfeld had already created "windows" in the painting's antique varnish, Richard went on. All sorts of discoveries were being made. Silberfeld said she was not working on *The Mill* to prove who had painted it but because "the painting needed work." The lifting of its varnish might take as long as a year. This deeply loved and influential painting, one that "changed the course of English landscape art," the "darkly glowing picture" that Walker so loved, "will not be seen again."

One thing was already clear, declared Charles Parkhurst: "The painting is not brown."[39]

Richard's piece had an immediate impact. A series of influential figures—including Geoffrey Agnew, Michael Jaffé, and perhaps even more significantly, John Walker—voiced their concerns directly with Paul Mellon. In his autobiographical memoir, Mellon recalled that on reading the Richard piece, "I became very disturbed and angry to realize that as President of the Gallery I had been left to find out about the cleaning of the Rembrandt in a newspaper article. I also wondered why the conservators should have begun with, above all, what many considered one of the Gallery's most important and perhaps most controversial paintings." Walker, entering his protest with Mellon, "went white with rage, saying, 'They'll absolutely ruin it.'"[40] In late October, Mellon wrote a lengthy and highly personal letter to Brown, pointing out that he had indicated his concern about the Gallery's cleaning and restoration practices before. Referring to Agnew, Jaffé, and Brealey, he admitted that some of them held extreme positions and could be overly critical. But "stormy effusions" aside, there could be some truth in their views, and he expressed alarm that "the Trustees, you and your Staff, and myself will be held responsible for the maiming, if not the destruction, of some of our own masterpieces." Mellon requested a detailed and immediate report, noting, "it is a subject more important than anything I have been concerned with in all my years as a Trustee or as President of the Gallery."[41]

Mellon was widely admired and respected, inside and outside the Gallery, as judicious and circumspect. He had been involved for decades with art dealers and academics and was aware of the poisonous disputes and incessant gossip that were part of both these cultures. He had refrained from interfering with professional decision making, leaving such matters in the hands of the staff. In 1977 and 1978, the protracted, eleven-year project of constructing the East Building was finally drawing to what seemed to be a triumphant, if costly, conclusion. This was not the time to be distracted by an internal dispute.

But Mellon was consumed by the accountability the trustees had incurred as guardians of the art collections. In March 1978, six months after Richard's article had appeared, he invited Agnew, Jaffé, and Mario Modestini, the art restorer employed by the Kress Foundation and so closely involved with Brown and the purchase of the Leonardo *Ginevra*, to come

to Washington and give their impressions of the Gallery's conservation program.[42] Just before their arrival, in April, he ordered all conservation work halted immediately and indefinitely. Brown's earlier report to Mellon does not seem to have survived. The staffing of conservation had been largely the work of Charles Parkhurst, but Parkhurst was Brown's trusted deputy, and Brown relied on his judgment. In effect, during the coming firestorm Brown largely absented himself and let Parkhurst take on the role of mediating between the staff and the Gallery president. By now, almost ten years into the director's job, Brown may well have realized the potential costs to his staff of Mellon's decision to call a moratorium on conservation. But he was always deferential toward his superiors, and the role Mellon played in the Gallery made him even more indispensable to its continued success than Brown himself.

Agnew, Jaffé, and Modestini made a multiday visit to the Gallery's laboratory during the first week of May and issued their reports to Mellon over the next few weeks. Although a number of trustees had visited the conservation department the previous January and indicated their satisfaction with the lab, Mellon's anxiety level remained high, and he paid for the costs of this temporary visiting committee personally.

The decision to invite those making charges to perform the investigation had predictable results. Staff members, who claimed that they were caught totally by surprise, since earlier comments about their work from trustees had been uniformly favorable, felt their professional qualifications were being put on trial. Their reactions ranged from discomfort to fury. This anger had been growing for a year, ever since May 12, 1977, when John Brealey came down for lunch and a short meeting. Brealey was already viewed suspiciously by the staff because of his broad attacks on American conservation methods. According to an account by Joyce Hill Stoner, a prominent Delaware conservator who knew and admired Brealey but was also sympathetic to American training methods, the meeting was bedeviled by a series of misunderstandings.[43] Arriving by train, Brealey went through the galleries and then had lunch with the conservators, whom he had not previously met. All would have been well had he left at that point, Stoner asserted, and apparently he wanted to, but his return ticket was for much later in the afternoon and Parkhurst invited him back to the "lab," a term Brealey detested. On the day of the visit, for some reason the conservators' easels were not in the room and the pictures were lying flat. This was not normally the case. *The Mill* could not

be turned over by Kay Silberfeld, possibly because it was resting on tissue paper while it was being treated. Brealey got angry and told Stoner it was like visiting a room where small animals were taken to be put to sleep. He was insistent that pictures had to be treated on an easel, rather than lying flat, emphasized the need to have artists rather than scientists involved in restoration, and delivered some of the sweeping generalizations he enjoyed making. Back in New York he investigated Silberfeld's training and grew highly critical of her participation. Parkhurst, who disliked Brealey on sight, had asked him down because he felt it helpful to "know your enemy."[44] He was also concerned that Brealey had the ear of Mellon and would transmit to him his unhappiness with Gallery methods. But the stratagem did not work out.

The visit, a year later, by Agnew, Jaffé, and Modestini was even less pleasant and much more consequential. The three guests spent May 2–5 in Washington, then lunched with the trustees to share their reactions. They were not favorable. The written reports revealed lots of hostility to the staff and skepticism about their approach to restoration. The origins of their antagonism went back a long way. Opening his comments, Agnew addressed Mellon directly, saying he was eager to accept the invitation to visit because he wanted to do all in his power "to prevent the same fate befalling the great collection at Washington as happened to the pictures at the National Gallery in London during the past thirty years."[45] The results there, Agnew insisted, against the weight of most professional evidence, not only had been counter to "the artists' original intentions" but, in some cases, "had actually caused damage." This position should have tipped Mellon off to Agnew's partisanship.

Agnew continued in words that could have been endorsed by some of the American specialists. Cleaning "is primarily an artistic process which makes secondary use of scientific aids and analysis." The good restorer must be an artist knowledgeable about and sympathetic to the methods and aims of the painter "on whose picture he is working." The fact that the principal painting restorer in Washington was a woman did nothing to change Agnew's gendered language.

After his preliminary comments, Agnew moved on to individual paintings. Rubens's portrait of the Gerbier family, the picture he had sold the Gallery, excited his particular contempt (Agnew's comments about the "reckless" attack on its varnish were quoted earlier). He went on to criticize the space used by the conservators, located in the West Building

where the old cafeteria had been. Agnew declared his shock at how dark it was, even on a brilliant day, and was concerned about the use of fluorescent lights to supplement the inadequate daylight. More than that he was disturbed (like Brealey) by the fact that cleaning was carried out with the paintings lying flat. His recommendation, for both the Rubens and the Rembrandt *Mill*, was to turn them over to Modestini for relining, judicious cleaning, retouching, and gentle varnish removal, all in the interest of restoring the tonal balance. While he was unimpressed by William Leisher's cleaning of Chardin's *Soap Bubbles*, he thought Leisher was "more modest and receptive" than Silberfeld: "He might be able to learn."

It was on Silberfeld that Agnew turned his big guns. She seemed "frightened" by the next stage of cleaning the Rembrandt, and in general was "far too set in the methods of pseudo-scientific cleaning and I could see no possible way in which her practices could be altered." Her treatment of other pictures—by Thomas Cole, by Degas, by Monet, by Bronzino, by van Dyck, among others—betrayed, to Agnew's eyes, clumsiness, bad judgment, and amateurish techniques. Waiting to be treated were a Raphael, a Tintoretto, and another Rembrandt. His larger conclusion was damning. "My examination of all these pictures fully confirmed my view that the present Conservation Department is not competent and could prove very dangerous." A "completely new start has to be made." It would take several years to build up a new department, and Agnew recommended several candidates, some of them English-trained, some of them students of Brealey. So far as a restorer was concerned, Agnew proposed a favorite pupil of Modestini, Gabrielle Kopelman, who had worked extensively for art dealers. By implication, he was urging the Gallery to fire the entire staff. Mellon's decision to stop their work (not yet formally confirmed by the director, although it would be by early June) was both "timely" and "courageous."

As negative as Agnew's comments were, Michael Jaffé was even harsher.[46] He sharply attacked Richard Buck's work on the Rubens Gerbier portrait, as well as Buck's explanation of what had been done to the picture. (Buck was no longer alive to defend himself.) "His report, garrulous enough on many pages, is silent on what experiments he tried before wholesale removal of the shellac layer." Jaffé repeated the charge that the picture was not in need of such massive intervention. It "had not before been so brutally maltreated as it looks today." The "painting has been

vandalised worse than if it had been slashed by a madman. It should not be exhibited again until properly restored." What was needed as soon as possible was "the minimising of the more disastrous effects of maltreatment." In view of the visitors' emphasis on working with the painting on an easel rather than flat, and the suspicion of American methods, it was ironic, as Leisher pointed out in a note to Parkhurst a couple of months later, that the Gerbier painting had, in fact, been cleaned on an easel, in an upright position, and that, although Buck had supervised, both the cleaning and in-painting had been done by two Europeans in residence at the Oberlin lab.[47]

So far as Rembrandt's *Mill* was concerned, Jaffé repeated the complaint that Silberfeld cleaned "horizontally," robbing her of any visual control. She worked by cold and artificial light, although he admitted there was no real alternative since the conservation studio lacked any natural top light. Her "running consultations" with specialists, however useful, could not substitute for "well trained skills, relevant aesthetic experience, moral stamina, and the temperament required of any leading restorer." Her Degas restoration was "appalling," Rembrandt's *Saskia* "hard to believe," and the Sano de Pietro *Madonna and Child*—so "precious and rare," a "pristine" example—had been marred by varnishing. Like Agnew, Jaffé proposed a rebuilding of the staff with a new chief restorer capable of recognizing his limitations and prepared to invite others to help on complex jobs like *The Mill*.

Mario Modestini's comments were somewhat more measured than the observations of Jaffé and Agnew, but their direction was similar.[48] The Rubens cleaning was "a disservice to the work of art," although he admitted that the damage done by recent cleanings should not be exaggerated. There seemed to him little reason to turn to American-trained conservators in reconstructing the department. The restorers in charge of the existing centers were mediocre at best. Studios, not schools, were where the art of restoration was best learned. Writing at the very end of May, Modestini appeared to assume that changes would be made quickly. To that end, he advanced the cause of his own assistant, Koppelman, suggesting she be given a free hand to fire people and make work assignments.

With these devastating reports submitted (though it is not clear the assistant director had yet seen them), Parkhurst sent Brown a memo dated May 26, which included staff responses to the visits of several

weeks earlier, as well as his own observations.[49] The whole affair, "though born of good and sincere desires on Mr. Mellon's part," was a miscalculation "born on English soil and largely self-serving in its general character." In essence it was an attack on the past and present conservation practices of the National Gallery, Parkhurst continued, and seemed often to be entirely unreasonable. Jaffé's comments when they were standing in front of the Rubens were "almost libelous . . . vicious, full of error, and spiked with innuendo. . . . The whole event was uncouth and unfeeling, . . . extremely unsettling" to the staff, and even frightening to them. By this time, Parkhurst had received two memos from Brown on the subject of the cessation of cleaning at the Gallery, but he had not yet passed them on to the staff, because "at this moment of pressure and fatigue it might be devastating to morale."

Parkhurst enclosed, along with his own comments, the reactions of three staff members present at the visit, William Leisher, Kay Silberfeld, and curator Arthur Wheelock.[50] All three professed confusion at some of the questions posed by the visitors and were surprised by their reactions, particularly to *The Mill*'s erstwhile "golden glow." Silberfeld gave a detailed account of the questions and answers, and summarized her confrontation with Agnew about whether or not she had done something to the painting. Defending his department, Parkhurst suggested to Brown that the best thing might be to invite a group of reputable American specialists, who might be more sympathetic, to inspect the work of the staff. Their report, he felt, could well mollify Mellon and other trustees. "When do you expect PM to tell us what is on his mind?" Parkhurst asked as he closed his memorandum.[51]

Meanwhile, picking up on the comments of the visitors, Paul Mellon had begun to question the location and character of the Gallery's conservation lab. In a memo to Parkhurst, Brown reported that Mellon wished the lab to have light levels that matched the West Building's painting galleries and wondered why no experts had been consulted on the location for the new lab.[52] Brown told Mellon that he himself wanted natural north light and was surprised to learn of the need for supplementing it with fluorescent lamps. But he explained that paintings were taken up to the galleries, as needed, to check on their appearance. Mellon responded that natural light was a necessity and directed Brown to find a suitable place within the gallery complex. Brown recalled that at one time the East Building was to have had a conservation studio at its very top, but it had

been crowded out by mechanical equipment, which consumed the entire top floor of the study center. In an interview some years later, Silberfeld recalled her disappointment on being separated from the curators who were moved to the East Building.[53] There had also been an effort to place a lab in unfinished space over the Fourth Street lobby ceiling in the West Building, but that had been abandoned when the cost estimates came in. Mellon seemed determined to have the whole conservation facility moved somewhere, regardless of the costs. Brown emphasized the need to coordinate any such plan with the larger flow of objects within the Gallery, from shipping dock through registrar and photo lab and back. He also noted that with the new government indemnification program, so central to future temporary exhibitions, the Gallery could not be too careful about its planning. However, he advised Parkhurst that once the East Building opened (only weeks away), it might be well to consider creation of a new space.

The laboratory location had been chosen, however, long before Silberfeld and Victor Covey came to the Gallery, as Covey wrote Parkhurst weeks later, after reading Brown's May 22 memo.[54] It was the fourth lab that he had installed, and far from having ignored expert advice, he and others had worked closely with Robert Feller, the longtime Mellon-supported chemist conservator working in Pittsburgh. It had been visited by many specialists before the arrival of Modestini, and had never provoked any criticism. The charges made by Modestini, Agnew, and Jaffé, in short, seemed misplaced, at best.

By the end of May, shock waves from the developing controversy had spread through the American conservation world. The staff had not been slow to tell colleagues about the moratorium and the disastrous visits. "None of the reputations are safe of any of the conservators who have worked here over the past six or eight years," sculptor curator Douglas Lewis wrote to Arthur Beale, who headed the Fogg Museum's conservation program.[55] Lewis found the origin of the nastiest comments to lie in New York. Rumors were flying everywhere. According to one staff member, Mary Davis, who directed the Kress Foundation, was quoted as saying, "There is a great scandal going on . . . the National Gallery is having their 'Watergate.' They don't want anyone to know what they are doing to 'The Mill.'"[56] What was happening to the Widener pictures, she went on, was absolutely scandalous. Davis had long been wary of Gallery conservation. In 1973 she had written Carter Brown complaining that a chief

conservator had been appointed without even referring his credentials to the Kress Foundation, "a violation of our Indenture, in spirit if not in the actual word."[57] The fact that Franklin Murphy was simultaneously chairman of the foundation and a member of the Gallery board did nothing to relieve her anxiety. She wanted Mario Modestini brought to Washington for a consultation and asked for biographical details on Victor Covey.

At the end of June, Charles Parkhurst urged the staff to exercise discretion about reporting meetings with senior officials, including the director.[58] And he pointed out that leaks might damage their case. A piece by Benjamin Forgey in the *Washington Star* for July 9, 1978, had already spread knowledge about the affair.[59] Arguing that the professional futures of Silberfeld, Leisher, and Covey were at stake, Forgey said the situation was unprecedented; he could not recall a similar one at any other museum. He reported on the recently imposed moratorium, meant to last until the next trustees meeting in October, and summarized the struggle between two schools of conservation thought, one typified by John Brealey, the other identified with the American centers at Oberlin and Cooperstown. Forgey, like Hochfield three years earlier, singled out the growing sums of money being committed to conservation and outlined the difficult choices facing restorers. His account of the competing philosophies was more balanced than Hochfield's essay had been, but he pointed out quite explicitly that the National Gallery staff were all American-trained.

Copies of Forgey's article were sent to the Gallery trustees and to officials at the Mellon Foundation. And Brown, who was quoted by Forgey at being pleased with the progress of *The Mill*'s cleaning, was contacted by Chief Justice Warren Burger, titular chair of the Gallery board. Brown told the jurist that Mellon wanted him brought up to date and summarized matters. Burger was philosophical. Observing that people often got dug in and opinions polarized, he expressed total confidence in Mellon's judgment about what to do, and declared he would support whatever decisions he recommended.[60] Franklin Murphy, the board member who was also the Kress Foundation chairman, told Brown he had never known Mellon to be more deeply committed to an issue.[61] Murphy expressed great confidence in Mario Modestini. Indeed, when Mellon wanted to include Brealey among the official visitors in May, Murphy persuaded him to send Modestini instead.

In case anyone had missed the Forgey article, several days later Jo Ann

Lewis published her own piece, "The Restoration Conflict and the National Gallery of Art," in the *Washington Post*. She focused on an unsigned memo (presumably by Brown) sent out a day or two earlier to international, national, and local conservation leaders, summarizing a meeting of the Washington Conservation Guild. It laid out a six-year struggle at the Gallery and described the Rubens controversy, the visit by the three specialists, their "accusatory" questions, and the substance of their reports. The Gallery staff still claimed to be unaware of any charges having been brought against them.[62]

Brown was quoted extensively by Lewis, saying that philosophical differences had been discussed openly with the staff, and suggesting that his own sympathies lay with the aesthetic rather than the scientific side. "My own view happens to be that consideration of natural light and the tonal balance of the work of art have been underemphasized in much of American conservation in recent decades," Brown declared. He also defended the trustees' intervention as appropriate, given their responsibilities. "That is where the buck stops. It is clear ... that the president of the board of trustees, in this case Mr. Mellon, is the chief executive officer." There was some special sensitivity to this issue because the American Association of Museums had published, just a month earlier, a report on museum ethics, three years in the making, which attempted to define the relationship between trustees and directors. "Trustees should not attempt to act in their original capacities," the report stated. "All actions should be taken as a board, committee, or sub-committee, in conformance with the bylaws of applicable resolutions." When Lewis reached Brown just before her story was printed, he declared that there was no question of trustee interference. Paul Mellon was the chief executive officer, even over the director. There was no disputing his authority.

Some years earlier another professional group, the Association of Art Museum Directors, had published a report stating that the museum director was responsible for "supervising the activities of the staff," creating the working conditions that "will enable staff members to perform to the full extent of their abilities." Brown had been a member of that committee. At least one correspondent, Clements L. Robertson, conservator at the St. Louis Museum of Art, angrily complained to Brown that the museum director's professional judgment, and the judgments of Parkhurst, Wheelock, Covey, and others, should not be challenged by trustees or "other subjective, arbitrary, opinionated outside influences."[63]

By this time, mid-July, it was also public knowledge—confirmed by Brown—that in the fall Koppelman would probably come to Washington as a full-time Gallery employee and start to train a new corps of assistants, chosen from art schools rather than conservation institutes.[64] A month earlier, Paul Mellon had written Modestini expressing his enthusiasm for Koppelman, his pleasure in her view that the current laboratory was adequate, and his expectation that the trustees would soon take action on her appointment.[65] Telephone calls and memos began to pile up, commenting upon Koppelman's abilities, some admiring her craftsmanship and skillful in-painting, others warning that she might be prone to overfinishing and worrying that her outspoken contempt for American conservation methods would set back the National Gallery program by many years.

In one document, dated June 14 (no year is indicated), a staff member created an annotated chronology that includes a summary of a meeting of the conservators with Brown about the crisis. Brown informed them that Modestini and Koppelman would be making a visit, with Mellon, to look at the lab, particularly its lighting, and that he expected the staff to accommodate Mellon's wishes and avoid a confrontation. He declared, according to this anonymous source, that Mellon could "scatter us (including himself) to the four winds. He went on to comment that Mellon like all wealthy men is accustomed to having his own way. He grew up with people taking action on his every whisper."[66] The paraphrase does not read at all like Carter Brown, but the summary, accurate or inaccurate, suggests the anxiety that had set in.

And this was reflected more generally. The memorandum, the visits, and the newspaper articles, as well as the contacts initiated by Gallery staff, brought a deluge of letters and telephone calls, particularly from professional conservators resenting the aspersions cast upon American training methods and the attacks on their colleagues in Washington. Some went to Brown, others directly to Mellon. Among those writing to Brown, protesting the treatment of the staff and commenting (favorably) upon the treatment being given to *The Mill*, were Ross Merrill, paintings conservator at the Cleveland Museum of Art, Robert Scott Wiles, conservator at the Corcoran in Washington, and Elizabeth Packard, the retired conservator at the Walters in Baltimore.[67] An alarmed assistant paper conservator sent a memo to Parkhurst reporting that Dillon Ripley seemed knowledgeable about most of the details and had been telling

a Smithsonian conservator to be sure to clean paintings on an easel, in an upright position.[68] One letter, which had immediate consequence, came from Sheldon Keck at Cooperstown, a leader, recognized by both admirers and detractors, of the reigning system of conservation training. Keck addressed himself to Covey and Silberfeld, acknowledging receipt of the articles and the memo they had sent him and arguing that there was a commercial connection linking Jaffé, Agnew, and Modestini that merited greater attention. Angrily, Keck went on to denounce Mellon's intervention. Perhaps "Mellon will eventually be made to realize that the Gallery as a national institution has a public obligation."[69]

Mellon could not let this pass unnoticed. A week later he wrote directly to Keck, declaring that he had imposed the moratorium precisely because of a public obligation.[70] As the chief executive officer he was responsible for the care and security of the artworks. Various people had expressed their concerns to him. "Even the slightest shadow of a doubt" suggested a need to stop and count to ten. The resulting decline in staff morale was unfortunate but less important than ensuring that current practices were correct. Mellon ended with something of a rhetorical flourish (his letter was elegantly crafted), declaring that he couldn't say if he might "eventually be made to realize" that current staff and care were ideal. But that he was "ignorant of the National Gallery's or my own responsibility to the nation and to the public is an accusation that I object to vehemently."

Keck replied, contritely, almost at once.[71] He acknowledged Mellon's sense of responsibility and apologized for the comment. "I hope you will consider the statement withdrawn and assure you that it will not be repeated." He ended by expressing the hope that a "truly non-partisan" committee could conduct an inquiry, something Brown thought improbable by this time. In fact, Keck would be asked, weeks later, to participate in such an effort.

It was really Parkhurst who undertook to find a solution. Sensitive to the collapse of staff morale, peppered by memos expressing shock and indignation, aware that the museum's reputation was suffering, conscious of his own part in shaping the conservation program, he developed a course of action. Brown left him largely to his own devices. Leisher, Silberfeld, and Covey complained that they had seen no charges, that Mellon had visited the lab just twice to see work in progress, and that Brown himself had come by only rarely, at least until recently. The

attitudes and practices of Gabrielle Koppelman were incompatible with their own, they told Parkhurst, and they would be unable to work with her.[72] It was basically an ultimatum. No commitments could be made. When Victor Covey received an inquiry from the keeper of conservation at the Tate Gallery in London, he responded in a letter draft he shared with Parkhurst that he could not accept any interns at the National Gallery in 1979. "I really do not know what to say about the present chaotic situation here at the present time or what the future holds for me or my conservators. The whole thing is like a nightmare. How anything like this can happen without one charge of wrong doing or any damage to any painting we have ever treated, quite frankly, does not make any sense to me."[73] Why Paul Mellon could listen to a dealer, an art historian, and two restorers who had been critical of almost every existing conservation program, was beyond understanding. "It certainly shows how a misuse of friendship with a financially powerful man can be used in a most destructive manner." If he and his staff were removed, Covey warned, it could mean the "demise of all training programs in this country and a return to 19th century methods in the treatment of paintings."

This was not, however, the letter Covey sent. Parkhurst, a shrewd and experienced administrator anxious to reduce all signs of hysteria, suggested a shorter note saying simply that when things cleared up he would see about accepting interns in 1979–1980. And Covey apparently agreed.

But even as he worked to calm feelings, Parkhurst was deeply upset by Mellon's intervention and determined to do something about it. At the end of July, he prepared for himself a methodically ordered and numbered set of notes covering the controversy's history.[74] He began by confessing he would be derelict in his professional duties if he didn't express to his superiors the conviction that a wrong was being done to the staff, that the National Gallery was being put, unjustifiably, in a bad light, and that an entirely inappropriate conservation program was being proposed as a new departure. The moratorium on conservation work had left his colleagues depressed and demoralized, and the action had implications for curators as well. There had been no malpractice at all, Parkhurst wrote. Practices at the National Gallery were no different than they were at the Louvre or the Rijksmuseum or the Cleveland Museum of Art, perhaps even more conservative than most.

Parkhurst went on to summarize Brealey's philosophy in a way that

could well be termed inaccurate and overdrawn. Brealey, according to Parkhurst, sought to hide the hand of the restorer; his approach was better suited to commercial interests who were focused on surface effects than to scholarship. It was a point of view, he argued, that should not be endorsed by the National Gallery of Art.

Even while presenting what was arguably a caricature of Brealey (who was not himself driven by economic gain), Parkhurst confided to his notes, more sensibly, the notion that false polarities had been created, oversimplified dualisms—European versus American, aesthetic versus scientific—that complicated efforts to move beyond the immediate controversy. In terms of what should be done, Parkhurst believed that the moratorium should be lifted, an acceptable due process reinserted (getting the president and the director into the lab more regularly and inserting them into an approval procedure), a show-and-tell produced for the senior officers at least once a year, a group of experts empaneled to evaluate the situation, and finally, the pursuit of Gabrielle Koppelman dropped for good. Many in the field considered Koppelman an excellent conservator, with impressive technical skills. For Parkhurst, deeply upset by ongoing events, she represented commercial values and cosmetic methods. The National Gallery should commit itself to true preservation, that is, removing as little as possible of a painting's protective coatings so as to reveal the original picture and making that picture presentable with the minimum of additions to avoid distracting the viewer.

Parkhurst's reflections anticipated the course events would take. But this required a direct exchange with Paul Mellon. And that could take place only with Brown's approval; Parkhurst accepted the Gallery's authority structure. On June 28, then, a month before he prepared his notes, he wrote to Mellon, explaining that he had been in touch with Brown and enclosing a copy of a report he had prepared. He was responding to Mellon's proposal to establish an in-painting training center at the Gallery, presumably to involve Koppelman. Parkhurst's report centered on the costs of creating such a center, the need for space to house it, and other relevant matters. He estimated it would consume at least a million dollars a year, and he questioned Koppelman's qualifications and salary. But he took the occasion to address Mellon directly about the ongoing situation. Shrewdly, he sought to deflect Mellon's notion of bringing in a newcomer to establish a new program by pointing to the Gallery's national function. He praised Mellon's desire to establish a center to train

apprentices for in-painting and cleaning but argued that conservation involved far more than that. It required training in structural evaluation as well. In-painting was only one of many skills. The "Gallery needs a stable, broad and on-going conservation program," he wrote. "We should act to assure the Gallery of its national leadership role, and the confidence of the profession. May we work together with you and the Board of Trustees to keep the leadership in the National Gallery where it belongs? I think we should." Thus Parkhurst ended his letter, seeking to turn a developing disaster into a real opportunity.[75]

Parkhurst also put some tactical pressure on his immediate boss, who had been getting letters of inquiry from significant congressional figures like Sidney Yates.[76] He reminded Brown that the Gallery would soon face its periodic accreditation review by the American Association of Museums. He doubted accreditation could be denied but pointed out that the museum was open to criticism, given the "ambiguities caused by a top management and policy level officer entering the structure at a lower, operating, level and taking action," as well as an assault on established conservation principles seemingly instigated by self-serving non-Americans, resulting in a demoralized staff and a dysfunctional conservation function. "These may or may not be cited," Parkhurst admitted. But "museums are thoroughly analyzed in the accreditation process for any signs of instability."[77] The inference to be drawn was that the Gallery needed to clarify the status of its conservation staff and return to more stable procedures.

Not long after getting Parkhurst's letter, Paul Mellon called and said he wanted to talk. According to Parkhurst, Mellon declared, "I am sympathetic and understand why you are upset."[78] He was off for several weeks to Wyoming and not personally available, but he deputized fellow trustee Jack Stevenson to confer with Parkhurst. As angry letters continued to pour in from friends and admirers of the conservation staff, a solution slowly inched forward. On August 14, Brown noted Mellon's communication that the trustees wanted additional advice and sought to bring to Washington a set of experts who would examine what had been done and create a report before September 14, when the acquisitions committee would meet.[79] The whole board would be meeting in October. Mellon suggested some specific names, and the same day Brown invited Everett Fahy, George Heard Hamilton, Robert L. Feller, Sydney Freedberg, Sherman Lee, Otto Wittmann, John Walsh, Sheldon Keck,

A. B. De Vries, and Hubert von Sonnenburg to participate. (He later moved the report date to October 20.) All accepted, submitted written reports, and in several cases were invited for interviews after having completed their written statements.

The panel included curators, museum directors, conservators, and academics, some of them known to be sympathetic with American conservation methods, and some known to be critical. Gallery staff, who continued to be on edge and send memoranda on a variety of subjects to Parkhurst, were not happy about all of the choices and missed no opportunity to suggest where there might be hostile bias. Kay Silberfeld, concerned about Brealey's influence, pointed out that Wittmann had avoided using the Oberlin facility to clean his Toledo paintings, and feared that Freedberg would be hostile because of his admiration for Everett Fahy, who was even more critical of the Gallery.[80]

But it was a distinguished assemblage, and each member of the group made an inspection visit. Their filed letters revealed strongly held differences, and Mellon, familiar with the range of academic judgments, admitted he was unsurprised by the presence of disagreement.[81] The overall tone, however, was quite different from the Agnew-Jaffé-Modestini comments of months earlier. Each of the panelists talked about both a series of individual works—by Rembrandt, Hobbema, Thomas Cole, Degas, George Caleb Bingham, van Ostade, and Winslow Homer, among others—and then offered a general judgment about the larger program.[82]

There remained naysayers. Everett Fahy, at the time director of the Frick Collection, was probably the most critical of all the commentators, explicitly endorsing the earlier views of Jaffé and Modestini. While most pictures, he conceded, were perfectly presentable, they did not pose insurmountable problems and thus did not require extraordinary abilities. But several—the Hobbema, the Manet, the Rembrandt *Mill*—raised questions both about the "skills of the Gallery's restorers" and, even more importantly, about "the competence of the Gallery's curators." The Hobbema *Village Near a Pool* should not be exhibited. Only if the Gallery had in place a gifted restorer would it have made sense to have cleaned the painting so thoroughly when it was already in a bad state of preservation. Similar errors of judgment had led to the work on *The Mill*. "Granted," Fahy wrote, "little irreparable harm has been done." But given what had already transpired with the Hobbema, the picture should not have been given to the same restorer. The fault lay with the curators, he insisted;

it was their obligation to monitor the work of conservation, and they should have objected to what had been done. There were other negative comments on a series of works: Monet's *Morning Haze* and Manet's *Bal de l'Opera* were both "unacceptable," a word Fahy used a number of times. A Byzantine *Enthroned Madonna* demonstrated incompetent craftsmanship, with some of its gold gone. Degas's *Madame René de Gas* suffered from not having blotchy gray areas removed. And, worst of all, Sano di Pietro's *Madonna and Child*, one of the few panel paintings in the United States that had retained its original tempera surface, had now been varnished. Fahy declared himself "appalled" by this.

Sydney Freedberg, the Harvard art historian who, several years later, would come to work at the National Gallery at Brown's behest, was more moderate in tone. He liked the appearance of Cole's famous quartet, *The Voyage of Life*, but was unhappy with the support; cracks had reappeared suggesting an unsatisfactory relining. Bingham's *Jolly Flatboatmen*, an American icon, also presented an excellent appearance despite one disfiguring vertical crack. Several other pictures showed "absolutely excellent repair." Manet's *Bal de l'Opera* seemed "sound" in surface and structure, but it was more "harshly brilliant" than expected. Contrary to the earlier comments of the British specialists, Bronzino's *Woman and Boy* was almost completely satisfactory; the boy's eyes had not been disfigured by restoration or overpainting. The varnishing of the Sano di Pietro was regrettable, Freedberg admitted, but the new varnishing was minimal and not obtrusive. And the hub of the crisis, Rembrandt's *Mill*, was significantly improved from its earlier state. "Its problems are inherent and they may not be correctable," a combination of Rembrandt's own techniques and chemical aging. "It is, as you can see from the above, a very mixed bag" Freedberg concluded, "more often than not adequate or satisfactory, occasionally excellent, and in a few instances below acceptable standard." A museum "of modest stature, might content itself," but the National Gallery requires a standard "nothing less than the very best."

Freedberg's summation, gracefully phrased, echoed Parkhurst's thoughts. The so-called antithesis between the scientific and artisanal schools of conservation was false. Neither could function without the other, Freedberg insisted. The scientist without "consummate skill of hand and sensitivity of eye can inflict harm upon the works he deals with; the 'artisan,' no matter what his sensibility and manual control, can just

as easily damage if he has unsound information. . . . The opposing schools would do better to proceed in mutual respect rather than in hostility."

The third commentator whose thrust was negative, somewhere between the views of Fahy and Freedberg, was Hubert von Sonnenburg, who, before Brealey, had overseen the Met's paintings conservation department. Sonnenburg, who cleaned and conserved many of the Met's greatest masterpieces, held a PhD in art history and trained as a restorer in Munich and London. Some on the Gallery staff were unhappy about his inclusion on the panel, for he was a friend of Brealey. Sonnenburg expressed his doubts about a series of cleaned paintings in strong terms. His report began, however, by stating simply that there was no evidence of any irreparable damage and that no picture had been ruined. He did feel that the Hobbema and a Manet had been overcleaned, and that varnish removal had been done in a "mechanical way." The Hobbema's treatment, in fact, was "clearly not up to the standards of any reputable public collection," and "evidence of an astounding shortcoming of the aesthetical aspects and the philosophy of the conservation trend becomes quite apparent." There were other examples of this, but Sonnenburg reported himself "pleasantly surprised" to see *The Mill*. There was no fundamental damage, and while some aspects of the picture seemed out of key, it would be possible to bring the painting back into balance at some future point when "a qualified restorer" had been identified.

The other members of the panel offered rather different reactions, both to individual paintings and to the staff. The Dutch specialist A. B. de Vries insisted that cleaning *The Mill* had been necessary and that he had tried without success to persuade John Walker of this need. Intervention was a wise decision. Elaborating further (by telephone), De Vries declared himself "100% without reservation for Miss Silberfeld's work." Not stopping there, he said that he found Michael Jaffé too "unreliable," Mario Modestini, while an "able virtuoso," "very vain," and Geoffrey Agnew "a man without eyes." George Heard Hamilton, a retired Yale and Williams College art historian and director emeritus of the Clark Art Institute in Williamstown, concluded that *The Mill* looked more like it had when Rembrandt painted it than at any time in the last two hundred years. As a result of the cleaning, it had gained a "strange spirituality." Some of the other paintings may well have raised questions, but Hamilton declared that both his first impressions and his final conclusions were

that "the paintings under consideration had been handled with caution, intelligence, experience, skill, and taste."

Otto Wittmann, the longtime director of the Toledo Art Museum, offered a series of specific judgments on individual paintings. No conservator himself, he concentrated on surface appearance. His praise was more constrained than Hamilton's. Where simple and direct cleaning was the need, Gallery conservators had done well. Cole's *Voyage of Life* was greatly improved; works by Manet, Bingham, Puvis de Chavannes, Braque, Homer, and Picasso all seemed capably restored. But the more complex Dutch paintings of the seventeenth century were another matter. Here Wittmann admitted evaluation was difficult. Hobbema's *Village Near a Pool* and Rembrandt's *Saskia* seemed out of balance to him, and he was unhappy about the Degas and the Monet *Morning Haze*. But *The Mill*, more difficult to judge, needed some kind of treatment. Overall, Wittmann expressed confidence in the staff; more experience would prepare them to handle more complex pictures. "Perhaps the conclusion might be that the conservation staff should be enlarged and the leadership strengthened with the addition of a Chief Conservator of Painting who would have greater experience with and knowledge of European painting." Wittmann accepted the important role of scientific approaches to conservation, but he came down on the side of sympathetic insight into the artist's original intentions.

The reaction of John Walsh, a Dutch painting specialist and future director of the Getty Museum, came close to Wittmann's. In more than half the cases, Walsh reported, he was perfectly happy with the results of the interventions. The simpler problems were solved. But there were others, more technically complex, that he did not like, and the staff had treated so few of these that he found the sampling to be unrepresentative. Hobbema, once more, was the least satisfactory of the treatments, and *The Mill's* cleaning, while it offered certain compensations, produced some unacceptable color contrasts. Walsh was also unhappy about the varnishing of the Sano di Pietro and raised questions about the pictures that had bothered other panelists—Manet's *Bal de l'Opera*, Degas's *Madame René de Gas*, and Chardin's *Soap Bubbles*. Unlike Agnew, Walsh found Monet's *Morning Haze* to have been successfully treated, without any optical interference.

As might have been expected, both R. L. Feller, of the Pittsburgh lab, and Sheldon Keck, from Cooperstown, sent in strong endorsements of

the Gallery's conservators. Feller inspected twenty-eight paintings and wrote a twenty-nine-page report. He believed there was "absolutely no question of physical damage having been done to any of these works," no evidence of "inexperience, ineptitude, or insensitivity." The "highest ethical and professional practices have been applied" in their care and treatment. He endorsed the process as well as the results and found the documentation accompanying the treatments to be thorough and persuasive. Feller went on to observe that there was nothing wrong with the use of fluorescent lamps in conservation work. The most expensive and widely used color-matching installations employed by American industry used them. The Gallery employed Criticolor tubes with custom-made ultraviolet filters. Gallery light continually changed, according to the time of day, the weather, the seasons, and the character of its artificial illumination, and therefore provided no absolutely stable criterion. Finally, in a dig at some of the other reports, Feller noted that the Sano di Pietro had in fact been varnished earlier, in 1942, as Kay Silberfeld's report noted. "Were not the treatment records consulted by those who were criticizing the work of the present staff?"

Sherman Lee of Cleveland, in one of the more eloquent and sharply stated reports, also took aim at some of the earlier criticism. Flatly denying the comments of Agnew and Jaffé that Degas's *Madame René de Gaz* had been "ruined," he contended that neither of them understood the cleaning process it had received. The picture had been badly damaged to begin with, and the treatment had been largely successful. Monet's *Morning Haze* demonstrated an excellent cleaning of a marvelous painting. Agnew's comments were "incomprehensible." As for *The Mill*, said Lee, "I have always, until now, found 'The Mill' disappointing. I find it now fascinating, moving and real, despite some areas of deterioration." In some general remarks at the end, Lee argued that truth (and falsehood) lay on both sides, but he was inclined to think that the scientific argument falsified less than the artistic. To "sell a picture," he wrote, "is not the same thing as to exhibit it in a humanistic institution dedicated to truth." Honesty was generally preferable to artifice, but one didn't always face so bald a choice. For "any one person or group to claim they know *the* path to salvation is the beginning of folly." "If I were you," he wrote Brown, "I would solidify and strengthen the organization you now have. They need support, consideration, and time." Lee's statement was echoed by Keck, who in his report assured the trustees that the work he had inspected was

"professionally and competently performed." He went on to declare that the conservators sought "unflaggingly to assure the continued structural and aesthetic integrity of each painting in the collection."

Before, during, and after the panelist reports, Brown was fielding reactions from other outsiders and from his staff. Joseph Alsop, Washington columnist and art lover, issued a strong defense of the staff, as did Dutch painting specialist Egbert Haverkamp-Begemann of the Institute of Fine Arts, who argued that the cleaning of *The Mill* should not be at all controversial, and that the public needed to be informed of that as soon as possible.[83] Seymour Slive of Harvard wrote Parkhurst supporting the work done on *The Mill*, denouncing the aesthetic-scientific split as false; he had thought the battle for cleaning had been won long ago.[84] Gertrude Rosenthal, a former chief curator in Baltimore, declared that Silberfeld and Covey would certainly have lived up to a curatorial Hippocratic oath—if one existed—having done no harm to works of art.[85]

In mid-September, while the panelists were reporting, Parkhurst sought to correct some of the more egregious errors made by Agnew, Jaffé, Modestini, and the blue-ribbon panel.[86] Evidently Brown had shared their comments with him. Agnew had declared Rembrandt's *Saskia* partially cleaned; Parkhurst pointed out that every area of it had been uniformly cleaned. Agnew, Jaffé, Fahy, Freedberg, Keck, Lee, and Walsh all claimed the Sano di Pietro had never been varnished previously; it had been, and Parkhurst did not know how the "unvarnished" myth had been propagated. Agnew's observation that Monet's *Morning Haze* had been "cleaned to a ghost of itself" was disproved by observation. "Marvelous to teach from," the fugitive images that Monet had inserted were mistaken for "excessive" cleaning by Sonnenburg. Fahy argued that the tears in Picasso's *Two Youths* could have been made less obvious. In fact, Picasso had rescued his damaged painting years earlier; repairing the tears would have meant covering up some of his own paint. Fahy also claimed that work on the Byzantine *Enthroned Madonna* had demonstrated "incompetent craftsmanship." In fact, very little had been done to the painting beyond some structural intervention on the back; its surface had barely been touched. It would need more extensive treatment in future.

In the end, despite the disagreements among the ten blue-ribbon panelists, some consensus report was necessary. That one was achieved must have seemed a minor miracle, the panelists being so deeply divided

about individual pictures. Charles Parkhurst actually kept a scorecard, recording pluses and minuses for each of the twenty-four pictures evaluated, based on written comments from the three earlier visitors and ten recent panelists.[87] Of the latter group, Fahy was the most consistently negative and Hamilton the most consistently positive. The bulk of the responses were, in fact, positive, but crafting the statement released to the press by the trustees an October 20, approximately six months after the imbroglio began, revealed the ongoing tensions. It began by noting, in one draft, "widespread confidence in the integrity and professionalism of the Gallery's conservation staff," but "widespread" was, in a final emendation, omitted. "No member of the panel, chosen to represent a broad spectrum of viewpoints on conservation," the statement continued, "found any evidence of physical harm to the Gallery's paintings." "The members of the panel also endorsed the principle of the Gallery's decisions to clean the paintings involved" (a slightly different statement than the original "generally endorsed the Gallery's decisions to clean the paintings involved"). The board of trustees expressed its confidence in the competence of the conservators and their curatorial advisers, and the moratorium was officially lifted.

The challenge of achieving consensus was revealed when Sydney Freedberg wrote Carter Brown in late October, thanking him for the statement but suggesting that it did not adequately represent the views of some on the panel, notably Everett Fahy and himself. "I realize that the statement had to be very diplomatically conceived, but it appears to me that it rather makes it seem that there were no adverse comments at all." Freedberg preferred a phrase like "in the nearly unanimous view" or "there was a virtual consensus."[88] Brown wrote back to record his "distress" about Freedberg's unhappiness, but reminded him that the one direct quote was from a summary paragraph in a letter from Freedberg himself. Going into the board meeting, Brown reported, the draft had indeed included the phrase "widespread confidence." But the trustees feared that this implied praise, however faint, might trigger additional questioning of individual panelists, and so struck the adjective. The board wished to stem any panic or sense that there had been actual harm. Members of the public who felt the cleaning of any masterpiece was "shocking" needed reassurance. Except for Fahy's view that it would have been better not to have cleaned the Hobbema at all, no panelist had opposed cleaning any

of the paintings. "Given the public's rather primitive understanding of these issues as either black or white, you can understand how important it was to get this across."[89]

The exchange between Brown and Freedberg captures both the delicacy of the situation—close to the level of a multinational diplomatic statement at the end of a difficult conference—and the corner into which the Gallery had been driven by executive actions that seem, in retrospect, ill designed even if well intentioned. The mobilization of the American conservation community in defense of the Gallery staff, the philosophical, aesthetic, and scientific differences about individual paintings, and the perceived intervention of nonprofessional trustees combined to create an impossible mix. Committees of specialists from outside the Gallery had already been advising on some of the more important decisions, and it is difficult to understand what basis an individual trustee would have for challenging staff judgments. Nevertheless, the trustees emerged with a Pyrrhic victory, a commitment that they be notified in advance about specific conservation projects. In a separate statement, invoking the Gallery's congressional charter, they reasserted their responsibility for the safety and care of the artworks and their freedom to turn to outside consultants for major undertakings. No staff could be large enough to include every specialty, they noted.[90] "I was satisfied that I had made my point," Paul Mellon concluded.[91]

For some months extramural actions lingered. Gabrielle Koppelman, when told of the board's decision, wrote directly to Mellon saying it was no surprise but hoping that the door remained open for a change of mind: "I feel that even those who rallied so readily to the cause of the embattled civil servants are not as totally committed to their position as it would seem at a superficial glance." Should there be room for further conversation, she was prepared to participate. With "proper planning," she observed rather tartly, the present conservation staff "could even be an asset."[92]

Paul Mellon continued, for a time, to monitor conservation issues. When Haverkamp-Begemann wrote Brown expressing concern about the proposed cleaning of *Joseph Accused by Potiphar's Wife*, a Rembrandt painting, Brown and Mellon, along with Jack Stevenson, another Gallery trustee, agreed that the cleaning should be suspended until some further meetings. But after a series of conversations, some of them including Parkhurst, the cleaning resumed. The staff, particularly Kay Silberfeld,

did not appreciate this new inquiry, a year after the old embargo. Writing Brown, she wondered if the October trustee statement had finally resolved the problem or if there would continue to be interventions from time to time.[93] She pointed out that the staff relied on curators and specialists for advice, but decisions about the need to work on pictures remained their own. "I am concerned by what I see as a shaky attitude towards our professionalism. . . . If our energies are regularly to be diverted from the work to a defense of the work, there is little point in having a painting conservation department."

For her part, Mary Davis of the Kress Foundation was never reconciled to Gallery staff. In March 1980 she wrote Brown (in a letter signed "with warmest regards"), reminding him that the indenture covering the Kress collection stipulated that no Kress gifts could be cleaned or conserved without express permission. "I am telling you right now that no permission will ever be given for Victor Covey or Kay Silberfeld to touch a Kress object, period. If you people insist on having incompetence there to ruin your collection that is perfectly all right but you are not going to ruin the Kress Collection."[94]

Nor was the Gallery itself quite finished with outside intervention. In January 1979 Brown invited Mario Modestini to consider treating the Rubens Gerbier painting, the picture that had, from some perspectives, started the entire controversy. Modestini declined, offering something of an implicit reproof to the director. While relining the picture might make sense, his preference for restoring its balance through some overpainting "is against the ethical conception of scientific conservation and the National Gallery would not like it." The only remaining option was changing the varnish. "Considering that confidence in your restorers has been re-established, I think they could easily revarnish the Rubens."[95] But by July, Modestini relented and agreed to work on the painting if he could do it in New York.[96] Brown got board approval and sent the picture on to New York. The Gallery administration seemed to have repudiated its statement of staff confidence, or at least qualified it. "Basically Carter is a politician," Modestini commented to an interviewer some years later.[97]

It was unclear just whose was the victory. No one was fired, and Benjamin Forgey wrote in the *Washington Star* in October, after the board of trustees statement was released, that the upshot was a complete vindication of the staff. While the controversy was sometimes put in philosophical terms, he continued, the incumbents viewed it politically. "This whole

mess was a political act on the part of self-serving people who wanted our jobs," Silberfeld declared.[98] "They have been given a clean bill of health," Brown declared of his staff.[99] Talk of a new conservation training program funded by the Mellon Foundation (and centered, presumably, on Gabrielle Koppelman), had quietly receded, and then had entirely disappeared. So it was all over. Ross Merrill's 1983 arrival as conservation chief further distanced the institution from recent events. Still, some in the Gallery felt the issues were not fully resolved until the arrival of David Bull. British-born, he would be appointed chairman of painting conservation in 1989, after years of consultation, and captured the confidence of most of the stakeholders, particularly the general trustees and the Kress Foundation.

Despite occasional articles in the Washington papers, the controversy did not really become a major public debate, even while it was making shock waves within the professional conservation community. Even a few of these observers thought the matter was overblown; one German conservator confessed he could see little difference between the pieces conserved by John Brealey and those worked on by National Gallery staff.[100] Years later, some curators felt that the American pendulum had swung toward Brealey's philosophy, and that museums in general had grown conservative in their conservation approaches.[101]

In any case, the controversy exposed rather than resolved a range of tensions, not merely among conservation philosophies but within the fragile set of relationships that constituted the museum itself. The trustees had invaded, however briefly, professional matters that they normally avoided, the director had failed to protect his staff, and the staff had complained to their peers elsewhere about their feelings of helplessness. These could all, in the fullness of time, be seen as anomalies, but for the moment they may well have seemed alarming.

Charles Parkhurst loyally assumed full responsibility for managing the problems and never lost admiration for Brown, his leader. But the director himself stayed largely outside the fray. Given the importance of Paul Mellon's role, it was not difficult for the staff to understand why, but some of them, barely noticed under better circumstances, felt victimized by the network of connections and privilege linking collectors, patrons, dealers, and trustees. Mellon observed sagely to Parkhurst, after things had quieted down, that it was easier to get into these situations than out of them. He may have forgotten that he had invoked this maxim

on previous occasions, calling it Agnes Allen's law.[102] But neither he nor any other trustees intervened in this fashion again.

The next few years, with the East Building opened and the West Building reconfigured, provided many moments of triumphant achievement. They eclipsed, in public memory at least, the traumas associated with conservation. The Gallery would now be reworked under Carter Brown in ways that went far beyond its physical changes. The organizational style and professional appointments associated with the early years of his directorship merit at least as much attention. Without them, the reputation as well as the accomplishments of the institution would have been far different.

Exhibiting Strategies

D espite the internal tensions exposed by the conservation con-
troversy, the opening of the East Building brought a burst of
favorable publicity to the National Gallery, and further estab-
lished Carter Brown as a symbol of the institution. A distinctive cult of
personality differentiated the Brown administration from the two that
preceded it, but that was not, of course, the only thing. What did seem
clear, in the years after the new building opened, was that the world of mu-
seum exhibitions had permanently changed. If Thomas Hoving and the
Metropolitan Museum had spearheaded these changes in the late 1960s,
a decade later Brown and the National Gallery had become the block-
buster's premium brand, enlisting corporate, governmental, and private
support on their behalf. The construction of the East Building and the
renovation of the West Building brought Brown an enlarged sphere of ac-
tion; he exploited these spaces, and his professionally accomplished staff,
in the interests of institutional aggrandizement. The transformations
that took place soon after his becoming director were routinized in the
late 1970s and 1980s, as his directorial style became more sharply etched.

The first order of business, to be sure, was promoting the reputation
of the East Building itself, justifying its enormous expense by fulfilling its
promise. In its early days, the the new building enjoyed largely favorable
responses from critics across the country (but not from abroad), some of
whom were almost gushy in their enthusiasm.[1] The thrust of their com-
mentary has been summarized by others, but it must be admitted that

some of the excitement rested on the comparatively dismal record of recent Washington architecture. Modernists especially had been disappointed by a string of major projects, from the Kennedy Center and the Hirshhorn Museum to the FBI Building and the Museum of History and Technology. But a general consensus held that I. M. Pei's East Building was a breakthrough, a thoughtful, original, and eye-opening solution to a difficult site, a building that was respectful of its location and the surrounding neoclassical structures, yet twentieth-century in spirit and materials. A complex structure to see or to analyze, the East Building had been presented, over the previous seven years, in diagrams and drawings and models and, finally, a film, to a variety of constituents, none more important than the journalists and architectural critics who would have so much to do with fixing its initial reputation.

High expectations surrounded the Pei scheme upon its 1971 release. National magazines and newspapers doted on the drawings, aided by Brown's running commentary of explanation and justification. It was not simply the building that Brown extolled, but the new functions to be served by the center for scholarship it would house. At a time when the Metropolitan Museum in New York was arousing bitter opposition to its expansion within Central Park, Brown proclaimed that further enlargement of his national institution was highly desirable. Green space was far more plentiful in Washington than New York, he pointed out, lessening any probability of protest.[2] Early reviewers, especially the local ones, turned into cheerleaders. "It may turn out to be the most beautiful museum in the country which is to say, almost automatically, in the world," Frank Getlein wrote in the *Washington Star*.[3] Benjamin Forgey, also writing for the *Star*, called Pei's solution for the difficult site "amazing."[4]

Over the next few years, national and even international architecture and construction journals sustained a drumbeat of praise. Some of it centered on the technical challenges that Pei's team had overcome. When pressed about the mounting costs, Brown pointed out that the project really involved several buildings, one of them the "covered piazza" that would house the cafeteria and the underground link.[5] This will be "a genuine national showcase," predicted Ada Louise Huxtable a year before the opening, even while admitting that it could only be judged when finished.[6] A year later she was even more excited. Washington is getting "A genuine contemporary classic," "the right building in the right place,"

a location "that has been crying for excellence." She reveled in an interior that featured the "baroque play of two-point perspectives," a building "whose logic and drama grow from the inside out."[7]

There were, of course, dissenters, particularly during the construction phase. "If I can just put on a blindfold as I approach the building and then come inside and open the blindfold," Senator Mark Hatfield told Brown at appropriations hearings in 1976, he was sure he would enjoy the view. At the moment "it is an eyesore," Brown admitted to the senators. The point of the design, Brown explained, "is not yet apparent because it is in a terribly awkward stage, something like an adolescent girl, with braces on her teeth. We think she is going to be a very beautiful woman when she grows up."[8] Others worried about the building's height. But even the objectors were willing to suspend judgment until completion.

Once the East Building was finished and the public admitted, the favorable tone only intensified. The "immense and noble addition to the National Gallery," Hilton Kramer told readers of the New York Times, in "the sheer grandeur and authority of its design, as well as in the scale and flexibility of its spaces" "overshadows all other contemporary museum construction."[9] There remained divisions of opinion—sometimes within the same journal. In February 1978, the New Republic ran an essay calling the East Building an "enormous, amorphous slab of stone that looks like a Norman fortress with sharp edges," "a monument to the philistine, jack-booted architecture of the '70s." "Beside the new building Albert Speer's Berlin looks civilized," the writer continued. "Washington is physically turning into Brasilia, and starts to resemble the current idea of its soulless, manic pace," no longer a "community" but a corporate headquarters, color-coordinated, with a big lobby, and no place to sit down."[10] Three months later, another columnist walked through the museum "reveling in the joy and confidence in the human spirit that seem not just to fill but to flood it with light. It is impossible to be solemn about art here."[11]

Brown carefully monitored the publicity, reacting with dismay to any negatives and bemoaning what he thought to be a New York snub. The New York Times did run a photograph on its front page, June 2, 1978, showing the assembled dignitaries inaugurating the building. That was an accomplishment, the first time since the Times scoop on the Ginevra purchase that the Gallery had been atop the first-page fold. But, Brown noted to his public relations director, Katherine Warwick, in later editions the photograph was dropped to the bottom of the page, because

the city edition added a piece on Soviet bugging at the American embassy. He was further upset that the *Times* relied on the Associated Press, rather than its own staff, for such an important story.[12] There was no perceived affront too small to go unnoticed. At least the Metropolitan didn't choose to announce the appointment of Philippe de Montebello as its new director the same day the East Building opened, though the news came soon thereafter. On the other hand, Brown could appreciate some critiques. A complaint by journalist Mark Jenkins about the Dresden show's arrangement brought the comment "Refreshing and in many respects bang on. Would like to meet him."[13]

So many visitors were coursing into the building (a hundred thousand in its first ten days) that the National Gallery was forced to close half of the West Building. The security staff could not handle the throngs; two hundred guards were needed, sixty more than had been in place before the opening. Temporary hires solved some of the problem. But the crowds made the building, or so Pei and Brown argued. Whether one took pleasure in crowds was, indeed, one of the dividing lines between building enthusiasts and more skeptical critics, though there were certainly other issues. Formalists debated placement of the building within a modernist or antimodernist vocabulary, urbanists argued about its contributions to the Mall and to the cityscape, postmodernists offered their own polemics, art critics considered the significance of the major commissions that studded both the exterior and the interior. On this last point, there were many expressions of disappointment, unhappiness that the National Gallery had apparently decided to play it safe. Only the Alexander Calder mobile in the atrium excited almost universal approval, followed by the Henry Moore. Noguchi, Rosati, Caro, Miró, Arp, and Motherwell "battle with the building, with its scale and its mood, and they usually lose," Paul Richard wrote in the *Washington Post*.[14] And Moore's work, he concluded, was already becoming a cliched accompaniment to new buildings. In years to come, many opinions would shift. James Rosati's painted aluminum sculpture was singled out by some as an inspired decision.

But comments upon the new art or the modernist oeuvre were less central to the debate over the East Building than the museumgoing experience itself. And here dissenters honed in on the contrast between the great, light-filled atrium Pei had provided, and the comparatively cramped and marginalized corner spaces reserved for the viewing of art. These were meant to suggest the intimacy of house museums, which

Brown had so much admired in cities like New York and Milan. Some foreign observers were particularly acerbic. Writing for the *Guardian*, Richard Roud admitted the new building was very beautiful but thought it "a disaster as a museum building." The "shocking fact," he wrote, was that the gallery spaces were confined to three towers and the painting exhibitions crowded into three tiny hexagonal rooms. Architects must remember, he lectured, that their "job is not only to build beautiful buildings, but to pay attention to what purposes these buildings are meant to serve." The Matisse cutouts were wonderful but could be reached, in their attic hideaway, only by way of a narrow spiral staircase. "A beautiful court setting off a couple of sculptures and a tapestry is no substitute for a modern museum."[15]

Nearer home, a resident of Alexandria, Virginia, wrote saying she kept hearing about the innovative architectural concept but all she found was a waste of glorious light and space in the atrium and the actual masterpieces diverted to "small, crowded, dark rooms," into which would-be viewers were "herded like sheep."[16] Another visitor, from farther away, protested that the "best" paintings were "tucked away in a vault-sized room, whose configurations cause a traffic flow akin to that in a pinball machine." There was "less exhibition space per cubic yard, not to mention per dollar of construction cost, than in any other major museum." That is, this visitor went on, unless the "great central shaft of light" was considered an exhibition piece.[17]

Architectural historian Anthony Alofsin, who has gathered together many of the reactions to the East Building, treats comments like this as evidence of the "public's long-standing mistrust of modernism in general."[18] It might also be argued that they reflected concern about the new focus of art museums in general, and the National Gallery in particular. For this contrast between the galleries and the central atrium became a recurrent trope, leading relentlessly to a discussion of the effacing of boundaries that once had separated commercial and noncommercial spheres of life. In attempting to describe the atrium to readers, architectural critics were driven to similes and metaphors that invoked, among other things, transit lounges, terminal buildings, shopping malls, department stores, railroad stations, and hotels. These associations were not all presented as negative. "Much of the best architecture in the United States was built for and by business," Christian Otto wrote in *Connois-*

seur. Otto disliked other aspects of the building but conceded that Pei had adapted his commercial references to serve in an art setting. Entering the central space, with its connectors, bridges, walkways, and large open area, you "circulate through the equivalent of Grand Central Station," passing from there to small, intimate galleries, each devoted to a single kind of art. This was a reenactment "of department store shopping, the canvassing of specialty areas." Similarly, scholars using the card catalog in the atrium of the study center "look about into nothing less than a Hyatt Regency lobby, where they have probably conventioned at one time or another." It was such "transformations of commercial space" that "monumentalise the art gallery, and perhaps explain its popular success."[19]

Similar observations were made by others, over the next year or two; observers equated the light-flooded atrium with, for example, "the festive quality of market place or bazaar." A *New Yorker* writer who visited the building in the spring of 1979 reported a "stunning experience," likened to childhood memories of Pennsylvania Station. "The station seemed to be saying, 'We have quite a city here.'" The same monumentality and pride attached themselves to the East Building. Hundreds of people were walking along the bridges, escalators, and walkways, and the correspondent likened it all to a Piranesi print. Brown was happy to oblige with a few words of his own, comparing Pei's ceiling to a Bach fugue and promoting once again his "house museums" and their protected spaces. "We live in a dangerous world . . . fears must be relieved and we must allow the layers of armor beneath to come through."[20] The contrast between the tight galleries and the atrium, troubling to some, was exhilarating to Brown. Thomas Hine, the *Philadelphia Inquirer* critic, was pleased by the overall approach but deemed the atrium "uncongenial" to the works of art it housed. This "is a building intended to bring great masses of people into intimate contact with works of art. . . . It provides a variety of places . . . a humane design, and it would be encouraging to see it, rather than the crowd-control philosophy of architecture, prevail."[21]

A crowd-pleaser with its enhanced public facilities, the East Building exemplified the aggressive approach to audience development that museums of the 1970s and 1980s were taking. Thomas Hoving may have led the charge in years past, but by 1978 he was, as an ex-director, no longer an active participant. Brown inherited the leadership mantle happily. The new spaces and his design and exhibition staff were establishing the

Gallery as a center for innovative installation. Visiting exhibitions were no longer consigned to the cramped and awkward areas previously reserved for them in the West Building.

The first major exhibition housed by the East Building, *The Splendor of Dresden*, summarized the trajectory and demonstrated the high stakes of museum programming and the tangled web of rivalries. It had been aggressively pursued by Brown in the face of competition from the Metropolitan, which, Hoving claimed, had originated the idea. According to one New York newspaper, the notion of doing a Dresden show was the brainchild of Olga Raggio, a Met curator, "but through the inscrutable ways of art world politics opened at the National Gallery in Washington."[22] Grace Glueck, in several pieces for the *New York Times*, some of them reprinted elsewhere, used the show as an opportunity to air concerns held by a few other museum officials. These centered on the National Gallery's "predatory taking of shows staked out by other institutions," its "insistence on being first to open shows it shares with other museums, its propensity for taking credit for exhibitions initiated by others, and its determined wooing of 'hometown' collectors for donations that might otherwise go to museums in their own areas." This last charge alluded to the Collectors Committee, many of whose members sat on the boards of other museums throughout the country but had been enlisted to fund National Gallery purchases of contemporary art. One unhappy Midwest museum official called the gallery "grabby," another complained that "we can't compete with the blandishments offered by Washington."[23] Moreover, the State Department was accused of supporting the Gallery's claims with foreign leaders. Glueck highlighted the complaints of new Met director Philippe de Montebello about the Gallery's failure to give his museum appropriate credit for a string of things, from the organization of the recent Tut show to the idea for the Dresden exhibition.

This was not a new theme. A year earlier, in a long piece for the *Times* Sunday magazine, "Moving In on the Met," Glueck had written of the National Gallery's political advantages, its closeness to official Washington (she pointed out the role of David K. E. Bruce, Brown's cousin, in helping the Gallery land several shows). Hoving got his licks in too. "They're touchy at the National Gallery, aren't they?" he was quoted as saying. "They take the position that they must get every exhibition first; if not they'll take their ball away and play another game." Glueck also spent a

good deal of time summarizing professional opinion about Brown's aggressive competitiveness and his apparent refusal to play by the rules in seeking advantages for his own institution.[24] "We both wanted to be King Kong," Hoving observed to an interviewer some years later.[25]

For his part, Brown was largely unapologetic about the Gallery's activism. He argued that Gallery donors were citizens of the United States as well as of their local communities. "There's a great sense of national pride in the new building—everyone feels it's a feather in the cap of our country. People are not so provincial that they have to restrict their giving to within a mile and a half of their own homes."[26]

As for the Dresden show, he acknowledged an "arm wrestle" with the Met over it, but insisted that the National Gallery had opened negotiations with the East German government before the State Department asked it to "sit out on the bench for a while," until larger political issues could be sorted out.[27] The Dresden people, somewhat confused, according to Brown, then began to talk to the Met. In the end, after relations grew quite strained, a high-level summer meeting between Met and National Gallery figures was arranged. It was hosted by David Rockefeller at his home in Seal Harbor, Maine.

The concentration of wealth and power at this 1976 conclave was impressive. Representing the Met were Hoving, Douglas Dillon, and Brooke Astor; Brown and Paul Mellon appeared for the National Gallery. Rockefeller served as referee "because Tom was given to some amount of exaggeration," Brown opined. An exchange of letters between Mellon and Dillon revealed how strenuous the competition had become. Mellon, while acknowledging "the preeminence of the Metropolitan in this country," so far as its "collections and its standing with the public," and regretting the "bizarre" circumstances that had led to the "contretemps," defended the National Gallery's special status as a first venue for international exhibitions, claiming it was "in the best interests of the United States and its cultural life." He assembled a list of precedents, dating to 1941, and urged the Met not to "abrogate" this "long-accepted understanding." Dillon maintained a contrary view of the background to the quarrel, and taxed the National Gallery with not fully living up to the position that Mellon had summarized. But he did agree that the National Gallery could serve as the opening venue for the Dresden show.[28]

It was determined, then, in an unofficial "treaty," that the two museums would share the exhibition, with Washington's turn coming first.

Dillon insisted that full credit be given to Met staff members who had been involved in the planning, and the Metropolitan was placed in charge of the catalog. Hoving's deputy (and the Met's future director), Philippe de Montebello, took charge of some of the German negotiations. However, Brown charged later, since the show did not open there the Met limited its investment. The result was a thin and somewhat disappointing text, far inferior to the Tut catalog, which had made it onto the best seller list.[29]

Unlike some other international shows of this period, *The Splendor of Dresden* served no obvious political objective, although there were certainly political implications. East Germany was not embarked on any sustained charm offensive with the United States, and the exhibited items did not reflect any ideological imperatives. Financing came from an IBM grant of $750,000, which Brown himself obtained. IBM had previously supported the making of a film on Leonardo da Vinci, and in 1974–1975 sponsored the visit of the Chinese archaeological finds, whose contentious Washington appearance has already been described. Increasingly comfortable with making requests to huge corporations, many of them with international interests, Brown would intensify and refine his technique in the later 1970s and 1980s, adding dedicated staff and enlisting the goodwill of public officials in his quest.

Events leading up to the Dresden opening were meticulously planned. In May 1978, various dignitaries were invited to witness the uncrating of the treasures—although, in fact, the crates had been opened earlier. "Let's get to Christmas morning," Brown told the assembled reporters, as jeweled cups, statuary, and porcelain came into view. Brown kept up a flow of repartee, searching for homely similes and self-deprecating confessions. The emeralds on a piece of South American granite looked "like huge lollipops," he remarked, and, as the porcelain appeared, he confessed he was glad not to be unpacking it. "I'm a notorious butterfingers. My wife won't trust me with the dessert plates."[30] The style was vintage Brown: somewhat heavy-handed, slightly forced, even corny, but relentlessly colloquial and designed to get attention. And the press was happy to oblige.

There was much to gape at. The installation provided by Gill Ravenel's team was dazzling. Consuming twenty thousand square feet on the East Building's unencumbered lower concourse, some eight hundred objects were placed within a series of specially constructed terraces. This was the

most expensive temporary exhibition created by the Gallery staff or, in the self-effacing words of Ravenel, "the largest and most lavish exhibition of all time."[31] Paintings, drawings, prints, armor, porcelain, silver, bronzes, and scientific instruments, all assembled by the rulers of Saxony, filled the floor. So elaborate an exhibition was only possible using the recently passed Arts and Artifacts Indemnity Act, which Brown—and several Met officials—had worked hard to make law. This exhibition was the first "in which the history of art collecting, rather than the history of art, is so comprehensively explored," Brown declared; indeed, the catalog's subtitle was "Five Centuries of Art Collecting."[32]

Rather than simply present the pieces individually, Ravenel's team, now including artist and draftsman Mark Leithauser, reconstructed interiors evoking Dresden settings, some of them no longer extant. They included portions of the fabled Kunstkammer as they had looked in the sixteenth century, the Green Vaults of the Residenz Palace, and an elaborate porcelain gallery. Some interiors contained their own special air conditioning and humidification systems to protect the fragile contents. The installation is "visually the most awesome thing of its kind ever to be seen in an American museum," Hilton Kramer told his readers in the *Times*. It was "a show almost too beautiful to be believed," and "can no more be 'reviewed' than the Louvre can be reviewed. Seeing it is an experience that people will talk about for the rest of their lives."[33] "America has never seen a richer exhibition," Paul Richard wrote. "It gleams with diamonds, silver, steel, ivories, and pearls . . . a fairyland of luxuries . . . and orgiastic greed." The "human mind can drink in only so much grandeur," he went on, but some insights could be gained. Among them, that science and art, decoration and technology, were once collaborators rather than adversaries. The Saxon rulers admired both art and engineering, and the show was filled with objects of extraordinary technical precision. Indeed, *The Splendor of Dresden* challenged the logic of Washington's art institutions, which "rigorously edit the history of art," claimed Richard. "They own no suits of armor, no pleasing jewelled pendants. They have taught us to look down at the decorative arts. They stress pictures above all."[34]

In a curious way, the Dresden installation represented both the culmination and the abnegation of the new building it was helping to inaugurate. On the one hand, this was an exhibition, as the Gallery's description asserted, that traced the evolution of the collection "as an extension of the political grandeur and magnificence of an autocratic state," leading

ultimately to the "idea of the public museum." "Public access rather than private delectation became the theme."[35] It was hard to find a better summary of the National Gallery itself, the amassing of precious objects by American millionaires who had founded and then helped expand an institution concerned with glorifying the nation-state in its political capital. The East Building was readying itself for the accumulations of a new generation, successors to the Mellon-Widener-Kress era, whose wealth would fill gaps created by the now abandoned collecting philosophy.

On the other hand, with its specially built walls and ceilings, the installation's meticulous and brilliant period settings denied or ignored the special architectural features of the host structure. The settings were frankly illusionistic, and could have been created in any open area. Once in the exhibition, visitors were cut off from the rest of the building, enveloped by the evocative interiors. In effect, the Gallery's design department had created its own museum. The costs were, to be sure, very high, for both the expensive materials and the hours of labor, and that put pressure on the administrators to raise the necessary funds. The IBM grant was indispensable, setting a pattern which the Gallery and other museums would follow in the years to come.

The dinners associated with the East Building's inaugural were in keeping with the Gallery's new practice of opulent hospitality. The first, to celebrate the Matisse cutouts, was held in the West Building. It was planned by Pamela Brown, along with Carol Fox, who had been brought in to coordinate the various openings. The first dinner in the East Building itself, after a congressional reception had been organized, feted the Collectors Committee. Bunny Mellon had special trapezoidal tables built (and trapezoidal tablecloths made) to echo the building's shape, and had as a centerpiece on each table a Calder mobile or stabile, just a couple of feet high. White wine and French bread were meant to suggest a French picnic. Red wine was taboo, lest the marble floor be stained. Dancing followed the speeches, and as the music began a spotlight picked out the soloist: it was Benny Goodman, Paul Mellon's favorite musician. When, just before dinner, a waiter dropped a bottle of champagne, Bunny Mellon remarked, "Well, that's the way this building's floors *should* be washed."[36]

The following night brought a "very American" meal for the Dresden opening, planned by Pamela Brown. After realizing that re-creating a Saxon banquet for the East German guests might lead to bone-throwing exuberance, a decision was made to feature American wines and some-

what lighter fare than the Mellon dinner of the night before. Everything from the chef to the sugar cubes was imported from Manhattan, a reassuring indication, for New Yorkers at least, that Washington had not yet managed to monopolize all good things in life.[37]

Unlike the Tut exhibition, the Dresden show did not create unending waves of enthusiasm and commercial profits. Jewelers who had profited from Egyptomania thought it unlikely that the baroque pieces of the Saxon court would inspire a craze for contemporary imitations, and they were right.[38] Similarly, the catalog failed to spawn a publishing frenzy. In New York the Dresden show, installed by the National Gallery team, had the misfortune of running just before, and for a few weeks opposite, Tut at the Metropolitan. Even the accompanying television feature, *The Priceless Treasures of Dresden*, suffered in comparison—a "glossy commercial," according to John O'Connor in the *Times*, cliche-ridden and ineffective.[39]

Because Dresden was not incomparable, it (and other elaborate exhibitions of the moment) touched off further doubts about the value of increasingly expensive blockbusters. Only months after ecstatically reviewing *The Splendor of Dresden*, Hilton Kramer wrote a column entitled "Has Success Spoiled American Museums?" He acknowledged the virtues of such exhibitions bringing great art to large audiences, attracting federal and corporate support, and providing significant revenues to museums. But at the same time, he wondered whether they were modifying the American art museum, "making it a more conservative and less creative and innovative force in our culture than it was only a few years ago." Business-oriented leadership seemed to be increasingly preferred by boards of trustees. The Metropolitan and the Art Institute of Chicago had recently appointed professional administrators as executive officers, men with no previous experience of art museums, Kramer pointed out. The sums provided by the government and corporate sponsors were making museums less autonomous and more dependent upon certain kinds of popular, fundable exhibitions that could sustain their increasingly lavish lifestyles. Characterized by safety and popularity, these efforts avoided anything that might offend, confuse, or bore a potential audience. The blockbusters were likely to drive away the kinds of shows that once had been hallmarks of museum programming.[40]

Whether Kramer's specific charges were justified—whether artists doing conceptual art, performance pieces, process art, had ever been avidly

welcomed by major urban art museums—his concern about a new trend was not unfounded. Attendance figures were an increasingly important part of the case for continued funding that the Gallery made annually to Congress and, through the press, to the broader public. The huge crowds that surged through the East Building in its first months appeared to demonstrate the wisdom of the expansion, although, it must be reiterated, the National Gallery, like the Smithsonian, charged no admission. Once the East Building had opened, Brown and other officials pointed to the Gallery's steadily increasing annual attendance in press briefings and periodic, sometimes weekly, reports. From June 1 to July 21, the Gallery claimed to have hosted some one million visitors, a record. The previous year, which itself had set a record, visitors numbered fewer than three hundred thousand in that same time period.

There were some who accused the National Gallery of trying to play it safe even in its permanent collection, with its captive core of tourists. *American Art at Mid-Century*, set up to complement *The Splendor of Dresden* in the early months, was the first exhibition of recent painting and sculpture hosted by the Gallery. It had been announced five years earlier, in 1973, and supervised by one of the new curators, E. A. Carmean, who was brought in from the Houston Museum of Fine Arts as part of the staff expansion. During the first half of the 1970s, the Gallery assiduously began courting collectors of twentieth-century art, like the Burton Tremaines, and succeeded in obtaining some seminal works, including a spectacular Franz Kline oil. Brown's strategy was to acquire, as he put it, the "old masters" of the twentieth century, to continue the Gallery's established emphasis upon high quality above all else.[41] He spent a decade wooing the Tremaines and their lawyer, reporting to Paul Mellon on his lengthy negotiations.[42] Local critic Paul Richard believed that Brown would need all his "caution" in stepping into the "dangerous waters" of recent art, and Brown seemed to heed these words.[43]

This safe approach engendered some resistance. In a review for the *San Francisco Chronicle*, critic and art historian Alfred Frankenstein complained that *American Art at Mid-Century* showed that the Gallery was letting others take chances while attempting to reap the glory. "It is high time the National Gallery realized that a great art museum is not a stock exchange. If its future plans indicate that it knows the difference it has not told the public or the press about them." The government in Washington was spending millions annually to encourage contemporary art,

Frankenstein went on, but the nearest the National Gallery could come to reinforcing that effort was to put on its show "a quarter of a century too late."

Brown decided to reply. "A great art museum is not a stock exchange," he agreed, but what was to be avoided were "the 'go-go' glamour growth stocks of the moment . . . these values change dramatically from month to month and year to year." Art historians like Frankenstein knew how unstable present judgments on contemporary art could prove to be, Brown declared, adding, in what may have been a deliberate dig at uranium king Joseph Hirshhorn, "how sorry is the record of art museums in gambling on the uranium mines of recent artistic production."[44] In effect, Brown was endorsing the stock-exhange metaphor he'd begun by denying, but distinguishing the Gallery's conservative, blue-chip approach from that of speculators who purchased or exhibited untried, avant-garde art. Hilton Kramer would have found his fears about commercial values invading the temple of art to be all too well founded, taking Brown's response to Frankenstein at face value. Even as it embraced modernism, the Gallery was determined to take as few chances as possible. Its other gesture to the recent past in the East Building's opening days, *Aspects of 20th Century Art: Picasso and Cubism*, seemed an even safer venture.

Few other reviewers were unhappy with *American Art at Mid-Century*, which featured the work of seven abstract expressionists—including Mark Rothko, Robert Motherwell, David Smith, Willem de Kooning, and Jackson Pollock.[45] But the show, along with the recent commissions, did raise questions about the Gallery's evolving identity. Brown continued to emphasize that its aim was not to become a museum of twentieth-century or contemporary art, but rather to salute, in tried and true Gallery fashion, the acknowledged masters of earlier decades. These were the new "old masters," whose work, as some critics argued, demonstrated that they stood on the right side of history.

During the next months, other temporary exhibitions of great significance made their way to the Gallery. Among the more notable was a show devoted to the Norwegian artist Edvard Munch, which brought with it not only admiring reviews and crowds of visitors but another federal indemnity grant, a royal visitor, and a healthy subsidy from a corporate sponsor, Mobil Oil.[46] Declaring in advance that the almost three hundred paintings, lithographs, and woodcuts by Munch would "blow your mind," Brown emphasized the East Building's "international sig-

nificance," the "beginning of nations talking to each other on the basis of cultural heritage, transcending ideological differences and obstacles to peace."[47] Norwegian-American relations had not seemed particularly troubled by ideological (or any other) divisions before the exhibition, but the theme of international reconciliation was a favorite one for Gallery officers to proclaim and corporate sponsors to echo.

Almost every new exhibition seemed to offer some novelty. This one, besides a dinner given in the still unoccupied space of the new scholar center, presented the first ever dance performance at the National Gallery, "Summernight," a ballet devised several years earlier but touching on many of Munch's themes. Calling it "the right idea for the right place at the right time," the *Washington Post* reviewer found space, in a very short note, for more comments by Brown, who seemed to be quoted in almost every column dealing with Gallery activities.[48] Norwegian actors presented a play in the East Building in a further act of cultural enrichment. And a smaller version of the exhibition, originally meant only for the National Gallery, was sent to the Museum of Modern Art in New York in response to a plea from its director, Richard Oldenburg. The following year, probably helped by the well-received retrospective, Norton Simon was able to sell a Munch at auction in New York for a price which came close to breaking the record for any twentieth-century painting. On almost every ground, then, the Munch exhibition achieved an enormous success—Norway's Tutankhamun, its ambassador happily proclaimed.[49]

The routinization of blockbusters became a recurrent theme in art museum circles, as the National Gallery and the Metropolitan staged a series of spectaculars in the late 1970s and 1980s. At this point objections focused, first, on a loss of intimacy, second, on dilution of serious educational goals, third, on merchandising mania, and fourth, on the unacceptable influence given to corporate sponsors. In many newspaper and national magazine pieces, the East Building and its exhibitions were singled out as emblematic of the new trends. The *New York Times*, in an editorial entitled "Gilding the Museums," noted the long lines, the publicity, the crowds, and the emergence of the museum director as promoter, and proceeded to work itself into a cultural lather. These "supercharged, supercrowded displays" were popular, admitted the *Times*, but at what cost? "Discovery, intimacy and surprise; the one-to-one relationship between art work and power; the personal and miraculous communion with the unexpected spirit of unfamiliar times and places that

comes from the spontaneous museum visit. Instead we have the museum as circus, or spectacle, or cash register for reproductions of unreproducable works of art. It informs, titillates—and subtly corrupts." The editorial referred to the National Gallery's rise in visitation, prompted by the opening of the East Building, but its main target was less Washington than recently departed Met director Thomas Hoving.[50]

Few waxed quite as indignant as the *Times*, but there were plenty of other moralizing declarations at just about this time. The *Wall Street Journal*'s Manuela Hoelterhoff, in "The Fine Art of Packaging Big Shows," summed up her target in the title. Reviewing *Pompeii A.D. 79*, she wondered whether the new "gargantuan" shows were detracting from "the serious experience of art." Museums, driven by financial necessity, would soon be less interested in providing "sober, illuminating fare than in entertaining shows that will draw the most impressive numbers." "Decorators and public relations specialists are beginning to loom alarmingly over curators and scholars."[51]

Some museum directors must have been puzzled by media journalists' sudden commitment to sobriety in the galleries and the demands of scholarship. This had not been a common theme in earlier years. There were certainly divisions of opinion within the art museum world about the early blockbusters and the construction of user-friendly museum annexes with large gift shops and elaborate eating facilities. Lorenz Eitner, director of the Stanford University Art Museum, admittedly an unlikely venue for blockbusters, asserted that shows like the Tut and Dresden exhibitions "pervert the nature of a museum." They "blot out everything else. They disorganize the museum totally."[52] But the sorrow expressed by media in a number of instances suggested crocodile tears, fealty offered to standards of erudition and refinement that were hardly common in the pre-blockbuster years and certainly not the usual focus of the critics.

And the large museums never stopped mounting scholarly shows. In 1979, for example, the National Gallery opened a groundbreaking exhibition, *Berenson and the Connoisseurship of Italian Painting*. Focusing on the curatorial impact of late nineteenth- and twentieth-century connoisseurs like Berenson and Giovanni Morelli, David Alan Brown, one of Carter Brown's recent appointees, sought to analyze the revolutionary effect of connoisseurship on the museum's task of authentication. In responding to this show, some critics wondered whether the museum had gone too highbrow. Despite the fact that David Alan Brown and the installation

designers had done "everything that intelligence, taste, and knowledge" allowed, Hilton Kramer wrote, the "museum exhibition is not an appropriate medium for the explication of intellectual history." There was no way, he continued, to educate the public about connoisseurship without a prolonged period of study. It was better to read Berenson's books than to see them on display. The exhibition simply presented viewers with "the appearance, rather than the reality, of an important episode in the intellectual life of art."[53] These were discouraging words for museum curators hoping to raise contextual issues alongside the aesthetic experience. As it turned out, however, the National Gallery decided to move the closing date of the Berenson show from May 13 to September 3, an almost four-month extension, "by virtue of its unexpected popularity."[54] Perhaps the public was better able to appreciate this exercise in cultural history than Kramer had allowed.

This mixing of exhibitions, more specialized and perhaps more cerebral subjects interspersed with crowd-pleasers, established a prevailing rhythm for many of the major American art museums during this period. Museum officials argued that the flashier shows subsidized the others and helped museums fulfill both their educational and their fiscal goals. Journalistic critics tended to ignore larger programming models in favor of the easier targets provided by commercially driven shows. Their attacks were fueled partly by suspicions of industrial giants like Mobil, Philip Morris, United Technologies, Control Data, Coca Cola, and ARCO.

The corporations were particularly criticized for their subsidies to science museums. Reporting on a white paper commissioned by the Center for Science in the Public Interest in 1979, a *Washington Post* writer quoted its characterization of the Museum of Science and Industry in Chicago as a "supermarket of corporate logos."[55] The Smithsonian Institution and the California Museum of Science and Industry came in for their share of rebuke as well. The issues for the science museums were clearer than for the art museums; sponsoring corporations had a direct and obvious stake in presentations about nutrition, atomic power, energy, and pollution. Corporate executives occupied positions on many museum boards, and their meetings were not normally a matter of public record. The situation with art institutions was arguably more benign.

Some journalists, particularly conservative journalists, condemned charges of corporate influence as overwrought. Writing under the head-

line "Art Incorporated" in the *Washington Post*, columnist George Will agreed that business support for the arts might reflect guilt or status anxiety, but he pointed out that businessmen were, "contrary to much current thinking, human."[56] Today's corporate patrons were an improvement over their predecessors, four or five hundred years earlier, and their involvement had grown spectacularly in the ten years or so since the Business Committee on the Arts had been formed. Mobil Oil was, said Will, the "thinking person's National Endowment." "A lot of aggressive nonsense is spoken about the allegedly sinister aspects of such activities. Corporations can't win for losing."

Such comments did not stop other journalists from sounding the warning siren. "The implications of conglomerates in art are regarded as ominous by men and women who have spent a career in museum work," Robert Taylor wrote in the *Boston Globe*. "When marketing research guarantees the audience, produces the catalogue, selects the objects for public sale and assembles the components," little room is left for the spiritual qualities of great art exhibitions. "The success or failure of a show is not the expression of a sensibility; it reflects the success or failure of a marketing concept."[57] Interviewed on the blockbuster trend in the late 1970s, Brown put the best possible face on the corporate alliances. "As museums we have been urged to work hard at obtaining more support from the private sector," he told Grace Glueck of the *New York Times*. "Corporations have a definite need to show self-interest to their stock-holders, and their initiative is a hallmark of American enterprise, as long as it's kept within the bounds of taste and propriety."[58] There certainly was a show business side to these exhibitions, Brown told Joseph McLellan of the *Washington Post*. But he insisted that "everything we do is educational." The Gallery had a "responsibility to offer the public things that supplement our permanent collection." McLellan saw the museums "smiling enigmatically like the Mona Lisa," standing between national treasures and corporate bankrolls, but concluded in the end that swelling attendance rolls (the National Gallery had more than quadrupled its annual visitation over the previous ten years) and fond memories of precious objects ultimately trumped the objections. The "final winner in the international exhibition game, if there is to be only one winner, is the art."[59]

A flood of commentaries in 1979 was touched off and perhaps exemplified by one exhibition in particular, which raised serious questions about

boundary issues. It involved Brown and the National Gallery, the Greek government, and Time Inc., particularly Zachary Morfogen, managing director of a Time-Life subsidiary, Books & Arts Associates. Morfogen, of Greek origin himself, had become involved with the show's subject, Alexander the Great, more than a decade earlier. In the mid-1970s, he presented his idea for an exhibition to Brown, through Ruder Finn, Time's public relations firm.[60] Brown became enthusiastic about the project. Complex political, financial, ethnic, and intellectual interests entered the lengthy negotiations for what would become *The Search for Alexander*, one of the more controversial entries in the blockbuster race. The Greek prime minister, the National Bank of Greece, and the Greek tourist ministry became involved, and in the end Time Inc., the bank, and the government of Greece would emerge as the exhibition's cosponsors.

At the heart of the plan was a group of objects unearthed in the Vergina Tomb, which, some archaeologists argued—although there were dissenters—had belonged to Philip of Macedon, the father of Alexander the Great. The site and its relics were introduced to hundreds of journalists, from around the world, at an extended and somewhat raucous news conference. This event began a deluge of stories. The president of Greece, Konstantinos Karamanlis, who had been prime minister while the exhibition was first being discussed, had a particular interest in seeing things move ahead. He was himself a Macedonian, and some saw the government's interest in the exhibition as a means of reemphasizing Macedonia's historic connection to Greece, a relationship that was sometimes called into question. In conjunction with the proposed exhibition, Time made preparations to publish a major biography, the Greek government built a new museum wing, and a television series and elaborate set of national advertisements were planned—all of this in support of a show that would make a two-year tour of the United States, starting at the National Gallery, then going on to Boston, Chicago, San Francisco, and New Orleans. The Metropolitan Museum of Art, which had declined to join the original museum consortium or to lend various artworks to the exhibition (some said because of irritation at the National Gallery's role), signed its own contracts with the Greek government and opened the show in late October 1982.[61]

Trouble began while the contracts were being drawn up. As details became known, some museum officials raised questions about the strict control of merchandising being exercised by the corporate sponsor,

including the requirement that each of the participating museums hire a "merchandising coordinator" and pay a nonrefundable deposit of twenty thousand dollars. Facing protests from the Boston Museum of Fine Arts, Ruder Finn, which was coordinating the whole enterprise, rewrote the contracts, making the National Gallery of Art the "fiscal agent" for the exhibition tour.

The broader concern was with the exhibition's gestation. Until then, more than one journalist pointed out, major museums had usually developed their own plans for shows, then sought out funds for their support. Now they had apparently abdicated even the function of organizing the exhibition's contents. When contracts were being signed, it still was not clear just which items would be part of *The Search For Alexander*. A cynical curator at the Museum of Fine Arts wondered if the next spawn of Tut would be an exhibition entitled "Bernard Berenson's Accountant."[62] Critics, including Sherman Lee of the Cleveland Museum, further pointed out that many Greek curators were opposed to the show. The assistant director of the Philadelphia Museum of Art, Arnold Jolles, declared that if the new pattern continued, museums would lose the creative control they previously had enjoyed and there would be "more gimickrcy."[63] Another Philadelphian complained that behind the blockbusters was "another piece of advertising for the oil companies that are taking us to the cleaners."[64]

The legacy of Tut seemed clear, and not everyone liked it. Even officials at the National Gallery expressed some concern about Ruder Finn's overstepping normal boundaries in its aggressive marketing proposals. The firm had been doing art marketing for twenty years and had steadily increased its sphere of operations. "They're not working in the gallery's or museum's interest," Katherine Warwick, the National Gallery's chief public relations officer asserted. "They're working in the corporation's interest." David Finn countered that Time was not going to be able to make any money from the actual exhibition; its profits would come from the book and television series, and it had signed a television contract even before the show was considered.[65] The surrounding promotion could only increase interest in the tour and bring more people into the actual exhibition. In effect, the spin-offs were created before the central event. Whether this exculpated the sponsor, or merely added to the indictment, depended on one's point of view.

Another proposed exhibition, a selection of art from the Hermitage

in Leningrad, attracted similar criticism in the late 1970s, because of the heavy involvement of Control Data, a Minneapolis-based corporation. Control Data, which was designing a database for the Russian museum's immense collection of more than two million objects, planned to sell Soviet-produced art books and other promotional materials in the United States through a subsidiary corporation. It would thereby get dollars from its marketing as return for goods it sold in the USA. Such trading was not uncommon at this time, although the products exchanged were not usually cultural. Control Data, which among other things owned Ticketron, had apparently been selling computers in Eastern Europe in return for a variety of goods it then exported, from shotguns to soccer balls. Asked by Control Data if it was interested in the Hermitage show, the Minneapolis Institute of Art, through its director, Sam Sachs, turned to the National Gallery for help in organizing. The National Gallery agreed, planning the opening for 1980.[66]

In the end, however, for reasons beyond its control, Control Data was unable to bring off the Hermitage exhibition. With the Soviet war in Afghanistan raging, the US government refused to grant a freedom-from-seizure waiver for the coming exhibition, and Control Data had to cancel, only months before the show's scheduled opening in Washington. Scrambling, Brown recovered by booking a postimpressionism show organized by Britain's Royal Academy of Arts. There was no time to get federal indemnification for a group of paintings valued at more than 150 million dollars. But Nina Wright, president of Ruder Finn, who had seen the show in London, got another corporate sponsor, GTE, interested, and came to Brown with the proposal. "Marriage brokers are a very old tradition," he wrote Harry Parker of the Dallas Museum, "and this was one Dolly that we were very happy to say 'hello' to."[67] The other museums involved—including Boston, Detroit, and Minneapolis—were also forced to improvise. In effect, the new show was a liberation. The arrangements with Control Data and the Hermitage were spiraling out of control, Brown told Parker, and when the State Department withheld its blessing, National Gallery administrators "breathed a sigh of relief."

Brown was not finished with the Russians, however. Always sensitive to political news, and using his aide Bob Bowen to monitor the press, Brown followed closely Ronald Reagan's meeting with Mikhail Gorbachev in Geneva in November 1985, which produced a cultural exchange

agreement. This might mean important art loans.[68] He immediately dispatched two available staff members, Charles Stuckey and David Bull, to Leningrad, where they stayed in an apartment owned by Armand Hammer, with Hammer himself coaching them on procedures. They were meeting with the director of the Hermitage when a call came in from Helsinki. Because the speaker was using English, Stuckey was given the phone. To his amusement, the callers were Philippe de Montebello of the Metropolitan Museum and James N. Wood of the Art Institute of Chicago. They were just a little late.[69]

Stuckey and Bull helped negotiate the first large art exchange between the United States and what was then still the Soviet Union. The National Gallery sent forty paintings to the Russians and, in return, was able to open a spectacular show, *Impressionist to Early Modern Paintings from the USSR*, in May 1986. Hammer's Occidental Petroleum provided the funding.

Six years earlier, in the spring of 1980, museum directors were addressing the blockbuster explosion. Brown had planned to participate, along with Zachary Morfogen and Nina Wright, in a session titled "The Partnership of the Corporation and the Art Museum" at a meeting of the Association of Art Museum Directors in Toledo. But June 6 was the very day his son Jay was scheduled for surgery, and Brown canceled the trip to Ohio, sending Charles Parkhurst in his place. Conscientious about his professional duties, even at a time of personal anguish, Brown wrote a lengthy letter to Harry Parker, one of the directors who had expressed second thoughts about the effects of the Tut exhibition, setting out his own position. It was, in effect, an endorsement of corporate cooperation and a response to the surging tide of criticism. Brown was prepared to make the National Gallery a symbol of the new order. (Parkhurst carried Brown's missive with him to Toledo, but these remarks went undelivered.)

Proud of his Harvard MBA, Brown began by citing a "general bias in American society today" against business. This offered museums an opportunity, for corporations were actively concerned with improving their image. Brown saw nothing wrong with this kind of collaboration and was pragmatic in assessing funders' needs. We must "do our part in giving them credit," he wrote, and convince the press to mention them in connection with exhibitions. Otherwise, he warned, this "well is going to dry up." It was "naive" to think that business executives would "peel off

hunks of money that belong to their stockholders out of a shared love of us or whatever branch of art history we are trying to present." If a corporation provided funds to make a show possible, assured the museum of its independence, and increased public awareness of the event, it was wrong to "object to their trying innovative ways of recouping their outlay if these commercial objectives are kept in the commercial sector."[70]

Thus Brown defended the Gallery's participation in *The Search for Alexander*. He insisted that the museum had retained total control over the scholarly and curatorial areas, and praised the diplomatic skills of Zachary Morfogen for making possible the loans of the Vergina Tomb finds and helping obtain the support of both the Greek government and of Mobil. Museums must always be vigilant, but there was nothing to indicate that corporations represented real threats to their independence.

Having sent off his speech and explained the reason for his nonappearance, Brown then insisted on getting back his thirty-five dollar advance registration fee. He was always delighted by small economies, and although the correspondence may have cost the Gallery more than the moneys involved, he succeeded in getting twenty-five dollars returned. AAMD kept ten dollars.[71]

Whatever the verdict on Time, Ruder Finn, Morfogen, and the evolution of *The Search For Alexander*, the show moved forward amid an avalanche of brochures, press kits, flyers, and advertisements, as well as a four-hour television special. There were also jewelry, posters, leatherette accessories, neckties, and an official trademark designed and approved by the government of Greece. Reviewers, however, were often unimpressed, and some were even hostile. Hilton Kramer, who had so admired the Dresden show, found a common problem vexing a series of National Gallery exhibitions—*Post-Impressionism*, *American Light*, an examination of American luminism, and *Alexander*. And that was the "triumph of scale over content," the inclusion of so many distractions that a show's message became blurred. Though *Alexander* was conceived on an "epic" scale," the art on view was not up to it. Confronted with full-color photomurals of the Greek landscape, "a good deal of the time we feel as if we were visiting not the National Gallery of Art but the Greek National Tourist Office."[72] In an earlier review, Kramer had complained about the show's advertising campaigns, which reminded him of old *National Geographic* magazines, and condemned the installation as melodramatic and slick. We have "crossed the boundary separating public education from out-

right hype."[73] Museums have "become prisoners of their own success," he concluded. "Having worked so hard to create a large public appetite for the definitive blockbuster, they now feel obliged to cater to its needs."[74]

Other reviewers echoed these reactions, most using more tempered prose. Some felt the show's publicity stopped just short of misrepresentation. Paul Richard of the *Washington Post*, normally sympathetic to the Gallery's efforts, found himself disappointed. "You may seek Alexander," he told readers, "but you will not find him." Like Kramer, Richard acknowledged the show's scale but found it "hollow at the core." The Gallery's brilliant installation work had turned against itself. There were niches and pilasters, a computerized slide show, cases "glowing like jewels,"but to what end?" This "is not a TV special, nor a lecture, a movie or a picture book. It is meant to be a show of ancient art works. . . . Where is Alexander? Where is his horse? Where the crystal casket?"[75] The ruler remained a mysterious presence, despite the inclusion of rarely seen Hellenistic art. Benjamin Forgey, writing for the *Washington Star*, was somewhat less critical but also could not come to terms with the mysterious ruler.[76]

The opportunity to criticize not simply the blockbuster form but the actual contents of a show proved almost impossible to pass up. More than that, identity politics came increasingly into play. Deborah Trustman, in a detailed review of the show's origins published in the *Atlantic*, captured some underlying tensions. As Trustman put it, American museums wanted to show beautiful Greek antiquities, the Greek government wanted to put Macedonia on the map, and Time wanted to project the story of Alexander the Great. With all the elaborate packaging that accompanied the exhibition, the public (and reviewers) might well be confused about the actual story.[77] Carter Brown, as much as possible, personalized the narrative. "The title turned me on," he declared to a *Washington Post* reporter. "We're going to play this like a whodunit." It was "divine happenstance" that led Manolos Andronicus to the tomb discovery just as the National Gallery was negotiating for an exhibition of Greek antiquities.[78]

The debates only increased the competition to get a place on *Alexander*'s tour. The stakes were high for museum directors, whose jobs would be threatened if they failed to get high-profile shows for their institutions. Boston's Museum of Fine Arts and the Art Institute of Chicago were the next stops after Washington, but a furious skirmish broke out

between San Francisco and New Orleans to obtain the final slot. John Bullard, formerly of the National Gallery but now director of the New Orleans Museum of Art, was still basking in the triumph of getting the Tut show a year or two earlier, and along with fellow city loyalists he launched a campaign to land *Alexander*. New Orleans, long disparaged "as a provincial cultural backwater, is emerging as a fine arts star," gloated the *Times-Picayune*, "and that kind of reputation is not to be sniffed at."[79] Congressmen and local politicians wined and dined anyone they thought might be helpful. The Greek ambassador, for example, was given royal treatment at Mardi Gras. And in the end, New Orleans won its trophy.

But so did San Francisco. It turned to a veteran enabler, Cyril Magnin, a prominent merchant and chief of protocol for the city, who had led a delegation to Egypt in order to land the Tut show. Magnin had also been instrumental in snagging a Chinese archaeological exhibition, meeting an envoy from the People's Republic at San Francisco Airport and taking him around the Napa Valley wineries. Magnin reminded the Greeks that San Francisco had recently been led by Greek-born Mayor George Christopher, and, with other arguments and inducements up his sleeve, he managed to snare the prize.[80] Chicago's mayor, Jane Byrne, similarly appealed to Greek pride. The city's fifteenth annual Greek-American parade was set to coincide with the opening of the exhibition at the Art Institute, and Byrne seized the opportunity, not simply to pay tribute to Greece's contributions to world civilization, but to announce that the city's next police commissioner would be a Greek-American.[81]

Such municipal campaigns reflected a desire to get on the big-time circuit with crowd-pleasing shows, whatever critics might have to say about their aesthetic or intellectual deficiencies. Well-publicized exhibitions brought in revenue and expanded tourism. Growing awareness of the economic impact of blockbusters gave museums some added influence in local politics.

Brown, of course, had long linked the fortunes of the Gallery, and of neighboring art museums, to the reputation of the city, and didn't hesitate to use his position, as well as his personal contacts, to lobby on behalf of institutional needs. Quantifying cultural advantages—comparing them, for example, with professional baseball or football franchises—would provoke considerable discussion and some actual market research in the aftermath of the great shows of the 1970s and 1980s. The National Gallery's role as enabler of many of these international exhibitions, and

its decisive voice in choosing partners, gave Brown still more power as a spokesman for museum interests nationally. When museum directors came up with an imaginative idea for a major exhibition, it made sense to seek out the National Gallery and see if it wanted to get involved. If Brown and his staff expressed enthusiasm, the odds of success were increased. The National Gallery inevitably would host the opening, no matter who had come up with the proposal, but the advantages of sharing its spotlight were clear. Roger Mandle of the Toledo Museum of Art suggested the El Greco show of 1981, William Jordan of the Meadows Museum in Dallas coordinated the writing of its catalog, and both Toledo and Dallas would host the exhibition. But it would open at the National Gallery in Washington.[82]

The succession of spectacular shows in the late 1970s and 1980s established a clear reputation for the National Gallery, which certainly pleased local boosters. "There is much more to Washington for tourists these days, than monuments, the White House, and Congress," Joseph Espo wrote in a widely reprinted 1979 article. "The city's cultural events, for example, once considered a poverty case, rival the government for attention, for the nation's capital now truly is a 'world class city.'" He went on to quote Brown on the "feast that awaits the people," and cited the crowds thronging the East Building.[83]

Even within a flood of triumphs, there were special highlights. *Rodin Rediscovered*, whose planning stretched back a dozen years to a visit Brown made to Stanford, was the first exhibition to use every level of the East Building. Brown told the staff that he wanted a show that had "a big opening and a big finish and drags the audience along by the short hairs in between."[84] Enormously popular, the Rodin exhibition attracted more than a million visitors during the course of its ten-month run, sometimes drawing eight thousand a day. June 28, 1981, brought fifteen thousand people into the show, breaking the single-day record set by the Tut exhibition three years earlier.[85] Accompanied by meticulously organized explanations of how Rodin, and more particularly the lost-wax method, worked, preparing for the show was a challenging and at some points a harrowing experience. Part of the difficulty lay in raising enough money. Unsuccessful in its attempt to keep the underwriting costs below a hundred thousand dollars, the Gallery confronted a much larger operation than originally anticipated. Brown traveled north to Armonk, New York, successfully prying four hundred thousand dollars from the coffers

of IBM. Both the Guggenheim Museum in New York and the California Palace of the Legion of Honor in San Francisco hoped to be part of a tour. But the Guggenheim could not raise the money, and the trustees of the Fine Arts Museums of San Francisco, which includes the Legion of Honor, were unenthusiastic. They did, however, host the show.

Almost as challenging was arranging transport. Gerald Cantor, the Rodin collector whose interest helped inspire the whole effort, spent two and a half million dollars to make a plaster cast of Rodin's *Gates of Hell*. Shipped from Le Havre to Baltimore and trucked to the capital, it arrived at the National Gallery but no door was large enough to allow entry. It took workmen three days to get it inside and set it up properly.

The show was organized like a waterfall, cascading from the top down. Visitors entered Rodin's presentation at the Paris Salon of 1870, then descended into a series of subexhibits, among them Rodin in his studio, created through vintage photographs, and then, after a first look at *The Gates of Hell* from a balcony above, plunged down to the final portion, which treated Rodin and the beginnings of modern sculpture. *The Gates of Hell* could be viewed both from above and below, and the design staff, led by Gill Ravenel, had come up with still another dramatic, ingenious, and widely praised museum experience.

Albert Elsen, a Rodin specialist and the show's curator, declared the installation "the most beautiful sculpture show I have ever seen mounted."[86] Ada Louise Huxtable pronounced it "a powerhouse that writhes and twists," overwhelming Pei's architecture in its pulsating energy.[87] Although some prominent critics, like Hilton Kramer, had problems with the show's treatment of Rodin, other reviewers, like Robert Hughes and Manuela Hoelterhoff, lavished praise on Ravenel and Mark Leithauser.[88] Peter Andrews likened the production values of *Rodin Rediscovered* to *Gone with the Wind*, except, he pointed out, the museum exhibition had taken far longer to produce.[89]

This torrent of special exhibitions, many of them made possible by the new spaces in the East Building, was accompanied by a lengthy and expensive effort to rethink and reorganize the West Building. Brown insisted that the East Building "was always a pavilion ... supposed to connote change and variability and excitement. Things we didn't have in the West Building which we felt should connote permanence ... the horizontal view of art history."[90] With the East Building finished, it seemed time

to turn energy back to the earlier, original mission. Those spectacular temporary shows, Brown insisted, were really just one part of his larger administrative brief.

Restoration, renewal, and improvement of the West Building now became a major imperative. As successful as the exhibition spaces on the main floor were, many people, particularly in the winter, entered the building on the lower level, through the door on Constitution Avenue, without realizing they hadn't reached the principal floor. There they were greeted by a rather meanly scaled interior and no apparent staircase access.[91]

Some of these problems were unhappy inheritances. The last-minute decision to add a dome when the West Building was constructed meant that planned staircases were displaced by heavy supports. The result, according to David Scott, was what Brown labeled a hypostyle, a lower-level space filled with columns, dreary and disorienting, precluding a true sense of the building interior.[92] Brown proposed creating an oculus there, allowing light in and making visitors aware of the floor above them. The plan worked, as even some of its critics acknowledged.

More would come. The "rabbit warren" of offices on the ground floor was cleaned out; an auditorium in the center, which had blocked the flow and sight lines from east to west, dismantled; and a long corridor running the length of the entire building, opened up. This spine facilitated access to shops, eating facilities, and additional gallery space for graphic arts and small sculpture. "Operation Breakthrough" was the label applied to the West Building effort, the necessary task, faced by all museum directors, of updating physical arrangements to meet changing needs and expectations. But here the scale was enormous. Paul Mellon agreed to have the A. W. Mellon Educational and Charitable Trust, due to be liquidated in 1980, committed to the task, and it provided a five-million-dollar grant. With additional aid from Mellon and the federal government, the more than sixteen-million-dollar budget was met.[93] Brown enlisted the interior designer Mark Hampton to put up trellises, and installed a fountain for the central eating area.[94]

By February 1983, Operation Breakthrough was substantially finished, completed in phases over the previous seven years. On February 3, as Benjamin Forgey wrote in the *Washington Post*, the bronze doors on Seventh Street slid open "for keeps."[95] The West Building now had four entrances.

The new spaces in the older building were a gift to Washington, Forgey continued, before quoting Brown's musical metaphor that the Gallery was like a great record collection with a section for symphonies (the main floor) and one for quartets (the ground floor, with its Widener rooms containing tapestries and Chinese porcelains, and the American paintings from the Garbisch collection).

David Scott coordinated much of Operation Breakthrough. The attention and money it consumed reflected concern about sustaining the West Building's popular appeal and the need to emphasize the permanent collection. Trustees and some observers feared it might be overwhelmed by the exciting spaces of the East Building. Preparing comprehensive catalogs for the collection and encouraging scholarship on the paintings and sculpture would return attention to the older mission. Organizing, hosting, and installing the temporary shows had to coexist with the somewhat more mundane obligations involved in catalog preparation. Here the curatorial staff that Brown had been assembling was critically important. The 1970s and 1980s saw major curatorial appointments within the Gallery. The development of Ravenel's installation team was accompanied by a steady stream of academically trained specialists who joined the Gallery staff, Brown and Parkhurst working together to lure them to Washington.

The opening of CASVA, the Center for Advanced Study in the Visual Arts, along with its extensive library, certainly made the National Gallery more attractive to scholarly curators, who now enjoyed an immediate academic community and the easy availability of textual resources. Even before the East Building was completed, these prospects had aided recruitment of a new group of specialists. In the fall of 1977 John Wilmerding, of Princeton University, arrived to become curator of American art, one of half a dozen new curators appointed in the early and mid-1970s. With advanced degrees and other academic credentials, they enhanced the Gallery's commitment to scholarly research. While Parkhurst was particularly active in curatorial hiring, visiting universities to recruit promising PhDs, these efforts were complemented by the backing of his director.

When excited by a prospective appointment, Brown invoked all of his resources, which included a well-developed web of connections with scholars and curators throughout the country, as well as social ties with collectors and philanthropists. He could afford to make unconventional

choices. Thus Andrew Robison, a philosopher with a university appointment but without formal art-historical training, was interviewed by Brown for the curatorship of prints and drawings. Robison recalled that Brown was delighted not only by his references, which included a number of Brown's friends, but also by the fact that Robison was himself a private collector.[96] Having grown up in a collecting family, Brown was sympathetic, and excited Robison with the vision of a great national collection of prints and drawings, on the scale of those existing at the Louvre, the British Museum, or the Uffizi in Florence.

Robison's connection with the director may have been special, because of Brown's interest in graphic art. But Brown's powerful work ethic, the heavy briefcases he took home from the office each day, his willingness to awaken at four in the morning in order to talk by telephone to European museum officials about possible exhibition loans, his eagerness to study and learn what he didn't already know, even after having served as director for a number of years—all of this reflected the character of his administration. The corps of senior curators Brown and Parkhurst recruited were, to be sure, not a demographic snapshot of the larger population. Entirely Caucasian and male in the early years (with the exception of Margaret Bouton, curator of education), generally privileged, usually trained at major universities, they formed a group of experts who could assume the task of writing the permanent collection catalogs that the National Gallery needed and had published so sluggishly. Production of authoritative, annotated, well-researched catalogs of their holdings is a continuing need for distinguished museums. Stretching over many years, they sometimes consume more than one generation of professional staff. With its new systematic catalogs, the National Gallery joined older American art museums that had long been performing this central function. Their publication was cited proudly in the annual reports the Gallery presented during the Brown years, however eclipsed they might be by the drama of temporary accessions and the glamor of new acquisitions.

To the outside world, the National Gallery, by the late 1970s, presented itself as a progressive, self-confident, carefully run, largely noncontroversial center of education, exhibition, and scholarship. The exterior serenity and interior gravity of the West Building was now complemented by the energy and novelty of the East Building; public relations management, glamorous visitors, and beautifully tailored events added to the serene mystique that was enjoyed in Washington. The Gallery's parent

organization, whose museums were now lining both sides of the Mall, enjoyed even more activity in those same years. But also, much less serenity. Dillon Ripley's secretaryship, during the 1970s and early 1980s, provides some fascinating contrasts in management style with Carter Brown's administration, as the Smithsonian Institution moved to strengthen its newer commitments to the arts and humanities.

The Secretary Carries On

Consolidating Dillon Ripley's Administration

The Smithsonian Institution's dramatic expansion, which Dillon Ripley launched in the mid-1960s, mingled spectacular success with disappointment. The secretary's ambitious agenda was a work in progress throughout the following decade, attracting enthusiasm, praise, and support, mingled with skepticism, criticism, and outright condemnation. Unlike Carter Brown's, Ripley's press notices, his appearances before congressional committees, and his staff appointments were often marked by contestation and debate. Ripley, like Brown, provided services to an international scholarly community, but he was pursuing reforms even more radical than those sought at the National Gallery, trying to make the Smithsonian a center for the arts and humanities, as it had traditionally been for the sciences. The huge size of the Smithsonian enterprise, the inevitable tensions between the central administration at the Castle and bureau directors scattered across Washington and beyond, complicated the administrative challenge that Ripley faced. Crises of one sort or another were a constant. Despite the disparities of scale and their differing responsibilities, Ripley's and Brown's approaches to museum culture and their powerful influence in Washington invite some extended comparison. Particularly so for the early 1970s, as the East Building was being planned and built, and Ripley struggled with the consequences of his own expansionist dreams.

Commencing in 1965, Ripley established the practice of outlining his goals and recounting his progress in a new annual publication, *Smithsonian Year*. This livelier format replaced the previous annual reports and

allowed Ripley to strike a more informal pose than his predecessors, min-
gling broad observations, apt quotations, and memorable encounters
with his yearly summations. As in the director's reports Brown would pen
the following decade, there were touches of drama and splashes of hu-
mor. But at its heart, *Smithsonian Year* documented the newly appointed
advisers and administrative reorganizations, the bureaus and buildings
added to the Institution's stock. These, like Brown's curatorial appoint-
ments, were spread across a number of years, but Ripley's far larger orga-
nization enabled him to establish new positions, consolidate old ones,
and expand the breadth of his own authority.

The newcomers were a mixed lot, some coming with strong academic
pedigrees, like Charles Blitzer, Philip Ritterbush, Robert A. Brooks, Rich-
ard Howland, and David Challinor. Challinor, whom Ripley knew at Yale
(along with Blitzer and Ritterbush), would become his assistant secretary
for science. Both Brooks, who would serve as undersecretary for four
years, and Howland had been classicists. Others were drawn from gov-
ernment, law, and business.

Ripley valued the members of his senior staff for their personal loy-
alty in the vigorous competition for resources taking place in the capital,
for their creativity, and above all for their capacity to translate his broad
notions into practical reality. Having come directly from a university
faculty to his new position, Ripley enjoyed intellectual encounters and,
like Brown, valued scholarship. Thinking big thoughts and sometimes
impatient with details, Ripley turned to those who knew what he was af-
ter and could execute these plans effectively. Famously late for meetings
and appointments, often gruff and indifferent to some of the niceties of
social intercourse, intimidating by reason of his considerable height and
exalted status, and prone to self-righteousness about his policy positions
and his struggles on behalf of a broad public, Ripley rarely wavered in his
self-confidence. He was able to transmit to many of his associates a sense
of limitless possibilities. He valued his first impulses, was generally con-
tent with quick judgments about people. Above all he stood committed
to a challenging dual agenda: identifying and cultivating new audiences
for Smithsonian programs, and strengthening the scope and quality of
research across the arts and sciences. This meant reaching the many in
Washington who still did not patronize the Mall museums, and develop-
ing effective linkages with universities and intellectual communities else-
where. Programs, bureaus, and staff positions multiplied. The pace was

breathless, and, to some in Congress, the cost was breathtaking. Sometimes the secretary moved much faster than the Smithsonian regents wished. Larger and more unwieldy than the National Gallery board, the regents included private and public members, among them the chief justice of the United States, who also chaired the National Gallery board, and representatives of both houses of Congress. They met infrequently and, according to some critics, were insufficiently attentive to the needs of the institution.

Ripley, for all his transformational impact, faced, from early on, relentless press criticism, congressional skepticism, and challenges from his governing board. "We live in a time of adversary news notices," Ripley wearily wrote one supporter.[1] Secure about his larger course, Ripley did admit some mistakes while stubbornly refusing to concede others. But, in the 1960s and 1970s at least, he continued to seek new blood for his administration and to face down his opponents. The accomplishments he oversaw were formidable.

Thus, within just a year of his installation Ripley created the Smithsonian Resident Associates Program (1965), a museum-based continuing education process that engaged local residents with films, concerts, lectures, exhibitions, field trips, travel visits, openings, and eventually a degree program, all available for a modest annual fee. A National Associates Program was soon linked to the amazingly successful *Smithsonian* magazine, which first appeared in April 1970. The magazine was a phenomenon. Starting with a subscription base of 160,000, it quintupled within four years and by 1975 was reaching one million people each month. The editors had identified a cohort of interested readers who both provided Smithsonian with a new audience and justified Ripley's confidence in their actual existence. In this he moved ahead of his regents, many of whom were convinced, at the start, that the magazine would fail. Senators Clinton Anderson and J. William Fulbright, Ripley recalled years later, were especially skeptical.[2] Had it collapsed, Ripley's job might well have been on the line.

The search for appropriate personnel to run these operations was exhaustive and consumed several years. Edward K. Thompson, formerly of *Life*, agreed to become the editor of *Smithsonian*. Writing the historian Marshall Fishwick, in 1968, about the possibility of his heading up the Associates, Ripley indicated that the notion of organizing a national society of friends had originated during the tenure of his predecessor, Leonard

Carmichael. Carmichael and the regents were worried about the day when Congress would withdraw or diminish its ongoing support, and so sought a way in which the Smithsonian might make its own way with "direct support from the people."[3]

Ripley was optimistic. Smithsonian's diversity, its "curious development" into a quasi-federal yet private institution, its "treasure house aura," all enabled it to offer a unique approach to nonformal education. But how in this "over-communicating, impersonal society can the educator and the museum director" help visitors (or readers) build on their "interest in learning," Ripley asked. He sought a "salvage opportunity" for those "who have had most of their zest and delight in learning squeezed out by the educational system."[4] The new magazine would be such a device.

Smithsonian provided Ripley with a monthly forum in the column he wrote, giving him an audience of millions and connecting both museums and research operations with an international readership. The magazine also helped with marketing operations. Smithsonian shops, enlarged and reconfigured during Ripley's tenure, also aided the larger merchanding effort. The magazine supplemented this, quickly swelling the income stream and justifying the initial investment.

The huge audience for *Smithsonian* was used also to encourage potential donors to the Institution, by focusing, in carefully written articles, upon their private collections. It played a role, for example, in Ripley's lengthy and ultimately unsuccessful quest to land the Jackson Burke collection of Japanese art. Ripley's discussions with Mary Griggs Burke went back at least to the mid-1960s, when they exchanged letters about the possibility of donating individual objects to the Freer.[5] Ripley grew more ambitious in the following decade. In 1975, reacting to a *New York Times* story about the Packard collection of Japanese art coming to the Metropolitan, Ripley urged Freer director Harold P. (Phil) Stern, to "take a more aggressive posture towards" the impressive Burke collection. "Mrs. Burke has told me during the summer that she considers the Collection her dominant interest at this time," Ripley went on, and she was not interested in giving it to the Metropolitan Museum. Her foundation could maintain it as a separate entity indefinitely. He hoped the Freer might consider hosting an exhibition. Ripley didn't want to enter directly into conversations with Mary Burke—his wife, Mary Ripley, was a cousin—because he didn't want to appear "bossy or on an inside track

with her about her own affairs." Nonetheless, if she developed an interest in the Smithsonian it might be possible, in time, to encourage her foundation to make a grant toward construction of an addition to the Freer. And he hoped, while Stern kept these thoughts confidential, that he would move ahead on assessing the costs connected with a Freer expansion.[6]

A year later, in 1976, *Smithsonian* editor Thompson wrote Ripley about plans to have Stern do a piece on the Burke collection. Mary Griggs Burke had been widowed the year before. "I know your interest in somehow getting a leg up on a legacy, and we will co-operate when you give the signal," Thompson declared.[7]

Mary Burke, eager to have something written for the magazine, had visited Stern and extracted a promise he would do the piece. She dangled a gift possibility before him. "Jackson said to me just before he died that as long as I had the collection we would never be apart." She wanted also to share her philosophy of collecting with Stern, and to emphasize her interest in just how the Smithsonian might present the objects. "I cannot possibly overstate the importance to me of the way in which these beautiful Japanese creations are placed on exhibition. It will influence me in planning for these objects after my death and it has given me a reason and goal to strive for during the rest of my life."[8] Ripley had suggested a Washington show in the next few years: "I don't suppose the dream of the underground exhibition gallery for temporary shows in connection with the Freer could come into existence that soon, but it would be wonderful!"

Alas for the Smithsonian, the gift would never come. Phil Stern, already ill, died six months later, in April 1977, and the *Smithsonian* article never appeared. Dillon Ripley set out almost at once to raise an endowment in Stern's name at the Freer, where Mary Burke sat on the visiting committee. Much of the Burke collection would go, years later, to the Minneapolis Institute of Art, with the Metropolitan Museum of Art also receiving major objects and financial support (Mary Burke had been born in St. Paul). The fact that these efforts in the 1970s ultimately failed does not reduce the strategic value *Smithsonian* held for pursuing institutional goals and campaigns.

Events as well as organizations were important to Ripley's program of popularization. In 1967 the first Smithsonian Festival of American Folklife took place on the Mall, a wildly diverse blend of performers and attractions that simultaneously entertained and instructed, reflecting

the Smithsonian's longstanding interest in vernacular music and dance. Ralph Rinzler, a musician and folklorist, who had spent four years with the Newport Folk Festival, was hired as a consultant to run the festival. Simultaneously an organizer, field worker, and conference convener, Rinzler was soon also making films for the Smithsonian and after three years was hired as a staff member. He broadened and changed the festival from year to year, introducing new kinds of programs and performers, and creating an expanded, twelve-week festival for the bicentennial year of 1976. Rinzler credited Ripley with encouraging him in the search for new audiences. It was his purpose, Rinzler said, "to bring people to the Institution who felt disenfranchised or unconnected entirely."[9] In a much publicized gesture, Ripley opened the museums to protestors in 1968 during the Poor People's March on Washington, keeping the buildings unlocked until late at night so that the rest rooms would be available, and generally welcoming all who wished to enter. Despite the fears of some at the Smithsonian, there was no damage reported.

The millions who flocked to the Mall for special events like the Folklife Festival were supplemented by those attracted to the carousel constructed near the Castle, or to the annual kite festival, which also began in the mid-1960s. There was jazz on the Mall, a puppet theater, and strenuous efforts to give Washington an active parks program. Ripley wrote President Johnson, in March 1968, that he hoped all this would be helpful when there was so much "news and worry in the press these days about the coming summer in the cities."[10]

Ripley criticized other institutions for what he claimed was a failure to engage with public needs and the living arts. A letter he sent to Roger Stevens, who headed the Kennedy Center, got press publicity after it was released by a New Jersey congressman. Warning that the new facility was in danger of becoming a "lifeless marble shell," a "passive receptacle for shows from elsewhere," Ripley called for the creation of workshops and studios, for playwrights, composers, and artists in residence, for performances by and for children, and for lower prices, tickets available at local post offices, and a range of other things. He hoped the Kennedy Center would not exist merely to save "people the trouble of traveling to New York to go to the theater or the opera."[11]

Links to the world of scholarship were also central for Ripley. Celebration of the two hundredth anniversary of James Smithson's birth inspired not only well-publicized pageantry on the Mall but a cluster of

conferences and addresses. One resulting publication, *Knowledge among Men*, brought together symposium addresses by eleven major scholars from throughout the world, including Claude Lévi-Strauss, Robert Oppenheimer, Lewis Mumford, Kenneth Clark, and Herbert Butterfield. Introducing the text, Ripley emphasized the unity of knowledge, its relationship to experience, and the need to incorporate objects in the advancement of learning. He deplored the reign of fashion and the growth of safe specialization, and argued that the Smithsonian motto might well be *"the pursuit of the unfashionable by the unconventional."*[12] He was confident about his institution's capacity to move along new fronts, and quickly launched a range of new activities in the arts and humanities.

Thus, in 1966 Ripley appointed a group of twenty academics, intellectuals, and administrators (several of them participants in his bicentennial symposium) to a new body called the Smithsonian Council. Soon thereafter, with additional members, it was chaired by the president of the Guggenheim Foundation, Gordon Ray. The council included a number of scientists like Yale zoologist G. Evelyn Hutchinson, Stephen Jay Gould, and Frederick Seitz, president of the National Academy of Sciences, but alongside them sat historians, anthropologists, critics, artists, and writers like Harold Rosenberg, Ada Louise Huxtable, Carl Schorske, and Barbara Tuchman. Meeting twice a year, in its early incarnation, the council served both as a sounding board for the secretary and as an informal visiting committee, evaluating and reporting on a range of research and exhibition activities. Council deliberations, sometimes summarized in *Smithsonian Year,* helped emphasize the role the Institution played within the international scholarly community but also provided a checkpoint, an outlet for praise and criticism that kept the secretary and his staff in touch with currents of opinion outside Washington. In carefully worded prose, the council sent a letter, after each meeting, to the secretary, pointing out strengths, weaknesses, and needs that merited attention. With the agenda set largely by senior Smithsonian staff, this offered Ripley and his lieutenants support for programs they were promoting or revising. The Council also provided occasions that brought together normally separated parts of the Institution, reemphasizing its singular identity. Without commencements and faculty meetings, Ripley was always looking for surrogates to highlight the Smithsonian's academic functions.[13]

About the same time, the Smithsonian began to assume other signifi-

cant academic functions. In cooperation with the American Philosophical Society and the National Academy of Sciences, it provided a home for editing and publication of the Joseph Henry Papers, a multidecade effort honoring the extraordinary career of the Institution's first secretary. And in 1970, as previously noted, Smithsonian agreed to acquire the Archives of American Art. A home was provided in the two-museum complex in the old Patent Office Building. The archives enjoyed some independent support, but the Smithsonian faced ongoing costs connected with their maintenance. Covering this budget added to the strains that would develop with congressional committees looking for savings. Local observers predicted that "droves of scholars can not be far behind."[14]

And then there was the issue of a resident scholar center, one of Ripley's long-standing goals. Creating a center for scholars was discussed at the very first Smithsonian Council meeting in October 1966, as councilors considered its possible relationship to a consortium of local universities. Ripley had already been lobbied by John White—a discussion he termed "unhelpful"—who had helped ignite the lengthy process that resulted in the National Gallery's CASVA.[15] Ripley had different ideas, but he was especially interested in some kind of international house or hostel, to be built on a new square just north of the National Archives. He raised this notion with architect Gordon Bunshaft, as he began working on plans for the proposed Hirshhorn Museum. These thoughts, in turn, were complicated by the slow emergence of the Woodrow Wilson International Center, a living memorial to the twenty-eighth president.[16]

The Wilson Center's evolution began in 1961, when President Kennedy, responding to a joint resolution of Congress, appointed a commission to propose something other than a conventional monument to honor Wilson.[17] The commission issued a report in 1966 recommending a center for scholarship that would host students of national and world affairs, allowing researchers and intellectuals to interact with elected officials and government staff. It was intended to acknowledge Wilson's personal bridge between the worlds of politics and academe, and to reflect as well his internationalist values. The report suggested locating the center on a new Market Square, a superblock just north of the National Archives (the same area Ripley had discussed with Bunshaft a year earlier), as part of an ambitious plan to revitalize Pennsylvania Avenue and create a cross axis leading from the Archives to the National Portrait Gallery. In 1968 Lyndon Johnson signed the Wilson Memorial Act establish-

ing the center, and in 1969 a board of trustees was appointed. In the years that followed, fellowships, seminars, lectures, and conferences brought together scholarship and political practice. Fellows came from throughout the world.

Ripley originally had something different in mind. In March 1966, a resolution was introduced in the House of Representatives expressing approval for the "establishment under the auspices of the Smithsonian Institution, of an International Center for Advanced Study in the Nation's Capital." Ripley hoped to sponsor a postgraduate center for Washington, at a time when there was little interest in doing so at local universities. He recalled, years later, that initially he conceived of it as a small department within the Smithsonian.[18] He wanted to avoid the revolving-door process in place at certain existing organizations, which hosted political figures temporarily out of office before they found new spots in government.

The campaign for the Wilson Center, however, offered an opportunity for Ripley. The living memorial idea had gained the support of a number of prominent officials, including former secretary of state Dean Rusk. So Ripley proposed that if the center were established, it be housed in the old Smithsonian Castle on the Mall, until the memorial itself could be constructed.[19] Ripley and Charles Blitzer testified on behalf of the project and enlisted the support of Representative Peter Frelinghuysen, a member of the Wilson commission. Senator Daniel Patrick Moynihan of New York, another old friend, sat with Ripley on the Pennsylvania Avenue Commission, a subcommittee of which recommended putting the memorial building on Market Square.[20] In 1969 newly elected president Richard Nixon, in a message to Congress on revitalization plans for the District of Columbia (and expanded self-government), specifically mentioned the "grand design" for Pennsylvania Avenue, including the Wilson memorial, as well as the coming addition to the National Gallery.[21]

Wolf Von Eckardt, architecture critic for the *Washington Post*, who had many problems with the grand plan, noted that the Wilson Center would be the nucleus for a "splendid new square across from the Archives Building" and the mainstay of an important new north-south axis. But, Von Eckardt argued, forty Wilson scholars would not provide enough life for so grand a square, and developers were skeptical as plans for hotels, apartment houses, and stores remained vague.[22] Low-cost housing for the visiting scholars remained a goal. In later years, Ripley hoped that Averell Harriman's houses might be offered and made into a kind of

miniature international house. But this also did not work out. "There's nothing like the inherent stinginess of the very rich," Ripley commented bitterly.[23]

Meanwhile, Brown and his associates at the National Gallery were putting the final touches to their CASVA scheme, aware of the Wilson project and Ripley's ambitions, and debating just how much information to share with Skidmore Owings & Merrill, the architectural firm responsible for the Pennsylvania Avenue Plan. There was concern about keeping control and budget away from Smithsonian hands.[24]

Ripley was torn between his position as a National Gallery trustee and his Smithsonian commitments. On receiving Paul Mellon's letter about the proposed Gallery addition in early 1967, he wrote that "the prospect was wonderfully appropriate and even thrilling," although he couldn't help adding that congressional committees and the Bureau of the Budget should be warned about the need for increased appropriations.[25] But the devil lay in the details. By October 1967, reacting to Brown's memorandum on the CASVA proposal, he shared with Charles Blitzer and Philip Ritterbush the discomfort his dual role had produced. "I am not sure how to evaluate my own thoughts, and whether they are objective in the manner of a Trustee or not. A bias tends to creep in. . . . One of the questions I asked myself is, to what extent does such a proposal advance or depreciate our own proposals, and am I being selfish thinking this way?"[26]

The first thing he wanted to know was whether Brown's plan for CASVA did anything for the local universities. An earlier goal had been to draw visitors into the ambience of these institutions, and so help enrich them. Secondly, there appeared to be no ideal of cooperation with the "PhD types" working in federal settings. Brown's proposal would have the center run entirely by Gallery trustees. It "sounds like another Hellenic Center, another Dumbarton Oaks, another Folger." It would be "small, the fellowship will be chaste and uncontaminated by contact with scientists or other persons not in the groove of the history of art."[27] The whole thing was too narrow and self-contained for Ripley's taste. He preferred an interdisciplinary character for this kind of center, reflecting the Smithsonian's own diversity. But he wasn't sure whether he should simply step aside, given his own institutional loyalties, or plunge ahead with "constructive" criticism. What he actually did remains unclear, but he certainly wanted to distance himself from the postgraduate models

being developed. Ripley was never happy with the expansion project, calling it "oppressively large" and likening the East Building to a Hilton Hotel, at least as viewed from the United States Capitol.[28]

Many of Ripley's senior aides did express disappointment with the plans. Charles Nagel, director of the National Portrait Gallery, felt unhappy that the CASVA proposal promised little cooperation with other centers, inside or outside the Smithsonian, and most notably the Wilson Center. He also was concerned that it would do little for fields unrepresented at the National Gallery, like "primitive" and "oriental" art.[29] Charles Blitzer urged prudence on the secretary, and took a somewhat more positive stance. CASVA was certainly a desirable addition to the local scene, an acknowledgement, "belated" to be sure, of the Gallery's responsibilities to scholarship. Nevertheless, he admitted, it was less than could be hoped. He urged Ripley to be nurturing and supportive while further details were worked out.[30] John A. Pope, the Freer director, was unabashedly enthusiastic, congratulating Carter Brown on his report and sending on a copy of his memo to Ripley, saying the proposed center filled a great need and should be endorsed.[31]

One aspect of the East Building plans that Ripley did admire was the organization of the National Gallery's first support group, the Collectors Committee. He ordered one of his staff members, Lynford Kautz, to prepare a memorandum for the Smithsonian about doing something similar. The Smithsonian, Kautz thought, might be able to attract as many as a thousand people to such a support group, two hundred and fifty to a region. Success, however, depended heavily on volunteer leadership. The National Gallery had the invaluable servies of Mrs. J. Lee Johnson (Ruth Carter Stevenson, in later years) of Fort Worth, who would in time become a Gallery trustee.[32]

There was no problem exchanging information about matters of this kind; the Smithsonian and the National Gallery did so all the time. In 1973 Robert Mason, executive director of the Smithsonian Associates, sent Brown a long memo detailing efforts over the previous three years to develop corporate support. In two and a half years, a quarter of a million dollars had been raised and some twenty-four corporate members acquired. Ripley, recognizing the need for venture capital to finance parts of the Smithsonian operation, had spoken in several cities. Letters were not enough, Mason reported, nor were general appeals. The more specific the proposal, the better the response. Chairs in the history of science

and mathematics had been created, through corporate support, as well as start-up costs for the Cooper-Hewitt Museum in New York. But Mason asked Brown if he had any suggestions for improvement.[33] Gallery development programs were getting the secretary's attention.

So far as the Wilson Center was concerned, Ripley viewed it, in later years, as something of a lost opportunity, damaged by issues of governance. Initial discussions had been positive; with Moynihan and Frelinghuysen on his side, Ripley enlisted Senators Byrd and Fulbright, and hooked up again with his old friend August Heckscher. President Johnson happily signed the legislation in October 1968, much concerned, Ripley recalled, "about establishing, in parity, if not in superiority, his role as an intellectual with that of his late predecessor."[34] This was a status that Ripley willingly acknowledged.

Ripley hoped the Center would concentrate less on political policy and more on cultural and ecological issues, something he was having trouble getting his Smithsonian colleagues to focus upon. But he ran into an obstacle when Douglass Cater, the presidential assistant who had been deeply involved with getting the legislation passed, insisted that the majority of Wilson directors be presidential appointees. Ripley wanted the Smithsonian regents to make the appointments, as they did for other bureaus, but Cater and Harry McPherson, another presidential aide, sought an autonomous Wilson Center, like the National Gallery or the Kennedy Center. Ripley was dubious. He feared the selection process would become politicized, as it had at the Air and Space Museum (and as was happening at the Kennedy Center), and that the political figures themselves would not attend meetings or become working board members.[35] This was certainly his experience with the Smithsonian regents. Cabinet secretaries were notoriously absent. He was willing to have the chairmanship put in the hands of the president, but nothing else. He also feared that seats would stay vacant while candidates went through a lengthy vetting process. In the end, Ripley lost the battle. He managed to make the Smithsonian secretary an ex officio board member, but that was about it. For a time, the center threatened to become a refuge for retired diplomats and former public officials, but changes of leadership, and the arrival of George Kennan, helped give it the academic flavor that Ripley had sought, while publication of the *Wilson Quarterly* established some legitimacy. By the late 1980s, Ripley allowed, the center had become "semi-autonomous."[36]

The separate building, with lodgings for the fellows, would never happen. The ambitious Pennsylvania Avenue Plan went nowhere. Other sites came up for discussion—the old Providence Hospital on Capitol Hill, the *Evening Star* building, Pershing Square, land just west of the proposed Canadian Chancery, the Auditors Building at Fourteenth and Independence, and the Smithsonian's own South Yard—but they were too large, too small, or too expensive.[37] Discussions dragged on for years. In Congress, Sidney Yates stood firm, saying he would approve no more money for building.[38] The Castle provided space on its third floor, but in the end the Wilson Center was moved to quarters in the newly completed Ronald Reagan Building and International Trade Center, where, like the Smithsonian, it operates with a mix of public and private funding.

The Wilson Center episode revealed the strengths and limitations of Ripley's interventionist strategies. He succeeded in getting the Smithsonian involved with a new entity and in getting that entity supported by legislative enactment, but not in shaping its final form or function. Smithsonian control was seen by some in government as an avoidance of effective supervision, and Ripley's empire building only made his opponents bolder.

Public relations problems intensified for the secretary at just about the time the Wilson Center was making its way through Congress and to presidential signature. In February 1970 *Business Week* ran an article, "Skirmish at the Smithsonian," reporting on a clash between Secretary Ripley and his regents at a January meeting.[39] There had been, according to the magazine, recriminations about wasteful spending on construction projects, dismay expressed at the costs of starting up *Smithsonian*, and opposition to his plans to switch investments from bonds and blue-chip equities into growth stocks. The meeting was a showdown. The Smithsonian chancellor, Chief Justice Warren Burger, imposed a ban on discussions afterward, but *Business Week* claimed that the discussions were more than simply disputes about money.

The extraordinary growth of the Institution in the six years since Ripley took over was causing some regents anxiety. He had already increased the number of employees by 50 percent, while Smithsonian admissions jumped even more, to over twenty million annually. With a budget of less than fifty million dollars a year to run its museums, galleries, and zoo, the Smithsonian was facing congressional reluctance to enlarge its appropriations. Ripley's efforts to pool the endowment funds of his various units

had led to bitter disputes with Agnes Meyer, a Freer board member who feared the rich Freer endowment would be dissipated as a result. There were already concerns that funds earmarked for acquisitions were being diverted to maintenance. Decisions were reached. The magazine plans would go ahead, the pooling of trust funds would be studied, and the General Accounting Office's critique of Ripley's management would be resisted. He had emerged the winner, *Business Week* concluded, but there would be another meeting in April. And Meyer, who was also the owner of the *Washington Post* and mother of its future publisher, Katherine Graham, vowed to fight on, although she would die later that year.

Confrontations with his board, and governmental criticism, were supplemented by various attacks—some professional, some personal—in the press. Even apparently innocent encounters—like the interview given to the *Post*'s food editor, Marian Burros, by Ripley's special events coordinator, Meredith Johnson, could present problems. Ripley, after getting an angry letter from the chairwoman of a House subcommittee on appropriations questioning the cost of a meal celebrating the Hirshhorn opening, unburdened himself to Johnson. "I have urged you in the past to stay away from them [reporters], because of the opportunities that they will take to introduce controversy into the Society pages." If such repercussions come from our congressional friends, he asked, "what will happen to the reactions among those who are not?"[40] In 1977 the *Washington Post* ran a string of critical pieces on Ripley, many of them by a staff writer, Charles A. Krause. This only increased the secretary's sensitivity.[41]

Some gossip columnists did make a habit of tackling Ripley, particularly Jack Anderson.[42] Anderson's popular *Washington Post* column, "Washington Merry-Go-Round," blazoned the headline "Ripley's $2,800 Search for a Gull" across its space in late November 1970. No adjective was spared. The "proud but poor" Smithsonian had recently sent its director on a two-week cruise through the "sunny" Aegean in search of the Audouin's gull. The secretary, he charged, had "sailed the epic, wine-dark seas around the isles of Greece aboard the good ship 'Pacific Gold,' which rents for $480 a day." Ripley, supplied with a Harvard-trained translator and accompanied by "aristocratic" friends "quaffed fine drink, lolled on beaches, sampled succulent Palaiokastritsa lobsters and viewed antiquities, all at public expense."[43]

Not quite public expense, to be sure. The Smithsonian itself had spent twenty-eight hundred dollars on the quest for the gull; the rest

came from a private grant to be used in connection with a symposium on Bronze Age culture. With all his wide-ranging knowledge Ripley could claim no expertise about the Bronze Age, but he had promised the donor he would visit archaeological sites. The Smithsonian's treasurer insisted the donor had approved. But not everyone was convinced. Earlier that year Anderson had proffered other charges against Ripley, these centered on influence peddling. In August 1970, he noted that Representative Julia Butler Hansen, whose subcommittee controlled the Smithsonian's public purse, got furious when asked how her son had ended up that summer on the Smithsonian payroll. She had never asked Ripley for anything, the congresswoman declared, but had merely sought Vice President Humphrey's help in finding a summer teaching job. Her son ended up working at the Smithsonian, Anderson wrote, getting personal counsel from the secretary and assistant secretary Blitzer and assistance toward landing his next museum job.[44]

Not every press notice was negative, of course. To many in Washington, Ripley was a hero who had transformed the musty national attic into a vibrant and dynamic force. Lloyd Schwartz entitled an article, just weeks after Anderson's attack on the Aegean cruise, "Daybreak at the Smithsonian: A Well-Packaged Relevance." The secretary had "captured the public imagination," Schwartz wrote, with his combination of "slick contemporary technology" and "reverence for the past." Museums were "cryptic colleges," Ripley told the reporter. "We don't give degrees . . . but are implicitly a part of the educational process."[45] And there were many other champions. After the General Accounting Office issued a report criticizing Ripley's failure to observe rules governing the blending of public and private funds, Daniel S. Greenberg in the *Washington Post* suggested that Smithsonian depictions of primitive man now include congressional probers and government auditors. Is "excellence compatible with the oafish ways of government?" he asked. Ripley had led the Smithsonian to spectacular successes, which perhaps had aroused the envy of investigators, he suggested.[46]

Just as the National Gallery was gearing up its fabled hospitality, Smithsonian parties were beginning to achieve their own reputation. "When the Smithsonian gives a party it's anything but conventional," the *New York Times* reported in October 1970.[47] The particular occasion was a benefit ball at the Renwick Gallery hosted by the Smithsonian Associates Ladies Committee, where more than a thousand guests were welcomed

by a group playing nineteenth-century brass instruments. There visitors confronted taxidermists demonstrating how to cure a hide before stuffing it, a metal specialist showing how to remove rust, and a painting restorer working on a canvas from the National Collection of Fine Arts—all demonstrating the diversity of Smithsonian collections and activities. And they were serenaded by, in addition to the brass band, an eclectic assembly of musicians ranging from the Marine Band to a rock group. The event had been preceded by a series of private dinner parties all over the city, including one hosted by Secretary Ripley at his Massachusetts Avenue residence. These were the kinds of notices that Carter Brown would soon be getting, and indeed Brown was in attendance at the Renwick, along with ambassadors, the local hostess Perle Mesta, donors, philanthropists, and members of Washington society. More than a year later Brown sent Ripley a "fan letter," congratulating him on saving the Renwick and supervising so sensitive a restoration.[48]

Criticism came not just from the media. Indeed, Ripley and his programs provoked some bizarre kinds of opposition, which caused no end of trouble. Perhaps the strangest and most troubling came in the form of a local resident, a freelance journalist and sometime collector of Asian ceramics named Robert Hilton Simmons. Simmons had served in naval intelligence and the merchant marine. He had an art history degree from the University of California, Berkeley and an interest in a variety of areas, glass and printmaking as well as ceramics. After moving to Washington, around 1965, Simmons was active in craft circles, helped curate some exhibitions, and served as a founding trustee of the Museum of African Art.

At some point in the late 1960s, Simmons began a series of campaigns against Ripley, charging corruption, double-dealing, and violation of legislative intent. One piece by Simmons, published in the *Washington Star* in May 1969, accused Ripley of endangering artworks by scheduling a dinner for a Smithsonian symposium in the Lincoln Gallery of the National Collection. "An art museum used like a cafeteria . . . billows of cigarette smoke enveloped paintings by Ryder, Cassatt, Eakins. . . . Carpets burned underfoot. . . . Glass smashed on the marble tile. . . . No professional museum director wants to play sitting duck to an ornithologist."[49] Simmons attacked Ripley's personal integrity, his scholarly judgment, his zeal for self-aggrandizement, and his administrative ineptitude. He sent letters of protest to Smithsonian regents and contacted sympathetic

congressmen. Not long after Simmons' article, Anderson ran a column in the *Washington Post* assaulting both Ripley and Robert Tyler Davis, the acting director of the National Collection of Fine Arts, for swapping art with dealers.[50] Why Simmons became so hostile is unclear. He was especially incensed by the firing of David Scott, the director of the National Collection of Fine Arts, and the concurrent creation of the Hirshhorn Museum, but many other things got his attention. With access to sympathetic newspaper columnists and government officials, some knowledge of art, and considerable energy, Simmons caused Smithsonian and Ripley a good deal of misery for an extended period of time.

Simmons's main point of entry was through Congress, a number of whose members were already upset by issues ranging from tax policies to Smithsonian growth and expenditures. In the years following the 1966 approval given to the Hirshhorn donation, Simmons raised questions about every aspect of the collection, the donor, the Hirshhorn board, and the site. He complained to the Internal Revenue Service, the Federal Bureau of Investigation, and to his own congressman, helping to force hearings on these charges and instigating a General Accounting Office audit. Smithsonian officials from Ripley on down were compelled to testify. The comptroller general of the United States found it necessary to defend the status of the Smithsonian as a private charitable trust, supported by the government but not a part of it.

Various congressmen and senators, often with their own political agendas, aided and abetted the controversy. In the summer of 1970, a House subcommittee reviewed a series of Simmons's charges, some of which were treated with incredulity. He was warned by the subcommittee chairman that he could be liable to legal action for his statements. Representative Jonathan Bingham, a New York Democrat, declared that he thought Simmons's "primary purpose here is to discredit Dr. Ripley and the management of the Smithsonian."[51]

The actual construction and opening of the Hirshhorn in the fall of 1974 did little to quiet its enemies.[52] Architectural critics from throughout the country competed for angry metaphors as Gordon Bunshaft's building shocked locals and visitors alike. Robert Hughes, in *Time*, suggested the building looked like "someone has deposited the set from the 'Guns of Navarone' on the Washington Mall." A squat cylinder, "sheathed in granite aggregate the color of flushed elephant skin," one "looks (in vain) for the muzzle of a 16 in. gun peeping from the slit." The building

would "make even Benito Mussolini flinch," Hughes continued, condemning Bunshaft's "gift for lumpen grandiosity."[53] Ada Louise Huxtable, whose notable gift for epithets had been used even more lavishly on the recently completed Kennedy Center, marched in lockstep with Hughes, declaring that the building was widely known around the city as "the bunker or gas tank, lacking only gun emplacements or an Exxon sign. . . . This is born-dead, neo-penitentiary modern . . . not so much aggressive or overpowering as merely leaden." Asserting that it was unclear whether Washington did something to architects or architects did something to Washington (where practitioners "fall on their faces with alarming regularity"), she labeled it a "marble doughnut."[54] Douglas Cooper, in a dismissive review of the museum's first catalog, relentlessly flayed almost everyone involved, likening the building itself to a "lunar blockhouse" and imagining "vast rockets emerging from its hollow center." The sculpture garden was "as mean and cramped as a municipal flower bed." He sneered at its advocates' pretensions to make Washington a showplace for modern art, labeled Joseph Hirshhorn's collection a "farrago of aberrations," and ridiculed Dillon Ripley's glowing catalog introduction, branding the "adventurous impressario" [sic] ignorant about the relationship between modern art and the work Hirshhorn had assembled.[55] Even the circumspect Paul Mellon supposedly cited Dorothy Parker's remark about Los Angeles: "There's a lot less here than meets the eye." (He did allow that he liked "the inside of the building better than I thought I was going to."[56]) David Scott, now at the National Gallery and heading the planning effort for the East Building, reported to Brown that the Hirshhorn had circulation and security problems, even though the new museum was soon setting Smithsonian admissions records.[57]

Brown, perhaps understandably, was more sympathetic than Scott toward the Hirshhorn project. When Scott wrote in a memo that the Smithsonian's new museum wholly overlapped with the National Gallery, and that the two would be going to Congress and the OMB for funds to do the same thing, Brown replied, "I think Washington and the country can absorb it." "I still posit our role as the high road, masterpiece route, with occasional contemporary exhibitions. The more shows and the more education Washington supports, the better."[58]

While this kind of generosity was not universal, there were some who admired the (much reduced) Hirshhorn sculpture garden as well as the building, and who were pleased with its art. Polemics produced reac-

tions. *Time* critic Robert Hughes, however critical of the building, admired Hirshhorn's "impetuous enthusiasm" even while asserting that he lacked the "balanced connoisseurship a great museum needs." Still, it was a relief to find one collection, at least, not subservient to rigid historical theory.[59] Dillon Ripley declared it all a "grand success."[60] He entered the vocabulary wars himself, declaiming at the opening, that "the vast and soporific panorama of Brobdingnagian horizontal buildings in Washington cannot be for us."[61]

The contested aesthetic status of the structure, and the power of the various architectural metaphors and similes, made earlier arguments about the Hirshhorn's violating the special space of the Mall more difficult to fend off. Charles Freer, as Ripley and some editorialists pointed out, was hardly a paragon of virtue himself, and his museum had been standing for half a century. But the Freer's understated classicism blended in easily with its neighbors and, for many, in Congress at least, housed a collection they barely knew. In any event, angry charges only grew more intense after the Hirshhorn opened and huge crowds flocked to see the collection. For some reason, much of the hostility came from Iowa. In 1971 Congressman Fred Schwengel, an Iowa Republican, joined some colleagues in charging that the tax benefits Hirshhorn had received for his gift had been excessive. Hirshhorn's attorney, Sam Harris, protested the charge in a letter to Ripley and provided him with persuasive support.[62]

Then Senator Dick Clark, an Iowa Democrat chairing a subcommittee on public buildings, proposed that the new museum change its name to the Franklin D. Roosevelt Gallery of Contemporary Art. This had in fact been the suggestion of Clark Mollenhoff, a Pulitzer Prize–winning columnist for the *Des Moines Register*. Since 1970 Mollenhoff had been Washington bureau chief for the *Register*, and a fierce critic of the arrangements that brought the Hirshhorn collection to Washington. Smithsonian aides met with Clark—"the tone of the meeting was amicable," one reported—to go over the gift agreement. They pointed out that the museum was not a monument or memorial, which presumably a gallery named for Roosevelt would be. Pat Moynihan, then ambassador to India and the chair of the Hirshhorn board, also met with Clark.[63]

Simmons continued to cause problems, feeding items to Ripley's nemesis, columnist Jack Anderson, denouncing the creation of the Hirshhorn as "the biggest scandal in the art world during the past ten years," and protesting an admiring piece on Ripley's accomplishments by

Philip M. Kadis in the *Washington Star*, "one of the most unethical pieces of disinformation to appear in the press this year."[64] It was Ripley's predecessor, Leonard Carmichael, he insisted, who had saved the old Patent Office Building, expanded the Museum of Natural History, and created the Museum of History and Technology, while Francis Sayre and Robert Goheen masterminded the establishment of the Woodrow Wilson Center.[65]

But most of all Simmons concentrated on David Scott, "declared a non-person at the Smithsonian" though responsible for everything that the National Collection of Fine Arts had managed to achieve. It was Scott who saved the Cooper Union collection, conceived the present function of the Renwick Gallery and named it, and brought the Archives of American Art into the Smithsonian. But "because he refused to betray the American people" by yielding the national contemporary art museum to Joseph Hirshhorn, "with one ruthless stroke Secretary Ripley extinguished Scott's career."[66]

Scott's career was far from extinguished, although it certainly took a different course once he left the Smithsonian. Brown snatched him up to coordinate design and construction planning for the East Building. Paul Mellon asked Ripley for a recommendation, and the secretary, as he remembered, said he might do a very good job, although he warned about personal issues. Scott stayed with the Gallery for many years and enjoyed a good relationship with Brown. But his abrupt departure from the Smithsonian had congressional impact. Senator Clinton Anderson of New Mexico requested more information about both Scott and Simmons, complained congressional committees were not being treated fairly, raised questions about art purchases, trades, and deaccessions, and wondered if the FBI had investigated Simmons. His letter could not be ignored.[67] Ripley wrote a lengthy reply, responding to the questions one by one. He said he could not explain Simmons's motivations, had been told an FBI investigation would be inappropriate, and detailed the reasons for the Scott move, an "apparent unwillingness or inability to work in harmony with other parts of the institution." Having responded in some detail, Ripley couldn't help expressing a final bit of anger. "I must in all candor say that in my view an inordinate amount of time has already been devoted to the irresponsible charges made by Robert Simmons."

Ripley claimed to have been puzzled and angered by the imbroglio, and, as he usually did in such situations, blamed the problems on personal resentments. He felt certain that Scott and Simmons got together

and pushed forward some of the charges that continued to plague him. Scott, he concluded, had gotten in over his head, and despite the difficulties that resulted, he was glad to have gotten rid of him.

In all of this Ripley relied more and more on his chief adviser and friend, Charles Blitzer. Together they launched a search to replace Scott at the National Collection. This was still a small museum, Ripley acknowledged, and he wanted to make a splash with a distinguished academic who was also a good lecturer. He didn't care much about administrative experience. "I wanted interesting individuals," Ripley declared, who would be adept at building up Smithsonian research.[68] In the end, they settled on Joshua Taylor of the University of Chicago, a popular professor and published author whose interests spanned the art of both hemispheres. Bilingual, in English and Spanish, Taylor had written a widely used text entitled *Learning to Look* and held a national reputation as an original thinker. Taylor took some persuasion—he was happy to remain in Chicago, he told Ripley—but after six months and assurances about his independence, he accepted. It proved to be a highly successful choice, and the decision to rename the National Collection the National Museum of American Art gave it a stronger identity. Taylor had broad sympathies; he was interested in folk art and religious art, in regionalism and decorative art, as well as modernism and historic American art.[69] He radiated intelligence and confident connoisseurship, and he would instigate a series of innovative and influential exhibitions and catalogs over the next eleven years. Ripley turned to him frequently for advice.

The number of museums within the Smithsonian meant there was almost always a directorship to fill. What made administrators successful varied—some brought peace to their staffs, others induced excitement and novelty, a fortunate few did both—but the quality of the choices were of fundamental importance to the secretary and his associates at the Castle. While public controversies eventually found their way up to the secretarial level, individual directors had to be prepared to handle criticism or staff disagreements on their own.

Ripley made two other important appointments at the time Joshua Taylor was brought to Washington. The recently established National Portrait Gallery shared the old Patent Office Building with Taylor's National Collection, and Charles Nagel, its first director, was retiring in 1969 after holding the position for five years. A national search ensued, with prominent art historians in the hunt. Here Ripley chose someone

who didn't quite fit the tastes of the museum's commissioners (to judge from some comments), and who was certainly quite different from Nagel. Marvin Sadik had directed art museums at Bowdoin College, in Maine, and the University of Connecticut. In an interview decades later, Sadik claimed he campaigned for the job.[70] While he had studied art history at Harvard and worked on a graduate degree, he was not a published scholar or a fabled teacher like Taylor. Ripley, however, liked the contrast and enjoyed appointing directors who were not to the manner born. Sadik was, Ripley recalled, "efficient, smart, clever, amusing, and in many ways, the natural antithesis of the rather reserved, ingrown professor that was Josh Taylor." He viewed them as an odd couple, two bachelors firing off memoranda dealing with their respective halves of the shared building, quarreling about signage and elevator usage and all the other housekeeping details that can occupy museum directors. But Ripley didn't mind the squabbling; he felt both directors were rational and responsible, and got their jobs done.[71] Sadik lasted twelve years in his job, developing a series of lively exhibitions and presiding over some important acquisitions. Taylor had a shorter tenure, dying in 1981.

In 1969 Ripley filled still another museum directorship, again making a somewhat unusual choice. This was Daniel J. Boorstin, a Rhodes scholar, lawyer, and prizewinning historian who had taught at the University of Chicago for some twenty-five years. A prolific and widely read author, Boorstin had become increasingly absorbed by material culture and the history of American technology. Boorstin served only four years as director of the recently opened Museum of History and Technology, before becoming Librarian of Congress in 1973. This was a museum that was being continually reorganized and occasionally renamed during this period; it was led by a whole series of directors and acting directors through the 1970s until, in 1980, it became the Museum of American History. These changes reflected broader shifts in academic history, particularly among social and cultural historians. The curatorial staff was meant, in Ripley's terms, to exemplify his view that original research belonged as much in museums of art and history as it did in museums of natural science and anthropology. The complexities of being simultaneously a productive scholar, an administrator, a specialist in civil service rules, a liaison between museums and universities, and a public spokesperson for the mission of a national institution, were rarely more challenging than at the Museum of History and Technology, and the Ripley administra-

tion found itself involved in continuous debate about its collecting and exhibition mandates.

There were other encounters that shook the early years of Ripley's secretaryship. One, according to his vivid recollection more than twenty years later, involved Annemarie Pope, wife of the longtime director of the Freer Museum, John A. Pope. Mrs. Pope had been the energetic first chief of SITES, the Smithsonian Institution Traveling Exhibition Service. She had led the operation since 1952 and enjoyed particular success with international collaborations, organizing exhibitions that toured American venues and sometimes opened at the National Gallery of Art. (In its early years, SITES dealt primarily with art shows.)

Ripley claimed that Mrs. Pope, by most accounts a formidable woman, had intimidated Leonard Carmichael, his predecessor, and enjoyed her own way on all issues. Ripley declared himself unafraid but made what he later acknowledged was an unwise move in an early brush with her, only months after arriving in Washington. As he recalled, she had recently fired much of her staff, and some of those remaining complained about her difficult and sometimes unpredictable behavior. Seeking to avoid problems, Ripley proposed that she leave her current post, become a special assistant for art exchange and cultivation, and write a history of SITES. At this suggestion, he recalled, "she turned white." She resigned within days, and her husband, a Carmichael appointee, threatened to destroy Ripley socially in Washington if he persisted. Annemarie Pope was a good friend of Agnes Meyer, the Freer board member and *Washington Post* owner who would be another thorn in Ripley's side because of their disagreement about Smithsonian financial policies. So the action was deeply fraught. In retrospect, Ripley said he found the episode fascinating; the Meyer connection may have explained why Carmichael had been so wary of Mrs. Pope.[72] Mrs. Pope went on the following year (1965) to found the International Exhibitions Foundation, which served as the principal supplier of foreign shows to the National Gallery in the waning years of John Walker's directorship. These relatively small, prepackaged shows, allowed the Gallery to avoid lending art to participating institutions. "When I first took my job," Brown declared, "she was our exhibitions department."[73] Even after Brown took over, the foundation continued to offer its services to the Gallery. During the twenty years following her creation of the foundation, Annemarie Pope and her staff organized more than 150 exhibitions, including twenty that came to the National

Gallery. She was a ferocious worker and made her organization an international force. John Pope remained Freer director until 1971.[74]

Annemarie Pope's resignation occurred just about the time of Ripley's official arrival in Washington. The pattern—standing up to or opposing a difficult senior staff person, offering an alternate position, and thereafter suffering persecution from portions of the local establishment—was a recurrent one, as Ripley and his advisors saw it. The Hirshhorn initiative—again, holding fast to something viewed as offensive by some members of a social or professional elite—possessed similar features. As did the firing of David Scott. Ripley considered himself a dissenter, attracting adversaries because of principled stands, often on behalf of access or preservation. This, in part, was what propelled Ripley into another of his creative but, as it turned out, somewhat confrontational accomplishments: the creation of the Renwick Gallery. His fondness for period exteriors and interiors energized his campaign for the Renwick, and also underwrote his effort to restore Castle offices to their original Victorian appearance. But the Renwick's cost overruns and contractual renegotiations provided Robert Hilton Simmons with still more opportunities for threatened lawsuits.

In his ruminations on the secretaryship, Ripley expressed unhappiness at his treatment by Chicago congressman Sidney Yates, a hero to many liberals and art lovers for his staunch defense of the two national endowments and his sympathy for many cultural causes. In all sorts of ways, Yates became a spokesperson for the arts and humanities, and for American intellectuals more generally. Yates offered little help, however, for a number of Ripley's projects, like the Wilson Center. The subcommittee chair dismissed Ripley's annual requests for more money, saying, in Ripley's words, "You made your bed, go lie in it. You've got the Wilson Center. You're stuck with it."[75] Ripley labeled Yates a "very ironic or irony-minded person" who "likes to make people feel uncomfortable, if he possibly can." He enjoyed being "sarcastic" and "sardonic," provoking difficult, uncomfortable replies by those testifying before him, whom he then sometimes castigated. "I think it's the south side of Chicago coming out in him," Ripley concluded, characterizing him as too much of a "city boy."[76] But his dealings with Yates were not atypical. More generally, Ripley found his encounters with congressional oversight to be uncomfortable.[77] Congress, he observed in his retirement, "is a mindless, bodi-

less organization that blunders around in the dark having a pillow fight with itself."[78]

While these appearances contrasted with Carter Brown's far more placid encounters with congressional committees, the Smithsonian registered some very impressive budgetary increases during Ripley's early years. Officials at the National Gallery spoke enviously of the squadron of legislators the Smithsonian could mobilize to attend to its needs, even while Smithsonian officials hinted darkly at opposition coming from Mellon interests and their lackeys. Naturally enough, the National Gallery and the Smithsonian kept close track of one another's budgetary successes. As a Gallery trustee, Ripley was, of course, aware of any changes and special requests, while notes in the Gallery's files indicate that its officers gawked respectfully at the huge gains their "parent" organization achieved.

Not every Smithsonian initiative worked out, and some opportunities Ripley did not seize, occasionally demonstrating real budgetary discipline. There was the failed experiment with running Hillwood, the Washington estate of the Postum and Grape Nuts heiress, Marjorie Merriwether Post. Post had recently built an elaborate house on the edge of Rock Creek Park and filled it with antiques, many of them bought in Russia, where one of her several husbands, Joseph Davies, had been the American ambassador. Hillwood was smaller than Mar-A-Lago, the 115-room house she had built in Palm Beach, and it didn't have its own golf course. Still, with its gardens it constituted a considerable estate. The proposal to donate it to the Smithsonian was one Ripley inherited, and one, he insisted, that was alien to his interests.[79]

Ripley was skeptical about Post's taste and connoisseurship—"Mrs. Post Toastie," he called her. She was, he allowed, an extremely able businessperson, but he expressed some contempt for her lifestyle—which he had encountered firsthand in Palm Beach. Among the regents, however, only John Nicholas Brown shared this feeling. The others were, Ripley claimed, "hypnotized" by her wealth and, after a sumptuous 1961 dinner, eager to accept the house as a monument/museum. Post formally indicated her intention to leave Hillwood to the Smithsonian in January 1963, not long before Ripley's arrival in Washington. Visiting her and the house, however, Ripley found her museum plans troubling. Post wanted mannequins dressed in livery to be present in every room, he recalled,

and the dining room set for thirty-six. She was making demands that would not have been tolerated at existing Washington museums, and this testimonial to great wealth seemed especially inappropriate for the Smithsonian. Moreover, after working with his advisers, Ripley determined that the ten-million-dollar endowment she had offered would be insufficient to operate Hillwood. And there were other houses—an Adirondack lodge, Mar-A-Lago in Florida—being dangled before potential buyers.

In the late 1960s Ripley informed the regents that Post's collection was not up to Smithsonian standards and might cause them to incur heavy operating losses. The Smithsonian returned the property, the endowment, and even some of the jewels Post had donated earlier. By the time the regents had agreed to divest themselves of the estate, the national mood had shifted and they were comfortable with the decision, Ripley recalled. Vietnam and student protests had made "this assumed pompousness and snobbishness" even less attractive. "It was a chapter in the Smithsonian of which we were glad to be without, and fortunately we could do it." Hillwood is run as a museum today, but without any Smithsonian affiliation. Ripley continued to pursue wealthy widow collectors, however, and invested a good deal of time attempting to land the porcelain and silver holdings of Mrs. Leonard Firestone.[80]

Much more to Ripley's taste, and a shining contrast to his experience with Hillwood, was the creation of the Anacostia Community Museum in 1967. This transaction advanced both his institutional goals of broadening museum audiences and reforming exhibit methods, and his Promethean self-image as a crusader for democratic values within a somewhat mummified establishment. He also had strong feelings about the need to do justice to neglected historical figures, in this case African-Americans, and to the wider field of African-American history. Ripley liked the notion of satellite museums—he wrote in the Metropolitan Museum's Golden Book, on its hundredth anniversary in 1970, that he thought the Metropolitan should move in that direction—but although Anacostia might have begun as a Smithsonian branch, it would assume its own character.

Ripley saw the new museum initially as an opportunity to dramatize the Smithsonian's mission on a local, neighborhood level. It had several purposes, one of them to provide continuing education, to respond to desires for diversion and information among those who didn't necessarily

have college degrees. *Smithsonian* magazine could help meet these goals, but it was, by comparison, static. Ripley and Blitzer discussed at some length the need to make people feel that "the exhibits and the things that they saw in these museums were just as exciting as anything they might read in the newspapers or, of all things, watch on television."[81] Ripley wanted museums to involve all of the senses. One exhibition at the Museum of History and Technology, on chocolate, exploited smell. There were also functioning odors in the bicentennial show *A Nation of Nations*, including garlic in a kitchen display. As part of their interest in "shock" exhibits, Ripley and Blitzer even talked about creating a "slum smell" for a presentation on urban poverty, although the notion was ridiculed when picked up by a national magazine. Ripley also recalled being approached by Tom Hoving of the Met—whom he found simultaneously "pushy" and "fun"—about the Smithsonian showing somewhere in its museums *Harlem on My Mind*, the controversial exhibition that rocked his directorship in New York. Ripley refused; it was too expensive and described a community he considered very different from those in Washington. He believed locals would find it quite alien.[82] But he sought other innovative displays that would connect with the dispossessed.

From all this, and a meeting at Aspen where he floated the idea, came the notion of creating a museum in a poor part of the city, accessible to residents who did not normally visit Smithsonian facilities. Ripley recalled his notion being greeted with disdain by curators, who worried about the safety of their art. Disregarding such concerns, he with some colleagues searched the Washington area for just the right site. They wanted a place in a stable neighborhood, without much crime or drug traffic, and lit upon a former movie theater in the long-settled black community of Anacostia. To direct the museum, Ripley chose John Kinard, a seminary graduate who had served in Tanzania with Operation Crossroads and become a coordinator of many of their African projects.[83] In Washington from 1964 on, he was a social worker and counselor, as well as the assistant pastor of a church in northwest Washington. Highly recommended by community leaders, and by Charles Blitzer, Kinard was not quite thirty-one when Ripley appointed him.

The museum opened in September 1967, just over three years after Ripley's arrival Washington. The popular dinosaur sculpture, *Uncle Beazley*, donated by the Sinclair Oil Company, was moved from the Mall to the outside of the new museum (at least for a time; it was later moved to

the National Zoo), and the Smithsonian celebrated another festive opening. Volunteers, foundations, and congressional appropriations, which Ripley credited to Congresswoman Julia Butler Hanson, one of his favorite lawmakers, made the operation possible, and the regents, for once, were enthusiastic about Ripley's expansionist ideas.

The Anacostia museum brought Smithsonian expressions of support from local sources. The *Washington Post* in 1970 noted approvingly that a group of art lovers and community workers in New York had urged the Metropolitan Museum to follow Washington's lead and set up neighborhood museums. Decentralizing large museums and bringing art closer to people, as libraries had long done with books, deserved more financial support.[84] Newspapers elsewhere took note of the growth of "minimuseums," a concept that had been talked about in America since the early twentieth century, and pointed to the success of recent storefront centers.[85]

John Kinard proved to be a strong director, a "kind of benign dictator," in Ripley's words, and served in that post until his death in 1989. He was more partial to art exhibitions than Ripley would have liked, and perhaps more activist in spirit, but the secretary admired him. Most important, the Anacostia Community Museum survived, and Kinard was able to sustain it through the civil unrest of the late 1960s. Never as well integrated into the larger Smithsonian as Ripley had hoped, and more limited in its neighborhood impact than originally envisaged, the museum's establishment was nonetheless one of the things he was proudest of in later years. In effect, it was simultaneously a community museum and the country's first federally supported museum of African-American history. Kinard soon determined to focus on African-American achievements and to emphasize local artifacts rather than serving as a branch of the Smithsonian itself, a miniature of the behemoth on the Mall.[86]

Even as he sought to reach underserved communities, Ripley expressed concern at the balkanization of the national experience. Toward the end of his life, he was skeptical about creation of a Museum of the American Indian, preferring a new museum devoted to the Americas, and alarmed by the role religion might assume in it. "I think that religion and religious observances are well designed to create terror and fantasy and warfare, usually on the wrong premises," he told an interviewer during his retirement. "It's a curious anomaly that religious efforts to purify and ennoble the human species through religion tend to promote wars and destruc-

tion and barbarity."[87] These were not new thoughts for Ripley, but he had avoided their public expression while secretary. They certainly would not have improved his standing with Congress.

Ripley's lengthy efforts to sharpen the Smithsonian's art profile and entice gifts from wealthy collectors exacted its toll. Reviewers and local critics took him to task for any hints of hyperbole. When the Smithsonian Museum of Natural History put portions of Armand Hammer's collection on exhibition in the spring of 1970, Paul Richard, new to the *Washington Post*, and Frank Getlein, in the *Washington Star*, launched angry responses. Richard complained the show included far too many "losers," "lousy work" by first-rate artists who had "lousy days." Ripley's catalog introduction became cannon fodder. He was lambasted for describing the work as "superb." The Goya was trivial, the van Gogh ugly, and the Cézanne a "thoroughly botched up job." Richard went into the tax benefits Hammer had gained, and the fact that the show had apparently been turned down by both the National Gallery and the National Collection of Fine Arts.[88] Getlein's piece, entitled "The Smithsonian's Latest Adventure in Art," was only slightly less acerbic. The location at Natural History did not bother him, but the quality of this group of paintings, assembled in fewer than five years, did: "leftovers, early pictures, untypical pictures, very minor efforts." Making matters worse, at least from a Smithsonian standpoint, Getlein advised visitors interested in seeing great work by these artists to go to the National Gallery of Art or the Phillips Collection. And he touted the 1970 summer reprise of the "brilliant" television documentary *Civilisation*, also at the National Gallery.[89]

An infuriated Hammer complained vigorously to the newspapers, challenging the reviewers point by point. He talked about how much money he had paid for the paintings, their exhibition in famous museums, their presence in commentaries by distinguished art historians, and the decision of museums in Kansas City, New Orleans, and Columbus, Ohio, to host the show. Most Americans, Hammer argued, did not live near museums like the Metropolitan or the National Gallery; they would now have an opportunity to see these things "thanks to the enterprise and efforts of such dedicated people as Mr. Ripley," who "should be commended for their efforts instead of being unjustly criticized by journalists masquerading as art historians."[90] The following year the embattled Hammer, with new acquisitions selected with the advice of John Walker, announced that he was leaving portions of his art collection to the Los

Angeles County Museum of Art and an important group of old master drawings to the National Gallery. While the quality of the work willed to Los Angeles was disputed (Walker wrote a letter to the *Los Angeles Times* challenging allegations that Hammer's gifts were largely second-rate), the Gallery bequest was considered superb.[91] Walker had insisted the drawings go to Washington.

Almost alone among various suitors and enablers throughout the country, Carter Brown, thanks in part to Walker, came out ahead in his relations with the wily oil tycoon, snagging not only Hammer's own collection of early drawings but a million dollars to purchase a Raphael drawing.[92] In return, Brown agreed to keep everything together and accepted a sign labeling them as the Armand Hammer Collection—but without renaming a part of the building, as Hammer would have preferred. It was all worked out in a lounge at National Airport. "He's a pretty good trader," Hammer said of Brown.[93] The Smithsonian received little for its trouble, but the pursuit of difficult donors was a theme of Dillon Ripley's entire administration, and he never stopped going after possible benefactors. Charm campaigns were part of the secretary's larger strategy. Letter after letter to wealthy prospects, along with countless meetings, telephone calls, memos, meals, and visits, testified to his commitment. Particularly challenging were the collection and endowment needs of the Cooper-Hewitt. Ripley consoled, counseled, and coaxed its first director, Lisa Taylor, who found her encounters with potential donors bordering on the surreal.[94] Cultivation of the rich may have been at odds with his egalitarian museological commitments, but Ripley accepted it as part of the job.

Summarizing this activity on behalf of the arts and humanities omits, to be sure, the Smithsonian's fundamental linkages to science, of far longer standing and, it could be argued, greater centrality to its mission. Ripley's concerns about ecology and the intensifying crises facing the natural world were in line with his professional interests but also anticipated themes that would be sounded with increasing alarm in the coming decades. It is important to acknowledge the scale and complexity of the Smithsonian enterprise but this book will consider just one example of its expansion in the sciences. The National Air and Space Museum, talked about and planned decades before Ripley's arrival, was designed, by Gyo Obata, and constructed during his secretaryship, between 1973 and 1976—the very years in which the National Gallery's East Building

was going up. Indeed, stories circulated about the two museums' competitive search for certain building materials. These were denied, but it was clear that the planners on each side of the mall were quite aware of the other team's efforts. And aware, as well, that they had to be sensitive to neighboring structures, above all the United States Capitol, which loomed above them. At forty million dollars, Air and Space cost less than half what the East Building did, although the money came from congressional appropriations rather than from private donations.

The display issues were also, of course, quite different. Air and Space mixed technological information, nostalgia, patriotism, and entertainment. Opened on July 1, 1976, in a grand gesture toward the national bicentennial, the huge structure would prove to be, in the years just after its opening, the most popular museum in the world. Officials anticipated 5 million visitors the first year; 9.6 million actually arrived. At certain points, when more than eight thousand people crammed into the building at one time, the museum had to be closed. During that first July some eighty-seven thousand supposedly entered the museum in the course of a single day.

Digesting the new commitments Ripley assumed in his first dozen years as secretary would complicate his last eight years in office. Rapid expansion, sometimes with barely a nod to congressional funders, placed the institution in a permanent financial strain. While revenues from memberships and commercial sources were exploited aggressively and visitation grew, the costs of modernization and research programs became increasingly difficult to meet. As a result Ripley and his senior staff would endure extended battles with congressional committees and scrutiny of what some considered to be creative book keeping. *Washington Post* articles peppered Ripley with charges of possible conflicts of interest, and a General Accounting Office report in 1977 demanded greater financial accountability.[95]

By 1976 the federal government was supplying almost 90 percent of the Smithsonian's budget. This did not stop Ripley from warning museums about the dangers of oversight that came with acceptance of federal money. "Money begets power," he told delegates to the American Association of Museums, "but the ultimate power rests with the dispenser of the money. Vast money produces regimentation and pedantry."[96] The *Washington Post* reporter noted, with intended irony, that the director of an institution receiving a hundred million dollars a year from the govern-

ment was questioning reliance upon public funds. The apparent anomaly typified Ripley's frankly confrontational style. At just this moment, he was tackling the "new luxurious modes of thought of the '60s, the mindless drive toward self-fulfillment," and an educational establishment with "an immense infrastructure of competitive yet complacent institutions providing careers to a welter of bureaucrats and teachers to teach teachers."[97]

Responding to official charges and newspaper editorials, by 1978 the secretary was announcing changes in budgetary procedures and disclosing the sources and character of private funds.[98] But the Smithsonian's local popularity remained high. Congressional critics didn't seem to matter when, in February 1978, DC mayor Walter Washington declared an "S. Dillon Ripley Day," pronouncing the secretary's life "the fulfillment of the American dream."[99] Decidedly not a rags-to-riches story, it was not clear how Ripley's ascent fit the classic trope, but this did not deter words of praise from his Washington colleagues. He would need them the following year when he faced another crisis, this one involving the great portraitist Gilbert Stuart. More particularly, two of Stuart's paintings, one of them the basis for the face of George Washington on the dollar bill, the other of his wife Martha. Both had been hanging since 1876 at Boston's Museum of Fine Arts, lent by the Boston Athenaeum, which had quietly begun to sell off part of its art collection in order to maintain its building. No one was quite prepared for what happened next.

The April 1979 announcement was straightforward. The National Portrait Gallery promised to pay the Athenaeum five million dollars for the two paintings, which would return to Boston for exhibition one year out of every five. The president of the Museum of Fine Arts regretted the departure but generously commented that in Washington the pictures would "be seen by a great many people, and you can make a case for that."[100]

Other Bostonians were less forgiving. "I don't think Boston should allow itself to be raided by Washington," declared a museum curator, hoping the courts would "uphold the interests of the people of Massachusetts."[101] There followed, over the next few weeks, a heated, sometimes fevered debate over whether the pictures should be allowed to leave. "Everybody knows Washington has no culture—they have to buy it," Boston mayor Kevin White declared, comparing the purchase to the Nazi plunder of European museums.[102] Senator Edward Kennedy proposed a congressio-

nal investigation into "the Smithsonian's offensive prosperity and vulgar extravagance."[103] The *New York Times* suggested a compromise site for the "rich Smithsonian," "about equidistant between the National Gallery and the Boston Museum of Fine Arts, called the Metropolitan Museum of Art." Once in New York, "the first family finally will have arrived."[104] The misleading reference to the National Gallery raised further complications, for it had just obtained, from a prominent Boston family, five Gilbert Stuart portraits of the first five presidents. Two were given, three purchased. Shunting aside issues of whether the paintings might better have gone to the National Portrait Gallery or the White House, Carter Brown insisted they were being acquired "primarily on their aesthetic basis." "Besides," he added, "the donor offered them to us."[105] Unlike the Athenaeum portraits, no campaign of opposition was organized.

A strident voice from New York added to the tumult. Hitherto, Hilton Kramer confessed in the *Times*, he had considered the National Portrait Gallery a benign operation concerned primarily with documenting what "others had far too long left unattended." Now it loomed as a threat, part of an engorged "federal museum establishment" on the prowl for loot from vulnerable institutions. "Until now, we have all tended to look upon the burgeoning Washington museum scene with a good deal of pride, admiration, and respect," he allowed, "but the time may be at hand when we shall have to begin to count the cost of these ambitious institutions."[106]

Ripley responded to all of this by reviewing the negotiations that had preceded the sale, and indicating the Smithsonian's hopes that private citizens would contribute to meet the costs. But the purchase agreement was suspended. A new agreement produced joint ownership, the Portrait Gallery and the Boston Museum of Fine Arts each paying half the total to the Athenaeum. The portraits would spend three years in Washington and three years in Boston, on an alternating basis. War between the two cities was averted.

In its last years, the Ripley administration was able to expand not only Smithsonian exhibition spaces but a major set of conservation and support facilities as well, notably at Front Royal, Virginia, and Suitland, Maryland. The Mall museums had by the 1970s accumulated tens of millions of objects. Most were small, part of the National Museum of Natural History's collections, but there were larger items as well. Whale skulls, fossils, totem poles, birds' eggs, insects, kachina dolls, a disparate hoard would be transferred to an almost five-acre structure in Suitland, con-

taining offices, laboratories, and four huge storage pods. These "giant thermos bottles," as some called them, provided half a million square feet of space in which computerized systems controlled temperature and humidity. Spectacle, oddity, beauty, rarity, all were available to museumgoers just a few miles away, but the more than one hundred million objects in the Museum Support Center formed the resource base for a whole series of disciplines. Labeled a "$50 Million Closet" by the *Washington Post*, almost all the costs had been met by congressional appropriations.[107] Putting it together was a considerable achievement. Ripley dedicated the center in 1983, but his mind and heart were focused on his last great building project, completed only after he had left office.

In his writings, speeches, and *Smithsonian* columns, Ripley had long pushed forward his notion of museums as activist centers of public education. Museums "are the greatest available laboratory for studying the problem of how to create interest," a problem "central to our quest for survival as people."[108] Skeptical about rigidly separating art and natural history collections, and critical of richly appointed museum structures, Ripley found a way at last to dramatize his commitment to internationalism, education, and display in a new quadrangle that focused upon the non-Western world. "I consider it the most significant project the Smithsonian has ever undertaken," he announced.[109]

The opportunity came from joining two very different collections. The first American museum devoted to African art had been created by a former diplomat, Warren Robbins, and housed on Capitol Hill in the early 1980s. Placed under Smithsonian control in 1979, and renamed the National Museum of African Art, it was run by Robbins until 1983. The growing collection, however, could not be effectively shown or stored in the complex of town houses and garages that Robbins had assembled, and in the early 1980s Congress authorized creation of a new museum complex to be constructed, underground, adjacent to the Castle. It would house the new museum and extend the Freer Gallery, which had filled its storage and exhibition spaces.

Not long after authorization Ripley would successsfully court his last grand donor, snatching some of his collection (and his money) from the sheltering arms of the Metropolitan Museum of Art. And he would do this with the cooperation of Carter Brown.[110] Arthur Sackler, the donor, was a wealthy medical publisher with a number of collections, one of them of Asian art. He had already made major gifts to a series of universi-

ties and had built a wing to house the Temple of Dendur at the Metropolitan, the Egyptian temple that Ripley had coveted more than a decade before. "Sackler was looking for something—posterity," Ripley recalled some years later. In the end Sackler donated four million dollars for the Smithsonian's fourteenth museum and allowed the Freer's director to choose one thousand objects from his holdings. He died shortly before the new museum's opening.

With this new complex, Ripley corrected what he considered to be a cultural bias in Washington. "Our entire awareness of others has been concentrated until recently on the so-called Western world," he told Paul Richard of the *Washington Post*.[111] But what about Oceania, Africa, China, and Japan? His rhetorical flourishes helped gather support for the project, despite legislative skepticism about further Smithsonian expansion.

Typically, Ripley's fund-raising ambitions brought some trouble in their wake, the most significant involving Saudi Arabia's five-million-dollar gift toward creation of a Center for Islamic Arts and Culture in the Quadrangle's International Center. Critics charged that details had been kept from the regents and that the Islamic center would enjoy too much influence. Ripley, in retirement, saw nothing wrong. "We are all sons of Arabia," he wrote. His dream of raising awareness of Islamic culture was "tarnished," as the gift ultimately was withdrawn after strong opposition.

Some commentators saw the roots of the dispute in "the ruling style" of the former secretary "and his cadre of Yale-educated lieutenants." The Smithsonian had "become Kremlinesque, notorious for its reluctance to tell Capitol Hill too much about what it was doing." This theme, sometimes sounded merely as a counterpoint to a larger hymn of praise, was played by several local journalists.[112] In a characteristically qualified but nuanced verdict, delivered about the time of Ripley's retirement in 1984, veteran critic Benjamin Forgey assembled an "astonishing" list of accomplishments, but added that Ripley "has been rightly accused of being secretive, arrogant, highhanded, and sometimes, vengeful in personnel matters." Acknowledging the drawbacks of his "patrician style" Forgey argued that for two decades Ripley had shaped presidents and congressmen alike around his goals. "Ripley made the battle plans; the high-level staff took care of the all-important political details."[113] His closest counselor, Charles Blitzer, who left the Smithsonian about the same time, confessed astonishment that one man could so dominate the character of this

extended, polymorphous institution.[114] Ripley's retirement years were saddened by the death of his wife, Mary, in 1996. He died at the age of eighty-seven on March 12, 2001, recalled, among many vibrant memories, for his ability "to open the Mall the way Nixon opened up China."[115]

The void opened by Ripley's retirement left Washington, in 1984, with only one commanding cultural figure, at least for the visual arts. Carter Brown seemed, to some, his logical successor as secretary. He had run a great museum for almost fifteen years, sharing the special pressures of public-private status. He was sympathetic to scholarship, had presided over major construction projects, had proven persuasive in congressional lobbying, was well known locally, and, barely fifty, could contemplate many years more of administrative leadership. More than that, Brown's ties with corporations had built an important base for exhibition sponsorships.

Did Brown want the job? Some of his friends thought so. The Smithsonian secretaryship was a far more challenging position. The supervisory board of regents exercised much looser control than did the National Gallery board, allowing more indepence of action. Publication and commercial outlets opened out to a broader public. Brown, who enjoyed firsts, would have been the first nonscientist secretary. If naked ambition were the only prod, the appointment had to attract.

On the other hand, the Smithsonian's complexity spelled problems. It would inevitably distance Brown from exhibition planning and the micromanagement he enjoyed so much. At the time, and subsequently, Brown denied any real desire for the post.[116] Interviewed in 1988 by Louise Sweeney for the *Christian Science Monitor*, Brown confided that he had a shot at the Smithsonian job but didn't want it.[117] Whether he could have avoided some of the controversies that lay ahead for the Smithsonian, or smoothed its relationship with Congress, is unclear. The budgetary challenges were immense, and deep political fissures always threatened, given the range of Smithsonian programs.

The Quadrangle, a portion of which is named for him, was Ripley's last substantial contribution to Washington. In retirement, he continued the ornithological work interrupted, but not curtailed, by his secretaryship. For the most part, Ripley, rarely absent from local newspapers during his long tenure, shunned the limelight. There were, of course, medals and honorary degrees, testimonials, dinners, and the usual festivities that enliven emeritus status in Washington. And there was watching his succes-

sors grapple with the legacy he had left them. Ripley's ambitious agenda complicated their task of keeping the institution in some kind of financial balance. Private resources multiplied, but budget deficits tempted some administrators to soften the boundaries that protected the Smithsonian from commercial exploitation. Like many another ambitious, imaginative, and energetic administrator, Ripley moved beyond what his financial base allowed. He was a tireless cultivator of private gifts, an inventor of merchandising opportunities, and an inveterate congressional lobbyist. But he could never stay abreast of his needs. Perhaps no one could. As with the National Gallery, the Smithsonian's grand expansion rested on a confluence of special circumstances, some of them particular to Washington and international politics, others reflecting a resurgence of museum activity almost everywhere. Ripley understood the larger trends and shrewdly used his pulpit to emphasize the educational role museums played. He was not above occasional demagoguery in selling his projects or assuming credit that he might, more generously, have shared with others. His self-image had him battling against the forces of reaction and elitism. Critics became adversaries and adversaries enemies. This outlook simplified complexity and led to some misjudgments. But Ripley accepted controversy as a legitimate price to pay for his innovations, and he aroused strong and lasting loyalties.

Carter Brown's professional tenure was much less troubled, at least in the press, but even he faced occasional public relations challenges. These came primarily because of his position as chairman of the Commission of Fine Arts, monitoring the new additions being made to the Washington landscape. As much as anything else this role allowed Brown to stamp his presence on the capital, one part of his larger campaign to promote the city's cultural reputation.

Minister of Culture

Shaping Washington

Writing to Carter Brown in 1960, in response to the news of his planned move to Washington, his friend Tony Athos ventured a prediction. The presidential campaign was still going on, but Athos prophesied that when "we get a President who can provide moral, intellectual as well as economic leadership, I have no doubt that you will be the youngest cabinet member in history & the first for culture."[1] Despite John F. Kennedy's election, the United States would not create a cabinet position for culture. But beginning in the 1970s, Brown was able to translate his various positions into an important sounding board for the arts in America, acting, in some ways, and in many minds, like an unofficial minister of culture. Nowhere was this more apparent than in his own city, Washington, DC.

Aside from his Gallery directorship, the single most important element underwriting this status was Brown's thirty-year chairmanship of the Commission of Fine Arts, a uniquely influential body charged with important responsibilities for the physical appearance of the national capital.[2] First appointed to a four-year term on the commission by Richard Nixon in September 1971, Brown became its chairman two months later, retaining that post until just before his death in June 2002. In those three decades, the commission would become embroiled with a number of emotionally charged and highly controversial decisions, as well as many judgments that were more mundane but nonetheless consequential—at least to developers and neighborhoods. Because of his prominence in Washington, Brown brought visibility to the commission

among constituencies that until then had barely known of its existence. At the same time, his work on commission matters contributed to his already considerable networking skills, associating the National Gallery with the larger cause of protecting the historic fabric of the national capital, and the quest for excellence in design.

The US Commission of Fine Arts had been established in 1910, part of an effort to recover the original planning goals that Pierre L'Enfant had set for the capital city a century earlier. All over the country, planners and architects were seeking to counter industrial blight and uncontrolled growth with new principles for urban expansion. Labeled by historians as the City Beautiful Movement, and energized by a string of American world's fairs, most notably Chicago's Columbian Exposition of 1893, this effort has been associated particularly with the creation of majestic city centers, complete with landscaped boulevards, fountains, heroic statuary, and neoclassical city halls. These were complemented by imposing railroad stations, museums, and carefully controlled systems of lighting, signage, and street furniture. For most cities these were new interventions in what had been explosive and spatially chaotic expansions. Growth was usually governed only by gridlike street plans meant to encourage real estate development. Economic appetite went largely unregulated. America's first zoning ordinances did not come until the World War I era.

Washington was different. Its early twentieth-century efforts were meant to reclaim a lost inheritance rather than to steer an entirely new course.[3] Monumental avenues and grand vistas lay at the very heart of the capital's legacy. They were, to be sure, incompletely realized. The "city of magnificent distances" created by L'Enfant's 1791 plan represented the triumph of ambition over reality. For decades, on either side of the Civil War, the contrasts between magnificent public buildings and the muddy squalor of surrounding spaces drew acerbic comments from visitors. As American architects and artists became increasingly professionalized by century's end, as international travel grew, as world's fairs demonstrated the possibilities of coordinated design, demands were heard to redeem the city from the haphazard and inconsistent decision making that had mangled its boulevards and allowed the construction of grotesque monuments.

Congress had the power to change the system, although it guarded its authority jealously. Beginning about 1901, however, just after the capital's

centennial, the Senate Park Commission invited a quartet of prominent artists and architects to serve on a special commission. They met, toured European cities, and produced a report endorsing the L'Enfant plan and urging a coordinated park system for the District of Columbia. The report, known as the Plan of 1901, was followed by the dissolution of the commission, but its recommendations were widely praised.

After some false starts, in 1910 Elihu Root, a senator from New York, introduced a bill calling for the appointment of a fine arts commission to offer advice on public art matters in the District of Columbia; the legislation proposed a seven-member board of qualified experts to "advise upon the location of statues, fountains and monuments in the public squares, streets and parks," and on other matters of art as required by the president or any congressional committee. With its usual insistence upon its own prerogatives, Congress exempted itself from the commission's deliberations. Approval quickly followed, and Daniel Burnham of Chicago, the chief of works of the celebrated Columbian Exposition and an influential architect and city planner, became its first chair. And so began a process of reviewing proposals that continues to the present day. Subsequent legislation, including the Shipstead-Luce Act of 1930, enlarged the commission's portfolio to include municipal as well as federal buildings, along with almost all of Georgetown and the land adjoining federal facilities. The commission could only recommend approval or disapproval of projects, but its prestige over the years was such that few authorities—from the military to the FBI to highway departments—refused to make the changes it proposed.

Prestige flowed from the fact that the commision's members were presidential appointees and included many figures of distinction. Commission members were unpaid, usually architects, supplemented by painters, sculptors, landscape architects, and a small number of nonprofessionals, among whom were government officials, writers, and museum directors. Both David Finley and John Walker, Brown's two predecessors at the National Gallery, had been members of the commission, Finley serving for some twenty years, the last thirteen as chairman, and Walker for only four. Their appointments emphasized the symbolic and substantive cultural role some hoped the Gallery would play in Washington more generally. Finley, who was deeply interested in historic preservation, a founder of the National Trust, and the owner of a great plantation house not far from Washington, was a formidable presence as chairman

in the 1950s and 1960s. However, even Finley could not match the length of service and the degree of celebrity that Carter Brown would bring to the commission.

In many ways, Brown was born to the role he would play here. He had been fascinated by architecture since boyhood, for it was one of his father's passions, and acquired easy control over its historical vocabulary as part of his broader liberal education. Since coming to Washington and coordinating planning efforts for the East Building, he had become even more familiar with the work of contemporary architects, and gotten to know quite a number of them. He had also spent time interacting with the many administrative bodies that were concerned with building plans. Rarely without opinions on almost any subject, Brown was especially vocal on design—graphic or architectural—and as a museum director was continually evaluating the merits of specific judgments offered by others. Personally fastidious, alarmingly articulate, and an omnivorous observer, he combined an antiquarian's love of tradition with an openness to innovation and a sympathy for modernism. Unintimidated by professional jargon, he possessed a facility at exposition that gave him easy entry into professional conversations, allowing him to hold his own with architects twenty and thirty years his senior. He was still in his thirties when he assumed the chairmanship.

Brown was also, by temperament and experience (he was, after all, a middle child), a natural mediator. When he first began to attend commission meetings in 1971, often held on a monthly basis, he was a clear choice to become its chair. Nominated for the post by architect Gordon Bunshaft, he reflected the recent tradition (at least since 1950) of placing a layperson rather than an architect in this important position. And he was also a Washington resident.

His immediate predecessor as chairman, William Walton, a former journalist and painter, had been a close family friend of the Kennedys and would be partly responsible for choosing I. M. Pei to design the John F. Kennedy Presidential Library in Boston. Walton also helped lead what was widely hailed as one of the commission's triumphs, saving Lafayette Square from destruction by massive office buildings, retaining the historic red brick houses across from the White House.

Benefiting from President Kennedy's personal backing and ongoing executive support, the commission enlarged its "federal area," the space over which it could issue advice about both new designs and the destruc-

tion that preceded them.[4] Walton lost his battle to place what became the Kennedy Center on another location, near the Mall, and he was unsuccessful in stopping Congress from altering the west front of the Capitol ("a national tragedy," he told the speaker of the House) but he did preside over a period that brought important modern architects to the city for the first time.[5] According to commission secretary Charles H. Atherton, Walton had a rough-and-ready manner of chairing, a contrast with what was to come.[6] But then he was presiding over a commission that included some extremely vocal and independent members, notably the architects Kevin Roche and Gordon Bunshaft. Those meetings under Walton, critic Wolf Von Eckardt remembered, "often had the fascination of a bullfight," with Bunshaft as "the most savage matador." Bunshaft, never afraid to push forward his views aggressively, "would prance about the models and drawings submitted for approval, thrust his pencil, wave his pipe, and make great drama of the *corrida* against Bad Architecture."[7] There were some notable failures. While Bunshaft and the commission may have (slightly) tamed the Watergate complex, they did approve the generally reviled FBI headquarters on Pennsylvania Avenue.

Bunshaft, however, was simultaneously a commission member and the designer of the Hirshhorn Museum. This conflict of interest was just one of many. Edward D. Stone Jr., a landscape architect, son of the better-known architect Edward Durell Stone, sat on the commission when one of his father's buildings came up for review (and was not approved). He absented himself from the discussion.[8] Brown himself was not immune to such conflicts, as the director of a museum whose location and status made any of its exterior decisions subject to commission scrutiny. Given his position at the Gallery, Brown was careful in taking positions, and usually well prepared for debates. Atherton recalled that he generally defended architects when they were facing problems with their clients, and often held conferences with applicants before the meetings.[9] The commission usually spoke with a unanimous voice under his chairmanship, although members recalled that Brown invariably dominated their meetings.

While the heated atmosphere of the 1970s and 1980s brought its own problems, the commission was no stranger to controversy in earlier decades. Developers, architects, politicians, veterans groups, and the general public had all periodically been infuriated by its views. Gilmore D. Clarke, who chaired the commission for thirteen years, was not reap-

Another fine French import. Carter Brown and assistant director Charles Parkhurst in front of Georges de la Tour's *The Repentant Magdalene* after announcing its accession, October 11, 1974. Photo courtesy of National Gallery of Art, Gallery Archives.

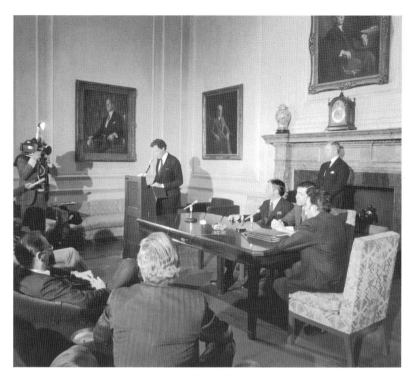

Announcing the Dresden show. Press conference for *The Splendor of Dresden: Five Centuries of Art Collecting, an Exhibition from the German Democratic Republic*, March 13, 1978. Carter Brown is at the podium. Seated, at the middle of the table, is Metropolitan Museum director Philippe de Montebello; the Met coorganized the show. Standing behind him is Earl "Rusty" Powell, who would succeed Brown as Gallery director in 1992. This exhibition helped open the East Building. Photo by Bill Summits, courtesy of National Gallery of Art, Gallery Archives.

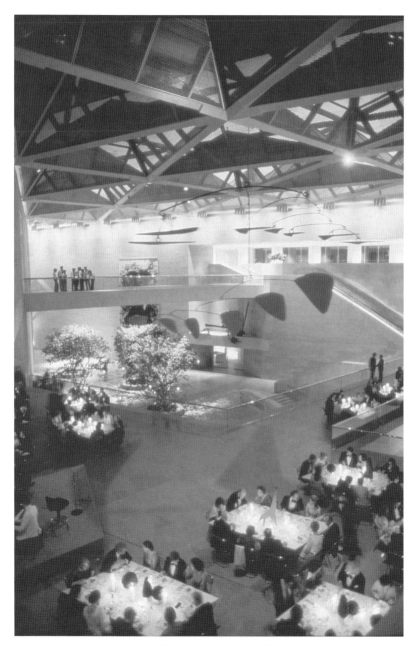

Strategic extravagance. Opening dinner for *The Splendor of Dresden*, May 31, 1978. The mobile overhead is by Alexander Calder, as is the small sculpture serving as a centerpiece on the table below it. Photo © Dennis Brack/Black Star, courtesy of National Gallery of Art, Gallery Archives.

Formally informal. The US pavilion for the thirty-fourth Venice Biennale was organized by the International Art Program of the National Collection of Fine Arts. Dillon Ripley (center) and two guests celebrate its opening at the NCFA in Washington, where the exhibition was also displayed, December 18, 1968. Photo courtesy of Smithsonian Institution Archives.

Smithsonian brain trust. Dillon Ripley and his senior staff. Ripley is seated between Sidney Galler and James Bradley, both assistant secretaries. Those standing include, at left, Philip Ritterbush and, behind Ripley, Charles Blitzer (in glasses). Photo courtesy of Smithsonian Institution Archives.

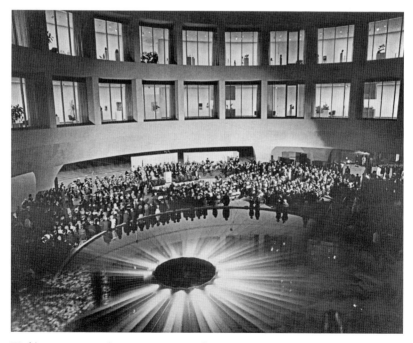

Washington goes modern. Interior court of Hirshhorn Museum and Sculpture Garden, opening night, 1974. Photo courtesy of Smithsonian Institution Archives.

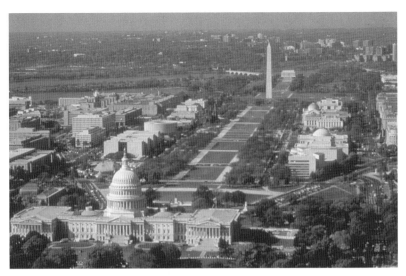

The Mall in Washington, viewed from the United States Capitol. On the right are the East and West Buildings of the National Gallery. Across from them stand the Smithsonian's Air and Space Museum and Hirshhorn Museum. Photo courtesy of the National Park Service.

One last Ripley expansion. Dillon Ripley, now retired as Smithsonian secretary, sits on a wall overlooking the recently opened Arthur M. Sackler Gallery, Enid A. Haupt Garden, and National Museum of African Art (and behind them, the Smithsonian Castle), 1987. The S. Dillon Ripley Center was created under the garden. Photo courtesy of Smithsonian Institution Archives.

Monumental accomplishment. Carter Brown and a fellow Fine Arts Commission member, landscape architect Edward Durrell Stone Jr., in front of the Vietnam Veterans Memorial, designed by Maya Lin, 1982. Photo courtesy of National Commission of Fine Arts.

"Minister of culture." Carter Brown presiding over a meeting of the US Commission of Fine Arts, December 11, 1985. On his left is commission member Frederick E. Hart, who executed the representational sculpture added to Maya Lin's Vietnam Veterans Memorial. Behind them is a portrait of David Finley, former commission chairman and first director of the National Gallery of Art. Photo courtesy of National Commission of Fine Arts.

Supervising the work. Constructing *The Treasure Houses of Britain: Five Hundred Years of Private Patronage and Art Collecting*. From left to right: Mark Leithauser, deputy chief of the Gallery's design and installation department; Gaillard "Gill" Ravenel, chief of the department; exhibition curator Gervase Jackson-Stops; and Carter Brown, 1985. Photo by William Schaeffer, courtesy of National Gallery of Art, Gallery Archives.

Painstaking (and expensive) attention to detail. A painter working on an Adamesque molding for *Treasure Houses of Britain*, 1985. Photo courtesy of National Gallery of Art, Gallery Archives.

The royal visit. Diana, Princess of Wales, and Carter Brown touring *Treasure Houses of Britain*, November 10, 1985. Photo © Dennis Brack/Black Star, courtesy of National Gallery of Art, Gallery Archives.

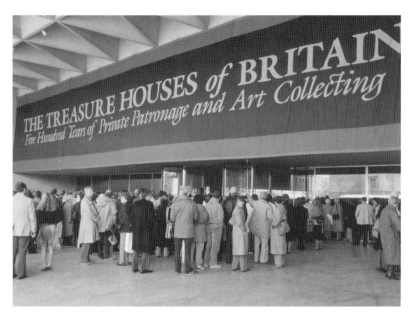

Another crowd-pleaser. Visitors wait outside the East Building to see *Treasure Houses of Britain*, 1985. The exhibition attracted almost a million visitors in 153 days. The museum extended its visiting hours and the exhibition dates to accommodate the demand. Photo courtesy of National Gallery of Art, Gallery Archives.

A polarizing experience. Andrew Wyeth and Carter Brown during a press photo opportu-
nity for *American Drawings and Watercolors of the Twentieth Century: Andrew Wyeth, the Helga
Pictures*, May 21, 1987. Photo courtesy of National Gallery of Art, Gallery Archives.

Happy birthday! Receiving line at the preview and dinner for *Art for the Nation: Gifts in Honor of the Fiftieth Anniversary of the National Gallery of Art*, March 14, 1991. From left to right: Gallery president Franklin Murphy (in background), Leonore and Walter Annenberg, Gallery trustee Ruth Carter Stevenson, Gallery trustee and US secretary of the treasury Nicholas Brady, and Carter Brown, March 14, 1991. Photo © Rex Allen Stucky Photography.

Dinner will be served. Table setting with place card for Paul Mellon at preview and dinner for *Art for the Nation*, March 14, 1991. Photo © Rex Allen Stucky Photography.

Have bags, will travel. Carter Brown at work in his East Building office, with a view of the US Capitol, ca. 1991. Suitcases under his desk testify to Brown's ongoing expeditions. Photo © Dennis Brack/Black Star, courtesy of National Gallery of Art, Gallery Archives.

The trophy of trophies. Visitors viewing Leonardo da Vinci's *Lady with an Ermine* in the exhibition *Circa 1492: Art in the Age of Exploration*, National Gallery of Art, 1991–1992. Obtaining this loan from Poland was one of Carter Brown's most elaborate campaigns. Photo © Dennis Brack/Black Star, courtesy of National Gallery of Art, Gallery Archives.

Saluting the Olympics. Carter Brown and representatives from the Palace Museum Beijing, Nanjing Museum, and State Bureau of Cultural Relics, China, working on the installation of *Rings: Five Passions in World Art*, at the High Museum of Art, Atlanta, Georgia, 1996. Photo courtesy of the High Museum of Art.

Back home again. Carter Brown lecturing at the John Carter Brown Library, Brown University, December 2000. Brown, a board member of the library, was the namesake and great-grandson of the Brown whose collection remains at its center. Photo courtesy of Anne Hawley.

pointed by President Truman after objecting to a balcony the president wanted added to the White House.[10] Architect John Russell Pope had clashed with commissioners in the 1930s when they voiced strong reservations about both his National Gallery proposal and his plan for the Jefferson Memorial. As early as 1914, the commission had invited opposition by serving notice on government departments that they needed to obey the same restrictions on height that private individuals or corporations accepted. All "parts of the District of Columbia should be developed as harmoniously as may be," the commission told the Interior Department in a characteristic rebuff.[11]

Some debates went on for decades. The Mall, the bridges across the Potomac, the Federal Triangle, public monuments and the landscaping of parkways, control over automobile traffic, and historic Georgetown were major sites of contest, but the commission also labored over the design of lampposts, fireplugs, telephone booths, awnings, open-air cafes, bus stop shelters, advertising signs, benches, fountains, trash cans, Christmas trees, kiosks, traffic lights, and a host of other outdoor fixtures.[12] When Hawaii and Alaska wanted their names added to those of the other states carved on the Lincoln Memorial, the Fine Arts Commission was among the bodies that had to approve the action.[13] When proposals appeared for advertisements atop taxicabs, it was the Fine Arts Commission that needed to make a recommendation.

As the commission's chairman, Brown moderated what were sometimes boisterous public meetings, where developers, architects, and citizens voiced their opinions. And Brown would appear regularly before congressional committees, testifying on behalf of his requested commission appropriation, wearing one of the several hats he put on as an institutional supplicant. He would also personally sign commission letters, taking on a function that Atherton had previously assumed. Accustomed to making public remarks, and fond of language that packed a punch, Brown gave columnists and editorial writers, as well as friends and foes, eminently quotable statements that summed up his—and the commission's—positions. Despite an onerous and sometimes unpredictable travel schedule, he put in lots of time at the commission, sometimes presiding over its deliberations immediately on returning from a foreign trip. Inevitably there were protests, expressed by those who, for one reason or another, disagreed with the advisory judgments the commission offered. "Any commission that would approve the design of the Union

Station Visitor Center, the Rayburn Building, the Kennedy Center, the Watergate complex and the D.C. Convention Center is certainly not interested in design for people," one angry reader wrote in to the *Washington Post*. "Their purpose seems rather to be the glorification of the egos of members of Congress and the federal establishment. Mussolini lives!"[14]

In the 1970s, 1980s, and 1990s, the decades when Brown presided, the Fine Arts Commission faced particularly contentious issues, some of them not unrelated to challenges that the National Gallery of Art and the Smithsonian confronted on a regular basis. These included the simple demands of growth, new structures to accommodate the goals of Washington's bureaucrats and the city's cultural promoters. The Mall alone would be adding the National Gallery's East Building, Smithsonian's National Air and Space Museum, the Hirshhorn, the Museum of African Art, the Sackler, and the International Quadrangle, with the Museum of the American Indian opening not long thereafter.

The back and forth on major projects could be extensive, especially when the Mall's sacred space was involved. Thus, at Brown's early meetings in the fall of 1971, the commission discussed the Smithsonian's projected Air and Space Museum, meeting with its director, astronaut Michael Collins, the architect, Gyo Obata, and various Smithsonian officials. Commisioners urged the redesign of certain facade elements, requested more details about the landscaping plan, and got assurances that there would be no display of planes or rockets on the two terraces flanking the museum building. They also complimented the architect on the changes that had already taken place, which made the building, they allowed, more open and less intimidating.[15]

But, typically for these hearings, the following month the commission expressed unhappiness with the newest revisions. Bunshaft, Roche, and Brown all commented that the proposed building had become more "chunky" and "clumsy." Everyone joined in, apparently troubled by the huge scale and the complexity of the roofline.[16] By February 1972, the commission was prepared to approve a new preliminary design, four masonry blocks connected by three glass-enclosed spaces. But Obata's massing studies met with less success. The tripartite effect of the structure, according to Brown, failed to "read to advantage," and the Independence Avenue facade met the ground awkwardly. Bunshaft felt the model was misleading, and Roche declared that the scheme was too preliminary for

approval.[17] More meetings with the architect and director followed, and more discussions about the materials to be employed.

By April the commission was willing to support the building's design, although its members were still disappointed that the plan was not more advanced. There were objections to the notches on the north and south sides as "being too 'decoratorish,'" and requests for more glass in certain areas, a grander entrance stair, and other modifications.[18] The May meeting saw Air and Space standing upon a more monumental, terraced base, with wider entrance stairs. The end glass areas were extended up and into the roof, and, as the commission had suggested, glass now surrounded the three cantilevered masses facing Independence Avenue. Brown still had some questions about the stone course details.[19] However, after months of intense conversation, the commission was ready to sign on, and by the fall Bunshaft, one of the more voluble critics, had completed his term and was replaced by the painter George A. Weymouth.

There was a sense of satisfaction about such interventions. Just a few years later Brown, testifying before Congressman Sidney Yates's committee, declared Air and Space to be one of the commission's successes. When asked why, by Yates, he replied that the original design "looked more like an aircraft carrier that got stranded on the Mall with a huge top deck totally out of scale." Happily, "a less congratulatory building has finally emerged," Brown reported.[20] The *Washington Post*, four years earlier, had praised the commission's push for a simplified design. "The Mall is not the place for architectural flair and excitement and what is needed here is not a monument to the art of architecture, but a simple, dignified shell" to display the art and technology of flight.[21] Architects needed thick skins to withstand client demands and critical reviews, so interactions with the commission were, despite some sharp differences, rarely hostile. And Brown, who could wield both a sharp tongue and a barbed pen in expressing opinions, also relied on his storied social graces to avoid, as much as possible, real nastiness.

Commission scrutiny also extended to buildings that were not governmental in origin or function but had an impact upon life in the city. In the 1970s, Washington's economic ambitions prodded planners to think about creating a modern convention center. The expanded federal agencies, an unusually convenient airport, excellent rail connections, museums, a growing hotel industry, and the larger spectacle of govern-

ment combined to make Washington an attractive site for professional and commercial gatherings. But its first such facility—a huge auditorium added to the Northern Liberty Market—was now more than seventy years old and, after a fire and various new uses, stood vacant. Across the country a new generation of structures was being conceived, modest in light of what would come decades later, but still massive. Atlanta, St. Louis, Baltimore, and Dallas were among the many cities at work developing such centers, but probably it was Chicago's McCormick Place, recently rebuilt after a fire, that best showed the value of such investments. New or enlarged athletic arenas were also being constructed, to host basketball and ice hockey, along with trade shows.

By 1973 District officials were proposing the Dwight D. Eisenhower Memorial Bicentennial Civic Center, including a convention hall to be located between Seventh and Ninth Streets, with Mount Vernon Square to its north. Just opened, and a near neighbor at Ninth and G Streets, was Mies van der Rohe's Martin Luther King Jr. Memorial Library, greeted ecstatically by Wolf Von Eckardt, the *Post*'s architecture critic: a "great and appealing building," he wrote in 1972. "People will like the Martin Luther King Memorial Library, not because they are supposed to like it, but because they will want to be there and will feel at home in it."[22]

In September the commission examined drawings and a model for the three-hundred-thousand-square-foot hall, prepared by Welton Becket Associates. There were spaces for retailing and meeting rooms. The commission declared its concern over the building's bulk, in relation to the domestic scale of nearby Mount Vernon Square, and faulted the absence of structural expression, especially in the roof. Carter Brown had stated this position earlier. The building was "handsome on the inside. You really know what is holding those spans up and it's a great achievement," visually exciting. The outside was another matter, however. "What concerns us is the danger of a building of this scale looking as if it had been sort of packaged, wrapped around with something which is flimsy." We all know, Brown went on, "the hole the Kennedy Center fell into."[23] That recently opened complex had been subjected to savage assaults by architectural critics for its "pseudo-monumentalism," "a cross," Ada Louise Huxtable had famously charged, "between a concrete candy box and a marble sarcophagus in which the art of architecture lies buried."[24]

Brown sought to avoid that kind of ignominy for the new convention center. And he emphasized the importance of the design in relation to ma-

jor sight lines. Vistas were always important to him, as to the commission more generally. The site was special, with "a view to the White House.... There is that marvelous axial mall up from the National Portrait Gallery... the view down from Mt. Vernon Square, the [old Carnegie] Library, which is one of the nicest buildings we have." The commission, Brown admitted, "spends a lot of time on very minor things around the city," so this project was critical; its visibility merited the attention being lavished on it.[25] Most successful convention centers, like Chicago's McCormick Hall (as Brown called it), had more isolated settings, but he liked the fact that "the guts" of the Chicago building were expressed, something that the Washington architects had not yet managed. Curiously, no commission members referenced the Mies van der Rohe library building nearby.

Kevin Roche took a similar position, arguing that there was a great building under the shell and urging the architects to allow more of the steel structure to show. "The trap of covering steel structures with concrete surfaces is that you produce these very large-scale simplistic sculptural forms which obstruct the idea of creating a festive atmosphere. I think it would be a much better building if you just let the realities of the thing express themselves." Acknowledging the architects' deadlines, Brown reminded them that "this city is going to be around for awhile, so is this building, so is the memory of the administration that built it, and we want them all to come out ahead as much as we can help it."[26]

By October the architects were back before the commission with photographs, drawings, and a new model. Members expressed satisfaction with the improvements but indicated there was room left for even more. The frame-trussed roof, dramatic in its outlines, had become more visible, making the structural logic far more expressive, but the rooftop air handling units had been better in the earlier version.[27]

The convention center skirmishes intimated what lay ahead. It took five years to obtain a congressional appropriation, and construction did not begin until 1980. By then the name, the design, the location—one block to the west—and the cost had changed. The interior was more clearly divided, the footprint reduced, and the exterior massing corrected to reduce the impact of its bulk. By this time, Washington home rule had been passed, and the city had a mayor, Walter E. Washington. He supported a convention center plan enthusiastically, and the city dedicated special hotel tax revenues to cover some of the costs.

When the center opened, in 1983, with Marion Barry as mayor, it con-

tained eight hundred thousand square feet and was, according to some references, the fourth largest such facility in the United States.[28] The commission's advice had borne some fruit, at least according to *Washington Post* critic Benjamin Forgey. Forgey admired the "engineering marvel" that was Hall A, with its "wonderful top of steel Vierendeel space trusses," an inspiring expanse that merited more celebration than it got. But he pointed to a lack of imagination, given the building's importance as a "symbolic and actual link between the two sides of Washington—the local, city side and the monumental, national side." There was "no *there*, there," no dramatic touch to give visitors a sense of celebration. Instead "of an ugly duckling or a swan we got a plain brown package that can, with some luck and skill, do Washington a lot of good."[29]

But luck and skill would not be forthcoming.[30] Within a short time, dozens of such centers would be constructed elsewhere in the United States, many of them much larger. Fourteen years after its opening, Washington's convention center had slipped from fourth to thirtieth in size. Despite commission efforts to improve it, the glass, steel, and concrete structure failed to capture public support. But despite Brown's prediction that it would be around for a long while, its life span was barely twenty years. A new, larger convention center, named for Mayor Walter E. Washington, would take its place. The Eisenhower Center was imploded in late December 2004, apparently unmourned and with few protests. Its site is now (2012) part of a vast, multiuse project, still under construction.

The brief life of the convention center suggests that, for some projects, commission deliberations breathed the air of an aesthetic playground, reflecting the loyalties and allegiances of the (mostly) modernist membership. The contrasting popularity of the beaux-arts Carnegie library that faced Mount Vernon Square (which Brown so admired), and the generally unloved (if critically admired) Mies library next to the convention center, might have served as a cautionary note. But neither was ever invoked. The King Library, protected by its status as the modernist master's only work in Washington, never obtained the acceptance Wolf Von Eckardt predicted. The convention center could claim no such distinction. But while its design may not have gained many friends, its failure was not the result of its architectural design. Problems arose throughout planning, financing, and development decisions that reflected the District of Columbia's anomalous political status. About these the Fine Arts

Commission could do nothing. At times it acted much like a manicurist, doing little more than cutting, coloring, and polishing the nails on an existing hand.

By the mid-1970s, there were signs of dissatisfaction with the commission. A series of *Washington Post* editorials complained about a high level of torpor. In August 1975 the paper remarked that the "commission's business seems lately to have been conducted with an air of impatience and a reluctance to fight the good fights." It had approved building designs that were "monuments to mediocrity." And then there was President Nixon's decision to appoint several campaign contributors as commissioners, breaking the "unwritten law" that the Fine Arts Commission be kept free of political patronage. The *Post* suggested to President Ford that he not reappoint Carter Brown, Edward D. Stone Jr., and Chloethiel Woodard, all "extremely active, busy people, heavily preoccupied with other responsibilities."[31] A "clean sweep" might revitalize commission work. Months later it again urged Ford to make new appointments, noting that the terms of five of the seven members had expired. While Brown and his colleagues carried on "with more diligence than lame ducks usually muster," the *Post* wanted "qualified and prestigious" members, including representatives of the local community. "There is no lack of respected and public-spirited architects, urban planners, artists and art historians in our town."[32]

The *Post* continued its campaign, some months later, commenting on the disarray of the city's monument making. The commission, it noted, had been excluded from important decisions and, in some cases, ignored; overall, its "prestige seems to have eroded." Condemning George Washington University's decision to demolish town houses that the commission sought to preserve, the *Post* asserted that "open and deliberate flaunting of a recommendation of the Fine Arts Commission is an act of unprecedented defiance."[33]

Just days earlier, Ford had reappointed Brown and Stone and named three new members.[34] For whatever reason, the *Post* (although not all of its columnists) stopped taking shots. Ford continued Nixon's practice of making some of the appointments entirely political—Wall Street financiers and personal lawyers, among them. In the first sixty years of the commission's existence, only seven members had been neither architects nor designers, and three of them had been directors of the National Gallery. Over the next thirty-two years, presidents Nixon, Ford, Carter, Reagan,

Bush, and Clinton appointed seventeen such commissioners, including Brown's successor as director of the Gallery, Earl (Rusty) Powell III.

While sometimes expressing concerns about the commission's power and influence, the press followed its deliberations intently, particularly as they related to historic preservation. Consciousness of architectural heritage and the threats to its survival had been present in the 1960s, when Brown arrived in Washington, but it grew far more intense during the following two decades. Tolerance, indeed enthusiasm, for eclectic styles combined with nostalgia, historical awareness, and economic motive to produce a broadly supported movement to save, restore, and reuse historic structures throughout the country. Washington enthusiasts rallied around the romanesque post office on Pennsylvania Avenue, with its looming clock tower, and the French Renaissance facade of the old Willard Hotel. The Pennsylvania Avenue Planning Commission, led by architect Nathaniel Owings, was prepared, even eager, to take these structures down in the 1960s. But by the early 1970s plans to do so were meeting strong resistance. The post office and the hotel did survive.

The continuing decay of urban centers, changes in transport and retailing patterns, new needs for business efficiency, technological innovations, physical renewal programs—all had placed in peril a wide range of buildings, major and minor. Businessmen were alarmed by the collapse of downtown districts, and some, in Washington and elsewhere, seemed intent on replacing anything that smacked of decrepitude with sleek new towers or even parking lots, which would at least lure drivers back into the center. Galvanized by specific losses—Penn Station in New York, Sullivan's stock exchange in Chicago—preservationists lobbied for better protection and tax considerations, and enjoyed some successes. The Brown family had been active in the larger movement for some time, particularly in Rhode Island. John Nicholas Brown had, among other causes, contributed to the restoration of Peter Harrison's Brick Market in Newport. Like his father, Carter Brown was an energetic member of the National Trust for Historic Preservation, which had been created relatively recently, in 1949. He served on its board of directors and, as a municipal promoter, was committed to protecting as much as possible of the L'Enfant vision for Washington.

But specific proposals for demolition, particularly when they were part of much larger changes, could raise complex challenges. There were

serious disagreements about the extent of salvage operations, about prospects for new housing, about the need to replace small, independent businesses. Well-financed developers were beginning to consider projects adjacent to major government buildings, and they made big promises to strengthen Washington's economic base. The proposals seemed worth taking seriously. Brown, along with the Fine Arts Commission, was sometimes at odds with local crusaders fighting development. The tensions increased when the reasons for preservation were primarily sentimental and associational, rather than aesthetic. Several important episodes in the District's late twentieth-century history suggest the complexity of the choices.

Probably the most memorable, and certainly the most painful, was the protracted six-year debate over the fate of Rhodes Tavern, a long-running serial filled with heroes, villains, and suspense. It began in November 1977, when prominent developer Oliver T. Carr Jr. announced plans to construct a forty-million-dollar mall, hotel, and office complex. He intended to fill much of an entire block, at Fourteenth and F Streets, with the existing Garfinckel's department store remaining as the mall's anchor tenant.[35] Other developers had recently announced plans for large projects nearby. With the impending opening of the Metro system, this part of downtown Washington, its neglected east end, seemed poised for impressive renewal.

The problem was that the block contained a number of historic structures, three of which—the Rhodes Tavern, the Metropolitan Bank Building, and the Keith-Albee Theater Building—attracted immediate attention. The Old Ebbitt Grill, another legacy, aroused less concern, since it soon became apparent that it could be deconstructed and moved as a restaurant to another part of the complex. The bank and the theater building, warned the development company, might have to be torn down. But Rhodes Tavern, initial newspaper reports declared, was to be preserved. The original plan, as announced, included a 365-room hotel, a two-level shopping mall, an underground garage, and 350,000 square feet of office space, a major addition for the city.

Preservationists were, at first, supportive. A spokesperson for Don't Tear It Down, the most active local group, declared that its members were confident that Carr would be able both to produce an attractive building and to retain the important existing structures.[36] Carr enjoyed a

good reputation and had access to financing. But there were some warnings that objections to the inevitable destruction could hold up the project for some time.

Rhodes Tavern, was, despite its shabby appearance and dubious physical authenticity, historically significant. Built in 1801, just one block from the White House and across from the Treasury Department, and used variously as a boarding house, town hall, bank, stock exchange, and press club, it was thought to be the oldest commercial structure in the District. It had been placed on the National Register of Historic Places in 1969. The appearance of the tavern itself had changed many times over the previous 170 years—indeed, portions of it had been demolished only a few years earlier—but it remained a vestige of the city's rapidly disappearing past.

Carr's commitment to preserve was quickly qualified. By February 1978, as he sought construction permits, it became clear that the developer was not prepared to assume the costs of preservation himself. Offering nine different plans for development to the Joint Committee on Landmarks, a local body that reviewed demolition proposals of any structure that had been placed on the National Register, representatives of the developer (who included David Childs, an architectural adviser) suggested that saving the historic structures in their entirety would cost eighteen million dollars; preserving just the Rhodes Tavern would cost one and a half million dollars, and the sum would also be reduced if just the facades of the bank and the theater building were retained. Carr indicated he would move ahead immediately if he obtained the demolition permits. But if the committee imposed a delay, he would make every effort on behalf of the older structures. He retained a consultant, the former director of Don't Tear It Down, to raise funds from private groups, foundations, and federal grants. Without this money, however, the structures would come down. "We will proceed with total demolition if we can't raise the funds," he declared. The committee voted a six-month delay in granting the demolition permits, and Carr promised to do his best.

Thus began an six-year saga of contentious debate, delay, and ultimate defeat for the partisans of Rhodes Tavern. The project designers were soon reversing their original priorities. The facades of the Metropolitan Bank and the Keith-Albee Theater Building would be saved. As beaux-arts structures they appealed to the sensibilities of a number of architects, as well as some preservationists. Childs proposed making the impressive

portico of the bank into an entry arch for the shopping mall. Part of the theater facade would be placed on a corner.

But Rhodes Tavern was another matter. Wolf Von Eckardt, the *Washington Post* architecture critic who applauded the larger efforts, opposed incorporating the tavern into the new ensemble.[37] So did the architects. "The large building would be hovering over it like a fish about to swallow it," Childs remarked.[38] The Fine Arts Commission apparently agreed with Childs. Employing one of the memorable metaphors that sometimes brought him trouble, chairman Brown declared the tavern a "poor little beat up derelict," "the rotten tooth in the smile of 15th Street."[39] The latter image was a variation on a metaphor Brown had employed in earlier press statements. Dental metaphors had also appeared in other Fine Arts Commission decisions.[40]

Thus in March 1978, after the six-month ban on demolition had been recommended to the District's preservation officer, the Fine Arts Commission declared that it would not oppose the razing of the Tavern.[41] At the same time the commission opposed issuing permits to demolish the bank and the Keith-Albee Theater Building. "To tear down the Albee and Metropolitan Bank buildings would be a crime no matter how sensitive the design of the new building," Brown asserted. In fact, he wanted only their facades to be retained, for he went on to indicate there would be no protest against taking down their back parts.[42]

Rhodes Tavern earned no such accolades from him. It did not complement the elegant beaux-arts touches, and it was unauthentic anyway. "To rebuild it would be fake, like a Hollywood set," Brown continued (notwithstanding the fact that many National Gallery installations did just that). "It's not worth moving because the important thing about it is its site."[43] A *Washington Post* editorial comment supported his position. Where would you "wind up if you carry the urge to preserve too far," the *Post* asked. Brown's question at the hearings—"Do we go back to the forest?"—got the paper's approval.[44] Representatives of neighborhood groups testified in support of the tavern's retention, but the commissioners were unconvinced. Although the commission would be called on to approve the final design, this ended its immediate role in the process. However, its stance would not be forgotten.

The campaign to save the tavern divided the preservation community. Part of the structure's appeal came from its association with the District's lengthy efforts to achieve home rule and representation in Congress. The

tavern had served as a polling place for Washington's first city council election in 1802. It had been the site of petitions for local government. All of this suggested links with a municipal past and political claims that had been overshadowed for a century and a half by national events. The tavern also appealed to some as a witness to history (particularly to inaugural parades), a reminder of a smaller, more intimate city that was beginning to disappear. Over the next several years letters poured in to local newspapers, bemoaning a loss of control, the failure of the courts and local government to protect public rights, and complaining about the broader legal processes themselves, among them the role of the Fine Arts Commission. Bitterness and cynicism surfaced, demonstrating the risks prominent figures face in staking out any position on such contentious issues.

All sorts of suggestions were made. Some preservationists imagined the tavern could be salvaged as a restaurant. Others proposed making it a history museum that would remind contemporaries "of the graceful city of human scale that early Washington became and the citizens whose vigorous humanity got in the way of the grand design." Brown's name was occasionally mentioned in the complaints. I "am sorry to hear that someone so powerful as Carter Brown finds that handsome old building aesthetically unexciting," wrote Richard Crouch to the *Washington Post*. Going "back to the forest" hardly seemed the issue.[45] The Fine Arts Commission, some years earlier, had been willing to sacrifice Lafayette Square until Jackie Kennedy stepped in. "The Rhodes Tavern needs another high-level patron to save it," wrote Nelson Rimensnyder.[46] "Carter Brown, Oliver Carr and the proponents of 'modern Washington progress' have declared [Rhodes Tavern] 'persona non grata' in our current golden age of architectural monstrosities," asserted another angry letter writer.[47] Four years later, critic Benjamin Forgey was still invoking Brown's "clever metaphor" of the missing tooth, declaring that "it perfectly sums up an attitude that is obviously ruinous to Rhodes Tavern and, by implication, terribly dangerous" to the downtown district of which the tavern was a part. "It is a suspicion of relative smallness that, for aesthetic, economic and other justifications, condemns whole city blocks to destruction. It is an attitude that, when put in practice, endorses boxlike speculative office buildings that fill those invisible zoning envelopes all over downtown."[48]

By this time, Rhodes Tavern had long since become a *cause celebre*. The

calls to action, the demands for greater sensitivity to history, the hostility to large-scale redevelopment, all revealed a popular sensibility that was not shared by the Fine Arts Commission, however much lip service they sometimes paid to it. Within weeks of the commission's decision not to oppose the tavern's demolition, a Citizens Committee to Save Historic Rhodes Tavern was formed, supplemented by a Committee to Preserve Rhodes Tavern and the National Processional Route Inc. and, over time, other groups. Tours were organized, tenants opened their spaces to interested visitors, a parade was held, rallies sponsored, and in May 1979 a "Paint-In" invited artists and photographers to "do their thing." Suggestions multiplied for the building's creative reuse.[49]

Meanwhile developer Carr offered to absorb the costs associated with preserving the facades of the bank and theater building in return for tax relief, abatements, and some fee waivers from the city, and also to suspend negotiations on the tavern for one year to permit fund-raising. Then he announced that changing conditions had made it impossible to absorb the costs of even partial preservation, and indicated that the price for such intervention had risen substantially. Carr was, however, willing to donate the tavern to the Junior League or lease it to them, "under certain circumstances."

The elaborate dance among developer, city officials, and interested stakeholders would continue for the next five years. There were suits, countersuits, court hearings, appeals (all the way to the Supreme Court), prominent endorsements, congressional committee actions, election promises, injunctions, and editorials, one succeeding another at a dizzying pace.[50] For a time, Carr held the Keith-Albee facade hostage until he was granted permission to take down the tavern. City officials, desperate to promote development, increasingly sided with him and against the tavern partisans, now led by an impassioned former government lawyer, Joseph N. Grano Jr., who had quit his job in order to pursue this preservation dream.

The climax came in 1983. The tavern, despite a string of demolition permits and partial construction of the mall project, still stood. After all legal alternatives were exhausted, a new tactic developed: testing local sentiment through a ballot initiative. More than twenty thousand signatures were gathered in support of the imitative, which was scheduled for a November 1983 vote. Statements of support and opposition multiplied, and prominent figures—including Secretary Ripley, congressmen, and

Clement Conger of the State Department—urged voters to endorse saving the tavern. City authorities insisted the vote had no legal bearing and sought to prevent it, but a federal judge, in September 1983, barred the District of Columbia from permitting demolition until after the vote.

On the eve of the referendum, there were clear signs of angry division. The *Washington Post*, some of whose staff writers and columnists had already indicated their skepticism about the preservation effort, came out decisively against it.[51] "At age 184, physically dead and historically exaggerated," an editorial intoned, "Rhodes Tavern—or the rubble at 15th and F Streets NW that passes for it—has managed to become Washington's biggest insignificant landmark and political issue." Noting that the Fine Arts Commission and Don't Tear It Down had endorsed the Carr project, the paper bemoaned the costly delay.[52] Letter writers protested its stance.[53]

Finally, after months of uncertainty, the voters spoke, approving the initiative that called for the District government to "support, advocate, and promote" tavern preservation. The initiative gained a 60 percent majority and carried 91 of 137 precincts. Most of the negative votes emanated from the largely white, upper-income Northwest neighborhoods in Ward 3, traditional backers of historic preservation. One commentator explained that the large yes vote came from those who had made the tavern into a symbol for "something that belongs to the city rather than the federal government or big business."[54] Mayor Barry was now required by the initiative to appoint an advisory committee that would work on the tavern's preservation. Debate continued. William Raspberry reminded readers again of Brown's "missing tooth" metaphor and admitted that he would "rather see Carr's commercial venture than the phony restoration of what's left of poor old Rhodes Tavern."[55] The courts apparently agreed. District government insisted that the vote was unconstitutional, and their view was accepted by the District of Columbia Court of Appeals, which lifted an injunction blocking the issuance of a permit.[56] Almost one year after the vote, on September 10, 1984, the tavern was demolished by bulldozers. Almost seven years after Carr's first announcement, the next phase of the project was allowed to proceed. Grano and his followers blamed Mayor Barry and the courts as much as they did the developer, but the game was, at last, over.[57]

The resulting Metropolitan Square, by now a hundred-million-dollar undertaking, opened in 1987. It incorporated facade elements from both

the Metropolitan Bank and the Keith-Albee building, and a refurbished Old Ebbitt Grill was opened inside. Landscape protection law had been changed. In 1978 the city council enacted the Historic Landmark and Historic District Preservation Act, restricting demolitions or radical changes for thousands of structures in a series of official historic districts.[58] But the Rhodes Tavern was totally gone.

It was still not forgotten years later. A musical group would proudly flaunt the name, and in 2002 Mayor Anthony Williams proclaimed Rhodes Tavern Day, affixing two large, ornamental plaques to the site, paid for in part by the pennies of schoolchildren. Carter Brown had, as early as 1979, proposed such a plaque as a way to commemorate the doomed building, although it took more than twenty years to achieve even that. Tavern partisans were loath to give him any credit, still fuming about the Fine Art Commission's failure to endorse their quest and protect the building. They had expected Brown to demonstrate greater loyalty to the city's history.

Brown's preservationist loyalties, however, had a different focus. The city's past, as represented by fragmentary and poorly maintained structures, was less important to him than the maintenance of specific traditions—notably restrictions on building height—and the nurture of good design. During his lengthy tenure at the Fine Arts Commission, the majority of debates hinged on quality of life issues, heavily impinged by aesthetic tastes. Preventing Washington from being turned into just another American city of high-rises and parking lots, retaining the quality of favored neighborhoods, like Georgetown, controlling developer ambitions, highway expansion, and quixotic design solutions driven by simplistic goals—these dominated the commission's agenda. Mediocrity—or worse—was not always preventable. The District needed hotels, office buildings, and investment. Anything that went wrong, from the massive, brutalist FBI Building (approved before Brown's time) to the smallest residential aberration, could be blamed on the commission. Denouncing the new Hyatt Regency Hotel near Union Station in 1976—"a mincemeat agglomeration of suburban motels with Regency pretensions," a "building with the charm of Alcatraz and the elegance of Attica," "flat-chested, bare, and square"—Wolf Von Eckardt saved his last words for the commission. This building, within walking distance of Capitol Hill and the Smithsonian museums, should have had "the architectural and—shall we say—cultural qualities the national capitol [sic] deserves

and that our Fine Arts Commission is supposed to look out for. That Fine Arts chairman Carter Brown and his group let this much tackiness slip by without a murmur [*sic*] is incomprehensible to me."[59] "Where the hell was the Commission when the blue ink was still wet for the Hirshy-covered Donut on Independence, the new Labor Department Wreck-tangle, the Lack Ness Monster on the C&O Canal, the Jedger Hoover Building, the Vile Pyramid at Wisconsin and K, and the Riot Regency Hotel?" screamed an angry G. N. Will in a letter to the *Washington Post*. "Fine Arts Commission? You gotta be kiddin'."[60] Even lighting fixtures that looked like "potato dumplings," "carnival balloons," or "matzo balls," strung along Tenth Street in the district's downtown, could be blamed on the Fine Arts Commission, although it claimed never to have seen or approved them.[61]

There were also failures in areas that Brown felt deeply about, notably the high-rises that would be constructed across the Potomac in Virginia, in Rosslyn and Arlington. This trend would be a source of frustration to those trying to preserve the special character of the national capital, which was also Brown's deepest commitment. Jurisdictional boundaries lay at the heart of the problem. The Fine Arts Commission's power stopped at the District's borders. Despite vigorous opposition from local residents, the National Park Service, the National Capital Planning Commission, the Arlington Planning Commission, and the Fine Arts Commission, the Arlington County Board gave permission in 1978 for the construction of ten-story luxury condominiums, two stories higher than zoning laws allowed. Arguing that the whole hillside was a "national shrine," Charles Atherton, secretary of the Fine Arts Commission, pointed to Arlington National Cemetery, the graves of the Kennedy brothers, and the Custis-Lee Mansion.[62]

Worse would soon come. The commission had been protesting construction of high-rises on the Arlington Ridge overlooking the city for decades. One *Washington Post* staff member described the "glittering array of high-rise buildings" as "a mini Chicago-on-the-Potomac."[63] Some thirty office buildings had been constructed there since 1962, many receiving height variances from the county board, but development fever had risen further.[64] In a dramatic move, the Interior Department in 1978, prodded by an angry interior secretary, Cecil Andrus, sued the Arlington County board over permits issued to a cluster of towers, notably four large developments overlooking the Potomac. These included the twin

twenty-nine-story Arland Towers, rising some 380 feet above the river overlooking the Kennedy Center, a twenty-four-story building on Seventeenth Street, and the proposed Rosslyn Center. The tallest building previously erected in Rosslyn was just fifteen stories. Brown declared that "in effect, 175 years of restraint is being cashed in on by three developers."[65]

The Virginians were defiant. Approvals had been issued, in some cases years before, and Arlington County insisted it had no obligation to protect owners of property within the District of Columbia or, for that matter, any federally owned property.[66] More than that, the board argued that the additions would "improve the quality of civilization." Some of its members declared they didn't like the view across the river of the decaying Georgetown waterfront, but they accepted it as a given. "Cecil Andrus is not secretary of the interior for Virginia," insisted one developer.[67] Testifying as a government witness before a United States district court, in December 1978 (along with representatives of the National Park Service, the General Services Administration, and the National Capital Planning Commission), Brown declared that erecting the proposed high-rises in Arlington (the first, Rosslyn Center, was already under construction) would be "akin to an act of urban vandalism." Only if "a building were wrapped in neon and allowed to blink" would it be "more of an intrusion." Judge Oren R. Lewis, who seemed overtly hostile to the witness and to the government's case, replied that while Brown had "an enviable reputation in the arts," he was not sure that he was "an expert on public nuisances." "You show him a picture and he wants to give a dissertation on Thomas Jefferson," he said of Brown. "I won't let you give Thomas Jefferson's opinion," he lectured the witness. "You are not to argue this case."[68]

Brown, David Childs, the National Capital Planning Commission director, and others admitted under questioning that they had no legal authority in Virginia, but said they felt a "moral responsibility" to register their protests, believing that the towers would ruin the skyline around the capital and thus constitute a public nuisance. Giving his decision weeks later and upholding the developers' right to build Rosslyn Center, Judge Lewis excoriated the federal government, declaring its position "arbitrary, capricious, and unreasonable," and criticizing it for taking action years too late.[69] The towers, and others, stand today, demonstrating the difficulty of controlling a landscape when the vista crosses political boundaries. Contrasting the rights of the "overlookers" with those of the "overlooked," Elizabeth Rowe, a political activist and former chair of

the National Capital Planning Commission, bemoaned the Rosslyn wall. Praising Andrus, Brown, and Childs, she concluded that "beauty has a hard time of it" "because our economic and political framework is rarely designed to protect it."[70]

Not everyone in government cherished the Fine Arts Commission. In 1981 David Stockman, President Reagan's choice to head the Office of Management and Budget abruptly, proposed abolishing it as an independent entity. The new administration argued that commission work should be supported by private rather than public funding. Congressman Yates argued forcefully against the change.[71] So did chairman Brown, but he had to be careful moving between Republicans and Democrats. As a skilled diplomat, he was able to maintain both his own chairmanship (Reagan would reappoint him) and the commission's independence. In the end, the Stockman proposal went nowhere.

There were also temporary successes, or at least impressive resistance. By careful negotiation and patient coaxing, as well as standing firm where it had some persuasive power, the commission was able to influence the shape of many projects. Among them was the Georgetown waterfront, an eagerly sought development prize. This area, flourishing in earlier centuries, was now disfigured and decayed, "one of the ugliest riverfronts in America," according to a *Washington Post* correspondent, marred by a lumberyard, parking lots, and a concrete factory.[72] It was also scarred by a freeway that might be prettified but could never be entirely masked.

Efforts to do something about the riverfront stretched over decades, and the story, like that of so many other commission interventions, cannot be easily summarized. But there are high points and low points. Georgetown residents in the 1970s and 1980s found themselves beset by commercial and residential expansions that, in style, materials, and scale, threatened to overwhelm the neighborhood. Actively defending their sense of history (and, some argued, expressing their sense of entitlement), some locals organized themselves into associations to monitor such incursions and protest. Thus in 1972, the Citizens Association of Georgetown cheered the Fine Arts Commission's decision to oppose construction of an eight-story building on the waterfront. Despite the fact that it met zoning requirements, the commissioners felt it was too high.[73] The architect was Arthur Cotton Moore, who would play a prominent part in Georgetown matters for years to come. With property values escalating—in some places more than quintupling in the late 1960s

and early 1970s—pressure only increased. And the Fine Arts Commission, with special responsibilities to Georgetown, found itself weaving back and forth. It was difficult to preserve Georgetown's traditional character while simultaneously acknowledging the legitimate demands of the market. The effort cost Brown and the commission some credibility in the press, as they appeared to temporize or contradict older positions.

Things heated up during the late 1970s when, after a redistricting ordinance that permitted commercial development on the riverfront, developers leapt into action with plans for stores, housing, and restaurants. Residents and some legislators responded. In March 1978, Senator Charles Mathias of Maryland introduced legislation which would commit the federal government to taking possession of some acreage between the river and the Chesapeake Canal at a fair market price and turning the whole site into a new national park, designed only for public recreation. Developers were stunned, one declaring that the bill was "incomprehensible." Local activists, on the other hand, were elated; "a life preserver to a drowning man," said one.[74] "Not since Verdun in the First World War has there been a piece of real estate more fiercely embattled," wrote Wolf Von Eckardt in the *Washington Post*. There had been "lawsuits, character assassinations, broken friendships and reputations," along with millions of wasted dollars, he noted.[75] The Mathias proposal was indeed radical, and might cost the government more than a hundred million dollars, but its chances of passage were not bright.

But compromise seemed possible. Many meetings were held during the summer of 1978, with Brown, Mayor Barry, Senator Mathias, and some developers putting their heads together to come up with a solution—a "love-in," Mathias declared. Meanwhile the legal battles continued, and in October, after another court decision, commercial development was ruled to be legal. "The city won," Wolf Von Eckardt announced. But, he added, even local partisans are glad "that the seven-year long legal battle of the Georgetown waterfront is over." Georgetown's "haughtiness" had been reproved, and the municipal planning office should be allowed to do its work," he wrote. "I don't think we want a 4 acre meadow here. But neither do we want a Coney Island."[76] Promising results seemed on the horizon, as a task force came up with some proposals the next summer, but Von Eckardt now grew pessimistic. "Georgetown's promised waterfront park is in danger of turning into a stagnating political morass," he reflected in June 1979. Georgetown citizens at a public hearing seemed

"bickering, heckling, shouting, pouting," and generally uncooperative, despite their legal defeats. He wondered whether they would welcome "non-Georgetown kids" playing in their "total park."[77]

The public meeting that so upset Von Eckhardt could, however, boast a real accomplishment. Or so it seemed. Led by architect David Childs of the National Capital Planning Commission, who was now heading a special Georgetown Waterfront Task Force, a group of leaders proposed creating a park along the riverside with trees, walkways, bicycle paths, and other amenities. The city desperately needed tax revenues, so some development was necessary. With Childs and Mathias involved, the various interest groups—government, local residents, developers—agreed to limit private development to just four of the twenty acres in question, and those next to the Whitehurst Freeway. Both District and federal governments and a developer, Herbert S. Miller, soon put together an eighty-million-dollar plan that would do just that, introducing a 180-foot-wide national park along the river, while permitting construction of several hundred town houses, offices, and retail stores. Childs, Miller, and interior secretary Andrus signed on to the planning document, and to celebrate the occasion some of the signers went on a river cruise to inspect their new kingdom.[78] Here was the origin of what would become, a decade later, Washington Harbour. Miller himself, who would go on to fame and fortune as the developer of Potomac Mills, and who already was involved in the construction of Georgetown Park, a "neo-Victorian concoction of luxury shopping mall and condominiums" on M Street, declared he was open to further compromise.[79]

But, as Von Eckardt noted, some Georgetown residents were unappeased, insisting upon "a park not a pathway." They were angry, articulate, resourceful, determined, and seemingly oblivious to successful riverfronts elsewhere. Defeated in the courts, the Fine Arts Commission was their last chance. And to the surprise of many, it fulfilled their fondest hopes, issuing a unanimous recommendation, albeit months later, against the project. Brown asserted that it looked "like a beached whale," too "much of the same thing," a terraced brick structure stretching for more than a thousand feet. Commission members wanted the waterfront land to be bought by the federal government in its entirety, for use as a "people's park." "Any building here is a mistake," Brown went on, admitting that, as things stood, the acreage was "one of the great eyesores of America."[80] Mayor Barry had supported the development agreement, and

the commission's decision, while only advisory, was a blow. Some members of Congress, notably Senator Mark Hatfield, who lived in Georgetown (as did Brown), did introduce new legislation to buy the land for a park, but that still appeared unlikely.

The developer, Herbert Miller, moved immediately to hire a new architect, choosing Arthur Cotton Moore, who promised to design much smaller buildings in a variety of colors and textures. Explaining the commission decision, Brown had complained about the "sheer mass of the project, undifferentiated in its components, and attempting to quote superficial aspects of a 'Georgetown' character that ends up giving the overall effect a nervousness," thus "demonstrating its incompatibility with the district's residential character."[81]

In March 1980, Moore presented his new, dramatically different plan: two curving buildings that girdled a yacht basin, along with five other structures for commercial and residential purposes.[82] These may have met some of the Fine Arts Commission's concerns, but many Georgetown residents remained, predictably, unhappy about the three hundred thousand square feet of retail being proposed, "something that attracts hordes of people," complained one.[83] The *Washington Post* found the plan attractive, although admittedly more from the water side than from Georgetown. It continued to argue that reserving the whole strip of land for park use made no sense. "An empty tract of this size and in this location would be little more than an unused back yard," while development would provide revenues "for a financially strapped city." The paper urged compromise on all parties, recomending that the Fine Arts Commission not toss the plan out entirely.[84]

The commissioners seemed to agree. While still criticizing the heights of the buildings, they gave partial approval the following week, and the developer agreed to request some architectural modifications. Disappointed locals continued to express opposition. Finally, in April 1980, the commission approved a scaled-down, sixty-million-dollar plan, although members admitted they would still have preferred a park for the entire site. The sixty-eight-foot structures, reduced from eighty-eight feet, would be the tallest ever approved for the Georgetown waterfront.[85] Again the *Washington Post* applauded. The Georgetown riverside, "when we last looked in . . . was your basic rubble-and-ruin design, embroidered with parking lots and topped with a well-aged cement plant." The new plan looked fine, a bit too monumental, but the architect did some

shrinking. "Now, in a burst of reason and realism, the Fine Arts Commission has approved the compromise design." Georgetowners prefer nothing but open land, the *Post* acknowledged, but rather than continuing to insist on a large empty park that the government cannot pay for, residents should devote themselves to making the approved proposal work.[86]

Everything seemed fine. Just a few final touches remained. But then, just one year later, in March 1981, the Fine Arts Commission surprised everyone by rejecting the (now) 154-million-dollar plan for housing and commerce.[87] This time the vote was split, 5–2. Brown brought up a new problem: the development fell within the Potomac River flood plain, and a presidential order, now four years old, had directed federal agencies to deny development within flood plains unless there was no practical alternative. The Fine Arts Commission occupied the agency category, according to a recent Justice Department communication. Brown added that he was worried about the precedent that would be set for the waterfront if the developers went ahead.

So, after years of testimony, debate, redesign, and carefully calibrated agreement, everything was up for grabs again. Some blamed politics. Wolf Von Eckardt declared that Lyndon Johnson was the last president who had seemed to care about the commission's competence. With a tone more of sorrow than of anger, Von Eckhardt held the Jimmy Carter administration responsible for packing the commission with political friends—a public relations specialist from New York, a lawyer from Pennsylvania—who lacked the appropriate credentials.[88] Could no artists be found, he wondered. "The commission is rapidly losing prestige," a dangerous slide since its presence and reputation were all that stood between "a dignified, beautiful national capital and the loud commercial schlock that overwhelms most other American cities."[89] Even Brown, whose many reappointments seemed to flout congressional intent in the enabling legislation, was not spared. "J. Carter Brown's commission seems to have become increasingly uncertain, shy of the limelight, shy of clear decisions." Whoever won, the commission looked to be the loser.

A month later, in response to a request from developer Herbert Miller, who declared his firm had been led, unfairly, to think approval was probable, the commission reheard testimony. And then it reaffirmed its opposition to the development. Speaking to a packed house (only about a hundred people, all who could fit into the Lafayette Square home of the commission), Brown admitted the waterfront was ugly and likely to

remain so. But the long-term future was more important, and precedents could be dangerous. The Washington Monument and the Capitol dome had taken many decades to complete, he pointed out.[90]

Again consternation blossomed. The *Washington Post* expressed its astonishment. The Fine Arts Commission had awarded Georgetown "its very own apparently permanent Blight to Remember." This "latest ill-considered decision" guaranteed that an "ugly complex of rubble, parking lots, trash, and ghosts of buildings past" might fester for generations. The *Post* had lost patience with the commission and urged Mayor Barry to ignore its recommendation and issue a building permit. Noting that the city might be liable for settlements from "reverse condemnation" lawsuits made by frustrated developers, it taunted Brown for his Washington Monument and Capitol dome examples.[91] Letters to the newspaper debated the wisdom of the Fine Arts Commission, while new articles informed the public about flood plain issues. Georgetown residents now found a new peril to brood about. If the plan were approved, exclaimed one of them, "it's going to make a great set for a flood-disaster movie."[92]

The scene now shifted from the Fine Arts Commission to the mayor's office and the city's agent for historic preservation, Carol B. Thompson, who was to decide whether the project would damage the historic character of Georgetown.[93] But economic interests were taking over. While Mayor Barry had campaigned supporting creation of a park, his top officials were now lobbying for commercial development, in effect urging defiance of the commission's recommendation. Members of the commission, notably Chicago architect Walter Netsch, continued to argue against the project's architectural character at the city hearing. And Georgetown residents threatened court action if the city signed on to the project. The head of the Citizens Association of Georgetown labeled the developers "idiots," the Washington Harbour Plan a "monster," and the District's planning office "a bunch of clowns."[94] But Thompson went ahead and approved the construction application, and, at last, development moved forward.

Hostility remained. In a largely glowing portrait of Brown the following year, Lynn Darling told *Washington Post* readers that there were moments when Brown's judgment could desert him, pointing to the waterfront fight. One participant (unnamed in the article) charged Brown with an arrogant desire to be recognized a hundred years later for the park he had installed. The District government's departure from prec-

edent in overruling the commission, however, seemed troubling. Commission power was hortatory, declared this commentator, and "once its opinion has been ignored . . . you risk the loss of what power you have."[95] Georgetown residents might disagree—Donald Shannon, president of a local association, wrote to the *Post* a week later praising resistance to the development scheme as brave and wise—but the lengthy and ultimately unsuccessful effort demonstrated the limits on commission power.[96]

As the 1980s moved forward, there would be new problems. Political appointees continued to fill commission seats, and Brown himself would be accused, by at least one commissioner, of divided loyalties, given his pursuit of wealthy developers on behalf of the National Gallery.[97] He denied the charges and carefully recused himself when there were clear conflicts of interest. But Brown and the commission did achieve some signal victories that helped burnish his broader reputation. The best known involved the construction of memorials, a set of campaigns that provoked bitter polemics and angry recriminations. If they produced some of the most severe pressures Brown ever confronted, they also yielded some of his finest hours.

In the last third of the twentieth century, Washington was emerging as an increasingly congested city of shrines, filled now with places honoring mass experience as well as individual heroes. Wounds were to be healed and scars covered by paying tribute to ordinary people as well as great leaders. In a city cluttered with statues of generals, admirals, inventors, scientists, politicians, and philanthropists, along with memorial fountains, benches, arches, columns, obelisks, carillons, stadiums, and auditoriums, there were long traditions of contention. Union officers on horseback, commissioned in the post–Civil War years, signified the triumph of the North in a place whose sympathies had been heavily southern. The following century saw aesthetic and political disputes swirl around both the Lincoln and the Jefferson Memorials. Recent historians have charted the changes in sensibility that underwrote new phases in the capital's monumental landscape.[98] By the late twentieth century, heroic male figures surrounded by allegorical detail were being repudiated in favor of more abstract and inclusive designs. But this repudiation was not uncontested.

Brown's Fine Arts Commission would plunge into and occasionally preside over the angry disagreements that accompanied this change. At stake were larger things than real estate profits or dreams of beautifica-

tion. Here the commission had to cope with issues of national conscience and civic identity, to satisfy interest groups struggling to control historical memory. An experienced mediator who could draw on his impeccable cultural credentials, Brown was able to steer bitter disagreements into lively conversations, and thus help to get several major memorials actually built. The experiences earned him credibility as an honest broker and a guardian of the local landscape, two roles he had long attempted to play. They provided a platform for him to stand on, even after leaving the Gallery directorship.

Although Brown would be actively involved in the debates surrounding a whole array of memorial proposals—for the Korean War, the United States Navy, Franklin D. Roosevelt, and World War II—his participation in the Vietnam Veterans Memorial project brought him the most attention, at least during his directorship. The story of that competition and the struggle to realize the architect's plan has been told many times. Unlike some other monument campaigns, stretching across decades, this was a highly compressed operation. The movement to create the memorial began in 1979, largely through the instigation of a wounded veteran, Jan Scruggs. Congressional authorization and provision of a three-acre site in Constitution Gardens, near the Lincoln Memorial, came the following year. So did the announcement of a design competition, with fifty thousand dollars in prizes. Although early estimates predicted a cost of somewhere between one and two million dollars, the memorial turned out to be dramatically more expensive.[99] But against all odds, many predictions, and a very slow start, the Vietnam Veterans Memorial Fund raised more than six million dollars from private sources, including a million-dollar gift from the American Legion.

During the spring of 1981, more than fourteen hundred entries poured in, fewer than the twenty-five hundred that had originally registered but still enough to make it one of the largest design competitions in American history.[100] In May, an eight-person jury that included architects Pietro Belluschi and Harry Weese (the Chicago-based designer of Washington's Metro system) selected the proposal of a twenty-one-year-old Yale University architecture student, Maya Lin. There was nervousness about this procedure, since an earlier jury and committee of experts, similarly distinguished, had so far failed to come up with a satisfactory proposal to memorialize Franklin D. Roosevelt—at least a proposal satisfactory to the National Capital Planning Commission and the Fine Arts Commission.

However, presentation of Lin's winning entry elicited powerful editorial support and, initially at least, impressive congressional endorsements.[101]

Thirty years later, the pace seems startling. The black granite wall descending into the earth, on which would be etched the names of more than fifty-eight thousand Americans killed in the Vietnam conflict, was constructed within eighteen months, by Veterans Day 1982. It took another two years, to be sure, for the compromise additions to be completed. Even so, five years from start to finish is a remarkably short time, in the context of public memorials. But those years were filled with high drama, bitter recriminations, unexpected interventions, official challenges, and extended commentaries from friendly and unfriendly critics alike. Through all of this, Brown and his commission were influential players.

Their involvement was not totally positive, at first. In the summer of 1979, according to Scruggs, the commissioners proposed a new site, in Virginia, on a road leading to Arlington National Cemetery.[102] That location seemed "sterile and deserted," according to memorial backers, but the Fine Arts Commission didn't push hard for it, and weeks later, with the help of Senator Charles Mathias of Maryland, the Mall location emerged as a priority in the legislation itself. It was unusual (some thought inappropriate) for Congress to specify a memorial site, but in June 1980, after careful maneuvering by the veterans, it did just that (though the secretary of the interior would have to approve the final details).

The following year, with the Constitution Gardens plot in hand, both the National Capital Commission and the Fine Arts Commission embraced the plan. Lin's design, which she presented personally, was first reviewed by the Fine Arts Commission on July 7, 1981. The commissioners also heard from a Vietnam veteran opposed to the design but found that testimony unconvincing and unanimously endorsed Lin's proposal, praising its "simplicity" and "nobility."[103] One month later, the National Capital Planning Commission added its approval.

Meanwhile, opposition was growing. Washington newspapers printed letters criticizing the memorial's abstraction, its minimalism, its black facade, its failure to acknowledge living veterans, and the absence of veterans on the jury. The most divisive experience in recent American history had left behind a legacy of mistrust that shrouded the discussion. A second meeting of the Fine Arts Commission, in October 1981, to consider

design details and granite samples, produced some angry reactions. In a letter, James Webb, veteran, author, and future United States senator, characterized Lin's monument as a "black hole" and proposed changing the stone's color to white and adding a flag.[104] Webb had earlier been asked to serve on the selection jury, but he had declined.[105]

Another veteran, Thomas Carhart, testifying at the second commission meeting, called the Vietnam Memorial a "shameful, degrading ditch—a black gash of sorrow," and claimed that it reflected political opposition to the war. He requested that the competition be reopened.[106] With rhetoric escalating, Brown responded that the memorial projected "an extraordinary sense of dignity and nobility," the result of its very simplicity. The commission then reapproved the design and the materials it deployed.[107]

Several influential critics threw their weight behind the project, some unexpectedly. Conservative columnist James J. Kilpatrick declared that "this will be the most moving war memorial ever erected." "We are not to have Greek columns, mausoleums, Corinthian curlicues," he wrote gratefully. Kilpatrick labeled charges that the memorial sent "a pacifist, anti-war message" the "sheerest fantasy," and urged readers to contribute to the fund, then only a third of the way toward its goal.[108] Days later, Benjamin Forgey, reviewing an exhibition of dozens of the most "meritorious" designs submitted, defended the choice of Maya Lin as obvious. The figurative proposals he found "too specific. They limit the range of possible responses." At the same time, the abstract symbols employed by several competitors seemed cliched. And some of the self-enclosed park proposals were just too "pretty." Lin alone "got to the heart of the matter," "aligning her earthworks" to the sight lines of the spot and leading visitors to reflect upon the sacrifice made by the fallen. This, after all, was the purpose of a memorial.[109]

But critics and columnists, even if they had been unanimous, could not quiet the protests that continued to erupt in late 1981 and early 1982. Veteran Tom Carhart, who had testified so vigorously before the Fine Arts Commission, carried his fight to the public, persevering with his plea to change the monument from black granite to white marble, lift the walls above ground, and place an American flag nearby. He warned of flooding and complained about accessibility.[110] Other veterans wrote to newspapers, some supporting the selection, others calling it morbid,

repugnant, insulting, a giant tombstone, and meant to satisfy the Fine Arts Commission rather than the community of veterans and the wider public.[111]

Letters to the editor were one thing, but now legislators became involved. More than two dozen congressmen, all Republicans and led by Henry Hyde of Illinois, sent a letter to President Reagan attacking the memorial as "a political statement of shame and dishonor."[112] To what extent this represented a broader opinion base was unclear, but Jan Scruggs, the project's originator and a staunch defender of Maya Lin's design, agreed, in early 1982, after a series of meetings, that a flagpole and sculpted soldier could be placed beside the wall.[113] Scruggs and his associates had, before organizing the competition, discussed the inclusion of figurative sculpture but decided against it.[114] This new concession, however, brought its own problems, for now the entire design would have to pass through another set of hearings. Besides which, the outspoken and controversial secretary of the interior, James Watt, whose involvement had been mandated by the legislation, now made his voice heard. Sympathetic with the proposed changes, he postponed the groundbreaking scheduled for early March. Watt insisted that his approval would have to wait for the agreement of both the National Capital Planning Commission and the Fine Arts Commission to the changes.[115]

The NCPC swung quickly into action, approving the two new features in early March, urging that they be located "so as not to compromise or diminish the basic design of the memorial as previously approved."[116] Maya Lin supporters were infuriated. Benjamin Forgey of the *Washington Post* called the new proposal a "monumental absurdity," the result of congressional influence on a "headstrong" cabinet secretary. He found the NCPC action contradictory. "To transform those noble walls into a backdrop for a lonely statue is an absurdity that ought not to be countenanced. To do so would be the true shame."[117]

That left the Fine Arts Commission as the last line of resistance against the changes. It acted almost immediately to approve the additions but prepared a letter to Secretary Watt stating that this approval was dependent upon the location of the statue and flagpole. Where the NCPC asked only that the flag and statue not detract from the wall, Brown specified that they would best serve as an "entry point" to the memorial itself, along with a directory to help visitors locate individual names.[118] The Fine Arts Commission planned to meet again to evaluate the changes.

Some of those opposed to Lin's design raised immediate objections, insisting the location of the flag and sculpture be set. Watt too presented new objections. Senator John Warner, a Virginia Republican, hurriedly called a meeting of various veterans groups to see if the existing compromise would hold. Under Warner's prodding, it did. Watt finally issued a construction permit, and work began at once lest he decide to revoke it.[119] The official groundbreaking took place March 26, 1982.

But the controversy remained alive, and indeed grew more intense. Opponents remained anxious about just where the statue and flagpole would be sited, suspicious about the qualified approvals issued by the NCPC and the Fine Arts Commission, and ultimately unreconciled to the chosen design. Contributors to national magazines weighed in with their observations. And Maya Lin now voiced her own exasperated response, complaining that the competition she had won fair and square had been turned into a "farce." That she was still a student rather than a certified architect did little to restrain her anger. She refused to call the sculpture and flagpole "additions"; rather, they were "changes." She spoke with contempt about the sculptor who had been selected, Frederick Hart, and accused him of "drawing mustaches on other people's portraits." "How can anyone do that and call himself an artist?"[120] Hart, who had worked with Felix de Weldon, creator of the highly realistic Iwo Jima Memorial, had been an unsuccessful entrant in the larger competition.[121] This undoubtedly added to Lin's irritation.

And the single flag, Lin continued, was going to make the whole "look pretty much like a golf green." The V shape she had devised for the wall was meant "to point at the Washington Monument and the Lincoln Memorial. . . . They're much stronger visually than any flag could be." Lin was upset by the way she had been treated by Scruggs and the Veterans Memorial Fund, feeling she had been victimized by reason of her gender, ethnicity, and youth. "I can't see how you go through a democratic process to choose a national monument and how such a small group of people can get their way anyhow."[122]

Lin did have powerful sympathizers. Harry Weese, the architect who had served on the jury, blamed much of the trouble on Secretary Watt: "It's as if Michelangelo had the secretary of the interior climb onto the scaffold and muck around with his work."[123] The chair of the jury, Grady Clay, a landscape architect and magazine editor, agreed that the changes were inappropriate. "To stick stuff into the composition at this point is

a hell of an intrusion." And there were others who opposed intervention into what had been clearly defined and closely followed procedures.

For his part, Frederick Hart voiced his own resentments. He had never met Maya Lin and found her anger to be misdirected. She hadn't seen his sculpture. "It is not Maya Lin's memorial nor Frederick Hart's memorial," he said. "It's a memorial to, for and about the Vietnam veterans."[124] Hart's statue was approved initially by a four-person panel consisting entirely of Vietnam veterans, including James Webb. It was unveiled in September, just before the first stage of the memorial was dedicated.[125] The three larger-than-life infantry soldiers conformed to traditional expectations of war memorials and did little to narrow the gap between Lin's champions and her detractors.

In the weeks before the Veterans Day ceremony in 1982, the debate was inflamed further by the commentary of social critic, novelist, and journalist Tom Wolfe, in the *Washington Post*. A year earlier, Wolfe had published *From Bauhaus to Our House*, the second installment of an ongoing fight against artistic modernism that had begun with *The Painted Word*. Maya Lin's design fit neatly within Wolfe's cultural narrative. His *Post* piece, in mid-October, subtitled "How the Mullahs of Modernism Caused a Stir," demonstrated both his skill at narrative compression and his capacity to stir outrage. Terming the memorial a monument to Jane Fonda, a notorious critic of the Vietnam War, Wolfe argued that its selection was foreordained by the prejudices of the jury, a committee of experts whose "mental structure" featured modernist boxes and abstract art as aesthetic ideals. Separated by class, values, and taste from those who actually fought in the war, they sustained the long campaign of repudiating bourgeois standards that had been proceeding for many decades. Their empire had now expanded from museum walls and glass skyscrapers to the terrain of civic monuments. Citing recent disputes over federal sculpture projects—in Hartford, Connecticut, and lower Manhattan— Wolfe lambasted the missionary zeal of the "mullahs" who seemed intent on denying pleasure to a bewildered and increasingly sullen public. Flaunting polls he claimed demonstrated how out of touch these experts actually were with broader opinion, Wolfe castigated their reluctance to compromise, their insistence on "bringing the millennial message of the museums and the galleries out onto the highway and parkland of life." There would be no flags "or, God forbid soldiers." In one of his less suc-

cessful predictions, Wolfe prophesied that this memorial, "far from lifting the accusing finger from those who fought in Vietnam," will be "the big forefinger's final perverse prank."[126]

Culture wars had joined with political lobbying and military conflict to create what seemed like an unholy mess. Letters streamed in to the *Washington Post*, many attacking Wolfe and defending Maya Lin.[127] And on the very day Wolfe's piece appeared, the Fine Arts Commission met to evaluate Hart's sculpture proposal along with the flagpole. The commission heard a series of witnesses speaking for and against the sculpture. Lin herself appealed to the commission to reject the statue and leave the visitor free to reflect on the design's meaning. After the testimony, Brown took his colleagues to the site, where a Styrofoam model of the statue was placed. They then returned to their meeting room.[128] Their decision to endorse the new plan was described by Brown in a special column printed some days later by the *Washington Post*, sharing the commission's logic with a wider audience.

It was Brown whose prestige protected the fragile agreements and concessions that ultimately enabled the project to be realized. Friends reported that in private he expressed his aversion to making realistic statuary part of the memorial. But he swallowed his preferences in the face of public pressure and the need for closure. His statement, emphasizing the need for healing represented by the monument, opened with a declaration of faith in the Maya Lin design, calling it "extraordinarily moving" and appropriate to the "sacred soil, right next to our dearest and greatest patriotic memorials." Brown admitted that had the commission refused to allow any additions, "we would have been great heroes in certain quarters." "This was not an easy decision," he acknowledged. But it offered the opportunity to introduce some useful changes.

One was the flagpole, "a wonderful thing to add, however dangerous a precedent, given the proliferation of flags on the Mall." As for the sculpture maquette, it was "acceptable," it "strikes a chord of recognition in those who care most deeply about their experiences" in Vietnam. But, like the flagpole, its proposed location was problematic. If "the sculpture is allowed to shiver naked out there in the field, to be an episodic element that is not integrated, that somehow relates to a flagpole which is so far away," it would "not combine to have the critical mass these elements deserve." Mingling homely metaphors with a careful analysis of the site as

visitors might perceive it, Brown was able to offer a reasonable defense of the commission's action. And he had managed to obtain a unanimous vote.[129]

In the *New York Times* Brown indulged his musical passion, likening the plan to a concert. A great symphony, he declared, "is not interrupted by another piece, but a concert program would contain other music designed to enhance the main piece."[130] The analogy may have been part of an internal argument rather than a strategy for broader persuasion. Once on board with a difficult position, Brown invariably beautified it with similes or metaphors. Scruggs himself declared that Brown "had walked safely through the political and artistic mine field." He had managed to avoid "outraging Maya Lin and her allies in the arts community" by insisting on a changed location for the new elements, but he accepted their presence in the final plan.[131]

Days later Secretary Watt, reluctantly or not, gave formal permission for the dedication ceremony. And the following February, the Fine Arts Commission was able to designate specific spots for both the statue and the flagpole. The struggle was over, although peace would come only after the memorial's completion and its ratification by grieving veterans and other visitors. In June 1983, as the memorial's success grew more apparent, Robert W. Doubek, who had worked with Scruggs and chaired the Veterans Memorial Fund, wrote Brown, thanking him for a financial gift and declaring that the monument would never have been "realized without your personal belief in the rightness of the effort and your sensitivity to and masterful handling of the tremendous emotional issues which surrounded it." Brown's "courageous leadership" largely remained an untold story, Doubek concluded.[132]

In an oral history, dictated some ten years later, Brown recalled I. M. Pei's capacity "to compromise where necessary in great civic efforts, and to help proselytize and bring people round. He got that pyramid built."[133] He could as well have been describing his own efforts on the Fine Arts Commission. He was certainly, in political terms, a survivor. Thirty years as commission chair, gaining reappointments during intensely partisan periods, took considerable diplomatic skill. His mettle would be tested by other controversies, most particularly the World War II Memorial, but these would take place after Brown had left his National Gallery post. The 1980s brought with them other professional challenges that required Brown's management. In the wake of expensive recent achieve-

ments—both the East Building and the massive renovation of the West Building—it was necessary to turn attention back to what all museums permanently seek: gifts and the funds necessary to increase the collection. The passing of time now presented a remarkable opportunity, and National Gallery leadership was determined to make the most of it.

"Treasure Houses of Britain"

The Anatomy of an Exhibition

T he first half of the 1980s, with the new East Building and the remodeled West Building available for multiple special exhibitions and for showing off the permanent collections, was golden for Brown and the National Gallery. The young director had now passed into middle age. Drawing from universities, foundations, government, and the occasional raid on other museums, he reshaped his professional staff which, in several areas, needed refreshment. Thus in late 1980, D. Dodge Thompson moved to Washington from the Philadelphia Museum of Art. Like Brown, Thompson had trained for museum work by adding a Harvard MBA to graduate study in art history. As chief of exhibitions he would be responsible for coordinating the frenetic calendar.

There were further changes. In 1982 John Wilmerding, the curator of American art, succeeded Charles Parkhurst as deputy director. Wilmerding's curatorial replacement was Nicolai Cikovsky. The next year Sydney Freedberg, a prominent Harvard art historian, became chief curator. Jack Cowart arrived as a curator of twentieth-century art.[1] And all of this followed Henry Millon's arrival from MIT to become director of CASVA, the Center for Advanced Study in the Visual Arts, along with the first group of CASVA fellows. Creation of the Gallery's research institute fueled local faith that the capital had emerged as a cultural destination worthy of its political status.[2]

The growth and nurture of the Gallery's Department of Installation and Design underwrote one of the most expansive programs of temporary exhibitions anywhere in the United States. In the early 1980s ten to

twenty special exhibitions, lasting from just a month to ten or eleven months, appeared annually, many of them designed by the team of Gaillard (Gill) Ravenel and Mark Leithauser. Some were modest in size, occupying no more than two or three thousand square feet, and might be visited, over two or three months, by thirty or forty thousand people. Placed in the graphics galleries of the West Building, or in one of the East Building's pods, these shows featured recent gifts, the holdings of foreign museums, or private collections. Scholarly and intimate in scale, they demonstrated a continued commitment to closely focused exhibitions. In the past two years, Brown told an interviewer in 1981, the Gallery had presented thirty-four exhibitions, twenty-nine of which were small and "highly focused."[3]

But running alongside these were larger, more elaborate installations, as many as three or four annually, that attracted hundreds of thousands of visitors, cost millions of dollars to produce, and advanced the Gallery's national and international reputation. The huge novelties of the 1970s—*Archaeological Finds of the People's Republic of China*, *Treasures of Tutankhamun*, *Splendor of Dresden*, *Art of the Pacific Islands*—were followed by still more ambitious shows. Four exhibitions opening at the Gallery in 1980 attracted more than three hundred thousand visitors apiece. One of them, *Post-Impressionism*, a hastily arranged replacement from London's Royal Academy for a canceled Hermitage show, recorded more than half a million in the hundred days it was up.

That year was not atypical. During the next five years, eighteen special exhibitions (out of a total of eighty-one) drew more than two hundred thousand viewers each. Half a million viewed *El Greco of Toledo*, while *Rodin Rediscovered* more than doubled that. To be sure, the Gallery's insistence that its shared exhibitions open in Washington obscured the fact that many of the crowd-pleasers were organized by other museums. Meting out credit to other institutions was not a Gallery attribute.[4]

Tempering the considerable costs were a series of large subsidies from major corporations, whose cultivation Brown had made into something of a specialty.[5] The potent political harvests possible in Washington, the social opportunities, and the huge audiences appealed to a broad range of corporations—GTE, IBM, Mobil, Republic National Bank of New York, Philip Morris, and Occidental Petroleum, among many others. Recruiting corporate philanthropists required extensive research, trained staff, and timely, personal interventions. A born salesman, Brown developed excel-

lent rapport with business representatives on the lookout for attractive shows to back. Some public relations firms, like Ruder Finn, were now specialist brokers for these transactions, bringing museum officials and businessmen together on projects of mutual interest. Brown exploited such opportunities, but relied heavily on his own networks, along with staff intelligence, to tap into these potentially lucrative sources.

Identifying a new corporate patron was only the first step in what might amount to a multiyear relationship. Corporations could return again and again to support exhibitions, if they found the results satisfying. Complex rules limiting corporate promotional strategies evolved as museums sought to protect themselves from aggressive commercial exploitation and corporations tried to extract as much publicity and goodwill as they could from the associations. The history of these relationships went back to the earliest days of the National Gallery in the 1940s, to wartime shows sponsored by *Life* magazine and Abbott Laboratories. And there had been other sponsorships by individuals, foundations, and government agencies throughout the 1950s and 1960s.

But massive intervention by business corporations really awaited the 1970s and 1980s and their new levels of cultural philanthropy. Brown's attempts to multiply business partnerships were enabled in part by his own MBA. He could point to it as evidence of his sympathy with management objectives and his familiarity with ledger economics. Cost-benefit analyses were not incompatible with powerful commitments to the arts, Brown could assert with deep conviction. His charm, along with the undeniable advantages of Gallery affiliation, helped bridge the gap between culture and commerce, and he succeeded in enlisting some enthusiastic converts. Alfred C. Viebranz, senior vice president of corporate communications at GTE in the early 1980s, retired from his position to come to Washington and serve as one of Brown's assistants for five years, from 1982 to 1987. Viebranz, who also helped initiate the Gallery's oral history program, offered advice on many matters, especially the delicate task of persuading hardheaded corporate leaders to transfer substantial sums of money from company coffers to an art museum.

The frantic pace posed challenges to exhibition planners at many museums, but the National Gallery group, headed by Ravenel, Leithauser, and Thompson, reveled in the pressure. "We have worked out so many loan agreements that we can, in a matter of minutes, negotiate the main logistical, administrative, and legal parameters of exhibitions," Thomp-

son told an interviewer years later, in 2001. "We have worked together so many times that we have almost come to know how our colleagues think."[6] The installation designers formed the hub of program planning for the Gallery; Brown privileged their role and advice, as a stream of elaborate shows coursed through both the East and the West Buildings. Some critics would argue that he acceded too much to their preferences, allowing Ravenel an extraordinary level of power. He was, in effect, the director's alter ego.

Much rested on Brown's enveloping connections—local, national, and international. While honorary degrees, medals, decorations, and institutional affiliations testified to his omnipresence, his most effective extramural work took place in Washington. He exploited social opportunities ruthlessly, making each contact count. "Now I simply mustn't monopolize any more of your valuable time," was apparently a favored brush-off line.[7] Embassy parties, filled with foreign diplomats, were especially rich occasions for connecting and reinforcing alliances. Those years of bachelorhood and the interval between his two marriages made Brown a particularly attractive guest, although sometimes he needed a last-minute escort.[8] Reliable, multilingual gallery associates were then prepared to accompany him. By most accounts, he was all business at these events. "Oh Carter Brown. I've been snubbed by him regularly at parties," reported a Harvard classmate in the early 1970s. "The control, the discipline, above all the good breeding allow him to function acceptably with people," wrote one critical journalist in an extensive profile for the *Washingtonian*, "but he is widely viewed as a man whose graces are accompanied by a certain sterile sense of Puritan obligation."[9]

His true feelings about being a darling of the gossip columns and a regular on the embassy party circuit Brown never disclosed. Friends claimed that the small talk must have exasperated and bored him, but if he was irritated by Washington socializing, he soldiered on without complaint. Much of it he clearly enjoyed, including the food, drink (Brown was more than a casual wine connoisseur), and glitter. And the very superficiality of so many of these encounters may have held its own appeal, requiring so little personal long-term investment.

Each great exhibition of this era had its own special narrative and resulted from a distinctive combination of ideas, opportunities, and personal contacts. Planning could take as long as sixteen years or as little as six months. But during the 1980s, one project was so extravagant, popu-

lar, expensive, and memorable that it merits special attention. Its subject, as well as its operational planning, reflected Brown's special interests and would have been impossible without the social bonds that underwrote his professional career. *The Treasure Houses of Britain: Five Hundred Years of Private Patronage and Art Collecting*, which opened at the National Gallery on November 1, 1985, and ran for 153 days, had a history almost as complex as its installation. Nurtured by Brown's romantic imagination and cherished memories, left for dead by several prominent experts in the course of its gestation, it survived to epitomize both the triumphs and the costs of Brown's larger approach to museum operations.

The story began in the late 1970s. A young cultural attaché at the British embassy in Washington, Lyon Roussel, was impressed by public interest in *Treasures of Tutankhamun* and *The Splendor of Dresden*. He approached Brown about doing something big with a British theme. Having recently visited Chatsworth, the country seat of the dukes of Devonshire, and recalling fondly his year of school, thirty years earlier, at Stowe, in Buckinghamshire, Brown responded sympathetically. Back in Britain, Roussel, now controller of the arts division of the British Council, pushed further. Visiting Washington in the summer of 1980, Julian Andrews, director of the British Council's fine arts department, proposed to Brown a country house show.[10]

The British Council's participation was fundamental. Created and subsidized by the Foreign Office to present British art, literature, science, and technology to the rest of the world, it sported a royal charter. Working through embassies and diplomatic offices, it operated institutes and schools, distributing library materials, lecturers, musical performers, and art exhibitions, as well as teachers. Partly an instrument of propaganda, partly a source of foreign intelligence, and partly a humanitarian educational instrument, the British Council survived war and retrenchment to attain new levels of vigor in the 1980s. An American celebration of British culture was immensely appealing. Unlike the Middle East, Eastern Europe, or Southeast Asia, traditional sites of activity, there would be few diplomatic challenges. And American public opinion would not require extensive cultivation.

But the tourist market was something else. Almost a thousand country houses across the British Isles were open to visitors, a major asset in the rising international competition for American tourist dollars. The National Trust and the Historic Houses Association had much at stake

in a successful exhibition. Founded in 1895, the National Trust held hundreds of buildings and gardens, thousands of acres, and miles of coastline in perpetuity for the people of Britain. Supported by public subscription and charitable contributions, it was independent of government. The Historic Houses Association, headed by George Howard, represented the private owners of historic properties, lobbying for economic, political, and legal benefits and offering technical advice to their membership. The British Council, the National Trust, and the Historic Houses Association thus had parallel but distinctive aims.

Keeping this alliance intact during the five years leading up to the exhibition was a major challenge. But despite several near derailments, Brown managed to do so. In December 1980 Brown, along with Ravenel, met in London with key partners to begin the planning. They included Julian Andrews of the British Council, Angus Sterling of the National Trust, and Lyon Roussel. Here Brown advanced his personal vision for the enterprise, a tribute to the country house as a "vessel of civilization," a container for the promotion of ideas, political and literary. The exhibition would be "a creative activity, rather like writing a novel." This, as opposed to the literal reproduction of a specific house or houses, would allow the organizers "flexibility." The National Gallery could be filled with objects of "the highest quality" culled from hundreds of houses, offering visitors an "impression of the successive owners—and their servants." Brown imagined a time line from the late sixteenth century to the 1930s, with the center of gravity in the eighteenth century.[11]

National Trust officials pointed out that their properties could not be the sole lenders, emphasizing the need to involve the Historic Houses Association. Experts would be canvassed to help select objects and prepare essays for the catalog. Symposia, lectures, and other events were discussed. Brown himself raised the possibility of an accompanying television series. Above all, a coordinator for the exhibition had to be appointed, to supervise this ambitious undertaking. The name of John Harris, scheduled to give the National Gallery's Mellon Lectures for 1981, aroused considerable enthusiasm, and Brown promised to talk this over with him in the near future.

John Harris was a largely self-taught architectural historian who had joined the Royal Institute of British Architects Library. In 1960 he became curator of its drawings collection (a position he still held in 1980), and over the next few decades, he organized dozens of exhibitions and

cocurated the memorable *Destruction of the Country House* at the Victoria and Albert Museum in 1974. A committed preservationist, an experienced curator, a specialist on country houses, a well-published author, Harris seemed a natural choice. Prying loose treasures from several hundred house owners, securing indemnification from two governments, arranging for packing and transport—these were daunting tasks for anyone, but Harris possessed strong credentials.

By December 1980, Brown was cultivating his many contacts within the British peerage. Describing plans to his friends the "Devonshires," he transmitted to the duke and duchess his hope of representing British culture and his goal of fielding "an all-star team" of managers. He was counting on the Devonshires for help, as well as his friend "Robin," the Marquess of Tavistock, heir to the Duke of Bedford's great estate, Woburn Abbey, which he was then managing. Chatsworth, home of the Devonshires, and Woburn Abbey were among the most publicized of the great establishments.[12]

Both Tavistock and the Devonshires responded warmly, pledging cooperation. They also promised to intercede with George Howard, just becoming chairman of the British Broadcasting Corporation after years spent restoring one of the greatest English houses, Castle Howard. There was a further card to play in the person of John Walker, the former Gallery director, who had his own personal and family ties with the British peerage. Walker had been retired from his directorship for eleven years by then, but he kept in touch. He nervously warned Brown about possible competition, the first of a string of complications that would surface in the next few years. In this case it was a plan by John Foster, aided by his "girlfriend," Mrs. Gilbey (of the gin-making Gilbeys, Walker explained), to exhibit treasures from English country houses, supported by the financial backing of Armand Hammer. "I shall do what I can to discourage the idea, but I thought you should know." Walker, eager to be of help, sounded almost plaintive about his failure to be more useful. "I am very sad not to have been of service to the Gallery," he wrote Brown.[13]

Brown, meanwhile, was refining the ideas advanced in previous months and adding some details. The exhibition, he wrote Roussel, would occupy the highly flexible galleries of the new East Building. It would be scheduled for winter, when the houses themselves were not open to the public. He foresaw a stay of four to five months, November through March or early April, and anticipated large crowds. Recent publications, like Mark

Girouard's *Life in the English Country House*, demonstrated public fascination with the subject. Brown reemphasized his aversion to re-creating specific houses, preferring a composite approach that organized objects by medium. A catalog could list the special holdings of each house. Done in this way, the exhibition would "contribute something new and unique rather than being a series of pale reflections of unreproducible experiences better had at first hand."[14] It was clear that Brown, still wavering among various models, preferred to avoid literal imitation in favor of evocation. He acknowledged the need for a generous corporate donor and promised that a search would soon begin. However, he told Roussel, British indemnification and concessions by British carriers would be important to hold costs down to some manageable level.

Good news and bad lay on the immediate horizon. George Howard of the Historic Houses Association deemed the proposal a "splendid idea," but warned that the British Tourist Authority, yet another organization charged with promoting the country's cultural attractions, was tentatively planning a similar exhibition, meant to open in 1983, two years before the National Gallery's effort. "It would be a great pity if the planning for these two exhibitions went forward in isolation," Howard observed.[15] The British Tourist Authority, meanwhile, got in touch with the Gallery. A delegation headed by Lord Edward Montagu of Beaulieu was making a study mission to American museums, and Montagu requested a meeting with Brown. Putting a positive face on the matter, Brown wrote back to Howard that the 1985 date had been chosen to comply with British Council wishes, but that the BTA's interest was welcome and the efforts should certainly be combined.[16]

Charles Parkhurst, Brown, Montagu, and Lewis Roberts of the BTA did meet in late March 1981, in Washington. Montagu outlined his approach, conceived originally in connection with the 1976 American bicentennial. It was much less ambitious, physically and intellectually, than the National Gallery scheme. Confronting Brown's notion of an imaginary country house with an invented history, filled with objects ranging from paintings to agricultural tools, Montagu abandoned his own plan. All agreed that a committee of specialists must be appointed, capable of resisting pressure from lenders to have their pet possessions included in the show. Both Montagu and Roberts argued that "English Country Houses," the working title, was far too restrictive, and even politically unpalatable. "British Country Houses" made far more sense. Brown im-

mediately concurred, noting that this would make possible loans from National Trust properties in Wales.[17]

The Washington conversation went on to consider Montagu's proposal of an honorary committee of notables, a device often used in Britain to add prestige and clout. Names like the Prince of Wales, Lord Clark, Evangeline Bruce, Walter Annenberg, and Gordon Getty came up, with Montagu hoping for a visit by the Prince and future Princess of Wales. This last seemed highly doubtful, but the growing celebrity of Diana (who had not yet visited the United States, beyond an airport stopover) made it a significant goal. The royal wedding was scheduled for the summer of 1981. Brown warned about the dangers of commercial overkill, but leaflets, postcards, maps, posters, and other "flat materials" were all possible. The next step was convening a lunch in London, in June. Meanwhile, Brown and Harris would continue their negotiations when Harris was in Washington for his Gallery lectures.

News that the BTA and National Gallery proposals had been combined was greeted with relief in Britain.[18] The hunt for money could begin. In a letter to Julian Andrews, Brown declared the climate favorable for private sector involvement, noting, however, that some potential patrons were already tied down. IBM was sponsoring *Rodin Rediscovered*, a very expensive show at the Gallery, and could not be approached immediately. American Express, proposed by Lord Montagu, was funding the El Greco exhibition, a show organized by the Toledo Museum of Art and slated for the Gallery in 1982. A television series would help, Brown continued, but the timing was crucial. It should not trail the exhibition, as had happened with *The Search for Alexander*, and the logical producer would be the BBC. (Indeed, Brown met with George Howard, now heading the BBC, at the British embassy in Washington.) With annual attendance at the Gallery reaching six million, there were grounds for confidence that a corporate angel could be found.[19]

The June 11 London luncheon was presided over by George Howard.[20] Present, along with Brown, were Gervase Jackson-Stops of the National Trust, Julian Andrews and Lyon Roussel of the British Council, Lord Montagu, and other interested parties. Brown emphasized the need for one focus and one coordinator—the author, in essence, of the historical novel that the exhibition would embody. He proposed John Harris. The Royal Institute of British Architects had agreed to give him time off to accept the assignment. There was universal assent. Jackson-Stops became

the National Trust representative on the committee formed to assist Harris. In addition to the Organising Committee, a Committee of Honour would be created (both maintaining British orthography). While the National Gallery agreed to raise the necessary funding, the British Council would serve as liaison between the coordinating team and the British government; a government indemnity would be essential to avoid enormously high insurance costs. The British Council would also supervise all packing and transport to and from Washington. All agreed that objects would be drawn from actual houses rather than museums, whenever possible. With the basic organization created, the group adjourned.

The second half of 1981 brought specification. As the exhibition coordinator, Harris outlined at length his dramatic vision.[21] Like Brown, he wanted to present the country house as something more than an accumulation of objects; it was a container for a way of life. He proposed specific sections: an Elizabethan wing, a Robert Adam dining room, a Victorian conservatory. As many as eleven different rooms, including a nursery, servants' hall, and library, would be displayed, with some actual rooms installed whole. Harris's script climaxed in the twentieth century with family members going to war, sons killed in battle, the house put up for rent or sale in the 1920s, barely surviving the 1930s, then saved by war uses when about to be sold or demolished. Reopened by a courageous owner, and nurtured by the National Trust and the Historic Houses Association, the house would become, in essence, the hero of a morality tale—an anticipation, in some respects, of the fictional Downton Abbey's recent popular narrative.

But, Harris went on, a story line was not sufficient. The show would require stunning works of art, including some from the queen. Country house influence in politics and elections also seemed worthy of inclusion. The larger rooms, he thought, might come from American sources, probably museums, with English imports limited largely to art.

Brown, meanwhile, continued to work on funding. A July 7 memo reviewed possibilities. The Heinz Foundation seemed promising. John Heinz, the Pennsylvania senator, was a close friend and had helped fund the Royal Institute of British Architects. His wife, Teresa, sat on the board of the Royal Oak Foundation, the American fund-raising arm of the British National Trust, and was a trustee of the Metropolitan Museum of Art. There was also S. C. Johnson & Son, better known as Johnson Wax. John J. Louis Jr., the great-grandson of the company's founder, currently

served as United States ambassador in London. It seemed a natural connection.[22]

Then, Brown mused, there was British Petroleum. And, despite his concern that they might be tapped out for several years, there was still IBM. Brown, Harris, Al Viebranz, and Carol Fox, a Brown assistant, did indeed meet with IBM's director of special programs about a sponsorship in the summer of 1982. Fox called the country house collections "the greatest museum in the world" and requested a gift of two million dollars, paid in installments over four years. This would be the Gallery's largest undertaking, and it might be possible to consider a cosponsorship.[23] IBM replied that the show seemed splendid but the fit wasn't right. It preferred being a sole corporate sponsor, and for an exhibition with only one venue the cost was too high.[24] The search would continue.

By the fall of 1981, news of the coming exhibition had spread widely. "All of London is buzzing with your proposed exhibition of treasures from English country houses," Philippe de Montebello wrote from the Metropolitan. "If they don't want money up front or gigantic royalties to repair roofs, resod lawns or pay taxes, and the exhibition can be shown twice," he told Brown, "I'd be interested in knowing a bit more about it."[25] Brown wrote back that the British preferred a single site, although he admitted that Los Angeles "had made an impassioned plea." As a consolation, "we have the prospect of perhaps sharing the English church objects show."[26]

John Harris was now working out his schematic procedures, using military titles to express his sense of organization. Sending memos to Brown, Harris playfully used World War II analogies, declaring himself "supremo," responsible to Brown as "overlord." He proposed a series of consultations, about the gallery spaces, construction of a fictional family tree, and the sequence of any tour, and reported that he would monitor country house collections to discover the finest works of art. All proposals would be "cleared with his overlord," but, "to use an expression made by Sir William Chambers to Chippendale when selecting furniture for Lord Melbourne's house: 'really, I have an eye for these things.'"[27] In March 1982, Harris wrote Brown that after further conversations with Jackson-Stops, the youthful adviser to the National Trust, he had decided to invite him to share his responsibilities for organizing the exhibition. Apparently, there would now be two "supremos." There was less happy news on the American front.[28] Following up on Harris's request, Dodge

Thompson had spoken with curators at more than half a dozen American museums—including the Metropolitan, the Cooper-Hewitt, the Detroit Institute of Arts, Boston's Museum of Fine Arts, and the Philadelphia Museum of Art—trying to identify period rooms and other architectural elements in their holdings. The results were disappointing.[29] Harris had counted on getting these interiors and urged the Gallery to canvass motion picture studios for rooms in storage.

Meanwhile, Harris was considering various exhibition titles ("Britannia Triumphs: Great Art Treasures from Ancestral Homes" was an early proposal) and working on a promotional brochure. His brochure summary was initially long on adjectives—"magnificent," "dazzling," the "greatest accumulation of art treasures in the world," the "greatest show on earth."[30] Weeks later, the summary (as presented to the Historic Houses Association) had grown more restrained but still promised a "gigantic" exhibition, a "feast of delight." The title was now "Britannia Magnificans: Great Art Treasures from Britain's Historic Houses."[31]

Encouraging his coordinator, Brown replied that he liked "Britannia Magnificans" but would change the subtitle to "The British Country House and Its Treasures." He wanted people to realize this was an objects show, without entirely losing the idea of the country house as an ensemble. Nonetheless, he confided to Harris, there was ambiguity to the words "country house" in America, and it might be necessary to put the phrase in quotation marks.[32]

In England, the British Council worried that high insurance risks would make packing and transporting the exhibition difficult. Council members were also concerned about conservation problems. Brown, Ravenel, Harris, and George Howard met again with British colleagues at the end of March 1982, addressing a series of details. Brown expanded on his point that Americans saw "country houses" simply as weekend retreats; it would be vital for the show's title to convey the wealth and grandeur of the British establishments.[33] Two years later, he was still hammering on this notion. "In the United States, with some suburban exceptions," Brown wrote, "farm land is generally populated with only rather rudimentary houses, and the civilized values that the British country house represents in terms of art patronage and collecting are totally urban in the American mind."[34]

At the March 1982 meeting, Harris presented a rough timetable. The exhibition was to open in October 1985. For that to happen, organizers

would need a list of proposed loans for the government's export commit-
tee in little more than a year, and agreement on all loans by January 1984.
Roy Strong, director of the Victoria and Albert Museum, now working
with the organizers, proposed that all of the works borrowed should for-
mally be lent to his museum, which would then assume the responsibility
of applying for export licenses. There were additional financial and pro-
grammatic matters. A special indemnity might be proposed to the Brit-
ish treasury for the country house show. Brown, urging bilateral govern-
ment cooperation, explained that the American indemnity ceiling was
four hundred million dollars. Poetry readings at the Folger Library, the
potential for touring satellite exhibitions, a symposium on English gar-
dens at Dumbarton Oaks, lectures on literature and the country house,
events at the Library of Congress, film projects, and visits from the Royal
Shakespeare Company—these and a variety of other supplemental pro-
grams also consumed the group's attention.[35]

Later that spring, there were tensions between the National Trust and
the Historic Houses Association that concerned Julian Andrews, but they
seemed to be under control. In July, John Harris arrived in Washington,
and planning meetings followed. One, on July 13, considered the size and
location of the show. The scale would be massive. Estimates ran to eight
hundred objects occupying thirty thousand square feet. The superior
flexibility, lighting, and climate controls of the East Building suggested
it as the appropriate choice. Harris went over his preliminary design and
argued for three supplementary exhibitions. This might mean as many as
four catalogs. Senior staff would tour the houses a year later, in June and
July of 1983, and negotiate the loans. The working title was now "The
British Country House and Its Treasures," and in keeping with Brown's
notions, every effort would be made to get television series, from both
the BBC and its commercial competitor ITV.[36]

On July 19 the Gallery sponsored a luncheon for Harris and a group
of Washington movers and shakers, including George Stevens of the
Kennedy Center and O. B. Hardison, director of the Folger Library.[37] In
August the *Daily Telegraph* in London ran an exuberant if somewhat mud-
dled story that Carter Brown would be erecting a stately home on a site
next to the National Gallery in Washington, to hold a special exhibition
on country houses beginning in October 1984. Dates and construction
details were all wrong, of course, but the story indicated that journalistic
coverage was starting to simmer, several years in advance.[38]

And then, with the complex pieces of this effort apparently moving forward, more or less in harmony, the bottom suddenly fell out. In a letter of September 6, 1982, John Harris wrote Brown with "Disastrous news . . . I am compelled to withdraw from the country house exhibition." His employer, the Royal Institute of British Architects, had been willing to tolerate his absence on the assumption that staff changes would be made after the exhibition had closed, in September 1986. These changes, however, had been brought forward to 1983, and he would not be available after that date. "There is no compromise possible," Harris concluded.[39]

The loss of the show's coordinator was bad enough. Shortly thereafter, Harris sent an even gloomier note to Brown. Certainly it was possible to think about appointing a replacement, "but I'm skeptical" that any new coordinator would work out. Now that he had withdrawn, Harris asserted, he could be more objective about the exhibition's prospects, and his view was not a promising one. Although three years remained before the opening, they were not enough. Only eleven months were left to negotiate as many as eight hundred loans, half of which might present problems. There was just no precedent for asking hundreds of private owners for loans of art.

Packing and collecting were a further challenge. Objects would have to arrive in Washington by mid-October, but at least half could not be picked up from their owners before early August, with each piece requiring an individual condition report. With 150 houses participating, this was "mind-boggling." "Unless owners are willing to release their finest treasures in mid-season," Harris wrote, "I don't see how we can overcome this problem." Worse, opposition was growing to lending some of the great pieces of furniture, because of conservation isssues. Gill Ravenel was coming to London in another week, Harris noted, and he expected they would talk further.[40]

At this crucial point, Brown was buoyed by a letter from Jackson-Stops, who had been told by Harris of his decision. Granted, it was disappointing to lose Harris, he wrote, but he did not "share John's pessimism about the exhibition." While not every object would be available, there were wonderful second and third choices. The National Trust would do everything it could to make the show a success. More than that, the challenge of collecting loans could be met by employing several firms of packers and assigning them to work in different regions.[41]

Impressed by Jackson-Stops's optimism, energy, and connections,

and after considering other possibilities, Brown, by the end of November, reached a conclusion. Jackson-Stops would become the sole curator. In retrospect, this was the most critical decision Brown made about the show. It would otherwise have died at this point.

Born in 1947, sixteen years younger than John Harris, Jackson-Stops had enjoyed a privileged education at Harrow and Christ Church, Oxford. Since then he had seemed in continual motion. In his midthirties, with dozens of *Country Life* articles to his credit, he had for some ten years been editor of the National Trust's guidebook series, as well as the author of guides to dozens of houses. He wrote easily, clearly, and with precision. He knew many house owners and, indeed, lived in an extraordinary place himself, the Menagerie, which he had restored and in which he gave celebrated parties. Most of all, he was zealous about the project, while insistent upon setting out the ground rules. Brown's invitation to curate was "very daunting, and I cannot at this stage commit myself without talking to you in much more detail," he wrote in a December 1 letter. But he would come to Washington in two weeks, excited by the chance to do some "real social history" rather than simply gathering "an amorphous collection of treasures." Whether he would in fact create a real social history, he certainly proved capable of assembling a collection of treasures.[42]

Jackson-Stops followed up with a second letter, ten days later, setting out his needs for salary and assistants in clear fashion. He was prepared to work weekends and holidays, and to give up, for the moment, all of his other writing. But he was certain about success. "I am absolutely confident that putting on an exhibition of this sort is within my capabilities, and indeed I think, with my knowledge of the English country house and key contacts with owners, I could do it better than anyone else."[43]

Brown was immediately won over by Jackson-Stops's charm and energy. "We have found the right person," he wrote George Howard. The "chemistry seems excellent between Gervase and the people here."[44] The choice was made just in time. The English organizers had grown anxious. Oliver Millar, the queen's picture surveyor, wrote Brown in late November that the "Country House Exhibition seems to be dying a natural death."[45] Edward Montagu, a week later, depressed by Harris's departure and Howard's leaving the presidency of the Historic Houses Association, proposed that Christie's be asked to collate all of the objects being requested.[46]

Brown was quick to reassure his colleagues abroad. While the exhibition "was suffering an interregnum," he told Millar, with Gervase Jackson-Stops "we are back on track."[47] He wrote Lord Montagu that "we are now well back on our way," and that a London meeting was being planned for March 1983. Funding remained the big problem. With the United States in the midst of a recession, the "corporate climate" had changed.[48] While Brown didn't mention it to Montagu, he had just been turned down by Mobil, the sponsor of *The Search For Alexander*. Herb Schmertz of Mobil, after giving it some thought, found the level of support too high.[49] Locating the right sponsor and negotiating terms took patience, fortitude, and flexibility. Brown usually had these available, but he needed a more effective presentation book, and with the help of Al Viebranz, that would be ready by February 1983.

The cast of characters continued to change in Britain, but the newcomers were familiar. The Marquess of Tavistock had become treasurer of the Historic Houses Association. Ties were retained to those who had dropped out, like John Harris. Thanking him for his continued support, Brown also credited Harris for promoting Jackson-Stops and explained how a new working title—"The Treasure Houses of Britain: Five Hundred Years of Private Patronage and Art Collecting"—reflected the emphasis upon great works of art rather than re-creation of an entire stately home.[50]

Always absorbed by the latest technology, Brown began a lengthy and detailed correspondence with another old friend, Edwin Land, the inventor-businessman of Polaroid fame, whom he addressed as "Din."[51] The subject was creating photographic images to be placed throughout the exhibition. Brown wanted a "montage of still images, either backlit or using reflected light," that would not require a full 360-degree experience, like IMAX, but still possessed a three-dimensional impact. He investigated display techniques being employed at Disney's newly created EPCOT Center in Florida, and planned for the New Orleans world's fair, scheduled to open in May 1984. Land steered Brown to Wendell Mordy, president of the Science Museum of Minnesota, in St. Paul, which had an Omnimax theater. And there were discussions with with James Pipkin, a Washington attorney who was also an amateur photographer. Jackson-Stops spent time with Pipkin reviewing (and admiring) his photographs.

As the summer of 1983 proceeded, Brown and Jackson-Stops remained

in regular communication; Jackson-Stops prepared itineraries for Ravenel and Leithauser of houses to be visited so the installation department could evoke them in their actual designs. Reports indicated the Prince and Princess of Wales would not act as patrons because they did not anticipate seeing the exhibition. In a telephone memo sent from England, Brown wondered if a personal invitation from the Reagans might make a difference; he was prepared to push for it.[52] But the most pressing concern remained sponsorship. During the next six months, many companies entered into the discussion. Budget estimates reached $2.7 million by the fall of 1983, including $1.5 million for construction and installation. The installation staff made at least three more trips to England in 1983, seeing eighteen houses on one of them and twenty-six on another.

Efforts to capture the Prince of Wales continued. Paul Mellon sent him a formal request November 1, 1983, saying that even without a personal visit, his involvement would help the enterprise enormously.[53] Six weeks later the prince and princess declared their willingness to be patrons of the *Treasure Houses of Britain*.[54] Other help soon appeared. Sotheby's declared it would mount an exhibition of treasures from British country houses for a month in the winter of 1983–1984, in aid of the Historic Houses Association.[55]

As 1984 opened, loan requests and installation plans were moving ahead smartly. But there still was no corporate sponsor. In January Philip Morris, and in April American Express, active funders at other times, declared they had to pass.[56] Finally, in May, a great success: the Ford Motor Company agreed to become the sponsor, its first such appearance at the National Gallery. Brown's staff worked with Walter Hayes, a former newspaper editor who had been Ford's director of public affairs. But the size of the grant, one and a half million dollars to be paid in two installments, made this something to be handled at the highest level, and that was through Ford's president and board chair, Philip Caldwell.[57]

With funding assured, it was time to turn on the charm and obtain the prizes. In a letter to the Dowager Marchioness of Cholmondeley at Houghton Hall, Brown asked for her Holbein, a Hogarth, an early Gainsborough, two chairs by the cabinetmaker William Kent, and finally, a Sargent portrait painted of herself more than sixty years earlier. "I fell in love with it on sight," Brown wrote her, recalling a recent visit, "and because of the interconnection between America and Britain" it "could be the linch-

pin of our final room. To begin and end our show with Houghton, from Holbein to Sargent, would provide us with the alpha and omega of British country house collecting. Since I think of you as the most artistically sensitive of all the British Country House owners," he went on, "it would mean so much to us all to have your great treasures representing Britain, and above all, you, for those few short months."[58] Lady Cholmondeley responded graciously. Brown got everything he requested, except for the Holbein.

Jackson-Stops, meanwhile, was making some progress with the "shy and difficult" Duke of Rutland. His millefleur tapestry, which organizers hoped to have as the show's opening display piece, needed conservation, and the duke insisted on it before lending. While Brown refused to offer free conservation, he thought something might be done. This proved insufficient. The duke would lend to the exhibition, but not the tapestry.[59]

As an exhibition, *Treasure Houses* enjoyed its own public relations firm, Rogers & Cowan in Washington (it also had a London office), matchmakers who brought museums and corporate sponsors together. Mabel (Muffie) Brandon, a longtime friend of Brown, with whom he had been romantically involved years before, was president of the firm, assisted by Elizabeth Perry, who would later join the Gallery's staff. Brandon's preparation included service as Nancy Reagan's social secretary. As one of its functions, Rogers & Cowan advised Ford on the exhibition's promotional possibilities—special dealer visits, giveaway leaflets, and a gala opening dinner. The firm also proposed that Ford consider sponsoring a film festival, lectures, and symposia, and running monthly articles in *Ford Times* and *Fairlane Magazine*.[60]

There was also the matter of congressional funding. In an ordinary year, Congress assigned money for special exhibitions as part of the Gallery's annual appropriation.[61] It was expected to cover half of their cost, the remainder to be raised from private sources. In June 1984, Brown requested a one-time, nonrecurring additional appropriation of $1.5 million from Congress, declaring that the exhibition program would cost five million in the fiscal year to come rather than the three million that had been the average over the previous decade. By the end of August, with costs rising, Brown sought, in a letter to the committee chairs, Congressman Sidney Yates and Senator James McClure of Idaho, two million

dollars for the *Treasure Houses* show, though he argued he was only seeking a net increase of seven hundred thousand dollars; the remainder was simply reallocating existing recommendations.[62]

In the course of making his request, Brown examined the comparative costs of temporary shows. *Treasure Houses*, with 680 works of art and 182 separate lenders, was now scheduled to cost some $4 million, or $100 a square foot. *The Splendor of Dresden*, half a dozen years earlier, contained 603 works of art in eighteen thousand square feet; it cost $2.8 million, or $156 a square foot. So although *Treasure Houses* was more expensive, it was larger and more economical. Never one to avoid illuminating the Metropolitan Museum's defects, Brown added that *Vatican Treasures*, shown there in 1983, had 168 artworks from a single lender and cost some $8 million, or $381 a square foot. The government was getting a bargain!

By the time the application for funds was submitted, however, Brown was temporarily out of action. In Yorkshire, in July 1984, he was on his way to Castle Howard with his wife. Notorious among his friends for his unconventional—read, distracted—driving habits, Brown launched his automobile onto a major highway but momentarily forgot English lane rules. The resulting crash injured both Carter and Pamela Brown, but Carter's injuries were the more serious: he broke his pelvis, his hip, and a number of ribs. Immediately after the accident, the Browns were taken in by the Duke of Sutherland (another lender), and for months thereafter Carter had to rely on a wheelchair and, later, a scooter to get around.

The setback, however, did not prevent Brown and Jackson-Stops from actively pursuing further pieces. There were disappointments. A furious Reresby Sitwell wrote to Jackson-Stops saying they could not have the John Stuart Copley painting *The Sitwell Children*, and he aimed his refusal directly at Brown. "Had he not started taking photographs without my permission, I might have relented, but I must say I was astounded that a gentleman of his obvious breeding and good manners should do such a thing!"[63] Jackson-Stops dismissed the note as a flimsy excuse while Brown laughed it off, saying he must have forgotten to ask. "Since the picture bears his family name, and he is in the business of renting his home out, a loan would do more for him than for us. Not worth the hassle," he concluded.[64]

Other things were very much worth the hassle. Upset at being turned down for an El Greco in Scotland, Brown sent a memo expressing his distress. "We should try to pull out all the stops. Americans love El

Greco," he wrote. If the picture was "cupping," conservation treatment could be offered, he continued, but "I suspect it is the general Scottish unwillingness to lend." On the other hand, perhaps some "quiet investigating" into who the trustees were "and what kind of pressure might be productive" lay on the horizon.[65] It was not to be. El Greco's *Lady in a Fur Wrap* would remain at Pollok House in Glasgow, because lending it, said the house's keeper of fine art, would mean disappointing many tourists. Brown proposed lending back the Gallery's great *St. Martin and the Beggar*. But nothing seemed to work. And the Vermeer at Kenwood was too fragile to move, and had been stolen just ten years before. Another disappointment.[66]

But there were, as well, successes. Writing the director of the Corsham Court Art Gallery for van Dyck's *Betrayal of Christ*, Brown declared it (another) linchpin of the exhibition. It was needed for the show's Robert Adam room, inspired by the very room in which the painting hung. "We know the picture is difficult to transport," Brown wrote, "that a new window will have to be built to get it in and out, and that the repairs . . . are complex."[67] Brown promised to meet the costs and suggested some replacements for the van Dyck while it was away. He also hinted at a foundation grant for conservation. Contacting Lord Methuen of Corsham directly, Brown managed to get the van Dyck committed to his show.

There was little intimidation in this lobbying (as opposed to some other shows), and indeed pressure came from both sides. The Duke of Buccleuch and Queensberry, one of Britain's wealthiest peers and supposedly the richest landowner in Europe, possessed a series of great houses and an extraordinary group of artworks. Active in political matters, colorful, sometimes truculent, but deeply committed to the countryside and an active manager of his own estates, "Johnnie" Buccleuch proved to be a canny bargainer. Brown had his eyes on several of his paintings, including a Rembrandt that was kept at Drumlanrig Castle, his Dumfriesshire home. Colin Thompson, retired director of the National Galleries of Scotland, served as an intermediary in the negotiations that followed. The duke would be willing to lend, he told Brown, but "a Rembrandt is a Rembrandt." This "important" picture had to be given appropriate attention. As the only Rembrandt in the show and "thus likely to be a star attraction to most of your visitors," the picture should appear "on the posters or the cover of the catalogue." This "would be a clear demonstration of its importance in the whole exhibition." If it was not considered

important enough to receive "star billing," Thompson added ominously, "I would advise Johnnie not to let it go."[68]

Brown replied quickly. It would indeed be their only Rembrandt, he admitted, and it would be used on a poster. And it might be reproduced on a catalog cover. It will "be the star of the show," he promised.[69] But there were other issues. In January 1985, just months before the opening, Buccleuch declared that, despite his goodwill for Brown personally and for the exhibition, "the time has come for some blunt words." Initially he had taken "the unhappy step" of opening his three houses to the public to show things in situ and avoid lending. Their absence would betray a trust. He relented because the Gallery's exhibition was so important and "because it offered the certain prospect of free passage to Washington for my wife, self and (following hints from you) our sons and daughter, plus free accommodation in a Washington hotel." He had told Jackson-Stops that borrowing the Rembrandt was "a non-starter," and "had it not been for your rigorous representations by telephone, I would certainly have stuck to my guns instead of weakly relenting again." The duke felt he had been "bounced," and that Brown had rejected his conditions on guidebooks and postcards and dodged the air travel commitment. But above all, Brown must not assume, as "apparently" he had done from the start, "that everything is automatically available to you and on your terms only. If you do, Rembrandt's Old Woman will be enjoying next Christmas at D'rumlanrig as shown in the enclosed photograph."[70] The letter was followed by another in March, demanding an answer and threatening to withhold all the other things that he had been planning to lend.[71]

Help was on the way. By early March 1985, the British Tourist Authority had decided to invite Buccleuch, the following February, as one of eight BTA/Ford–sponsored publicity visitors, to promote the exhibition and country house visits. Brown expressed his gratitude.[72] As things developed, the Duke of Bucchleuch turned out to be one of the exhibition's most generous lenders. From Drumlanrig Castle, Bowhill House, and Boughton House came two dozen objects, mainly paintings, but porcelains and furniture as well.

The bargaining did not go unnoticed, at least in Britain. A hostile article in *Private Eye*, appearing in October 1984 and sent to Brown directly, accused him of being snobbish and arrogant, outdoing the Metropolitan Museum with his pretentious ambition. Cultivating his "glitzy" reputa-

tion with corporate executives and politicians, "he drops names without a twitch of embarrassment" and "keeps people waiting or honours them with a call in the middle of the night. But such is his power to charm and flatter that nobody minds—until they're dropped from his entourage." No wonder his "intimates call him 'Zeus.'" The British government, struggling simply to keep its Arts Council afloat, was underwriting the insurance cost of the "world's most expensive blockbuster exhibition," to be "displayed in a ridiculous pastiche of a country house built into the Gallery."[73]

The author, to be sure, ignored the ambitions of many house owners, and took no notice of the formidable transport costs. Ferrying gentry and objects across the ocean was not cheap, but Brown was unafraid to operate at the highest levels, as usual. Ambassador Charles Price promised to speak to British secretary of state for defence Michael Heseltine about using the Royal Air Force to carry oversize items for the show.[74] Brown also wrote Caspar Weinberger, the US secretary of defense (who was briefly visiting London), to put in a good word for the cause.[75] Twenty-five percent of the objects were too large to fit into a 747, he pointed out, and the Royal Air Force flew to Dulles twice each week.

Prime Minister Margaret Thatcher and Heseltine came through. By March 1985, Brown could assure the lender of a pair of eighteenth-century mirrors that "Mrs. Thatcher has just committed" to have the RAF bring over the more complicated and fragile exhibits. The mirrors previously hung in the state bedchamber at Stowe. Never one to miss a selling opportunity, Brown added, "Having spent a marvelous year at Stowe, I have a particular personal hope you will allow its erstwhile splendour to shine through."[76] The girandole mirrors were lent.

Most of Brown's efforts centered on British Airways, the only British carrier offering nonstop service between London and Dulles Airport, and on Lord King, its recently appointed chairman and a Thatcher favorite, then in the process of taking the government-owned airline private. Another complex series of negotiations began. Brown mused about requesting two hundred free round trips, a subsidy of $185,000 at current coach fares, and freight for hundreds of pieces.[77] He promised credit in the catalog and guide book. We "expect the exhibition to be seen by some two million visitors," he wrote Lord King in October 1984.[78]

Some on his staff worried about a quid pro quo. In a memo recounting his strategy, Brown insisted that no BA logo would be included in the

catalog. "I stressed what a breakthrough it was to be able to get a Washington entity to use British Airways . . . and said that because of our private side we were in a position to do this and other Washington agencies were not."[79] Brown could accommodate many of the airline's requests. It would be mentioned in all press releases, noted at either the entrance or exits to the exhibition and in the Gallery's calendar of events list, acknowledged on a poster as the official carrier of the exhibition, thanked in the catalog, included in its bookmark insert, and credited in an audio-visual presentation installed at the start of the exhibition.[80]

The haggling continued for weeks, but finally, in a letter of April 23, the details were spelled out. Along with the other acknowledgments, British Airways would receive a table for ten at the gala opening dinner. The Gallery would get a 50 percent rate reduction for freight and handling of art objects, and BA would supply passenger tickets at any level and to any gateway cities, equal to half of the total cargo rate.[81] This finessed the issue of whether certain individuals would be flying tourist, first-class, or Concorde, an earlier hangup. In a note the very next day to Lady King, Brown triumphantly announced that her husband's company had become the official courier for the exhibition, offering many curators, conservators, couriers, and lenders free passage.[82]

The extended negotiations with British Airways typified the delicate transactions that surrounded this exhibition and others of its kind. To meet the costs of such spectacular shows, museum directors had to afford donors opportunities for self-promotion and commercial exploitation, but without damaging their institutions' status or cultural authority. Boundaries, sometimes arbitrary, sometimes almost imperceptible, had to be set, although it was not easy to control third-party escapades or rogue opportunists. Like colleagues elsewhere, Brown was continually reassessing just where the barriers should be placed. In one early memo on promotion, in September 1984, Brown declared that the National Gallery would sell no three-dimensional reproductions of works of art, and would retain rights of review and approval over material sold in its shops. Any sense of commercialism was to be concealed. Pressed by Ford and Muffie Brandon to place the Ford logo on exhibition tickets, Brown refused. It could be printed on the back side of passes only. "The image of Ford would not be served by anything interpreted as turning these passes into an ad," Brown wrote Brandon.[83]

Brandon meanwhile was planning the advertising, which would in-

clude two airport dioramas, placed near the gates for the New York–Washington shuttles, along with Metrobus posters and metrorail dioramas. Extensive publicity in the late spring and summer of 1985, both in the United States and in Britain, encouraged advance tour bookings; there were to be newspaper and magazine supplements as well, one of them an unprecedented and lavishly illustrated issue of *Architectural Digest*, achieved after extended and sometimes painful discussions.[84]

There were also late complications, the most serious being a growing number of conservation problems. Warnings about a looming crisis had been coming for several years. In early 1982 Julian Andrews had declared conservation a major dilemma.[85] Gallery personnel, like Ross Merrill, and later David Bull, were seconded to work on the task, and a special panel, chaired by Norman Brommelle, who had previously served at the Victoria and Albert Museum, was appointed. There were hopes this might be enough.

By December 1984, it was impossible to avoid confronting the costs any longer. Hundreds of thousands of dollars were at stake. Some British foundations had been approached, but the response was meager. Brown sought help from Ford, the exhibition sponsor. The situation was unusual, he explained to Ford's incoming chief executive officer, Donald Petersen.[86] Work for temporary shows was ordinarily borrowed from museums or from owners who had acquired their objects in the recent past and held them in salable condition. Country house owners practiced deferred maintenance, Brown explained delicately. They lacked the money to do much about tackling conservation needs. More than that, the conservation panel in the United Kingdom had been slow getting information to the Gallery. Conservators did not travel to individual houses until the loans had been agreed on. Then there were hundreds to visit, and many final decisions were quite recent.[87]

Ford did not want to pledge additional funding. Writing to Harold Williams, president of the Getty Trust, Brown said the transition in corporate leadership taking place there made further requests unrealistic.[88] Things were getting worse. Some owners were refusing to lend unless the art could be made safe for travel. Congressional help was also unlikely. At their last hearing, Gallery officials had been told that public moneys could not be used to conserve privately owned objects. Senator James McClure of Idaho had insisted that conservation be a British responsibility.[89]

The Getty Trust was a last hope. In his letter to Williams, Brown

noted that J. Paul Getty had himself lived in a great English house (Sutton Place, in Surrey), and would certainly have valued participation. The conservation tab would not be cheap. The estimate now stood at more than 350,000 pounds.[90] A grant to cover these costs would make a lot of friends for the Getty Trust in Britain, Brown promised. He also invited Williams to the lenders dinner the following fall.[91]

Williams's initial reaction was negative; Getty guidelines limited grants for objects to those in public collections and on permanent exhibition. When John Wilmerding, who was handling the negotiation, indicated that many of these were major artworks already on public exhibition in their houses, Williams relented, but insisted that the requests come not from the National Gallery but from the owners or their associations. The Getty would pay only direct conservation expenses, not transport or insurance. Wilmerding recommended creating a list of eligible artworks and developing a draft letter.[92] In the end, after applications from the National Trust and the Historic Houses Associaton, Getty awarded a hundred thousand dollars for cleaning and repair.[93]

By March 1985 Brown was prepared to abandon the crutches he had been using since graduating from the wheelchair and the scooter following his summer accident. The final months of preparation for the exhibition found him putting out fires, salving bruised egos, offering last encouragements, and supervising final details for some of the exhibition's associated events. Her Majesty the Queen was proving to be a bit of an obstacle, and one that even Brown's aggressive ingenuity could not overcome. Writing on her behalf, Lord Airlee refused the loan of some old master drawings. The theme of the exhibition was country houses, Airlee wrote, and art was being lent from Balmoral, Sandringham, Osborne House, and other royal estates. Windsor Castle, however, the home of the drawings, was not a country house but the sovereign's official residence. And drawings were not to be lent unless they were central to an exhibition's theme.[94]

Months earlier, Airlee had written Brown to say that Queen Mary's Dolls' House was also unavailable.[95] But for that, at least, a substitute was available, from Nostell Priory. Brown had been visiting it the day of his accident. Its owner, Lord St. Oswald, not a particular fan of Americans, had vowed to lend nothing to the Washington exhibition, but upon his death his son and heir determined to let it go.[96] This eighteenth-century marvel of construction, rumored to have been done by Thomas Chip-

pendale himself, was placed in the exhibition's last room, the final object in the catalog.

The royal family did, however, provide the exhibition with an enormous boon. Obtaining the patronage of the Prince of Wales had been a challenge, because of his skepticism about seeing the show. But now an actual visit by the prince and princess emerged as a possibility. Since the summer of 1984, prolonged and detailed discussions had been taking place, aided by Brown's personal relationship with Nancy Reagan.[97] Like almost everything in Washington, politics and protocol surrounded the arrangements. Frequent telephone calls followed, involving Brown, Selwa Roosevelt, the chief of protocol and presidential representative to the local diplomatic corps, and various White house staff members. The White House was anxious about any bad publicity such a request might bring just before the election. And there was concern about being turned down. A presidential assistant wrote Brown that "until a firm acceptance has been received the White House would rather not send a letter."[98] By late December the British ambassador reported that following their Australian trip, the second week in November, the royal couple could visit, staying at the British embassy. All depended on the Reagan invitation.[99] And indeed, after the Reagan letter, the visit was officially confirmed.

Exulting in this triumph of micromanagement, Brown plunged in with various proposals. Correspondence was massive, telephone calls frequent. The dates of the visit, November 9–11, coincided with the Veterans Day weekend, upsetting the White House. Brown countered that the long weekend made it easier to get guests into town. He immediately began planning as much as he could of the visit, offering to host meals, arrange for television coverage, and above all get the Waleses to the exhibition. "I mentioned shooting her in front of the doll's house if it came through."[100] The embassy declared that the White House, embassy, and Gallery would each get one day. Discussions with the British ambassador raised interesting issues. Brown explained that if the Gallery offered a dinner, Monday night was better than Sunday because they would have to close the Gallery to the public for part of Sunday to host it. The ambassador's reaction "was very strong to that, and he understood completely that in a democratic society you won't want to get caught closing something to the public."[101] Monday night was chosen, following a presidential dinner the night before. Among other things, Brown hoped, somehow, to get Ronald Reagan into the East Building; he hadn't yet visited.[102]

There were other issues. Muffie Brandon asked if Donald Petersen, Ford's chairman, could escort the couple, along with Brown and the Mellons, on their walk through the exhibition. "You can imagine the importance of Mr. Petersen's presence at such occasions," she wrote, "not only for his own personal interest, but also to represent the thousands of members and workers of the Ford Motor Company."[103] Plans for a fox hunt moved ahead, in conjunction with a Sunday lunch at the Mellon farm in Virginia. After Washington the Waleses would fly to Palm Beach for a polo match (the prince was scheduled to play). Brown was invited to fly down with Armand Hammer and join the festivities.[104]

Given the extraordinary interest in Diana, news of the trip was greeted with huge excitement, and insiders gave the credit to Brown. "It looks as if Carter is pulling off a miracle," someone told a *Washington Post* reporter, just weeks before the embassy announcement.[105] Brown continued to exploit other connections. He wrote his sister, Angela Fischer, that Angus Sterling, head of the National Trust, was available for a Boston lecture in the weeks after the November opening. "This might bring Boston more about the Anglo-Saxon heritage than they care to hear," Brown admitted wryly, but Sterling was "charming" and presumably armed with superb slides. The National Trust, he noted, was the largest landowner in Britain after the queen.[106] Intermittent jealousies, resentments, and rivalries beset the British side. Julian Andrews was upset by the failure to acknowledge the British Council on the catalog's title page. Given the terms of their contract and a government indemnity, the omission was "extremely disappointing and disturbing."[107] Brown assured Andrews that the British Council would get special mention in the exhibition guide (750,000 copies), overshadowing the twenty thousand copies planned for the catalog's first printing.[108] Lady Hesketh, author of the *Treasure House Cookbook*, hoped that Michael Saunders Watson of the Historic Houses Association wouldn't be controlling speakers at the opening.[109] And the Duchess of Devonshire (Debo to family and friends like Brown), after thanking the staff "for saying funny things," confessed it would "be so comical" to see those grasping stately owners there.[110]

Diplomatic successes continued. Princess Margaret declared her intention to visit, and US ambassador Price, in London, gave a dinner for the Prince and Princess of Wales in July, with many lenders present.[111] Julian Andrews reported that the evening went splendidly. "You will be relieved to know that Buccleuch was particularly friendly!"[112] The spe-

cial handling of his Rembrandt was in place. Brown's response enclosed a clipping from the *New York Times*, which offered both a preview of the exhibition and a meticulous recounting of the packing and shipment process. Brown crowed that "it is difficult to get the New York press to concede much to Washington," and "it does not hurt to have . . . a paper with that amount of readership across the country, taking an interest in what you all are up to."[113]

Press coverage was intense. Readers of the *New York Times* gained insight into the "mind-boggling" installation, thirty-five thousand square feet, "the essence of the English country house as a backdrop for 500 years of decorative history." The seventeen period rooms stuffed with more than seven hundred objects included a ninety-foot Jacobean Long Gallery, a sculpture rotunda more than thirty feet high, and the Waterloo Gallery, featuring great English portraits along with old masters purchased by wealthy landowners in the years after Wellington's triumph.[114] Gill Ravenel explained that "you begin with a group of objects and then you build a room, like a glove, to hold them." Gervase Jackson-Stops had taken the installers and designers to more than 120 British country houses.[115] Twenty-seven air flights carried the treasures across the ocean; eighty-five house owners had requested they be the last pickup.[116] The present installation, wrote Paul Richard, "does its objects proud." It was "the best work" Ravenel and Leithauser had ever done.[117]

The years of planning, traveling, cajoling, and negotiating finally climaxed, in November 1985, with the show's opening, followed, a few days later, by the elaborately orchestrated royal visit. "In all humility," Jackson-Stops told the *Washington Post*, "it is the most fabulous exhibition that has ever been done in any museum anywhere in the world."[118] A PBS television special in three parts, produced by Michael Gill (of *Civilisation* fame) and funded by Mobil, followed, featuring sixteen lavish English country houses and almost that number of articulate aristocrats. The *Washington Post* ran a special supplement (complete with an error-laden "Royal Message"); indeed, the *Post* turned itself into one long advertising brochure for the first two weeks of November.[119] *Burlington Magazine*, *Architectural Digest*, and *House & Garden* afforded further publicity.

The exhibition and the royal visit provided rich fare for journalists. They dined exuberantly, working as many variations as possible on ancient themes. The several hundred British lenders in Washington, many of them bearing titles, generally acted their parts to perfection. Bejeweled

duchesses and florid-faced earls thronged the city's better hotels. "They are everywhere . . . with their double-vented jackets, tweed skirts, cheeks eternally rosy."[120] Dinner dances fought for attention with events at the British embassy, Washington National Cathedral, and the National Gallery.[121] Brown himself was part of the story. "Stroking, smiling, bowing to the scraping of the social violins," wrote a *Washington Post* staff writer, he was enjoying "his finest hour."[122] The advance work for the visit had been exhaustive and comprehensive.[123]

Some soul searching ensued. "For a country that threw off the yoke of the British Empire, there are an awful lot of loyalists around," wrote Desson Howe in the *Washington Post*. "Tuck the Constitution away in a dusty cupboard. . . . The legacies of independence . . . will be overshadowed as adult Americans enter the Court of St. James's world with heads bowed. . . . There'll always be an England. In America."[124] Jonathan Yardley took a darker view, pointing out that "while we are going berserk at the sheer ecstasy of it all, our royal visitors are taking us to the cleaners."[125] Americans were paying for a show promoting British tourism and British exports.

The Prince and Princess of Wales fulfilled many assignments. Among their other duties, the royal pair visited a J. C. Penney store in Springfield, Virginia. Nationally, the chain was mounting a "Best in Britain" campaign. The local outlet's salute to the mother country featured a multimillion-dollar selection of clothes, shoes, and other goods. At their center, to the amusement of the Prince of Wales, was a Rolls-Royce perched atop hundreds of Wedgwood teacups. "*El Tacko*" was the response of one unimpressed observer. The princess was surprised by the absence of double-breasted suits. The store promised a "royal line" next season.[126]

Media featured the princess's clothes, the guest lists, and the etiquette rules that were either slavishly followed or imperfectly understood.[127] Brown, almost everywhere, was the only "mere mortal" going to all three great dinners, noted the *Sunday Times* of London.[128] And he was always available for comments upon the crowds, the royal visitors, and the arrangements. These last ensured that public contact was carefully controlled. "Whether the royal couple really met a cross-section of Washington is debatable," Carla Hall noted in the *Washington Post*. The three black-tie dinners included almost no African-American guests.

That's "just how it fell out," said a Gallery spokesman. "What can I say?" exclaimed the embassy's social secretary.[129]

As usual, Brown forged a personal relationship with his patrons. On learning from Diana that the amount of standing she did was hurting her back, he shipped her—or, rather, her lady in waiting—a set of exercises proposed by his orthopedist.[130] To the prince he sent a Sony Sport Walkman.[131] Frugal to the last, he submitted his receipt ($54.17) for Gallery reimbursement, adding that he had received "the attached thank you note" in the prince's own writing.[132] And he placed the prince on his Christmas card list, sending along some taped reflections on the *Treasure Houses* show.

In the first weeks, social activity overwhelmed coverage of the exhibition as a whole. There were stories about individual objects, about the lenders, about the complexity of packing and shipping, about the costly installations. There was advice for those wishing to visit the great houses for themselves, or to purchase home furnishings inspired by the treasures. But not very much appeared discussing the purported theme or the show's assumptions.

Not that it mattered to the Gallery or the lenders. In numerical terms, *Treasure Houses* was a hit even before it opened. Extended for an additional month, it came close to setting a record for Gallery attendance, eclipsing the fabled *Treasures of Tutankhamun* held nine years earlier. Some 990,000 visitors trooped through during its twelve-week stay, just 10,000 short of the official goal.[133] It was, however, half the number Brown had promised Lord King a year before. Thousands of copies of the hefty catalog were sold, along with Gervase Jackson-Stops's *The English Country House: A Grand Tour*, with its James Pipkin photographs. By December, Brown could write his funders at Ford that "we have an extraordinary hit on our hands." The show could accommodate no more than six thousand visitors a day, he noted, but some eighty thousand had shown up at the National Gallery on one recent Friday.[134] Extending its stay by a month, to April 13, would allow for 150,000 added visitors.[135] He hoped Ford might be interested in meeting the additional expenses. Ford was indeed interested. Donald Petersen told Brown in February that another hundred thousand dollars was available to support the extra weeks.[136] In his thank you note, Brown observed that the previous weekend the National Gallery had experienced its largest attendance for any three-day

period, 220,000.[137] And he floated the notion to Her Majesty's private secretary that in view of the extension perhaps the queen mother might consider dropping in. She had apparently asked about the show at a recent dinner.[138] But this was not to be.

Congratulatory letters poured in. From Arthur Sackler, Geoffrey Agnew, George Shultz, Caspar Weinberger, Eunice Shriver, Clifton Daniel, Democrats, Republicans, and nonaligned. His American colleagues declared Gervase Jackson-Stops "the next Kenneth Clark of Britain."[139] The Duke of Bedford basked in a "miraculous" exhibition. "One is so used to seeing them in our tacky, crumbling old houses that to see everything displayed, lit in perfect settings was something unique in one's life."[140] For the Marquess of Tavistock it was "quite simply the greatest exhibition any museum has ever put on anywhere in the world or ever will put on."[141] Gill Ravenel thanked Brown for letting him be part of the larger experience. "It transcends any precedent, any traditional definition, or experience of 'exhibition.' It has been a unique extended event." Ravenel admired Brown's "vision" and "tenacity." "Also many people said it couldn't be done (Roy Strong et al, EAT CROW), but then only you could have envisioned it and made it real."[142]

The Michael Gill television feature, a three-part series written by Cambridge historian J. H. Plumb, began to appear on screens in December, to respectful if less than rapt attention. "The general feeling," wrote John Corry in the *New York Times*, "is that we are at a tutorial," everyone "extremely polite and a little-self-conscious." The accompanying music "sounds like 'Masterpiece Theater.'"[143] .

The *Times* was far more generous when it came to the exhibition. John Russell, who wrote what could only be called an extended puff piece in the newspaper's Sunday magazine, "The Private Palaces of Britain," followed up several days later with a glowing report of the actual show: "I have a confession to make. I did not believe that it could possibly be as good as it is." The "exhibits are so powerfully evocative that they bring a whole period to life." Nowhere was "there a hint of Disneyland." It was, if anything, too good. Visitors would be spoiled by the perfection.[144]

In the *Los Angeles Times*, William Wilson echoed Russell by saying that some worried the show would be "just a pop-up Architectural Digest or Sotheby's auction catalogue" whose "predictable success would further erode museum standards already excessively preoccupied with pandering to popular taste." Never fear, he reassured his readers. *Treasure Houses*

was "a superlative exhibition whose only threat to standards will come from any watered-down carbons that others may attempt in its wake."[145]

Coverage of the show often focused on Brown.[146] *Treasure Houses* was "his idea, he nurtured it, found money for it, courted the lenders . . . and found more money again. It was he who snared its royal patrons. . . . And if that weren't enough, he very nearly gave his life for the show, in an auto accident. . . . This one is his baby, silver spoon and all."[147] In Chicago and in Los Angeles as well as in the capital, Brown's biography, and particularly his year at Stowe, was embedded within the larger mystique of the exhibition's gestation and development. Occasionally the Anglophilia of the Gallery's greatest patron, Paul Mellon, was included among the relevant details, along with the financial challenges of maintaining the houses so lovingly evoked by the exhibition. But to a remarkable extent Brown, now sixteen years into his directorship, remained at the center, credited with energizing the National Gallery and its remarkable exhibition record.

Like most newspapers, national magazines generally treated *Treasure Houses* with adulation, showering generous adjectives upon its design and its organizers. There were some major exceptions. One came from Robert Hughes, whose notorious review in *Time* was titled "Brideshead Redecorated." Hughes used the occasion to reflect upon "the uninflected worship of money that marks the 1980s," yoking *Brideshead Revisited* with *Dynasty* and making Lord Marchmain "the Blake Carrington of the American upper middle classes." He focused on the sentimentality, the extravagant opening-night events, the endless shuttle of titled aristocrats across the Atlantic, and concluded that the show was "a fund raiser, aimed at drumming up more American support for that collectively unique, financially insecure, historically indispensable phenomenon, the Stately Home." Acknowledging the remarkable objects on display, and the threats to their survival, Hughes charged that the exhibition "embraces conventions of glamour . . . that few social historians would accept today." England "was by no means the serene garden of precedence and patronage suggested by the masterpieces of Gainsborough or Robert Adam."[148]

A somewhat different take on the country house theme was advanced by British historian David Cannadine in the *New York Review of Books*. Like Hughes, he invoked Evelyn Waugh's Brideshead. Unlike Hughes, however, he raised questions about the taste of the country house owners and the valuation placed upon the institution itself. While these stately

homes might indeed be termed "treasure houses," Cannadine allowed, labeling them "vessels of civilization" and "the envy of the rest of the world" seemed "little more than hyperbole." The "best that can be said about this is that it is the language not of scholarship but of sentiment.""Aristocrats and gentry were more likely to be philistine than cultured, indifferent to art rather than drawn to it." And the argument that the country house needed to be preserved, along with its hard-pressed ownership, struck Cannadine as an unpersuasive polemic. "There are already more than one hundred country houses in the expert care of the National Trust; just how many more do we actually need?" "Once it was the country-house culture which could be called parasitic on the country-house elite; now it is the elite which more and more depends on the culture."

Most damaging of all, Cannadine argued that the exhibition paradoxically subverted the claim of its most ardent supporters: that the country house treasures were best retained where they were. "Many country houses are inaccessible, open rarely, contain at best indifferent works of art, and show them badly and inexpertly." "This marvelous museum display" made such objects easily available, under better viewing conditions, and for a far larger audience. The British national heritage was better served by the National Gallery of Art in Washington than by its hundreds of increasingly decrepit mansions. Thus Cannadine simultaneously challenged the country house ideal while praising the National Gallery's physical presentation.[149]

Some few dissents and qualifications aside, American reviews remained overwhelmingly positive. In Britain, however, home to many country house skeptics, there were more frequent expressions of disquiet, some based on the fragility of the objects shipped, others focused on the possible dispersal of the treasures to foreign (American) purchasers. Iain Pears, writing in the *Oxford Art Journal*, acknowledged the "gorgeous things" on display, the "breathtaking" range of objects, and a catalog that "set new standards," but also argued that the owners may have been persuaded to participate by a "massive rise" in the value of the exhibits, "if—or no doubt when, in many cases—they arrive in the sale room." Pears concentrated on the hugely successful marketing effort and its benefit to the exhibition's sponsor, Ford, as well as its idealized notion of English country life. Brown's introduction "reproduces exactly the image of the country house that all those eighteenth-century politicians,

bankers and landlords hoped to create when they . . . wanted to dazzle the world and solidify themselves as the cultural lynchpin on which civilisation depended."[150]

A more strident tone was set by Leslie Geddes-Brown, whose review, "The Great British Heritage for Sale," appeared in *Arts* in early 1986. Quoting one specialist who called the exhibition a "disgraceful kind of Harrods sale," the article featured denunciations by Timothy Clifford, director of the National Galleries of Scotland. "Experts now foresee an unparalleled art drain starting in Britain as soon as the exhibition closes," wrote Geddes-Brown. The splendidly detailed catalog would become a buyers guide. Precedent was found in the celebrated *Art Treasures of Great Britain* exhibition, held in Manchester in 1857. According to Clifford—repeating a claim (exaggerated and unsubstantiated) by a British Museum keeper in the early twentieth century—half of the works exhibited in Manchester had been exported by 1900. Magnified or not, there were huge losses over time. Clifford and others predicted a recurrence and prophesied significant price rises for every object on display.[151]

Jackson-Stops at once sent a rejoinder to the *Times* of London, declaring it naive to think art objects could be saved by making them less accessible. He pointed out that most of the art in the show was owned by charitable trusts, which were not empowered to sell, even if they wanted to. He denied any analogy with Manchester, whose art treasures did not begin to depart until the 1870s, and then as a result of widespread agricultural depression. The largest exodus did not take place until even later.[152]

Further attacks followed after the exhibition had closed. In October 1986, Peter Watson wrote in the *Observer* that the thirty-five paintings lent by the National Trust for the *Treasure House* show had "been damaged to such an extent that the Trust has decided it will never again lend on such a large scale." Chipped paint and varnish, flaking paint, and cracks reflected not only careless handling but the contrasts in temperature and humidity between the country houses and the National Gallery.[153] Jackson-Stops immediately challenged the piece in another letter; of more than eight hundred objects sent out, fewer than a dozen showed any damage at all, and none of major concern. *Burlington Magazine*, allowing condition reports to settle debates about damage, praised the exhibition as a "triumph," demonstrating "what good museum display can do

for works of exceptionally high quality." Suggestive rather than imitative interiors and "close access to great pictures" meant that everything was shown to great advantage.[154]

Critics, however, were heartened by an unexpected American source, a September 1986 editorial in the *Art Bulletin*, read faithfully by art historians of many kinds. In "Art History and the 'Blockbuster' Exhibition," editor Richard Spear credited the second generation of blockbusters in the 1980s with balancing the books at major museums, but blamed them for elbowing out "exhibitions of substantial historical value based on intellectual rather than marketing considerations," for placing curatorial staffs under such pressure that they were "neglecting their permanent collections," for circulating masterworks in shows of little consequence to a point where they would be unavailable for more significant exhibitions, and finally, for mechanizing attendance methods to a point where "crowded viewing conditions threaten to dehumanize the entire experience." The editorial singled out *Treasure Houses* as an "intellectually vacuous blockbuster," whose installation, lavish catalog, and media coverage seemed to focus as much "on the social activities" as on the "works of art." "No substantive ideas motivated the exhibition." Certainly some "important works were made available for aesthetic pleasure and scholarly study," the editor admitted. But "at what expense, literally and figuratively, and with what permanent contributions to knowledge?"[155]

The phrase "intellectually vacuuous blockbuster" was soon a rhetorical weapon for unfriendly commentators. Sydney J. Freedberg, the National Gallery's chief curator, dashed off a fifteen-hundred-word response to Spear, while Jackson-Stops contented himself with a more concise defense of his show.[156] Denying that Gallery staff were overburdened ("not one of the curators of the National Gallery's permanent collections was involved") or that the socioeconomic foundations of patronage "were passed over in total silence," Jackson-Stops wondered if the editor's "political sensibilities were offended by one of the underlying themes . . . that eighteenth-century country-house owners were generally not the ogres and exploiters we have been taught to think, but men and women of vision, liberal by the standards of their time." Spear responded with a lengthy restatement, expressing doubts about the benevolence of corporate sponsorship, invoking Hans Haacke's socially critical art, and insisting that the transport of large canvases as well as panels was a hazardous undertaking.

In Britain, *Apollo* also offered a defense. Denys Sutton, in one of his last editorials, acknowledged "some of the razzamatazz surrounding the exhibition" to be "disturbing." But, he continued, the show "gave enjoyment to thousands," and he challenged the *Art Bulletin*'s "ill-informed" notion that "an exhibition is only valid if it serves the aims of art historians and is under their control. . . . The purpose of art exhibitions is not to bolster up the egos of academics but to give pleasure to those who visit them. Long live the pleasure principle!"[157] This motto Carter Brown could have easily endorsed.

Brown avoided direct involvement in these debates, although he maintained some combative correspondence with Donald Hoffman, the longtime art and architecture critic of the *Kansas City Star*. When Hoffman wrote him in reproach, citing the *Art Bulletin* editorial, Brown countered with Sydney Freedberg's unpublished letter. The reaction was sharp. Objecting to Freedberg's defense of the exhibition as the ultimate in "opulence and grandeur," Hoffman launched an attack, not only on the show but on the Reagan administration. "I've always thought America was founded by breaking away from Britain and all its odious values and appurtenances of a rigid class system," he wrote. "Shame on our National Gallery for organizing such a deadening exhibition."[158] This kind of response convinced some that hostile reactions were ideological. At one point Brown referred to the show's detractors as "leftist," a rare descent, for him at least, into political name-calling.[159]

No other show, during his twenty-three-year tenure as director, was so closely identified with Brown personally, and none better reflected his social, aesthetic, and museological values. Self-consciously constructed from the start as a crowd-pleaser, built around a carefully nurtured network of social and political contacts, enhanced by the most ambitious and elaborate installation yet achieved by the Gallery, it reflected Brown's admiration of the role played by patrons and collectors in the progress of civilization. That it could be successfully marketed only increased its allure to him and to his staff, despite questions about the show's intellectual value. Brown's nostalgic enthusiasm underwrote a romanticized vision of history, whose darker elements, as some critics pointed out, remained recessive, even invisible. Invariably upbeat about future plans, his optimism extended retrospectively. It fed his professional self-confidence and sustained his energy.

The six-year project had been taxing. Sixteen staff visits to Britain had

been made. One of them, during which Brown had his auto accident, lasted six weeks. The schedule could be ferocious. A file memorandum covering just two days of meetings in New York and London in early 1985 had Brown attending to details of three separate shows, conferring about art purchases, cultivating donors, and attending openings, all this while still in a wheelchair. He dictated letters and memos in taxis and airport lounges and took midnight telephone calls. On one visit to London he got to sleep at 4 a.m. and set his alarm for 6.[160] But he never seemed to flag. It was during this period that his second child, Elissa, was born. And just as the exhibition entered its second week, his mother, suffering from lung cancer, died. One day before her death Brown had dictated a fourteen-page letter to her describing the opening and, in much greater detail, the visit of the Waleses. Somehow finding the time to narrate a day-by-day, and at certain points, hour-by-hour account of the dinners, tours, receptions, press conferences, helicopter rides, television apearances, and personal conversations that punctuated the royal visit, he demonstrated both his remarkable memory and his sympathetic rapport with the celebrity guests. Gossip and personal observations were mingled with arrangement details. Even in a letter to his dying mother he was punctilious about including titles and identifications. He seemed to be writing for the historical record, to make certain that nothing was lost and everything correct.[161]

Months later, in this same spirit, Brown reviewed videotapes and television transcripts of the opening, preparing an edited version to be shown to Gallery trustees. Bloopers—such as ABC's assurance that *Treasure Houses* was at the Smithsonian, accompanied by directions to the Castle—would be omitted.[162] Sensitivity to media coverage lay at the heart of Brown's larger program, and was generally marked by a high degree of success. It would be needed as Gallery officers turned their attention to more permanent challenges—adding to the endowment, and the collection.

Campaigns and Conquests

A mong the world's great art museums, Washington's National Gallery of Art is a relative newcomer. Its 1941 opening came generations after American cities like Boston, New York, Chicago, and Cleveland had established their institutions. Youth, a persistent theme invoked by Gallery promoters, has served to amplify its remarkable record of accomplishment and to allay criticisms of institutional inadequacy or gaps in the collection. The "new kid on the block" motif remained an ingrained part of the Gallery's self-presentation through the 1970s, and beyond. "The Met received its first Renaissance Italian drawings in 1880," curator Andrew Robison explained in 1988. "We were given ours in 1943. We're half a century behind. There is really no way to catch up."[1]

As time passed, however, need and opportunity combined to create new strategies that celebrated the institution's history as well as its ambition. Considered immensely rich and self-sufficient, as a result of the Mellon benefactions and the collections it acquired early on, the Gallery stood aloof from development schemes during the Finley and Walker administrations. Staff members were still engaged in cataloging the huge gifts that had begun to fill the building, and when special opportunities presented themselves—like the Leonardo *Ginevra de' Benci*—a donor like Ailsa Mellon Bruce stood prepared to fund them. And the Kress Foundation continued to be extremely generous.

But the expenditures associated with the East Building, which opened in 1978, ushered in a new era for Gallery fund-raising and acquisitions programs. For one thing, the building project came close to exhausting

the principal the Gallery had accumulated over many years, an endowment, John Walker claimed, worth some sixty million dollars when he retired in 1969.[2] For another, it tapped out Paul Mellon, the major private donor for acquisitions, as well as his foundation. Ailsa Mellon Bruce had died in 1969. The new space, and a new interest in twentieth-century art, meant the Gallery would be seeking additions to its holdings in this area. The additional responsibility of administering and supporting CASVA, the Center for Advanced Study in the Visual Arts, expanded the universe of needs.

Gifts to fund purchases were particularly welcome, because the Gallery did not finance acquisitions through deaccessions, a device sometimes employed by other museums. This was Carter Brown's proud boast during Thomas Hoving's time of troubles at the Metropolitan, where much of the controversy related to deaccessioning. The policy deflected potential criticism and was a strong selling point when courting potential art donors. But it imposed still another constraint on buying opportunities.

Brown had already been successful in attracting corporate support for special exhibitions. It was indispensable to his program. But this phase was different; it concerned the permanent collection, and the sums involved would be considerably higher. The Mellon family could not continue to be the almost exclusive source of private funds. One clear, if partial, solution was the creation of support groups committed to the Gallery's future, and specifically to the identification of possible new donors to the collection. But primary responsibility for any changes lay with the board of trustees, which would have to organize and take command of the operation.

The shape of the future was charted in the Collectors Committee's funding of the new works commissioned for the East Building, among them, the Calder mobile and the Miró tapestry. Selected to lead the forty or so supporters in 1975 was Ruth Carter Johnson, daughter of San Antonio millionaire and newspaper magnate Amon Carter. She had recently grown interested in the role of museums and art collecting, getting to know Paul Mellon and, through service on Harvard's Fogg Museum Visiting Committee, Carter Brown.

In its early years, the Collectors Committee did not have free rein to select the art it was paying for. It chose among a small set of options that had been approved by the Gallery's trustees. Nonetheless, the excitement of

meetings in Washington, the personal tours and festivities led by Brown, and involvement with the work of important contemporary artists energized the group. Originally planned as a three-year venture, slated to end with the East Building's opening, the committee thrived and voted to make itself permanent, changing the basis for membership from a one-time gift of fifteen thousand dollars to annual payments of five thousand dollars. By the mid-1980s, it was providing half a million dollars a year for the purchase of twentieth-century art. Around the same time, it voted to limit its membership to one hundred. "A waiting list to give money away?" exclaimed Jo Ann Lewis in the *Washington Post*. "Where else could that happen besides the National Gallery?"[3] The Collectors Committee's national makeup further validated the Gallery's efforts to mobilize supporters from throughout the country, transcending the parochialism of its location. Johnson would be rewarded, in 1979, with membership on the board of trustees, becoming the first woman to join it.

Several years earlier, another trustee had been appointed who would become central to the development program. John (Jack) Stevenson was senior partner at the Wall Street law firm of Sullivan and Cromwell and a trustee of the Andrew W. Mellon Foundation. He arrived on the board in 1975, replacing Stoddard Stevens, Paul Mellon's personal lawyer. Four years later, Paul Mellon assumed the board chairmanship, when Chief Justice Burger decided it no longer made sense for him to continue in that role, and at Mellon's request, Stevenson became Gallery president. It was Stevenson who was responsible for the second outside group organized to support the Gallery, the Trustees Council, created in 1982. As the museum's chief executive officer (Mellon deferred to the president on routine matters), Stevenson did not want to enlarge the board simply to cultivate contributions. The five general members already outnumbered the four ex officio appointments, and he worried that if changes were proposed, Congress, responsible for most of the annual funding, would demand more representation or greater control over Gallery policies.[4]

Increasing the number of trustees, then, seemed dangerous. Yet potential donors wanted some demonstrable acknowledgment of their connection with the Gallery. The Trustees Council was intended to provide this, and to provide the board with advice and additional fund-raising, something like an executive committee. The press was often confused by the distinction between the board of trustees and the Trustees Council,

referring to members of the latter, sometimes in obituaries, as trustees. Of course they were not. The small, nine-person board remained. But its preservation posed some unexpected problems.

In 1983 Stevenson and Ruth Carter Johnson married, meaning one couple held two of the five general trustee seats. Mellon went along with this, but years later told Franklin Murphy, who had replaced him as chairman, that it was a mistake to have two members of the same immediate family on the board. He should have intervened earlier, he confessed, and now he believed that one of the two should leave.[5] Shortly thereafter, in 1993, Jack Stevenson resigned and his wife became chair, succeeding Murphy. By this time, the first chairman of the Trustees Council, Robert H. Smith, a wealthy Washington real estate developer and a collector himself, had joined the board and become its president. Both of these groups, then, the Collectors Committee and the Trustees Council, served not simply to raise money, but as vestibules to Gallery governance.

Still another support group appeared in 1986. Meant to be more inclusive, it was called the Circle. Chaired, at first, by Robert H. Smith and Katherine Graham, publisher of the *Washington Post*, its participatory focus was, and remains, largely local. Membership initially cost as little as a hundred dollars a year, although the minimum would later rise to one thousand dollars, with various grades above that. The charge was to "provide the Gallery with the means to respond to unexpected needs and opportunities." Without admission fees, the National Gallery could not offer some of the usual quid pro quo that other art museums had available. But a variety of special privileges were available, and in effect the Circle formed the counterpart of a general membership group, albeit with a fairly elevated entry plateau.

These initiatives certainly proved useful to the Gallery. But alongside them came a more dramatic intervention to help it compete with other museum purchasers in an increasingly inflated international market. Thus, in 1982 the National Gallery announced a campaign to raise a fifty-million-dollar endowment. Paul Richard, in the *Washington Post*, declared it preparation for "life after the Mellons."[6] This was the National Gallery's first deliberate attempt to create an endowment, and it had a name: the Patrons' Permanent Fund. Again, the effort was principally the work of trustees and influential friends, led by Paul Mellon and coordinated by Jack Stevenson, but Carter Brown's reputation was a significant part of the strategy.

Mellon thought their goal should be twenty-five million dollars. Some of that would be raised in a silent phase, as in most capital campaigns. A planning meeting with key staff members Carol Fox and Carroll Cavanagh, the Gallery's general counsel, set the target higher, fifty million.[7] Several of the trustees—among them, Franklin Murphy, a former UCLA chancellor, and Carlisle Humelsine, president of Colonial Williamsburg—were veteran campaigners, as were Paul Mellon and Ruth Stevenson. Confident of the Gallery's capacity to attract support, the board decided against a feasibility study but hired Robert Conway, a senior consultant for Brakeley, John Price Jones, a firm that specialized in fund-raising, to run the actual campaign. Jan Krukowski, who had recently created a company handling strategy and communications for nonprofits, designed a brochure—one that had to be carried by hand. "It was designed to be too big to hide," recalled Carroll Cavanagh.[8]

Donors were expected to make six-figure contributions, at least. Mellon set the tone with the first gift, five million dollars. He personally solicited contributions and hosted luncheons and dinners in their interest.[9] The Mellon name continued to confer legitimacy. "We contact people of wealth," reported John C. Whitehead, a member of the glittering campaign committee, which included Brown, Robert Smith, Bruce Dayton of Minneapolis, and Katherine Graham. "Of course we mention Mellon." "I don't ask someone for contributions," Smith told *Post* critic Paul Richard. "I go to people I know."[10] Some prospective donors wondered why the Gallery needed to move beyond the Mellon family fortune. More significantly, some feared it might mean that Paul Mellon had begun to move away from his long-standing commitment to the institution. "I wouldn't say Paul Mellon is weaning the Gallery," Jack Stevenson declared. But inevitably "he is winding down." "It is time we did something for Paul," Stevenson went on. "He has already done so much. And he is, after all, not the only rich person in the country."[11]

Methodically, the campaign committee set about contacting potential contributors throughout the country. They were coy, for a time, about the contributors' names and the amounts of their donations. "I doubt they're releasing that figure, to be perfectly honest with you," Katherine Warwick told the *Washington Post* in early 1983. John Hay Whitney's two-million-dollar bequest to the fund had just been reported, but she insisted that Gallery trustees felt strongly about not announcing other figures. "It's private donations, and they just feel for the moment it should

remain private. I don't think they ever will" release the names and numbers. As it turned out, she was wrong.[12]

One of the first targets was billionaire publisher and art collector Walter Annenberg. His most recent involvement with a major art museum had been an ill-fated effort to establish a center for art communications at the Metropolitan Museum of Art, a few years earlier. Opponents of the plan, including the widow of James Rorimer, Tom Hoving's predecessor, had tried to enlist Brown in their resistance effort, but as far as can be seen, he did not join in.[13] The local opposition was so ferocious that Annenberg withdrew his gift.

Annenberg, whose philanthropies were generous in scale, nationally famous, and quite diverse, knew and liked Brown, who had visited the Annenberg complex, Sunnylands, in Rancho Mirage, California. They shared a number of friends and convictions, chief among them Anglophilia. Richard Nixon had appointed Annenberg ambassador to the Court of St. James in 1969, the year Brown took over the Gallery directorship. He was an admirer of Kenneth Clark's *Civilisation* series, and, indeed, its success had helped inspire his plan for the Metropolitan. In 1978 Annenberg had contacted Brown about plans to record the art of the world and document it for public television.[14] He was still thinking about an institute or school of some sorts, but he now wanted no part of New York City, despite the invitation of John Sawhill, the president of New York University, to join forces with him. Using one or both of the two schools of communication he had founded, at the University of Pennsylvania and the University of Southern California, was an option, but he raised the question of whether the National Gallery might be interested in some joint venture, perhaps through its extension department. Although nothing came of this, Annenberg visited the Gallery, attending dinners and openings, and remained in touch.

He also sought to help the Gallery obtain Thomas Eakins's *Gross Clinic*, then sequestered at Thomas Jefferson University in Philadelphia. Writing Brown, Annenberg called it "our greatest American painting" and remembered trying to purchase it years before at the urging of John Walker. The picture belonged in Washington, he insisted.[15] And he hoped to arrange at least for its exhibition there.

Some months earlier, in April 1980, Brown had dictated a memo quoting Walter Annenberg as saying that others must do their part to support the National Gallery, that the Mellons could not play the principal

role indefinitely.[16] Apparently Lenore (Lee) Annenberg, his wife, who was closely involved in many of the philanthropies, also thought the Gallery should have an acquisitions fund. But until then their gifts had been relatively small, five or ten thousand dollars, with the occasional loan of a painting for exhibitions. Annenberg was also a member of the Collectors Committee.

Notes in the archives of the National Gallery demonstrate the careful planning that went into the wooing of the Annenbergs. In October 1980 Annenberg met with Jack Stevenson, Paul Mellon, and Brown. Mellon had sent a letter outlining the campaign, and indicating his wish to have half of the fifty million dollars in hand before approaching some others.[17] His own gift, and pledges from Whitney and the Lila Acheson Wallace Foundation, had provided almost ten million dollars. An outline of the approach to take with Annenberg divided the Gallery pitch into need, method, and inducements, emphasizing an idealistic appeal that acknowledged the Gallery's unique role. Gallery officials hoped for a ten-million-dollar gift.

Annenberg, however, proved to be more frugal than expected. But he did donate two million dollars, a gift cited as centrally important for the launching of the campaign by trustees like Franklin Murphy. Annenberg explained his position in a telephone call to Brown in early November. He was, according to Brown's memorandum, apologetic, and hoped that he had not seemed too dogmatic at their meeting. He could not do more for the National Gallery, he explained, than he had done for the Met— where he had been a trustee. However, he was concerned about Mellon's reaction. Brown, in his memo summary of the conversation, replied that Mellon was touched by Annenberg's generosity, "without emphasizing it much. He [Annenberg] then repeated, perhaps a touch defensively, that there was absolutely no way he could abrogate his established pattern. He asked if PM thought he was being too rigid. I said that I was sure the ambassador would understand that PM believed that there is no institution in the United States that is quite in the same category as the National Gallery." Annenberg said he understood.[18]

There was, to be sure, something else that emerged from their talk— "the best thing to come out of it all," Annenberg declared: plans for a major dinner to honor Andrew W. Mellon. Brown agreed to Annenberg's banquet suggestion at once, and began working on it. Annenberg stressed that "it should be white tie, and I [Brown] ventured 'with deco-

rations.' Oh definitely with decorations," Annenberg replied.[19] The proposal undeniably suited the Gallery's culture of elaborate entertainment. Out of this conversation emerged the Andrew W. Mellon dinner, held biennially at the Gallery; the first one, in January 1983, also celebrated a gift of ninety-three works of art from Paul Mellon. This stately event would be attended, on several of its iterations, by the president of the United States, giving a speech of his own. White tie and decorations—newspaper reporters gloried in the cascading rainbows of medals adorning prominent guests—would, as Annenberg hoped, be the male costume of choice.[20] Brown himself "looked as if someone had sprayed him with 10 colors of silly string," one writer gushed.[21] Though presented as a people's museum, the lavish spaces of the East and West Buildings were cherished as settings for exclusive and privileged moments of self-indulgence. In this, despite its unique status, the National Gallery differed little from its sister institutions, and Annenberg was frank about the dinner's value for development purposes.

Meanwhile, Mellon and his associates were finding success in their canvassing, though it did take more time than they had imagined. In March 1985, almost five years after the campaign had begun, and one month before its scheduled ending, it was opened to the public at large for contributions. In a letter to more than thirty thousand recipients of Gallery publications, Brown requested support. "Not one penny will ever be used for anything except art acquisition," he promised.[22] The goal had almost been reached, $47.5 million of the $50 million. There had been fifteen gifts of more than a million dollars each, some from foundations, others from supporters like Robert H. Smith and his wife, Ian Woodner, the Sacklers, and Stavros Niarchos. Brown emphasized that the smaller contributions he was now soliciting, if they arrived by April 30, might be matched by the Andrew W. Mellon Foundation. "Here is a first-time-ever opportunity to express your appreciation," Brown wrote in his letter.[23] This was clearly an effort to give the local public a sense of ownership in what could well have been regarded as a millionaire's pursuit—the acquisition of great art.

The Patrons' Permanent Fund more than met its goal, thanks not only to individual donors but to foundations like the Ahmanson in Los Angeles and the Hallmark in Kansas City, dedicated for the most part to their own geographic areas. Franklin Murphy, for a time head of the Times-

Mirror Company in Los Angeles and earlier, chancellor of the University of Kansas, was instrumental in procuring these grants.

It was not long before significant acquisitions began to arrive in the Gallery, beneficiaries of the new endowment. The first purchase was suitably dramatic. Just months after reaching the fifty-million-dollar target (and subsequently hitting fifty-five million), the National Gallery paid a record price for an American painting, slightly more than four million dollars for Rembrandt Peale's portrait of his brother, *Rubens Peale with a Geranium*. Brown traveled to New York for the ninety seconds of bidding at Sotheby's, although he did not bid himself. "When the auctioneer identified the new owner as the National Gallery," wrote the *Washington Post* in a front-page story, "the standing-room-only crowd burst into applause." Never one to miss an opportunity, Brown responded, "Any donations will be gratefully received."[24] Afterward he paid tribute to the donors. The painting was "a gift to the nation from all the people who have contributed to the Patrons' Permanent Fund," including, he added, "many Washingtonians who gave an overwhelming response last spring when we canvassed for this permanent endowment for art acquisition."[25]

Over the next several years, a steady stream of artworks flowed into the Gallery as a result of this new spending power, paintings by Guercino, Rubens, and Guido Reni, among others. When privately purchased, the price of the art was never stated, in accordance with Gallery precedents, but the amounts were often in seven figures.[26] These were important additions to the collection, but with the fantastic rise in prices of the 1980s—just before the 1990 market collapse—interest on the endowment was usually inadequate to capture great masterpieces. Indeed, several years of accumulated interest might be required for just a down payment. In 1990, at the peak of the mania, John Hay Whitney's widow sold Renoir's *Moulin de la Galette* at auction for seventy-eight million dollars.[27] Two days earlier, at another auction house, van Gogh's *Portrait of Dr. Gachet* had been purchased for $82.5 million.[28] And there were now institutional competitors with access to far larger reserves, notably the J. Paul Getty Museum in California. The permanent hunger for collection growth required strategies beyond the simple raising of money. It meant the pursuit of collectors.

This, of course, had been the enormously successful pattern set in the Gallery's earliest years, when directors Finley and Walker obtained the

priceless collections of Widener, Kress, and Rosenwald. Matching these triumphs would have been difficult for any successor, and indeed Carter Brown's major failing, according to some of his most generous admirers, was in the pursuit of acquisitions. They argue, in effect, that planning great temporary exhibitions and attending to the growth of the permanent collection constitute a zero-sum game, and that Brown devoted too much time and energy to the one and not enough to the other.[29]

Sensitive to the complaint, Brown defended his record in various reports and public statements, over a long period of time. There is much evidence to support him. The cornerstone for this was, of course, Paul Mellon, whose art began to enter the Gallery significantly only after Brown became director. Retaining Mellon's confidence and sustaining his commitment to the Gallery was Brown's highest priority. Their relationship was crucial to the Gallery's welfare, and on the whole it seemed to flourish. Mellon had been responsible for Brown's 1969 elevation to the job and, despite occasional tensions and disagreements, supported him publicly throughout his tenure. Rumors floated, then and later, about rifts between the two, particularly during the last years of Brown's directorship. On more than one occasion, Mellon had expressed his concern that the blockbuster exhibitions might diminish interest in the permanent collections and distract the energies of the staff. His memoir, moreover, *Reflections in a Silver Spoon*, paid relatively little attention to Brown, expending more time and affection, as one commentator pointed out, on Prince, an Alsatian guard dog that was part of the security system.[30] Brown had privately expressed surprise at some of Mellon's statements and, while planning his own autobiography, suggested Mellon might have felt some rivalry with him. He was, Brown reflected, "a great friend to me," but not "a friend of mine."[31]

Nonetheless, Mellon voiced no open disagreement and gave the director a free hand on almost all professional matters. For his part, Brown expressed the utmost deference to his greatest patron. Indeed, attentiveness to Mellon's wishes permeated the entire staff. Inconveniencing or irritating him was a cardinal sin. The key fact was that Brown retained the loyalty of his most important donor and reaped the rewards, in terms not simply of money but of extraordinary art.

Paul Mellon began his remarkable set of gifts early in Brown's administration. In September 1970, he purchased for the Gallery Cézanne's *The Artist's Father*, the most important addition since his sister's financing of

Leonardo's *Ginevra* more than three years before.[32] Rumors placed the cost at well over one and a half million dollars. Characteristically, Brown enthused, "It's a powerhouse. For sheer scale, intensity and impact, I would put this painting up against anything in our collections."[33] There were some precedents for this generosity. In 1964, Paul and Ailsa had presented the Gallery with a group of French paintings, and Paul had made a few other gifts as well; in 1965, for example, he had donated a large group of paintings by George Catlin of Native Americans, with the request that they be lent liberally. But it was not really until the 1970s, starting with the Cézanne, that Paul Mellon's gifts reached a truly wondrous level. They would include other Cézannes, as well as paintings by Gauguin, Degas, Manet, and Canaletto. In January 1983, Paul and Bunny Mellon, in one single gift, presented fifty paintings, twenty-four pieces of sculpture, and nineteen prints and drawings, among them works by Monet, Bazille, Cassatt, Seurat, Vuillard, and van Gogh.[34] Three years later, in July 1986, the Gallery announced the gift of 186 works of art from the Mellons, which almost immediately went on view as a special exhibition.[35] This assemblage followed upon Paul Mellon's retirement from the board. And even more would come in the next several years. All told, by the time Brown left his directorship, Paul Mellon had enriched the Gallery with more than a thousand works of art, in addition to moneys donated for the purchase of other pieces and endowments for CASVA, and, of course, the East Building.

There were few, if any, collections available with the range and quality of Paul Mellon's. John Hay Whitney, former trustee, fellow Yale alumnus, and good friend of Mellon, came close in quality. His estate presented the Gallery with nine paintings, including several masterpieces, but it also distributed works of art to the Metropolitan, the Museum of Modern Art, and the Yale University Art Gallery.[36] More significantly, some of the greatest pieces were retained by the family, to be consigned to auction.[37] The Mellon collection was also divided, of course, among the Gallery, the Virginia Museum of Fine Arts, and the Yale Center for British Art, but Mellon attempted to make the divisions appropriate to the various collections.

Carter Brown could take little credit for the Whitney gift; its origins went back to an earlier era. But he was an active suitor when it came to the art of another storied American millionaire, Averell Harriman. The benefaction came early during Brown's tenure, in 1972, when the former

ambassador and governor presented the Gallery with twenty-three pictures, mainly impressionist and postimpressionist. Works by Cézanne, Picasso, Seurat, and Matisse, some quite modest, they had been gathered by Harriman and his late wife, Marie, in New York, and were meant to join the new National Lending Program and be made available for borrowing by other American museums. Viewed by some, in Paul Richard's phrase, as a "minor league system, a place for relatively recent pictures . . . not yet ready for permanent installation," the lending collection's quality was immediately raised by the gift, and to an impressive level.[38]

"The Harriman gift is quite a haul," Brown declared. He was not the first National Gallery director to court Harriman. In 1960 a larger group of Harriman artworks was featured in the first of a series of exhibitions devoted to great American private collections.[39] John Walker initiated it, perhaps hoping for largesse from the featured collectors. Little came, however, from subsequent collector shows, including those featuring the collections of André Meyer of New York, Leigh and Mary Block of Chicago (both in the Walker era; described in chapter 2), and Morton G. Neumann, also of Chicago (in 1980, during Brown's directorship). Offering a podium to out-of-town collectors made sense. "There are things that Neumann owns for which we'd give our eye teeth," a Gallery official told Paul Richard of the *Post*. "You will sense in this exhibition our recognition—and our thirst."[40] A gift of just two or three pieces would justify the show. Nothing came from the Neumanns, though years later Brown was still voicing hope.[41]

There were certainly options and strategies available to Brown that enabled the Gallery to encourage donors with names less famous than Mellon, Whitney, and Harriman, and with collections that were smaller or more focused. The decision to acquire twentieth-century art and the opening of the East Building created an entirely new class of prospective donors, and Brown, along with his curators, set about cultivating them. In 1978, upon the opening of the East Building, the Gallery sponsored a show entitled *Aspects of Twentieth-Century Art*, perhaps, Paul Richard suggested, "a glimpse" of the building's future. Visitors should examine the names of the art's owners, Richard advised; they represented "a tense, ongoing courtship." These works of art "have not been pledged or promised, but with maximum politeness, and with the fervent crossing of curatorial fingers, they are all being eyed for eventual inclusion" within the permanent collection. There was a quid pro quo, Richard explained;

the Gallery conferred prestige, and the potential price tags—or deduction values—of the artworks would undoubtedly be enhanced by their exhibition.[42]

Under Brown's direction the Gallery also began experimenting with novel and untested arrangements in the interest of important acquisitions. This became apparent with the quest for the Meyerhoff collection. Robert and Jane Meyerhoff lived in the Baltimore area, and had been generous philanthropists to a set of local institutions. Meyerhoff, an MIT graduate, had made a fortune in construction and, with his wife in the lead, had assembled an impressive group of post–World War II paintings and drawings by prominent American artists. Jasper Johns, Ellsworth Kelly, Roy Lichtenstein, Robert Rauschenberg, and Frank Stella dominated the assembly. Exactly when the Meyerhoffs began to connect with the Gallery is unclear, but it was their affinity with Jack Cowart, curator of twentieth-century art, that proved most significant. On meeting Cowart, soon after his arrival in Washington from the St. Louis Museum of Art, they "hit it off," according to Jane Meyerhoff. "Our relationship with the National Gallery before Jack arrived was that we didn't have one—except to visit it."[43] The National Gallery was not the first museum to express interest in their collection. Robert Meyerhoff had been president of the Baltimore Museum of Art, and that museum naturally enough had entertained hopes of being the recipient.[44]

Cowart visited the Meyerhoffs' collection and was enthusiastic about it. There was one catch, however. The couple lived on a horse farm in Maryland (Meyerhoff raced horses) and wanted the art to remain within a country museum, operated by a foundation. Could something be done that would protect their plan, yet give ownership to the Gallery? Cowart conferred with Brown, his director, and a solution appeared, which was announced in early 1987. Upon the death of the Meyerhoffs, the paintings would in fact be given to the National Gallery. They could be lent or exhibited. But except for that they would remain in the Meyerhoff home. This museum, in some ways a satellite of the National Gallery—the first off-site operation the Gallery possessed—would be maintained by the Meyerhoffs' foundation. The National Gallery "gains all the privileges of ownership without all the responsibilities," Jo Ann Lewis wrote in the *Washington Post*. For their part, the Meyerhoffs were pleased that their art would gain a large, urban audience while largely remaining in the rural setting that they enjoyed. A provision ensured that if the foundation

trustees decided to close the museum at some future point, the art would revert to the National Gallery.[45] Cowart, the main connection, paid tribute to Brown's "vision and enthusiasm," for he had convinced his board that the arrangement was manageable and appropriate.[46]

There were critics, to be sure, of several kinds. The Meyerhoffs had, at just about the same time, contributed several million dollars toward the purchase of Barnett Newman's fourteen-painting series *Stations of the Cross*, and some saw the transaction as "earnest money" toward the larger arrangement, although Gallery officials denied this.[47] Still sharper was the response from Baltimore. Weeks before the announcement, in early December 1986, Brown was sent a copy of a letter from the governor of Maryland to the Baltimore Museum of Art's trustees.[48] Upset at reports that the Meyerhoff art was going to Washington because museum trustees had not done enough to keep it in Baltimore, the governor argued they had made every effort to do just that, for ten years. He, museum director Arnold Lehman, and the museum's president had joined forces in appealing to them, the governor even hosting the Meyerhoffs in his office and proposing a new modern art wing to be named for them. Despite all this, they had decided to go with the National Gallery. Brown, reading the letter, wrote Clement Conger of the State Department, who had sent it to him, "It is always sad to see this kind of hand-wringing." However, he pointed out, retaining the collection, physically, in the Meyerhoff house, not far from Baltimore, "should serve that community as well."[49]

Coming to this unusual agreement with the Meyerhoffs, in the interest of acquisition, seemed to open Brown and the National Gallery to other adventurous possibilities, although these did not always work out well. At some point in the 1980s, Brown took his chief financial officer, Daniel Herrick, on a trip to Pasadena for a meeting with collector Norton Simon and his wife, Jennifer Jones. Brown proposed that the National Gallery administer the Simon collection, leaving it in California but pursuing an active borrowing (and lending) program. This would enrich museums on both coasts. According to Herrick, Jones found the proposal intriguing but Simon did not.[50] There were other meetings as well, but Simon was unwilling to confront the inevitable loss of control. The Simon Museum remains an independent institution today, although from time to time there have been discussions about creating a special relationship with the nearby Getty Museum.

There would be no National Gallery West, but in June 1988 Brown dic-

tated a memo that described a project centered on the University of Miami. A Miami neurosurgeon, Philip George, had called to say that he and a group of friends were interested in establishing a new art museum at the university, reflecting the growing wealth of southern Florida and the ambitions of its resident collectors. They wanted, however, to give their works of art to the National Gallery, on the condition that it would lend them back. The group included Marty Margulies ("whom we have tried to cultivate," Brown noted) as well as Phil Frost, who "sadly" had given his collection of Russian avant-garde art to the Hirshhorn.[51] Brown continued to be preoccupied by Margulies, aware that he was interested only in the "big time." The National Gallery offered that possibility. (Though Brown did not mention it in his memo, the University of Miami already possessed an art museum, the Lowe, which had been accredited by the American Association of Museums in 1972. In 1987 the state of Florida designated it a "major cultural institution.")

His interest whetted, particularly by some of the potential donors, Brown indicated that his trustees disliked the idea of branches, but he mentioned the recently concluded Meyerhoff agreement, and also the National Lending Service. He invited some of the principals to a Washington lunch (not attended by Gallery president Jack Stevenson), and afterward wrote associate counsel Elizabeth Croog, outlining a possible arrangement.[52] The university wanted to host a major art museum capable of attracting important collectors; this was a late venture into the field, Brown noted, but then so was the National Gallery itself. The university would raise twenty-five million dollars over the next four years to construct the building and would undertake to solicit key art collectors. The National Gallery would advise on technical, programmatic, and construction issues. Title to the art would be vested in the trustees of the Gallery; the works would be accepted primarily for display in Miami but would be made available, from time to time, for exhibition at the National Gallery or through its National Lending Service. The Gallery would be responsible for conservation, but not for security in Florida. It would be represented on the new museum board, but would not hold a majority of the seats. The emphasis would be on Latin American art, and, in the absence of a single donor, the museum could be named the North-South Museum at the University of Miami, an affiliate of the National Gallery of Art. This was approximately where things stood as of the end of July 1988. Consulted, Jack Stevenson expressed some concern that the

National Gallery might be seen as the bad boy in Miami, threatening the city's arts establishment.[53]

After a second meeting between Gallery officials and University of Miami trustees in October, Jack Cowart flew to Miami to visit several private collections. The following March, Brown, his deputy director Roger Mandle, and other Gallery officers met in Miami with university officials. One month later, in April 1989, a formal proposal was sent on to Washington describing creation of the National Gallery of Art at the University of Miami, with a concentration on post–World War II and Latin American art. The University of Miami's board of trustees was soon to hold its annual meeting. Brown told Gallery trustee Robert H. Smith that a decision should be made soon, as one of the Miami people was coming up within the week for talks with him. Brown was cautious. His "instincts," he told Smith, were that the time and energy needed to administer the new institution could constitute a drain on other Gallery projects. But in view of all the effort already invested, a systematic evaluation was appropriate, and he had requested one from Mandle.[54]

The Mandle memorandum recommended against a formal National Gallery presence at the University of Miami. Too many other things were happening in Washington. What could be offered were the options available to other institutions—participation in the National Lending Service, some cooperative arrangements for exhibitions, special educational programs along with curatorial and administrative advice. These could be the basis for a fruitful and supportive relationship. More than that, the Gallery could open its own space for a major exhibition of what Miami area collectors had amassed. In return for lending visibility to their fundraising and prominence to their support, the Gallery would hope for introductions to major Miami funding sources and collectors. This would not be "establishing affiliate relationships," as Robert Smith feared, but merely broadening programs already in place. While in the long run some substantial works of art might come from affiliation, the cost was simply too great—the meetings, telephone calls, correspondence, special events, regular trips—which presumably the deputy director's office would have to coordinate, to say nothing of burdens on the director, the education department, and other parts of the museum.[55]

A telephone conversation between Brown and Robert Smith endorsed these conclusions.[56] Smith argued that the Gallery commitments entailed in formal affiliation would be too numerous and specific given the uncer-

tain return. Staff would end up putting in "ten times" the time and effort expected and inevitably would encounter frustration. They "were asking us to invest for the future; we were not long-term investors." Were fifty or seventy-five first-rate artworks to come right away, the project might be reconsidered. In their absence, the decision to opt out made the most sense. So after almost a year of discussion and negotiation, the proposal was basically buried.

There were some victims along the way. Ira Licht, who had directed the university's Lowe Art Museum for ten years, resigned in April 1989, believing he had been bypassed in the lengthy discussion. And in May the *Miami Herald* published a detailed recounting of the episode, realizing Stevenson's fears that there could be negative repercussions from any kind of agreement.[57] Broadly accurate, if occasionally misleading ("the new campus museum would become the first satellite operation"), the article quoted Brown as saying it was "unlikely" such a relationship could be sustained, with a federal institution singling out one university for a partnership role. The president of the University of Miami indicated that fund-raising efforts to construct a new building, either alone or with another institution, would continue. Gail Meadows, the story's author, ended on a cautionary note. She noted the recent Meyerhoff gift. "To some," she wrote, "the National Gallery's visit smacks of a raid, a takeover in a town that has made international headlines the last two years with its yeasty cultural zest. They are not alone" in their fears, she added, referring to a recent Hilton Kramer piece in the *New Criterion* that was highly critical of the National Gallery's recent efforts to lure art from across the country. "It should not be the role of a National Gallery to deny to communities elsewhere in the nation the cream of their artistic resources," Kramer had declared.[58]

Kramer's comments came amid what would be the most aggressive campaign for acquisitions of the entire Brown era, an unprecedented effort to gather works of art from throughout the United States as part of an elaborate celebration of the National Gallery's fiftieth anniversary, to take place in 1991. Indeed, the University of Miami proposal may have been doomed by the energy being poured into the anniversary project at just the same time. Gallery officials did not want major distractions, or any loss of momentum, as they pursued possible leads.

There had, as previously noted, been similar celebrations at the Gallery, notably, in 1966, at its twenty-fifth anniversary. Among other events,

medals were struck at that time and given to twenty-five educators. Indeed, there was a mild obsession with anniversaries: the tenth and the fifteenth had also been given special attention. But the fiftieth would be marked by a far more ambitious effort to honor the massive expansion, physical and intellectual, that had taken place. In effect, this would be a commemoration of the Carter Brown–Paul Mellon era; Brown had directed the Gallery for twenty-two of the previous twenty-five years, and Mellon had served as president or board chair for most of that time. Planning began formally in 1986, when Alfred C. Viebranz, a corporate executive who had been serving as the Gallery's corporate relations director, was named as coordinator of the special projects connected with the anniversary.[59] Robert Smith chaired a special fiftieth-anniversary committee on behalf of the trustees. The development department moved forward with its carefully researched expertise. And the long campaign began.

The quest for art objects (and the raising of some five million dollars specifically earmarked for anniversary purchases), reflected a number of long-term goals. First, filling in some of the many holes in what was still a relatively young collection. Second, identifying, both inside and outside Washington, committed supporters, some of whom had given things before, and some of whom were entirely new. Third, expanding the institution's stakeholders, individually and geographically, well beyond its original inner core, thus reinforcing the direction of newer patron and membership groups like the Circle. And finally, acknowledging the increasingly central role twentieth-century art was playing in the permanent collection. It was, however, an effort bound to attract criticism, as it siphoned off some local treasures that museum directors and curators elsewhere had long been eying. Shrugging off such protests, Gallery officials insisted they were not competing with other places, merely offering patriotic collectors the chance to do something for the national art museum and share in its civic ownership.

Brown committed himself personally to the effort, tirelessly talking up his institution throughout the country, taking a far more active role than he had during the Patrons' Permanent Fund drive. When it came to major gifts and close friends, he was known to be somewhat diffident. His own giving had been comparatively modest. One colleague likened him to an adolescent boy admiring a girl but finding himself unable actually to ask her for a date. Curators would, in such cases, need to take up the slack. But he could, in fact, be extraordinarily effective going after

artworks, clinching deals negotiated by others. This was true even with intimates. Thus Senator John Heinz, perhaps Brown's closest Washington friend, presented an impressive portrait of Rear Admiral George Melville by the great Philadelphia painter, Thomas Eakins.[60]

An even greater gift came from another Washingtonian. In the period after he had separated from his second wife, Brown had been seeing much of Pamela Harriman; the two were something of a couple in Washington for several years. Fourteen years younger, Brown apparently enjoyed the trappings of wealth that Harriman's lifestyle displayed, luxuries that he valued but did not want to pay for himself. Harriman, who would be appointed ambassador to France by President Clinton in early 1993, was a legendary fixture on the international scene. Her first marriage to Randolph Churchill, her romantic entanglements with a series of famous and powerful men—ranging from Harriman, Baron Elie de Rochschild, Gianni Agnelli, and Stavros Niarchos to John Hay Whitney and Edward R. Murrow—and her later marriages had together brought her money and power. Glamorous, well informed, cosmopolitan, witty, active in Democratic Party politics, she provided companionship and some level of financial patronage to Brown, who told one interviewer that he had hoped to inherit her Middleburg, Virginia, horse farm. He went on to praise her intelligence, her fund of knowledge, and her conversation. There was even talk of marriage, Brown confided. This would not happen. But Pamela Harriman would dispense one significant art trophy to her good friend.[61]

Pamela's fifteen-year marriage to Averell Harriman had ended with his death in 1986. The couple had given important artwork to the National Gallery, and Averell Harriman had been an enthusiastic supporter of the lending collection. One of their greatest pictures, Vincent van Gogh's *Roses*, remained in Pamela Harriman's possession, however. Brown prevailed on her to give it to the Gallery—apparently to the consternation of her late husband's heirs—and it became the first still life by van Gogh to enter the collection. Averell Harriman "hoped I would give it to the National Gallery," Pamela Harriman declared. "I think it very important a work of art of this quality is kept within the United States."[62] A detail from *Roses* adorned the cover of the elaborate catalog commemorating the anniversary gifts and their 1991 exhibition.[63]

Brown himself gave a pen-and-ink study of an eagle, by Titian, and Gallery curators or former curators, David Rust, John Wilmerding, and

Andrew Robison among them, made other gifts. Robison, the curator of prints and drawings, was the most active curatorial presence in the campaign, and was thanked profusely by Brown for his leadership and for personally cultivating so many donors. The research that Robison coordinated was crucial to the plan, as he told Brown it would be at the start, in 1987 or so. It was necessary to find out what people had that the Gallery wanted, and how they might be persuaded to give things up. The Gallery general counsel at this time, Philip Jessup, provided advice. Partial or promised gifts offered a way out for those unwilling to part outright with precious possessions. Wish lists and donor files multiplied. Curators discussed their needs. Long before the effort went public, visits were made to possible benefactors. Robison himself believed that while the quality of gifts needed to be high, the Gallery had to be inclusive, to move across a variety of media, and to culminate it all with an exhibition that would celebrate the venture.[64]

The first order of business was, of course, the Gallery's principal donor. Just a few years earlier, on the occasion of Paul Mellon's retirement from the board of trustees, the Mellons had presented several hundred works of art. But there remained extraordinary things in Mellon hands, and the first ask for the anniversary campaign was to secure these. Putting their heads together, the curators assembled a photo archive of Paul Mellon's private holdings—in London, New York, Washington, and Antigua. And then they drew up a list. Robison described, years later, the meeting held in Brown's office, with Mellon, Brown, and Robison in attendance. Brown described the campaign, and Robison made the pitch, saying that the curators hoped Mellon might contribute something in each of the fields he collected. Mellon asked how many fields the staff thought he collected in. Robison told him eight and, after Mellon inquired about what they thought worthy of receiving, handed him the list. According to Robison, silence followed as Mellon glanced through it, and made occasional noises to himself. The list was extensive and included van Gogh landscape drawings, the great Cézanne *Boy in a Red Vest*, illustrated books (among them a copy of the *Nuremberg Chronicle*), some British paintings not yet pledged to Yale, and other prizes. In the end Mellon put the list in his pocket and murmured, "I don't think there will be any problem." The curators were delighted, and Mellon was, as the results would show, as good as his word.[65]

Not everything the Mellons had was going to the National Gallery.

In November 1989, around the time of the discussion in Brown's office, a series of Mellon-owned artworks would be sold by Christie's in New York and London. The auctions had generated considerable publicity with predictions that they would bring in more than a hundred million dollars.[66] Art prices had risen dramatically. Some of the paintings being sold had already been donated to the Yale Center for British Art; the proceeds from these would establish an endowment there for acquisitions. And Paul Mellon insisted that he and his wife would continue both to maintain their collection and to support the cultural institutions they had been sustaining.

The paintings to be sold in New York included Manet's *Rue Mosnier, Paris*, purchased by Mellon thirty years earlier for a little more than $316,000 at the Jacob Goldschmidt sale. It was bought by the J. Paul Getty Museum for a staggering $26.4 million. "Lucky us—we never dreamed we would have a chance at this painting," John Walsh, the Getty director, told a telephone caller. "We envisioned it hanging someday in the National Gallery in Washington. We are ecstatic. There could hardly be a more important Manet."[67]

While the loss of the Manet might have depressed some at the Gallery, the Mellon auctions and benefactions elsewhere could in fact be used to advantage during the anniversary campaign. They enabled Gallery representatives to tell possible benefactors that they understood existing commitments, and to inform sister institutions that they respected their agendas. Their own greatest benefactors were giving art elsewhere and retaining important things for their own purposes. In going around the country, Robison said he checked in with corresponding curators, to let them know he was in town and to reassure them about his intentions. They were after only a slice in the larger pie, one or two works from any given donor, and some of the things being sought might look better in the context of the National Gallery's collection than in a local museum. He encouraged people to consider giving something wonderful to the campaign, but just one thing. There was a floor, however; nothing would be accepted whose total value was less than fifty thousand dollars. Some did treat him as a carpetbagger, Robison admitted, but these were, after all, private possessions that the Gallery sought, and the owners retained freedom of choice.[68]

This reasoning did not, of course, stop all protests, as some critics and local museum directors fumed over what they considered to be art raids.

But the aggressive attempt to locate a new generation of donors was important in defining a post-Mellon era for the Gallery. In the opinion of some on the staff, the Gallery had been too reticent about seeking gifts in the past, too gentlemanly and reserved. This was an inheritance from an older day. There were many, too, who continued to assume that any acquisition need would be met by Paul Mellon writing a check. But that was not how Mellon operated, and the anniversary campaign offered an opportunity to make this clear.

The anniversary campaign was also aided by a significant change, at first touted as temporary, in federal tax policy. A relief envelope of twelve months opened up in the 1986 Tax Reform Act, legislation blamed for devastating the ambitions of American museums.[69] No longer able to deduct the appreciated value of donated art, and lured by huge auction prices, donors had dramatically cut their museum giving. The American Association of Museums reported a 47 percent decrease in museum gifts during the four years following the act's passage. The National Gallery of Art experienced an 86 percent decline in the number of gifts between 1986 and 1987. As a result of intense pressure by museums and art organizations—including the National Gallery of Art—Congress allowed a one-year return to the old rules for 1991, and the sudden rise that followed convinced legislators to extend it further. Happily for the National Gallery, this legislative change coincided with its anniversary campaign; it reported receiving some 1,514 objects in 1991, a huge gain over the 205 objects donated in 1990.[70] Whether the anniversary project or the tax relief was the principal cause remains unclear. Brown received some credit from other museum directors, like David Ross of the Whitney Museum of American Art, but a spokeswoman for the National Gallery insisted that "as a Federal employee" Brown "had not been permitted to lobby Congress."

The triumphant exhibition *Art for the Nation*, featuring more than three hundred donated works (more than five hundred were given), opened March 17, 1991, accompanied by an elaborately illustrated and well annotated catalog. It had been preceded, months earlier, by indications of what was to come. In December 1990, for example, the National Gallery announced that it had purchased at auction the previous summer (for five million dollars) a great Spanish baroque painting, Jusepe de Ribera's *Martyrdom of Saint Bartholomew*. The money came directly from the fiftieth-anniversary committee. The gift could not be made public

until an export license had been issued by British authorities. "We'd been holding our breath since the middle of July and had become quite blue," Brown told the press.[71]

The Ribera would be in the exhibition, of course, but most of the display consisted of art directly donated or promised. Washington reviewers were generally exultant, focusing, as might be expected, on the splendid Mellon gifts. "One expects on such occasions," Paul Richard wrote, likening the event to a family birthday party, that "Daddy will provide the most impressive gifts of all, and that's what happens here."[72] There were more than 160 donors, but the range and quality of the Mellon offerings was stunning: a Cézanne sketchbook, George Stubbs's *White Poodle in a Punt*, the *Nuremberg Chronicle*, Verlaine's *Parallèlement*, the seminal *livre d'artiste* illustrated by Pierre Bonnard, along with the preparatory drawings, the Degas waxes that made the Gallery into the world's greatest repository for Degas sculpture. And these were just highlights.[73] There were also ten bent-metal Calders, two Rothkos, Whistlers, and works by Winslow Homer, Maurice Prendergast, and Edouard Manet, all of which came from one or both of the Mellons.

There were other things to marvel at as well, a number of them gifts from famous names—a Thomas Cole Catskills landscape from Mrs. John D. Rockefeller III; a much admired Toulouse-Lautrec, *Marcelle Lender Dancing the Bolero in Chilperic*, from Betsey Cushing Whitney, in honor of her late husband and Gallery trustee, John Hay Whitney; a Pissarro from Mr. and Mrs. David Rockefeller. But for some reviewers the novelty lay in encountering a new generation of collectors and a more latitudinarian approach to the collection. More than half of the gifts were twentieth-century pieces, and there were quite a few photographs, by figures like Edward Weston, Walker Evans, Paul Strand, August Sander, and Ansel Adams. "You can sense the old guard changing—the superrich retreating, and a new breed of collectors emerging to replace them," wrote Richard.[74] Among them were scholars, dealers, corporations, and artists or their families.

While the exhibition was dramatic, it capped some longer-term trends. Gallery curators and Brown had been working for some time to procure these kinds of gifts. Over the previous few years, important work had come from donors like Rita Schreiber (widow of California entertainment mogul Taft Schreiber), the Lionel Epstein family (collectors of Edvard Munch), the Cafritz Foundation, and others. The Cafritzes and

their foundation (on whose board Brown sat) had funded the Henry Moore outside the East Building in Brown's early years as director; in 1984 they contributed to the purchase of Veronese's *Martyrdom and Last Communion of St. Lucy*, one of the major old masters to enter the collection during that period.

Special effort had been put into enlisting the support of twentieth-century artists; contributors included Claes Oldenburg, Roy Lichtenstein, Richard Diebenkorn, Ellsworth Kelly, the widow of Barnett Newman, John Marin's son and daughter-in-law, and Milton Avery's widow. Robert Frank presented contact sheets, work prints, thousands of rolls of film, and vintage photographs.[75] The Mark Rothko Foundation, with the endorsement of the artist's children, had been associated with the Gallery since the early 1980s and continued to make gifts. The artist Jacob Kainen, along with his wife, offered a series of prints and drawings, dating from the fifteenth century to the twentieth. While twenty-one states were represented by gifts of art or cash, more than half the donors, as Richard pointed out, lived in Maryland, Virginia, or the District of Columbia. The Brown directorship, he noted in his review, despite its great exhibitions, extensive publications, and devotion to scholarship, "long has been regarded as somewhat less successful in adding works of art to the permanent collection." The birthday show "will dim that complaint," he predicted.[76] Washington journalists ran interviews with some of the new Gallery patrons, who described how they had come to make their gifts. Janice H. Levin of New York, who gave a Monet, *The Garden at Argenteuil*, had become involved with the Gallery in part because her friend Ian Woodner, a major Gallery benefactor who had assembled an extraordinary drawing collection, confessed that participating in loan exhibitions was fun. The Ganzes, of Los Angeles, who expected that most of their American paintings would go to the Los Angeles County Museum of Art, nonetheless found the National Gallery "in a class by itself." "It was a compliment to be included," Jo Ann Ganz declared.[77] Others were driven by patriotism, gratitude, and admiration.

Some New Yorkers were impressed, even intimidated by the effort. David Tunick, a New York art dealer, told Grace Glueck of the *New York Times*, "They came into my gallery, pointed to an Annibale Carracci drawing, and said, 'That's it.'" Tunick, said Glueck, was "not describing a robbery but a donation." This was Tunick's "contribution" to the anniversary campaign. Raking in 550 works of art, the National Gallery was

demonstrating its clout, "a patriotic persuader that gives heartburn to officials of less well-connected institutions." Glueck's article was peppered with headlines like "Hard Sell in Kid Gloves" and "Making Out Like, Well, a Bandit." Carter Brown, she confided, seemed "to enjoy the role of a pitchman," promoting his museum right in the heart of the Metropolitan Museum's neighborhood. "Stumping the country, Mr. Brown and his aides are highly skilled at conveying the impression that the gallery is America's premier museum." Met officials refused to comment on the "incursions," but "several local collectors" confessed they felt more welcomed by the National Gallery than the Met. "You call Carter Brown or Andrew Robison and they call right back," said Peter Josten, a New Yorker who contributed a sixteenth-century Italian drawing. "The Met is so huge and so hard to connect with." Another donor, an art dealer, expressed her delight at the dinner invitation and the catalog illustration, "We've given things to the Met, the Modern, the Whitney and the Brooklyn Museum, but no one else has made this much of a fuss." Robison, said Glueck, allowed that "things could get sticky" if local institutions wanted the same thing the museum had gotten, and sometimes joint agreements or other arrangements were worked out.[78]

Michael Brenson, reviewing the exhibition for the *New York Times*, was more strident than his colleague. Paying tribute to the range and importance of the art on display, and to the National Gallery's need to raise money for its acquisitions, Brenson also observed that it "wants visitors to believe in its formidable ability to acquire, in its ability to accumulate chips that it can cash in when it pleases, and in its capacity to succeed wherever it makes a commitment." He found the "uneasy blend of serious connoisseurship and flagrant self-promotion" to be troubling, and worried about the way the Gallery had been courting collectors. "It has exhibited private collections of uneven quality and even allowed collectors to write the catalogues for their shows." Referring specifically to earlier shows featuring collectors Jo Ann and Julian Ganz, the Manoogian Foundation, Walter Annenberg, and Sarah and Lionel Epstein—all donors to the current exhibition—Brenson asked if a museum was "ever justified in renouncing its independent curatorial voice, even if doing so encourages collectors to donate work?"

Most of all, despite his tributes to the Mellon gifts and a number of old master pieces, Brenson was upset by the Gallery's refusal "to engage, through contemporary art, the messy, conflicted, dynamic side of con-

temporary life," which it would need to do before it "truly earned the right to be considered America's national museum." He complained that the "weakest part of this exhibition is the contemporary art," pointing to work by Malcolm Morley, Susan Rothenberg, and Sandro Chia as examples. These suggested no coherence to programming in this area, and a "craven" ambivalence about plunging into its maelstrom. To specify his charges of complacence and self-satisfaction, Brenson singled out for attention the exhibition's prominent placement of Albert Bierstadt's *Lake Lucerne*, a rediscovered canvas just donated to the Gallery. It was positioned at the exhibition entrance. Bierstadt, Brenson charged, "painted an idealized, fictional America—polished, accessible, Edenic." Featuring the painting in this manner meant the Gallery was "inevitably indicating its attraction to Bierstadt's seamless, untroubled, almost public-relations style."[79]

Brenson's assault was singular in a number of respects, overstated, and hostile in a way that some in Washington associated with New York resentment generally and the *New York Times* specifically. No one denied that exhibitions like this were uneven, and that some of the gifts may have reflected marginal tastes, particularly in the contemporary area. But seizing upon the display of private collections (some of which had been shown in other museums throughout the country, including the Metropolitan Museum of Art) as a pretext for expressing anxieties about curatorial independence, and brooding about the serenity of Bierstadt's *Lake Lucerne* as a political metaphor, exposed some strong personal antipathies. There were indeed others critical of the Gallery's acquisitive aggressiveness, although some of them, like Hilton Kramer, could not be said to share Brenson's attachment to the contemporary art scene.

Brenson's critique of the Gallery's ambivalence toward contemporary art, however, may have found some sympathy among Gallery curators trying to push the institution onto a more adventurous course, both in collecting and exhibiting. Far less knowledgeable about, or sympathetic to, recent art, and joined in this by his vital allies in the Department of Installation and Design, Brown was sometimes reluctant to follow his more ambitious curators when they sought cutting-edge works reflecting recent taste. A number of Gallery trustees were also skeptical, even about icons like Barnett Newman and Mark Rothko. The acquisition of Newman's *Stations of the Cross* had seriously divided members of the board.[80] In view of all this, the National Gallery's assemblage of recent

work, acquired in the few short years since its policies had changed, had gained it some credibility among collectors of contemporary art.

Even more compelling were the quiet negotiations going on with collectors Herb and Dorothy Vogel, whose extraordinary gift of minimalist, postminimalist, and conceptual art would be announced the following year, another coup for the Gallery's curator of twentieth-century art, Jack Cowart.[81] The retired postal clerk and his wife, a retired reference librarian, had assembled more than two thousand works of art. "We've never been able to save," declared Dorothy Vogel. "We've always spent our money on art. Now we live on my pension, and Herbie spends his on art."[82] The Gallery managed to put together enough money to purchase an annuity for the couple, which promptly went into the purchase of still more art. The story drew national attention, and the Vogels enthralled Brown, despite the fact that some on staff found the contemporary material unfathomable.[83] This acquisition, and establishment of the Gemini G.E.L. Archive, documenting the artists' workshop and print publisher that had been created in 1966, demonstrated a more audacious contemporary program than critics like Brenson would admit. The 1984 Gemini opening was attended by more than a dozen artists—including Ellsworth Kelly, Jasper Johns, and Robert Rauschenberg—the first time this had happened in Gallery history. They were feted by the Meyerhoffs at their farm the next day.[84] Cowart and Ruth Fine, the curator of modern prints and drawings, had to struggle against indifference and even some hostility to expand the Gallery's holdings in this area, but they managed to do so.

Among the art collectors apparently represented in the anniversary show were the Annenbergs, credited with the gift of five drawings. These ranged from a sixteenth-century pen-and-ink by Martin van Heemskerck to two Picassos. In fact, as a Washington newspaper pointed out, the Annenbergs had given, not the art, but the money to buy it. Nothing had come from their collection, and despite their five-million-dollar gift in 1989, they constituted one of the great disappointments of Brown's last years and perhaps the only low moment of the birthday campaign.

Walter Annenberg professed great affection for Brown. The two exchanged notes over many years, Annenberg advising his younger friend at one point that his diplomatic skills suggested the possibility of becoming an ambassador. Brown dismissed this thought by saying he was happy in his current position, adding that one of the great posts, such as

that held by Annenberg in London, "I simply never could afford." But he thanked Annenberg for the thought (apparently put in his ear by Dillon Ripley) and ended, "I cannot begin to tell you how much it means to me to think of your continuing friendship."[85] Brown continued to be effusive in his letters. In December 1987 he wrote a tribute, responding to a request from Lee Annenberg, to be placed in a special book celebrating Annenberg's eightieth birthday. He praised Annenberg's capital gift for the Patrons' Permanent Fund and his invention of the Andrew W. Mellon dinner. "Your statement then of loyalty as a citizen, and admiration for what Paul and his family have done, still rings in my ears."[86]

At other points in their correspondence, Annenberg urged Brown to be as friendly as possible with the Met. In a memo summarizing a telephone call, Brown noted Annenberg's comment that "Philippe [de Montebello] could be difficult." Brown declared that the Gallery had tried to be cooperative, and the two museums would be sharing several shows during the coming year. "He seemed pleased," Brown wrote.[87] That same spring of 1986, Brown saw Annenberg at the White House, where the philanthropist was receiving a Medal of Freedom from President Reagan. He reiterated his enthusiasm for showing the Annenberg collection at the National Gallery, an effort that Brown had been pushing since the 1970s. Nothing had yet come of that, but Annenberg did lend three Gauguins for exhibition at the National Gallery and the Art Institute of Chicago.[88] And in June 1988, pleased with the Gauguin show, Annenberg declared the National Gallery to be one of three possible museum destinations for his collection.[89]

In July 1988, Brown learned from his curator of exhibitions, Dodge Thompson, that the Philadelphia Museum of Art was planning an exhibition of the Annenberg collection for the following year. Joseph Rishel, the chief curator, was already at work on the catalog. It all stemmed from a conversation Annenberg had with director Anne d'Harnoncourt in the spring of 1986, about the same time Brown was pushing a Washington venue. He promised Philadelphia the show, but the itinerary would soon be expanded.[90] "You may have known about the exhibition but it is news to me," Thompson remarked.[91]

Brown did know of the plans because he had been in rather extended conversations with the Annenbergs about the fate of their collection for some time. In a lengthy letter to both Walter and Lee, in January 1988, Brown indicated that he had reviewed with his own board the notion

of the National Gallery administering a museum at Sunnylands in California. Calling their art "the finest of its kind still left in private hands," Brown detailed a vision that incorporated features he admitted might seem "mutually exclusive": the "intimacy and perpetuation of an individual creation and the institutional safeguards of a public trust in perpetuity," all reconciled by a "national, federally-supported, institution with a far-seeing and flexible Board."

And then Brown launched into a sales talk meant to take the Annenbergs' breath away. He foresaw (after the Annenbergs had departed the earth) a Sunnylands open to the public on a regular schedule, although visitors might be required to reserve in advance. Such an institution might well have its own board (with Gallery representation) and its own endowment. "But, to avoid the uncertainties of such a frail child going out into the world on its own, the Trustees of the National Gallery of Art would take responsibility for the works of art in perpetuity." Because visiting Palm Springs was seasonal in nature, Brown continued, some of the collection might be exhibited in Washington. "There, in our beautiful new top-lit galleries, we would show your masterpieces." The previous year's attendance was seven million, Brown reported, and some years it exceeded eight million. "The Mall, beyond being the symbolic *sanctus sanctorum* of the American patriotic experience, receives some 26 million visitors a year, and is the most highly visited museum complex in the world." The Gallery was proud of its position on "Main Street USA," that is, Pennsylvania Avenue, where its nearest neighbor, the National Archives, housed both the Constitution and the Declaration of Independence. Unashamed to drape the flag over his institution, Brown clearly hoped the appeal to patriotism (and audience size) might nurture a positive reaction.[92]

Walter Annenberg responded immediately, promising to show Brown's letter to Lee and agreeing that the prospect of keeping Sunnylands open for winter visitors was appealing. He assured Brown that he would not reveal his plans to representatives of the Metropolitan Museum, who would be coming to Palm Springs shortly.[93] Lee Annenberg was a Met trustee, and Annenberg had earlier served on the board. A few days later, on Annenberg's invitation, Brown phoned and they talked about the collection. Annenberg seemed enthusiastic about a Sunnylands museum operated by the Gallery. When Brown thanked him for not revealing his proposal to the Met, Annenberg responded that it would

have been improper, "like holding an auction and telling someone what the other side had bid."[94] Annenberg, who valued formality of speech and courtly behavior, invariably emphasized his own punctiliousness when dealing with Brown.

He also recounted discussions with the mayor of Rancho Mirage, and possibly rezoning some of his property to allow for commercial development along Bob Hope Drive. This would generate an income stream sufficient to support the ongoing museum. Annenberg thought that it might yield as much as five to eight million dollars a year. The pictures could be shown there for four months and exhibited elsewhere the rest of the year—New York, Philadelphia, Washington. Annenberg went on to praise the Gallery's administrative structure, remarking that with its four ex officio members, "you were more or less guaranteed that you were not getting clowns." He had "less fortunate experiences with boards of fifty people or more." Brown, encouraging the search for commercial support, noted that the Yale Center for British Art, funded by Paul Mellon, had shops at street level. And then he went for the jugular. "I said that I had never thought of him and Lee particularly as New Yorkers, but that I had always thought of them as Americans. He seemed to take my point. He did remind me that his wife was very close to the New York group."[95]

In late May, Brown returned to his theme. Reporting on the enthusiasm being generated by the Gauguin show, he wondered whether the Annenbergs had given more thought to the proposal for Sunnylands.[96] Annenberg responded that he had not given it a lot of attention but that his ideas centered around "four permanent sites," three of them museums (including the National Gallery) and Sunnylands. He was now an octogenarian but expected to have several years to work things out, "and I trust you will not only be understanding, but sympathetic as well."[97] Brown sent copies of the correspondence to Franklin Murphy in California, who was then chairing the Gallery board.

The following year, 1989, Brown was still lobbying Annenberg and attempting to polish their relationship further. This time the main subject was the coming Andrew W. Mellon dinner, which again, following Annenberg's suggestion, would be white tie. Brown expressed his delight that the Bushes were receiving the diplomatic corps in white tie, and that Washington was preserved from another "Jimmy Carter Situation." "I shall never forget when he came to see the Tutankhamun Show, and the Egyptian Ambassador was dressed to the nines, and President Carter

appeared in a cardigan sweater and no tie."[98] And then, indicating that he was aware that there were plans for some temporary exhibitions of Annenberg's art, Brown renewed his earlier requests for a Washington stop, "although, as between temporary and permanent, in this changing world, we believe that the nation can offer a very special kind of perpetuity!" Brown proposed several possible dates for an Annenberg exhibition, from 1989 to 1991, each coinciding with important occasions, like board meetings or the fiftieth-anniversary celebration. Eventually Annenberg chose the spring–summer 1990 option, continuing to radiate goodwill. He phoned Brown in May 1989, saying that if the Gallery could find a major Klimt painting, he would buy it and donate half to the Gallery, permitting it to be shown there half the year. Brown told him finding one was a "near impossibility" but said he would keep his eyes open. In a memo describing the conversation, Brown noted that perhaps a "smashing large poster" could keep Annenberg's interest alive for the interim.[99]

In August, Brown wrote Annenberg to say he had just visited the Philadelphia Museum to see the Annenberg paintings there. He found it wonderful to view them "in a different context" and endorsed the ecstatic review in the *Wall Street Journal*. He got a "tremendous high" from the visit, and fantasized about having Annenberg's favorites joined by "some delicious new arrival," perhaps one of "Paul's goodies" that Christie's was about to auction. "I know how pleased he [Mellon] would be to see any of his wayward progeny return."[100] Three months later Annenberg did indeed select a "delicious new arrival" for his collection, but it did not come from Paul Mellon's collection. It had belonged, instead, to Joan Whitney Payson, John Hay Whitney's sister, and was being sold by her daughter. Annenberg paid more than forty million dollars for Picasso's *Au Lapin Agile*, at the time the third most expensive artwork ever sold at auction.[101] It (along with two other additions) would join the group of paintings to be displayed at the National Gallery the following spring.

For his part, Annenberg gave Brown renewed confidence in September 1989, when he called, with some urgency, to say he had just visited the Norton Simon Museum in Pasadena and spotted reproductions and note cards featuring Annenberg pictures. He assumed the Philadelphia Museum had undertaken a marketing venture, and he was not happy about it. "He [Annenberg] said whatever profits are realized from sale of reproductions should be shared equally with the four museums on the tour," Brown reported in his memo.[102] Always a businessman, Annenberg

said that if Philadelphia wanted a fee from the Gallery for the use of transparencies, they should pay no more than the cost of participation. Annenberg added some comments about the Simon collection, which, aside from a few spectacular pieces, he felt to be cluttered with junk.[103]

To be sure, Annenberg was often critical about the display of (other people's) art. He was not entirely impressed by Pei's East Building and, just about this time, transmitted his opinion to Paul Mellon. In a letter of explanation and apology, Annenberg confessed that old editors stuck their nose into all sorts of business. There followed a critique of the Miró tapestry, the positioning of the Calder mobile, and the "cubicle-like" galleries on the main floor. Still, Annenberg was willing to admit he might be mistaken. Reading in the *New York Times* that Pei had been named one of six recipients of a hundred-thousand-dollar award for lifetime achievement in the arts, Annenberg wondered if he had been wrong in his assessment of the architect.[104]

Correspondence between Brown and Annenberg continued for the next few months. Annenberg called to indicate that the *New York Times* would be running a story on the Annenberg Foundation's five-million-dollar gift to the National Gallery acquisitions fund. Brown asked if the fifteen-million-dollar gift to the Met would be announced at the same time, and Annenberg said it would. An earlier five-million-dollar grant to Philadelphia, the previous spring, had matched another donor gift and was not tied to acquisitions. Annenberg felt the Philadelphia Museum had suffered because of its location, and he was pleased with Anne d'Harnoncourt's direction. They had made "a ton of money" from his own collection being shown there.[105] In fact, according to the *Philadelphia Inquirer*, the Annenberg pictures had been the second best attended show in the museum's history, and the best attended since 1970.[106] More than twenty thousand catalogs had been sold, and the membership rolls increased by 10 percent. This would set a high mark for the National Gallery to match, and it weighed on Brown's mind.

Brown missed no opportunity to defend his institution. Annenberg told Brown, at a White House event in December 1989, that Katherine Graham, publisher of the *Washington Post*, wanted to give him a dinner the next spring. Annenberg promised to attend, provided she not invite certain staff members, notably Paul Richard, the *Post*'s art critic, whose comments on himself and his collection had been unfair.[107] Richard had visited Palm Springs, interviewed the ambassador, and noted the open-

ing in Philadelphia. The story itself was a scathing portrait of Annenberg, presented as an angry, smug, pompous, narcissistic moralizer, contemptuous of other collectors—notably Armand Hammer, Norton Simon, and Daniel Terra—and linked to an unsavory past through his father's racketeering ties and imprisonment for tax evasion. Annenberg had told Richard that there would be no Annenberg museum at his home. "Absolutely not. Under no circumstances."[108] Brown did not respond directly but suggested instead that the Philadelphia Museum, not the National Gallery, had provoked the Richard story. He believed, or hoped, that Annenberg acknowledged the connection.[109]

The intervening months were taken up with scheduling the Annenberg exhibition, whose coming to the National Gallery was announced at the biennial Andrew W. Mellon dinner (attended, once again, by Annenberg). As it turned out, the exhibition would run (and open) simultaneously with the showing of the Emil Bührle collection. A German-born Swiss arms dealer and munitions manufacturer, Bührle had assembled a major group of impressionist and postimpressionist paintings. Gallery officials were nervous about the timing of the twin openings, but Annenberg, who would have liked the exhibitions held side by side, offered no objections.[110] In the end the Bührle collection would be placed in the East Building, while Annenberg's pictures were shown in the West Building.

Planning for the Bührle show had begun in 1986, with an awareness of the risks attached to showing a collection assembled by someone accused of collaborating with the Nazis and importing some of his art illegally into Switzerland from confiscated French collections. The anxieties were well founded. Michael Kimmelman, in the *New York Times*, launched a furious attack on the National Gallery for hosting the show, which he saw as a public relations coup for the Bührle family. It was "an exhibition that the National Gallery should never have undertaken," he wrote. "The astonishing thing is that this public institution evinces no embarrassment." He also observed that comparisons between Bührle's art "and the more predictable, less refined works" in the Annenberg collection "can hardly please Walter Annenberg."[111]

In a lengthy memo Brown expressed his anger at the *Times* and at the review, which he thought deeply unfair—an "indefensible" "diatribe" that should be ignored. The National Gallery "should stick by its highroad belief in its own mission as an art institution. . . . This is guilt by association."[112] The Annenbergs apparently made no protest, and Brown

was soon reporting ecstatic reactions to their collection. People "continue to walk out of your exhibition with stars in their eyes," he told Annenberg.[113] He faxed a memo indicating that in the ninety-two days the show was up, some 341,473 people had seen it. Ever the competitor, Brown noted that Philadelphia had had it for 104 days, achieving just 339,488 visits. He was still in there fighting.

But the end was near for the lengthy courtship. And it came with an embarrassing thud for the Gallery. The Annenbergs had determined the destiny of their collection, and it was New York's Metropolitan Museum. Annenberg had made his conditions clear to Met director Philippe de Montebello and president William Luers. He wanted his paintings kept together and specified that they could never be lent, sold, or placed in storage. The Met came up with a plan. In the late summer of 1990, after the Annenberg pictures had left Washington and were hanging in the Los Angeles County Museum, the Met commissioned an eight-foot-square model of its nineteenth-century European painting galleries, with scale photos of each Annenberg painting placed in the space to be devoted to it, surrounded by adjoining rooms containing the existing collection.[114] Annenberg's art would be integrated with the great impressionist paintings the museum already owned. According to Christopher Ogden's account, Lee Annenberg declared it "brilliant." "I took one look and said, 'Walter, this is it.'"[115] As a further inducement, the Met promised to create a thirty-minute film starring the Annenbergs at Sunnylands talking about their art.[116]

The announcement came on the front page of the *New York Times*, March 12, 1991.[117] Annenberg had called the disappointed directors in Washington, Philadelphia, and Los Angeles the day before. Brown immediately wrote back a gracious note, thanking him for the advance notice and assuring Annenberg that while he lamented the decision, "it will not make any difference to our relationship; I have enjoyed both personal and institutional friendships with you."[118] In public Brown presented a stiff upper lip. "I have been hearing such reports for a long time, so this comes as no surprise," was his statement through the Gallery press office, adding that he expected the Annenbergs would remain generous supporters.[119] In private he was infuriated by the timing, which came just days before the fiftieth-anniversary celebration (which Annenberg would be attending) and the opening of the long-planned exhibition. According to some sources, he blamed his old adversary, the *New York*

Times, whose publisher, Arthur (Punch) Sulzberger, now chaired the Met board. It was something of an ambush, he thought, or, as he told *Newsweek*, "a tad quaint."[120]

Sulzberger, in turn, was nervous about Annenberg's reactions to anything in the *Times*. Max Frankel, his executive editor, recalled a note from the publisher asking him to remove any "zingers" from Kimmelman's review of the Annenberg pictures. Kimmelman may hold critical opinions about individual paintings, Sulzberger allowed, "but there are ways of indicating this . . . without cutting off the balls of the owner. This is truly important for me and for New York."[121]

Annenberg's attendance at the anniversary dinner was not entirely comfortable. The *Washington Post* made much of an incident on the reception's receiving line when Brown moved hurriedly out of his place to retrieve a guest's dropped bracelet, just before Annenberg was to arrive at his spot. Everything froze until Brown returned, and the *Post* began its coverage with the story.[122] There were indeed people at the reception angry enough not to talk with Annenberg, and the publisher, on returning to California, sent a letter of apology to Franklin Murphy, his good friend and the Gallery board chairman. He expressed sadness at the announcement's timing, saying in hindsight that it should have been delayed. Annenberg allowed he did not postpone the news because he was worried about it leaking out, which would have been worse.[123]

Brown took note of the awkwardness and, while regretting it, admitted he saw no way to avoid it. Some "of our many generous and patriotic donors, the scale of whose gifts was painfully obvious to them as being of a different order of magnitude from yours, might have felt a little bit of discomfiture" at the disclosure's timing, he told his friend. And then, in more clipped prose, Brown wrote, "I suspect that some may have felt that if the Metropolitan has a board meeting every month, their leadership might have chosen a different occasion on which to work out the paper work details on something which had been in gestation for so long."[124]

In the end, Gallery officials, notably Murphy and Brown, agreed that it was best to put the whole thing behind them.[125] *Newsweek*, again, asserted that Met officials "can wipe their sweaty palms and breathe deep gulps of relief now that they've taken the gold in the Annenberg Olympics." Annenberg explained that he chose the Met because it and the Louvre were the only two "complete museums in the world."[126] The Los Angeles County Museum of Art received from Annenberg, days later, a

ten-million-dollar gift, not a "consolation prize," its director, Earl Powell, insisted. *Newsweek* claimed that Philadelphia's chances were hurt by the social establishment's condescension to Annenberg decades earlier, and that the National Gallery possibility was damaged by the opposition some Washingtonians had mounted against his ambassadorial appointment. Los Angeles, which had at best an outside chance of getting the art, saw any chances doomed by a *Los Angeles Times* interview that, like Richard's piece in the *Washington Post*, evoked Annenberg's family history and was interpreted by the collector as a "vicious and personal attack."[127] Annenberg did not blame Murphy or Brown for the articles, and all of them remained in correspondence. And there were continuing gestures of support for the National Gallery.

The Annenberg pictures, had they come to the Gallery, would have crowned Brown's tenure. It was the one great trophy collection (outside of Paul Mellon's) that would have elevated him in this area alongside his two predecessors. With the Andrew Mellon, Widener, and Rosenwald gifts, the Annenberg offering would have accentuated the Pennsylvania flavor of the National Gallery's holdings. It didn't happen. But there had been impressive additions, and there would be more. Months after the fiftieth-anniversary show opened and the Annenberg prospect vanished, the National Gallery announced that it would receive a substantial portion of Ian Woodner's old master drawing collection, which included work by Dürer, Rembrandt, Raphael, and Leonardo. Woodner had died the previous year, and in an arrangement that was part gift and part purchase, the Gallery obtained more than 140 sheets.[128] There were other institutions interested; Woodner drawings had been exhibited in London, Vienna, Madrid, and New York. At one point, Brown was clearly worried that the Met would win Woodner's affections as it had Annenberg's. It held a special reception for the collector, flying over the Duke and Duchess of Devonshire for the occasion. "Meanwhile, we are stalking the quarry," Brown wrote Franklin Murphy, asking him to "light a candle for us," an expression he would employ again with others.[129] In the end Woodner favored Washington, where his real estate ventures had flourished.

The acquisition of the Woodner drawings was announced at the October 1991 Andrew W. Mellon dinner, with hints of further largesse to come. The Woodners held more than fifteen hundred additional master drawings, along with sculpture, bronzes, and paintings. "This is not the

last gift we'll ever give the gallery," one family member told the *Washington Post*. "It's an ongoing story."[130]

Also an ongoing story was the National Gallery's exhibition program. Just two days after the celebratory Mellon dinner the Gallery opened what was probably Brown's single most ambitious exhibition, at least from a global perspective, and the last blockbuster of his directorship. Behind it lay years of planning and a climactic display of his considerable, if sometimes ruthless, political and diplomatic skills.

Goodbye Columbus

Celebrating the Quincentenary

As the 1980s ended the National Gallery extended its exhibition ardor. Cold War tensions, the source of several earlier presentations, had been largely replaced by glasnost which stimulated a new raft of museum activities. In the post-détente era, art exhibitions remained political and economic weapons, as fresh regimes sought legitimation through liberalized art policies. Taking a slightly longer and certainly darker view, art historian Francis Haskell commented unhappily in 1990 that "the death of Franco and the arrival on the scene of Gorbachev have probably been responsible for more great pictures being on the move than at any time since the end of the Napoleonic wars, or at any rate since the heyday of Mussolini's cultural diplomacy."[1] Dramatic if short-lived congressional cuts and the recession of the later George H. W. Bush years posed their own challenges. Still, the Gallery could rely upon its corporate sponsors and long-term federal help for a number of its important exhibitions, and attendance remained high. Brown himself, now in his fifties, was no longer a boy wonder, but his personal story, social background, and professional successes continued to fascinate the press. He remained the public face of the National Gallery and the decisive voice in shaping its policies. With Dillon Ripley retired, and changing leadership at the Kennedy Center and the national endowments, no one challenged his status as the capital's cultural arbiter.

There were institutional missteps and controversies, to be sure. *New York Times* critics continued to complain about everything from missed opportunities to patron poaching. Gallery administrators fretted over

the huge costs of the elaborate shows and warned that the trajectory was insupportable. Scholars carped about the "corruption" of great museums, and some commentators linked Brown with Hoving as directors "who have allowed the museums to become instruments of self-glorification," who "have sold out art in order to make their museums great commercial institutions."[2] But the special flair persisted. The sweep of the exhibitions remained global and, whenever possible, linked to the visits of foreign heads of state, particlarly when they wore crowns. This heightened the drama of openings and attendant dinners, ensuring local press publicity. Gill Ravenel's department of installation and design, central to selecting and scheduling exhibitions, extended the Gallery's reputation for eye opening and expensive presentations. Senior staff and curators came and went, but leadership of the design department and exhibition management remained basically the same.

The Gallery's exhibition schedule was crowded. Retrospectives of great artists like Titian, Malevich, and Matisse, tributes to Americans Robert Rauschenberg, Jasper Johns, and Ellsworth Kelly, forays into cultures that stood outside the Gallery's areas of concentration, from Turkey to Indonesia, surveys of American art, samplers from foreign museums like the Fitzwilliam in Cambridge or the Budapest Museum of Fine Arts, were joined by smaller shows in the prints and drawings galleries. Most of these received largely favorable attention from local critics like the *Washington Post*'s Paul Richard, Hank Burchard, and Jo Ann Lewis. Enthusiasm broke through ordinary boundaries. "There has never been such a pair of shows anywhere in the world," Burchard gushed over the Titian and van Dyck exhibitions in 1990. "We may as well give ourselves over to sin, because after this, Heaven is bound to be a disappointment."[3]

The Gallery's good press stood in striking contrast to the travails of some sister institutions. The Smithsonian Institution, in the post-Ripley era, facing administrative reorganization and upheaval, attracted considerable attention, some of it hostile. The angry debate over the *Enola Gay* exhibition at the Air and Space Museum distracted from ongoing programs. Despite major financial challenges, including massive renovation and updating needs, the Smithsonian refrained from adopting the National Gallery's recent strategy of a coordinated, multiyear capital fund drive, relying instead on its Associates programs, its magazine, and the somewhat decentralized fund-raising of its bureau chiefs. The Corcoran Gallery of Art suffered from rapid changes in leadership and an avalanche

of belligerent commentary in 1989, after canceling an exhibition of Robert Mapplethorpe photographs. The cancellation, meant to appease political criticism, resulted in a massive loss of support and the resignation of its director. According to one board member (who was only half joking), the Corcoran might be on the road to "becoming an American furniture wing of the National Gallery of Art." "On one occasion," noted a *Washington Post* reporter, Carter Brown "was seen walking through the Corcoran, looking at spacious rooms, commenting how wonderful they would be to display all the furniture the National Gallery owns but has no space to exhibit."[4] Mergers and acquisitions rumors, from time to time, even enveloped the beloved Phillips Collection, facing challenges of its own. When the National Gallery and the Phillips organized *The Pastoral Landscape* exhibition, *New York Times* critic John Russell commended the operation. But he added that "at one time, when the future of the Phillips Collection was unclear, the National Gallery had its jaws wide open in hopes of taking it over."[5]

The Gallery waited out temporary government cuts and emerged, over the long run, with appropriation increases. These came the more readily with an apparently unending spiral of attendance increases and the glitter of Gallery receptions and celebrity visits. How closely those in Congress followed exhibition reviews is unclear, but even when controversy came, Brown adroitly distanced the Gallery from political danger.

This could be seen even in what was, by general agreement, the most polarizing National Gallery exhibition of the late 1980s, the showing of several hundred "Helga" drawings, sketches, and watercolors by Andrew Wyeth that opened in May 1987. Local reporters acclaimed Wyeth as the first living American painter given a one-man show at the Gallery, although this priority was hedged by the exhibition's highly focused character. It was not a retrospective. Still, to insiders and outsiders alike, it seemed to break several of the complicated rules governing Gallery exhibitions. And it aroused the opposition of many staff members.

This group of works had a complicated history. Created in "secret" over the fifteen years between 1970 and 1985, the art "cache" was owned by a wealthy Pennsylvania publisher, Leonard E. B. Andrews. He had purchased what he termed a "national treasure" (along with its copyrights) for an unknown figure, estimated at between six and ten million dollars, in the summer of 1986. Somehow Andrews persuaded Brown and some Gallery curators to host the exhibition. Andrews promised at least one

gift to the Gallery, a major Wyeth watercolor, and suggested more would be forthcoming.[6] Months before the opening, a seemingly endless spate of newspaper stories began. Interviews with Wyeth, with Wyeth's wife and business manager Betsy (who had not known about her husband's obsession with Helga), and with Andrews fueled the growing debate, which was tinged with salacious comments about the artist-model relationship. "Like an avalanche of Styrofoam and saccharin," Robert Hughes wrote in *Time*, "*le cirque Helga*" "came roaring down the narrow defiles of silly-season journalism."[7]

Just a few Helga portraits had been viewed previously. Now more than two hundred works on paper would go on display. The accompanying catalog, put out by a major American art publisher, Harry N. Abrams, with a foreword by Brown, became a main selection for the Book-of-the-Month Club, the first time an art book had been so designated, according to *Post* critic Paul Richard. Indeed Paul Gottlieb, heading Abrams, had helped bring Brown's attention to the pictures, a sequence that aroused still more criticism.[8] Was the exhibition driven by the publisher's desire to increase sales? Any profits earned by the book were dedicated to the Leonard E. B. Andrews Foundation. With a print run of more than a hundred thousand, these promised to be substantial. Other moneys would come from the five museums presenting the exhibition after its Washington debut.

Despite the status of the participating museums (including Boston's Museum of Fine Arts, the Detroit Institute of Arts, and the Los Angeles County Museum of Art), Wyeth's extensive representation in major collections, and a record of previous exhibitions, skeptics bemoaned the enterprise as soon as the first announcements appeared. Philippe de Montebello of the Met announced they had been offered an opportunity to show the Helga series. "We quite pointedly and as a conscious decision declined to do so," he told the press.[9]

Two major issues emerged. One concerned the nexus of art and money, the enhancement in value a Gallery show meant for Andrews's investment. The other, still more divisive, involved Wyeth's professional reputation. Simultaneously revered and derided, he was a lightning rod for the larger culture wars, a symbol in the battle over modernism. For many believers, as well as some doubters, Andrew Wyeth was the "spiritual leader of Middle America," in the words of one critic, an alternative to the urban-inspired, Europe-nurtured modernism that had dominated the

art market for decades. Wyeth validated bourgeois values, rural-centered and tradition-minded. Both his father and his son were celebrated artists as well. "They arouse emotions that happily require no moral choices," Henry Allen wrote of the family, "poignance, wistfulness, nostalgia, depression, self-awareness.... The Wyeths stand for their audience's nobility in the face of the quiet calamity of the 20th century."[10]

Fourteen years earlier, Hilton Kramer had taken on Andrew Wyeth, suggesting that his art "does not appeal to our curiosity but to our prejudices. Its mission is not to question or to complicate our emotions but to confirm them." Wyeth's image of reality "bears about as much relation to reality as a Neiman-Marcus boutique bears to the life of the old frontier."[11] In an even more controversial riff, Kramer insisted that Wyeth "can't paint." "It's provincial, it's sentimental, it's illustration and it's without substance."[12] Another major critic observed that "those committed to modernism hold Wyeth in contempt of art. Others gauge their contempt for modernism by their love of Wyeth."[13] Henry Geldzahler, who had been curator of twentieth-century art at the Met, labeled Wyeth's philosophy as "Poor Richard's Almanack.... His skies have no vapor trails, his people wear no wristwatches."[14]

Such disparagement enraged Wyeth admirers who found complexity, reassurance, inspiration, and insight in his work, and who vigorously objected to the denigration of his skill. They wrote to magazines and newspapers responding to reviewer attacks. At the time of the Gallery opening, a *New York Times* piece complained that while the Helga pieces would visit six cities, the destinations excluded Gotham. "The city's curators think New York is too good for Helga." Quoting Montebello, it cited local specialists who charged the "caper" was "beneath the dignity of a serious museum,""sentimental" stuff more suitable to be seen on "greeting cards, not in museums." "I resent the snobbery of museums that enjoy hefty tax exemptions and public contributions," this Wyeth lover went on, "and are perfectly willing to play to the public when it comes to Egyptian gold. Museums ought to assert a standard of taste. But shouldn't they also feel some obligation to show legitimate art that clearly interests the public?"[15] Others disagreed. It was a "dangerously pernicious populist notion" that a public museum should be "guided by what the public wants to see—in other words, be guided by the ratings, just like a television network," argued another aroused letter writer.[16]

By some accounts Brown, who liked Wyeth's work and knew the art-

ist, saw the show as both a justified tribute to a popular painter and a major opportunity. His deputy director, John Wilmerding, was even more enthusiastic, insisting Wyeth had transformed American realist painting.[17] *Time* and *Newsweek* had run cover stories on Wyeth in the summer of 1986, while during the same period the *New York Times* featured at least half a dozen pieces on the artist, his family, and the Helga pictures.

The self-serving pronouncements of Leonard Andrews, who would profit from any reproductions, posters, slides, and gift shop items created during the exhibition tour, added to the mix. Andrews drew the line at T-shirts and balloons but allowed images to be reproduced on shopping bags.[18] Aware that some staff members remained skeptical, perhaps even hostile, Brown prodded them into support, or at least silence. He was the voice and vision of the institution, and it was difficult to oppose his wishes. In later years, several curators argued in private that the decision to host the show was a mistake and not really comprehensible. The effort appeared unseemly, violating the National Gallery's hard-won insistence upon the highest standards of quality. Critic John Russell, a longtime supporter of Brown and Gallery exhibitions, called it an "absurd error."[19]

The black-tie preview opening for the show attracted a range of celebrities, including secretary of state George Shultz. Wyeth was especially pleased by Shultz's presence, but, as the *Washington Post* reported, "probably the happiest man was Leonard E. B. Andrews."[20] Reassuringly, at least to the exhibition's sponsors, the public response seemed overwhelmingly positive. In the days just after the opening long lines formed around the West Building early in the morning, as eager visitors sought their free passes.[21] Even before the opening, Brown reported that "an unprecedented 10,000 tickets" had been reserved, many through Ticketron.[22] Predictions of one million visitors materialized; half a million copies of the catalog were supposedly in print. Soon after the Washington stay had ended, a thirty-six-minute videotape narrated by Charlton Heston was announced, available in museum stores for $39.95.[23]

Some critics weighed in with negative verdicts, several of them before the show actually opened. Accepting the National Gallery's wish to honor a popular artist, Edmund P. Pillsbury, then directing the Kimbell Museum in Texas, complained that Wyeth was a poor draftsman, "more of an illustrator than a great painter." His art was "anecdotal, not profound." Geldzahler, who had tackled Wyeth years before, observed that with Ellsworth Kelly, Jasper Johns, and Willem de Kooning at work,

"you don't give Andrew Wyeth a one-man show." To "single him out is only pandering."[24]

Brown and Wilmerding acknowledged the debate. Wilmerding's essay opening the Abrams book cited some of the criticism as it began.[25] Brown, insisting that artistic merit had been the sole criterion the National Gallery had used in scheduling the Helga exhibition, condemned the "knee-jerk reaction among intellectuals in this country that if it's popular it can't be good." This would become a favorite theme in later years. Brown also emphasized that the Gallery was not acclaiming the Helga pictures as masterpieces but placing them "for critical comparison with other 20th-century art . . . in the museum's graphics gallery," exhibited along with a group of drawings on loan from the Whitney Museum in New York. "I think the man's mastery of a variety of techniques is dazzling."[26]

The exhibition and the tour that followed did little to bridge the divisions. Some critics, sympathetic to Wyeth's approach and to his earlier paintings, and eager to separate themselves from the blinding publicity, still found the display of drawing technique unpersuasive. Writing in the *Wall Street Journal*, Jack Flam conceded that the National Gallery had produced a "discreet and tasteful installation" of this "essentially tasteless endeavor," but he left the show "with a diminished estimate of his work."[27] Roberta Smith, writing two years later as the Helga Pictures made their final stop at the Brooklyn Museum, sustained the earlier critiques, calling it a "theme show" carrying "all the sentimentality and sensationalism" of "an afternoon soap."[28]

Admirers of Wyeth remained unmoved. Jeffrey Schaire, editor of *Art & Antiques*, whose photographs had helped propel the early story in 1986, insisted that the art world was angered by Wyeth's "commitment to an essentially private vision," different from that of the commissions adorning corporate lobbies, public plazas, and restaurants.[29] And not all prominent critics adopted a hyperbolic tone. Condemning the hoopla and "striptease" expectations, John Updike, encountering the exhibition in Boston, found himself deeply admiring a number of the pencil sketches and several of the finished paintings. He compared Wyeth to Edward Hopper and discovered elements of abstraction that could have come from a Franz Kline.[30]

After everything was added up, the National Gallery's decision still looked questionable. Attendance, superb by the standards of most mu-

seums, impressive even for the National Gallery, fell below some expectations. Five hundred and fifty thousand visits demonstrated huge popularity but set no records. An exhibition of Winslow Homer watercolors a year earlier had drawn more visitors per day. After the tour had ended, Leonard Andrews, despite earlier statements that he had purchased the art to prevent it from being "sold and scattered around the world," peddled the whole "national treasure," or as much of it as he owned, to Japanese interests.[31] It seemed to some that the Gallery had been had, imposed upon by the collector-turned-dealer, made accomplice to his ambitions. No one in authority at the Gallery publicly criticized the decision to hold the show, but in private many fumed, and it stood as the single most questionable exhibition decision made during Brown's last years as director. It did little, however, to threaten his general standing or the Gallery's influence, and even some of his perennial critics treated it as an aberration rather than a portent.

For evidence of greater success, there was much to choose from in the exhibitions of the late 1980s and early 1990s, although quite a few of them were hosted rather than organized by the Gallery (which still insisted on its right to be the first venue). The blockbusters included *The Art of Paul Gauguin*, which pulled in almost six hundred thousand in just three months of 1988; *The Age of Sultan Suleyman the Magnificent*," which attracted close to four hundred thousand in 1987; *Collection for a King: Old Master Paintings from the Dulwich Picture Gallery*, with attendance of almost half a million in 1985; and *The Shaping of Daimyo Culture*, held in late 1988 and 1989. There were also focused shows on Titian, van Dyck, Berthe Morisot, Cézanne, and many others. Each exhibition enjoyed its own carefully designed dinner, complete with extraordinary menus, opulent table settings, visiting celebrities, uplifting speeches, occasional music, and extensive press coverage. The Gallery's chief of protocol for such events, coordinator of its themes and menus, was Genevra Higginson, who enjoyed her own press coverage. These glittering occasions became moments of affirmation, opportunities for Brown (who always spoke if he was in town) to charm the guests, demonstrate his erudition, and inspire those of his staff who were present with a reminder of their mission and the Gallery's greatness. Some staff sat poised, behind a screen, to fill any seats left empty by no-shows. Years later, guests recalled such evenings with astonishment and awe; no other institution in Washington—with the possible exception of the White House—came close to producing

the same glamour. Any doubts about the extraordinary level of financial and professional investment demanded by the temporary exhibitions were addressed, if not allayed, by the dinners' testaments of faith.

Admittedly the participants engaged in this rite of self-congratulation constituted a tiny group of makers and shakers—diplomats, socialites, collectors, celebrities, lenders, and politicians, along with some curators and museum workers—but this was the small world that made the National Gallery's programs possible. Presidents, prime ministers, princes, prelates, cabinet secretaries, and ambassadors were honored as exhibition collaborators. These were not empty gestures, as Brown and his associates did not hesitate to press them into service to fulfill the Gallery's agenda. Such collaborations often consumed many years of preparation, and Brown's strategic, tactical, and diplomatic skills were called upon again and again as challenges threatened to become crises and derail the planners' dreams. Frequently international, even regal in scope, the exhibitions' scale, cost, and impact worried some Gallery supporters, who fretted that their temporary dazzle might distract the museum from its continuing but quieter mission of displaying, conserving, and interpreting its permanent holdings of artistic masterpieces.

The lengthy gestation, multiple authorship, intellectual ambition, and worldwide reach of such exhibitions was best exemplified by the final, most grandiose, and most imperial of Brown's extravaganzas. This was the National Gallery's commemoration of the five hundredth anniversary of the Columbian voyage, *Circa 1492: Art in the Age of Exploration.* The conceptual origins of the show stretched back to the early 1970s, when National Gallery officials were figuring out how to celebrate another important anniversary, the bicentennial of American independence in 1976. Brown had proposed surveying world art during that year, but withdrew the notion after realizing that 1776 was far from an artistic high point. More than a decade later, a senior staff member came up with a similar plan for 1492, and pressed it forward.

The originator was the Gallery's chief curator, Sydney J. Freedberg. Well published and an internationally recognized specialist on Italian painting of the high Renaissance and Baroque periods, Freedberg had taught at Harvard for three decades. His many students included Carter Brown, born just two years before Freedberg received his Harvard BA. Flamboyant, sharp-tongued, opinionated, and learned, Freedberg, in his sympathies, associations, and historical method, was a throwback to an

earlier National Gallery era but enjoyed far better academic credentials. Closely associated with Bernard Berenson and I Tatti, decorated by several governments for public as well as academic service, Freedberg, beginning in 1983, when he was sixty-eight, would spend five years at the National Gallery, advising on acquisitions, organizing shows, and supervising the creation of a systematic catalog for the Gallery's Italian paintings. Less than sympathetic with the Gallery's turn to contemporary art, he provided heft for traditionalists on the staff, and threw himself energetically into larger Gallery plans.

Only months after arriving as senior curator Freedberg issued a memo, in May 1984, proposing a three-part exhibition with the working title "Circa 1492: The World's Art in the Time of Christopher Columbus."[32] The title came easily, for Freedberg had just published, the year before, *Circa 1600: A Revolution of Style in Italian Painting*, a book incorporating three lectures he had given at Cornell in 1980. For someone so identified with formalist approaches, Freedberg's 1492 outline was surprisingly sociological and contextual. The National Gallery, he insisted, must mount the chief artistic celebration of the anniversary. Freedberg was a veteran of many political battles and believed in careful preparation. We "had better stake out a claim for our intentions very quickly," he wrote, "lest we find our primacy usurped by some regional institution." It was time to devise a scheme and "announce our plans widely, thus obliging other institutions to defer to us." This overtly competitive language must have appealed to Brown, who invariably asserted and reaffirmed the National Gallery's special status.

The first part of the tripartite proposal presented what Freedberg called "The Age of Discovery," European art at the time of Columbus, with a concentration on late fifteenth-century Spain and Italy. The objects would be chosen both for their artistic merit and their linkages to material and cultural history. The second theme, "America Discovered," covered indigenous art of the western hemisphere—Mexican, Peruvian, American Indian, and Eskimo—emphasizing changes that emerged from contacts between native and discoverer cultures. The final theme, "The Continent of Fabled Treasures: The Indies and Cathay," covered places Columbus might have reached if the Americas had not stood in his way. Freedberg wanted to include Korean and Japanese as well as Chinese and Hindu art, in a display of "extraordinary visual luxury."

In the year that followed, presumably with Brown's approval, Freed-

berg wrote specialists in Asian art at Berkeley and Harvard, seeking reactions and suggestions. Most were enthusiastic, one pointing out that the culture of the medieval warrior class in Japan climaxed around 1500, another indicating that had Columbus reached China he would have found in its porcelains, brocades, and lacquers international influences.[33] Nothing records Brown's own reaction to this proposal, and while Freedberg was contacting academic colleagues, Brown was advancing another vision. One part centered on Genoa, the birthplace of Columbus, as a patron of the arts. The anniversary would provide leverage in getting otherwise impossible loans. The problem, Brown mused in a history-oriented memo of June 27, 1985, was that Genoa had survived by being a very private city. Unlike the squires and peers who owned British country houses (that exhibition was just about to open when Brown offered his reflections), the Genoese filling their palazzi with art treasures had little sense of public responsibility. Their spectacular homes were still largely closed to the public. Still, they held extraordinary things. To pry them away, briefly, the National Gallery might lend things back to Genoa.[34]

As a trump card, Brown invoked the person of Mitchell Wolfson, whom he had recently visited in Florida. An active collector of art, furniture, and graphics who had spent many years in Genoa, Wolfson had recently moved back to the United States and was in the process of creating a museum in Miami Beach. The exhibition could be shared with the new Wolfsonian, as it would be called. There were shipping and banking interests in Genoa that might offer support. If appropriate curators were identified, and Wolfson brought on board, the Gallery could decide either to move ahead or to "deep-six" the proposal.

The other part of Brown's early Columbian program involved a survey of five hundred years of Spanish art.[35] This show, opening at Madrid's Prado and presented as a gift to the people of Spain, would then travel to American museums including the National Gallery, the Metropolitan, and the Kimbell. This notion was abandoned, by the end of 1985, in favor of a conception very close to the one outlined by Freedberg. The arrival of the Daimyo show further convinced Brown that a worldwide 1492 survey made sense. "The ethos from which Columbus came, and the one that he would have reached had he known more, builds in a kind of dramatic irony," with the added benefits of "giving us an excuse for exhibiting some sublime works of art in both sections."[36] His August 25, 1986, memo acknowledged the challenges entailed in getting the necessary

loans from Europe and the pressures arising from the Gallery's event-heavy 1991 anniversary year.

By the summer of 1986, contributors to the catalog had been identified. Freedberg invited André Chastel, an acclaimed French art historian, to write the principal essay.[37] Chastel, who had delivered the Mellon Lectures at the Gallery thirteen years earlier, was noted for his sensitivity to context. Freedberg projected an exhibition of six to eight hundred objects, examining the "exploratory state of mind" of Renaissance man. Chastel could not take on the commission. But the invitation initiated the scholarly program more than five years before the scheduled exhibition date.

The lead time was necessary because of the daunting character of the loan proposals. As with the *Treasure Houses* show, only more so, Brown would become personally, even intimately, involved with extended and even more torturous negotiations, preparatory to consummating loan agreements. Several seasons of horse trading, deal making, and occasional intimidation were now in store. A huge list of possibilities had been compiled by the end of 1986—armor, tapestries, paintings, furniture, enamels, ivories, bronzes, medals, sculpture, glass, ceramics, jewelry, bindings, manuscripts—bearing handwritten comments like "Absolute Must," "Perfect," and "Beautiful."[38]

To bolster the show's status, Brown would invoke his governmental connections and various credentialing agencies, worldwide. The process was quite different from the *Treasure Houses* experience, when loan requests were confined to one country and to lenders holding a vested interest in the exhibition's success. This time Brown needed all the help he could get. He appealed to the Council of Europe, proposing it "adopt" the *Circa 1492* show. This would strengthen the Gallery's hand in requesting loans and possibly allow some coordination with a European museum. Created in 1949, the Council, whose goal was greater unity among the nation-states of Europe, was active in cultural and educational matters and had an extensive exhibitions program. But Brown's proposal went nowhere.[39]

Brown turned also to Daniel Terra, ambassador at large for cultural affairs, and to secretary of state George Shultz. Shultz sent Brown the draft of a letter requesting the cooperation of foreign governments.[40] It recalled, in some ways, the tradition of inviting foreign states to participate in an international exposition. Shultz's letter, in what presumably

were Brown's words, spoke of a "remarkable exhibition" and the need for "objects of exceptional importance."

But the most pressing need was for a coordinator. While Brown was always available for heavy lifting, he could not supply day-to-day supervision. To fill this role, he appointed a young attorney whom he had first met in 1970. Jay Levenson was then a senior at Yale, assisting a college advisor who was preparing a Dürer show in Washington. After studies at the Institute of Fine Arts, Levenson worked on a Gallery exhibition of fifteenth-century Italian engravings from the Rosenwald collection. He then entered law school, but remained close to Gill Ravenel. When, after some years of legal practice, he returned to art history, the possibility of curating *Circa 1492* opened up. His background, personality, and languages were appealing, and for three and a half years, starting in the spring of 1988, he was assigned the task of organizing the experts, traveling to persuade institutions and private owners to part with their holdings, and helping to shape the exhibition's intellectual structure.[41] Years later, Levenson still relished the freedom he had to make his own decisions and mediate among the divergent and sometimes clashing interpretations of the period presented by major historians. Scholarly disagreements complicated the task of producing a significant catalog, but with a star-studded board of advisers and an emphasis on broad themes, Levenson saw the project through.[42]

With his team largely in place by early 1988, Brown stepped up the pace of his international maneuvering, paying particular attention to Italian and Spanish contacts.[43] He wrote Francesco Sisinni, director general of Italy's Ministry of Culture, a crucial if controversial figure in cultural matters, proposing a collaboration to inaugurate the restored Palazzo Ducale in Genoa, in 1992.[44] He dined with a Spanish official in Madrid, to learn more about plans for a Seville show in 1992.[45] In June he wrote Gilbert Grosvenor, head of the National Geographic Society (on whose board Brown sat), proposing a four-part television series on Columbus. Their joint effort, Brown indicated, might excite corporate interest in *Circa 1492*. He had already contacted some leading historians and had assembled an "all-star" production team, including animators.[46]

Meanwhile Brown was dashing off memos about possible loans. He noted, in July 1988, that Madrid's Museo Municipal contained a Pedro Berruguete *Madonna and Child* of the 1490s, "better" than any Berruguete in the Prado. Its architectural background would fit the exhibition's

theme of spatiality, although this was a panel painting and not in particularly good condition. Since the National Gallery was lending Madrid a Goya portrait of the Duke of Wellington for a state visit from Queen Elizabeth, he had some leverage.[47] He proposed to Levenson that they borrow from the cathedral in Toledo. The star piece in the Gallery's *European Vision of America* show, more than a decade earlier, had been an allegorical statue of America, in silver, that became known in-house as the "Toledo Tomato."[48] Plucking the tomato had been onerous. The archbishop primate of Spain was reluctant to lend until Franklin Murphy, traveling at the time in Spain, had pledged Kress funds toward a new archepiscopal museum. It was built, and the grateful archbishop lent *America*. Another Gallery friend was financing cathedral reconstruction and reported that Toledo's four silver statues, each representing a continent, might be available.[49]

Meanwhile, Levenson had returned from one of his many European trips, scouting out prospective lenders in London, Florence, Milan, Venice, Modena, and Nuremberg. As would often be the case in coming years, there was good news and bad news to share with the steering committee. Several European curators foresaw Gallery conservation help and welcomed collaboration. Others were pessimistic. Objects relating directly to Columbus would be very difficult to obtain, Levenson predicted, given the levels of activity aroused by the quincentenary.[50]

The idea of an exhibition in Genoa, organized by the National Gallery and the Italian Ministry of Culture, remained alive in the winter of 1988–1989. In December, Brown plunged deeper into the turgid waters of Italian cultural politics, meeting officials and corporate executives. Italians also wanted to exploit the Columbus year with a series of art exhibitions, both in Italy and the United States. Various proposals surfaced, including one that eventuated in *Titian, Prince of Painters*, presented by the National Gallery in 1990–1991. The Metropolitan was planning its own Italian shows, and Philippe de Montebello would soon be in Rome for further meetings and announcements. The Italians suggested to Brown a survey of Italian culture from antiquity onward. For political reasons they desperately wanted a Washington presence, though they were interested in other American venues as well.

In response, determined to protect existing arrangements, Brown proposed two shows, one opening Columbus Day 1991 (this would become *Circa 1492*), the other opening Columbus Day 1992, celebrating Italy. He

recounted, in a lengthy memo, the elaborate dance performed by Italian officials, each warily protecting his own turf. Spectacular loans were dangled before him, among them Botticelli's *Birth of Venus*. The offers reached a point where Brown warned that this might be politically dangerous, recalling the bad old days half a century earlier when Mussolini had brazenly deployed Italian masterpieces abroad in pursuit of influence. Talks with others, who warned of ongoing disputes and instability, convinced him that close collaboration would be a "rocky road."[51]

Returning to Washington, Brown immediately had to smooth relations with the Metropolitan, which had been asked earlier to host a Titian show.[52] The competing claims and ambitions of major American museums dominated the none too simple world of transatlantic exhibition politics. Brown declared that, while in Venice, he had proposed sharing the Titian survey with the Met, each of the two American museums taking half. A wary Montebello replied that after breakfasting with some Italian officials in New York, he understood that the National Gallery might cede its claims to half a Titian exhibition in return for favored treatment on loans for another, unnamed show, in 1992. Brown cautiously replied that everything was still iffy. The two directors sparred back and forth, with Brown offering to relinquish plans for any Titian show, "if we felt we were being given sufficient justification by the Italian side."[53]

Meanwhile, the timetable for the 1992 exhibition was tightening. By 1989 loans would need to be confirmed, at least in principle, and 1990 would see essays and sample catalog entries due. *Circa 1492* would open October 12, 1991, and close February 16, 1992. Everything seemed in place, but in February 1989, when Brown and Levenson journeyed back to Italy for another meeting with Sisinni, they confronted an even more tangled set of possibilities. Levenson's minutes recorded the convoluted encounter.[54]

Sisinni opened the February session by praising the relationship between the Ministry of Culture and the National Gallery, but pressing hard for an Italian art survey, which he called "Perché Colombo," that would come to Washington in the fall of 1991 (exactly when *Circa 1492* was meant to open) and then travel to Genoa the following May. Sponsored by Olivetti, the exhibition would cement the relationship between the United States and Italy and exemplify the Gallery's philosophy of cultural exchange.

However startled, Brown had to move delicately. He was aware that

various power brokers in Genoa were at something of a standoff, argu-
ing about who should get the inevitable kickbacks.[55] Retaining Sisinni's
cooperation would be critical for the loan agreements. Yet Sisinni's
proposal was clearly impossible. Brown explained to the group that al-
though there had been discussions about a Genoese collaboration, when
the "Perché Colombo" idea emerged he thought the two exhibitions
would be complementary and separated by a year, the Washington show
opening in 1991, and the Italian in the fall of 1992. While the Gallery show
was horizontal, surveying one year, the Italian show would be vertical,
moving across time.

In tactical retreat, Sisinni said he would prefer the "vertical" show
to open first but would leave the timing to Brown. Italian participants
stressed the need to avoid bureaucratic infighting, which might damage
this historic moment for Italy on the world stage. The infighting, how-
ever, had already begun; several of the Italians indicated their unhappi-
ness with the "Perché Colombo" idea, and argued that dispatching an
Italian art show to Genoa was like sending coals to Newcastle. Some of
those present thought Paris might be a better venue. Sisinni was appar-
ently taken aback by the opposition and the internal disagreements.

Brown responded by arguing that Italy needed to be well represented
in *Circa 1492*. A major Spanish exhibition was coming to the Metropoli-
tan in 1992, and the Portuguese were already assembling objects for a big
show in Seville. Led by Brown, Gallery officials would stoke the fires of
nationalistic rivalry again and again in the months ahead, as they urged
their Mediterranean friends not to be outdone by their neighbors. Ulti-
mately, the group meeting in Rome endorsed Brown's notion of sending
Circa 1492 to Genoa in the fall of 1992, a great port city and natural site
for an exhibition on exploration. Meeting the Italian prime minister's
diplomatic secretary later on, Brown drew the analogy to an opera in two
parts, scene 1 set in Washington, scene 2 in Genoa.[56]

Back in Washington there was the budget challenge to consider. Based
on an assembly of some five hundred objects, the proposed exhibition
came in at slightly more than eight million dollars, a staggering total. More
than half would be allocated to insurance and shipping costs; $1.2 million
would pay for installation.[57] There was also coordination with various
American bureaucracies, including the Columbus Quincentenary Jubi-
lee Commission, whose sponsored events, Levenson conceded, included
"some fairly odd items." One was the scheduled arrival, on Columbus Day

1991, of a replication of the Columbus fleet in Miami. Why Miami? Miami, it turned out, was the home of the commission chairman. Levenson wondered whether there was a chance of rerouting the ships to Washington. Given the fact that Columbus had never reached Florida (or Washington), the capital's claims seemed as good as any other.[58] Then there were contacts to be nurtured with diplomats from China, Portugal, and Mexico. Brown dined with John Negroponte, the ambassador-designate to Mexico, and lobbied for support in gaining loans. The ambassador seemed enthusiastic.[59]

Brown was soon flying all over the world to promote the exhibition's cause. In May 1989 he was in Paris, deciding whether to go to Rome and Venice to press the Gallery's case for certain loans. Weeks later, in Tokyo, he chatted with Giorgio de Marchis, director of Japan's Italian Cultural Institute, who had helped arrange a string of important Italian loans for a Japanese exhibition on European art. Brown wondered how they had managed it. De Marchis confessed that he and his colleagues had worked the various local soprintendentes individually, chatting them up, asking advice, and giving them information about the exhibition. Long before the meeting of the committee that decided the fate of the loan requests, they had signed up.[60] Already frustrated with the Italians, Brown was impressed. In June 1989 he noted for the file that someone at the American Academy in Rome was writing a book on how things were done in Italy. "He points out that their style is not to reach any kind of positive decisions if humanly possible." A yes means a no. Because "no one takes a position," "there is no loss of 'bella figura.'" "He says . . . one must continuously stroke and reapproach."[61]

Indecisiveness was not the only problem. There was real opposition to the National Gallery, and challenges to the philosophical logic of its exhibiting policies. Professor Francesco Negri Arnoldi, who had attended one of the February meetings with Brown in Rome, wrote a lengthy and eloquent letter of protest to him in April. Justifying his opposition to Brown's proposals, Arnoldi launched an extended condemnation of the "frenetic and uncontrollable" traffic in artworks whose presence in museum shows was "not always indispensable" or "well motivated." Indeed, Arnoldi argued, the exhibition of certain masterpieces was "exploitative and a pretext." "As a serious scholar and a respectable director of one of the greatest galleries in the world," he wrote Brown, "you cannot but agree with me as to the absolute lack of valid reasons, at least on the

scientific level, for the presence of so many masterpieces of Italian Renaissance art in the planned exhibitions." Historical celebration did not require original works by Uccello, Mantegna, Botticelli, and Leonardo. They "neither add nor detract from the scientific importance of the discovery. . . . If these artists belong to the *age* of Columbus, they certainly do not belong to his *world*, much less to his culture." Making Leonardo do Vinci into "an explorer like Columbus," probing "the realms of intellect and the imagination," was a poor excuse to move paintings from one side of the Atlantic to another. Anticipating Francis Haskell's critique, published the following year, he labeled such efforts "a form of vain self-celebration that has nothing to do with a serious cultural policy" or "a proper valuation of the work of art." With time and opportunity he could go further, Negri Arnoldi went on, but this was impossible. "Don't hold it against me," he added, hoping to see Brown again "on another, more pleasant occasion."[62]

Brown took the letter seriously, arrested both by the position taken and the passion with which it was defended. And perhaps, as well, by the Italian's courage. He turned to Jay Levenson for help in drafting a response. A final version was sent May 12. Brown did not try to defend the "vertical" "Perché Colombo" show, which had been planned in Italy. But *Circa 1492* was another matter, and Brown insisted on its value. The new subtitle, "Art in the Age of Exploration," made clear that it encompassed the cultural history of the entire era. Editing Levenson's draft, Brown placed greater stress on the exhibition's professional credentials. He emphasized the printed catalog and the role major scholars had played in its planning, art historians as well as historians. Brown also added language clearly intended to flatter the recipient, changing "your letter" in Levenson's draft to "your thoughtful and so well-expressed letter," and going on to invite Negri Arnoldi, a historian of Italian art who was teaching in Viterbo, to consider contributing an essay on Italy to parallel what was planned for Portugal and Spain.[63]

The mixture of civility, cajolery, and possible compensation was not atypical for Brown, who preferred to co-opt opponents rather than to contradict them. Brown proposed that the two of them hold another meeting, but whether they did so is unknown. Nor do the files contain any written response to Brown's letter. One thing is clear, however: no essay by Negri Arnoldi appeared in the *Circa 1492* catalog.

There were many other connections to be nurtured as the Gallery

ramped up its preparations. Writing to Ted Turner of the Turner Broadcasting System, Brown opened by noting that it had been a long time since they had sailed together, but that during his constant traveling "CNN is my absolute lifeline," doing "an enormous amount of good in communicating the American story and style of openness," more effective, in fact, than any governmental entity. But what he really wanted was to involve Turner with "the most ambitious exhibition" ever planned by the National Gallery. Two specially relevant themes would be dramatized. First, the emergent role of globalism and the global village and, second, the crucial role of communications in spreading the idea. It was Gutenberg's invention of moveable type, Brown continued, that promoted the Columbian discoveries, a fifteenth-century counterpart to modern satellite communication. Perhaps Turner Broadcasting would wish to become a corporate sponsor of the exhibition. Leaving little to chance, Brown invoked members of the Gallery's board, secretary of state James Baker and Paul Mellon among them, who felt strongly about the Gallery's impact on international relations. Brown confessed to wearing another pertinent hat, as a trustee of the National Geographic Society. Having surveyed these linkages, he ended by hoping Turner would give the matter some thought. If Turner did, it did not result in any action.[64]

There were also Japanese corporations to cultivate. While in Japan, Brown launched an aggressive campaign to get the *Yomiuri Shimbun*, the country's best circulating newspaper and a sponsor of the recent Daimyo show, to become an exhibition supporter. The newspaper's president, Yosoji Kobayashi, entertained Brown on his visit, and Brown prepared a lengthy memo summarizing their discussions. Many subjects were covered before Brown introduced his Columbian pitch. This did not, he confessed, produce "much ignition," though Columbus excited interest, and the Japanese wondered if *Circa 1492* might travel to Japan. They were, however, already financing reconstruction of the Columbian fleet. According to Brown, Kobayashi, also chairman of Nippon Television, quickly grasped the broad worldview embodied in the exhibition and lectured his staff about its importance. Playing along, Brown declared that the show would include Europe but "put it in its place." Kobayashi's enthusiasm "would indicate to me that we have a live one here." It might simply take some time.[65]

Brown, however, misread his host. Responding to a request that shortly followed for a two-million-dollar subsidy, the *Yomiuri Shimbun*

declared there had been some misunderstanding. While it was prepared to support a Japanese visit for *Circa 1492*, it could not support a show of this scale with only one venue, and that in Washington. The Daimyo exhibition at the National Gallery, which the paper had subsidized, was different: that was a symbol of Japanese-American cultural relations.[66]

This was certainly a disappointment. But Brown rarely accepted rejection as final. He proposed writing another letter, praising the newspaper's grasp of the exhibition's global conception and requesting $750,000. A team of scholars would shortly be visiting Japan in search of loans. He suggested a meeting.[67]

Temporarily suspending his Japanese quest, Brown returned to possible American or European sponsors. He phoned his friend Paolo Viti of IBM, proposing it join a corporate quartet; Viti reiterated that the company's policy was not to share. Trying to carve out an exception, Brown suggested they think about becoming the exclusive sponsor for the pre-Columbian section.[68] This, the final section in the exhibition, promised to be spectacular, for Brown had met with the president of Mexico and gotten important loan pledges. Viti, going over details of strategy with Brown, agreed to think about it and to put in a good word at several Italian banks.

But even as Brown pursued corporate sponsors, the international diplomacy of loan arrangements remained an even higher priority, and he undertook this at a dizzying pace. Disappointments continued. The Vatican refused to lend the Codex Borgia; it was planning its own exhibition.[69] Some desirable suits of armor had been reserved by European museums with their own Columbian agendas. And Spanish bishops were resisting various church loans.[70] Perhaps higher authorities might help.

At embassy dinners and other social events in Washington, as well as in a series of quick European trips, Brown continued to press his case. Corporate friends paid for Concorde flights when he had to reschedule European trips in order to attend a dinner at the Portuguese embassy for Prime Minister Cavaco Silva. Unfortunately, the prime minister's time was monopolized by Brent Scowcroft and other government officials. Sometimes affairs of state took precedence over Gallery needs.[71]

But special opportunities opened from time to time. Thus, Brown sat himself down one evening in an empty chair next to secretary of state Baker. The occasion was a party at the British embassy honoring the ambassador's birthday. Brown reminded Baker of his trustee status, and the

secretary "apologized for not getting to meetings. I picked up this theme again in our talk, and said there were ways he could be helpful without coming to any meetings, and he asked me with interest how." This was an invitation not to be ignored, so Brown took up several "situations" concerning foreign loans, described the *Circa 1492* exhibition, and asked Baker if he could invoke his name. The secretary replied "by all means."[72] Brown also mentioned his upcoming lunch at the Italian foreign ministry in Rome. He was already in contact with Ambassador Vattani, an advisor to Prime Minister Giulio Andreotti, who was hoping to arrange a meeting between Andreotti and Brown during an upcoming state visit.[73]

And then there were the Portuguese. According to Levenson, the Gallery's ambitions to borrow *The Temptation of Saint Anthony* by Hieronymus Bosch and an altarpiece panel by Nuno Gonçalves, along with a very fragile monstrance, had met a check. The director of the Museu Nacional de Arte Antiga in Lisbon, where all of them were housed, was outraged. A Lisbon meeting was being organized by museum directors who would be affected by the exhibition, and Levenson was concerned about its recommendations.[74] Friends in power had recently been replaced in a government shake-up. The views of the new culture secretary were not yet clear. Levenson got the American cultural attaché in Lisbon to meet with him. Brown also visited Lisbon, acknowledging Portgual's central role in the Age of Exploration, and emphasizing its prominence in the exhibition. He later wrote Santana Lopes, the new cabinet minister (and a future prime minister), that "the Bosch would speak as no other work could to the greatness of Portugal's collections and the pivotal position Portugal occupied in the world of the 16th century."[75] A special section of the exhibition was planned around the painting, and Brown offered conservation help and evaluation. (Not long thereafter, to be sure, Brown was telling an Italian soprintendente that "my dream has always been that Italy would dominate the exhibition."[76])

Santana Lopes turned out to be extremely sympathetic, arguing that Portugal had to open up more to the world. One thing helping the Gallery, he pointed out to Levenson, was traditional Portuguese paranoia about Spain. If Spain was participating—and it was—Portugal could not stand aside. Museum officials tended to be too conservative about loans, he continued, although some pieces had major conservation problems. When Brown indicated he could hold a press conference describing the exhibition, Santana Lopes was enthusiastic. This could help shape pub-

lic opinion over the heads of the museum directors.[77] At Lisbon airport, shortly before departure, Brown spoke to reporters from three different newspapers and distributed outlines of the exhibition. Gallery people returned home convinced they had regained the ground lost when their friends in power had been replaced, and more optimistic about their chances for the loans. The Portuguese proved to be very generous; the final catalog included more than a dozen significant loans, the Bosch and the Gonçalves among them. And one opponent, the director of the Museu Nacional de Arte Antiga, would shortly be fired.[78]

Then it was the turn of the Germans. Brown desperately wanted to borrow a Dürer self-portrait. There were two of special appeal, one hanging in the Prado, the other in Munich's Alte Pinakothek. He had started thinking about them almost two years earlier, conceding the obstacles. He hoped his "powerful friends in Spain" might assist his getting the one in the Prado, although he admitted it was unlikely.[79] Still, he continued to try.[80] But he also turned to Hubert von Sonnenburg, in Munich, to plead his case. The National Gallery had just sent an exhibition of its impressionist paintings to Munich, and the show drew large crowds. Sonnenburg, head of the Doerner Institut and soon to be appointed director general of the Bavarian State Paintings Collection, was grateful to the Gallery but said the Dürer was one picture he could never lend. It was extremely popular and on panel. He felt certain the Prado would not lend its either. He could help on other loans, but Brown had to accept the "political realities."[81]

Accepting political realities, Brown was also experienced in reshaping them. He could do nothing in Munich, but remained in active pursuit of Prime Minister Andreotti, with the help of his friend Gianni Agnelli of Fiat.[82] He also met with the ambassadors of Austria and Italy in Washington, tried to meet the former American ambassador to the Vatican, and, later that year, turned a meeting between Pamela Harriman and the president's Turkish counselor to the exhibition's advantage. Harriman mentioned one of the desired loans. We should take steps "to use this contact to pursue whatever recalcitrant objects are still outstanding."[83]

In the course of his campaigns of persuasion, Brown highlighted the extravagant pledges already made. Seeking the sword of Cesare Borgia from the Fondazione Caetani in Rome, Brown boasted that Turin was sending a Leonardo drawing, the Accademia in Venice releasing Carpaccio's *Miracle of the True Cross*, and both the Topkapi Museum in Istanbul

and the Waffensammlung in Vienna providing armor. He hoped he might unite the sword with its leather scabbard, owned by London's Victoria and Albert Museum. Brown had the support of the Agnellis and Prime Minister Andreotti. But he was not persuasive enough for the Fondazione Caetani or the Victoria and Albert. Neither the sword of Cesare Borgia nor its scabbard would make it to Washington.[84]

Nonetheless, European treasures were plentiful. North America presented different problems. An article in *Art & Auction* quoted Brown or, as Levenson suggested, misquoted him, about the scarcity of usable exhibition materials representing Native Americans in the sixteenth century. Sensitive to the criticism that ensued, Brown turned to Smithsonian colleagues and Native American leaders, among them W. Richard West, assuring them of his interest, requesting suggestions, and arguing that 1492 was not a high point for every art tradition. English, French, and most German art had been omitted. Their summits came at different times. Exclusions, he insisted, masked no discriminatory intent, but this line of criticism would become strident after the show's opening.[85]

While the search for Native American pieces continued, increasingly Brown sought objects that would enhance the show's distinction for critics and art historians. Some of them were panel paintings. These works on wood were vulnerable to changes in temperature and humidity, and had long been considered too fragile for travel. But Brown and his conservation staff, as well as some experts from other institutions, thought such fears were overstated; temperature-controlled travel was now possible. Pleading for panel loans from the director general of the Patrimonio Nacional in Spain, Brown pointed out that the Gallery and the Met had sent eleven panel paintings to the Franz Hals show in London in 1989, and that the Sienese exhibition at the Metropolitan had included some 112 panels. There already were panels in the *Circa 1492* exhibition from Portugal, England, and Italy.[86]

Personnel changes in Spain complicated these loan requests. Brown shared his frustration with his friend, the Spanish ambassador in Washington, enclosing a list of requests. He did emphasize that the Spanish section would be the largest in the Mediterranean portion of the exhibition and expressed delight on learning that King Juan Carlos was likely to come to open the exhibition in October 1991. This only made him more determined to effect those other loans, he told the ambassador. He

was scheduling another trip to Madrid to hold discussions with anyone the ambassador suggested.[87]

At least by the end of 1990, the corporate sponsors had been lined up. Ameritech had taken the lead, followed by Nomura Securities, the Mitsui Taiyo Kobe Bank, and Republic National Bank of New York.[88] Japanese corporations were much involved with *Circa 1492*, for in addition to the Mitsui Bank and Nomura, Canon USA helped finance a 35-millimeter film produced for the exhibition. At the press conference held on Columbus Day 1990 (scheduled by his public information officer, Ruth Kaplan, a full year earlier), trumpeting the more than four hundred objects coming from twenty different countries, the Gallery declared it was still seeking a European partner.[89] Republic National Bank of New York, controlled, despite its name, by European Edmond Safra, was as close as he would come to filling that role. All this was supplemented by an extraordinary special congressional appropriation of two and a half million dollars, a response to a presidential request—further acknowledgment of both the special occasion and the persuasive powers of Carter Brown.

Early 1991, just eight months before the planned opening, saw Brown still trying to finalize loans, a process that continued right up to the opening. Things had grown more challenging with the beginning of Desert Storm and the onset of the Gulf War in January. Offensive combat was halted by the end of February, but museums throughout the world had grown nervous. When Brown visited Philippe de Montebello in New York, the Met's director thought he might be coming in to discuss loan cancellations and exhibition changes. Montebello insisted on business as usual for the Met, though he reported that Italy was basically closing down its loans until the war was over, and he feared the reaction might spread to England and France.[90]

The Gulf War did indeed complicate Brown's loan strategy. In February, Prado director Alfonso Perez Sanchez wrote to say that his protesting the war had led to his dismissal; he planned a return to academic life. So he could do nothing about a Brown proposal to exchange the Gallery's *Alba Madonna* by Raphael for Madrid's Dürer self-portrait. Brown offered his condolences but refused to abandon his designs on Dürer.[91] A month later he was still attempting to deal, this time writing Thyssen-Bornemisza in hopes of getting *his* Dürer, *Jesus among the Scribes*.[92] In April he congratulated the new Prado director, Felipe Garin, pleading, "We

come to you on bended knee for the Dürer Self-Portrait." Again he proposed exchanging the Raphael and, in language he also used with other institutions, declared his desire for the "Prado to be able to take its place, along with the other great museums of the world, in helping commemorate in the American capital what is arguably the most important single cultural and historical observance that will take place in our lifetimes."[93] Internal memos expressed his concern that Spain might be playing favorites, lending important Spanish paintings to Paris as part of the 1492 celebration.[94] "We must keep the heat on," he wrote an American embassy official in Madrid, suggesting, among other things, that the king of Spain come to Providence, while on his forthcoming American visit, and stop at the John Carter Brown Library.[95] In a later note he offered to arrange some sailing opportunities.[96]

The middle of June saw Brown still petitioning the Spanish ambassador for the Dürer.[97] The exhibition was now just four months away. He was also in touch with the chief of the royal household, noting that the Dürer would be the only Prado painting in the show and would help give Spain the importance it deserves "as a guardian of world art of the highest order." It would be helpful, Brown urged, if the king indicated his support for the loan.

But Dürer spelled disappointment. The registrar of the Fondazione Thyssen-Bornemisza turned down the request for *Jesus among the Scribes*. A transatlantic trip during winter was too hazardous; the panel was too important ever to be moved from the museum.[98] And, Brown reported sadly to the Spanish ambassador July 1, the executive committee of the Prado's Patronata had refused to lend the self-portrait. Brown had to abandon this quest. "There is still what we consider a rather old-fashioned prejudice about generically not lending any panel whatsoever, even if small and in wonderful condition." It was important to settle such matters "if the Spanish section of Circa 1492 is going to avoid being an embarrassment."[99]

As the exhibition grew closer, some promises evaporated. Late in June, Brown appealed to the widow of his friend Nicholas Phillips, owner of Luton Hoo, an estate in Bedfordshire. Crushed by debts amid a property crash, Phillips had committed suicide in March. After an earlier Brown visit, "Nicky" had written indicating he would lend a fifteenth-century Spanish painting by Bartolome Barmejo, *St. Michael Triumphant over the Devil*. After his death, the trustees had decided on a no-lending policy for

Luton Hoo. Just four years later, executors would sell the painting (for ten million pounds) to the National Gallery in London.

Brown tried everything that could be imagined. He noted that the painting was in the catalog that was already being printed, that the press had been notified of its inclusion, that the conservation during travel would be excellent, that the prior commitment could be grandfathered so it would constitute no precedent, that the king and queen of Spain would attend the opening, that Britain was not well represented in the exhibition, that panel pictures were coming from other places, that laws had been changed in Taiwan to permit loans, that the provenance of the painting could be kept quiet, that the trustees of Luton Hoo could be invited to the opening, and that Nicky Phillips had written "in his own hand" his approval of the loan. All to no avail.[100]

In the final months preceding the exhibition, one threat above all had to be met. It was Poland, newly liberated from Soviet domination and in the midst of a momentous transition, where Brown confronted the severest test of his political influence, diplomatic skills, and worldwide connections. The trophy was an internationally famous Leonardo da Vinci panel painting, *The Lady with an Ermine*, painted just before the Columbian voyage, in 1489–1490. Held by the Czartoryski Museum in Kraków, it was a national treasure. Brown had been working on this prize since 1987, when he wrote his friend John Whitehead, George Shultz's deputy, describing it as as "the most illuminating" expression of European culture at the time of Columbus and requesting his aid in getting it. Leonardo (along with Dürer) was to be one of the two artists featured in *Circa 1492*. In November 1989, attending the opening of the Cedar Rapids Museum in Iowa, Brown met with its director, Joseph Czestochowski, taking him "into my confidence" about his desire for the painting. To burnish his credentials, Brown recounted his father's efforts to return a Veit Stoss altarpiece to a church in Kraków. Brown wondered whether the Vatican might help. Czestochowski, grateful for Brown's appearance at the opening, suggested contacting Cardinal Marcinkus, who until recent scandals had been in charge of Vatican finances. He also would approach the head of the Kosciuszko Foundation in New York.[101]

The loan request was made officially in 1990. As early as February 1990, Czestochowski had warned Brown in a confidential memo that the request would be denied by the museum, urging him to apply influence on an official level, possibly through the State Department or the Polish

ambassador. The curator at the Czartoryski Museum had not yet signed the letter of rejection and didn't want Brown to know about it. Czestochowski suggested he keep the information quiet for the moment.[102] Brown mentioned the problem to secretary of state Baker during his unexpected dinner encounter with him the following month.[103] A year later Brown sent Baker a note, attaching his own letter of request to the Polish foreign minister. The loan held "the highest priority" to the Gallery, and he hoped that it could be pressed during the coming state visit of President Lech Walesa, just days away.[104]

And that was what happened. According to Jay Levenson, Joseph Reed, chief of protocol (and a Brown friend), was riding to a State Department lunch with Walesa. During their short trip, Reed requested the loan, and Walesa, grateful to the administration for recommending forgiveness of much of the Polish debt, quickly agreed. The story later made it appear that Walesa had responded to a direct request from President Bush. The Czartoryski family, owners of the painting and the museum before the Polish government took it over, offered no objections. The Gallery had been in contact with them, as a precaution.[105] By April, Brown was treating the loan all as a fait accompli. In May, pressing other Leonardo loans on the Italians, he wrote Prime Minister Andreotti, inviting him to various events and boasting that "a fabulous Leonardo da Vinci coming from Kraków" would be part of the exhibition, along with drawings from the queen of England.[106] The Polish loan was quickly brandished with curators and cultural officials as a demonstration of the exhibition's significance. An international May press conference announced the loan officially, and a reproduction of the picture appeared on the cover of the press kit.

All of this was premature. The Kraków museum staff, which had opposed the loan the previous fall, were furious. They saw the Walesa promise as impulsive and unwise, placing a precious possession at unnecessary risk. Angry letters passed between Warsaw and Kraków, and museum officials dug in their heels. By mid-July it seemed it was all over: the Leonardo would not travel, a tremendous defeat for the exhibition planners. A July 15 State Department cable informed Brown that the whole staff of the Czartoryski Museum had tendered their resignations. The minister of culture, Marek Rostworowski (an art historian and former curator of the Czartoryski Museum in Kraków), felt it impossible to accept them, so the loan had been suspended. The American ambassador expressed

keen disappointment but asked the minister whether the presidential chancery had been informed. Apparently not, said Rostworowski; they had wanted to tell Brown first because of printing deadlines.[107]

The situation was complicated. It turned out that President Walesa did not have the authority to lend a state-owned object. Only the museum director did, subject to the approval of the minister of culture, who had been appointed not by Walesa but by the prime minister. In Warsaw, the American ambassdor, Thomas Simons Jr., warned that while things had not yet gone public, they were potentially a source of tension "between the presidency and the intelligentsia to which Polish politics is prone at this formative stage." Simons advised everyone to avoid "public steps which would put us in the center of a political and even a constitutional squabble, and keep it an issue for the Poles to resolve themselves." He recommended Brown put off printing the catalog as long as possible, but urged Washington to express both disappointment and continued hope and Brown to communicate directly with the minister of culture.[108]

Brown swung into action immediately. Within twenty-four hours he was writing to Rostworowski, congratulating him on his appointment (now six months old) and indicating that the Gallery would be communicating through American ambassador Simons in Warsaw. Combining the carrot with the stick, Brown made his gallery's links to government absolutely clear. "You will understand that, since the Ambassador represents one of our nine Trustees, the Secretary of State, and since this national gallery is supported by the federal government," diplomatic channels seemed appropriate. But then he invoked the fraternity of connoisseurs and art lovers. We "feel strongly here at the National Gallery about our role as a scholarly institution," viewing colleagues in Poland as "part of an extended international family toiling in the same vineyards." He hoped that, "as men of good will and good faith," they could solve the problem to mutual advantage. He announced he would visit Poland within five days to press his case and offer assurances for the painting's safety. He promised a major loan to the Polish museum, and special insurance, as much as one hundred million dollars. He concluded with the oft-invoked list of great works coming to Washington from throughout the world, an invitation to attend the dinners in early October, and promises of glory. "For Poland to . . . take center stage in this great commemoration can only be in the interest not only of every patriotic Pole, but particularly of our colleagues in the art-historical world. . . . A principal beneficiary will

be the Czartoryski collection itself, which stands to garner international recognition and, we earnestly hope, future friends and supporters."[109]

Brown could count on continuing support from his friends in government. Awarded the National Medal of Arts by President Bush in July, just as the situation was boiling over, he thanked Polish ambassador Kazimierz Dziewanowski for his congratulations, noting that both the president and Secretary Baker were following the status of the loan while they traveled.[110] And the State Department did keep Brown informed of developments. J. C. Dean of the Polish desk called him July 19 to say that all of the Czartoryski collection curators continued to declare their intention to resign if the loan went forward.[111] Baker's deputy, Joseph Reed, a good friend and confidant, called saying the Polish minister of culture wished to avoid a confrontation with the nation's intellectual community.[112]

The situation demanded dramatic action. On Sunday, July 21, Brown left for a whirlwind trip to Poland, arriving, via Paris, on a Monday night; he would leave Wednesday morning, arriving home in time for his Fine Arts Commission meeting. He had fewer than one and a half days to reverse the latest decision. A series of meetings with Polish officials ensued as Brown sought to shore up support and allay opposition. He used every argument in his arsenal, and somehow they worked. The loan was newly and officially endorsed. The sympathetic Polish ambassador to Washington hailed Brown's "heroic trip to Warsaw" in a letter, finding it "crowned with total success." It was the director's "inexhaustible patience and persistence" that had produced the happy ending. In his thank you note, Brown remarked prudently that the loan agreement had not yet been signed, though the details were being worked out.[113]

There was almost nothing Brown would not try. During the Warsaw stop, an embassy official told him that Pope John Paul II was planning to dedicate a children's hospital in Kraków in August. Brown mused that if the pope "could just drop by the Czartoryski Museum and pay his respects to Kraków's great treasure, the Leonardo, it would give an opportunity to launch the wonderful gesture on the part of Poland," referring, of course, to the loan.[114] Thanking the embassy officer for his information, Brown felt that a papal visit would "pull the teeth of any negatives" and declared he would work through the papal nuncio in Washington and the American ambassador to the Vatican.[115]

In fact, he wrote the pope directly, seeking any source of sympathetic connection. Expressing delight on learning he would dedicate the new

hospital wing, Brown invoked his own son, Jay, who had been recently hospitalized. He wondered if the pope might not, while in Kraków, visit the Leonardo, or at least mention it while he was there. This would allow everyone to "appreciate the extraordinary generosity of this gesture on the part of Poland," in the service of the exhibition's theme, "which is globalism and international understanding." He also recalled again his father's liberation and return of the Veit Stoss altarpiece from John Paul II's old church in that city. "Ever since he attended a Mass there that you conducted as Bishop, he has instilled in me a special reverence for your ministry and for the significance of Kraków as a great center of learning and art."[116] No record of the pope's response exists, at least in the Gallery archives.

There was fallout from the ferocious campaign to snare the Leonardo. A detailed account of the negotiations soon ran in the Polish newspaper *Gazeta Wyborcza* (there was practially nothing in American newspapers). The director of the Czartoryski Museum, Tadeusz Chruścicki, explained that opposition to the loan was based on an "established principle" among "cultured peoples" that "some works of art are not to be moved from their places." No security arrangements could guarantee absolute safety. The Polish reporter explained that the National Gallery had worked through American politicians to influence Walesa, and the curators had very little say in the matter. A few resigned, although Chruścicki pointedly did not. The Brown visit to Warsaw contained new proposals, Chruścicki allowed, but he didn't reveal any details. A destitute institution may gain by serving one that is rich, the article concluded, but not without abandoning principles.[117]

After reading the article, Brown wrote Chruścicki urging that final arrangements be accelerated. Though Brown had once suggested the Gallery might send its own Leonardo to Kraków in return for the loan, the conservation department warned it could not travel. The wooden supports and paint layers were too fragile. It was a board decision, Brown admitted, but likely to be unfavorable. He suggested instead putting before the board three of the Gallery's most important pictures: the *Small Cowper Madonna* by Raphael, which had come from the Widener collection; the van Eyck *Annunciation*, bought by Andrew Mellon from the Russians in 1930; and the rare Raphael portrait of Bindo Altoviti that had been in the Kress collection. Their quality was meant to acknowledge the status of the Kraków Leonardo. Brown favored sending the Raphael portrait.

Given the fact that the Czartoryski Museum was still searching for a lost Raphael (a reproduction currently hung in its place), Brown thought that displaying this Raphael during Kraków's summer festival could call world attention to the quest and aid its recovery. It was on panel, but "I have been able to get our staff not to oppose the loan though it has never been lent and is unique in this hemisphere."[118] The description was meant to mollify curators and art historians in Poland and to show good faith. Cables suggested that public opinion in Poland remained hostile to the loan, so Brown tried to curtail further publicity until the final details were worked out.

These efforts were wearying. In August 1991, two months before the opening, Brown was exchanging notes with former chief curator Sydney Freedberg about his presidential medal—both were appalled at its design—with the distracted director reporting that the "current cliff-hanger" was the Kraków Leonardo. "Light us a candle," he wrote Freedberg, a phrase he had used before.[119] Maybe that did the trick. By September, everything was settled. Indeed, facing new problems with the Italian loans, Brown was now using the Kraków Leonardo to convince feuding Italians to cede already promised treasures.

A new Italian ambassador in Washington further complicated matters. In early September, Brown was complaining that a Mantegna from Milan's Brera was now being withheld because of an upcoming Mantegna exhibition going to London and the Metropolitan. Italian officials argued it would be away too long. Brown produced a letter by Sisinni pledging the painting well before the New York exhibition was set; it had been assigned an important spot in the planned installation, and its absence would force unhappy changes. There was no time for a substitute. It would be the most important picture sent from Italy. Its only competitor in the paintings area "is also by an Italian artist, but is coming from Poland in an arrangement worked out by President Walesa in deference to the White House." The "Mantegna would thus appear, on an international level, to be of all the more importance to the Italian image!" He didn't add that he had been using the Mantegna loan to persuade others, particularly in Spain, to part with their own treasures.[120]

Meanwhile in Italy, Levenson was pushing hard to get other long-promised loans released. The Gallery assumed it had the d'Este *De sphaera*, an astronomical manuscript from Modena, but officials claimed they had earlier rejected the request. Under pressure, they relented.[121] It,

along with a fifteenth-century manuscript of Ptolemy's *Geographia* from the National Library in Naples, would come to Washington.

But there would be no Mantegna. Despite everything that Brown tried, including personal appeals to Italian senators, the show would include nothing by the artist. Levenson met with an aide to Sisinni, pointing out that the "figure" section in the Italian paintings section was weak. Various substitutions were discussed, and Levenson emphasized the importance of the Carpaccio *Miracle of the Relic of the True Cross*, held by the Accademia in Venice.[122] This would, in the end, be sent, and Brown congratulated Levenson. The Carpaccio will be a "show-stopper," he predicted.[123]

Diplomacy also prevailed when it came to making arrangements for the various events accompanying the exhibition. A fiftieth-anniversary medal was promised for the speaker of the Italian Senate (and former prime minister) Giovanni Spadolini, at the Andrew W. Mellon dinner. The Italian side would be pleased, Brown noted in a memo.[124] They were apparently nervous about being upstaged by the Spaniards the previous evening at the *Circa 1492* dinner, although they had provided "the lion's share" of the masterpieces. He also remained in close touch with Gianni Agnelli and repeatedly thanked him for his support, financial and political.[125] Agnelli reported that Spadolini said there were good things from Italy on display. Brown, who had worked hard to make that happen, responded that "there was no question that Italy won the 'Olympics' in the exhibition." By comparison, he confided, Spain had not lent major works.[126]

Even the angry Poles were assuaged by press conferences and special treatment. One Polish journalist, Marta Engel, having received a tour of the show, wrote in a Kraków newspaper just before the opening that the Leonardo loan would prove to be a great boon. The painting had its own conservator and would benefit future tourism more than paid advertising in magazines like *Newsweek*. The reproduction on the cover of the National Gallery's calendar was really a national calling card. "Most Americans had difficulty placing Poland properly on the map of Europe," Engel wrote, "and they certainly do not know about the existence of Kraków." It was good to make them realize that "apart from President Walesa and the Gdansk Shipyard we also have treasures of world culture."[127]

There were also some personal grievances for Brown to deal with. His

former chief curator, Sydney Freedberg, wrote a note that mingled congratulations with complaint. "I am unhappy that my role seems to have been overlooked," Freedberg remonstrated. The catalog made a brief mention of his having given "early help," but that comment scarcely acknowledged that he had "invented the idea, developed and articulated the concept, recruited the major experts and did the initial review of their loan lists." This was, Freedberg added, no criticism of Jay Levenson, who had done a "masterly" job of execution. But the catalog's description "seems to falsify the historical record of a very important event in the Gallery's life," and he hoped for some way of correcting it. Freedberg was leaving for surgery in Boston, and may have been feeling depressed and anxious.[128] But he did have a point; the memo he wrote in May 1984, almost eight years earlier, certainly laid out the show's major themes, provided its title, and proposed specialists.

Brown sent flowers to the hospital, and a long note that handsomely acknowledged Freedberg's role, going back to the aborted *Circa 1776*, when Freedberg had noted that the concept might be perfect for the quincentenary. Brown thanked Freedberg profusely and admitted that the final show certainly belonged to both Freedberg and Levenson.[129]

By this time, however, reviews were appearing and Freedberg, a Gallery loyalist, closed ranks. He commiserated with Brown about a Michael Kimmelman review in the *New York Times* that he found "outrageous—thick-witted, uncomprehending and condescending." In a final insult, Freedberg wondered if Kimmelman might be "in the pay of the Metropolitan."[130] Brown made no comment on this but pointed out that the *Wall Street Journal* had run a much better review. "Jack Flam is an art historian and has a little more sense."[131]

Kimmelman's critique raised some of the charges that would be repeated by others. While praising an "ecumenism that is both timely and welcome"—mingling Benin sculptures, Aztec stone carvings, and Leonardo drawings in the same show—he wondered if the point could have been made just as well "without borrowing some of the more precious and fragile objects." One Leonardo painting, the Gallery's own, might have been enough. "When important works of art are sent flying around the world for less than compelling reasons, questions about responsibility arise." Kimmelman also pondered why, in so inclusive an exhibition, "some cultures were excluded" (France, for one), and challenged the notion that "Western formalism" was an appropriate way to examine

non-Western cultures. A "magnificent muddle," *Circa 1492* was "the kind of blockbuster that seems a throwback to the celebratory excesses of a 1960's world's fair."[132] One exasperated reader wrote in to protest: "For heaven's sake! Can't Michael Kimmelman ever enjoy an exhibition at the National Gallery of Art . . . without carping?"[133]

The Kimmelman review, however, was no anomaly. *Circa 1492* opened amid a mood of guilt, anxiety, and accusation surrounding the Columbian voyages. Debates about European expansion and exploration had grown angrier and more polarized over previous decades. They climaxed with the quincentenary, as charges of exploitation and repression were hung around the once-revered explorers. Allegations of racism and ethnocentrism came easily to hand, and any presentation that exalted "the Discovery" invited opposition.[134] In Washington, three protestors were arrested at Union Station after pouring red dye on its Columbus statue and spray-painting the slogan "500 Years of Genocide."[135] "If any historical figure can be loaded up with all the heresies of our time— Eurocentrism, phallocentrism, imperialism, elitism and all-bad-things-generally-ism—Columbus is the man," declared Garry Wills.[136] Rarely has an American holiday "been subject to such prolonged and furious revisionism," the *Washington Post* editorialized.[137]

Intimations had come just before the opening. Brown had requested from the MacArthur Foundation in Chicago half a million dollars to produce a videodisc. It was meant to supply an interdisciplinary framework for the exhibition and to be used for educational purposes.[138] Brown was admittedly pessimistic. The foundation's "mindset seems to be of advanced political correctness," he wrote in a memo after an initial meeting. Its three representatives were "obviously uncomfortable with objects," and their agenda stressed social, political, and anthropological concerns. One of the experts objected to a glaring asymmetry: an emphasis on science in the European section and its omission when American Indian materials were displayed. "Their interest is in showing the world view and achievements of those who comprise the modern United States. . . . I was told that the objects from the hemisphere in the show did not give a sense of people and their daily lives," while European objects did.[139] No grant was made.

It was hard not to be dazzled by the treasures on display. Art historian Robert Rosenblum wrote Brown a "fan letter" in late October. "I had almost forgotten what a thrill great art can be, so thank you for rejuvenat-

ing those jaded spirits," he wrote. "Eurocentric though I am, the message came through with awesome and beautiful force."[140] Brown responded gratefully and wondered if Rosenblum could provide a testimonial to the Sunday *New York Times*. "Your prestige in the art world is such, that it might provide a needed antidote" to the Kimmelman notice. The Sunday *New York Times* "is unfortunately the one pipeline into the world of high culture that so many people out and around our country rely on."[141] Rosenblum declined; he noted a letter of "intelligent protest" that had just appeared and confessed that personal issues made intervention impossible.[142]

Washington critics were more generous than Kimmelman. This was, wrote Paul Richard in the *Washington Post*, a "fabulous exhibition," "fabulous in quality, in beauty and in scope." The "finest of its 569 objects are so wrapped with wonder that they can scarcely be believed." *Circa 1492* presented its trophies without apology. It did not "resemble the politically correct 'multicultural' exhibits today so much in vogue," Richard told his readers. "Most such shows suggest, at least as subtext, that notions of high quality are instruments of oppression used to marginalize the art of most non-Europeans." Nothing like that happened here; the African, Islamic, American, and Asian masterworks "rarely wither in the glow of those nearby Leonardos."[143]

Locals responded not simply to the exhibition but to its showbiz touches. The opening dinner more than matched the splendor of any previous Gallery production: 550 guests, including the king and queen of Spain; seventy-five (cooked) wild turkeys—at least one for each table—accompanied by foods representing Europe, Africa, Asia, and the Americas; a Cathay lychee bombe glacée whose surface markings suggested "the longitudinal lines of a cartographer's globe" (this was Brown's observation); wines from Japan, Spain, and California; music from Spain, Mexico, Peru, Bolivia, Colombia, and Guatemala—the details were overwhelming.[144] Brown labeled the show "our three-act adventure opera."[145]

The huge crowds forced the Gallery to adjust the show's layout and extend its hours. The spaces were enormous. A "visitor can be excused for thinking he has covered more territory in less time than Columbus himself ever did," wrote Eric Gibson in the *Washington Times*. Gibson did wonder whether the Gallery had "overreached itself," giving the public "more than it can reasonably be expected to absorb." And while conceding it presented "great spectacle," he suggested such a "megaexhibition"

was less about art and more about "public relations" and "an institution's muscle." It was an extraordinary feat but "not a trend that should be encouraged," despite the many compliments he had just strewn.[146]

Having gotten his loans, at whatever cost, Brown didn't stop tinkering. A perfectionist about physical arrangements, he fired off a series of memos. Before the opening, he found some of the wall texts to be inaccurate and others misleading, but he liked the quality of the silk-screening.[147] Crowds were good on Sunday, particularly late afternoon, but numbers were thin at noon. Perhaps more advertising was needed. He noted that restrooms on the mezzanine were "technically open," following an earlier suggestion of his, but still had the word "staff" on them, and better signage would be needed to steer visitors there. More chairs were needed in the lounge; visitors had been sitting on the floor.[148] He proposed borrowing furniture from the library reading room, which no one ever seemed to use. And one of the manuscripts, from Ghent, was causing some crowding because its illustrations were too small to read. Brown had a replacement in mind and apologized for the original decision to place it in the vestibule.[149] He worried about lost sales of the massive catalog to out-of-towners. It weighed more than eight pounds (even without any index) and was too heavy to carry away. He suggested the Gallery offer to mail it, charging only actual postage.[150]

Minor criticisms aside, Brown was delighted by the overall performance of the staff and sent out a "Memo to All Hands" in mid-October, congratulating them on what he declared to have been the most challenging week in the Gallery's fifty-year history.[151] It had incorporated visits by royalty (including the queen of Norway), the lenders' dinner for *Circa 1492*, the opening of the exhibition and the attendant press events, meetings of the trustees and the Trustees Council, the Andrew W. Mellon dinner, and a continuing round of special receptions, tours, and presentations. A heady mix, but all this, in effect, was what the Gallery lived for.

As the months passed, newspaper reviewers were joined by critics in general interest and literary magazines, as well as by scholars writing for colleagues in professional journals. The exhibition—and even more, its catalog—stimulated an impressive number of reviews. Conceding the show's undeniable popularity, along with the extensive promotional effort, most writers acknowledged the serious intellectual ambitions that had been invested in *Circa 1492* (a contrast to some earlier blockbusters like the King Tut exhibition and *Treasure Houses of Britain*), but many

questioned the arguments, assumptions, and display logic. The challenge of choosing and assembling the objects themselves, so consuming an effort for so long a time, got much less attention or commendation, although some, like Creighton Gilbert in the *New Criterion*, expressed their gratitude for this "rare sequence of star turns. It is probably just ungrateful," he concluded, "to ask that the exhibition be what it is not, when it is already more than just about any other assemblage of great things." The array of masterpieces recalled the "Musée Napoleon, which once aspired to do this permanently." The "grand scale" and a string of curatorial "coups" rested on the willingness of museums around the world to make "magnanimous" gestures, and the generosity of corporations and the United States Congress to underwrite the costs.[152]

Gilbert did note the tension between the exhibition's twin themes—discovery and creation—and its ambitious effort to demonstrate, simultaneously, cultural connections and respect for each culture on its own terms. The title, of course, omitted any mention of Columbus, and this, as Brown admitted, was deliberate. The show's focus was not the explorer himself but his age. The title also might be, some at the Gallery hoped, a way of sidestepping some of the combustible issues associated with the Discovery. The awkward absence of the principal figure became a theme as well for several reviewers in the popular press.[153]

But it was just this ambivalence that caused some on the right to rebuke the National Gallery. In his *Commentary* review, Richard Ryan complained that the exhibition "failed to explain" why Europeans increased their technical mastery and scientific ambitions in this era, while China, for example, dominating all of East Asia, never managed to "surpass its own medievalism." No hypotheses were offered, for this "would have dragged the National Gallery into the messy business of passing value judgments on other cultures. Ming xenophobia is off-limits, apparently."[154]

The problem that *Circa 1492* "insisted on skirting" was multiculturalism. Ryan belittled Carter Brown's praise, in the show's Acoustiguide, for a Benin bronze, and particularly for his saying, "This head is for me one of the most beautiful bronzes in the world." Such a judgment clearly exaggerated what was a "psychologically empty image." Nor did the exhibition confront the rapid absorption of European forms and materials by native cultures, or European appropriation of native processes. Examining assimilation comprehensively would have forced cultural comparisons, inviting "arguments about the ethical and political character of

colonized societies prior to their absorption." Ryan focused briefly upon the Aztecs and the "lethal majesty of the Aztec theocracy," the "orgies of human sacrifice," which, in the catalog, were transformed into "a kind of wistful naturalism." There were "no obvious conclusions the National Gallery's curators did not struggle valiantly to overlook."[155] Increasing the bitterness of the pill he had proffered, Ryan contrasted the Gallery's effort with a show at the Metropolitan Museum of Art. *Resplendence of the Spanish Monarchy* was "without question a superior act of curatorship. Focused, elegant, original, aesthetically moving, historically revealing," it presented the European involvement with Africa and the Americas as reflecting an "emphatically Iberian nature." Ryan turned then to praising the armor and tapestries that made up the Metropolitan show, ending with a tribute to the "Westernization of the world" as a humanistic vision that seemed, in 1992 at least, to be a distinct possibility.[156]

There were certainly other rumblings from the right about a loss of intellectual nerve and pandering to multiculturalism, but there were also, as Brown anticipated, attacks from the left, some of them finding the exhibition project fundamentally flawed, intellectually dubious, or ideologically tainted. Thus, for example, Homi Bhabha, praising the organizers for their "laudable attempt to staunch the 'nationalist' sentiment of 'Discovery-Pride'" in an exhibition of "creative heterogeneity," complained that the show ended up essentially endorsing "the centrality of the Western museum." Presenting "art from the colonized or postcolonial world," "disinterring forgotten, forlorn 'pasts,'" and making choices "catholic and noncanonical" was all well and good, but this only became "part of the post-Modern West's thirst for its own ethnicity." "The globe shrinks for those who own it." Without distinguishing between art that has "known the colonial violence of destruction and domination," and work that has simply moved "from courts to collectors, from mansions to museums," the audience "can only be connoisseurs of the survival of Art, at the cost of becoming conspirators in the death of History."[157]

Stephen Greenblatt, writing from a different angle in the *Times Literary Supplement*, mourned the loss of what had once made the exhibited objects vital, their physical context. "The sword is taken from the hands of the warrior, the altarpiece is removed from the shrine." To be sure, this was the fate of many museum displays. But there was something special about the losses in *Circa 1492*. What was presented "is less the Age of Exploration than the Age of Exhibition," "the desire at once to preserve

our history and to efface it." This was, in the end, an "attempt to com-
memorate Columbus's voyage and at the same time to avoid the political
dangers implicit in any commemoration," a bid "to transcend ideology
through the catholic embrace of world Art." There was something naive
about this effort, Greenblatt concluded, but "also a last sign in our cul-
ture of a utopian principle of hope."[158]

Greenblatt's critique captured a core element of Brown's religion of
beauty, his ongoing belief in the redemptive power of the art exhibition
and its capacity, indeed, "to transcend ideology." The relentless efforts to
capture trophies from throughout the world epitomized both the trium-
phant status of the National Gallery as a node of international museum
culture and the political power of the United States. But they also re-
flected Brown's determination to assemble the most powerful examples
of human skill and creativity. He fought hard for every one and bitterly
lamented each loss. This was what counted for him, in the end. Political
positioning, political correctness, cultural judgments, all paled beside
the quest to assemble these remarkable pieces. He believed in their trans-
formative power, convinced that others would also see the light. Their
pursuit justified almost anything. The flair of the showman, the zeal of
the connoisseur, and the deftness of the international diplomat had been
combined for one last effort—at the National Gallery at least—to realize
his broadest goals.

No one realized it was a last effort until, just two weeks after *Circa
1492* closed, Brown made a sudden announcement, while hosting a din-
ner party for his board of trustees at his own home. Scholarly reviews
were still arriving, debate about multicultural evasions continuing, and
memories of crowds fresh, but references to Carter Brown would soon
attach "former" to his National Gallery directorship. Brown told his
startled guests he intended to leave his position of almost twenty-three
years as soon as was convenient. After the initial shock, the search for a
new director quickly began.[159] Three months later, the board of trustees
introduced its choice, Earl (Rusty) Powell III, director of the Los Angeles
County Museum of Art and a former Gallery curator.[160] By the fall Brown
was gone, his stationery now reading "Director Emeritus." For once an
expression whose triteness overshadowed its accuracy was actually true:
an era had ended.

Retirement Projects

C arter Brown's January resignation came as a stunning surprise, to insiders and outsiders alike. While one or two friends apparently knew his thinking, there had been no public hints that he wanted to leave. His most extravagant exhibition had just closed, and he seemed at the peak of his powers. He was not yet sixty.[1] An obsessive search for some convincing explanation began almost immediately and continues years later.

In his official statement, Brown spoke of a need to spend more time with his family and to serve the many organizations, some twenty or thirty, on whose boards he sat or for whom he consulted. Both reasons seemed plausible. His son, Jay, was undergoing spinal surgery, his recent divorce certainly had added stress to the lives of his two children, and his extended sets of professional obligations—chairing the Fine Arts Commission and the jury for the Pritzker Prize in architecture, involvements with the National Trust, the World Monument Fund, Brown University, the Kennedy Center, the National Geographic Society, the White House Historical Association, the John Carter Brown Library—did indeed constitute a heavy set of responsibilities.

But plausibility fell short of persuasion. These commitments, and his son's illness, had been going on for some time. More professional obligations would soon be added. Brown would continue to travel extensively and to figure heavily in the Washington party circuit. Nothing appeared to justify so sudden and complete a withdrawal from a position of such power and visibility.

Many exegeses were offered, at the time and since, and various rumors circulated around Washington. Health problems. A dissatisfaction with changes in Gallery board leadership. A rift with Paul Mellon. A sense that the glory days of the touring exhibition were over. Problems with the Gallery's administrative staff. It is difficult to rule out anything absolutely, although Brown did, in letters addressed to friends, flatly deny rumors he had AIDS.[2] He also, more obliquely, spoke about this to reporters.[3]

Accepting his explanations at face value might also be reasonable. Brown said he wanted to leave with everything going well, with his energy still high, to try something different. He continued to be absorbed by dreams of missionary glory, eager to spread his religion of culture to further outposts. Memories of the huge audiences Kenneth Clark had created for his *Civilisation* series two decades earlier must have remained sharp and tempting. And after thirty-one years of working at the Gallery, he may well have simply wanted a change, confident that he could transfer to other spheres the authority he had earned at the museum helm.

Brown's post-Gallery years were active. He set up an office with secretarial help to coordinate his complicated schedule. Telephone logs and correspondence files reveal an enthusiastic embrace of networking, linking former associates, celebrities, political figures, family members, politicians, diplomats, foundation executives, academics, and professionals across a range of fields. He responded to needs, requested favors, and simply stayed in touch with an astonishing assortment of people. Continual, at times even continuous travel, within and outside the United States, kept him busy. His life was "overflowing," he wrote a friend in 1993.[4] Newspaper notices barely slackened from his days as director—he was chairing discussion panels, attending embassy receptions and Gallery openings, escorting notables at society events and gala concerts, participating in benefits, welcoming visiting celebrities, frequenting White House dinners. And enjoying a happy and satisfying relationship, in his last years, with Anne Hawley, director of the Isabella Stewart Gardner Museum in Boston.

There were also statements to issue. Brown remained a willing commentator on almost anything to do with the visual arts, architectural preservation, museum policy, and popular taste, retaining his ensconced status as an arbiter of culture and a darling of the local journalistic world. The annual Pritzker Prize offered an opportunity to expound on the contributions of contemporary architects, and there were apparently unending series of boards and committees to join, and others to turn down.

After retirement, Brown became a trustee of the newly created Chelsea Art Museum in New York, joined the board of Phillips Auction House, became involved with Corbis, the image holding company owned by Bill Gates, was appointed one of three trustees of the Doris Duke Charitable Foundation, and served as a director of the Vira I. Heinz Endowment.

Some of these positions came with substantial honoraria. Brown had to give up his salary, which in 1991 came, with benefits, to $268,000.[5] He was never quite convinced that he was rich enough to despise additional income. This became clear in 2001, when he decided to sell at auction the Leonardo da Vinci drawing he had inherited from his father. Handled by Christie's, in London, it fetched 8.14 million pounds and tied the auction record for old master drawings.[6] This was just the kind of trophy that Brown had gone after while director of the National Gallery, but he decided against a gift to the Gallery for reasons of estate planning.[7] A decade earlier he had contributed a master drawing to the Gallery as part of the fiftieth-anniversary campaign, but making some sort of gift then was absolutely necessary, to retain credibility as a fund-raiser. Despite his comparative wealth, Brown was not, himself, a generous donor of money or objects. Tendencies toward munificence may have been constrained by immediate comparisons with wealthier friends, but his long-established patterns of frugality extended to personal expenditures as well. Georgetown neighbors, like celebrity biographer Kitty Kelley, complained about his reluctance to paint his Victorianized house. Hearing Brown explain that his maintenance costs were high, Kelley passed the hat and pledged $32.60 to the campaign for refurbishment.[8]

Financial issues aside, Brown spent much of his retirement on several major projects, whose inclusionist goals carried forward some of the themes that had marked his Gallery years. And some decisions he had made while still in office had lingering consequences that reflected ongoing debates in the museum world.

One of them was the controversial world tour (first stop, the National Gallery) of the Barnes Foundation collection. The extraordinary but heavily secluded art collection, located in Lower Merion Township, in the Philadelphia suburbs, was being transformed in the early 1990s by the Barnes Foundation president, Richard Glanton, an African-American attorney who had succeeded Franklin Williams in 1990. In accordance with Barnes's wish, four of the five board members were appointed by Lincoln University, the first institution founded specifically to provide

"higher education in the arts and sciences" for "those of African descent." Admission to the collection, part of an educational institution Barnes had painstakingly created, was restricted in number, in part because of the suburb's hostility to crowds and traffic congestion. The endowment was small, revenues meager, and maintenance inadequate. Warning about the safety and security of the fabulous artworks, the deterioration of the building, an absence of effective environmental controls, and the very limited audiences allowed to visit, Glanton justified aggressive entrepreneurial methods to increase Barnes revenues and visitation.[9]

Apparently on the advice of Walter Annenberg, a longtime critic of Barnes's restrictive policies, Glanton initially proposed to raise money by selling fifteen paintings from the collection, despite specific prohibitions against this in the indenture that established the Barnes Foundation. When a groundswell of indignant opposition made this impossible, Glanton moved forward with another idea, again propelled by Annenberg, to mount an international tour of selected masterpieces while the building was undergoing renovation.[10] Focused upon impressionist and postimpressionist masters, the exhibition would also include work by fifteen painters, among them Picasso, Modigliani, Braque, Gauguin, Seurat, and Rousseau, but well over half the paintings were by Renoir, Cézanne, and Matisse. In keeping with Barnes's intent, they had never been loaned before, or (with rare exceptions) even been reproduced in color. A contract to produce a full-color accompanying catalog was signed with the noted publishing house of Alfred A. Knopf. The show promised to be a crowd-pleaser, and Glanton set the museum fees high, several million dollars a stop. After opening in Washington (the National Gallery, as organizer, did not pay the fee), it was scheduled to go on to Paris, Munich, and Tokyo before completing its tour at the Philadelphia Museum of Art. While Rusty Powell, Brown's successor, wrote the director's forward for the catalog, it was Brown and his staff—including the veteran team of Dodge Thompson, Gill Ravenel, and Mark Leithauser—who had seen to the touring arrangements and local installation.

Planning had begun when Glanton came to Brown in 1991, again apparently on the suggestion of Annenberg, to request the National Gallery's organizational assistance. Brown was no unwilling participant. In a letter probably leaked by a Barnes staff member, he argued that only the National Gallery had the size, stature, and connections to organize the show properly and produce an effective catalog. A partnership would be

mutually advantageous, he wrote Glanton. "In sum, there is no substitute for experience."[11] Brown also provided testimony before the Montgomery County Orphans' Court, which was being petitioned to allow the paintings to leave Merion; Barnes, again, had explicitly prohibited the practice in his trust indenture. There were loud protests against the exhibition (and Glanton), primarily from Barnes students and employees, and from local residents.

Albert C. Barnes, who had clashed with the Philadelphia art establishment, had conceived of the institution he created primarily as an educational setting. His unusual and idiosyncratic curriculum, influenced by John Dewey, was built around continuous student access to the art. The student protesters, Annenberg claimed, were "totally unconstructive," "a bunch of complainers who act as if they're important figures in the art world. They're nothing. The tour is the best way to raise the funds to bring the Barnes into the 21st century." Glanton called them "children who don't want anyone else to play with the toys in the attic."[12] Permission for the tour was granted by Judge Louis Stefan, who accepted the combination of need and opportunity presented by Glanton, Annenberg, Brown, and others.[13] A "serendipitous circumstance has presented itself to the Foundation," the judge declared, allowing it to "restore, protect and display" parts of its collection while accumulating funds toward its expensive, twelve-million-dollar program of renewal. The exhibition and catalog would be accompanied by a video, *Citizen Barnes*, narrated by Carter Brown.

Almost nothing about the Barnes collection was uncontested, including its need for elaborate renovations. The exhibition stirred controversy in unexpected places. On behalf of the show, the National Gallery had applied to the Federal Council on the Arts and Humanities for three hundred million dollars' worth of insurance; it could save them hundreds of thousands of dollars. The request came from Brown on his final day as director. And it was successful. However, the 1975 Arts and Artifacts Indemnity Act had been intended to cover international shows, and granting this application (when only one work of art was coming from abroad) would, in effect, extend its application to domestic exhibitions. Brown, himself a member of the council (he didn't attend this meeting), proclaimed his delight at the decision and insisted the enabling legislation did not prohibit such an action. The only thing necessary was a change in rules.

Others disagreed. The acting chair of the National Endowment for the Humanities had voted against approval because he thought it unfair ("Every other museum in the country but the National Gallery has to live by these regulations"), and some other council members also were concerned about a "back-door arrangement."[14] Within days a council attorney challenged the action, saying the decision had been made, illegally, in a closed session. Weeks later the council reversed its decision, responding to the objections made by its legal counsel.[15] This back-and-forth did not imperil the exhibition, since the Gallery went ahead and purchased private insurance, with the aid of a two-hundred-thousand-dollar grant from its corporate sponsor, GTE. But the reversal disappointed and surprised some council members, particularly Brown, who had been hoping to use the case not simply to aid the Barnes exhibition but to expand governmental indemnification substantially and permanently. This attempt at policy change, however, achieved without any congressional consultation, angered Representative Sidney Yates, who declared the need for further study during hearings on the National Gallery's budget, soon after the original vote. Not until 2007 would Congress authorize such an expansion.

There were other issues. At least one former Barnes conservator charged that some of the paintings were in no condition to go on tour; the inspection and conservation actually undertaken had been done quickly, to meet the tight deadlines imposed by the exhibition schedule.[16] The Gallery opening itself attracted the attention of picketers, primarily Barnes students or former students. Brown professed surprise, once again, remarking that the proceeds of the tour would in time benefit the students.[17] Reviewers exclaimed over the beauty of the rarely viewed paintings, but there was some unhappiness that the spacious Gallery installation violated the distinctive, if very crowded, hang that Barnes himself had mandated.[18]

Nonetheless, others were eager to get, at last, a better view of special favorites. One newspaper, concerned by the long lines to enter the Gallery, complained that its charter forbade charging for admission. "So which price does the gallery want its patrons to pay," asked the *Washington Times*, "the money or the wait? Congress ought to change the charter so gallery officials can decide for themselves."[19]

The ensuing tour brought in millions to the Barnes Foundation, and set records almost everywhere. The collection "got the reputation for be-

ing the girl you can't have," Brown suggested in one of his characteristic metaphors. "The mystery of seeing these hidden treasures . . . gave it serious news value."[20] More than four million people saw the show in Europe, Asia, and America. In a further petition to the orphans' court, Glanton managed to have the tour extended; the fortunate new bidders were the Kimbell Art Museum in Fort Worth and the Art Gallery of Ontario in Toronto (replacing the Los Angeles County Museum of Art). The eighty or so paintings formed a show of just the right size, "not too many to overwhelm visitors," Glenn Lowry of Toronto explained, "not too few."[21] The Kimbell showing eclipsed attendance records for any art exhibition yet held in Texas, yielding more than a hundred million dollars in local revenue. "We thought we might get 250,000 people, and we ended up with more than 430,000," museum director Edmund Pillsbury told an art critic.[22] The Toronto stop brought, in addition to a large dose of prestige, an even more useful addition to provincial coffers. Museum parties and openings were opulent.[23]

The transformational enthusiasm recalled the scale of Brown's first true blockbuster, almost two decades earlier, *Treasures of Tutankhamun*. His role in the Barnes extravaganza was more modest, that of enabler and promoter, although his participation was critically important. He visited several of the tour sites, negotiated with the Japanese (reporting back directly to Glanton), offered tactical advice, and emphatically endorsed the exhibition plan. Breaking Barnes's indenture in order to make the collection more accessible seemed to him a reasonable price to pay, although controversy and litigation would be ongoing during the next seventeen years. Opponents seemed to Brown "incorrigible elitists"; he referenced, in an unsent letter to Hilton Kramer, "the arrogance of possession," and insisted that "the checkbook is not as significant to the history of human creativity as the brush."[24] In any struggle between museum traditionalists bent on protecting existing arrangements and populists aiming to expand the audience base, Brown would certainly be found among the latter. His missionary instincts were aroused by the Barnes opportunity. He was even prepared to engage in historical revisionism, or perhaps auto-intoxication. "I have this little theory," he told the *Washington Post*, that Barnes would be "absolutely overjoyed" by the exhibition, and particularly happy with the National Gallery's free admission "so the good folk of Washington and Anacostia and Northeast neighborhoods can come in on their own time."[25]

Brown had previously endured, in several of his international shows, condition challenges raised by conservators, and he was prepared to battle for objects so long as Gallery staff were confident no damage would be done. And that was their position when it came to the Barnes pictures. The risks seemed worth taking. The tour demonstrated that a Carter Brown accolade remained invaluable. When he declared on a visit to the Art Gallery of Ontario that its presentation of the Barnes paintings was "the best displayed exhibit yet," "Toronto entered the big leagues," wrote a reporter for the *Toronto Sun*.[26] It seemed as simple as that. The blockbuster exhibition continued to credential as well as to attract, precisely the kind of function Albert Barnes abhorred generations earlier when he established the strict rules that were now being so broadly violated.

Related objections were voiced regarding another Gallery exhibition, opening just weeks after Brown's departure, *The Greek Miracle*. Most of the thirty pieces of Greek sculpture came directly from Greek sites and museums and were being shown abroad for the first time. The marbles and bronzes were extraordinary, and their beauty as well as their significance received extended tributes from critics. However, a flood of angry responses soon made the exhibition notorious, a textbook case for students of exhibition politics and museum ideology. The *New York Times* proved, not unexpectedly, to be a particular nemesis.

The first problem was the show's rationale, or lack of one, beyond simply making available masterpieces normally accessible only to world travelers. The stars included a slab from the Parthenon frieze, the *Kritios Boy* (the earliest surviving work breaking from the tradition of the archaic kouros), and a renowned statue of Nike, bending to untie a sandal, from the Acropolis Museum in Athens. There was no question about the sculptures' quality. But the show's lengthy subtitle, which began "Classical Sculpture from the Dawn of Democracy" seemed a stretch, either an excuse for a "politically inspired promotion for Greece" or an ethnocentric gambit. "This show doesn't even pretend to be scholarly," Michael Kimmelman complained in the *New York Times*. "It is the sort of masterworks display in which you are encouraged not to think too hard or ask too many questions, just be dazzled."[27]

Holland Cotter, reviewing the show at the Metropolitan, where it went after leaving Washington, argued that the objects had been gathered "not in the interest of new scholarship" but "as a kind of travel brochure, replete with a jingoistic promotional title meant to perpetuate

cliches about art and its meaning that recent art history has been trying to dislodge." The exhibition "not only lacks any evidence of a shaping hand but has barely an original thought in its handsome head." Art, Cotter continued, was no "miracle," and "classicism" was not absolute perfection. This was "an official art created by a culture notable for its profound distrust of peoples outside its own borders." The Cotter critique combined, in its own way, the thrust of objections to *British Country Houses* and *Circa 1492*, that is, charges of intellectual vacuousness with what Brown might have considered politically correct disapproval of cultural bias (a "golden age" that accepted slavery). The catalog Cotter simply labeled "undistinguished."[28]

The critical onslaught was continued in *Time* by Robert Hughes, who labeled the show an "exercise in political propaganda," with "practically no scholarly value," and by David D'Arcy in *Art & Auction*.[29] Angry letters, including one by author Nicholas Gage, flowed in to both magazines, and Brown resented the attacks as inappropriately personal and wrongheaded.

Just as significant to some critics was the issue of risk—and not only to the Greek sculpture. To get the treasures out of Greece, the Met and the National Gallery, between them, agreed to send some seventy paintings, old masters and French impressionists, to the National Museum in Athens, which had upgraded its security and environmental controls for the occasion. Here Cotter was less severe than Kimmelman, who griped that worries about a plane or truck catastrophe were now deemed to be alarmist by the two museums. Exhibitions of this kind, he concluded, "are really about power," about "the power of the National Gallery and the Metropolitan to act like big game trophy hunters, mounting on their walls the bounty of other nations."[30] Other critics, particularly Eric Gibson in the *Washington Times*, also brooded about disaster, and argued that "If irreplaceable works of art are sent around the world only for their value as spectacle, then they should stay where they are." If "the gallery is borrowing these precious objects mainly to demonstrate once again that it has the clout to do so, then the risk of sending them will be difficult to justify."[31] Gibson did warm up to the exhibition in a subsequent review, but he still bemoaned the pressures on museum directors from organizers of extraordinary shows.[32] He invoked the memory of Brown's securing the Polish Leonardo for *Circa 1492*. And he interviewed James Beck of Columbia University, director of ArtWatch International, who

was hostile to megashows, and to *1492* in particular, angry about "institutional muscle-flexing museums showing how much clout they have with lenders, corporations and governments."[33]

Brown vigorously defended the project, along with its political implications. The show had actually been spurred on by an outside curator at Georgetown University, who was developing an exhibition celebrating the birth of democracy in Greece. When still director, Brown described it as part of a string of anniversary celebrations: Columbus at five hundred, the Gallery at fifty, and now the much older origins of democracy. "Fifth-century Greek art is one of the most significant epochs in history," he told a *Washington Post* writer before the exhibition opened, "and we have an election coming up in this country." The recent surge of democratic regimes offered further justification.[34] It was "amazing," he went on in another interview, "that there is a kind of equivalency between these great political breakthroughs and the art . . . a sense of the value of the individual, which is what makes it so stirring." Philippe de Montebello, also interviewed, concentrated on aesthetic issues rather than politics: "This is an exhibition made up of Greek originals."[35]

By the time of the opening, however, defending the theme and the show would be the task of the new director, and Rusty Powell stepped in to do just that. There would be other exhibitions inherited from Brown's administration that would open in the next year or two, but none captured the blend of political opportunism, trophy display, and extraordinary art that had characterized so many of his most popular presentations quite as explicitly as *The Greek Miracle.*

During the next several years, Brown found outlets beyond the National Gallery to express his missionary zeal for the arts. One of them involved the 1996 Olympic Games, awarded in September 1990 to the city of Atlanta. From many standpoints, Atlanta seemed an improbable choice. It had beaten out, among others, Athens, for the honor of hosting the games on the hundredth anniversary of their modern renewal. Local promoters lobbied International Olympic Committee delegates hard, and large sums of money were pledged to enhance local amenities. The event offered Atlanta the chance to counter the region's lackluster reputation for support of the arts, and to highlight its own considerable institutional accomplishments. H. L. Mencken's famous essay "The Sahara of the Bozart," written more than seventy years earlier, still served to define southern culture for many outsiders. According to one account, in 1991,

not long before his retirement, Brown visited Atlanta for a farewell dinner and asked the director of the High Museum of Art, Ned Rifkin, if he had plans for any exhibitions tied to the Olympics. Rifkin told a reporter, "I had the pedestrian idea of doing a show of what each culture thought was its artistic treasure," but Brown was pessimistic about Atlanta's chances to get the loans.[36]

The two met again the following year, Rifkin claiming to be the first visitor to Brown's new Pennsylvania Avenue offices.[37] Rifkin invited Brown to participate in the Cultural Olympiad that normally complemented the sporting events. Atlanta's agenda included concerts, new plays, a film festival, dance performances, museum shows, a conference of Nobel laureates, and, if Brown agreed to coordinate it, an elaborate art exhibition to be held at the High.

Brown embraced the notion enthusiastically and, over the next several years, and certainly for much of 1995, promoted the show even before he had loan commitments. To journalists it was a sign of his continuing involvement with the world of art museums, and also a suggestion of continuing power. Paul Richard in the *Washington Post* presented the former director "doing clerk work," "on his office floor on hands and knees shuffling through folders," looking for a slide. This was "a most unlikely sight," "that most patrician of American museum men—if the art world boasted nobles, he'd be at least a prince," without the staff of retainers that used to work for him.[38] In a city "where those out of office are presumed either dead or in Florida," Grace Glueck wrote in the *New York Times*, Brown "is still in everyone's rolodex." His activities make clear "that he is still an ambitious, high-energy mover and shaker." "I come from a great line of preachers. I believe in the arts, and I have a sort of Messianic zeal about broadening their audience," he told her.[39]

Brown's scheme was entitled *Rings: Five Passions in World Art*, a show built around human emotions, tackling art's universal capacity to excite feelings, whatever their origins. "We've had enough reminders about all the things that separate us," Brown observed. "We should be talking more about what human beings have in common."[40] It would be an expensive project, costing more than three million dollars, much of that provided by Atlanta's Olympic Committee, some coming later from Equifax, the credit score company. By the start of 1995 Brown was promoting a plan to gather more than a hundred works of art evoking five interconnected emotions: love, anguish, awe, triumph, and joy. Spanning the centuries

and reflecting the international character of the larger event, the art would come from dozens of countries. It would be accompanied by recorded music, "the first time a major art exhibition has used music as an integral soundtrack," Brown reported.[41] Leon Botstein, president of Bard College and an active orchestra conductor, consulted on the specific choices.

Actually, Brown had integrated music into an Acoustiguide tour tape a few years earlier, for the National Gallery's *Titian: Prince of Painters*. Convinced that late Titian was "like an analogy of the late Beethoven," Brown made some late Beethoven string quartets, along with Palestrina and Scarlatti, part of the background. "This is a first for us to try to do it thoughtfully, matching the music to the art history and the mood and emotion with the paintings.... The risk was to depart from being strictly chronological, to go beyond that and through to the emotional equivalent." Acoustiguide usage had tripled for the show, he told a *Washington Post* reporter, "so I think this experiment has worked."[42]

Though there was a precedent, by the time of the Olympics six years later, Brown's rhetoric and musical insertion had become more ambitious. His aim now was a *gesamtkunstwerk* incorporating portions of Beethoven's "Missa Solemnis," the Dies Irae from Arthur Honegger's Third Symphony, sections of a Mahler symphony, and a raga performed by Ravi Shankar, each coupled with a specific work of art. All would be part of a CD-ROM, again narrated partly by Brown. The catalog itself, to be published by Harry Abrams, was made a Book-of-the-Month Club selection, only the third time an art book had been chosen, and a preview of the music was performed, accompanied by slides, in February, months before the opening, in Atlanta's Symphony Hall. All in all it was an intensely publicized exhibition, in the spirit of Brown's earlier blockbusters. Extensive and largely favorable news interest was generated, and Brown made himself available for countless interviews, book signings, and other promotional events.

Predictably, critics and museum specialists were divided over the plans. Whether the various cultural events "will turn out to be art, circus or some blend of the two" remains to be seen, wrote a reporter for the *New York Times*.[43] Keith Christiansen, a Met curator of European art, thought Brown's approach evinced "an unconvincing thesis and a misguided idea for an exhibition." The Olympic rings, after all, were put on T-shirts and beer cans, "so why not on an art exhibition? It's about as meaningful as

that, isn't it?"[44] No one doubted Brown's capacity to get the necessary loans, although his choices were extremely ambitious. "His years at the National Gallery gave him the clout, the contacts, and the friendships" that were demanded.[45] "It is hard to say no to this man," wrote Benjamin Forgey in the *Washington Post*. "His combination of power, prestige, tact, and persistence probably is unmatched in the museum world."[46] Remarkably, Brown compared securing loans to dentistry, "extracting objects from the mandibles of art institutions." As the reporter commented, this effort required "more than biceps and a pair of pliers"; one needed also "an understanding of the hierarchies and politics of museums and, in many cases, the governments that control them. . . . It takes persistence and savvy."[47]

On display in Atlanta would be Buddhist sculpture from Korea, India, and Thailand; great American landscape paintings; a Matisse from the Hermitage in St. Petersburg; Munch's *Scream* from Oslo; and, the most publicized piece of all, Rodin's marble *The Kiss*, usually housed in the Musée Rodin in Paris. Each of the 125 artworks was given a place within one of the five highlighted emotions. The juxtapositions were startling. Rembrandt, Titian, and El Greco shared the space with a sun mask from Ecuador, Byzantine icons, a Persian illumination, and Nigerian and Egyptian sculpture. The scope, appropriately for the Olympics, was worldwide. Traditional taxonomies were thrown overboard.

Seen "strictly as an exercise of connoisseurship," admitted Forgey, an old supporter of Brown's, the show was impressive. Indeed, Forgey used words like "stupendous," "enticing," "entertaining," "evocative," "provocative," "surprising," and "extraordinary." But it was also "irritating" and "troubling." However powerful the larger argument, it "does flirt constantly with the danger of taking objects too far out of their cultural context," and as a result "we understand less, rather than more." The "machinery of the show," the recorded music and Brown's sonorous voice, could be obtrusive and even "creaky." But "when it works it really works." Forgey's final advice was to "suspend disbelief, enjoy the performance, and let the maestro lead you on his magic carpet ride."[48]

The *Washington Post* had long been a friendly voice. It was, of course, quite different at the *New York Times*, and Roberta Smith didn't fail to disappoint. "Blockbuster art exhibitions often excel at superficiality," she began her scathing review, but *Rings* deserved a specific award, "the first blockbuster whose organizing principle is based on a logo." Special

contempt was directed at the willingness of curators and directors "to ship fragile works against their better judgment," and her targets included a number of the world's greatest museums: the Prado, the Rijksmuseum, the Vatican, the Palace Museum in Beijing, and the Hermitage. More than that, *Rings* demonstrated, "in unusually extravagant form, that great artworks do not, by themselves, make great exhibitions." There were many masterpieces, but these wonderful objects "are constantly degraded and limited by the show's simplistic universalizing." They were accompanied by mediocre objects "that don't so much arouse the emotions as pander to and manipulate them." Labels were "cursory," lighting inadequate, and the audio guide consisted mainly of music. "It is as if one were walking through a museum-masterpiece calendar." Smith advised visitors to enjoy the great art as such and disregard its setting.[49]

Smith came down on the show with special force, although some others shared her hostility. "I felt less inspired than just plain drowned in spectacular greatness," complained Malcolm Jones in *Newsweek*.[50] Jones was particularly concerned with the heavy didacticism of Brown's taped tour. His reaction was ironic, in view of Brown's earlier comment that "people do not want to be lectured."[51] "This ringmaster never lets you forget that you are looking at important stuff that's good for you. . . . But, boy, does it take the fun out of looking at art."[52] "Brown went to Atlanta to turn people on," wrote Jed Perl in the *New Republic*, "and he's so fixated with his new, emotionally charged approach to art education that he's ended up abandoning the basics. Color, line, form and space are pretty much irrelevant." The "seigneurial sheen that Brown brings to what is basically shameless pandering *is* unusual," a kind of "aesthetic demagoguery." With *Rings*, "the blockbuster goes bionic."[53] Brown was "a master of the pre-arranged emotion." "Rarely has so much great art been put to such lame use," complained Christopher Knight in the *Los Angeles Times*, calling it "Masterpiece Theatre meets Pirates of the Caribbean."[54] "Never before have such sublime works of art been put in the service of such dopey ideas," wrote Deborah Solomon in the *Wall Street Journal*, her words paralleling Knight's and appearing on the same day. Why five emotions, she asked, and not six or seven? "Have neuroscientists discovered a core of five emotions common to Parisians and Zulus alike? Have art historians agreed on five basic sentiments manifest in everything from ancient Shang bronzes to Bill Viola videos?" The number, of course, was

keyed to the five Olympic rings, reflecting a populist sensibility and the belief "that a popular show must pander to mass taste."[55]

There had always been doubters and dissenters, but these reviews were so much more acidic they provoked Brown, uncharacteristically, to make some response. He seemed particularly put off by Solomon's *Wall Street Journal* notice and contested her observations. His survey of emotions was not meant to be exhaustive, his purpose was never to create "a populist affair," and his approach was "consonant with the cutting edge of modern neuroscience and cognitive psychology." Perhaps "it is time to challenge viewers of varying degrees of book-learning in art history to accept the experimental, and flock not only to the tried-and-true monographic show" devoted to some impressionist or "classic modern master," which was the tactic "revenue-hungry museums" had adopted so often in "recent years."[56] His letter to the newspaper attempted to turn audience-pandering charges against themselves, presenting *Rings* as an alternative to revenue-seeking special exhibitions.

The harshest judgments, those already quoted, were rendered by nationally recognized critics, writing for sophisticated metropolitan audiences. There were others, however, who defended the show, a triumph that "only members of the art establishment could hate—and they do passionately. The rest of us," wrote Lawson Taitte of the *Dallas Morning News*, "can follow Mr. Brown through his arcs of feeling and rejoice that he has reemphasized the emotional rather than the intellectual side of art."[57] Defenders argued that elitist critics and academic art historians were the only ones miffed by the exhibition's violation of traditional boundaries, and that Brown deserved credit for gathering a series of extraordinary objects and removing them from their usual contexts. Robert W. Duffy in the *St. Louis Post-Dispatch*, acknowledging the risks and problems involved in "moving rare and delicate objects" great distances, concluded that "Carter Brown has brought the incandescent torch of the visual arts into the middle of the centennial playing of the modern Olympics with a triumphant grace that one can only cheer, or perhaps even bow before." This "artful pragmatist," "aesthete, genius, politician, Solomon and amiable foreman all at once," had produced a series of revelations. "When the dancing stops and the music has fallen away, one emerges from this complicated, often painful and frightening but ultimately fulfilling experience better than he or she was before."[58]

In organizing the show as he did, Brown certainly knew the risks. "The traditional show tries to bring things as near like as possible, so we went at it from the other end of the telescope," he told one interviewer. The show is "egregiously impolitically correct," he went on. "We're saying all these people have things in common. It's an anathema. If you mention the word 'universal,' you have shown how benighted you are."[59] Brown had, of course, been through these wars before, notably with *Circa 1492*, and he refused to alter his course. The multimedia elements of *Rings* reflected his consuming interest in employing technology for audience development, along with a long-standing infatuation with music. What appeared to some as heavy-handed and repetitious recorded advice on the audio accompaniment, reflected Brown's didactic enthusiasm, a lifetime of sharing knowledge and insights with any audience, sometimes at considerable length. It was this same enthusiasm and energy—labeled by some reporters as almost "child-like"—that had powered so much of the National Gallery's programming under his directorship. "The things I'm doing now are extrapolations of what I did at the gallery," Brown insisted in 1996, while some objectors were branding the Atlanta show his "five-ring circus," even before it had opened.[60] Extension or caricature, it was not quite clear.

As with most blockbusters, visitors voted with their feet, and attendance was good. But Brown continued to smart over the critical response. In August 1996, weeks after some of the searing reviews, he wrote *New Yorker* editor Tina Brown that many were emerging from the exhibition with "tear-stained faces," and suggested that the cultural olympics was a subject "ripe for plucking." The New York critics' angry accounts added "the spice of controversy" to it.[61] Writing to a public relations specialist at his publisher, Abrams, Brown reported that audience responses to his speaking tour had been good. Most sales of the catalog had come after his lectures. He wondered how "some of the ridiculous art critics' reviews" had affected sales. He continued to argue that the show's success was "overwhelming," with "huge lines" and "sell-out crowds," but clearly he was angered by the "art critic pack journalism" that had savaged the show. He suggested having *Rings* reviewed by a drama critic and offered to make himself available for a "chat," if Abrams felt "there were particular reviewers" who might give the book "a fair shake."[62]

In Atlanta, Rifkin and his deputy, Michael Shapiro, saw *Rings* as crucial for the High Museum's future, the first in a series of major shows that

would expand its visitor base and increase membership. By its closing, it had been seen by better than three hundred thousand people and had become the city's most profitable art exhibit, surpassing a 1984 showing of *China: 7,000 Years of Discovery*. Thousands of new members joined the High during the Olympic summer, and visitors were spending twenty-one thousand dollars a day in the museum shop, ten times the amount recorded the previous summer.[63] Twenty-two hundred visitors a day, the average in late August, was not quite what organizers had originally hoped for, but there were crowds lining up and museum officials expressed satisfaction.

Rings: Five Passions was, however, the last major exhibition that Brown directly inspired or coordinated. Without the base and staff support of a major institution, and lacking the leverage of a director's position, projects on this scale were difficult to sustain. His legendary cajolery and persistence could go only so far. In some ways, it was astonishing that he had pulled off the loans for this show during retirement. With relatively little to offer lending institutions or individuals as recompense, he traded on old friendships and long-standing debts. And, despite the forceful denunciations, *Rings* showed it had legs. It even enjoyed an afterlife, its features reprised several years later in a television documentary for PBS.[64]

The documentary made its premiere on another Brown media operation, one he had begun thinking about as he was planning *Rings*. In many ways, it was the culmination of his absorption with technology and new media. A sometime movie producer himself, and an ongoing campaigner for more public exposure to the arts, Brown had participated in the extraordinary success of the *Civilisation* series a generation earlier. He was also a veteran of documentary narration, at the Gallery and elsewhere. Thus, in 1992, when Harold E. Morse asked him to chair the board of Ovation, a television network devoted to the arts, Brown leapt at the chance. The official announcement came in 1993, when Brown's connection was made public and he declared himself Ovation's "godfather."[65]

The network was based in Alexandria, Virginia, across the river from Brown's Washington home. Optimistic predictions had it running seven days a week, twelve hours a day, with all of its programming devoted to the visual and performing arts. It promised not to show movies. Brown described plans to show how museums mounted exhibitions, putting "curators on camera," and there would be experiments in presenting musical performance. "TV is our new reality," he declared. "It validates things. It's

the electric fireplace." Brown and Morse were both investors and board members, and attracted support from political and cultural leaders, including Terry Sanford, a former North Carolina governor and senator, and Agnes Gund, the president of the Museum of Modern Art.[66]

The early plans proved premature; it took more money and persuasion to get the operation going than was originally expected, at least twenty million dollars. In late 1995 the New York Times Company declared it would acquire a stake in Ovation.[67] Service would begin in October using an existing cable channel; the following year, in April 1996, it would begin to operate its own channel, with the expectation of reaching about four million subscribers.[68] There were to be twenty hours of programming a week, including profiles, specials on jazz and folk music, and documentaries on artists and photographers.

Eighteen months after its launch, a Washington reviewer reported, the jury was still out. Brown had enlisted friends like Teresa Heinz, widow of his good friend Senator John Heinz and now wife of Senator John Kerry, to join the board, and new investors included Time Warner Cable and J. P. Morgan. Getting a national subscription pool was difficult, and subscription itself did not always translate into viewing. The task of creating an audience for the network was considerable, and growth was much slower than anticipated.[69] Nonetheless, the larger challenge of defining and connecting with a new public kept Brown involved and stimulated, preserving his *Civilisation* memories and ambitions.

Brown also found release in recalling his own life history and paying tribute to his father. What had begun years earlier as a series of conversational reminiscences with friends and fellow architecture buffs culminated in a multimedia lecture centered on Windshield, the Neutra house he had known growing up. It also inspired a Harvard exhibition and catalog. Speaking to great acclaim about Windshield in Newport and on Fishers Island, Brown was soon delivering his talk at the National Gallery, at historical societies, and for preservation groups, and offering to present it (sometimes for a fee) to interested clubs as well. It proved to be a considerable crowd-pleaser, a dazzlingly fluent presentation that mingled home movies, slides, and family snapshots with a powerful platform delivery. Brown remained a natural performer; drama, music, audio guide talks, press conferences, after-dinner speeches, tours—these were expressive outlets he had long enjoyed. He gave many lectures in his retirement, on a variety of subjects, but none surpassed the impact of the

Windshield speech, which allowed him simultaneously to champion his passion for architectural modernism, indulge his love of telling anecdote, and expound on his family tradition of artistic patronage.

One aspect of Brown's professional life that did not change fundamentally from his years as director was the chairmanship of the Fine Arts Commission. He continued to receive presidential appointments, from Bill Clinton and George W. Bush, and maintained a high profile, locally and nationally, thanks to his involvement in controversial projects. Several of the most difficult to adjudicate were memorials, most notably the World War II Memorial, whose design and location stimulated lengthy and acrimonious debates. In this particular case, Brown's actions dismayed some who had applauded his championing of Maya Lin's Vietnam Memorial. Many of those who admired the restraint, abstraction, and understatement of the Lin design expected Brown to share their contempt for the very different approach taken by architect Friedrich St. Florian, one that seemed overdone, ornate, and pompous. Even worse, it was placed on the hallowed ground of the Mall.

Like a number of other national monuments, the World War II Memorial had a lengthy planning history, consuming seventeen years after the initial proposal by an Ohio congresswoman, Marcy Kaptur, and costing more than a hundred million dollars.[70] These funds were raised privately, if slowly, by a prestigious committee. Its campaigns emphasized the fact that tens of thousands of veterans were dying annually, a thousand a day by the late 1990s, and that the time to honor them was running out. The Fine Arts Commission, and Brown as its chairman, played a crucial role in negotiations for the site and modifications of the winning design. Brown's passionate and protective interest in the local landscape, and his struggles against clear intrusions into protected national spaces, had been demonstrated again and again over the previous decades. And so had his skill and diplomacy in seeing through decisions that had been challenged by a range of opponents. He had warned against the proliferation of commemorative sculpture and the congestion of parks and plazas. Thus, his willingness to support construction on land between the Lincoln and Washington Monuments, perhaps the most sensitive strip of real estate in Washington, caused special outrage, and even some astonishment.

The memorial had originally been suggested for another site, near the Vietnam Memorial, in Constitution Gardens. This was on the edge

of the Mall, and both the American Battle Monuments Commission and the National Capital Planning Commission had accepted it. But in 1995, when it came before the Fine Arts Commission, Brown proposed that it be constructed around the Rainbow Pool, at the east end of the body of water that ran from the Lincoln Memorial to the Capitol. While the pool itself was less celebrated than the Reflecting Pool opposite the Lincoln Memorial, the location was both more prominent and more accessible than the original choice. Brown believed the memorial would attract many visitors and, in view of its subject, merited a conspicuous place in the city. He may also have wanted to overshadow the only previous World War II memorial, the Iwo Jima Memorial in Arlington, a bronze version of the famous photograph. He was clearly no admirer, and in 1998 when it was revealed that he had called it "kitsch" at a Fine Arts Commission meeting, there were demands from Congress and the military for his immediate resignation.[71] It was a rare verbal misstep, and he was forced into an elaborate parsing of his own language to defend himself. In any event, his decision about the site would produce plenty of turmoil.

The competition, supervised by the General Services Administration and coordinated by Bill Lacy, the executive director of the Pritzker Prize, attracted four hundred entrants, and was organized around the Rainbow Pool location. Two separate juries chose the same winner, Friedrich St. Florian, who had been dean of architecture at the Rhode Island School of Design in Providence. He was almost fifty years older than Maya Lin had been when she won her competition a few years earlier, and the generational difference was clearly apparent in their approaches.

Opposition grew after the design was publicly unveiled by President Clinton.[72] The scheme called for fifty columns, thirty-five feet tall, in two semicircles, representing the states of the union. St. Florian shortened the columns by two feet in response to criticism that the complex appeared to obscure views of the Lincoln Memorial. There were complaints that the plan would require the destruction of a number of elm trees. It also included a berm with a large underground exhibition area, dubbed at once a "stealth museum."

Objections poured in, critiques of the size and elaborateness of the winning design, with its carved eagles and laurel wreaths and a pervasive air of triumphalism. Some saw intimations of imperial glory and echoes of Albert Speer's architecture for the Third Reich. Of course, St. Florian also had his defenders. There were those who found the traditional

materials and historic references reassuring in a city dominated by neo-classical shrines and public buildings. Memories of World War II, unlike those of Vietnam or Korea, were consensually supportive; in retrospect, the sacrifices made seemed justified. Veterans and noncombatants alike found the self-celebration more than palatable.

But even many of the sympathizers agreed that there were problems with the location. Small and aggressively vociferous groups organized themselves in protest, and made a point of showing up at Fine Arts Commission meetings. In July 1997, both the National Capital Planning Commission and the Fine Arts Commission turned down the proposal, even while Brown insisted that the new site was appropriate. Letter writers expressed their (mainly) negative views about the site and the design, many in the pages of the *Washington Post*, and national media picked up on what had become a full-blown controversy. The *New York Times* selected July 4—shortly before the commission turndowns—to express its editorial view. Do "we really need or want a World War II memorial inserted between the Washington Monument and Lincoln Memorial?" it asked. Going forward with this expensive project "risks thrusting the turbulence of this century into two remarkable memorials," it answered. On that ground alone, the proposal "should be weighed, delayed and in our view given a different setting."[73] "Hallowed Ground," the phrase used in the editorial, seemed constantly to be coming up in objections.

Brown, however, was committed to the memorial. "We are more dedicated to that site now, if that is possible," he told onlookers at the hearing. The chairman of the Battle Monuments Commission declared that the design needed only some "fine-tuning" and "a change in scale."[74] Opponents, using phrases like "the rape of the Mall," were momentarily encouraged by the rejections and intensified their efforts. "The destruction of the Mall is all but assured, with no vote of Congress, no vote of the people, and zero public debate," one of them declared, asking dissenters to pressure Congress.[75] Many other suggestions poured in, some of them quite specific.[76]

The following year, in May 1998, the Battle Monuments Commission and St. Florian were back, with a much modified plan. Most of the memorial was now below street grade, and following commission recommendations, natural features, water and landscape, were now emphasized. The columns, eventually increased in number to represent not only the states but the District of Columbia and various territories, were short-

ened to half their size, the elms were spared, and the exhibition area, once mandated by the Battle Monuments Commission, was eliminated. The Fine Arts Commission now approved, in preliminary form at least, "an extraordinarily improved design," in Brown's words.[77] Fountains were planned for the base of two granite arches, and there was a new emphasis upon contemplation, a "sacred precinct" framed by waterfalls. The view between the Washington Monument and the Lincoln Memorial was virtually unobstructed.

Considerable opposition remained. A year later, with still further modifications, most of them aimed at making the memorial less obtrusive, the commission gave its final approval. The five hours of hearings were hosted by the Interior Department in its auditorium, a larger room than the space assigned in the National Building Museum, where the commission often met. Brown welcomed the interest. "I feel like my grandfather, the preacher, who only filled the church on Christmas," he proclaimed, using an image he had deployed before, in connection with *Rings*. "We love people to come to our meetings. We make decisions every four weeks that affect all of us."[78] Groundbreaking would take place a few months later, on Veterans Day 2000. And the memorial itself would be dedicated in 2004.

Carter Brown was not around to see it. But he was substantially responsible for the fact that it was built at all, and completed by then. His role in getting a series of other monuments constructed, and modified—the Vietnam Memorial but also the memorials to Franklin D. Roosevelt and Korean War veterans—was considerable, but his part in seeing the World War II Memorial built was especially significant. Both supporters and opponents agreed about this. Critics complained that he had rammed through "his own grandiose vision at the expense of common sense," and that he was "entranced by the chance to alter the center of the Mall."[79] Two years later, in a tribute rather than a critique, Richard Moe, the president of the National Trust, pointed to his chairmanship as the role Brown "was born to play," a "great aesthetic sense balanced with a stern practicality," combining "vision, wit, diplomacy and sheer tenacity."[80] Mediating among contending interests while projecting a vision of his own was something Brown had been doing for decades, inside and beyond the National Gallery. His work at the Fine Arts Commission was, in many ways, an extension of his museum directorship, except that

in his last ten years he didn't have to worry about any controversy damaging his leverage with his board of trustees.

The struggle to get the World War II Memorial built was Brown's last. Not long after the commission granted its final approval, in the summer of 2000, he was diagnosed with the disease that killed him, multiple myeloma, a blood cancer. The last eighteen months of his life continued to be active, despite aggressive stem-cell treatments and lengthy hospitalizations. The optimism that had supported so much of his professional career did not desert him as he continued, as much as possible, to remain active in the causes and organizations that had filled his retirement. While his physical appearance betrayed the ordeal he was experiencing, and he was now spending much of his time in Boston and Cambridge, with treatments at the Dana Farber Institute, he continued to attend a variety of events, some of them celebrating him. Only weeks before his final hospitalization he told guests at a Cathedral Choral Society benefit in his honor, "The River Styx is long. I've come out on the other side."[81] He was confident that he could surmount his last crisis and, according to friends and family, maintained his serenity until the end.

Although he had been ill for more than a year, Brown's death came as a shock, particularly to those who had not seen him for a while. The sense of loss was palpable. He had been prominent as a producer of and commentator on cultural events for more than thirty-five years. While he never occupied a cabinet position, as his friend Tony Athos had foretold in the early 1960s, he was viewed by many in the press as an official spokesman on aesthetic issues, authoritative, credentialed, and, if not always outspoken, given to memorable metaphors and unexpected similes. Rarely reluctant to offer an opinion, and filled with exuberance about his own projects, Brown combined a perpetually (sometimes annoyingly) youthful enthusiasm with an acceptance of practical limitations. An undeniable child of privilege with a lifestyle that could be termed self-indulgent, he employed colloquial language and homely metaphors while promoting causes and preoccupations that were refined and even recondite. He valued opportunities to identify with common preoccupations, if he was sometimes awkward at pulling them off. The blend disconcerted some observers. It meant, to those summing up the significance of his career, that words like "elitist" and "populist" could be mixed together, almost in the same sentence. He had always sought large audiences and, while

denying that he counted the gate compulsively, took pleasure in the large crowds his exhibitions attracted, and the commerce they stimulated. These were not the only validations he sought, but they demonstrated to him that some things were being done right.

And such numbers helped his cause with funders—governmental, corporate, and individual. Popularity sometimes hurt his status with critics, Brown acknowledged, but he used it to justify breaking with conventional subjects and methods. When accused of crowd-pleasing, he rarely denied the charge, although, unlike his sometime rival, Thomas Hoving, he never presented himself as a rebel against authority or railed against the stupidities of establishments more generally.

As tributes poured in and obituaries were written in June 2002, Hoving's name came up with some frequency. It did so partly because he had anticipated to a large extent the elaborately staged, and powerfully promoted, blockbuster exhibitions that were hallmarks of the Brown years at the National Gallery. And partly because it recalled a time when the New York and Washington museums had been actively competitive, despite the greater resources and anthological holdings of the Metropolitan. Brown remained absorbed by the rivalry. In a letter to Hoving written in early 1993, Brown thanked him for sending a copy of his memoirs and, after correcting some mistakes, added that despite "the bits of history we might in our heart of hearts know were different," he admired Hoving's writing and his "skills in general, which I hope you know I have always considered to be nothing short of spectacular."[82] In public, at least, Brown was prepared to acknowledge "a new, more mellow and more human Tom—without the old edge," one prepared to admit mistakes. But hedging his bets, he admitted, "That may just be a clever new strategy."[83]

No one could really challenge the Metropolitan's extraordinary resources, or the size and talents of its professional staff. But Brown had managed, using governmental connections as well as the ingenuity of his talented personnel, to dramatize the National Gallery's identity as no one before or since has, to infuse its sometimes breathless schedule of shows with excitement. He had, as admirers pointed out, substantially enlarged every aspect of his museum's portfolio—budget, attendance, outreach, space, endowment, collection size, international reputation, staff, scholarly contribution—while still finding time to fulfill other professional obligations. His extensive socializing and attention to public functions,

which certainly had its hedonistic elements, worked to bolster vital connections with congressional underwriters and enablers from the embassies who helped so significantly with his international loans.

Government had, in effect, been complicit with the museum's growth, officials finding usefulness in the Cold War and détente shows and basking in the reflected glory of headline-stopping crowds, in Washington and on tour. Patronizing culture paid dividends, Brown could assure both the bureaucrats and the corporate clients who directly funded his most lavish productions. That there was a bottom line did not seem incompatible with the idealism that accompanied these efforts. Brown pointed to his business training and art history studies as demonstrating the intellectual alliances made possible by an affluent society. Great art was ultimately affordable, he insisted, and so were overpowering museum experiences.

Brown's power rested on his skills as a dramatizer, an authorizer, a broker, and a go-between. This role he accepted from an early age, although it occasionally resulted in frustration. It was easier to see the creativity in more active pursuits like film directing, architecture, painting, or composing. He sometimes seemed to envy the satisfaction they brought and, particularly in music, found release in performance. And he loved the work of display management. Admiration for professionals was never diluted by jealousy, however. Brown remained an enabler of the talents of others, most notably, perhaps, Gill Ravenel. Never defensive or put off by high intelligence or proficiency, he was able to transfer his personal competitiveness to the institutions that he worked for or helped establish, most notably, of course, the National Gallery of Art. His adversarial feelings were largely reserved for the one museum that could persuasively challenge the Gallery's special national status—the Metropolitan—along with some of its local allies.

Brown was not usually introspective. He was, at heart, to the dismay of some friends, a natural booster, an enthusiast, a positive thinker who avoided the deeper reflections that could produce, in some, depression and gloom. He enjoyed solving problems, or getting others to help him solve them, and found enough to do without worrying about ultimate meaning. In the redolent phrases of William James he was "once born" rather than "twice born," believing that all was well with the world and one was "forbidden to linger" on the darker side of things. Only at the

very end of his life was there some flirtation with anything like mysticism or deeper and unconventional (for Americans) spiritual practices. His inherited Episcopalianism was sufficient; its rich set of rituals and architectural traditions satisfied his aesthetic as well as his spiritual needs.

The optimism, the energy, the positive thinking were all to be tested in the last eighteen months of his life. There were hopes, at the start of treatment, that he might get an additional five years of life, but lung infections resulting from his reduced resistance made that impossible. Brown drove himself to the hospital for his last stay, and he continued to use fax machines and e-mail in the intensive care unit, practically up to the day of his death. That occurred June 17, 2002. He was just sixty-seven.

In the weeks that followed, tributes to Carter Brown's life and work multiplied, in memorial services, newspaper obituaries, the minutes and resolutions of the many organizations he had served, and private letters. A number of the accolades captured his focused energy on behalf of the National Gallery, his ambitions for Washington, his involvement with so many of the international exhibitions that had come to define an entire museum era, his work on behalf of cultural organizations, local and national, and his melding of patrician standards and popular goals. Others concentrated on his personal qualities, his erudition, love for the arts, and international social schedule. He had touched an enormous number of people during his long career, and there was a sense among many of his supporters that the extravagant dreams and lavish rhetoric he had nurtured would not be easily duplicated in the years to come. The combination of aristocratic background, cosmopolitan education, civic-mindedness, and crusader personality topped by a fiercely competitive, even personally devouring work ethic, called to mind the Kennedy administration forty years earlier. Charm, good looks, self-assurance (if not self-confidence), and rhetorical skill explained some of the hold Brown had on his admirers, but he had also presided over an impressive era of institutional advancement.

It was difficult to take issue with these accomplishments or, in the shadow of his recent death, to raise points of criticism. There were certainly those who had felt intimidated, rebuffed, or victimized by what they perceived as Brown's condescension or hauteur. Others were uncomfortable with the courtier's mask he had donned so often in his years of surmounting the intrigues of Washington politics and international negotiations. The energies that sustained his career were powered by

robust if unresolved personal tensions that only a personal biographer might be able to uncover. The effects rather than the causes of this stress have been of primary concern throughout this book, the identification he forged between his institutional triumphs and his sense of self. Always in motion, always on stage, Brown had transmitted to the National Gallery of Art his sense of drama and spectacle. The skills were not readily transferrable to successors, and they eclipsed the slower, quieter, more permanent gains that often accompany more understated administrative strategies. Without the princely gifts of Paul Mellon, the Gallery's permanent collections would have enjoyed modest growth during Brown's tenure. He lacked the inclination for the lengthy, slow, and sometimes tedious wooing of collectors. Quick campaigns were more his forte. But there were some exceptions even here, great victories and vibrant memories. Exploiting the opportunities that his times and his background allowed, Carter Brown had recast the expectations of museumgoers throughout the world and, along with Dillon Ripley, burnished Washington's cultural stage.

Postscript

The world of the art museum in America continues to reflect the blended influences of personal leadership, economic circumstances, and political reality. The interplay of donor ambitions, corporate strategies, charismatic command, and promotional energy shapes creation of programming and policy. To this, even more than in Carter Brown's day, must be added the immense but not fully understood role of technology, digital technology particularly, and the proliferation of accessible images to a point unimaginable just twenty years ago. There is also a new level of audience expectations for contemporary art, more aggressive and interactive, whose outlines are just beginning to emerge. While attendance at major shows in large cities remains high, their impact has been lessened by decades of conditioning. As more and more institutions turn to their own collections for special exhibitions, the truly startling blockbuster, a generator of headlines and spurting revenues, has become rarer, except perhaps in New York, where the Metropolitan Museum and MoMA can still generate waves of visitor passion. And, perhaps, in Asia and its stable of new institutions.

The ongoing growth of the Met, as it accepts extraordinary collections and opens newly installed wings devoted to the art of the world, suggests the audacity of Brown's campaign to make the National Gallery its viable competitor in the heady exhibition sweepstakes that characterized the 1970s and 1980s. That he succeeded in causing so much consternation among New Yorkers, especially those working for the *New York Times*, testifies to his theatrical skills as well as his professional talents. In an era

populated by quite a few highly assertive and colorful museum directors, Brown more than held his own, retaining press attention for his institution and making its programming practically synonymous with his name. Something of a personality cult established itself locally in Washington, and its memories linger on. Brown's departure initiated a more restrained and understated Gallery personality, and perhaps some withdrawal from the ambitions that underwrote its expansionist moment. Certainly the rivalry with the Met seems to have waned.

Awareness of limitations and a tone of prudence may indeed be said to characterize the broader claims of Washington and its cultural institutions in these later years. The Smithsonian, despite some significant additions to its cultural empire, has confronted a series of challenges and faces formidable financial obstacles as it tries to modernize facilities, adapt to new audiences, and master the ongoing balkanization of its history museums. Federal support for the arts and humanities has, in real dollars, retreated from the levels reached during the 1970s and 1980s, while the national endowments, the principal distributors of this largesse to nonfederal institutions, continue to be targets of bitter criticism. The easing of Cold War tensions, or, at a minimum, the blurring of East-West definitions of cultural freedom, has reduced the pressure to subsidize interventions across a whole variety of fields.

From this angle, one of Brown's aptitudes as an impresario, his flair for global deal making, might appear to be time-bound, appropriate to the needs of his day but hardly indicative of any fundamental or long-term shift in the pursuit of museum politics. The decline of international drama as an element in exhibition practice may be temporary, but there seems little question that the highly personal diplomatic exertions that marked some of the Gallery's most celebrated shows have been eclipsed by rather different patterns. Show trials, intellectual property rights, and restitution claims are among their replacements. Lawyers now can rival directors in policy influence, and they have multiplied within the art museum world.

Other Brown contributions, however, remain undeniably relevant. His assiduous wooing of corporations to support temporary exhibitions remains an inescapable part of museum strategies, even as directors wrestle with defining the limits of commercial exploitation, and as the scale of corporate giving achieved in Brown's era has lessened. While the National Gallery did not itself mount shows that directly featured brand

names or individual companies (unlike some other major institutions), it grappled with the propriety of endorsements and the associations that flowed from outside subsidies. Brown got involved with these problems regularly, as he patrolled the borders of his public-private partnership. Such scrutiny was critical for Brown and his Gallery predecessors because of their generous direct support from congressional appropriations, but it also has meaning for other American museums, almost all of which benefit, directly or indirectly, from some kind of public assistance. Making a case for public support, indeed for increasing it, even while preserving independence from the tastes and preferences of the funders, was a delicate balancing act. Brown's active promotion of the indemnification program was part of this larger strategy, eagerly endorsed also by Dillon Ripley. Ripley was not as successful at avoiding congressional skepticism about expansion, but his pursuit of novelty and growth exceeded even Brown's, and his major publishing venture, *Smithsonian*, set new standards.

Brown and Ripley both encouraged closer connections between the worlds of academic scholarship and museum activity. Ripley could draw on a much longer tradition at the Smithsonian, even as he expanded its scope with the Woodrow Wilson Center. Brown, with his report defining the contours of CASVA, the Gallery's research center, and his enthusiastic support for its operations, was able to change the culture of his own institution fundamentally. The systematic catalogs and individual projects that emerged during the years of his directorship were significant additions to scholarship and nurtured the careers of a generation of curators and academics. A number of American art museums have been able to establish fellowship opportunities for young curators, but on the whole, outside of the Getty and a few other places, the costs of sustaining research institutes have been beyond them. In making claims for the special status and needs of the Gallery as a national institution, Brown reaffirmed his belief in the capital city's cultural distinction, and added to its claims as a nursery of serious scholarship.

These, and longtime service on the Fine Arts Commission, were notable contributions, particularly in a local setting. More profound, and more contested, were the steps he took toward theatricalizing the museum experience and raising the bar for special, media-hyped exhibition encounters. Keenly aware of the popular draw offered by the multiplying theme parks of his day, fascinated by the relations between large spaces and crowds of people, and determined to craft experiences that could

prove ingratiating and transformative, Brown relied upon his installa-
tion and design department to come up with powerful, if expensive, ap-
peals to public taste. First with the East Building and then with the West,
Brown pushed his architects and designers to enhance user-friendliness,
setting in motion, or at least embracing, a trend that continues to the
present, and on a much amplified level. The light-filled agora of the East
Building typified and prefigured the wings and expansions that were
multiplying across the country—museums as gathering places, shopping
malls, restaurants, and performance venues. Inserted within were spaces
that would accommodate three-dimensional narratives, plots, story
lines for the spectacularly lit and cleverly arranged art pieces themselves.
Brown stressed the importance of viewer comfort, clear visual orienta-
tion, and overall coherence in the shows he hosted. He was as attentive
to detail as any theatrical manager. His youthful admiration for pioneer-
ing practitioners of special effects, like Virginia Museum director Leslie
Cheek, lasted through his entire career. Once-in-a-lifetime experiences
were always on tap at the National Gallery.

The success of these visiting shows depended, of course, on getting
the word out, early and often. A shrewd manipulator of media, and a
sometime filmmaker himself, Brown cultivated relations with critics and
journalists, remaining on alert to counter bad news with good, radiating
an optimism and enthusiasm laced with erudite references. The Gallery
became a prodigious publicity machine, exploiting the presence of po-
litical and social celebrities in the interest of ever-expanding attendance.
Growth was the indispensible credential for congressional goodwill, the
source of the museum's annual bounty. Exhibitions, along with the per-
manent collection, became the subjects of films, television specials, and
well-illustrated books that could enlarge the potential audience. The
endless interviews and colorful quotations that Brown offered up were
devices to help that happen, although, officially at least, increasing at-
tendance was disclaimed as a goal in itself.

The whirlwind of activity proposed high, perhaps impossible, stan-
dards for institutions elsewhere, lacking the celebrity exposure of the
National Gallery or its staff budget. And it set up what some critics saw
as an endless cycle of rhetorical hyperbole and physical risk. The massive
international exhibitions made fragile objects vulnerable, exposing them
to the hazards of temperature change and continual handling. An out-
spoken believer in technology's wonders, Brown insisted that the risks

were often overstated, and argued that the benefits of increased exposure should overcome most doubts. But there was wear and tear nonetheless, and the ever-increasing demands for spectacular international shows forced many museum directors into budget-straining competitions for whatever the latest sensation might be, and threatened to overshadow the quieter appeals of painfully gathered permanent collections.

It could be argued, to be sure, that contrasting temporary exhibitions with permanent collections exaggerates the tension between them or even creates a false division. Museum visitors enticed by the excitement of a special show might look beyond its confines to see other artwork and return to enjoy other museum programs. Building the number of repeat visitors was many a director's goal. Here the National Gallery was not so good a model, because so many of its visitors were tourists making rare and probably unrepeated trips to the capital. Locals, who tended to take their institutional riches for granted, had to be prodded into attention. And with its free admission, museum membership could not provide the support it did in other places.

On the other hand, its national status allowed the Gallery to exploit feelings of patriotism and loyalty that were hard to duplicate elsewhere. Brown and his advisers, particularly in the fiftieth-anniversary campaign, succeeded in attracting gifts of art from across the nation, a crusade that sometimes irritated museum professionals whose local donors and collectors were seduced by Washington glamor. Waving the American flag didn't win over everyone, as the gift of Walter Annenberg's collection to the Met demonstrated, but it proved to be a valuable weapon in the never-ending contest for collection additions. Marrying the frankly elitist, hugely expensive, and sometimes inscrutable standards of masterpiece collecting with a sense of national purpose and public interest was a considerable accomplishment, and Brown proved to be masterful in linking the fortunes of the Gallery with the cultural health of the country. Paul Mellon was, of course, the linchpin in these efforts to gather capital as well as art, but Brown's active involvement made a difference.

The successful pursuit of art and money inspired self-celebration, promotional padding that could easily degenerate into pretension. Some felt snubbed or denigrated by Brown's ambitions or repelled by his manner. But while years of small talk at dinners, receptions, parties, and openings, paired with innumerable press conferences and interviews, should have eroded the fresh-faced enthusiasm that the young Brown

started out with, it didn't. His dogged pursuit of larger goals never really seemed to be damaged or diluted. Protected by an impressive level of self-absorption, and powered by unshakable faith in the rightness of his cause, Brown retained over some four decades the zeal of a liberator entitled to make the best use of any opportunity. Figures of all ranks and positions, foreign and domestic, were potential allies, to be won over by force of personality and transmission of a powerful story line. Criticism, from reviewers, scholars, or other curators, seemed to have little impact, although every once in a while Brown lashed back. Self-discipline and friendly supporters combined to restrain the temptation of angry responses, which shielded him from endless entanglement.

Institutions are much more than the sums of their staff and supporters. They change over time, often effacing the impact and even the memory of their earlier leadership. For Brown and the National Gallery, and for Dillon Ripley and the Smithsonian, this has not yet happened, although eventually it will. But decades after retirement, they remain a presence for many who work there, and for some who visit. Ripley aimed to change museum audiences; Brown aimed to change museum experiences. Both succeeded, and Brown, even today, is invoked as a symbol of achievement that brought drama and excitement to daily activities. Collapsing the worlds of art, culture, and entertainment, this spirited ringmaster preferred the sonority of the lavish prologue to the crack of the whip. But in the end, the show went on as he envisaged it.

Acknowledgments

My greatest debt, of course, is to the two remarkable men who are at the center of this book. I met Carter Brown and Dillon Ripley on a few, mainly formal occasions, and I served for several years on the Smithsonian Council during Ripley's secretaryship. Beyond that I had no connection with them, but I am grateful to have had these encounters.

This project began on the initiative and with the strong encouragement of Barry Munitz, then president of the J. Paul Getty Trust. I am grateful for his indispensable support and for the help of others at the Getty Trust, especially Deborah Marrow and Jack Miles. Without them this book would not have been written. I am also grateful for a Mellon Emeritus Fellowship from the Andrew W. Mellon Foundation and for research support from my Preston and Sterling Morton Professorship at the University of Chicago.

My research was aided by the help and generous hospitality of the staff of the National Gallery Archives, Maygene Daniels and Anne Ritchie especially, ever patient during my many months of residence there, along with Jean Henry, who greatly facilitated things in more recent days. Earl A. Powell, Gallery director, and Elizabeth Croog, general counsel, also enabled my work to go forward. Smithsonian Archives specialist Pamela Henson smoothed my way, located hard to find materials, and provided access to the invaluable interviews she conducted with Dillon Ripley; Ellen Alers, also at Smithsonian Archives, helped greatly with both picture and text research. At the Fine Arts Commission, its longtime secretary, the late and much missed Charles Atherton, tried to answer my ques-

tions; other staff members, including Susan Raposa, cooperated fully as well.

When Carter Brown materials were housed at the Brown University's John Nicholas Brown Center, Joyce Botelho was very helpful. At a later point, the staff of the John Hay Library, where the Brown family papers now reside, worked hard to expedite my inspection of large quantities of material; Jennifer Betts speeded a whole group of images to the Press. Staff at the University of California, Los Angeles, particularly Annie Watanabe-Rocco, facilitated my labor in the Franklin Murphy Papers. I thank Anne Rowe, director of collections, Annenberg Foundation Trust, for transmitting certain letters, and David Resnicow, of Resnicow Schroeder, for correspondence concerning *Rings* and Ovation. Librarians at my home institution, the University of Chicago, especially Ellen Elizabeth Bryan, also helped on the many occasions when I had questions about web access or needed to locate specific texts. And I appreciate the work of Heather Welland in assembling some source materials.

My research was also enabled by the willingness of many people who knew Carter Brown or Dillon Ripley to be interviewed by me. I begin with Brown's sister and brother, Angela Fischer and Nicholas Brown, who gave me access to Brown family papers and permission to quote from them, and who, along with Brown's children, Jay and Elissa, met with me in Providence. Anne Hawley, closest to Carter Brown in his final years, sat through several interviews and provided great encouragement and extensive documentation. I thank as well Roberta Ripley for her kindness in permitting me to quote from Ripley materials in the Smithsonian Archives. Amy Meyers and Jules Prown, as always, were helpful and informative concerning Paul Mellon, as was John Baskett, who helped create the Mellon memoir. My interviewees, in addition to those I have just mentioned, included Irene Bizot, Robert Bowen, E. A. Carmean, Carroll J. Cavanagh, David Childs, Jack Cowart, Elizabeth Croog, Ruth Fine, Carol Fox, Grace Glueck, the late Anne d'Harnoncourt, John Harris, Daniel Herrick, Ann Hoenigswald, the late Thomas Hoving, Ruth Kaplan, Gilbert Kinney, Joseph Krakora, Jay Levenson, Mark Leithauser, C. Douglas Lewis, Angela LoRe, Kent Lydecker, Roger Mandle, Paul Matisse, Thomas Michie, Hank Millon, Philippe de Montebello, Julianna Munsing, the late Charles Parkhurst, I. M. Pei, Elizabeth Perry, the late Edmund P. Pillsbury, Bonnie Pitman, Earl A. Powell, Danielle Rice, Joseph Rishel, Andrew Robison, Russell Sale, George Sexton, Charles

Stuckey, Dodge Thompson, Arthur Wheelock, John Wilmerding, Martha Woolf, and the late James N. Wood. I am grateful to all of them. My thanks also to Frank Zuccari for his careful reading of my chapter on the conservation controversy, and to Barbara Mirecki for her invaluable help with proofreading.

My editor at the University of Chicago Press, Robert Devens, was supportive and gentle in transmitting a variety of suggestions, and I much appreciate the efforts of his successor Timothy Mennel, as well as Russell Damian, Joel Score, the readers for the press, and Bonny McLauglin, who prepared the index. The book's dedication to the memory of my friend and colleague Barry D. Karl acknowledges the debt I owe to his wisdom about many things, particularly the history of philanthropy. As always, my wife, Teri J. Edelstein, an experienced museum administrator and art historian, provided continuous encouragement, inspiration, and useful criticism as she read my chapters and assisted me with research, textual and visual. Her patience, intelligence, and resourcefulness were essential to this project, and to me. It could not have been completed without her.

In a book of this size and detail, errors may be inevitable, despite strenuous efforts in the interest of accuracy. I apologize for any of them.

Notes

The following abbreviations have been used in the Notes:

JCB J. Carter Brown
JNB John Nicholas Brown
PM Paul Mellon
SDR S. Dillon Ripley
JW John Walker
JHL/BU John Hay Library, Brown University
NGA National Gallery of Art
NGA/GA National Gallery of Art, Gallery Archives
SI Smithsonian Institution
SI/SA Smithsonian Institution, Smithsonian Archives
NYT *New York Times*
WP *Washington Post*

In recent years box numbers have been changed at NGA/GA. For the new boxes, please consult staff there. RG 2, the reference group most commonly invoked in these pages, refers to files from the Office of the Director at NGA. Another RG 2 refers to the Director's Transitional Files. These will always be so identified to distinguish them from the others. All RG files are in NGA/GA. All Press Scrapbooks are also in NGA/GA. All RU Files can be found in SI/SA.

Most of the oral history interviews cited in the notes, with the major exceptions of the SDR interviews and the JCB tape transcripts, are in NGA/

GA. The SDR interviews are in SI/SA. The JCB tape transcripts, dictated by him in the last years of his life, are in JHL/BU.

The JCB Papers at JHL/BU were fully organized after the writing of this book was under way. The portions I first consulted were then at the JNB Center. Some materials used had not yet been processed. These are here referred to as JCB Personal Correspondence as opposed to JCB Correspondence.

Chapter 1

1. The best source for the early history of the Brown family is James B. Hedges, *The Browns of Providence Plantation: Colonial Years* (Cambridge, MA: Harvard University Press, 1952). More recent work, like Charles Rappleye, *Sons of Providence: The Brown Brothers, the Slave Trade, and the American Revolution* (New York: Simon & Schuster, 2006), has concentrated on the eighteenth and nineteenth centuries.

2. JCB, tape transcript, February 18, 2002, box 211, JCB Papers, JHL/BU. Many of the details in this chapter are taken from the transcripts of tapes dictated by JCB in the last years of his life, as steps toward a biography-autobiography of JNB and himself, tentatively titled "Braided Lives," and from dictated summaries of the proposed book. These exist in various versions with no overall consecutive pagination. Where possible the date of the interview is given as a guide, but not all of the quoted material is dated.

3. For more on Natalie Bayard Brown see the biographical note in RIAMCO, Rhode Island Archival and Manuscript Collections Online, reachable through http://library .brown.edu/collatoz/info.php?id=272.

4. *Harvard Class of 1922: Twenty-fifth Anniversary Report* (Cambridge, MA: Printed for the Class, 1947), 113.

5. Hers was not a unique act of maternal concern. When Franklin Delano Roosevelt entered Harvard, some years earlier, his mother Sara had moved to Cambridge; with somewhat less money at her disposal than the Browns, she could not design her own Commonwealth Avenue quarters, as John Nicholas's mother apparently did.

6. JCB, tape transcript, January 9, 2002. JNB's mother fixation, JCB recalled, had a triple focus: his own mother, mother church, and alma mater (Harvard).

7. Thomas S. Michie, "The Furniture and Furnishing of Windshield," in *Richard Neutra's Windshield House*, edited by Dietrich Neumann (Cambridge, MA: Harvard University Press, 2001), 69n5, 84. The essays and photographs in this book, which accompanied an exhibition, are central to the story of Windshield. See also JCB, tape transcript, January 8, 2002.

8. For more on Anne Brown, see Joyce Botelho, "Kindred Spirits: John and Anne Brown and the Building of Windshield," in Neumann, *Windshield*, 88–105.

9. See Sarah Bullard, "The Lady in the White Silk Dress,"in *A Kind of Grace: A Treasury of Sportswriting by Women*, edited by Ron Rapoport (Berkeley, CA: Zenobia, 1994), 131–46. The essay appeared first in *Sports Illustrated*, September 13, 1982.

10. The quote comes from Lester Kinsolving, "Uninhibited Anne and the Battle of Newport," *Washington Guide* (November–December 1984), 16–19, a rather uproarious and candid account of her life.

11. This is noted in the Kinsolving piece, attributed to JCB, and mentioned in JCB's introduction to *The Martial Face: The Military Portrait in Britain, 1760–1900* ([Providence, RI]: David Winton Hall Gallery, Brown University, 1991).

12. *Providence Bulletin*, November 21, 1985, Press Scrapbooks, vol. 296, NGA/GA. The comments were included in her obituary.

13. Tom Dowling, "The Rise of Carter Brown," *Washingtonian* (August 1971), 82.

14. "Milestones," *Time* 20 (November 11, 1932): 40. *Time* was still deploying "the richest baby in the world" phrase for JNB.

15. The response to Neutra's questionnaire is reproduced in Neumann, *Windshield*, 122–25.

16. JCB, "Windshield: A Reminiscence," in Neumann, *Windshield*, 108.

17. Thomas S. Michie, interview with author, July 15, 2010.

18. E. A. Carmean, interview with author, May 20, 2010.

19. Kevin Chaffee, "About Town," *Washington Times*, March 9, 1993, E2.

20. See JCB, tape transcript, January 9, 2002.

21. Robert Bowen, interview with author, June 13, 2006.

22. JCB, tape transcript, September 20, 2002.

23. JCB, tape transcript, January 8, 2002.

24. Ibid.

25. Carmean, interview with author.

26. Madeline W. Lissner, "Curator Strikes Peers as 'Brilliant,'" *Harvard Crimson*, June 3, 2006.

27. JCB, tape transcript, January 8, 2002.

28. See JCB, tape transcript, January 16, 2002.

29. JCB, tape transcript, January 8, 2002.

30. Ibid.

31. Ibid.

32. A brief obituary notice for Athos, Harvard Business School Class of 1970, can be found: http://www.altacompanies.com/hbs/1970/timeline.htm

33. JCB, tape transcript, September 20, 2002.

34. The following summary is based upon JCB's notes of an interview with Francis Henry Taylor, October 31, 1957, JCB Personal Correspondence, JHL/BU.

35. JCB to Craig Smyth, January 14, 1958, JCB Personal Correspondence.

36. JCB notes on interview with John Coolidge, January 15, 1958, JCB Personal Correspondence.

37. Charles Cunningham to JCB, January 16, 1958, JCB Personal Correspondence.

38. JW to JCB, March 26, 1958, JCB Personal Correspondence.

39. Secretary to the Board of Trustees, Courtauld Institute to JCB, Jan. 28, 1958, JCB Personal Correspondence.

40. Bernard Berenson to JNB, February 19, 1958, JCB Personal Correspondence.

41. JW to JNB, no date, JCB Personal Correspondence. JW enclosed a letter from Blunt dated December 19, 1957. Kenneth Clark, Jan. 1, 1958, also wrote directly to JNB about JCB's Courtauld eligibility problems.

42. JW to JCB, March 11, 1958, JCB Personal Correspondence.

43. This visit is described in Calvin Tompkins's profile of JCB, "For the Nation," *New Yorker*, 66 (September 13, 1990), 48–90.

44. JCB to parents, September 17, 1958, Anne Seddon Kinsolving Brown Papers, Carter Brown, 1934–60, box 13, JHL/BU.

45. Bernard Berenson to JNB, October 26, 1958, ASKB Papers, box 13.

46. JCB to parents, October 1, 1958, ASKB Papers, box 13.

47. See JCB, tape transcript, and JCB to parents, October 27, 1958, ASKB Papers, box 13.

48. "Museum Director Who's Every Hostess's Dream," *NYT*, March 8, 1970, 78.

49. Author's conversation with William R. Johnston, Walters Art Gallery, March 2004.

50. JCB to Leslie Cheek, March 9, 1960, JCB Papers.

51. This is in a foreword to K. Richmond Temple, *Designing for the Arts: Environments by Leslie Cheek* (Williamsburg, VA: Society of the Alumni of William and Mary, 1990). Cheek thanked JCB in a letter of April 6, 1988, recalling the earlier visits and declaring, "You are the towering statue in the museum world today, and you do me great honor." JCB Papers, box 4.

52. See the reference in JCB, tape transcript, September 25, 2002, and JCB's comments in Sandra McElwaine, "The Patrician Chutzpah of J. Carter Brown," *Art News*, 78 (September 1979): 56.

53. In the spring of 1960, JCB made something of a midwestern grand tour, visiting museums in Chicago, St. Louis, Detroit, Minneapolis, Oberlin, Toledo, and Cincinnati, among others. Detailed letters to his parents record his reactions, a mixture of admiration and condescension. See ASKB papers, Carter Brown, box 13.

54. JCB, tape transcript, September 25, 2002. And see JCB, "The Curator Who Put People in the Picture," *WP*, October 18, 1995, B1.

55. JCB to JW, December 14, 1959, JCB Personal Correspondence.

56. JW to Francis Keppel, December 4, 1959, RG 2, box 26, NGA/GA

57. Francis Keppel to JW, December 15, 1959, RG 28B, box 14, NGA/GA.

58. JCB, tape transcript, January 8, 2002. "If I had kept him waiting for another year, I wouldn't have had that chance and would have gone on to Detroit," JCB reflected years later. "Who knows what I would have ended up doing?" I have not found corroboration for this in NGA files.

59. JCB, tape transcript, January 8, 2002.

Chapter 2

1. See Raymond Arsenault, "The End of the Long Hot Summer: The Air Conditioner and Southern Culture," *Journal of Southern History*, 50 (November 1984): 597–628.

2. Henry James, *The American Scene* (New York: Penguin, 1994), 265.

3. A string of books have covered cinematic Washington and its politicians. For a recent anthology see Iwan W. Morgan, ed., *Presidents in the Movies: American History and Politics on Screen* (New York: Palgrave Macmillan, 2011).

4. JW, *National Gallery, Washington* (New York: Abrams, 1974), 24.

5. For more on Finley, see David A. Doheny, *David Finley: Quiet Force for America's Arts* (Washington, DC: National Trust, 2006).

6. Among them, David Cannadine, *Mellon: An American Life* (New York: Vintage, 2006); Philip Kopper, *America's National Gallery of Art: A Gift to the Nation* (New York: Abrams, 1991); and Meryle Secrest, *Duveen: A Life in Art* (Chicago: University of Chicago Press, 2004).

7. JW, *National Gallery, Washington*, 24.

8. JW, review of *Masterpieces of the Frick Collection, NYT*, May 17, 1970, 275.

9. JW, "The Other General in Boston," review of *Museum of Fine Arts Boston, WP*, June 28, 1970, F8.

10. John Canaday, "John Walker Knew Art—Even If He Didn't Love It," *NYT*, November 10, 1974, 175.

11. For one interpretation, see Geoffrey T. Hellman, "Profiles: Custodian," *New Yorker*, 34 (October 25, 1958): 49–85.

12. Kopper, *America's National Gallery*, 252–55.

13. See the obituary tribute "Huntington Cairns," *WP*, January 26, 1985, A18.

14. PM (with John Baskett), *Reflections in a Silver Spoon: A Memoir* (New York: William Morrow, 1992), 308.

15. See Franklin Murphy, oral history interview, January 24, 1990.

16. Ibid.

17. JCB, tape transcript, February 18, 2002, JHL/BU.

18. JW, *National Gallery, Washington*, 49

19. Michael L. Krenn, *Fall-Out Shelters for the Human Spirit: American Art and the Cold War* (Chapel Hill: University of North Carolina Press, 2005), 24–26, 132–33, 138–39.

20. JW to Mrs. West, December 8, 1966, JW Papers, RG 28B, box 25, NGA/GA.

21. See Mrs. Marcia Zuesse to JW, November 22, 1966, JW Papers, RG 28B, box 25. JW's response was dated November 26, 1966.

22. JW to Arthur Schlesinger Jr., September 17, 1950, JW Papers, RG 28B, box 18.

23. JW to PM, November 10, 1947, JW Papers, RG 28B, box 15.

24. JW, *Self-Portrait with Donors: Confessions of an Art Collector* (Boston: Little, Brown, 1974), 303–4.

25. JW to General R. G. Owens Jr., June 26, 1968, JW Personal Correspondence. JW actually consulted Pentagon specialists to see how long it would take certain numbers of marchers to pass a reviewing stand.

26. JW, *Self-Portrait*, 306.

27. Elizabeth Foy, oral history interview, May 15–16, 1989.

28. Ibid.

29. Ibid. According to former curator Douglas Lewis the phrase was coined by a paintings curator. See C. Douglas Lewis Jr., oral history interview, April 21, 2004. Peacock Alley was employed by staff again and again.

30. Elizabeth Foy, oral history interview, May 15–16, 1989.

31. Charlotte Curtis, "Guests Flock to National Gallery Party," *NYT*, March 19, 1966, 14.

32. *Art News*, September 1969, 25.

33. JW, *Self-Portrait*, 202.

34. JCB, "The Curator Who Put People in the Picture: John Walker's Truly National Gallery of Art," *WP*, October 18, 1995, B1.

35. Foy, oral history interview, May 15–16, 1989.

36. Barbara Kober, "Interest Spurred in National Gallery," *Los Angeles Herald-Examiner*, July 9, 1962, Press Scrapbooks, vol. 77, NGA/GA.

37. *Washington Star*, November 20, 1966, Press Scrapbooks, vol. 77.

38. *Washington Star*, June 6, 1962, Press Scrapbooks, vol. 77.

39. Dorothy McCardle, "Car Bites Secret Service," *WP*, June 7, 1962, B9.

40. Maxine Cheshire, "Gwen Cafritz to Walker to Calder," *WP*, June 13, 1965, F17. The headline here referred to a request by John Walker to the sculptor Alexander

Calder, to create a fountain that would "dance and sing in perpetual movement" for the proposed sculpture garden.

41. JCB to JW, December 26, 1961, RG 2, box 19,

42. Ibid.

43. Ibid.

44. Scottie Lanahan, "The Best Looking Men in Washington," *WP*, June 3, 1966, C2.

45. F. B. Adams Jr. to JCB, June 3, 1963, JCB Personal Correspondence, JCB Papers, JHL/BU.

46. Letters about the Zodiac Club are in JCB Personal Correspondence.

47. Nancy Tuckerman to JCB, August 13, 1963, JCB Personal Correspondence.

48. Anthony Athos to JCB, July 1963, JCB Personal Correspondence.

49. JCB to PM, November 24, 1966, JCB Personal Correspondence.

50. JW, *Self-Portrait*, 191.

51. Andrew Hudson, "Color Film Portrays Some of Gallery's Art," *WP*, January 4, 1966, A9.

52. John Canaday, "Twenty-Five and All of a Sudden Breathing," *NYT*, March 20, 1966, 135. Canaday considered the National Gallery's goal, "that a new museum can aspire to eminence as a summary of the history of art through superior examples," to be an "impossible ideal." The "riverbed" was "dry."

53. Emily Genauer, "25 Candles Burn Brightly," *New York Herald Tribune*, March 27, 1966, Press Scrapbooks, vol. 93.

54. Ibid.

55. JCB to JW, August 24, 1966, RG 2, box 11.

56. JCB argued that, late in the JW administration, a Turkish exhibition from the Topkapi Museum may have been the first time NGA hired an outside designer, someone who had worked on Philip Johnson's Dumbarton Oaks Pavilion. See JCB, oral history interview, February 7, 1994; JCB, tape transcript, September 25, 2002.

57. "Gallery's Doors to Open First Time to Moderns," *WP*, August 14, 1963, B4.

58. Jean White, "New Masters Collect Critics," *WP*, December 18, 1963, D1.

59. For coverage, see Jack C. Landau, "Vast Mellon Art Collection Here on Loan," *WP*, February 20, 1966, B2; Miles A. Smith, "Anniversary Show Sets New Record," *WP*, March 18, 1966, B1; Charlotte Curtis, "Guests Flock to National Gallery Party, and Some Look at the Art," *NYT*, March 19, 1966, 14; "An Art Evening to Remember," *WP*, March 20, 1966, F1.

60. Bazy McCormick Tankersley, "Praise for the Block Collection," *Chicago Tribune*, May 21, 1967, A4.

61. Eleanor Page, "It'll Be Exciting Art Week for Leigh Blocks," *Chicago Tribune*, May 1, 1967, B9.

62. Louise Hutchinson, "Blocks Show Collection of Art in Capital," *Chicago Tribune*, May 4, 1967, C8. Press Scrapbooks, vol. 79, contains many clippings from Chicago newspapers noting the exhibition.

63. The auction was covered extensively by newspapers. *Time*, 78 (November 24, 1961): 52–60, ran a story on the event, "The Solid-Gold Muse."

64. For a dramatic description, see Sanka Knox, "Museum Gets Rembrandt for 2.3 Million," *NYT*, November 16, 1961, 1, 36. The purchase of the Fragonard for the National Gallery received a decidedly modest second billing.

65. Milton Bracker, "The Rembrandt Bid," *NYT*, January 7, 1962, 1, 79.

66. This was within a perceived rise in attendance among art museums more generally. See McCandlish Phillips, "Attendance Soars at Museums Here," *NYT*, November 27, 1961, 1, 32.

67. Lincoln Kirstein, "Rembrandt and the Bankers," *Nation*, 193 (December 9, 1961): 474–76.

68. "Capital to Display Rembrandt's 'Titus'" *NYT*, May 26, 1965, 44.

Chapter 3

1. JCB, tape transcript, February 15, 2002, JHL/BU. Much of this chapter and its quotations are based on the transcripts JCB dictated, from notes, as part of the "Braided Lives" project. His detailed recollections, some told to an interviewer, are spread through the tapes. The *Ginevra* story occupies a large share of the transcripts.

2. JW, *Self-Portrait with Donors: Confessions of an Art Collector* (Boston: Little, Brown, 1974), 46–47.

3. For more on the painting, see JW, "*Ginevra de' Benci* by Leonardo da Vinci," *Report and Studies in the History of Art* (Washington, DC: National Gallery of Art, 1967), 1–38; David Alan Brown, *Leonardo da Vinci: Origins of a Genius* (New Haven, CT: Yale University Press, 1998), 101–21; the catalog entry in David Alan Brown, ed., *Virtue and Beauty: Leonardo's Ginevra de' Benci and the Renaissance Portraits of Women* (Princeton, NJ: Princeton University Press, 2001), 142–45; and Jennifer Fletcher, "Bernardo Bembo and Leonardo's Portrait of Ginevra de' Benci," *Burlington Magazine* 131 (1989): 811–16.

4. JW, *Self-Portrait*, 49.

5. JCB, tape transcript, February 15, 2002.

6. Henry Kamm, "$6 Million Refused for Leonardo," *NYT*, November 24, 1965, 1, 27. Some of these purchases were described in the Kamm story, although the prince claimed he had stopped selling.

7. JCB, tape transcript, February 15, 2002.

8. Gerald Reitlinger, *The Economics of Taste: The Rise and Fall of Picture Prices, 1760–1960* (London: Barrie and Rockliffe, 1961), 202. It is unclear whether the Benois family ever received the money, as imperial debts were repudiated several years later by the revolutionary government. Ironically, the most expensive painting of the era may have turned out to be a bargain, at least for the Hermitage.

9. JCB, tape transcript, February 15, 2002.

10. Hans Adams's daughter, Nora, would live in the Pell household in the 1970s, while working at the International Bank for Reconstruction and Development. See Linda Charlton, "They're Royal Rulers without Magic Wands," *NYT*, April 16, 1976, 39.

11. Milton Esterow, "Available, Say Many," *NYT*, November 24, 1965, 27; Kamm, "$6 Million Refused."

12. See Mario Modestini, oral history interview, November 5, 1993. Ernest Feidler indicated that Modestini's role was central. "He went over the portrait literally with a microscope for 2 hours," he told *WP* reporter John Carmody when the story broke. "What Modestini saw," Carmody continued, "convinced Gallery officials that they must have the only known Leonardo outside European museums." Carmody, "A $5 Million da Vinci Spans Sea in Suitcase," *WP*, February 21, 1967, A1, A10.

13. Carmody, "$5 Million da Vinci," *WP*, February 21, 1967, A1, A10.

14. Ibid.

15. Milton Esterow, "Leonardo Oil Brings $5-Million," *NYT*, February 19, 1967, 1. It was a relatively rare front-page notice for NGA, something JCB would remember eleven years later when the East Building opened.

16. According to a *WP* reporter the story broke because Agnew's Gallery, in London, pressed a Canadian bid for *Ginevra* that was half a million dollars more than what the NGA paid. When told the painting had just been sold, the word got out through Agnew's. See Sarah Booth Conroy, "The Saga of Leonard da Vinci's 'Ginevra,'" *WP*, September 22, 1974, H4. Conroy credits JCB with writing a memo to JW on December 17, 1966, that set in motion the final stage of negotiations.

17. It should be noted that the *NYT* was also a sharp critic of Hoving and the Met during the 1960s and 1970s.

18. See JCB, tape transcript, February 15, 2002.

19. Milton Esterow, "Gallery Confirms Buying Leonardo," *NYT*, February 21, 1967, 44.

20. Milton Esterow, "A 'Bird' Worth $5-Million Flies Here in Cloak-and-Dagger Style," *NYT*, February 22, 1967, 26, also carried these details. Carmody, "$5 Million da Vinci," A1, A10, had offered the details a day earlier.

21. Esterow, "Gallery Confirms Buying Leonardo."

22. JCB remarked diplomatically at the time, "It wouldn't be fair to single out a particular patron." Carmody, "$5 Million da Vinci," A1.

23. "A Winner at Last," *WP*, March 30, 1967, A16.

24. Andrew Hudson, "Another Promising Art Season," *WP*, August 20, 1967, H7.

25. Andrew Hudson, "National Gallery's da Vinci Purchase Caps Its Collection," *WP*, February 23, 1967, E2.

26. Henry J. Seldis, "'Ginevra' Puts D.C. on Art Map," *Los Angeles Times*, April 24, 1967, D20.

27. "The Shadow of Another Smile," *Shreveport Times*, March 26, 1967, Press Scrapbooks, vol. 95, NGA/GA. This editorial appeared in a number of other newspapers, under different titles. It is unclear just where it originated.

28. See display ad, *NYT*, November 17, 1967.

29. David Braaten, "Washington Offbeat," *Washington Star*, February 22, 1967, Press Scrapbooks, vol. 95.

30. John Canaday, "Art: Debut of Leonardo's 'Ginevra,'" *NYT*, March 17, 1967, 38.

31. John Canaday, "John Walker Knew Art." Canaday was unhappy with Walker's condescending portrait of Samuel Kress, the "storekeeper" patron whose conviction was "that merchandise should be well lighted and attractively presented."

32. Frank Getlein, *Washington Star*, January 10, 1973, Press Scrapbooks, vol. 159.

33. John J. O'Connor, "TV: Study of da Vinci Marred by Reverential Tone," *NYT*, June 21, 1972, 87.

34. *NYT*, November 17, 1967, 95.

35. "Your Date . . . with Ymelda Dixon," *Washington Star*, March 20, 1967, Press Scrapbooks, vol. 95.

36. Anne Sue Hirshhorn, Letters to the Editor, "Collectors' Mania," *WP*, March 8, 1967, A16.

37. *Indianapolis Star*, March 3, 1967, Press Scrapbooks, vol. 95.

38. Harold Town, "Toronto Life," March 31, 1967, Press Scrapbooks, vol. 95.

39. JCB, notes made on conversation with Kenneth Clark, October 19, 1968, box 19, RG 2.

40. John Carmody, "Gallery: It's Superb," *WP*, February 16, 1972, B1. Actually, Malraux confided to JCB, he preferred the *Mona Lisa*. And he told JCB, "You speak French like an angel."

41. Thomas Hoving, *Making the Mummies Dance: Inside the Metropolitan Museum of Art* (New York: Simon & Schuster, 1993), 248–74.

42. Ibid., 250–51.

43. Ibid., 261.

44. Ibid., 263.

45. These phrases recur in various parts of the JCB tape transcripts. See, for example, those for March 17, 2002.

46. Lincoln Kirstein, "Rembrandt and the Bankers," *Nation* (December 9, 1961), 474–76.

47. Bernard Weinraub, "A Velazquez Brings $5.54-Million," *NYT*, November 28, 1970, 1, 17. See also Phil Casey, "Sold in 2½ Minutes," *WP*, November 28, 1970, B1–B2.

48. See Bernard Weinraub, "Britain Mounts Campaign to Save Velazquez Painting," *NYT*, November 30, 1970, 55.

49. The NGA got high marks for its food. See "Washington's Young National Gallery Is Host to Centenarian Museums," *NYT*, November 30, 1970, 57.

50. Dorothy McCardle, "Centennial Celebration: Centennial Celebrations," *WP*, November 30, 1970, B2.

51. JCB taped transcript, January 8, 2002. This was also part of the outline-summary of "Braided Lives."

52. See "Art: The Met: Bealguered but Defiant," *Time*, 101 (February 26, 1973): 43–45. Some consequences of the Velázquez purchase are treated in Michael Gross, *Rogues' Gallery: The Secret History of the Moguls and the Money That Made the Metropolitan Museum* (New York: Broadway Books, 2009), 248–52.

53. John Canaday, "Metropolitan Was Buyer of $5.5-Million Velazquez," *NYT*, May 13, 1971, 1, 50.

54. John Canaday, "What Price Art?" *NYT*, November 28, 1970, 17.

55. Robert E. Tomasson, "Dale Art's Value over $22-Million," *NYT*, May 25, 1966, 44. Twenty-three years later, forty-three paintings from John Dorrance's impressionist collection brought five times this total at auction. Judd Tully, "Dorrance's Paintings Fetch $116 Million," *WP*, October 19, 1989, C3.

56. Michael Brenson, "The Museum Connection," *NYT*, January 6, 1984, C17.

Chapter 4

1. Geoffrey T. Hellman, "Curator Getting Around," *New Yorker*, 26 (August 26, 1950): 31–49. Ripley was in India when the article appeared and said some of the details (about his service with the OSS) caused Nehru to order him out of the country. Hellman, a good friend, would write a string of *New Yorker* pieces on Ripley in coming years, as well as a Smithsonian history and commentaries on Smithsonian events. See SDR, seventeenth oral history interview, March 3, 1982, SI/SA.

2. See SI/SA for the long series of oral history interviews, which form the basis for

many of these pages. Conducted by Pamela Henson, they begin June 24, 1977, and are filed by date of interview.

3. SDR, first interview, June 24, 1977.

4. SDR, second interview, September 30, 1977.

5. SDR, fourth interview, January 3, 1978.

6. This was the origin of today's Lewis Walpole Library, a department of the Yale University Library, in Farmington, CT.

7. SDR detailed his Yale recollections in his fifth interview, March 6, 1978. Other, major aspects of his Yale years are recounted in the twelfth interview, October 7, 1980.

8. SDR, fifth interview, March 6, 1978.

9. SDR, eleventh interview, February 26, 1980.

10. Ibid.

11. SDR, seventeenth interview, March 3, 1982.

12. SDR, nineteenth interview, May 10, 1983.

13. SDR, twentieth interview, July 1, 1983.

14. SDR, nineteenth interview, May 10, 1983.

15. SDR, twenty-second interview, January 11, 1984.

16. The narrative is based on a lengthy letter by SDR to Crawford Greenewalt, February 16, 1963, box 6, SDR Papers, SI/SA.

17. This is described in the February 16 SDR letter to Greenewalt.

18. Undated 1963 note, Mrs. Joseph Allen Patterson to SDR, box 6, SDR Papers, SI/SA.

19. The letter was from a member of Yale's class of 1929 who worked in the editorial offices of the *Saturday Evening Post*; the signature cannot be made out. [?] to SDR, n.d., box 6, SDR Papers.

20. SDR, twenty-second interview, January 11, 1984.

21. Earl Warren formally made the offer on May 20, 1963. See box 6, SDR Papers, SI/SA.

22. SDR to Kingman Brewster, handwritten note, undated but responding to a letter of June 26, 1963, box 6, SDR Papers.

23. Wilmarth Lewis to SDR, June 19, 1963, box 6. SDR Papers.

24. SDR, twenty-second interview, January 11, 1984.

25. SDR, twenty-third interview, April 4, 1984. In his interviews Ripley demonstrated some hostility to Brewster, which may well have shaped his recollection.

26. SDR, twenty-second interview, January 11, 1984.

27. A summary of SDR's income can be found in box 6, SDR Papers. Most of the dividends came from a trust fund created by Mary Ripley's mother.

28. SDR, twenty-second interview, January 11, 1984.

29. Box 6, SDR Papers.

30. SDR, twenty-third interview, April 4, 1984.

31. Robert Goelet to SDR, October 1, 1963, box 6, SDR Papers.

32. Ernst Mayr to SDR, June 18, 1963, SDR Papers.

33. SDR, twenty-third interview, April 4, 1984.

34. Ibid.

35. Ibid.

36. In the twenty-third interview, April 4, 1984, SDR described his relationship with Charles Blitzer and Phlip Ritterbush.

37. Dorothy McCardle, "In Summer They're with the Wild Birds," *WP*, July 17, 1963, D1. McCardle's comments came only shortly after announcement of Ripley's appointment.

38. Herman Schaden, "Smithsonian Chief Has a Happy Dream," *Washington Star*, October 16, 1964.

39. SDR, twenty-fifth interview, June 3, 1985.

40. See Leonard Carmichael to JW, December 17, 1962, JW Personal Correspondence, NGA/GA. Carmichael asked Walker for his opinion of Scott, who was then still at Scripps College. He was appointed assistant director of NCFA in 1963.

41. See SDR to Sidney Yates, April 25, 1975, SDR Papers, box 318.

42. Aline B. Saarinen, *The Proud Possessors* (New York: Random House, 1958), 270.

43. Ibid., 273.

44. SDR, twenty-fifth interview, June 3, 1985.

45. JW to Joseph Hirshhorn, November 5, 1964, RG 2, box 10, Director's Transitional Files. Months earlier JW had proposed Hirshhorn think about donating sculptures for a Franklin Roosevelt Memorial, to be created on Constitution Avenue next to the NGA. That notion was now abandoned in favor of the sculpture garden.

46. SDR, twenty-sixth interview, March 14, 1986.

47. Ibid.

48. SDR, twenty-eighth interview, September 24, 1986.

49. See SDR, twenty-fifth interview, June 3, 1985, for recollections on creation of the Cooper-Hewitt. For its history, see Russell Lynes, *More Than Meets the Eye: The History and Collections of Cooper-Hewitt Museum* (n.p.: Smithsonian, 1981).

50. For more on the gift, see Grace Glueck, "Met Is Given $60 Million Linsky Art Collection," *NYT*, March 4, 1982, A1.

51. Paul Richard, "Archives for Art," *WP*, May 5, 1970, D1, covered the acquisition announcement.

52. For SDR's comments on absorption of the Archives of American Art, and his heavy reliance upon Charles Blitzer, see SDR, twenty-eighth interview, September 24, 1986. See also fourth interview with Charles Blitzer, September 12, 1986, SI/SA.

53. SDR to Marshall Fishwick, January 16, 1968, box 211, SDR Papers.

54. See Boris Weintraub, "What Sells Magazines?" *Washington Star*, July 13, 1977. Within seven years, *Smithsonian*'s circulation had reached 1.5 million, and each issue contained sixty-four pages of advertising.

55. SDR, twenty-eighth interview, September 24, 1986.

56. Ibid.

57. Ibid. A sanitized version of this appears in SDR, "The View of Tomorrow," in *The Smithsonian Experience* (Washington, DC: Smithsonian Institution; New York: Norton, 1977), 243.

58. SDR, twenty-eighth interview, September 24, 1986.

59. PM to SDR, November 24, 1964, RG 2, box 10.

60. Ripley proposed this at a Gallery board meeting, January 19, 1965. See RG 2, box 7.

61. More material on this issue can be found in RG 2, box 2.,

62. See JCB to JW, July 28, 1967, RG 2, box 13. This lengthy letter described a meeting of the National Capital Planning Commission, at which both Gallery building proposals and the Hirshhorn sculpture garden were considered. At this point JCB was

pushing for a skating rink, and was worried that the Hirshhorn cross-axis sculpture garden might be approved. The commission approved the Hirshhorn plan in December 1967, but rescinded its approval, in favor of a smaller sculpture garden, on May 6, 1971. RG 11, box 24, is filled with correspondence and memoranda referring to the complex sculpture garden discussion.

63. Undated JW memo, RG 2 box 11, Director's Transitional Files. The memo had attached to it a letter from SDR to JW, dated November 6, 1964, and was written, presumably, soon thereafter.

64. Ibid. Tensions between the NGA and SI over the sculpture gardens lingered for decades. In 1989 JCB apologized to Hirshhorn director James Demetrion for drawing an inappropriate contrast between the two facilities before a congressional committee. See James Demetrion to JCB, February 28, 1989; JCB to Demetrion, March 9, 1989; and JCB to Sidney Yates, March 9, 1989, RG 2, box 79.

65. Undated JW memo, RG 2, box 11, Director's Transitional Files. At their January 1977 meeting, NGA trustees authorized establishment of a Special Collection for objects worthy of retention but not appropriate to the Permanent Collection. By this time there were three categories: the Collection; the Permanent Collection; and the Special Collection. See Minutes of Board Meeting, May 5, 1977, box 421, SDR Papers. SDR put into his files NGA board minutes.

66. JW to Alan Pryce-Jones, October 6, 1965, RG 2, box 11, Transitional Subject Files.

67. Geoffrey T. Hellman, *The Smithsonian Institution: Octopus on the Mall*, (Philadelphia: Lippincott, 1967), 153.

68. RG2, box 11, Transitional Subject Files.

69. PM (with John Baskett), *Reflections in a Silver Spoon: A Memoir* (William Morrow, 1992), 303.

70. Ibid., 303–4. See also memo from Gallery administrator E. James Adams to JW, September 8, 1965, RG 2, box 11, Director's Transitional Files, describing how PM and John Hay Whitney would be marching.

71. PM, *Reflections*, 305. A series of exchanges between PM and SDR in the 1964–1966 period indicates the level of tension and PM's punctilious attention to SI statements and publications. They can be found in RG 2, box 10. The fact that Ripley was an NGA trustee obviously complicated matters, as did jousting over proposed Arts Council legislation. House and Senate bills disagreed on whether the director of NGA and the chairman of the Fine Arts Commission should hold seats on the Arts Council. Ripley was eager to have what would become the national endowments housed in the Smithsonian, but White House staff decided against that. PM was clearly irritated with SDR, who, in turn, as his interviews reveal, resented NGA procedures.

72. RG 2, box 11, Director's Transitional Files.

73. JCB memo to JW, March 19, 1965, RG 2, box 11, Director's Transitional Files.

74. Howard Taubman, "The Invisible Artist," *NYT*, September 29, 1966, 58.

75. For more on the Philadelphia experiment, see Andrew McClellan, *The Art Museum from Boullée to Bilbao* (Berkeley: University of California Press, 2008), 173–74.

76. Charles Blitzer interview, September 16, 1985, SI/SA.

77. For more details, see Barry Hyams, *Hirshhorn, Medici from Brooklyn* (New York: Dutton, 1979), and Gene H. LePere, *Little Man in a Big Hurry: The Life of Joseph H. Hirshhorn* (New York: Vantage, 2009).

Chapter 5

1. An earlier version of this chapter appeared as Neil Harris, "Reinventing the National Gallery," in *A Modernist Museum in Perspective: The East Building, National Gallery of Art*, edited by Anthony Alofsin (Washington, DC: National Gallery of Art, 2009), 23–45.

2. Joseph Hudnut, "The Last of the Romans: Comments on the Building of the National Gallery of Art," *Magazine of Art* 34 (April 1941): 169–73.

3. See Emily Genauer's recollection of the building's reputation, "The Arts . . . ," *Newsday*, July 17, 1971.

4. David W. Scott, oral history interview, August 26, 1993.

5. The projections were not much exaggerated. In 1999 graduate enrollment in the United States stood at slightly more than 1.8 million. See *Statistical Abstract of the United States* (Washington, DC, 2003), 123:180. For 1965 levels, see *American Universities and Colleges*, 16th ed. (New York, 2001), 1:25.

6. See the 1969 interview of JCB undertaken by the Twentieth Century Fund for Karl Meyer, *The Art Museum: Power, Money, Ethics* (New York, 1979), RG2, box 81.

7. For more, see JCB memo, March 24, 1969, RG2, box 18, NGA/GA; JCB conversation with Stoddard Stevens, April 12, 1967, RG2, box 12; and JCB memo, April 19, 1967, RG 11, box 25, Records of Building Planning. White was making the rounds in late 1966. Rudolf Wittkower of Columbia University told Brown that White's proposal had been discussed by them in December 1966. See JCB memo, Notes on a Conversation with Professor Rudolf Wittkower, RG 11, box 14. Brown spoke with White himself in September 1967.

8. See JW's comments in his oral history interview, July 27, 1987.

9. JCB, oral history interview, February 7, 1994. In his tape transcript, JCB argued that JW was feeling the pressure of the new SI secretary, whose motto, JCB thought, might be "Tomorrow, the world." JCB, notes for tape transcript.

10. JW, oral history interview, July 27, 1987. JW claimed that the notion the land had been reserved for the NGA was illusory. In the 1960s it held tennis courts, convenient for congressional staff, which occasioned a little nervousness, according to JCB's recollection. There is scattered evidence JW was thinking about a new wing years before Paul Mellon's gift. See Frank Eyerly to JW, April 5, 1963. Eyerly was managing editor of the *Des Moines Register*. Accepting a luncheon invitation from JW in Washington he wrote, "This may indeed be an historic hour in the history of The National Gallery for out of it may come your decision to build a wing in which to house an assemblage." JW Personal Papers, RG 28.

11. For more on the complex issue of Smithsonian-NGA competition, see JCB to JW, June 27, 1967, RG 2, box 12. See also letters between PM and SDR in the spring and summer of 1965, RG 2, box 10.

12. PM to SDR, July 21, 1965, RG 2, box 10.

13. See RG 11, box 22, for various documents, including a statement by SDR about the aims and procedures of the National Collection of Fine Arts, and a National Gallery analysis that specified the areas of competition and recommended various responses, including establishment of a committee to coordinate the activities of the two institutions.

14. For an example of Walker's pursuit of Hirshhorn, see JW to Joseph Hirshhorn, November 5, 1964, RG 2, box 10, Director's Transitional Files. SDR often hear-

kened back to 1937 legislation that envisaged a national museum of modern art on the Mall, under direct Smithsonian asupervision. Eero and Eliel Saarinen actually designed such a building, which would have been the Mall's first modernist structure, but plans fell through. SDR believed his creation of the Hirshhorn was a fulfillment of this earlier commitment. For the Saarinen models (1939), see Laurence Vail Coleman, *Museum Buildings* (Washington, DC: American Association of Museums, 1950), 1:61.

15. SDR to PM, November 30, 1965, RG 2, box 10. In this letter, SDR argued that Washington had many of the "components" for an advanced institute, "lacking only the coordinating force. It seems to me that the Smithsonian *could* provide the coordination."

16. Meg Greenfield, "The Politics of Art," *Reporter* 35 (September 1966): 27.

17. President Johnson announced the gift November 6, 1967. See the front-page coverage, Paul Richard and Phil Casey, "Mellons Give 20 Million for New Gallery Wing," *WP*, November 7, 1967, A1, A11, and the editorial "The National Gallery," *WP*, November 10, 1967, A24. As early as 1971, JCB was trying to recover the moment when the proposal for a study center had exploded into a far more ambitious (and expensive) scheme for additional exhibition space. See the memo by David Scott to JCB (in response to a JCB request), January 19, 1971, RG 11, box 12, attempting to recapitulate the various stages in the building's gestation. The period covered was only four years, but already it was proving difficult to determine just when and how the original scheme had ballooned. JCB's effort at precision came just as the trustees were making their formal endorsement.

18. JCB memo, June 6, 1967, RG 11, box 38. The memo summarized conversations with Stoddard Stevens, PM, and JW on Nantucket Island. During this period JCB met frequently with Stevens, who was concerned about issues of confidentiality, worried that the Gallery "not bite off more than we can chew," and eager to involve Harvard with the project.

19. JW was already suggesting that JCB had begun to run the institution. "Everything seems to go so smoothly without me that I sometimes feel I might just as well stay away for good," he wrote JCB from England. Even during this time of intense planning, JW was taking his long summer vacation in England. JW to JCB, July 26, 1967, RG 11, box 12.

20. Notes on these conversations, conducted in the summer of 1967 with John White, Wolfgang Stechow, Seymour Slive, Marvin Eisenberg, Charles Sawyer, and many others, can be found in RG 11, box 14.

21. For the report see RG 2, box 18.

22. See JCB memo, April 19, 1967, RG 11, box 38, for a revealing conversation with Stoddard Stevens at Dulles Airport and during a drive to Washington.

23. JCB. "What Is to Become of the National Gallery of Art?" *Connoisseur* 178 (December 1971): 259–62.

24. JW memo to staff, November 1, 1967, RG3, box 15B. Others were already projecting higher costs. Stoddard Stevens had argued, several months earlier, that while the building might cost twenty million dollars, it probably needed a ten-million-dollar endowment, principally for the fellowships. See JCB memo, August 10, 1967, RG 11, box 12.

25. JCB to JW, July 19, 1967, RG 11, box 13. The assumption was that while the outer shell would be constructed, parts of the interior might remain unfinished for a time.

26. For the estimate, dated August 26, 1970, see RG 11, box 13.

27. The timetable for action began with Board approval at a meeting in October 1967, completion of a preliminary design by April 1969, construction begun by July 1970, and occupancy in July 1972. RG 11 box 12.

28. See draft of letter from JW to SDR, April 20, 1964, RG 2, box 10. And see JW to Sir Philip Hendy, March 23, 1964, RG 2, box 5.

29. JW, *National Gallery of Art, Washington* (New York: Abrams, 1976), 49.

30. Michael L. Krenn, *Fall-Out Shelters for the Human Spirit: American Art and the Cold War* (Chapel Hill: University of North Carolina Press, 2005), 22–23.

31. JCB to JW, July 19, 1967, RG 11, box 13. As late as 1973, Stevens was still urging deferral of parts of the project, referring to the lengthy process of building the Cathedral of Saint John the Divine in New York as a possible model. See JCB memo, November 20, 1973, RG 2, box 7, Director's Transitional Files.

32. See the JCB memo summarizing his meeting with Belluschi, May 17, 1967, RG 11, box 12; and, also in box 12, a memo on a July 18, 1967, meeting between the two.

33. Notation is attached to a letter from SDR to JW, November 6, 1964, RG 2, box 11, Transitional Subject Files. See also the Smithsonian's statement on a proposed National Museum Act, dated November 24, 1964. The mimeographed statement has a scrawled label (in what seems to be JW's hand) reading NGA-Smithsonian competition. SDR proposed that the Smithsonian, as part of this legislation, house a coordinated program of research, training, and publication in the museum field. See box RG 2, box 11.

34. JCB referred to the "double ring ceremony" in an undated memo to George Hartzog, director of the National Park Service, RG 11, box 12. In the same memo he worried that coupling the sculpture garden with the new building "might trigger some comments that the Gallery had gone the route of some institutional form of territorial imperialism." On the loss of funding, see Spencer Rich, "Park Project Funds Are Cut," *Washington Post*, April 16, 1969, D1.

35. Robert Engle to JCB, June 21, 1971, RG 11, box 24.

36. JCB to Manus Fish, August 2, 1974, RG 11, box 24.

37. See JCB, memo to JW, August 9, 1966, and JCB, letter to John Woodbridge, June 6, 1966, both RG 11, box 24. Woodbridge was the Skidmore Owings & Merrill architect in charge of planning the sculpture garden at this point. Brown suggested movable chairs, a sheltered desk selling Gallery postcards and slides, a tot lot for children, and a Seventh Street bridge that could be overflowing with greenery. The SOM version of the sculpture garden was brought to the trustees in May 1967.

38. See Linda Newton Jones, "Some Congressmen Challenge Avenue Plan," *WP*, March 22, 1975, B6, for struggles over the six-hundred-million-dollar Pennsylvania Avenue Development Corporation plan, with the tunnels dropped and the Willard Hotel retained.

39. Significant changes were already under way. For more on tourism and the city's internationalization, see Carl Abbott, *Political Terrain: Washington, D.C., from Tidewater to Global Metropolis* (Chapel Hill, 1999).

40. See James Lardner, "Tourism Attempts a Come-back," *Roanoke Times and World-News*, September 24, 1978, Press Scrapbooks, vol. 236, NGA/GA.

41. See "Revitalizing the Urban Heart of Washington," *WP*, February 5, 1972, B11. This article consisted of an extract of President Nixon's 1972 message to Congress.

42. "The Sickest City," *Richmond Times-Dispatch*, October 16, 1975.

43. This review of building activity appeared in Jerry Knight, "Adding Up D.C.'s 'Renaissance' in Construction Projects," *WP*, December 31, 1978, D1.

44. Philip Wagner, "Culture Blooms on Potomac," *Buffalo News*, May 28, 1966.

45. See Joseph B. Espo, "Washington's Losing Its Image," an article highlighting Washington's recent cultural expansion that was reprinted in newspapers throughout the country in April 1978, in Press Scrapbooks, vol. 252. JCB is quoted extensively.

46. See, among other documents, PM to Kermit Gordon, August 24, 1964, RG 11, box 22. Gordon was director of the Bureau of the Budget. There is much more in RG 11, box 25, on the board of trustees' response to the Pennsylvania Avenue Plan, which would go through many revisions during the next ten years.

47. See the agonized discussion of how to word a letter to the Pennsylvania Avenue Commission in late 1967, contained in RG 11, box 22. While not yet director, JCB was assigned the responsibility of managing the Gallery's official response. The letter he sent, June 30, 1967, after getting memos from other Gallery officers, paid fewer compliments to the Pennsylvania Avenue Plan than director Walker had in an earlier draft.

48. See Wolf von Eckardt, "New Design Retains Objectives of First," *WP*, April 8. 1966, B3.

49. See Paul Delaney, "Capital's Redevelopment Comes under New Fire," *NYT*, November 29, 1970, 45.

50. Wolf von Eckardt, "National Square: Mythical Complex," *WP*, April 29, 1969, C1.

51. "A People's Palace on Pennsylvania Avenue," *WP*, February 6, 1974. A24.

52. JCB to Leland Allen, n.d., RG 11, box 25. Internal evidence suggests the note was written in the spring of 1974.

53. For more on the Washington Metro, and on the furious debates about super-highways, see Zachary M. Schrag, *The Great Society Subway: A History of the Washington Metro* (Baltimore: Johns Hopkins University Press, 2006).

54. See, for example, Erving Goffman, *The Presentation of Self in Everyday Life* (Garden City: Doubleday, 1959) and *Behavior in Public Places* (New York: Free Press, 1963); Edward T. Hall, *The Hidden Dimension* (Garden City: Doubleday, 1966); Jane Jacobs, *The Death and Life of Great American Cities* (New York: Random House, 1961); William H. Whyte, *The Last Landscape* (Garden City: Doubleday, 1968); Bernard M. Rudofsky, *Streets for People* (Garden City: Doubleday, 1969); and Oscar Newman, *Defensible Space: Crime Prevention through Urban Design* (New York: Macmillan, 1972).

55. See, for example, JCB memo to Pei, September 24, 1975, RG 11, box 3. Appended to the memo is an article by William Marlin ("New York Plazas," *Christian Science Monitor*, June 13, 1975), which contains references to Whyte and his study of plazas. The inclusion of the article reflected JCB's interest in creating places for people to sit in the Fourth Street plaza to the east of the West Building.

56. Thomas Hine, "Tower of Art, Monument of Our Time," *Philadelphia Inquirer*, May 28, 1978.

57. See Neil Harris, "Spaced Out at the Shopping Center," *Cultural Excursions: Marketing Appetites and Cultural Tastes in Modern America* (Chicago: University of Chicago Press, 1990), 278–88.

58. For Gruen and his philosophy of shopping centers, see M. Jeffrey Hardwick, *Mall Maker: Victor Gruen, Architect of an American Dream* (Philadelphia: University of Pennsylvania Press, 2004).

59. Wolf Von Eckardt, "Downtown Design," *WP*, December 13, 1977, C1.

60. Christian Otto, "Washington—A New Centre for the Arts?" *Connoisseur* 198 (August 1978): 325.

61. JCB to Pei, Oct. 28, 1968, RG 11, box 3.

62. JCB to Carter Wiseman, November 8, 1990, RG 2, box 81.

63. JCB to Pei, June 17, 1970, RG 2, box 12.

64. "Preliminary Outline Program for the Proposed East Building," July 9, 1968, RG 11, box 15B. Unsigned, this was presumably by JCB.

65. JCB, oral history interview, February 7, 1994.

66. Russell Lynes, "National Gallery's New Building is Triangular Triumph," *Smithsonian* 9 (June 1978): 46–55.

67. Kiki Levathes, "Growing Pains for Gallery Addition," *Washington Star*, July 2, 1972.

68. Ibid.

69. JCB to Pei, August 13, 1970, RG 2, box 12.

70. JCB memo to David Scott, undated, but some time in 1971, RG 2, box 12.

71. I.M. Pei interview with the author, July 22, 2004.

72. Ada Louise Huxtable, "Pei's Elegant Addition to Boston's Arts Museum," *NYT*, July 12, 1981, D23.

73. "I. M. Pei and Partners," *Architecture Plus* (March 1973), 65; clipping in RG 11, box 30.

74. JCB credited William Howard Adams, in charge of the Gallery's extension service and organizer of the Kenneth Clark lectures, with the idea. See JCB, tape transcript, January 15, 2002.

75. Christopher Wright, "Planning Unit Stalls Gallery Annex," *Washington Star*, March 31, 1971.

76. JCB to Nathaniel Owings, August 14, 1968, RG 11, box 25.

77. See Robert Engle, memo to JCB, June 29, 1973, RG 2, box 12.

78. Wright, "Planning Unit Stalls Gallery Annex."

79. JCB to Sterling Tucker, March 16, 1978, unsent, RG 2, box 30.

80. JCB continually urged Pei to make the plaza "the people place." He noted to Pei that he had earlier sent a newspaper clipping to reaffirm the Gallery's interest "in having the plaza turn out to be a friendly place for our visitors. When you came up with the suggestion of combining benches and planters . . . I eagerly agreed." JCB to Pei, August 30, 1977, RG 11, box 2.

81. Stoddard Stevens, in conversation with, among others, JCB, JW, and Pietro Belluschi on April 6, 1967, suggested a "moving platform" as part of the underground link. See JCB, "Notes on a Conversation," April 6 1967, RG 11, box 12.

82. See, for example, Philippe de Montebello, "Art Museums, Inspiring Public Trust," in *Whose Muse? Art Museums and the Public Trust*, edited by James Cuno (Princeton, NJ: Princeton University Press, 2004), 157, 161

83. See JCB memo, January 22, 1971, RG 2, box 12.

84. Scott, oral history interview, August 26, 1993.

85. Louise Lague, "Brown's Bag," *Washington Star*, July 10, 1977.

86. JCB to Scott, February 9, 1971, RG 2, box 13.

87. Undated memo on "stolen" menu from the Fountain Cafe, RG 11, box 24. JCB's memo reads, "This is a stolen copy of the menu to the new outdoor cafe in Central Park that Tom Hoving put in. . . . It is a wild success and was written up in *Time* last

week." Information was also gathered on the skating rink at Rockefeller Center, a complex JCB much admired.

88. Dorothy McCardle, "Trying to Equal the Met," *WP*, October 8, 1973, B3.

89. Margaret H. Kearney, "Open to Anyone" (letter to the editor), *WP*, October 16, 1973, A19.

90. William van den Toorn to JCB, October 10, 1973, RG 2, box 12. Van den Toorn was concerned about the loss of the "well-maintained plebeian tennis courts" that occupied the East Building site. In his return letter, JCB told him that while the new eating facility would not be precisely where the tennis courts were, it would serve many more people. "Eating is, I hope you will agree, an even less elitist activity than tennis." JCB to van den Toorn, October 15, 1973, RG 2, box 12.

91. See JCB to I. M. Pei, October 12, 1973, RG 2, box 12. The reporters put their confusion into quotes, JCB told Pei, but it was indicative that in celebrating a theatrical event "the East Building upstages the whole show."

92. JCB, Letters to the Editor, "Public Cafeteria," *WP*, October 22, 1973, A29.

93. JCB to van den Toorn, October 15, 1973, RG 2, Box 12.

94. Scott, oral history interview, August 26, 1993.

95. Elinor Horwitz, "We Can Have Neon Signs," *Washington Star*, September 3, 1977.

96. Robert Campbell, "One Against The Majority," *Boston Globe*, June 25, 1978.

97. JCB to Scott, June 6, 1974, RG 2, box 13.

98. Scott, oral history interview, August 26, 1993.

99. JCB to Scott, March 24, 1972, RG 2, Box 13.

100. See the various memos in RG 2, box 13.

101. William Walton to JCB, February 25, 1970, RG 2, box 12.

102. Katherine Warwick to JCB, February 16, 1971, RG 2, box 14,

103. Memo from Katherine Warwick to JCB, May 10, 1971, RG 2, Box 14, details the "messy situation," blaming Wolf Von Eckardt. But the positive reactions eased the problem.

104. See Scott's memos to JCB about metro stations and their placement, September 29 and November 8, 1972, RG 11, box 15b. "For the sake of orientation we must keep NGA firmly lodged in their thinking and visualizations," he wrote of the Metro planners.

105. See JCB memos, September 1 and 3, 1971, RG 2, box 14.

106. *WP*, July 29, 1972. Philadelphia pioneered the Percent for Art Program in 1959; New York's program began in 1983.

107. JCB to Thomas Messer, July 19, 1972, Messer to JCB, July 28, 1972, RG 2, box 11.

108. JCB to Sir Roland Penrose, April 4, 1973, RG 2, box 11.

109. JCB to Penrose, April 19. 1973, RG 2, box 11.

110. See the correspondence between JCB and Stanley Westreigh, RG 2, box 11.

111. Marguerite Duthuit to JCB, June 30, 1973, RG 2, box 11.

112. See the Gabo letter, June 16, 1975, RG 2, box 11.

113. See JCB memo of a telephone call with Pei, April 20, 1978, RG 2, box 11. Oldenburg had called Pei, indicating his interest in providing something for the new building.

114. The comments about Noguchi, di Suvero, and a Washington artist were made at a July meeting. See minutes, July 25, 1975, RG 2, box 11.

115. JCB memo, October 28, 1975, RG 2, box 11.

116. In his taped reminiscences JCB insisted that his friend, Paul Matisse, "was the hero" of the Calder saga. For the details, see Paul Matisse, oral history interviews, July 23 and November 13, 1998.

117. JCB to Henry Moore, May 7, 1973, RG 2, box 12.

118. JCB memo, June 25, 1974, RG 2, box 12.

119. Correspondence and memos about the Moore commission can be found in RG 2, box 12. See JCB memo, June 25, 1974.

120. JCB to Gwendolyn Cafritz, June 26, 1975, RG 2, box 12.

121. JCB to Moore, July 1, 1975, RG 2, box 12.

122. Michael Cannell, *I. M. Pei: Mandarin of Modernism* (New York: Carol Southern Books, 1995), 268–69.

123. JCB memo, November 5, 1975, RG 2, box 12. JCB also proposed to Moore that he cast the piece for a new museum in North Carolina. Gordon Hanes, of Winston-Salem, a member of the Collectors Committee, had admired it. See JCB to Moore, November 10, 1975, RG 2, box 12. North Carolina was a textile state, JCB pointed out, and spindles played a large role in its economy. *Large Spindle Piece* did end up at the North Carolina Museum of Art in Raleigh.

Chapter 6

1. JW to JCB, July 26, 1967, RG 2, box 13, NGA/GA.

2. JW, oral history interview, July 17, 1987.

3. PM to JCB, February 19, 1969, JCB Personal Correspondence, JHL/BU.

4. PM did give JW an office and a secretary. See Paul Richard, "The Touch of Class," *WP*, June 19, 2002, C1, arguing that JCB's treatment of Walker—never consulting him and rarely inviting him back—"was one of the rare uglinesses in Brown's gallery career." (Walker may have confided in Richard.) JCB, for his part, thought JW was treated badly by the trustees. He had recommended a gift but there was none. "There was no dinner. There was no ceremony. It was just insensitive, and it was Stoddard. And the Mellons tended to have a court and who's in and who's out, and suddenly just nobody thought about it particularly." JCB, tape transcript, January 16, 2002, JHL/BU.

5. Gerald Clarke, "A Portrait of the Donor," *Time* 111 (May 8, 1978): 79.

6. JCB, tape transcript, February 18, 2002.

7. There were rumors in the late 1960s, basically unfounded, that Walker might decamp for another institution. See Maxine Cheshire, "Very Interesting People," *WP*, October 20, 1966. B1.

8. Richard, "Touch of Class."

9. "Report of the Director," *Annual Report 1970. National Gallery of Art, Washington* (July 1, 1969–June 30, 1970), 9.

10. Meryle Secrest, "And Now—the Rembrandts," *WP*, July 6, 1969, 110.

11. JCB, tape transcript, February 18, 2002. Brown was happier with the appointment of Robert Amory Jr., a Harvard-trained lawyer, sailing companion, former deputy director of the Central Intelligence Agency, and brother of Cleveland Amory, the writer and social historian.

12. Meryle Secrest, "Gallery Appointments," *WP*, September 8, 1970, B12.

13. Paul Richard, "Gallery Appoints," *WP*, October 3, 1970, C2. Three days later,

the NGA confirmed Parkhurst's appointment along with that of Konrad Oberhuber as research curator in the graphic arts and Alessandro Contini-Bonacossi as archivist. Richard, "National Gallery Names 3 Historians," *WP*, October 6, 1970, B5.

14. These, and other details, are taken from Charles Parkhurst, oral history interviews, November 10 and December 6, 1988.

15. Parkhurst had already met JNB, but this was his first encounter with JCB.

16. "Report of the Director," *Annual Report, 1972, National Gallery of Art, Washington* (July 1, 1971–June 30, 1972), 20.

17. "Director's Review of the Year," *Annual Report, 1974, National Gallery of Art, Washington* (July 1, 1973–June 30, 1974), 9.

18. Ibid., 25.

19. "Director's Review of the Year," *Annual Report, 1975, National Gallery of Art, Washington* (July 1, 1974–June 30, 1975), 9.

20. For more on the transaction, see Grace Glueck, "National Gallery's Negotiations with France Described," *NYT*, September 27, 1974, 50. For the story of the negotiations and the Washington reception, see Paul Richard, "La Tour's 'Repentant Magdalen' Arrives at the Gallery," *WP*, September 27, 1974, B1, B13.

21. JCB, tape transcript, February 2, 2002.

22. JCB, oral history interview, July 27, 1998.

23. Jeffrey Simpson, "Exhibition-ism," *Art News* (March 1983), 60–67, offers an important and detailed review of the impact and costs of temporary exhibitions over the previous fifteen years, and the growth of installation design.

24. JCB, oral history interview, February 7, 1994.

25. C. Douglas Lewis Jr., oral history interview, January 30, 2004.

26. Parkhurst, oral history interview, November 10, 1988.

27. A typescript of Varnedoe's eulogy for Ravenel was provided by Carroll J. Cavanagh.

28. JCB, oral history interview, February 7, 1994.

29. Ibid.

30. JCB to assistant director, April 19, 1971, RG 2, box 7.

31. Paul Richard, "'African Art in Motion': Evoking a Unity beyond Art," *WP*, May 2, 1974, B1.

32. John Russell, "Films and Music Portray African Art," *NYT*, May 4, 1974, 37.

33. John Canaday, "Esthetics versus Anthropology in the Art of Africa," *NYT*, June 16, 1974, 127.

34. Richard, "'African Art in Motion,'" B13.

35. Paul Richard, "A New Angle on the Mall," *WP*, December 18, 1977, L12.

36. Meryle Secrest, "African Exhibit," *WP*, January 27, 1970, C1, C8.

37. Lorraine Cooper's story was printed by Kentucky papers like the *Henderson Gleaner-Journal*, February 12, 1970, Press Scrapbooks, vol. 125, NGA/GA.

38. "Museum Director Who's Every Hostess's Dream," *NYT*, March 8, 1970, 78.

39. JCB to Douglas Dillon, November 20, 1969, RG 2, box 80.

40. He said this while still assistant director. See Charlotte Curtis, "Guests Flock to National Gallery Party," March 19, 1966, *NYT*, 14.

41. *Annual Report 1973, National Gallery of Art, Washington* (July 1, 1972–June 30, 1973), 20.

42. "Illumination," "Talk of the Town," *New Yorker*, 49 (April 7, 1973), 32–34.

43. Dorothy McCardle and Sally Quinn, "Marking a Historic Occasion," *WP*. March 30, 1973, C1.

44. Author's interview with Robert Bowen, June 13, 2006.

45. Betty Beale, "Super Chic Preview," reprinted from *Washington Star* in *Kansas City Star*, April 9, 1973, Press Scrapbooks, vol. 134. The Carters were presumably Mr. and Mrs. Edward E. Carter; he headed Carter Hawley Hale and was a founding president of the Los Angeles County Museum of Art. The Becks were Mr. and Mrs. John A. Beck of Houston; Audrey Jones Beck, the granddaughter of Jesse H. Jones, Houston entrepreneur and New Deal administrator, was a major collector of French impressionist and postimpressionist art and a donor to the Museum of Fine Arts, Houston.

46. See Paul Richard, "Chinese Cancel Art Preview," *WP*, December 10, 1974, B1, B5.

47. "An Unacceptable Deal," *WP*, December 11, 1974, A18. A year earlier, on the occasion of the NGA showing of Soviet-owned art, the *Post* had thanked "world power politics for supplying the Russians with the incentive" to loan great paintings to the West. See "Art for Detente's Sake," *WP*, February 8, 1973, A22.

48. Murrey Marder, "Who Won the Big China-U.S. Press Preview Confrontation?" *WP*, December 12, 1974, A21. See also Ann Wood, *New York Daily News*, December 12, 1974, Press Scrapbooks, vol. 169.

49. Tom Dowling, "The Best Way to Fight Censorship," *Washington Star*, December 12, 1974, Press Scrapbooks, vol. 169. Dowling had written, a few years earlier, one of the most hostile profiles JCB received from the press during his years as director.

50. These, and other newspaper comments, can be found in the Press Scrapbooks, vols. 172–75.

51. Hilton Kramer, "Old Pleasures for the China-Watchers," *NYT*, December 13, 1974, 58.

52. Paul Richard, "Chinese Art: Classy, not Classless," *WP*, December 12, 1974, C1, C17.

53. John Russell, "A Sampling of Leningrad's Riches," *NYT*, August 10, 1975, 83.

54. Katherine Kuh, "Auguste Rodin Affair," *Saturday Review* 54 (December 25, 1971): 22–23.

55. Frank Getlein, *Washingtonian*, May 1973, 110, Press Scrapbooks, vol. 159.

56. "Tourist Travel and the Bicentennial," a report issued by the Metropolitan Washington Council of Governments, produced the figures. See Jack Eisen, "Bicentennial to Bring 25 Million to the Area," *WP*, November 23, 1972, G1.

57. JCB memo, December 29, 1969, RG 2, box 69.

58. JCB to Hoving, April 15, 1970, RG 2, box 80.

59. JCB memo of telephone call, June 2, 1970, RG 2, box 80.

60. Theodore Rousseau to JCB, September 16, 1970, RG 2, box 80.

61. JCB to Hoving, October 4, 1972, RG 2, box 80.

62. The Harriman gift, almost two dozen pieces, including work by Picasso, Matisse, and Gauguin, was termed by JCB, "quite a haul." See *Newsweek* 79 (February 14, 1972): 48. Paul Richard, in "A Gift of Harriman Art," *WP*, February 2, 1972, B1, B3, declared that Harriman had succeeded in raising both the prestige and the quality of the National Lending Service. These articles were found in RU 613, box 55, SI/SA, in a folder of materials covering NGA kept by the Secretary's Office of SI.

63. Parkhurst's comments can be found in a folder concerned with the National Lending Service, RG 2, box 81.

64. NGA memo, January 11, 1971, emphasizing the public services performed by NGA. Extension, publications, exhibitions, and the cafeteria are all classified as continuing public services in need of expansion and, in the case of the cafeteria, of more space. RG 2, box 12.

65. See, for example, Paul Richard, "MoMA: Seeking Direction," *WP*, January 7, 1972, B1, and *Arts Magazine* (April 1972), for comments on the resignations.

66. For more on Clark see Meryle Secrest, *Kenneth Clark: A Biography* (New York: Holt, Rinehart, 1985).

67. Ann Turner to JCB, November 13, 1969, RG 2, box 19.

68. Clark to JCB, July 14, 1981, RG 2, box 19.

69. JW to Kenneth Clark, October 27, 1960, RG 2, box 19.

70. JCB notes on Clark comments, October 19, 1968, RG 2, box 19.

71. JCB to Clark, March 6, 1969, RG 2, box 19.

72. SDR to Leonard Miall, September 18, 1969, RG 2, box 19.

73. Miall to SDR, September 26, 1969, RG 2, box 19.

74. SDR to Clark, October 8, 1969, RG 2, box 19.

75. Ripley would attend the Gallery's October 27 showing, a glittering opening preceded by a dozen small dinner parties in different parts of the city. Gallery guests, who included Dean Acheson, John Nicholas Brown, and the British ambassador, entered through a new dark red awning "specifically chosen by Brown to reflect the pink in the exterior marble." Meryle Secrest and Sally Quinn, "British Films Cast Spell," *WP*, October 28, 1969, B1, B2.

76. See clipping from *Daily Telegraph*, October 17, 1969, RG 2, box 19.

77. Clark to JCB, October 15, 1969, RG 2, box 19.

78. JCB to David Finley, October 17, 1969, RG 2, box 19.

79. JCB to Clark, October 21, 1969, RG 2, box 19.

80. William Howard Adams memo, November 17, 1969, RG 2, box 19.

81. "Waiting in the Rain for 'Civilisation,'" *WP*, November 10, 1969, D10.

82. Sally Quinn, "Confused Afternoon,", *WP*, November 24, 1969, C1.

83. JCB to Clark, September 18, 1970, RG 2, box 19.

84. JCB to Clark, September 18, 1970, RG 2, box 19.

85. Toni House, "Gallery Goes Hip for 70s," *Washington Star*, June 29, 1970, Press Scrapbooks, vol. 123.

86. Kenneth Clark, *The Other Half: A Self Portrait* (New York: Harper & Row, 1977), 225.

87. Clark to JCB, December 23, 1970, RG 2, box 19.

88. Clark to JCB, December 8, 1970, RG 2, box 19.

89. Clark, *Other Half*, 225.

90. Roger Greenspun, "Screen: Story of Western Civilization," *NYT*, March 14, 1970, 22; William C. Woods, "'Civilisation' in 13 Easy Installments," *WP*, January 14, 1971, G1.

91. JCB to Clark, March 24, 1978, RG 2, box 19.

92. Henry Mitchell, "A Time for Ushering in the Modern," *WP*, October 27. 1973, B1.

93. Maxine Cheshire, New Faces . . . ," *WP*, November 14, 1972, C2.

94. John Dorsey, "Museum Director, a Man Born to the Job," *Sunday Sun*, June 28, 1970, Press Scrapbooks, vol. 125.

95. "Museum Director Who's Every Hostess's Dream," *NYT*, March 8, 1970, 78.

96. Ibid. This lengthy profile invoked JCB's mother, and allowed him to tell several stories, including his Institute of Fine Arts student triumph with an Indian textile.

97. "Washington's Young National Gallery Is Host to Centenarian Museums," *NYT*, November 30, 1970, 57. This event celebrated the centennials of the Met and Boston's Museum of Fine Art.

98. Paul Richard, "Corcoran Grant," *WP*, May 15, 1971, C1.

99. See JCB, tape transcript, January 15, 2002.

100. For coverage see *NYT*, June 18, 1971, 35.

101. Maxine Cheshire, "Public Eye on a Private Toast," *WP*, December 12, 1972, B2.

102. "Washington's Party," *WP*, January 9, 1973, Press Scrapbooks, vol. 159.

103. Louise Lague, "Brown's Bag," *Washington Star*, July 10, 1977, clipping in RU 613, box 420, Office of the Secretary, SI/SA.

104. Brown's separation and coming divorce from Connie Mellon was handled concisely, "Two Separations," *WP*, September 27, 1974, B2.

105. Noticed also in "Notes on People," *NYT*, September 24, 1976, 33.

Chapter 7

1. See Eugene L. Meyer, "Philadelphia: No Site for '76," *WP*, May 18, 1972, A22. Meyer reviewed the role of political interests in foiling Phladelphia's schemes.

2. For more on the bicentennial celebrations, see John Bodnar, *Remaking America: Public Memory, Commemoration, and Patriotism in the Twentieth Century* (Princeton, NJ: Princeton University Press, 1992), 226–44.

3. Although, in the various historical commentaries of the bicentennial, they get almost no mention.

4. Lyn Spillman, *Nation and Commemoration: Creating National Identities in the United States and Australia* (Cambridge: Cambridge University Press, 1997), 94–135, explores the bicentennial in a comparative framework.

5. Patrick Brogan, *Times* (London), June 26, 1976, Press Scrapbooks, vol. 184, NGA/GA.

6. "Talk of the Town," *New Yorker* 52 (June 21, 1976): 24–26.

7. Helen Dudman, "Eye of Jefferson Show Is Triumph for Former Missourian," *St. Louis Post-Dispatch*, June 6, 1976, Press Scrapbooks, vol. 184.

8. Grace Glueck, "Capital to Show Medici Venus," *NYT*, June 26, 1975, 82. See also *Chicago Daily News*, November 15, 1975, Press Scrapbooks, vol.184.

9. Joshua Taylor, director of the National Collection of Fine Arts, saw the show at the British Museum and found it smart, expensive, crowded, and "totally incomprehensible," less an exhibition than "a mass/class trade book with no sense whatever of the actuality of objects." Joshua Taylor to Charles Blitzer, October 28, 1975, Charles Blitzer Papers, Box 12, Record Unit 281, SI/SA,

10. Paul Richard, "The Eye of Jefferson: Blurred Vision?" *WP*, June 6, 1976, 153.

11. Benjamin Forgey, "A Nay for 'The Eye of Thomas Jefferson,'" *Washington Star*, August 1, 1976, Press Scrapbooks, vol. 184.

12. *Art Journal* (Fall 1976), Press Scrapbooks, vol. 184.

13. John Russell, "Jefferson a Winner at the National Gallery," *NYT*, June 5, 1976, 13.

14. Victoria Donohoe, *Philadelphia Inquirer*, June 13, 1976, Press Scrapbooks, vol. 184.

15. See the extensive comments on Ravenel, and JCB's relationship with him, in JCB, oral history interview, July 17, 1998.

16. For some unexpected appropriations of the exhibition, see Melani McAlister, "'The Common Heritage of Mankind': Race, Nation, and Masculinity in the King Tut Exhibit," *Representations* 54 (Spring 1996): 80–103.

17. A large literature exists on this subject. For a start, see Richard G. Carrott, *The Egyptian Revival: Its Sources, Monuments, and Meaning, 1808–1858* (Berkeley: University of California Press, 1978); Scott Trafton, *Egypt Land: Race and Nineteenth-Century American Egyptomania* (Durham, NC: Duke University Press, 2004); and Donald B. Kuspit, "Our Egypt," *Art in America* 67 (March/April 1979): 86–94.

18. For a summary, see Jeffrey Abt, *American Egyptologist: The Life of James Henry Breasted and the Creation of His Oriental Institute* (Chicago: University of Chicago Press, 2011), 303–17.

19. These details are culled from the many contemporary newspapers and magazine accounts of the Tut episode.

20. "Tut-ankh-Amen Treasure Shown," *NYT*, November 4, 1961, 21. This spelling of the king's name, an inheritance from the 1920s, would be changed for upcoming tours.

21. *New York Daily News*, November 17, 1961, Press Scrapbooks, vol. 74.

22. "Attendance Mark Is Set for Museum," *Chicago Tribune*, January 4, 1963, 13.

23. See Steven Rosen, "Third Tut's the Charm," http://www.lacitybeat.com/article.php?id=2427&IssueNum=114.

24. These figures and observations are based on the annual reports of the Metropolitan Museum of Art for this period.

25. For more on Silver, see James Feron, "Tut Show's Creator Leaving Met for New Wonders," *NYT*, December 24, 1978, WC2.

26. See Thomas Hoving, *Making the Mummies Dance: Inside the Metropolitan Museum of Art* (New York: Simon & Schuster, 1993), 55–57, for recollections of Silver. Other passages in the book detail the string of exhibitions he designed. See also Leah Gordon, "Boomer of the Arts," *NYT*, Nov. 30, 1975, 257.

27. Hilton Kramer, "Great Art Works in a Hi-Fi Setting," *NYT*, November 13, 1970, 23.

28. "The Metropolitan Extends Hours," *NYT*, October 9, 1968, 37.

29. JCB said of Hoving, "He was the son of the person who created the sucess Tiffany's was and had a falling-out with his father, and I think really wanted to prove for all time that he was as good at business as at art history. He'd call me up when the Tut show was on at the end of the day to ask what the cash register ticket tapes were." JCB, oral history interview, July 17, 1998, NGA/GA.

30. Milton Esterow, "Gift of Egyptian Temple Posing Problems," *NYT*, January 26, 1966, 58.

31. Ibid.

32. John A. Wilson, "Temple Acquisition" (letter to the editor), *NYT*, February 8, 1966, 38

33. Milton Esterow, "An Egyptian Temple Stirs a U.S. Tempest," *NYT*, September 23, 1966, p. 2.

34. Hoving, *Making the Mummies Dance*, 58–63. Hoving, capitalizing on the tour, had published *Tutankhamun: The Untold Story* (New York: Simon & Schuster, 1978), which would be condensed into a *Reader's Digest* volume the following year.

35. McCandlish Phillips, "Egyptian Temple is Delivered Here," *NYT*, August 22, 1968, 22. There were, to be sure, tart exchanges between Hoving and irritated longshoremen, who raised various objections both to the ceremony and the cost.

36. Hoving, *Making the Mummies Dance*, 402. For Hoving's description of the Tut negotiations, see 401–14.

37. For this, and the next few comments about Brown and the National Gallery of Art, see Hoving, *Making the Mummies Dance*, 346–48.

38. Linda Charlton, "Treasures of Tutankhamen," *NYT*, October 29, 1975, 42.

39. Paul Richard, "An American Tour for King Tut's Treasures," *WP*, October 29, 1975, B11.

40. Charlton, "Treasures of Tutankhamen."

41. Benjamin Forgey, "A Golden Visitor," *Washington Star*, September 9, 1976, Press Scrapbooks, vol. 184.

42. Margaret Mason, "The Mystique of Merchandise as Star," *WP*, September 7, 1976, B1, B3. For the store's opening, see Marian Burros, "Profiles in Chic," *WP*, September 7, 1976, B3.

43. Grace Glueck, "Met Guarantees Egypt $2.6 Million," *NYT*, September 28, 1976, 45.

44. Grace Glueck, "Egyptian Art Glitters in Capital," *NYT*, September 9, 1976, 49; Judith Martin, "A Pharaoh's Treasure," *WP*, September 9, 1976, E5.

45. Ibid.

46. Grace Glueck, "Are Art Exchanges a Game of Propaganda?" *NYT*, September 26, 1976, D1.

47. For example, see Peter Coleman, *The Liberal Conspiracy: The Congress for Cultural Freedom and the Struggle for the Mind of Postwar Europe* (New York: Free Press, 1989). Frances Stonor Saunders, *The Cultural Cold War: The CIA and the World of Arts and Letters* (New York: New Press, 2000), provides, in addition to her own argument, an extensive bibliography that includes these sources.

48. Glueck, "Are Art Exchanges a Game?"

49. Philip M. Kadis, "The Competition Is Keen," *Washington Star*, November 28, 1976, A1, A8, Press Scrapbooks, vol. 99.

50. Ibid.

51. Michael Kernan, "Lord Carnarvon, A Vestige of Empire," *WP*, November 13, 1976, B1.

52. Joy Billington, "Scoop! The Next Big Trend," *Washington Star*, November 16, 1976, Press Scrapbooks, vol. 184.

53. *National Geographic*, 151 (March 1977), actually ran two articles, one on ancient and one on modern Egypt. Press Scrapbooks, vol. 196, NGA/GA.

54. John Sherwood, "Toasting King Tut," *Washington Star*, November 16, 1976, Press Scrapbooks, vol. 184.

55. Hilton Kramer, "Hailing the Romantic Treasures of Tutankhamen," *NYT*, November 16, 1976, 41.

56. Sherwood, "Toasting King Tut."

57. Paul Richard, "Thrilling Installment In the King Tut Story," *WP*, November 16, 1976, C1, C3.

58. C. Douglas Lewis Jr., oral history interview, March 24, 2004.

59. Feron, "Tut Show's Creator," *NYT*, WC2.

60. *Reston Times*, December 2, 1976, Press Scrapbooks, vol. 196.

61. William Gilden, "Tickets for Tut Dropped," *WP*, December 23, 1976, C1.

62. Juan Williams, "Crowds Wait For Hours," *WP*, December 29, 1976, C1, C10.

63. Douglas Crooks, "Land of Nile Floods U.S.," Medill News Service, *Uptown News*, February 1, 1977, Press Scrapbooks, vol. 197.

64. Virginia Tanzer, *Delmarva News*, Feburary 3, 1977, Press Scrapbooks, vol. 197.

65. George Herbert, "King Tut's Appeal," *Norfolk Ledger-Star*, February 2, 1977, Press Scrapbooks, vol. 197.

66. F. D. Cossitt, "King Tut Lines Still Hours Long," *Virginia Pilot*, February 13, 1977, Press Scrapbooks, vol. 198.

67. "Banishing the Press," *NYT*, March 13, 1977, 26.

68. *Washington Star*, March 22, 1977, Press Scrapbooks, vol. 199.

69. Marlene Cimons, "Treasures of Tut Captivate the Capital," *Los Angeles Times*, February 14, 1977, D1.

70. "King Tut Exhibit Keeps the National Gallery Lively," *Newark Star-Ledger*, March 7, 1977, Press Scrapbooks, vol. 199.

71. Ruth Dean, "Our Primer on Your Prospects at 'Tut,'" *Washington Star*, March 3, 1977, Press Scrapbooks, vol. 198. Dean's article provided a graphic account of the hazards and challenges of waiting in line.

72. JW to Bernard Berenson, April 23, 1948, JW Personal Correspondence, NGA GA.

73. Eric Wentworth, "The Long, Slow Line," *WP*, March 8, 1977, C1.

74. Dorothy Kantner, "King Tut's Curse Still Works," *Somerset American*, March 7, 1977, Press Scrapbooks, vol. 198.

75. Juan Williams and Jean M. White, "Waiting For King Tut," *WP*, March 16, 1977, B1.

76. Paul Richard, ". . . Coping With the Crowds: Waiting for King Tut," *WP*, March 16, 1977, B1.

77. Eric Pace, "Tut Tickets Advertised By Scalpers," *NYT*, December 13, 1978, C23; Dale Fetherling, "Bill Takes Aim at Ticket Scalping,"*Los Angeles Times*, June 26, 1978, B3, 25.

78. Grace Glueck, "The Tut Show Gives a Midas Touch," *NYT*, December 24, 1978, 23.

79. "King Tut Tours are Big Sellout," *Chicago Tribune*, August 23, 1977, B10.

80. Glueck, "Tut Show."

81. Seattle Museum director Willis Woods claimed his institution had spent more on housing the Tut show, rebuilding an entire pavilion, than any other museum. "Seattle Welcomes Visit of Boy King," *Spokane Daily Chronicle*, July 13, 1978, Press Scrapbooks, vol. 235.

82. Daniel Heninger, "Leisure and the Arts: Tutankhamun's Treasures Challenge the Present," *Wall Street Journal*, November 17, 1978, 25.

83. Dave Smith, "On Sale Now," *Los Angeles Times*, January 3, 1978, B1.

84. "King Tut Tickets Nearly Sold Out," *Los Angeles Times*, January 7, 1978, B5.

85. Maryanne Conheim, "The Lines, Always the Lines," *Philadelphia Inquirer*, December 19, 1978, Press Scrapbooks, vol. 227.

86. Glueck, "Tut Show."

87. See, for example, Barbara Ettorre, "From Tut's Tomb, a Lively Fad," *NYT*, December 6, 1978, D1; Marilyn Chase, "Museum Show Inspires Tutmania," *NYT*, March 8, 1978, C1, C9; Peter Gorner, "King Tut Proves a Gold Mine to Curious, Curators," *Chicago Tribune*, December 21, 1976, A1; Elizabeth Stevens, "The Selling of King Tut," *Baltimore Sun*, December 31, 1978, Press Scrapbooks, vol. 227; "Tutglut," *Time*, 112 (December 11, 1978), 79.

88. See "Tutmania Finds Relief in a Spate of Books," *Publishers Weekly* 214 (November 20, 1978): 41–50.

89. "Would you like your family to be buried in a mausoleum?" Trinity Church Cemetery asked, pointing out that planning ahead "was one of the hallmarks of the kings of Egypt." *NYT*, January 30, 1979, A13.

90. Hilton Kramer, "Tutankhamen Show in New York at Last," *NYT*, December 20, 1978, C17.

91. JCB to Harry Parker, June 4, 1980, RG 2, box 26. The long letter to Parker, written for a session of the American Art Museum Directors meeting in Toledo that JCB could not attend, was a defense of corporate patronage and business support.

92. Richard Ryan, "1492 and All That," *Commentary* 93 (May 1992): 41.

93. See the survey of excesses in *Winnipeg Free Press*, December 30, 1978, Press Scrapbooks, vol. 119.

94. Kramer, "Tutankhamen Show."

95. See, for example, Roger Ricklefs, "Ancient Art: Museums Merchandise More Shows and Wares," *Wall Street Journal*, August 14, 1975, 1.

96. Grace Glueck, "Moving in on the Met," *NYT Magazine*, February 27, 1977, 185.

Chapter 8

1. "Capital Comment," *Washingtonian*, December 1967, Press Scrapbooks, vol. 107, NGA/GA.

2. C. Douglas Lewis Jr., oral history interview, February 12, 2004, NGA/GA.

3. JCB taped transcript, January 16, 2002, JHL/BU. JW felt, JCB added, that labels could be changed at some future point. NGA had "nothing more than a summary catalog because they didn't really want to unleash all the department of truth and get into this."

4. Lewis, oral history interview.

5. Paul Richard, "The Figure behind the National Gallery," *WP*, August 16, 1970, E1, E2. This was an extensive profile. Richard commented on revised attributions for American artworks in "Changing Artists," *WP*, June 25, 1970, C1, C5, and several years later, quoted Brown in another article on the Metropolitan Museum's reattributions, "Old Masters That Aren't," *WP*, January 20, 1973, C2.

6. For more, see Paul Richard, "The National Gallery of Art Reconsiders," *WP*, March 13, 1973, B1, B2.

7. Ibid. Richard had been invited to NGA to examine its records on the paintings, an unprecedented step.

8. Paul Richard, "The Mystery of the Two Vermeers," *WP*, February 12, 1970, B1.

9. Ibid.

10. Journalists wrote a series of amused (and amusing) responses to reattributions, wondering why a picture, physically unchanged, might be more or less interesting because its authorship had changed. See John McKelway, "The Rambler," *Washington Star*, March 14, 1973, Press Scrapbooks, vol. 157.

11. Alexis E. Lachman, letter to the editor, *WP*, March 22, 1973, A27.

12. *Akron Beacon-Journal*, March 15, 1973, Press Scrapbooks, vol. 157.

13. "Art with Alexander Fried," *San Francisco Examiner & Chronicle*, March 25, 1973, Press Scrapbooks, vol. 157.

14. See also David L. Shirey, "National Gallery Relabels Some Art," *NYT*, March 13, 1973, 86.

15. Albert E. Elsen, "B. Gerald Cantor and the Stanford Rodin Collection," in *Rodin's Art* (New York: Oxford University Press, 2003), 10.

16. See chapter 6, note 54.

17. JCB to Anna Somers Cocks, May 5, 1989, RG 2, box 9, Records of the Office of the Director. "Louis XIV Did Not Sleep Here" (editorial), *Apollo* 129 (April 1989): 230–31, claimed that at NGA scholarly values were put "at the bottom of the ladder."

18. Meryle Secrest, "Light Is Dimming the National Gallery," *WP*, July 10, 1969, K2.

19. See, for example, the JCB memo, September 17, 1975, on the lighting of the Gulbenkian Foundation museum, RG 2, box 79, NGA/GA.

20. See David Bomford and Mark Leonard, eds., *Readings in Conservation: Issues in the Conservation of Paintings* (Los Angeles: Getty Conservation Institute, 2004).

21. The history of art conservation efforts is described in Francesca G. Bewer, *A Laboratory for Art: Harvard's Fogg Museum and the Emergence of Conservation in America, 1900–1950* (Cambridge, MA: Harvard Art Museums, 2010).

22. For a brief summary, see Jonathan Conlin, *The Nation's Mantelpiece: A History of the National Gallery* (London: Pallas Athene, 2006), 179–82.

23. *An Exhibition of Cleaned Pictures, 1936–1947* (London: National Gallery, 1947).

24. Hendy's introduction has been reprinted as Reading 64 in Bomford and Leonard, *Readings in Conservation*, 498–506. The quotations in this and the next paragraph are taken from these pages. In this same anthology, see also Sheldon Keck, "Some Picture Cleaning Controversies: Past and Present," Reading 57, 426–40, and Jaynie Anderson, "The First Cleaning Controversy at the National Gallery, 1846–1853," Reading 58, 441–53.

25. See Charles Parkhurst, oral history interview, November 10, 1988, for his recruitment of the conservation team.

26. Ibid.

27. Buck had earlier (in 1949) been involved in a conservation controversy at London's National Gallery. See Conlin, *Nation's Mantelpiece*, 182.

28. Report by Geoffrey Agnew, May 5, 1978, RG 3, box 1, Records of the Office of the Assistant Director.

29. For more on Brealey, see the summary by Calvin Tomkins, "Profiles: Colored Muds in a Sticky Substance," *New Yorker* 63 (March 16, 1987): 44–70. Tompkins refers briefly (p. 62) to the NGA moratorium, discussed later in this chapter.

30. Sylvia Hochfield, "Conservation: The Need Is Urgent," *Art News* (February 1976), 26–33.

31. Leon Harris, "The Whitecoats Are Coming!" *Town & Country*, November 1976, Press Scrapbooks, vol. 229.

32. See Mark Aronson, "The Conservation History of the Early Italian Collection at Yale," in *Early Italian Paintings: Approaches to Conservation. Proceedings of a Symposium at the Yale University Art Gallery*, edited by Patricia Sherwin Garland (New Haven, CT: Yale University Art Gallery, 2003), 30–53. This symposium explored the history of restoration approaches at a series of institutions.

33. See Patricia Sherwin Garland, "Recent Solutions to Problems Presented by the Yale Collection," in *Early Italian Paintings*, 54–70.

34. See John Brealey, "Who Needs a Conservator?" in Bomford and Leonard, *Readings in Conservation*, Reading 27, 118–23. This essay was originally published in 1983 in *Training in Conservation*, a symposium.

35. Diane Dwyer Modestini, "John Brealey and the Cleaning of Paintings," in *Essays in Memory of John M. Brealey, Metropolitan Museum Journal* 40 (2005): 32. See also, in this same issue, M. Kirby Talley Jr., "An Old Fiddle on a Green Lawn: The Perverse Infatuation with Dirty Pictures," 37–50.

36. Paul Richard, "The Mystery of 'The Mill,'" *WP*, September 16, 1977, B1, B3.

37. "H. C. Frick May Buy Rembrandt's 'Mill,'" *NYT*, March 5, 1911, C2, erroneously reported that Frick, not Widener, was the buyer, but did represent British consternation at the painting's leaving for America. For the Widener purchase, see "'Mill' For Widener Home," *NYT*, April 8, 1911, 13.

38. As quoted by Arthur K. Wheelock Jr., "The Art Historian in the Laboratory: Examinations into the History, Preservation, and Techniques of 17th Century Dutch Painting," Roland E. Fleischer et al, *The Age of Rembrandt: Studies in Seventeenth-Century Dutch Painting* (University Park: Pennsylvania State University Press, 1988), 217.

39. Richard, "Mystery of 'The Mill,'" B3.

40. PM (with John Baskett), *Reflections in a Silver Spoon: A Memoir* (William Morrow, 1992), 311.

41. PM to JCB, October 13, 1977, RG 2, box 7. Marked confidential, the letter revealed PM's anger, as well as his shrewd assessment of some of those making charges. It also reflected his unhappiness with recent Gallery reframings of pictures given by himself and Averell Harriman, problems which went back earlier in the year.

42. PM to Jaffé, March 27, 1978, RG 3, box 1, Records of the Office of the Assistant Director. Unless otherwise indicated, the remaining archival materials in this chapter are from this box, or from RG 2, box 43, Records of the Office of the Director, Subject Files, Conservation. RG 2 or RG 3 will be used to indicate the source.

43. Joyce Hill Stoner, oral history interview, July 7, 1995.

44. Parkhurst, oral history interview, November 10, 1988.

45. This was how Agnew began his report, dated May 3, 1978, RG 3. The quotations following are taken from the report.

46. Jaffé's report is dated May 9, 1978, RG 3. The quotations that follow are taken from that report.

47. Memo from Leisher to Parkhurst, July 27, 1978, RG 3.

48. The Modestini report was dated May 29. 1978, RG 3.

49. Parkhurst memo to JCB, May 26, 1978, RG 3.

50. Leisher's memo was dated May 9; Silberfeld's, the most detailed, May 3; and Wheelock's, the briefest, May 8.

51. Parkhurst to JCB, May 26, 1978, RG 3.

52. Memo from JCB to Parkhurst, May 22, 1978, RG 3.

53. Kay Silberfeld, oral history interview, May 27, 1992.

54. Memo from Covey to Parkhurst, July 28, 1978, RG 3.

55. Lewis to Arthur Beale, July 25, 1978, RG 3.

56. This typed memo is dated May 30, 1978, RG 3.

57. Mary M. Davis to JCB, September 20, 1973, RG 2, box 62.

58. Parkhurst memo, June 29, 1978, RG 2, box 43.

59. Benjamin Forgey, *Washington Star*, July 9, 1978, Press Scrapbooks, vol. 231.

60. JCB memo, July 10, 1978, RG 2.

61. JCB memo July 10, 1978, RG 2.

62. Jo Ann Lewis, "The Restoration Conflict at the National Gallery of Art," *WP*, July 14, 1978, B2.

63. Clements L. Robertson to JCB, July 18, 1978, RG 2.

64. Lewis, "Restoration Conflict," B2.

65. PM to Modestini, June 24, 1978, RG 2.

66. Chronology and "National Gallery of Art's Painting Conservation Department. Relevant Events," dated June 14 [1978], RG3.

67. All of these can be found in RG 3, box 1.

68. Judy Walsh to Parkhurst, July 26, 1978, RG 3.

69. Keck to Silberfeld and Covey, July 20, 1978, RG 2.

70. PM to Sheldon Keck, July 28, 1978, RG 2. PM must have gotten hold of a copy of the letter.

71. Keck to PM, August 1, 1978, RG 2.

72. Memo signed by Covey, Honigswald, Leisher, and Silberfeld, all conservators, to Parkhurst, July 26, 1978, RG 2.

73. Draft of letter from Covey to Viscount Dunluce, July 19, 1978, RG 3.

74. This can be found in RG 3, box 1.

75. Parkhurst to PM, June 28, 1978, RG 3.

76. See memo from Parkhurst to JCB, July 21, 1978, RG 2. JCB quickly wrote Yates and enclosed a copy of Sylvia Hochfield's *Art News* article of February 1976.

77. Parkhurst to JCB, July 5, 1978, RG 3.

78. Parkhurst memo to file, July 11, 1978, RG 3.

79. JCB memo, August 14, 1978, RG 2.

80. Kay Silberfeld, memo entitled "Talk," August 28, 1978, RG 2.

81. PM, *Reflections*, 313.

82. Most of the reports can be found in RG 2, box 43. However, the reports by Sheldon Keck and Sherman Lee are to be found in the Records of the Office of the Assistant Director, RG 3, box 1. This is also where the three earlier reports by Agnew, Jaffé, and Modestini are located.

83. Joseph Alsop to JCB, July 11, 1978, and Egbert Havekamp-Begemann to Parkhurst, July 29, 1978, both RG 2.

84. Seymour Slive to Parkhurst, July 24, 1978, RG 2. Quoting Kenneth Clark's statement, that "cleaning is a battle won," Slive reflected on "how much blood would be let over the issue," just months after Clark's comment had been published.

85. Gertrude Rosenthal letter, July 29, 1978, RG 2.

86. Parkhurst to JCB, September 15, 1978, RG 2.

87. The checked paper scorecard can be found in a folder labeled DCL Panel Reports, September 1978, RG 3, box 1.

88. Freedberg to JCB, October 28, 1978, RG 2.

89. JCB to Freedberg, November 6, 1978, RG 2.

90. Board statement of October 20, 1978, RG 2.

91. PM, *Reflections*, 313.

92. Koppelman to PM, November 30, 1978, RG 2.

93. Kay Silberfeld to JCB (via Charles Parkhurst), May 31, 1979, RG 2.

94. Davis to JCB, March 4, 1980, RG 2, box 62. Davis corresponded extensively over the years with JW, JCB, and Charles Parkhurst, and relations between the Kress Foundation and NGA seriously deteriorated in the 1970s.

95. Modestini to JCB, April 16, 1979, RG 3.

96. JCB to Modestini, July 27, 1979, RG 3.

97. Mario Modestini, oral history interview, November 5, 1993.

98. As quoted in Benjamin Forgey, "National Gallery Conservationists Cleared," *Washington Star*, October 21, 1978, Press Scrapbooks, vol. 230.

99. Paul Richard, "Gallery Cease-Fire: Staff Wins Conservation War," *WP*, October 21, 1978, F1, F6.

100. Memo from Dr. Weber, chief conservator in Dresden, October 2, 1978, RG 2. Weber was visiting the Met in New York when he dictated the memo.

101. Cynthia Saltzman, "In Preserving Art, Big Museums Seek Unvarnished Truth," *Wall Street Journal*, February 4, 1982, 1, 18.

102. JCB note for file, December 31, 1970, RG 2, box 7.

Chapter 9

1. See Anthony Alofsin, "The Opening of the East Building: Acclaim and Critique," in *A Modernist Museum in Perspective: The East Building, National Gallery of Art*, edited by Alofsin (Washington, DC: National Gallery of Art, 2009), 47–63.

2. Grace Glueck, "Capital Gallery Shows Plan for Wing," *NYT*, May 6, 1971, 52. At the time, the cost of the project was still projected to be forty-five million dollars.

3. Frank Getlein, "An Historic Turn in the History of Art Museums," *Sunday Star*, May 9, 1971, Press Scrapbooks, vol. 259, NGA/GA.

4. Benjamin Forgey, "A New Kind of Building for D.C.," *Washington Star*, May 5, 1971, Press Scrapbooks, vol. 259.

5. "Mellons, Money, and a National Gallery," *Washington Star*, December 24, 1976, Press Scrapbooks, vol. 259.

6. Ada Louise Huxtable, "A Spectacular Museum Goes Up in Washington," *NYT*, May 22, 1977, 61.

7. Huxtable, "A Capital Art Palace," *NYT*, May 7, 1978, SM 15 et seq.

8. *Department of the Interior and Related Agencies Appropriations for Fiscal Year 1977: Hearings before a Subcommittee of the Committee on Appropriations, United States Senate*, 94th Congress, Second Session, 1122–23.

9. Hilton Kramer, "Going Beyond the 'Edifice Complex,'" *NYT Magazine*, May 7, 1978, SM16.

10. "Washington Diarist," *New Republic* 178 (February 18, 1978): 145, Press Scrapbooks, vol. 244.

11. "Washington Diarist," *New Republic* 178 (May 27, 1978): 38, Press Scrapbooks, vol. 244.

12. JCB to Katherine Warwick, note attached to clipping from *NYT*, June 2, 1978, Press Scrapbooks, vol. 243.

13. Mark Jenkins, "Much Ado about Collecting," *Washington Tribune*, July 15, 1978, Press Scrapbooks, vol. 243. JCB's note is on a "buck sheet" attached to the clipping.

14. Paul Richard, "Monumental Modern," *WP*. May 21, 1978, G1

15. Richard Roud, "The Artist Who Fell Off His Trapezoid," *Guardian*, November 19, 1978, Press Scrapbooks, vol. 234. Roud also disliked both the recently built Beaubourg in Paris and Mies van der Rohe's Museum of Modern Art in Berlin. Quite a few reviewers treated these three museums together.

16. Clair B. Marcus, letter to the editor, *WP*, March 27, 1979, A18.

17. Quoted in Alofsin, "Opening of the East Building," 50.

18. Ibid. Two pages later, however, Alofsin quotes Pei biographer Carter Wiseman, who suggested that some architectural critics were negative because they "resented the building's success wtih the public."

19. Christian Otto, "Washington—A New Centre for the Arts?" *Connoisseur* (August 1978), 325. Elsewhere in his review, Otto was distinctly critical of Pei's larger concept, contrasting it with Louis Kahn's Kimbell Museum in Fort Worth, Texas, to Kahn's advantage. JCB scribbled in an attached buck slip to Katherine Warwick that it was "the only negative I've seen," and "reliably off the mark on virtually every point." See Press Scrapbooks, vol. 243. See also chapter 5, note 61.

20. *New Yorker*, 55 (May 12, 1979), 33–34.

21. Thomas Hine, *Philadelphia Inquirer*, May 28, 1978, Press Scrapbooks, vol. 241.

22. Harriet Senie, *New York Post*, October 29, 1978, Press Scrapbooks, vol. 227.

23. Grace Glueck, "Metropolitan and Other Museums Fume at 'Washington-First' Policy," *NYT*, July 3, 1978, 25.

24. Grace Glueck, "Moving In on the Met," *NYT*, February 27, 1977, 183.

25. Paula Spann, "Thomas Hoving's Artful Revenge," *WP*, September 17, 1986, B1. Spann was reviewing Hoving's novel *Masterpiece*.

26. Glueck, "Metropolitan and Other Museums," 25.

27. JCB, oral history interview, July 17, 1988.

28. PM to Douglas Dillon, September 3, 1976; Dillon to PM, September 15, 1976, both in RG 2, box 7.

29. JCB, oral history interview, July 17, 1988.

30. Paul Richard, "An Elegant Crate Show of Dresden Treasures," *WP*, May 3, 1978, D11.

31. "The Splendor of Dresden," *WP Sunday Magazine*, SM36. This lavishly illustrated multipage article typified the extended attention *WP* gave to major NGA exhibitions.

32. Ibid.

33. Hilton Kramer, "'Blockbuster' Art at National Gallery," *NYT*, May 30, 1978, C1.

34. Paul Richard, "Porcelains, Gems and Guns in a Cabinet of Wonders," *WP*, June 4, 1978, H1.

35. NGA press release, March 31, 1978, Press Releases, NGA/GA.

36. Carol Fox, oral history interview, March 12, 1993.

37. Donnie Radcliffe and Joseph McLellan, "Black-Tie and Swords," *WP*, June 1, 1978, B1, B3.

38. Nina S. Hyde, "Fashion Notes," *WP*, June 4, 1978, M13.

39. John J. O'Connor, "Priceless Treasures of Dresden," *NYT*, June 27, 1978, C16.

40. Hilton Kramer, "Has Success Spoiled American Museums?" *NYT*, January 14, 1979, D1.

41. NGA press release, October 27, 1972.

42. JCB to PM, August 8, 1979, RG 2, box 7. Almost ten years earlier, JCB had sent PM a memo describing his conversation with the Tremaines' lawyer, Ralph Colin, about their collection. See JCB memo, February 10, 1970, and JCB to PM, February 13, 1970, also in RG 2, box 7. The Tremaines donated more than a hundred works. But Emily Tremaine changed her will and sold the remainder of the collection, the proceeds going to the Emily Hall Tremaine Foundation. See JCB notes for tape transcript and Kathleen L. Housley, *Emily Hall Tremaine: Collector on the Cusp* (n.p.: Emily Hall Tremaine Foundation, 2003), 195–99. Hoving referred to the Tremaines as "will danglers."

43. Paul Richard, "Moving into the 20th Century," *WP*, September 1, 1974, Press Scrapbooks, vol. 230.

44. The letter exchange, with the JCB letter dated July 7. 1978, can be found in Press Scrapbooks, vol. 241.

45. Paul Richard, "Seven Abstract American Heroes," *WP*, June 11, 1978, K1-K2, was one of the favorable reviews.

46. Donnie Ratcliffe, "Praise and Pride at a Preview Dinner," *WP*, November 10, 1978, E3. The dinner was held in the yet to be open study center. "It could very well be the only time dinner will be served in this space," JCB told the guests.

47. Paul Richard, "Munch Exhibit for the National Gallery," *WP*, May 17, 1978, B5.

48. Alan M. Kriegsman, "'Summernight,'" *WP*, November 11, 1978, F2.

49. Radcliffe, "Praise and Pride."

50. "Gilding the Museums," *NYT*, n.d. (late September 1978). Because of a newspaper strike the editorial was never printed in the *NYT*, but it was printed in a number of other newspapers like the *Lexington Dispatch*, September 23, 1978; the *Modesto Bee*, October 5, 1978; and the *Columbus Republic*, October 3, 1978. All in Press Scrapbooks, vol. 230.

51. Manuela Hoelterhoff, "The Fine Art of Packaging Big Art Shows," *Wall Street Journal*, May 26, 1978, 15.

52. Joseph McLellan, "The Modern Medicis," *WP*, July 22, 1979, L1, L3.

53. Hilton Kramer, "Grappling With the Mysteries of Taste," *NYT*, February 11, 1979, D29.

54. NGA Press Release, July 25, 1978.

55. William Gildea, "Science Shows Plug Away: Museums Criticized For 'Corporate Bias,'" *WP*, July 7, 1979, B1, B4.

56. George F. Will, "Art Incorporated," *WP*, November 30, 1979, A15.

57. Robert Taylor, "Curators Cringe at 'Alexander' Tactics," *Boston Globe*, July 21, 1979, 15.

58. Grace Glueck, "2 Companies to Run Art Shows," *NYT*, July 19, 1979, C15.

59. McLellan, "The Modern Medicis."

60. Some of the show's history is described by Glueck, "2 Companies to Run Art Shows." See also Maryanne Conheim, "Putting Art Appreciation on Bottom Line," *Philadelphia Inquirer*, September 9, 1979, Press Scrapbooks, vol. 254. This volume of clippings has many strong warnings about corporate control and support of major art exhibitions.

61. See Michael Brenson, "'Alexander,' Show of Hellenistic Art," *NYT*, October 27, 1982, C19.

62. Quoted by Taylor, "Curators Cringe." Calling this "Tut II," Taylor argued that the "mass audience is all but computed, sealed and delivered."

63. Conheim, "Putting Art Appreciation on Bottom Line."

64. Ibid.

65. Both quoted ibid.

66. Glueck, "2 Companies to Run Art Shows."

67. JCB to Harry Parker, June 4, 1980, RG 2, box 26.

68. Author's interview with Charles Stuckey, August 30, 2007; author's interview with David Bull, November 14, 2012.

69. Ibid. Hammer accompanied the NGA art being sent to the Russians with a large number of his own paintings and drawings.

70. JCB to Parker, June 4, 1980. RG 2, box 26.

71. The correspondence can be found in RG 2, box 36.

72. Hilton Kramer, "When the Size of a Show Overwhelms Its Content," *NYT*, December 7, 1980, D1, 35.

73. Hilton Kramer, "Alexander Days in Washington," *NYT*, November 14, 1980, C19.

74. Kramer, "When the Size of a Show," 35.

75. Paul Richard, "Searching for Alexander the Great," *WP*, November 16, 1980, M1.

76. Benjamin Forgey, "Glorious Glimpses of Great Alexander," *Washington Star*, November 18, 1980, Press Scrapbooks, vol. 256.

77. Deborah Trustman, "Museums and Hype: The Alexander Show," *Atlantic* 246 (December 1980): 71–79.

78. Elizabeth Becker, "New World Awaits Alexander's Conquest," *WP*, September 7, 1980, G1, G5.

79. "Treadmill to Celebrity," *New Orleans Times-Picayune*, November 24, 1980, Press Scrapbooks, vol. 256.

80. Malcolm N. Carter, "Museum Wars," *Saturday Review* 7 (August 1980): 29–32.

81. *Chicago Sun-Times*, May 17, 1981, Press Scrapbooks, vol. 257.

82. Janet Kutner, "El Greco Exhibition Paints Pretty Picture for Dallas Museum of Fine Arts," *Dallas Morning News*, February 12, 1981, Press Scrapbooks, vol. 258.

83. Joseph Espo, "Washington's Losing Its Image"; the story appeared, on various dates in April 1979, in newspapers like the *Providence Journal*, *Pittsburgh Press*, and *Baltimore News-American*. Press Scrapbooks, vol. 252.

84. Peter Andrews, "The Making of a Blockbuster Exhibit," *Saturday Review* (August 1981), 19–21.

85. The closing date of the exhibition was extended from January to April 11, 1982, giving it a run of almost ten months. Long lines were avoided, NGA spokesmen said, because the spaces used in the East Building were so large.

86. Albert Elsen to Parkhurst, August 13, 1981, RG 2, box 81.

87. Ada Louise Huxtable, "The Legacy of Museum Design of the 1960's." *NYT*, November 29, 1981, D26. Huxtable now qualified her earlier praise of the East Building, pronouncing it an "uneasy draw" dependent on the nature and scale of specific displays, and noting that the plunge from the "small spiral stairs to Rodin's monumental 'Gates of Hell'" was "an architectural absurdity."

88. Hilton Kramer, "The Public and Private Rodin," *NYT*, July 5, 1981, D19. Kramer's

review centered on Rodin rather than the installation as such. It stimulated an angry comment from Elsen in his letter to Parkhurst (see note 86). Elsen also wrote letters to the *NYT* (July 26, 1981, D27) and to JCB (August 13, 1981), the latter, which JCB forwarded on to Pei, excoriating Kramer; RG 2, box 80. See also Manuela Hoelter-hoff, "Auguste Rodin's Sculptures," *Wall Street Journal*, September 11, 1981, 31; Robert Hughes, "The Old Man and the Clay," *Time* 118 (July 6, 1981): 72–73.

89. Peter Andrews, "The Making of a Blockbuster Exhibit," 19–21. Andrews pointed out that JCB first suggested a Rodin show in 1969.

90. JCB, oral history interview, February 7, 1994.

91. Ibid. In 1976 the Fourth Street entrance lobby had been remodeled, in time for the King Tut exhibition.

92. David W. Scott, oral history interview, August 26, 1993.

93. PM (with John Baskett), *Reflections in a Silver Spoon: A Memoir* (William Morrow, 1992), 320.

94. JCB, oral history interview, February 7, 1994.

95. Benjamin Forgey, "The Glorious New Space at the National Gallery," *WP*, February 3, 1983, D1.

96. Author's interview with Andrew Robison, October 19, 2007.

Chapter 10

1. SDR to Mrs. Karen Johnson Keland, October 8, 1976, RU 2, box 364, Office of the Secretary, SI/SA.

2. SDR, thirty-fourth interview, July 7, 1988.

3. SDR to Marshall Fishwick, January 16, 1968, RU 2, box 110.

4. Ibid.

5. SDR to Mrs. Jackson Burke, December 16, 1965, box 6, SDR Papers, SI/SA.

6. Memo from SDR to Dr. Stern, August 28, 1975, SDR Papers.

7. Edward K. Thompson to SDR, January 2, 1976, RU 613, box 365.

8. Mary Burke to Stern, October 19, 1976, RU 613, box 365. She enclosed a copy of this letter in a note she wrote SDR on the same day.

9. Richard Gagne, "Ralph Rinzler, Folklorist," *Folklore Forum*, 1 (1996),

10. SDR to President Johnson, March 1, 1965, RG 2, box 11, Director's Transitional Files, NGA/GA. This box contains a variety of materials relating to SI.

11. Betty James, "Kennedy Center Outlook Called 'Lifeless' by Ripley," *Washington Star*, undated. The clipping quotes a letter sent by SDR to Roger Stevens, a friend and director of the Kennedy Center. RG2, Box 11, Director's Transitional Subject Files.

12. SDR, Introduction, Paul H. Oehser, ed., *Knowledge among Men: Eleven Essays on Science, Culture, and Society Commemorating the 200th Anniversary of the Birth of James Smithson* (New York: Simon & Schuster, 1965), 11.

13. The author served on the Smithsonian Council from 1978 to 1991.

14. Paul Richard, "Archives for Art," *WP*, May 5, 1970, D1.

15. See JCB memo, April 19, 1967, RG 2, box 38.

16. RU 613, Box 425, Office of the Secretary, is filled with letters to and from SDR about possible sites for the Wilson Center.

17. The history of this undertaking is described in the Charles Blitzer interview, August 20, 1985, SI/SA.

18. SDR, thirty-fourth interview, July 7, 1988, reviewed the history of the Wilson Center and his ideas about it.

19. Wolf Von Eckardt, "Rusk Favors Study Center," *WP*, March 11, 1966, B2.

20. Wolf Von Eckardt, "Market Square Needs Throb for Its Heart," *WP*, March 21, 1966, B1.

21. Nixon's April 28, 1969, address was an important one, endorsing, aside from the Woodrow Wilson memorial, voting representation in Congress for residents of the District, added authority for its mayor and city council, and passage of a bill to create the rapid rail system that would eventually become Washington Metro.

22. Wolf Von Eckardt, "Nixon Backs 'Grand Design' for Avenue," *WP*, April 29, 1969, B1, B3.

23. SDR, thirty-fifth interview, July 8, 1988.

24. JCB memo, April 19, 1967, RG 11, box 38, Records of Building Planning and Construction. JCB was recording a meeting with NGA trustee Stoddard Stevens at Dulles Airport and during a drive back to Washington. Stevens preferred to keep plans for CASVA as quiet as possible, at least until plans for other schemes, which seemed more doubtful, had matured.

25. SDR to to PM, January 16, 1967, RG 11, box 14.

26. SDR memo, October 4, 1967, RU 613, box 110, Office of the Secretary. The memo is addressed to Charles Blitzer and Philip Ritterbush.

27. Ibid.

28. SDR, thirty-third interview, May 20, 1988.

29. Charles Nagel to SDR, October 9, 1967, RU 613, box 110, Office of the Secretary.

30. Blitzer to SDR, October 5, 1967, RU 613, box 110, Office of the Secretary.

31. John A. Pope to SDR, October 6, 1967, RG 11, box 14. Pope, not a Ripley favorite (nor was Pope's wife, Annemarie), sent a copy of his memo to JCB, which is why it is in NGA Archives. JCB thanked him.

32. Lynford Kautz memo, October 1, 1974, RU 613, box 55, Office of the Secretary. Ripley's files contain a great deal of material concerning NGA (as NGA files contain material about SI), and he read press releases and reviews of NGA openings. It was after reading things JCB had sent him that he contacted Kautz for the memo.

33. Robert Mason to JCB, November 30, 1973, RG 2, box 79.

34. SDR, thirty-fourth interview, July 7, 1988.

35. See Dorothy McCardle, "Fund Raisers," *WP*, June 9, 1970, B1, B3. The article covers the swearing in, by HEW secretary Robert Finch, of the heavily Republican 107-member advisory committee for the Kennedy Center.

36. SDR, thirty-fourth interview, July 7, 1988.

37. See Wilson Board of Trustees memo to SDR, October 21, 1977, RU 613, box 425, Office of the Secretary.

38. James Billington to SDR, May 26, 1977, RU 613, box 421, Office of the Secretary.

39. "Skirmish at the Smithsonian," *Business Week*, February 21, 1970,

40. SDR to Meredith Johnson, October 11, 1974, RU 613, box 273, Office of the Secretary.

41. See, for example, Krause, "Smithsonian Chief's Link to Bank Is Investigated," *WP*, February 7, 1977, A1; Krause, "Ripley's Son-in-Law Given Smithsonian Aid for Work," *WP*, March 15, 1977, A1; Krause, "Electronic Security Guards Ripley's Office,"

WP, March 16, 1977, C1, C5. The last article specified many of the security details, attacked the cost, and ridiculed Ripley for damaging a lock on his safe.

42. There were many Anderson attacks. See, for example, Washington Merry-Go-Round, "Taxpayers May Drive Ships off Seas," *WP*, November 7, 1970, F15, for SDR-ordered restrictions on contacts between his staff and Congress.

43. Jack Anderson, Washington Merry-Go-Round, "Ripley's $2,800 Search for a Gull," *WP*, November 23, 1970, C7.

44. Anderson, Washington Merry-Go-Round, "Conservatives Ambush Consumer Bill," *WP*, August 27, 1970, G7.

45. Lloyd Schwartz, "Daybreak at the Smithsonian: A Well-Packaged Relevance," *Washington Star*, March 25, 1970, Press Scrapbooks, vol. 111, NGA/GA.

46. David S. Greenberg, "The Museum Man," *WP*, February 7, 1978, A17.

47. "Innovations Everywhere at a Smithsonian Party," *NYT*, October 3, 1970, 17.

48. JCB to SDR, January 31, 1972, RU 613, box 55, Office of the Secretary.

49. The piece was used in congressional hearings and reprinted in various places.

50. Anderson, Washington Merry-Go-Round, "Smithsonian Swaps $30,000 Painting," *WP*, December 18, 1969, H7. The "taxpayers were badly skinned," claimed Anderson. "Davis had to reach into the public art treasury stealthily as a wristwatch hustler on a Naples street corner." The swap in question was of a "superb Flemish painting" for a Benjamin West. See Anderson, "Smithsonian's Art Goof," *WP*, July 12, 1970, C7, and Anderson, "FAA Fires the Man Who Spoke Out," *WP*, July 16, 1970, E23, for further attacks on SI policies and, directly or by implication, on SDR.

51. *General Hearings before the Subcommittee on Library and Memorials of the Committee on House Administration*, 91st Congress, Second Session, July 1970, 503.

52. See RG 2, box 80, for a collection of articles, many of them critical, about the Hirshhorn.

53. Robert Hughes, "The Avid Eclectic," *Time*, 104 (September 30, 1974), 70–73.

54. Ada Louise Huxtable, *NYT*, October 6, 1974, 121.

55. Douglas Cooper, "Haul Casts Pall on Mall," *New York Review of Books*, May 29, 1975, Press Scrapbooks, vol. 168.

56. Mellon was quoted in *Newsday*, October 2, 1974, Press Scrapbooks, vol. 168.

57. David Scott memos, October 22, 1974, and October 29, 1974, RG 2, box 10, Director's Transitional Files.

58. JCB memo to Scott, January 29, 1973, RG 2, box 79.

59. Hughes, "Avid Eclectic."

60. SDR to Mrs. Carl Tucker, September 30, 1974, RU 613, Box 273, Office of the Secretary.

61. James Auer, *Milwaukee Journal*, November 24, 1974, Press Scrapbooks, vol. 168. Auer noted that the building had been subjected to almost "unprecedented abuse."

62. Harris's letter is dated January 28, 1971. More on the Hirshhorn fight can be found in Charles Blitzer Papers, RU 281, Box 12, SI/SA. Among other materials are correspondence with Sam Harris, Hirshhorn's attorney, congressional reports and legislation, and letters from various figures, including Sherman Lee, director of the Cleveland Museum of Art, opposing creation of a national collection with an individual donor name.

63. Robert A. Brooks to SDR May 15, 1974, RU 613.

64. For Anderson comments on Simmons, see Washington-Merry-Go-Round, "Coca Cola Set to Defend Franchises," November 27, 1972, B11. For Anderson attacks

on the Hirshhorn, see Washington Merry-Go-Round, "Mall Memorial to Hirshhorn Probed," April 11, 1970, C11; "U.S. Monument to a Smuggler?" *WP*, December 13, 1970, B7; "Jimmy the Greek Says," *WP*, March 16, 1974, E49.

65. See RU 613, box 429, Office of the Secretary, for a lengthy letter of Simmons, *Washington Star*, July 25, 1977, denouncing the Kadis article in the *Washington Star*, June 26, 1977.

66. Robert H. Simmons, "David W. Scott: Champion of American Art," *Federal Times*, May 16, 1983, Press Scrapbooks, vol. 284.

67. Clinton Anderson to SDR, November 7, 1969. A copy of this letter, along with the SDR response of November 19, 1969, can be found in the folder housing the twenty-fifth SDR interview, June 3, 1985.

68. SDR, twenty-eighth interview, September 24, 1988.

69. For an early positive response see Meryle Secrest, "He Finds Time For a change," *WP*, March 13, 1970, B12.

70. Interview with Marvin Sadik by Mike Richard, July 12, 1999, Edmund S. Muskie Archives and Special Collections Library, Bates College (digilib.bates.edu/collect/muskieor/index/assoc/HASHO194.dir/doc.pdf).

71. For his comments on Taylor and Sadik, see SDR, twenty-eighth interview, September 24, 1986.

72. SDR told the stories about Mrs. Pope in the twenty-sixth interview, March 14, 1986.

73. As quoted in Paul Richard, "Honor for Art's Sake," *WP*, November 7, 1985, C3, See also Barbara Gamarekian, "Working Profile: The 'First Lady' of a World of Art," *NYT*, November 24, 1984, I, 9.

74. There are letters from and about Annemarie Pope in RG 2, box 61. In one memo from JCB, attached to a letter she wrote him, September 12, 1980, he warns staff to be careful about giving her possible dates for shows that had not yet been authorized. Mrs. Pope was an aggressive negotiator.

75. SDR, thirty-fifth interview, July 8, 1988.

76. Ibid.

77. For a typical encounter between Yates and Ripley, see *Department of the Interior and Related Agencies Appropriations For Fiscal Year 1979*, February 23, 1978, 292–99, 330–34.

78. SDR, twenty-ninth interview, October 15, 1986.

79. For more on Ripley's views on Hillwood and Mrs. Post, see SDR, thirtieth interview, March 19, 1987.

80. Some of the extensive correspondence between SDR and Mrs. Firestone, primarily 1975–1977, as well as memos about her collection, can be found in RU613, box 447, Office of the Secretary.

81. SDR, thirty-first interview, March 19, 1987.

82. Ibid. For more on Ripley and Blitzer's adventures in smell and slum evocations, see Robert C. Post, "'A Very Special Relationship': SHOT and the Smithsonian's Museum of History and Technology," *Technology and Culture* 42 (2001): 423.

83. For a profile of Kinard, see Jacqueline Trescott, "Anacostia Advocate," *WP*, September 16, 1977.

84. "Neighborhood Museums," *WP*, July 28, 1970, A14.

85. "Minimuseums?" *Christian Science Monitor*, July 28, 1970, Press Scrapbooks, vol. 125.

86. For more on Anacostia, see Edward P. Alexander, *The Museum in America: Innovators and Pioneers* (Walnut Creek, CA: Altamira, 1997), 147–59.

87. SDR, thirty-third interview, May 20, 1988.

88. Paul Richard, "An Exhibition of Losers by Major Masters," *WP*, March 28, 1970, C1, C6.

89. Frank Getlein, "The Smithsonian's Latest Adventure in Art," *Washington Star*, March 29, 1970, Press Scrapbooks, vol. 125.

90. Armand Hammer, "The Hammer Collection," *WP*, April 4, 1970, C1, C4, C5.

91. See JW "Art Letter," *Los Angeles Times*, January 9, 1972, V47. Walker, who had been a trustee of the Los Angeles County Museum of Art, was challenging some of the judgments of *Times* critic Henry J. Seldis about the gift.

92. See Steve Weinberg, *Armand Hammer: The Untold Story* (Boston: Little, Brown, 1989), 368, 380–81, and Carl Blomay (with Henry Edwards), *The Dark Side of Power: The Real Armand Hammer* (New York: Simon & Schuster, 1992), 190–91. JCB described his relationship to Hammer (and the disastrous 1970 exhibition) in taped transcripts, February 20, 2002, JCB Papers.

93. Jo Ann Lewis, "Armand Hammer's Final Say," *WP*, October 9, 1990, E1. John Wilmerding, interview with author, June 18, 2012, described the frantic negotiations with Hammer in Washington. Also JCB, tape transcript, February 20, 2002, JCB Papers, JHL/BU. JCB, who had mixed feelings about Hammer, reported that PM did not. "Dr. Hammer should crawl back under the rock from whence he came," PM apparently told JCB.

94. See, for example, SDR to Lisa Taylor, May 24, 1976; SDR to Mr. and Mrs. Linsky, May 24, 1974; Lisa Taylor memo, June 29, 1976; SDR to Mr. and Mrs. Linsky, October 8, 1976; SDR to Mrs. Harvey Firestone Jr., December 23, 1976; SDR to Nelson Rockefeller, September 1, 1976; Lisa Taylor to SDR, November 22, 1976, all in RU 613, box 364, Office of the Secretary.

95. See "GAO's Tour of the Smithsonian," *WP*, February 12, 1977, A14, an editorial following articles by Krause. See also Krause, "Yates Declines Smithsonian Position," *WP*, March 1, 1977, C3.

96. Tom Zito, "Ripley on Museums: Beware of Handouts," *WP*, June 1, 1976, B1.

97. Ibid.

98. Donald P. Baker, "Ripley Agrees to Alter Budget Procedures of Smithsonian," *WP*, February 23, 1978, A3; Donald P. Baker, "Smithsonian Makes 1st Accounting of its Private Funds to Congress," *WP*, February 24, 1978, A10. Smithsonian treasurer T. Ames Wheeler revealed that in fiscal 1979 *Smithsonian* magazine made four million dollars in profits, and the museum shops $1.5 million, all of which was to be put into the endowment.

99. Judith Martin, "Ripley Has His Day," *WP*, February 24, 1978, D3.

100. Grace Glueck, "A Stuart Portrait of Washington Sold," *NYT*, April 6, 1979, A1.

101. Ibid.

102. Michael Knight, "Boston City Officals Go to Court," *NYT*, April 11, 1979, A1.

103. Virginia Adams and Tom Ferrell, "Ideas & Trends," *NYT*, April 15, 1979, E7.

104. "Where to Hang George and Martha," *NYT*, April 10, 1979, A18.

105. Grace Glueck, "5 Stuarts Go to U.S. Gallery," *NYT*, April 10, 1979, C10.

106. Hilton Kramer, "The Stuart Paintings Uproar," *NYT*, April 22, 1979, D1, D33. Kramer had recently addressed the possibility (dire in his view) that the federal government might try to apportion arts funding in ways that would diminish the central-

ity of New York's cultural role. See Kramer, "Critic's View, The Importance of New York," *NYT*, April 9, 1979, D1, D24. New York is "the arts capital of the country" and "it is probably not beyond the power of the Government to destroy, or at least seriously undermine and diminish, New York's position in the arts."

107. Phil McCombs, "The $50 Million Closet," *WP*, May 10, 1983, B1.

108. SDR, *The Sacred Grove. Essays on Museums* (New York: Simon & Schuster, 1969), 101.

109. Edwards Park and Jean Paul Carlhian, *A New View from the Castle* (Washington, DC: Smithsonian Institution Press, 1987), 11.

110. JCB delivered a tribute to Arthur Sackler at a Metropolitan Museum memorial service, in which he recalled introducing Sackler to SDR. He repeated the talk at SI. See Memorial Tribute, June 17, 1987, RG 2, box 3, Directors Transitional Files. And see JCB, tape transcript recalling introducing Sackler to SDR, JHL/BU.

111. Paul Richard, "The Smithsonian's Mystery Building," *WP*, August 30, 1987, G1, G8, G9. SDR, wrote Richard, "is a scientist, a dreamer and a builder with few peers. He played the government like a harp" (G9).

112. Among them, Charles A. Krause. See "Ripley's Son-in-Law Given Smithsonian Aid for Work," *WP*, March 15, 1977, A1.

113. Benjamin Forgey, "Ripley's Believe It & Build," *WP*, September 15, 1984, C1.

114. For anecdotes of SDR's fearlessness and awestruck recollections of his accomplishments, see *Secretary and Mrs. S. Dillon Ripley: A Celebration. Twenty Years at the Smithsonian*, a pamphlet recounting dinner tributes, February 1, 1984. A copy can be found in Director's Transitional Files, RG 2, box 1.

115. See Ken Ringle, "S. Dillon Ripley, the Muse in the Museum," *WP*, March 13, 2001, C1. The observation was by Ralph Rinzler, who had directed the Festival of American Folklife.

116. See JCB, tape transcript, January 8, 2002. "I didn't want to just become a paper pusher," Brown declared about his saying no to Warren Burger's query about the SI secretaryship. "I loved my opportunities to be hands on with objects and installations, aquisitions, exhibitons, interpretations." In this taped interview JCB also indicated he had turned down Franklin Murphy's proposal that he be one of two candidates to head the Getty Trust.

117. Louise Sweeney, "Master Showman, National Gallery Director J. Carter Brown," *Christian Science Monitor*, November 9, 1988, Chronological boxes, NGA/GA.

Chapter 11

1. Anthony Athos to JCB, October 20, 1960, JCB Personal Correspondence, JCB Papers, JHL/BU.

2. The most detailed examination is Sue A. Kohler, *The Commission of Fine Arts: A Brief History, 1910–1995* (Washington, DC: Commission of Fine Arts, 1996).

3. See Constance McLaughlin Green, *Washington: Capital City, 1879–1950* (Princeton, NJ: Princeton Unviersity Press, 1963), 132–46; John W. Reps, *Monumental Washington: The Planning and Development of the Capital Center* (Princeton, NJ: Princeton University Press, 1967).

4. Tom Braden, "A Legacy to Be Long Remembered," *WP*, February 1, 1972, A19.

5. For the letter, see Walton to Speaker of the House, June 22, 1966, RG 2, box 30.

6. Charles H. Atherton, interview with author, April 5, 2004.

7. Wolf Von Eckardt, "Rating Washington's Architecture," *WP*, January 6, 1974, P18.

8. Minutes of the Commission of Fine Arts, April 19. 1972, Archives, Commission of Fine Arts.

9. Author's interview with Charles Atherton, April 5, 2004.

10. See Clarke obituary, *WP*, August 11, 1982, C6.

11. Kohler, *Commission of Fine Arts*, 46–47.

12. See, for example, "Overhead D.C. Traffic Lights Urged for Safety," *WP*, January 23, 1972, D11; Paul Hodge, "Fine Arts Panel Urges City to Curb Enclosed Sidewalk Cafes," *WP*, December 16, 1981, B1, B12. Indulging his taste for puns JCB suggested that the overhead lights were "an opportunity for Washington to cover itself with glory."

13. Paul Hodge, "Lincoln Memorial," *WP*, April 5, 1979, C1, C5.

14. Maria Josephy Schoolman, "Nixon Was Right" (letter to the editor), *WP*, July 27, 1980, D6.

15. Commission Minutes, November 17, 1971.

16. Ibid., December 15, 1971.

17. Ibid., February 16, 1972.

18. Ibid., April 19, 1972.

19. Ibid., May 17, 1972.

20. Department of the Interior and Related Agencies Appropriations for Fiscal Year 1977, March 18, 1976, 94 Congress, 2 Session, 692.

21. "A Fitting Birthday Gift," *WP*, September 23, 1972, A14.

22. Wolf Von Eckardt, "A Modern Master's Monument," *WP*, August 19, 1972, C1.

23. Commission Minutes, June 26, 1973.

24. These words are found, not in Huxtable's formal review of the Center, which was negative but more restrained ("Some Sour Notes Sound at the Kennedy Center," *NYT*, September 19, 1971, D25) but in Huxtable, "A Look at the Kennedy Center," in *On Architecture: Collected Reflections on a Century of Change* (New York: Walker, 2008), 84. The essay is dated September 7, 1971. Huxtable had also been critical of the Center's location half a dozen years earlier.

25. Commission Minutes, June 26, 1973.

26. Ibid.

27. Ibid., October 17, 1973.

28. For local hopes see Stuart Auerbach, "D. C. Joins Race for Convention Bookings," *WP*, December 6, 1982, B1, 11.

29. Benjamin Forgey, "Downtown's Plain Brown Package," *WP*, December 4, 1982, C1, C4.

30. There were dour forecasts. See Kenneth Bredemeier, "D.C. Convention Center: The Neighborhood Hasn't Kept Up," *WP*, November 8, 1982, A1, A26.

31. "Twentieth Century Washington," *WP*, August 29, 1975, A28.

32. "The Commission on Fine Arts," *WP*, February 3, 1976, A14.

33. "Needless Demolition," *WP*, August 18, 1976, A18.

34. "Fine Arts Appointees," *WP*, August 13, 1976, B4.

35. Phil McCombs and Anne H. Oman, "$40 Million Mall Is Planned," *WP*, November 12, 1977, A1.

36. Ibid. For more on Don't Tear It Down see Anne H. Oman, "Saving The Pieces of Urban History," *WP*, December 1, 1977, 122. Also see Oman, "Injunction Bars Foley Company," *WP*, October 13, 1977, DC3.

37. Wolf Von Eckardt, "Big Stakes in a New City Game," *WP*, March 4, 1981, B1.

38. Oman, "Downtown Mall," *WP*, April 13, 1978, DC3.

39. JCB to Congressman Diggs, March 13, 1978, RG 2, box 30.

40. "No Snaggle-Teeth for 17th Street," *WP*, August 15, 1974, B9. The commission rejected a planned Federal Home Loan Bank Board building, saying it would leave the block "snaggle-toothed like a boy hit by a baseball bat." Presumably this was JCB speaking.

41. Anne H. Oman, "Arts Commission Won't Oppose Demolition of the Rhodes Tavern," *WP*, March 9, 1978, DC4.

42. Ibid.

43. As quoted in William Raspberry, "Dogged Defender," *WP*, May 6, 1981, A19.

44. "Around Town: Back to the Forest," *WP*, March 5, 1978, C6.

45. Richard Edelin Crouch, "Rhodes Tavern" (letter to the editor), *WP*, March 31, 1978, A18.

46. Nelson Rimensnyder, "Rhodes Tavern" (letter to the editor), *WP*, March 17, 1978, A22.

47. Tedd McCainn, "Wrecking Ball" (letter to the editor), *WP*, November 11, 1979, B6.

48. Benjamin Forgey, "One for the Rhodes," *WP*, September 24, 1983, C1.

49. Anne H. Oman, "History of Tavern the Focus of Move to Save It," *WP*, May 18. 1978, DC2; Joseph P. Mastrangelo, "Parading about the Rhodes," *WP*, August 25, 1978, C5.

50. Oman, "History of Tavern."

51. For example, Dorothy Gilliam, "Initiatives," November 5, 1983, B1, asserted that Initative 11 on Rhodes Tavern trivialized the process of preservation and did not promote participatory democracy.

52. "Rhodes Tavern: No," *WP*, November 5, 1983,

53. See for example *WP*, November 12, 1983, A18.

54. Joe Pichirallo, "Rhodes Tavern Initiative Carries 91 Percent," *WP*, November 10, 1983, B4. See also Joe Pichirallo, "Voters Favor Saving Historic Rhodes Tavern," *WP*, November 9, 1983, A15.

55. William Raspberry, "Rhodes Tavern: Fool's Gold," *WP*, June 6, 1984, A25.

56. Karlyn Barker, "Appeal to Save Rhodes Tavern Turned Down," *WP*, September 7, 1984, C1. The plaintiffs appealed the ruling all the way to the United States Supreme Court.

57. Barker, "After the Fall: Last of Rhodes Tavern Reduced to Rubble," *WP*, September 12, 1984, C1.

58. Jack Eisen, "D. C. Law Preserves History," *WP*, August 19, 1981, B1.

59. Wolf Von Eckardt, "A Grand Hotel Cut Down to Size," *WP*, June 19, 1976, B1, B4.

60. G. N. Will, "This Is Fine Arts?" (letter to the editor), *WP*, August 2, 1976, 18.

61. "Matzo Balls on 10th Street," *WP*, July 20, 1976, A16.

62. Sandra G. Boodman, "3 Federal Agencies Oppose 10-Story Building in Arlington," *WP*, July 28, 1978, C1; Boodman "Arlington Building Approved," *WP*, August 2, 1978, B4.

63. Sandra G. Boodman, "Rosslyn: Arlington's High Rise City," *WP*, December 7, 1978, VA1, VA2.

64. For an unhappy view of Rosslyn architecture see Richard Cohen, "Lost in the Canyons of Dismal Buildings," *WP*, December 5, 1978, C1, C5.

65. Sandra G. Boodman, "Battle Over a Skyline," *WP*, December 4, 1978, A1.

66. There are materials relating to this controversy, and letters from JCB, in RG 2, box 29.

67. Boodman, "Battle Over a Skyline," A2.

68. Sandra G. Boodman, "High-Rise Va. Buildings Held An 'Act of Urban Vandalism,'" *WP*, January 23, 1979, A9

69. Jane Seaberry, "Judge Refuses to Halt Work at Rosslyn Center," *WP*, December 39, 1978, B1.

70. Elizabeth Rowe, "Giving Beauty a Hard Time" (letter to the editor), *WP*, January 1, 1979, A14.

71. See materials in RG 2, box 30, Records of the Director of the National Gallery, Subject Files, Commission on Fine Arts.

72. Kenneth Bredemeier, "Mix of Park, Housing Approved for Georgetown Waterfront," *WP*, July 14, 1979, B3.

73. Kirk Scharfenberg, "Arts Panel Opposes Georgetown Office," *WP*, April 20, 1972, B1.

74. Patricia Camp and Anne H. Oman, "Georgetown Waterfront Proposed as National Park," *WP*, March 7, 1981, B1, B3.

75. Wolf Von Eckardt, "Park Plans on the Waterfront," *WP*, June 10, 1978, B1.

76. Wolf Von Eckardt, "On the Waterfront," *WP*, October 21, 1978, F1.

77. Wolf Von Eckardt, "1 Riv, Too Many Views," *WP*, June 30, 1979, B1.

78. Kenneth Bredemeier, "Mix of Parks, Housing Approved for Georgetown Waterfront," *WP*, July 14, 1979, B3.

79. Benjamin Forgey, "The New City In Town: On The Waterfront," *WP*, October 24, 1981, B1.

80. Kenneth Bredemeier, "Panel Assails Proposal for Waterfront," *WP*, December 12, 1979, D1, D7.

81. Kenneth Bredemeier, "Georgetown Waterfront Plan to Be Redesigned," *WP*, January 18, 1980, C5.

82. Kenneth Bredemeier, "New Waterfront Plan Opposed in Georgetown," *WP*, March 5, 1980, C1.

83. Ibid.

84. "On the (Georgetown) Waterfront," *WP*, March 6, 1980, A18.

85. Kenneth Bredemeier, "Scaled-Down Georgetown Design Wins Art Commission Approval," *WP*, April 9, 1980, C1.

86. "Back to the Waterfront," *WP*, April 10, 1980, A14.

87. Paul Hodge, "Waterfront Plan for Georgetown Rejected by U.S. Fine Arts Commission," *WP*, March 11, 1981, A1.

88. On President Carter's appointments, see Paul Hodge, "11th-Hour Appointees," *WP*, January 24, 1981, B1, B3. In its last hours the Carter administration appointed two nonprofessionals, Alan Novak and Harold Buirson, to the Fine Arts Commission, in addition to three other appointments in November 1980, two of whom were architects. Thus within months there were five new members added to the seven person commission.

89. Wolf Von Eckardt, "Dearth of Design," *WP*, March 14, 1981, C1, C4.

90. Paul Hodge, "Arts Unit Reaffirms Opposition to Waterfront Development," *WP*, April 8, 1981, C3.

91. "From Fine Arts to Ugly Waterfront," *WP*, April 12, 1981, D6.

92. Hodge, "Waterfront Project Faces Flood of Problems," *WP*, April 23, 1981, DC4.

93. Eugene Robinson, "Georgetown Waterfront Battle Heats Up Again," *WP*, July 3, 1981, B1.

94. LaBarbara Bowman, "Power in Georgetown," *WP*, October 28, 1981, C1, C6.

95. Lynn Darling, "To the Gallery Born," *WP*, October 31, 1982, M13–15, 17. This lengthy Sunday magazine piece sprinkled some ancient anecdotes within a broadly admiring frame.

96. Donald H. Shannon, "Who's Arrogant?" (letter to the editor), *WP*, November 11, 1982, A26.

97. The charges, by Diane Wolf, commission member, were noted in Barbara Gamarekian's somewhat adversarial piece, "The Fine Art of Directing (and Genteelly Fighting for) the National Gallery," *NYT*, February 16. 1990, A16.

98. See Kirk Savage, *Monument Wars: Washington, D.C., the National Mall, and the Transformation of the Memorial Landscape* (Berkeley: University of California Press, 2009).

99. "Planning Snags Delay Action on New Memorials," *WP*, February 14, 1980, DC6.

100. Paul Hodge, "An Unpopular War, a Lasting Memorial," *WP*, February 12, 1981, DC1, DC2; Henry Allen, "Vietnam Memorial Design Is Selected," *WP*, May 7, 1981, F1, F3.

101. See, for example, Wolf Von Eckardt, "Of Heart & Mind: The Serene Grace of the Vietnam Memorial," *WP*, May 16, 1981, B1; Philip Geyelin, "A Memorial in the Healing Spirit," *WP*, June 1, 1981, A11. Certainly, there was no unanimity. See "Washington Diarist," *New Republic* 184 (May 23, 1981): 43, and Robert C. Lorbeer, "Inadequate Memorial" (letter to the editor), *WP*, May 16, 1981, A12, for early expressions of disapproval.

102. Jan Scruggs and Joel C. Swerdlow, *To Heal a Nation: The Vietnam Memorial* (New York: Harper & Row, 1986), 15.

103. Kohler, *Commission of Fine Arts*, 126.

104. Ibid., 127.

105. Scruggs and Swerdlow, *To Heal a Nation*, 51.

106. Kohler, *Commission of Fine Arts*, 127.

107. Jack Eisen, Metro Notes, "Commission Rejects Veteran's Protest, Reapproves Vietnam Memorial Design," *WP*, October 14, 1981, C3.

108. James J. Kilpatrick, "Finally, We Honor the Vietnam Dead," *WP*, November 11, 1981, A27.

109. Benjamin Forgey, "Model of Simplicity: Another Look at the Vietnam Memorial Model," *WP*, November 14, 1981, C1.

110. Tom Carhart, "A Better Way to Honor Viet Vets," *WP*, November 15, 1981, C5.

111. See letters to the editor, *WP*, January 9, 1982, A22.

112. "War Memorial Faces Hurdle at Interior," *WP*, January 13, 1982, A21.

113. Paul Hodge, "Vietnam Vets' Memorial May Begin in Two Weeks," *WP*, February 19, 1982, A18.

114. Scruggs and Swerdlow, *To Heal a Nation*, 51.

115. Benjamin Forgey, "Memorial Delayed," *WP*, February 27, 1982, C1.

116. Benjamin Forgey, "Vietnam Vet Memorial Action," *WP*, March 5, 1982, B9.

117. Benjamin Forgey, "Monumental 'Absurdity,'" *WP*, March 6, 1982, C5.

118. Benjamin Forgey, "Commission Acts on Vets Memorial Design," *WP*, March 10, 1982, B6.

119. Scruggs and Swerdlow, *To Heal a Nation*, 106–7.

120. Rick Horowitz, "Maya Lin's Angry Objections," *WP*, July 7, 1982, B1, B7.

121. Scruggs and Swerdlow, *To Heal a Nation*, 49.

122. Horowitz, "Maya Lin's Angry Objections."

123. Isabel Wilkerson, "'Art War' Erupts over Vietnam Veterans Memorial," *WP*, July 8, 1982, D3.

124. Ibid.

125. Benjamin Forgey, "Hart's Vietnam Statue Unveiled," *WP*, September 21, 1982, B1.

126. Tom Wolfe, "Art Disputes War: The Batle of the Vietnam Memorial," *WP*, October 13, 1982, B1, B3-B4.

127. See, for example, Letters To The Editor, *WP*, October 18, 1982, A12; October 20, 1982, A12; and October 21, 1982, A18.

128. Scruggs and Swerdlow, *To Heal a Nation*, 133.

129. JCB, "The Vietnam Memorial Decision," *WP*, October 14, 1982, A15.

130. Irvin Molotsky, "Changes Set in Viet Memorial," *NYT*, October 14, 1982, C17.

131. Scruggs and Swerdlow, *To Heal a Nation*, 133.

132. Robert W. Doubek to JCB, June 25, 1983, RG 2, box 29.

133. JCB, oral history interview, February 7, 1994.

Chapter 12

1. Paul Richard, "Museum's New Faces; National Gallery Adding to its Staff of Curators," *WP*, September 3, 1983, C1.

2. See Judith Miller, "The Capital Becomes a Boom Town," *NYT Sunday Magazine*, May 3, 1981, 29, and Barbara Gamarekian, "National Gallery of Art a High Point of Culture," *NYT*, Feb. 15, 1983, A30.

3. Lori Simmon Zelenko, "Forum: What Is the National Gallery of Art Doing Today," *American Artist* 45 (May 1981): 10.

4. See Grace Glueck, "Metropolitan and Other Museums Fume at 'Washington-First' Policy," *NYT*, July 3, 1978, 25.

5. On corporate patronage, see Diane J. Gingold and Elizabeth A. C. Weil, *The Corporate Patron* (New York: Fortune, 1991). This text, issued for the fiftieth anniversary of NGA, traces and documents corporate support of exhibitions for the entire history of the museum.

6. As quoted at http://www.nga.gov/feature/nouveau/concept_dodge.shtm.

7. Tom Dowling, "The Rise of Carter Brown," *Washingtonian* (August 1971), 45.

8. Author's interview with Julianna Munsing, May 20, 2004.

9. Dowling, "Rise of Carter Brown," 45.

10. See letter from JCB to JW, December 5, 1980, RG 2, box 53, NGA/GA, describing the interest of the British Council in creating a show tracing British cultural traditions, and JCB's proposing something on country houses. Unless otherwise noted, archival references to the exhibition are taken from these subject files.

11. Notes of December 2, 1980 meeting sent by Julian Andrews, RG 2, box 53.

12. JCB to "the Devonshires," December 18, 1980; JCB to the Marquess of Tavistock, December 19, 1980, both in RG 2, box 53.

13. JW to JCB, December 24, 1980, RG 2, box 53. Walker was referring particularly to his relationship with Armand Hammer and his hope to get the Gallery more gifts of drawings from him.

14. JCB to P. Lyon Roussel, February 22, 1980, RG 2, box 53.

15. George Howard to JCB, January 15, 1981, RG 2, box 53.

16. JCB to Howard, February 3, 1981, RG 2, box 53.

17. Memo of conversation, March 23, 1981, RG 2, box 53.

18. Howard to Julian Andrews, March 27, 1981; Andrews to JCB, March 23, 1981, RG 2, box 53.

19. JCB to Andrews, March 27, 1981, RG 2, box 53.

20. This description is based on notes provided by Julian Andrews, who sent on a formal record of the June London luncheon meeting on September 11, 1981, RG 2, box 53.

21. John Harris to JCB, May 28, 1981, RG 2, box 53.

22. JCB memo, July 7, 1981, RG 2, box 53.

23. Carol Fox to Richard P. Berglund, August 12, 1982, RG 2, box 53.

24. Berglund to JCB, September 7, 1982, RG 2, box 53.

25. Philippe de Montebello to JCB, October 13, 1981, RG 2, box 53.

26. JCB to Montebello, November 3, 1981, RG 2, box 53.

27. There were two memos, both undated, but presumably late 1981, RG 2, box 53. One was labeled "Conditions of Engagement," the other, "Suggested schematic procedures for planning country house exhibition."

28. Harris to JCB, March 17, 1982, RG 2, box 53.

29. Dodge Thompson to JCB, March 25, 1982, RG 2, box 53.

30. Harris to JCB, April 1, 1982, RG 2, box 53.

31. Harris to JCB, April 19, 1982, RG 2, box 53.

32. JCB to Harris, May 3, 1982, RG 2, box 53.

33. Minutes of meeting at BBC, March 3, 1982, RG 2, box 53. A timetable was proposed and an object list discussed.

34. JCB memo, October 17, 1984, RG 2, box 53.

35. Minutes of meeting at BBC, March 30, 1982, RG 2, box 53.

36. Notes of luncheon meeting. July 13, 1982, RG 2, box 53. The meeting was attended by, among others, Harris, Thompson, Ravenel, Al Viebranz, Franny Smith, and Elizabeth Croog.

37. Dodge Thompson, memo of May 20, 1982, RG 2, box 53, suggested names for the luncheon, including Stevens, and it was held July 19, to introduce or reintroduce Harris to important local figures, some of whom were possible collaborators.

38. *Daily Telegraph*, August 10, 1982, RG 2, box 53.

39. Harris to JCB, September 6, 1982, RG 2, box 53.

40. Harris to JCB, September 17, 1982, RG 2, box 53.

41. Gervase Jackson-Stops to JCB, September 28, 1982, RG 2, box 53.

42. Jackson-Stops to JCB, December 1, 1982, RG 2, box 53.

43. Jackson-Stops to JCB, December 10, 1982, RG 2, box 53.

44. JCB to Howard, December 16, 1982, RG 2, box 53.

45. Oliver Millar to JCB, December 16, 1982, RG 2, box 53.

46. Edward Montagu to JCB, December 3, 1982, RG 2, box 53.

47. JCB to Millar, December 20, 1982, RG 2, box 53.

48. JCB to Montagu, December 16, 1982, RG 2, box 53.

49. See JCB memo, November 15, 1982, RG 2, box 53.

50. JCB to Harris, March 2, 1983, RG 2, box 53.

51. The letters and memos were written between April and October of 1983. See JCB, memo of conversations with Edwin Land, April 5, 1983, RG 2, box 54.

52. Telephone memo, July 8, 1983, RG 2, box 54. Later that month George Howard, now Lord Howard of Henderskelfe, wrote confirming that the Prince and Princess of Wales could not serve as patrons. See Howard to JCB, July 28, 1983.

53. PM to Prince of Wales, November 1, 1983, RG 2, box 54.

54. Edward Adeane to PM, December 23, 1983, RG 2, box 54. The Honorable Edward Adeane was principal private secretary to the Prince of Wales.

55. JCB memo, November 9, 1983, RG 2, box 54.

56. Stephanie French to A. C. Viebranz, January 30, 1984, RG 2, box 54. See also Susan Bloom to JCB, April 16. 1984. Bloom was vice president for cultural affairs at American Express.

57. See JCB memo, May 8, 1984, RG 2, box 54. See also JCB memo of May 9, 1984.

58. JCB to Lady Cholmondeley, June 13, 1984, RG 2, box 54.

59. JCB memo, June 20, 1984, RG 2, box 54.

60. The detailed sixteen-page paper prepared for Ford can be found in RG 2, box 54.

61. Interestingly enough, the Metropolitan Museum of Art carefully followed the trajectory of congressional appropriations for the National Gallery. See memo from Linden Wise to Philipppe de Montebello, June 5, 1985, NGA Folder, Archives, Metropolitan Museum of Art. Wise had spoken with Elizabeth Croog, associate general counsel of NGA, about how this formula worked.

62. JCB to Congressman Yates and Senator McClure, August 31, 1984, RG 2, box 54.

63. Reresby Sitwell to Jackson-Stops, September 10, 1984, RG 2, box 54.

64. Jackson-Stops to JCB, September 10, 1984 and JCB to Jackson-Stops, September 19, 1984, RG 2, box 54.

65. JCB memo, August 28, 1984, RG 2, box 54.

66. John Jacob to JCB, September 14, 1984, RG 2, box 54.

67. JCB to A. Wilson, October 16, 1984, RG 2, box 54.

68. Colin Thompson to JCB, November 5, 1984, RG 2, box 54.

69. JCB to Thompson, November 26, 1984, RG 2, box 54.

70. Buccleuch to JCB, January 14, 1985, RG 2, box 54.

71. Buccleuch to JCB, March 7, 1985, RG 2, box 55.

72. Lewis Roberts to JCB, March 5, 1985; and JCB to Roberts, March 13, 1985 (only in draft), RG 2, box 55.

73. *Private Eye*, October 4, 1984, RG 2, box 54. Someone scrawled over the top of the copy in the files, "You should sue."

74. Charles Price to JCB, November 30, 1984, RG 2, box 55.

75. JCB to Caspar Weinberger, December 7, 1984, RG 2, box 55.

76. JCB to Paul Channon, March 18, 1985, RG 2, box 55.

77. JCB to Dodge Thompson, November 29, 1984, RG 2, box 55. In his memo JCB noted that Air India had provided hundreds of free trips in connection with the Festival of India.

78. JCB to Lord King, October 30, 1984, RG 2, box 55.

79. JCB memo, February 19, 1985, RG 2, box 55.

80. JCB to John Meredith, March 8, 1985, RG 2, box 55.

81. Rosemary Serra to JCB, April 23, 1985, RG 2, box 55.

82. JCB to Lady King, April 24, 1985, RG 2, box 55.

83. JCB to Mabel Brandon, March 21, 1985, RG 2, box 55. Brandon accepted the decision. "No one at the Ford Motor Company wishes this exhibition to be commercialized." Brandon to JCB, March 22, 1985,

84. See for example Susan Mary Alsop to JCB and Pamela Brown, April 16, 1984, as well as a lengthy JCB memo, April 27, 1984, RG 2, box 55, for the complex preparations. Paige Rense, the editor in chief, came to Washington and indicated that such coverage for an exhibition was unprecedented for *Architectural Digest*.

85. Julian Andrews to JCB, May 13, 1982, RG 2, box 53.

86. JCB's argument was based on a memo from Dodge Thompson, December 12, 1984, RG 2, box 54.

87. Memo of JCB telephone call with Robert Taub of Ford, December 19, 1984, RG 2, box 54. JCB indicated that previous estimates of the conservation costs were now much too low.

88. JCB to Harold Williams, December 28, 1984, RG 2, box 54.

89. Described in Dodge Thompson memo to JCB, December 12, 1984, RG 2, box 54.

90. JCB to Williams, December 28, 1984, RG 2, box 54.

91. JCB to Williams, March 21, 1985, RG 2, box 55.

92. John Wilmerding memo, January 7, 1985, RG 2, box 55.

93. The application to the Getty was filed by Michael Saunders Watson, head of the Historic Houses Association (Lord Howard had died), January 30, 1985, requesting 66,000 pounds in matching funds. RG 2, box 54.

94. Lord Airlee to JCB, April 24, 1985, RG 2, box 55.

95. Airlee to JCB, January 16, 1985, RG 2, box 54.

96. Sheila Hale, "British Country Houses Packing Up Treasures for U.S. Show," *NYT*, August 8, 1985, C10.

97. JCB to Nancy Reagan, July 30, 1984, RG 2, box 55. Nancy Reagan had written a personal note to JCB on hearing of his automobile accident.

98. William F. Sittmann to JCB, October 19, 1984, RG 2, box 55.

99. JCB to Michael Deaver, December 26, 1984, RG 2, box 55.

100. JCB telephone call memo, January 16, 1985, RG 2, box 55.

101. JCB memo of telephone call, February 11, 1985, RG 2, box 55.

102. He would, soon. See Donnie Radcliffe, "'Treasure Houses of Britain': The Reagans Get First Look," *WP*, October 31, 1985, B1, B8.

103. Brandon to JCB, March 1, 1985, RG 2, box 55.

104. JCB memo, May 13, 1985, RG 2, box 55.

105. Donnie Ratcliffe, "Burt's Gain Could Be First Lady's Loss," *WP*, February 19, 1985, B2.

106. JCB to Angela Fischer, April 19, 1985, RG 2, box 55.

107. Andrews to JCB, October 3, 1985, RG 2, box 55.

108. JCB to Andrews, telex, October 11, 1985, RG 2, box 55.

109. Lady Hesketh to JCB July 15, 1985, RG 2, box 55.

110. Duchess of Devonshire ("Debo") to NGA Staff, April 23, 1985, RG 2, box 55. This was part of a more general note of appreciation.

111. JCB reply to Princess Margaret announcement, August 1, 1985, RG 2, box 55.

112. Andrews to JCB, July 23, 1985, RG 2, box 55.

113. JCB to Andrews, August 14, 1985, RG 2, box 55. The clipping was the Sheila Hale article, August 8, 1985, *NYT*.

114. For a detailed, well-illustrated, but concise printed guide to the show and its construction, see Gervase Jackson-Stops, "The Building of 'The Treasure Houses of Britain,'" *Antiques* 130 (July 1986): 116–31.

115. Barbara Gamarekian, "An Exhibit to Bring the House Down," *NYT*, September 10, 1985, A20.

116. JCB to Duke of Devonshire, January 15, 1986, RG2, box 56.

117. Paul Richard, "Grandeur Enclosed: The National Gallery's Inspired Installation," *WP*, November 3, 1985, H6.

118. Quoted in Jo Ann Lewis, "The Making of Majesty: The National Gallery's Dig for Buried English Treasure," *WP*, October 27, 1985, SM6.

119. The *WP* noted the errors in the 116-page supplement and blamed them on the British Tourist Authority, which had provided the material. The "Royal Message" had the prince and princess referring to John Adams as the third president of the United States (he was the second), and referring to him as an ambassador when he was in fact a minister to the Court of St. James. See Chuck Conconi, "Personalities," *WP*, November 4, 1985, B3.

120. Elizabeth Kastor, "The Social Seen: Henry Ford II's Reception at the Octagon," *WP*, November 4, 1985, B1.

121. Barbara Gamarekian, "A Gala for 'Treasure Houses of Britain,'" *NYT*, October 31, 1985, C10.

122. Mary Battiata, "Carter Brown & the Shining Heritage," *WP*, November 7, 1985, C1.

123. See the JCB file memo, February 22, 1985, RG 2, box 56, describing a meeting with Eric Rosenberger, a former White House advance man, and containing several pages of suggestions about handling the press and its pools, photo opportunities, protocol problems, and related matters.

124. Desson Howe, "Have You Hugged a Brit Today?" *WP*, November 7, 1985, C5. Related thoughts were expressed by Eugene V. Thaw, "House Proud," *New Republic* 193 (December 9, 1985): 38–41.

125. Jonathan Yardley, "Reflections on the Royal Visitation," *WP*, November 11, 1985, C2.

126. Coverage of the J. C. Penney event was extensive, and occasionally mocking. See Jacqueline Trescott, "All Prepared Pennywise," *WP*, November 11, 1985, C1, and "Keeping Up with the Waleses," *WP*, November 12, 1985, B1, B5.

127. For example, Betty Cuniberti, "Charles Hails Welcome Fit for a Princess," *Los Angeles Times*, November 11, 1985, A1, A7; Betty Cuniberti, "Guest-List Hopefuls Inundate Gallery," *Los Angeles Times*, September 27, 1985, E1; and Lois Romano, "To Get In, the Whole World Would Just Di," *WP*, September 10, 1985, E1, E9.

128. Tim McGirk, Cindy Blake, and Henry Porter, "Profile Title Wave Hits Washington," *Sunday Times*, November 3, 1985. The White House dinner was dubbed "the Night of the Hard-Haired Ladies."

129. Carla Hall, "Gone with the Windsors," *WP*, November 13, 1985, B1.

130. JCB to Lady Anne Beckwith-Smith, November 19, 1985, RG 2, box 56.

131. Prince Charles to JCB, February 22, 1986, RG 2, box 56. Prince Charles wrote his thank you note from Palm Springs, where he was enjoying the hospitality of the Annenbergs.

132. Reimbursement request to NGA, March 18, 1986, RG 2, box 56.

133. Sheila Hale, "British Country Houses Packing Up Treasures for U.S. Show," August 8, 1985, C10.

134. JCB told others, at other times, that more than eighty thousand people had thronged NGA on a single day. See JCB to Leila Mawa, January 15, 1986, RG 2, box 55.

135. JCB to Robert Taub, December 13, 1985, RG 2, box 55.

136. Donald Petersen to JCB, February 10, 1986, RG 2, box 56.

137. JCB to Petersen, February 20, 1986, RG 2, box 56.

138. JCB to Sir Martin Gilliat, March 6, 1986, RG 2, box 56.

139. Bailey Morris, "Spectrum: Best of British Treasure," *Times* (London), October 16, 1985.

140. Duke of Bedford to JCB, November 8, 1985, RG 2, box 55.

141. Tavistock to JCB, December 13, 1985, RG 2, box 56.

142. Ravenel to JCB, April 14, 1986, RG 2, box 56. JCB responded with a note of appreciation, JCB to Ravenel April 21, 1986.

143. John Corry, "British Treasure Houses," *NYT*, December 16, 1985, C22.

144. John Russell, "The Private Palaces of Britain," *NYT Magazine*, October 27, 1985, SM47 ff; John Russell, "England's Glory: The Country House," *NYT*, November 3, 1985, H1, H35.

145. William Wilson, "The Estates of the Art of Stately Homes," *Los Angeles Times*, December 1, 1985, T3, T4.

146. For example, Irwin Molotsky, "Banged-Up Legs, a Bang-Up Show," *NYT*, November 7, 1985, B23. "Mr. Brown denies that he is in competition with the Met, but the director of the Met, Philippe de Montebello, says this is indeed the case."

147. Battiata, "Carter Brown & the Shining Heritage."

148. Robert Hughes, "Brideshead Redecorated," *Time*, 126 (November 11, 1985), 64–65.

149. David Cannadine, "Brideshead Re-Revisited," *New York Review of Books*, December 19, 1985, 20, 22.

150. Iain Pears, *Oxford Art Journal*, 9 (1986), 74–76.

151. Leslie Geddes-Brown, "The Great British Heritage for Sale," *Arts*, January 19, 1986.

152. Gervase Jackson-Stops, letter, *Sunday Times*, February 2, 1986.

153. Peter Watson, "Trust Counts Cost of Damaged Paintings," *Observer*, October 26, 1986.

154. "The Country House Comes Home," *Burlington Magazine* 128 (June 1986): 391.

155. [Richard Spear], "Art History and the 'Blockbuster' Exhibition," *Art Bulletin* 68 (September 1986): 358–59.

156. Both letters were published, along with Spear's response, in *Art Bulletin* 69 (June 1987): 295–97.

157. "The Pleasure Principle," *Apollo*, 125 (January 1987): 2.

158. Hoffman to JCB, January 5, 1987, RG 2, box 56. This type of attack had been launched by Debora Silverman, in *Selling Culture: Bloomingdale's, Diana Vreeland, and the New Aristocracy of Taste in Reagan's America* (New York: Pantheon, 1986).

159. JCB to Lord Charteris of Amisfield, January 14, 1985, RG 2, box 56. JCB's observation was that "except for the occasional leftist snippings in the press," the mood was one of a "continuing euphoria" about the exhibition.

160. JCB, Memorandum for the File, January 9, 1985, RG 2, box 55. The memorandum covered December 4–6, 1984.

161. JCB to Mrs. JNB, November 20, 1985, RG 2, box 56. The letter was written on his personal stationery, with the salutation "Dearest Ma." Anne Brown died on November 21.

162. JCB memo, January 15, 1985, RG 2, box 56. Confusion about Smithsonian-NGA relations lingered at the highest levels. At a dinner inaugurating NGA's Aztec art show in 1983, Vice President Bush "thanked retiring Smithsonian chieftain S. Dillon Ripley for letting everybody use the gallery for dinner, which must have surprised J. Carter Brown." Phil McCombs, "Art & The Big Guns," *WP*, November 10, 1983, C3.

Chapter 13

1. Paul Richard, "Renaissance Masterstrokes: Italian Drawings at National Gallery Renaissance Masters," *WP*, September 21, 1988, C1.

2. JW, oral history interview, July 27, 1987.

3. Jo Ann Lewis, "Jack Cowart & the Century's Trove," *WP*, February 24, 1987, C1.

4. John Stevenson, oral history interview, June 24, 1992, NGA/GA. Among other things, Stevenson feared Congress might want to use the Gallery for entertaining.

5. PM to Franklin Murphy, June 15, 1991, Franklin Murphy Papers, Special Collections, UCLA Library.

6. Paul Richard, "The Quest for Millions," *WP*, March 17, 1982, B1.

7. Carroll J. Cavanagh, oral history interview, November 18, 1992. As Cavanagh remembered it, the original goal was twenty-five million, but he and Carol Fox recorded the larger figure by mistake.

8. Ibid.

9. PM (with John Baskett), *Reflections in a Silver Spoon: A Memoir* (William Morrow, 1992), 377.

10. Richard, "Quest for Millions."

11. Ibid.

12. Phil McCombs, "Arts Beat," *WP*, January 5, 1983, C7. The paragraph was headed, "T'AINT NONE OF YER BUSINESS."

13. A large folder in the NGA files documents the effort to create this center at the Met. Mrs. Rorimer wrote JCB, February 22, 1987, asking for his help in opposing it, and enclosing a Hoving description. The New York press excoriated Annenberg and the museum. See, for example, Pete Hamill, "Heir to a Soiled Fortune Buys Museum's Soul," *New York Daily News*, March 2, 1977, RG 2, box 61.

14. JCB memo, July 14, 1978, RG 2, box 61.

15. Annenberg to JCB, October 6, 1980, RG 2, box 61. This celebrated picture would, decades later, become the center of a controversy as Alice Walton attempted to purchase it for the Crystal Bridges Museum in Bentonville, Arkansas, in partnership with NGA. A strenuous fund-raising campaign ensured that it would remain in Philadelphia.

16. JCB memo, April [no other date], RG 2, box 61.

17. PM to Walter Annenberg, October 9, 1980, RG 2, box 61.

18. JCB memo of telephone call, November 3, 1980, RG 2, box 61.

19. Ibid.

20. See, among others, "Personalities," *WP*, January 29, 1983, C3; Elizabeth Kastor, "The Glitter and Glow of Paul Mellon's Goodbye," *WP*, May 4, 1985, D1; and Donnie Radcliffe, "The Gallery's Week Worth Toasting," *WP*, October 11, 1991, D2.

21. Martha Sherrill, "Bush and the Munificent Mellon," *WP*, April 28, 1989, D1.

22. Paul Richard, "Funds for Art's Sake," *WP*, March 9, 1985, C3.

23. Ibid.

24. "National Gallery Pays $4 Million for Portrait," *WP*, December 6, 1985, 1.

25. Ibid., A21. See also Desson Howe, "The Peale Deal," *WP*, December 11, 1985, C4.

26. See Benjamin Forgey, "NGA Buys 3 Italian Paintings," *WP*, December 16, 1986, C1, C6; Paul Richard, "National Gallery Buys Rubens," *WP*, May 28, 1990; and Richard, "National Gallery Buys Dutch Masterpiece," *WP*, August 19, 1991, B1, B4.

27. Judd Tully, "Renoir's 'Moulin' Sells for $78 Million," *WP*, May 18, 1990, B1.

28. Judd Tully, "$82.5 Million for van Gogh," *WP*, May 16, 1990, A1. JCB commented on the sale at a Gallery dinner, noting that the painting would probably leave the country. "But we live in a global village, so we should at least rejoice that people take art so seriously." One guest remarked, "Carter can make something good out of nothing." Martha Sherrill, "At the National Gallery, Agog over van Gogh," *WP*, May 16, 1990, F10.

29. See, for example, Michael Kimmelman, "J. Carter Brown: A Farewell to an Era," *NYT*, February 23, 1992, H1, H37.

30. PM, *Reflections*, 314–15. The review was in *Women's Wear Daily*, February 18, 1992. A clipping of the review can be found in the files, along with JCB's memo to Joseph Krakora, January 29, 1992, discussing ways of promoting the new Mellon book. RG2, box 11, Records of the Office of the Director, Subject Files, Board of Trustees,

31. Notes for "Braided Lives," JCB Papers, JHL/BU.

32. Grace Glueck, "National Gallery Gets Early Cezanne," *NYT*, September 30, 1970, 1, 38.

33. "Trophy of Tenacity," *Time*, 96 (October 12, 1970),

34. "Personalities," *WP*, January 29, 1983, C3. President Reagan accepted the art at the Andrew W. Mellon dinner.

35. Benjamin Forgey, "Tracing an Artistic Journey: Paul Mellon's Gifts," *WP*, July 20, 1986, H1, H6.

36. Phil McCombs, "NGA Given Nine Major Paintings," *WP*, December 29, 1982, B1, B4.

37. See Sarah Booth Conroy, "The Whitney Way," *WP*, May 26, 1983, B1, B15.

38. Paul Richard, "A Gift of Harriman Art," *WP*, February 2, 1972, B1, B3.

39. JCB described his lengthy courting of Harriman, and John Walker's early involvement, in taped transcripts, Feburuary 15, 2002.

40. Paul Richard, "Museum Minuet: The Gentle Art of Courting a Collector," *WP*, August 31, 1980, G1.

41. For more on the Neumann collection see Deborah Solomon, "The Collector Who Is Breaking a Thousand Curators' Hearts," *NYT*, December 9, 1997, 114.

42. Paul Richard, "The Curatorial Courtship," *WP*, August 29, 1978, D1.

43. Jo Ann Lewis, "Jack Cowart & the Century's Trove," *WP*, February 24, 1987, C1, C4.

44. See Benjamin Forgey, "NGA to Get Postwar Collection," *WP*, January 9, 1987, B1, B8.

45. See Jacqueline Trescott, "Meyerhoff Estate to Become Wing of National Gallery," *WP*, March 5, 2008. The Baltimore County Council had voted, days earlier, to allow the home to be used as a gallery.

46. Lewis, "Jack Cowart," C4.

47. Ibid., C4.

48. It was also made public by the *Baltimore Sun*. See Benjamin Forgey, "NGA to Get Postwar Collection."

49. Conger sent Brown a copy of the governor's letter (received from a friend), December 18, 1986; that copy and JCB's reply to Conger are in RG 2, box 10, Director's Transitional Subject Files, Museums.

50. Author's interview with Daniel Herrick, May 13, 2010. Rusty Powell recalls JCB visiting Simon on a series of occasions to discuss the possibility of NGA taking over the collection. Simon, according to Powell, was suspicious of both the federal government and NGA. Author's interview with Powell, June 14, 2012. A brief paragraph notes the negotiations in Suzanne Muchnik, *Odd Man In: Norton Simon and the Pursuit of Culture* (Berkeley: University of California Press, 1998), 274. Simon famously dangled proposals before a series of institutions, including UCLA.

51. JCB memo, June 8, 1988, RG 2, box 3, Director's Transitional Subject Files.

52. JCB memo to Elizabeth Croog, June 22, 1988, RG 2, box 3, Director's Transitional Files.

53. JCB memo, July 22, 1988, RG 2, box 3, Director's Transitional Files.

54. Brown to Robert H. Smith, April 12, 1989, RG 2, box 3, Director's Transitional Files.

55. The Mandle memorandum is dated April 12, 1989, RG 2, box 3, Director's Transitioanl Files.

56. The call took place April 14; the JCB memorandum was dated April 19. RG 2, box 3, Director's Transitional Files.

57. Gail Meadows, "National Gallery, UM, Flirt with Deal," *Miami Herald*, May 8, 1989. A copy of this article is in RG 2, box 3, Director's Transitional Files.

58. Hilton Kramer, "Modern Art at the National Gallery," *New Criterion* 7 (April 1989): 4.

59. NGA Press Release, August 1, 1986. Viebranz was succeeded by Elizabeth Perry as corporate relations director.

60. This was included in an early 1991 announcement of art gifts promised to NGA. Heinz had earlier presented another painting to NGA.

61. C. David Heymann, *The Georgetown Ladies' Social Club: Power, Passion, and Politics in the Nation's Capital* (New York: Atria, 2003), 231–33.

62. Elizabeth Kantor, "National Gallery to Receive van Gogh's Rich 'Roses,'" *WP*, June 21, 1989, A1, A10.

63. See the NGA press release, June 20, 1989. The same day, three important works by Picasso, Matisse, and Brancusi, gifts from the Rita and Taft Schreiber collection, were announced. JCB admired Pamela Harriman's giving the picture even while she was in some financial difficulties. See JCB taped transcripts, February 15, 2002.

64. Author's interview with Andrew Robison, October 19, 2007.

65. Ibid. Some on the NGA staff, among them librarians, had hoped for some of the illustrated books and graphic art going to the Yale Center for British Art, and correspondence in the files indicates continuing concern about their destination.

66. Rita Reif, "42 Artworks Collected by Paul Mellon to Be Sold," *NYT*, August 8, 1989, C13.

67. Reif, "Getty Museum Buys a Manet for a Record Price," *NYT*, November 19, 1989, C18.

68. Andrew Robison, author's interview.

69. Congress added six months to the gift deadline in December 1991. See Jo Ann Lewis, "Art Tax Break Extended," *WP*, December 4, 1991, C3.

70. William H. Honan, "Through Loophole In Tax Law, Art Gifts Pour Into Museums," *NYT*, December 12, 1991, C15.

71. Judith Weinraub, "National Gallery's Ribera Gift," *WP*, December 22, 1990, D1, D10.

72. Paul Richard, "The Gallery's Golden," *WP*, March 17, 1991, G5.

73. Some of these would come to NGA only after PM's death.

74. Richard, "Gallery's Golden," 65.

75. Paul Richard, "The Artist's Gift of a Lifetime," *WP*, September 7, 1991, B1.

76. Richard, "Gallery's Golden," G5.

77. Heidi L. Barry, "Parting with Cherished Works of Art," *WP*, March 21, 1990, 10.

78. Grace Glueck, "The National Gallery Is Really Making Out Like, Well, a Bandit," *NYT*, March 11, 1991, C13, C16.

79. Michael Brenson, "National Gallery Puts Its Gifts on Display," *NYT*, March 18, 1991, C11-C12.

80. Author's interview with Jack Cowart, April 14, 2010.

81. See, among other pieces, Michael Ryan, "Trust Your Eye," *WP*, April 12, 1992, M10.

82. Carol Vogel, "National Is Pledged 2,000 Work Collection," *NYT*, January 8, 1992, C13.

83. Author's interview with Jack Cowart.

84. Author's interview with Ruth Fine, May 11, 2010.

85. Annenberg to JCB, March 2, 1987; JCB to Annenberg, March 9, 1987, RG 2, box 61.

86. JCB to Annenberg, December 21, 1987, RG 2, box 61.

87. JCB memo, May 8, 1986, documenting May 3 telephone call, RG 2, box 61.

88. JCB memo, October 7, 1986, RG 2, box 61.

89. Annenberg to JCB, June 9, 1988, RG 2, box 61.

90. Christopher Ogden, *Legacy: A Biography of Moses and Walter Annenberg* (Boston: Little Brown, 1999), 524.

91. Memo from Dodge Thompson to JCB, July 29, 1988, RG 2, box 61.

92. JCB to the Annenbergs, January 29, 1988, RG 2, box 61.

93. Annenberg, to JCB, February 1, 1988, RG 2, box 61.

94. JCB memo, February 19, 1988, RG 2, box 61.

95. JCB memo, February 10, 1988, RG 2, box 61.

96. JCB to Annenberg, May 31, 1988, RG 2, box 1, Director's Transitional Files.

97. Annenberg to JCB, June 9, 1988, RG 2, box 1, Director's Transitional Files.

98. JCB to Annenberg, February 1, 1989, RG 2, box 61.

99. JCB memo, May 1, 1989, RG 2, box 61.

100. JCB to the Annenbergs, RG 2, box 61, August 9, 1989.

101. Judd Tully, "$40.7 Million for Picasso Work," *WP*, November 16, 1989, C1.

102. JCB memo, August 29, 1989, RG 2, box 61.

103. Annenberg to JCB, August 29, 1989, RG 2, box 61.

104. Annenberg to PM, September 18, 1989, RG 2, box 61.

105. JCB memo, September 26, 1989, RG 2, box 61.

106. A clipping from the *Philadelphia Inquirer*, September 26, 1989, editorial page, was inserted in RG2, box 61, Records of the Office of the Director, Subject files, Fine Arts-Foundations.

107. JCB memo, December 4, 1989, RG 2, box 61.

108. Paul Richard, "The Art and Anger of Walter Annenberg," *WP*, May 23, 1989, D1.

109. JCB memo, December 4, 1989, RG 2, box 61.

110. JCB memo, June 2, 1989, RG 2, box 61.

111. Michael Kimmelman, "Was This Exhibition Necessary?" *NYT*, May 20, 1990, H35, H40.

112. JCB memo, May 18, 1990, RG 2, box 61. The memo was addressed to the Art and Education Committee of the Board of Trustees.

113. JCB to Annenberg, July 16, 1990, RG 2, box 61.

114. The Met's campaign and the larger competition is described by William H. Honan, "A Diplomatic Dance to Win the Annenberg," *NYT*, April 1, 1991, C11-C12. The article was accompanied by photographs of Philippe de Montebello, the winner, and the three other directors.

115. Ogden, *Legacy*, 526.

116. Honan, "Diplomatic Dance."

117. John Russell, "Annenberg Picks Met for $1 Billion Gift," *NYT*, 1, C12.

118. JCB to Annenberg, March 11, 1991, RG 2, box 61.

119. Jo Ann Lewis, "Annenberg Art Collection Going to N.Y.," *WP*, March 12, 1991, E1, E4. The subhead on the article read "Metropolitan to Get Works National Gallery Coveted."

120. Jack Kroll, "Giving Well Is the Best Revenge," *Newsweek* 117 (March 25, 1991): 50–51.

121. Max Frankel, *The Times of My Life and My Life with the New York Times* (New York: Random House, 1999), 517.

122. Sarah Booth Conroy, "For the Gallery's 50th Birthday, Wristful Thinking," *WP*, March 15, 1991, C1.

123. Annenberg to Murphy, March 25, 1991, RG 2, box 61. Annenberg sent JCB a copy of his letter to Murphy.

124. JCB to Annenberg, March 21, 1991, RG2, box 61, Records of the Office of the Director, Subject Files, Fine Arts-Foundations.

125. Murphy to Annenberg, April 1, 1991, RG 6, box 61,

126. *Newsweek*, March 25, 1991,

127. Margaret L. Davis, *The Culture Broker: Franklin D. Murphy and the Transformation of Los Angeles* (Berkeley: University of California Press, 2007), 338.

128. Paul Richard, "Gallery Gets Coveted Collection," *WP*, October 11, 1991, D1, D2.

129. JCB to Franklin Murphy, Feb. 20, 1990, RG 2, box 1, Director's Transitional Files.

130. Richard, "Gallery Gets Coveted Collection," D2.

Chapter 14

1. Francis Haskell, "Titian and the Perils of International Exhibition," *New York Review of Books*, August 16, 1990, 9.

2. Jonathan Yardley, "A High Price to Pay for Merchandising the Arts," *WP*, October 13, 1986, B2. Yardley was reviewing Debora Silverman's *Selling Culture*, a book that concentrated upon Diana Vreeland and the Metropolitan Museum of Art but whose argument could easily be extended to NGA.

3. Hank Burchard, "Open Eyes & Say Awe," *WP*, November 9, 1990, 44.

4. Chuck Conconi, "Personalities," *WP*, August 24, 1990, C3.

5. John Russell, "Centuries of Blue Skies o'er a 'Pastoral Landscape,'" *NYT*, November 13, 1988, H35.

6. Paul Richard, "The Wyeth Show as Money Magnet," *WP*, February 4, 1987, D1, D11.

7. Robert Hughes, "Art: Too Much of a Medium-Good Thing," *Time* 129 (June 1, 1987): 77.

8. Ibid. See also Paul Richard, "Wyeth's Book of The Month," *WP*, January 31, 19897, G1, G7.

9. Richard, "Wyeth Show as Money Magnet," D11.

10. Henry Allen, "The Wistful Realm of the Wyeths," *WP*, July 3, 1987, B1-B2. The critic Allen quoted who described Wyeth as the "spiritual leader of Middle America" was Jay Jacobs.

11. Hilton Kramer, *The Age of the Avant-Garde: An Art Chronicle of 1956–1972* (New York: Farrar, Straus, 1973), 250.

12. As quoted in Douglas C. McGill, "'Helga' Show Renews Debate on Andrew Wyeth," *NYT*, February 3, 1987, C13.

13. This was Carter Radcliffe, as cited by Allen, "Wistful Realm."

14. Richard Corliss, "Art: Andrew Wyeth's Stunning Secret," *Time* 118 (August 18, 1986): 56. This was a cover story.

15. "For the Love of Helga," *NYT*, February 6, 1987, A30.

16. "Met Museum Did Well to Refuse Wyeth Show," *NYT*, February 21, 1987, 26.

17. McGill,"'Helga' Show Renews Debate."

18. Douglas C. McGill, "Art People," *NYT*, October 9, 1987, C37.

19. John Russell, "For Museums, an Accent on Sense and Taste," *NYT*, December 27, 1987, H35.

20. Sarah Booth Conroy, "All Eyes on Helga," *WP*, May 22, 1987, B1.

21. Kara Swisher, "Wyeth's Early Risers," *WP*, May 25, 1987, C7.

22. Chuck Conconi, "Pesonalities," *WP*, May 20, 1987, D3.

23. McGill, "Art People."

24. Ibid.

25. John Wilmerding, *Andrew Wyeth: The Helga Pictures* (NY: Abrams, 1987), 31n1.

26. As quoted in McGill, "'Helga' Show Renews Debate."

27. Jack Flam, "The Wyeth Show: Of Hype and Helga," *Wall Street Journal*, June 12, 1987, 12.

28. Roberta Smith, "Wyeth's Helga, Alone and Floating," *NYT*, June 23, 1989, C26.

29. Jeffrey Schaire, "Wyeth's Hidden Helga and the Art Establishment," *NYT*, August 18, 1987, A17.

30. John Updike, "Heavily Hyped Helga," in *Just Looking: Essays on Art* (New York:

Knopf, 1989), 175–87. The essay appeared originally in the *New Republic* 197 (December 7, 1987): 27–30.

31. Andrews was quoted in McGill, "Art People."

32. The memo, dated May 4, 1980, can be found in RG 2, box 50, Records of the Office of the Director, National Gallery Exhibitions, NGA/GA. Unless otherwise indicated, the archival sources from this chapter come from boxes 50–53 in these files.

33. Letter writers included James Cahill of Berkeley, who wrote back November 23, 1985; John M. Rosenfield of Harvard, who transmitted his response from Seoul, November 29, 1985; and Robert Mowry from the Asia Society.

34. JCB memo, June 27, 1985, RG 2, box 50.

35. William B. Jordan to JCB, June 11, 1985, RG 2, box 50. Jordan was deputy director of the Kimbell Art Museum.

36. JCB memo, August 26, 1985, RG 2, box 50.

37. Freedberg to André Chastel, August 22, 1986, RG 2, box 50.

38. Annotated preliminary list for European decorative arts, dated December 1986, compiled by Candace Adelson, RG 2, box 50.

39. JCB memo, April 6, 1987, RG 2, box 50.

40. George Shultz to JCB, November 3, 1987, Records of the Office of the Director, RG 2, box 50.

41. For a portrait of Levenson at the time, see Martha Sherrll, "The Navigator to '1492,'" *WP*, October 10, 1991, D1, D11.

42. Author's interview with Jay Levenson, August 14, 2006.

43. The exhibition, along with the Titian retrospective, was announced in the fall of 1989. See Barbara Gamarekian, "Exhibitions are Planned on Titian and 1492 Art," *NYT*, October 13, 1989, C22.

44. JCB to Francesco Sisinni, April 27. 1988, RG 2, box 51.

45. JCB memo, April 15, 1988, RG 2, box 51.

46. JCB to Gilbert Grosvenor, June 22, 1988, RG 2, box 51.

47. JCB memo, July 20, 1988, RG 2, box 51.

48. JCB claimed to have used the phrase first in a toast given at the Pan-American Union. The Spanish ambassador "grew apoplectic," he recalled. JCB, tape transcript, February 20, 2002, JCB Papers, JHL/BU.

49. JCB memo, July 20, 1988, RG 2, box 51. A series of memos bearing this same date were fired off by JCB to his staff.

50. Memo from Jay Levenson, July 21, 1988, RG 2, box 51.

51. JCB memo for the files, December 14, 1988, RG 2, box 51.

52. JCB memo, January 6, 1989, RG 2, box 51.

53. JCB memo, January 6, 1989, RG 2, box 51.

54. Meeting minutes provided in Jay Levenson memo, February 6, 1989, RG 2, box 51. JCB created his own impression of the meeting in a memo dated February 9.1989, RG 2, box 51.

55. JCB memo, February 9, 1989, RG 2, box 51. This was JCB's own version of the meeting.

56. Ibid.

57. The budget can be found in RG 2, box 51. The catalog itself would be expensive, the proposed honoraria coming close to $150,000.

58. Levenson memo, March 1, 1989, RG 2, box 51.

59. JCB memo, May 9, 1989, RG 2, box 51.

60. JCB memo, May 15, 1989, RG 2, box 51. The JCB memos were usually sent to Dodge Thompson, coordinating the exhibitions, to Levenson, and often to Ravenel in the design and installation department.

61. JCB memo for file, June 13, 1989, RG 2, box 51.

62. Francesco Negri Arnoldi to JCB, April 15, 1989, RG 2 box 51. The letter was translated, somewhat awkwardly; the original, in Italian, is in the file.

63. In the files are a May 8, 1989, draft of a letter to Negri Arnoldi by Levenson; a memorandum to Levenson from JCB proposing changes; and the final letter dated May 12, 1989. In an internal memo dated May 15 JCB indicated the "key" importance of Negri Arnoldi to NGA plans, and concern about his opposition. For all of these see RG 2, box 51.

64. JCB to E. R. Turner, May 23, 1989, RG 2, box 51.

65. JCB memo, May 22, 1989, RG 2, box 51.

66. Akihiko Itoh to JCB, July 13, 1989, RG 2, box 51.

67. Proposed JCB letter, dated October 16, 1989, RG 2, box 51. It is not clear that the letter was sent. One of Brown's public relations advisers proposed a delay in seeking Japanese support; some other potential corporate supporters were leery of collaborating with a Japanese sponsor.

68. JCB memo, October 23, 1889, RG 2, box 51.

69. JCB memo, January 22, 1990, RG 2, box 51.

70. Levenson to JCB, February 22, 1990, RG 2, box 51.

71. JCB memo for file, January 22, 1990, RG 2, box 51. Brent Scowcroft was US national security adviser at the time.

72. JCB memo, March 16, 1990, RG 2, box 51.

73. JCB memo, February 20, 1990, RG 2, box 51.

74. Levenson to Exhibition Steering Committee, March 22, 1990, RG 2, box 51.

75. JCB to Pedro Santana Lopes, April 16, 1990, RG 2, box 51.

76. JCB to Antonio Paolucci, June 26, 1991, RG 2, box 52. JCB was arguing for some specific loans in this letter.

77. Memo from Jay Levenson to Exhibition Steering Committee, March 22, 1990, RG 2, box 51.

78. JCB memo, May 1, 1990, RG 2, box 51.

79. JCB memo, July 20, 1988, RG 2, box 51.

80. JCB to Jorge Semprun, July 6, 1990, RG 2, box 51. Jorge Semprun Maura was Spanish Minister of Culture at this time.

81. JCB memo, February 8, 1990, RG 2, box 51.

82. JCB to Ms. Tracy Roberts, May 3, 1990, RG 2, box 51.

83. JCB memo, December 4, 1990, RG 2, box 51.

84. See JCB to Giacomo Antonelli, October 22, 1990, RG 2, box 51. Levenson had proposed the reunion of these two items in a February 2, 1990, memo to the Steering Committee.

85. JCB to Rick West, December 10, 1990, RG 2, box 51. This was a recounting of a lengthy conversation with West, who would be the first director of the Smithsonian's National Museum of the American Indian, and contained references to other contacts with Smithsonian specialists.

86. JCB to Gomez de Pablos, March 7, 1990, RG 2, box 51.

87. JCB to Jaime de Ojeda, March 12, 1991, RG 2, box 51.

88. During his 1989 Japanese trip, JCB had met with the chairman of Nomura Securities. See JCB memo, May 22, 1989, RG 23, box 51.

89. Press kit, October 9, 1990, RG 2, box 51. The plan was divided into three acts, with statements by JCB, Levenson, and other NGA officers, lunch, slide presentations, and appearances by the sponsoring corporations. It typified JCB's attention to media cultivation, and the work of Ruth Kaplan.

90. JCB memo, February 12, 1991, RG 2, box 51.

91. Alfonso Pérez Sánchez to JCB, February 18, 1991; JCB to Pérez Sánchez, March 8, 1991, RG 2, box 51.

92. JCB to Baron Thyssen-Bornemisza, March 22, 1991, RG 2, box 51. "Dear Heini," JCB began, assuring him that NGA had successfully transported panel paintings in the past. One month later, April 23, 1991, he wrote the baron and his wife, indicating that he was confident the Prado would lend NGA its Dürer for the exhibition.

93. JCB to Felipe Garin, March 23, 1991, RG 2, box 51.

94. See JCB memo, May 1, 1991, RG 2, box 52.

95. JCB to Joe Zappala, n.d., RG 2, box 51. Presumably this was in April 1991.

96. JCB to Don Sabino Fernández Campo, June 5, 1991, RG 2, box 52. Fernández Campo was chief of the house of the king. "The New York Yacht Club, of which my father was commodore, now occupies our family house . . . on the waterfront, and I know that if His Majesty had a minute for a sail, that could be easily arranged."

97. JCB to Ojeda, nd, RG 2, box 52, enclosing a fax of his note to Director Garin of the Prado.

98. Lucia Cassol to JCB, May 13, 1991, RG 2, box 52. Cassol was the registrar of the Fondazione Thyssen-Bornemisza. JCB had written three separate times requesting the Dürer.

99. JCB to Jaime de Ojeda, July 1, 1991, RG 2, box 52.

100. See JCB to Mrs. Nicholas Philips, June 12, 1991, RG 2, box 52. JCB sent a copy of this letter to Gervase Jackson-Stops, his old friend and collaborator, hoping he might be of use.

101. JCB memo, November 11, 1989, RG 2, box 51.

102. Joseph Czestochowski to JCB, February 22, 1990, RG 2, box 51.

103. JCB memo, March 16, 1990, RG 2, box 51.

104. JCB to James Baker, March 15, 1991, RG 2, box 52.

105. Author's interview with Jay Levenson.

106. JCB to Giulio Andreotti, May 1, 1991, RG 2, box 52.

107. State Department cable, July 15, 1991, RG 2, box 52.

108. Ibid.

109. JCB to Marek Rostworowski, July 17, 1991, RG 2, box 52.

110. JCB to Kazimierz Dziewanowski, July 18, 1991, RG 2, box 52.

111. Memo, July 19, 1991, RG 2, box 53.

112. Memo of Reed call, July 19, 1991, RG 2, box 52. Reed told JCB, after a meeting with the Polish minister of culture, that NGA would get 85 percent of what it wanted, but there were a few things that would not come (including, possibly, the Leonardo).

113. Dziewanowski to JCB, July 25, 1991; JCB to Dziewanowski, July 29, 1991, RG 2, box 52.

114. JCB memo, July 24, 1991, RG 2, box 52. JCB circulated this to several senior members of his staff.

115. JCB to Michael Hornblow, July 25, 1991, RG 2, box 52. Hornblow was chargé d'affaires in Warsaw.

116. JCB to Pope John Paul II, July 26, 1991, RG 2, box 52. In tape transcripts, JCB, after describing his father's part in recovering the altarpiece and the future's pope's relationship to it, confided, "I had always hoped that I could use that for loans from the Vatican, but I never quite figured out how to do it." JCB, tape transcript, February 19, 2002.

117. A translated copy of the July 30 article in *Gazeta Wyborcza* is in the files, RG 2, box 52.

118. JCB to Tadeusz Chruścicki, July 31, 1991, RG 2, box 52. A condition report from Sarah Fisher, July 26, 1991, said transport of *Ginevra* was risky in view of the insecurity of its paint.

119. Freedberg to JCB, August 2, 1991; JCB to Freedberg, August 8, 1991, RG 2, box 52.

120. JCB to Ambassador Designate, September 6, 1991, RG 2, box 52.

121. Levenson to JCB, September 10, 1991, RG 2, box 52.

122. Levenson memo, September 11, 1991, RG 2, box 52.

123. JCB to Levenson, September 20, 1991, RG 2, box 52.

124. JCB memo, October 2, 1992, RG 2, box 52.

125. JCB to Agnelli, September 23, 1991, RG 2, box 51.

126. JCB memo of telephone call from Agnelli, October 21, 1991, RG 2, box 52.

127. Marta Engel, October 9, 1991, clipping in file, RG 2, box 52. See also Jacek Kalabiński, "Lady with an Ermine," *Polish News Bulletin*, August 8, 1991, a supportive piece emphasizing the careful protections being afforded the painting, but noting, "In America it is unthinkable that the President would instruct the director of a museum to lend a painting which should not be moved." In fact, in the years after its Washington trip, *Lady with an Ermine* would make other lengthy voyages to exhibitions.

128. Freedberg to JCB, October 14, 1991, RG 2, box 53.

129. JCB to Freedberg, November 5, 1991, RG 2, box 53.

130. Freedberg to JCB, October 29, 1991, RG 2, box 53.

131. JCB to Freedberg, November 5, 1991, RG 2, box 53.

132. Michael Kimmelman, "'Circa 1492': A Magnificent Muddle," *NYT*, October 29, 1991, H1, H37.

133. Anthony Gerber, "Praiseworthy Blockbuster," *NYT*, November 10, 1991, H4.

134. See Levenson memo to JCB, April 7, 1992, commenting upon newspaper coverage in *NYT* and the *Wall Street Journal*, raising issues of political correctness and the "shoals" that threatened the exhibition. Levenson defended the manner in which objects were chosen and emphasized the need to stress the "ambiguity" of the Columbian encounter, the tragedies of civilizations destroyed, the seeds of world unity being planted.

135. "Storm over Columbus Celebrations," *WP*, October 15, 1991, B1.

136. As quoted by Charles Krauthammer, "Hail Columbus, Dead White Male," *Time* 137 (May 27, 1991): 74.

137. Ibid. The *WP* editorial, "Hailing Columbus, Carefully," appeared October 12, 1991, A24. Newspapers and magazines were filled with articles about the controversy, and dozens of books were published. See, for example, Nina King, "What Hath Columbus Wrought?" *WP*, October 13, 1991, 1, 8. A helpful guide to the debate is Bryan Le Beau, "The Rewriting of America's First Lesson in Heroism: Christopher Columbus on the Eve of the Quincentenary," *American Studies* 33 (Spring 1992): 113–27.

138. JCB to Peter Gerber, August 23, 1991, RG 2, box 53. Gerber was director of the MacArthur Foundation's educational programs. JCB had been trying to arrange a MacArthur grant since October 1990, approaching Pamela Harriman for her help. Much earlier, PM had tried to interest MacArthur in the Patrons' Permanent Fund.

139. JCB memo, September 27, 1991, RG 2, box 53.

140. Robert Rosenblum to JCB, October 23, 1991, RG 2, box 53.

141. JCB to Rosenblum, November 4, 1991, RG 2, box 53.

142. Rosenblum to JCB, November 10, 1991, RG 2, box 53.

143. Paul Richard, "Around the World in Masterpieces," *WP*, October 12, 1991, D1.

144. Cynthia Grenier, "Feast Fit for a King Ushers in '1492' Art," *WP*, October 10, 1991, E1. Genevra Higginson, the dinner coordinator, declared the resemblance JCB posited to be "sheer serendipity" but declared, "We started growing plants in our greenhouses a year ago for this evening."

145. Hank Burchard, "Discovering Three Worlds," *WP*, October 11, 1991, N65.

146. Eric Gibson,"1492 Comes to National Gallery," *Washington Times*, October 11, 1991, E1.

147. JCB memo, October 9, 1991, RG 2, box 53.

148. JCB memo, November 4, 1991, RG 2, box 53.

149. JCB memo, October 15, 1991, RG 2, box 53.

150. JCB memo, November 12, 1991, RG 2, box 53.

151. JCB memo, October 15, 1991, RG 2, box 53.

152. Creighton Gilbert, "A Celebrated Age," *New Criterion* (January 1992), 45–48.

153. See Eric Gibson, "Columbus: Is He Lost in All the Hoopla?" *Washington Times*, September 8, 1991, D3.

154. Richard Ryan, "1492 and All That," *Commentary* 93 (May 1992): 42. Ryan's review stimulated some angry responses, including one by Martin Weyl, director of the Israel Museum. JCB described it as an "extremely silly article" and "one of the more benighted critiques." See JCB to Robert H. Smith, RG 2, box 2, Director's Transitional Files.

155. Ibid., 43–44.

156. Ibid., 44–45.

157. Homi K. Bhabha, "Double Visions," *Artforum International* 30 (January 1992): 85–89.

158. Stephen Greenblatt, "A passing marvellous thing . . . ," *Times Literary Supplement*, January 3, 1992, 14–15.

159. Some editorialists brought up multiculturism at JCB's retirement. Praising his tenure, the *Washington Times* regretted the "political correctness" of parts of *Circa 1492* and hoped the trustees would resist pressure "to choose someone with chips about sexism, racism and elitism all over the shoulder." "Whither the National Gallery?" *Washington Times*, February 4, 1992, F2.

160. Carol Vogel, "National Gallery Appoints Director to Succeed Brown," *NYT*, April 29, 1992, C15.

Chapter 15

1. JCB's successor as director, Earl (Rusty) Powell, recalled a conversation months earlier in which JCB suggested he was thinking about retirement in the near future.

But Powell seems to have been almost alone in knowing this. Author's interview with Rusty Powell, June 14, 2012.

2. JCB to Wilhelmina Cole Holladay, October 29, 1982, box 5, JCB correspondence, JHL/BU. Brown had received a letter, October 10, 1982, from "A Concerned Friend," warning him about these rumors.

3. Speaking of the health rumors, JCB pointed out that he had recently donated blood to his son, "an oblique but clear denial to whispered suggestion that Brown, a man who tends toward the gaunt at the best of times, has AIDS." Elizabeth Kastor, "Carter Brown, Personally Speaking," *WP*, April 2, 1992, D1.

4. JCB to Mme. Fabrice Gaussen, July 18, 1993, box 5, JCB Correspondence. The letter describes recent travels to Rome, Florence, Geneva, Prague, Avignon, and St. Petersburg, and upcoming trips to New England and the Netherlands, as well as work for the Pritzker Prize, the American Academy in Rome, and the World Monuments Fund Forum.

5. A chart, taken from the *Chronicle of Philanthropy*, pegged his salary at $195,000, with $73,055 in benefits. See Michelle Singletary, "Probing the Pay at Nonprofits," *WP*, May 3, 1993, 17.

6. Blake Gopnik, "Leonardo Drawing Sets Record at Sale," *WP*, July 11, 2001, C1.

7. This was stated by JCB in tape transcript, February 19, 2002. By this time he had been diagnosed with blood cancer.

8. Ann Gerhart and Annie Groer, "The Reliable Source," *WP*, May 1, 1997, CO3. JCB apparently feared his neighbor might decide to do a celebrity biography of him.

9. Much has been written on the Barnes Foundation, its history, and the controversial move to its new Philadelphia location. Biographies of Barnes, films, and extensive newspaper and magazine coverage are available. For one scholarly study of Barnes, see Mary Ann Meyers, *Art, Education, and African-American Culture: Albert Barnes and the Science of Philanthropy* (New Brunswick, NJ: Transaction, 2004). Chapters 16–18 treat the 1990s and beyond.

10. Meyers, *Art, Education and African-American Culture*, 326, argues that the idea for the traveling exhibition originated with one of Annenberg's nieces, Cynthia Hazen Polsky. Annenberg then took it up with Brown.

11. JCB to Glanton, January 24, 1992, as quoted in Anne Higonnet, "Whither the Barnes?" *Art in America* 82 (March 1994): 68. JCB wrote a letter, March 25, 1994, disputing some of the facts presented by Higonnet, but not denying authorship of the letter to Glanton. JCB insisted that the the NGA did not initiate the Barnes tour but had been invited by the foundation to get involved months earlier, and this letter was a response to that request. For photocopies of articles and other materials relating to the Barnes see box 24, JCB Papers.

12. Carol Vogel, "A Controversial Man in an Eccentric Place," *NYT*, April 4, 1993, H34.

13. Carol Vogel, "Barnes Gets Go-Ahead on International Tour," *NYT*, July 24, 1992, C18.

14. Jo Ann Lewis, "Arts Council Eyes Broader Insurance Program," *WP*, March 2, 1993, E1, E3. See also William H. Honan, "Dispute over Insurance Imperils a Barnes Show," *NYT*, March 6, 1993, 16.

15. Jo Ann Lewis, "Arts Council Reverses Vote to Insure Show," *WP*, April 10, 1993, C1, C6.

16. Among other critiques, see Robert Hughes and Daniel S. Levy, "Art: Opening

the Barnes Door," *Time* 141 (May 10, 1993): 61–64; and Steven Vincent, "Tour de Force," *Art & Auction* 15 (April 1993): 80–85, 113–14.

17. Ann Geracimos, "Wow of an Opening and Show," *Washington Times*, April 30, 1993, E2.

18. A favorable review came from Michael Kimmelman, "A Famous Collection Escapes Its Moorings," *NYT*, May 2, 1993, H35.

19. "Just You Wait . . . and Wait," *Washington Times*, June 26, 1993, C2.

20. Carol Vogel, "An Art Tour Comes Home, Its Fortune Made," *NYT*, November 19, 1995, H47.

21. Ibid.

22. Janet Kutner, "Barnes Exhibit Drew Record Crowd," *Dallas Morning News*, August 17, 1994, 27A.

23. Barbara Kingstone, "Barnes Gets Seal of Approval," *Toronto Sun*, September 18, 1994, S10; Deirdre Kelly, "From Street Cars to Salons: Banking on the Barnes," October 22, 1994. Kelly spent most of her time analyzing the economic impact of the show on Toronto, describing public displays of "Barnesmania."

24. "Incorrigible elitists" was used in a letter from JCB to John Herdeg, May 5, 1993; the letter to Kramer, marked unsent, is dated May 13, 1993. Both are in box 23, JCB Correspondence, JHL/BU.

25. Dale Russakoff, "A Bitter, Beautiful Legacy," *WP*, May 2, 1993, G7.

26. Kingstone, "Barnes Gets Seal of Approval."

27. Michael Kimmelman, "Sublime Sculptures in a Dubious Setting," *NYT*, November 22, 1992, 31.

28. Holland Cotter, "Greeks at the Met," *NYT*, March 12, 1993, C1

29. Robert Hughes, "Art: The Masterpiece Road Show," *Time* 141 (January 11, 1993): 48; David D'Arcy, "Whatever Happened to J. Carter Brown?" *Art & Auction* 16 (June 1994): 84–87, 114.

30. Kimmelman, "Sublime Sculptures."

31. Eric Gibson, "Will Exhibit of Greek Art Travel Well?" *Washington Times*, June 7, 1992,

32. Eric Gibson, "'Greek Miracle': Touchstone of Classic Art on Exhibit," *Washington Times*, November 22, 1992, D1.

33. Eric Gibson, "Masterpieces on the Move," *Washington Times*, December 13, 1992, D1.

34. Judith Weinraub, "NGA Snares Greek Exhibit," *WP*, June 5, 1992, C1.

35. Louise Sweeney, "Three-Way Swap Brings Greek Statues to U.S.," *Christian Science Monitor*, June 11, 1992, 12.

36. Grace Glueck, "Still Packaging Culture for the Multitudes," *NYT*, April 14, 1996, H1.

37. Ned Rifkin, "Foreword," in *Rings: Five Passions in World Art*, edited by Michael Shapiro (New York: Abrams, 1996), 11.

38. Paul Richard, "J. Carter Brown, Lord of the 'Rings,'" *WP*, December 12, 1995, B1.

39. Glueck, "Still Packaging Culture."

40. Ben Brown, "Let the Arts Extravaganza Begin," *USA Today*, March 22, 1996,

41. Bradley Bambarger, "Olympic Arts Exhibition Attuned to Savall's Music," *Billboard*, March 2, 1996.

42. Todd Allan Yasui, "The Music Is the Message," *WP*, November 5, 1990, B7.

43. Peter Applebome, "At the Atlanta Games, Culture Will Be a Serious Competitor," *NYT*, February 1, 1996, C11.

44. Ibid.

45. Joanna Shaw-Eagle, "Passions Exhibit Set for Atlanta," *Washington Times*, March 21, 1996.

46. Benjamin Forgey, "Olympic Visions: Five Ring Circus," *WP*, July 14, 1996, C1.

47. Catherine Fox, "Lord of the Rings," *Atlanta Journal-Constitution*, n.d. (probably early July 1996).

48. Forgey, "Olympic Visions."

49. Roberta Smith, "Esthetic Olympics, in 5 Shades for 5 Rings," *NYT*, July 4, 1996, C9, C15.

50. Malcolm Jones Jr., "The Arts Games," *Newsweek* (July 29, 1996), 64.

51. Ben Brown, "Let the Arts Extravaganza Begin," *USA Today*, March 22, 1995, 7D.

52. Jones, "Arts Games."

53. Jed Perl, *New Republic* 215 (October 7, 1996): 32–34.

54. Christopher Knight, "Wins, Losses," *Los Angeles Times*, July 5, 1996.

55. Deborah Solomon, "The Art of the Olympics," *Wall Street Journal*, July 5, 1996.

56. JCB letter, *Wall Street Journal*, July 29, 1996,

57. Lawson Taitte, "Olympians of Art Gather," *Dallas Morning News*, July 22, 1996, 19A.

58. Robert W. Duffy, "Linking Art & Games," *St. Louis Post Dispatch*, June 30, 1996.

59. Ellen Kanner, "Love, anguish, awe, triumph, and joy," http://bookpage.com/9608bp/nonfiction/rings/html.

60. Glueck, "Still Packaging Culture." See also the article by Joan Altabe, http://www.examiner.com/article/the-games-are-about-more-than sports-1.

61. JCB to Tina Brown, August 1, 1996, box 2, JCB Correspondence.

62. JCB to Elizabeth Robbins, October 21, 1996, box 2, JCB Correspondence.

63. Miriam Longino, "High Exhibit," *Atlanta Journal Constitution*, August 23, 1996, 01D.

64. http://museumsandtheweb.com/mw99/papers/mencher/mencher.html.

65. Carol Vogel, "Carter Brown to Ovation, New Arts Cable Network," *NYT*, March 3, 1993, C15.

66. Ibid.

67. "The Media Business," *NYT*, September 20, 1995, D5.

68. Hanns-Jochen Kaffsack, "Will Americans Stand Up and Cheer for Ovation" *Deutsche Press-Agentur*, April 25, 1996.

69. Ann Geracimos, "Ovation Network Looks for Audience," *Washington Times*, January 18, 1998, D1.

70. For more on its history, see Nicolaus Mills, *Their Last Battle: The Fight for a National World War II Memorial* (New York: Basic Books, 2004).

71. Karl Ringle, "Art Criticism Meets a Few Angry Marines," *WP*, March 11, 1998, D01; Rowan Scarborough, "Arts Chief: Marine Memorial 'Great,'" *Washington Times*, A4.

72. See Janny Scott, "Planned War Memorial Sets Off Its Own Battle in Washington," *NYT*, March 18, 1997, C13.

73. "Hallowed Ground in Jeopardy," *NYT*, July 4, 1997, A18.

74. Linda Wheeler, "W.W. II Memorial Goes Back to Drawing Board," *WP*, July 25, 1997, A01

75. Bill Press, "The Rape of the Mall," *Washington Times*, July 31, 1997, A17.

76. Boxes 101–102, JCB Papers, contains clippings and letters relevant to the controversy. JCB complained about a huge campaign of misrepresentation that had poisoned the discussion. See JCB to Ada Louise Huxtable (one of the competition judges), July 28, 1997, describing a "cabal of messianic detractors." Box 102, JCB Papers.

77. Patria Gaines, "W.W. II Memorial Moves Closer to Reality," *WP*, May 21, 1999, B01; Ronald J. Hansen, "Fine Arts Panel OK's Concept of Memorial for World War II," *Washington Times*, May 22, 1998, C9.

78. Linda Wheeler, "W.W. II Memorial Clears Key Hurdle," *WP*, July 21, 2000, A01.

79. Joshua Fishkin, "Monumental Error," *New Republic* 223 (September 25, 2000): 14.

80. Richard Moe, "Carter Brown's Washington," *WP*, June 19, 2002, A21.

81. Kevin Chaffee, "Choral Benefit Honors Brown," *Washington Times*, April 10, 2002, B8.

82. JCB to Hoving, January 5, 1993, box 4, Post-1992 Correspondence, JCB Papers.

83. Jo Ann Lewis, "Master Impressionist," *WP*, February 21, 1993, G4; clipping found in JCB Papers.

Index